© 2007 by Andrew Balerdi

About the Author

Born and raised in the United States, SUSAN RONALD has lived in England for more than twenty years. She has consulted for five British government departments and The National Trust, and she is the author of *The Sancy Blood Diamond*, a six-hundred-year history of a cursed gem, and *France: The Crossroads of Europe*, a cultural and historical overview for young adults. She lives in Oxfordshire, England.

Also by Susan Ronald

The Sancy Blood Diamond
France: The Crossroads of Europe, as Susan Balerdi

The Pirate Queen

QUEEN ELIZABETH I,
HER PIRATE ADVENTURERS,
AND THE DAWN OF EMPIRE

Susan Ronald

HARPER PERENNIAL

NEW YORK • LONDON • TORONTO • SYDNEY • NEW DELHI • AUCKLAND

HARPER ● PERENNIAL

FIRST HARPER PERENNIAL EDITION PUBLISHED 2008.

Designed by Leah Carlson-Stanisic

The Library of Congress has catalogued the hardcover edition as follow:

Ronald, Susan.
 The pirate queen : Queen Elizabeth I, her pirate adventurers, and the dawn of empire / Susan Ronald.—1st ed.
 xxiv, 471 p., [16] p. of plates : ill., maps ; 24 cm.
 Includes bibliographical references (p. [430]–442) and index.
 ISBN: 978-0-06-082066-4
 ISBN-10: 0-06-082066-7
 1. Elizabeth I, Queen of England, 1533–1603. 2. Elizabeth I, Queen of England, 1533–1603—Relations with merchants. 3. Queens—Great Britain—Biography. 4. Great Britain—History, Naval—Tudors, 1485–1603—Economic aspects. 5. Great Britain—History—Elizabeth, 1558–1603—Sources. I. Title.
DA356 .R58 2007
942.05'5092B 22 2006053171

ISBN 978-0-06-082067-1 (pbk.)

08 09 10 11 12 /RRD 10 9 8 7 6 5 4 3 2 1

For Doug

There is no jewel, be it of never so rich a price, which I set before this jewel—I mean your loves. For I do more esteem it than any treasure or riches, for that we know how to prize. But love and thanks I count unvaluable [invaluable], and though God hath raised me high, yet this I count the glory of my crown: that I have reigned with your loves. This makes me that I do not so much rejoice that God hath made me to be a queen, as to be a queen over so thankful a people . . . so I trust by the almighty power of God that I shall be His instrument to preserve you from envy, peril, dishonor, shame, tyranny, and oppression, partly by means of your intended helps

—EXTRACT FROM ELIZABETH I's *Golden Speech* TO PARLIAMENT
NOVEMBER 30, 1601

Contents ❧

Illustrations ❧

Title Page: *Elizabeth I's signature*, by permission of the Bodleian Library, University of Oxford, from Ashmole 1729, fol. 13

Part title I: *Coronation Procession of Queen Elizabeth I*, by the kind permission of the Archivist, the College of Arms, London

Part title II: *Fan-shaped world map by Michael Lok*, by permission of the Bodleian Library, University of Oxford, ref. 4°E 2.Jur(4)

Part title III: *Map from the Bay of Biscay to the Southern English Coast*, by Thomas Hood, by the kind permission of the National Maritime Museum, Greenwich

Part title IV: *Map of the East Indies*, by Ortelius, by the kind permission of the National Maritime Museum, Greenwich

Queen Elizabeth I, c. 1578, believed to be painted in oils by Nicholas Hilliard, by permission of the Liverpool Museums and Walker Art Gallery

Robert Dudley, Earl of Leicester, by van der Meulen, by the kind permission of the trustees of the Wallace Collection, London

Philip II of Spain, by unknown artist, by permission of National Portrait Gallery, London

Lord Admiral Charles Howard, by the kind permission of the National Maritime Museum, Greenwich

Map of the Gulf of Mexico and the Caribbean, by Jacques Dousaigo, by the kind permission of the National Maritime Museum, Greenwich

Map of Virginia Coast, by the kind permission of the National Maritime Museum, Greenwich

Sir William Cecil, by permission of the Bodleian Library, University of Oxford, ref. LP 38

Sir Francis Walsingham, by John de Critz, by permission of the National Portrait Gallery, London

Sir John Hawkins, by the kind permission of Plymouth Museums and Art Gallery

Sir Francis Drake, by Nicholas Hilliard, by permission of the National Portrait Gallery, London

Martin Frobisher, by permission of the Bodleian Library, University of Oxford, ref. LP 50

Sir Walter Raleigh, by "H," by permission of the National Portrait Gallery, London

Map of Drake's circumnavigation of the globe, by permission of the British Library

Robert Devereux, second Earl of Essex, by unknown artist, by permission of the National Portrait Gallery, London

The Deed of Grant of Virginia to Sir Walter Raleigh, by the kind permission of Plymouth Museums and Art Gallery

View of the Thames, by the Flemish School, by the kind permission of the Museum of London

Troops Arriving in Antwerp, by permission of the British Library

Letter from Elizabeth I to Sir William Cecil in the queen's hand, 1572, by permission of the Bodleian Library, University of Oxford, ref. Ashmole 1729, fol. 13

View of River Thames and the Tower of London, by permission of the British Library

The Armada Tapestry, by the kind permission of Plymouth Museums and Art Gallery

Matthew Baker, shipwright, Designing a Ship, by the kind permission of the Pepsyian Library, University of Cambridge

Baker's design of a ship using a cod to demonstrate the desired shape, by the kind permission of the Pepsyian Library, University of Cambridge

Map of Western Atlantic from Newfoundland to Brazil, by Freducci, by permission of the National Maritime Museum, Greenwich

The Armada Portrait of Queen Elizabeth I, by kind permission of His Grace the Duke of Bedford and the Trustees of the Bedford Estates

Acknowledgments ❧

To perhaps misquote Sir Isaac Newton, "If I have been able to see as far as I have, it is because I have been able to stand upon the shoulders of giants." Great subjects like Elizabeth Tudor and all her adventurers have survived to be written about from the Elizabethan era to the current day due to the loving attention of so many individuals across the generations—both known and anonymous. They are too numerous to thank individually here, but I would like to thank each and every one of you en masse. I owe you so much above all others for allowing me to glimpse into Elizabeth's world. To the scores of original-manuscript collectors like Sir Thomas Egerton; Sir Thomas Bodley; Robert Cecil, the Marquis of Salisbury, through to Sir Hans Sloane, my thanks for your feverish gathering of letters and papers of national and international importance, and your keeping them safe for later generations. To the Victorian greats like Julian Corbett, Michael Oppenheimer, and all the researchers and painstaking editors of the thousands of letters engrossed into the volumes of the *Calendar of State Papers*, the *Acts of the Privy Council*, the Hakluyt Society, and the Seldon Society for its *Register of the High Court of Admiralty Pleas*, I am truly in your debt. The modern greats like R. B. Wernham, Irene A. Wright, Conyers Read, Professor Kenneth R. Andrews, John Sugden, N. A. M. Rodgers, and David Loades are the true masters of Elizabeth's maritime England, and Geoffrey Parker remains unexcelled in my opinion as the English language's expert on Philip II and the Dutch Revolt. Without the great institutions and their incredibly helpful staffs at the British Library, the National Archives, the Caird Library at the National Maritime Museum, the University of Oxford and the Bodleian Library, the Bank of England, the Folger Shakespeare Library in Washington, D.C., and the most remarkable Archivio de Indias in Seville, this book would simply not have been possible.

I would also like to thank all those who had a hand in making the visual side of the book so very special. To the National Portrait Gallery; the National Maritime Museum Picture Library; the Bodleian Library; the Pepysian Library, Magdalene College,

Cambridge; the British Library; the Walker Gallery and Liverpool Museums; Museum of Plymouth; Museum of London; the Royal College of Arms; the Wallace Collection; and particularly His Grace, the Duke of Bedford, I would like to extend my special thank-you.

My personal thanks to my researcher, Andrew Baleidi, for freeing me up to complete this book by beginning research on the next one for me. To my sons—Matt, Zandy, and Andrew—thanks for putting up with me. To my mother, my heartfelt thanks for your support. To my editor, the extraordinary Hugh Van Dusen at HarperCollins, and the entire HarperCollins team (Marie Estrada, Robert Crawford, and all those behind the scenes), thank you, thank you, thank you. To my agent, Alexander Hoyt: Who would have thought . . . ?

And to my husband, Doug, without whom nothing could ever be possible, this is for you.

Author's Note ✣

For those readers looking for a bodice ripper about Elizabeth's loves, I fear I would disappoint you in *The Pirate Queen*. But if, on the other hand, you always wanted to know *more* about Elizabeth as a person and a monarch, then please read on. Since I was a young child I have been fascinated by Elizabeth Tudor beyond her putative love affairs, and especially how this phenomenal woman had been able to rule with an iron fist in an age of pure male domination. She was the first female ruler of England to rule in her own right. However one speculates about her real reasons, she was determined to remain her own mistress and thereby guarantee England its independence from foreign domination. I especially wanted to know how she was able to achieve this so successfully.

The Pirate Queen, in part, provided me, and hopefully will provide you, with many of the answers. She had the quick intellect of her mother, her father's boldness, and both of their bad tempers. She was hugely vain and courageous; highly educated and gifted; monumentally abused in her youth and shunned by family, church, and society. She at times played her advisors and courtiers consciously off against one another, and more often than not she listened to the sage counsels of William Cecil, Lord Burghley, above all others. Robert Dudley, Earl of Leicester, remained the love of her life, and, as such, it is immaterial if that love was consummated. In the queen's mind, she was a virgin, married to the country, and intent on keeping England independent of foreign princes, come what may. Elizabeth was all these things, and many more.

In her time, the English Renaissance took root and flourished, spawning the great talents of Sidney, Gascoigne, Spenser, Kyd, Marlowe—and killing three of the five in "service of the realm" prematurely. Great poets like Raleigh, the embodiment of courtly love and adventuring, as well as Dyer, a gentleman adventurer, too, help us glimpse behind the curtain of time into Elizabeth's court. Chettle, Nashe, Lodge, and, of course, the remarkable Shakespeare, all found their voice in Elizabeth's England. But why was this so? The reasons are far too varied to do justice to here, other than to say that the writers themselves reflected the times: ordinary people went to the

theater to learn about history or England's friends and foes. It was a time of tremendous change, and the queen herself wanted to engage her people (on her side naturally) in the process. That engagement process was a double-edge sword—making and breaking the lives of her most gifted early writers. It also transformed English from a language spoken by very few on the fringes of Europe into the ever-changing, ever-growing world lingua franca that it is today.

In the cauldron brewing between Protestant and Catholic, courtier and adventurer, Spain and the Papacy, Ireland and Scotland, the Dutch and their Spanish overlords, Elizabeth remained constant, imperious, and imperial. She dominated all she surveyed through cunning, wit, loyalty, charm, bad temper, an aura of extreme wealth, and parsimony. It was her parsimony that aggravated her courtiers and councillors to distraction, making her seem weak and indecisive. She was famous for giving her "answer answerless" and wearing her opponents down with her rhetorical arguments. Yet in the end, she became the embodiment of the English psyche and kept the country independent from the Catholic threats posed by Spain and the Papacy. She survived more than twenty assassination attempts, and, with her, England survived, too.

She was above all an incredibly astute businesswoman as head of state. She feared marriage for myriad reasons, and knew instinctively that by naming an heir she would sow the seeds of her own destruction. For forty-four years she successfully evaded this fundamental issue at the heart of her reign. Nonetheless, she was no empire builder. In the simplest terms, if she had been, then she would have wanted a family to keep the Tudor Dynasty alive. But her aversion to empire wouldn't prevent her gentlemen adventurers from embracing the concept.

All English foreign interests were, at the outset of Elizabeth's reign, either financial or defensive. Antwerp was the main export and money market since the fall of Calais to the French a year before she came to power. With the growth of Protestantism in the Low Countries, Antwerp's stranglehold on northern trade came under threat, and England needed to look elsewhere for foreign trade, or perish. The mid-1550s saw the first English forays into a faraway commercial entente with Russia through the formation of the

Muscovy Company, in the hope that it would lead to a northerly route to Cathay [China] and direct trade with the Far East. When this failed to materialize, other routes—not already claimed by the Portuguese or Spanish empires—were sought. When both great world empires resisted English "interloping," viewed by the English as attempts at commercial trade, the age of English maritime expansion, or merchant and gentlemen adventuring on a large scale, was born. It is the relationship between Elizabeth and this disparate breed of men and how they worked together for what was believed to be the common "weal"—the enrichment of England and themselves—that is the primary focus of *The Pirate Queen*.

Still, to better understand that focus, it is also vital to understand how weak England was when the twenty-five-year-old Elizabeth became queen. Defense of the realm—and the queen—was the greatest worry on everyone's mind. Throughout her personal writing, the single-minded attention she gives to "security" is quite heartbreaking. And the central theme of security remains the golden thread woven through the intricate fabric of her reign—security for herself before she came to power, supplanted by security for the realm thereafter. In her mind, to create a secure realm, she needed two things: peace and money. When peace was gained at home through deft footwork by the queen and her advisors within the first year of Elizabeth's reign, the disappointed French (under the mother of Mary Queen of Scots), who had tried to invade England, found themselves ousted instead from Scotland. It was through Elizabeth's gentlemen adventurers that the attempt was foiled, and through her merchant adventurers that money was raised to protect the realm and pay for England's soldiers. In those days, plunder was how soldiers and mariners believed they were paid for the risks they took, and it remained common military policy until World War II, to turn a blind eye to the practice.

It was precisely these two groups of adventurers who would eventually deliver the security for the realm that both the queen and the country craved. They would, inadvertently, mind you, transform England into the nascent modern economy and empire that would dominate the world by the end of the eighteenth century. Had Philip II of Spain allowed the English to trade freely in his American

dominions and beyond, it is entirely possible that the British Empire would have been quite different.

I have a passion for original sources and, before beginning any research in earnest, go through original manuscripts to get a better feel for the individuals I will be writing about. In Elizabeth's case, I was blessed with a wealth of material. Gentlemen adventurers like Sir Francis Walsingham; Robert Dudley, Earl of Leicester; Sir Walter Raleigh; and Sir Francis Drake provided me with a rich vein to tap into. Merchant adventurers like Sir Thomas Gresham; William Cecil, Lord Burghley; and his second son, Sir Robert Cecil, wrote nearly every day during their tenures in office. Only some of those original manuscripts are detailed in the selected bibliography along with other primary and secondary sources.

Before beginning to read on, there are a number of points that I feel need clarification at the outset. The first relates to dates. In 1582, Pope Gregory XIII introduced the Gregorian calendar that we use today. In October 1582, all Catholic countries moved their dates forward by ten days, which is sometimes termed New Style by authors, with the Julian calendar dates termed Old Style. By 1587, most of Europe used the Gregorian calendar. England, however, refused and did not adopt this calendar until 1751. This meant that when it was March 11 in England, and the first day of spring, the date in France was March 21. In addition, New Year's Day was on March 25 in England. The reasons for England's stubbornness on this matter will become apparent in the course of the book. Since my references are for the most part English, I have converted any New Style dates to Old Style for ease of understanding. Also, I have made New Year's Day January 1, instead of March 25, for the same reason.

Place names were also different from time to time, and after the first usage of those names, I have put the modern equivalent in square brackets []. Thereafter, I use the original name, which has been introduced previously. In quotations, I have also provided modern meanings for obscure words, where I felt the reader would have difficulty, in brackets [] next to the offending word. These definitions have, by and large, been provided by the Oxford English

Dictionary entry for that word. Spellings have also been modernized into American English, except where they appear in direct quotations from the period. I have, where appropriate, inserted modern British English spellings in these quotations.

Rates of exchange between currencies are derived from a number of sources ranging from the *Calendar of State Papers*, to merchants' certifications, to the Bank of England. Thanks to the Bank of England I have been able to provide you with a good estimate of what, say, £1,000 in 1599 for example would be worth today. (It's £129,890 by the way.) I must stress, however, that these modern conversion rates are approximate only, and are primarily based on the Retail Price Indices available at the time, again through the Bank of England. Since conversion rates in modern times fluctuate more rapidly than in Elizabeth's era, it's important to remember that a glut or shortage of commodities (gold in particular) in a commercial market would have a greater effect on currencies than, say, what a loaf of bread (a local product) might cost.

When I began writing, the U.S. dollar was struggling to keep below $2 to the pound sterling. By the time I finished the book, the dollar rate had improved to $1.75 to the pound (though still fluctuating). The prognosis from the Bank of England, UBS, CFSB, and Barclays for the coming year is that the dollar-to-sterling exchange rate has been $1.65 to the pound, but the dollar rally would be short lived. To hedge my bets, I've used $1.85 to the pound in my conversions, mainly because I believe that this is the dollar's natural level for the next year. Again, the conversion rates to today's currencies are not exact, and are merely intended to be a representative modern equivalent in dollars and sterling in an effort to aid the reader's understanding.

In an attempt to add clarity for the non-British reader, I have also tried to treat elevations to various aristocratic titles uniformly. Once an individual receives a title, I wrote out his full name, for example, Robert Dudley, Earl of Leicester, and thereafter referred to him as Leicester. This is the way it is normally handled in the United Kingdom. Similarly, since there was a plethora of "Marys" during Elizabeth's reign, I have usually tried to adopt their titles as soon as possible so that they could be more readily differentiated.

There are two terms that are used repeatedly throughout the book: Merchants Adventurers/merchant adventurers. On the former, whenever the words Merchants Adventurers appear, it is intended to signify the Company of Merchants Adventurers or their members. Whenever the term is not capitalized, it means investors or merchants who are traders. Whichever one it is intended to be will be clear in the sentence.

"Pirate" is a word at the heart of the book. The word "privateer" was not coined until the eighteenth century, and I had a terrible objection to using a word that had not as yet been invented, and then to describe someone with that word used for the first time two hundred years into the future. In the 1560s and 1570s, the words "pirate," "corsair," and "rover" are used interchangeably for the queen's illegal traders. An "interloper" was specifically someone who traded illegally in a foreign country either against English interests or foreign ones. (These tended not to be pirates at all.) When a "pirate" raided shipping with the queen's (or another ruler's) approval, they are described as holding "letters of reprisal" or "letters of marque."

As Elizabeth's "pirates" (for that's what many of them were, essentially) evolved into her "adventurers" the word "pirate" is filtered out. An adventurer in Elizabeth's time was anyone who was prepared to take a risk—from the financial entrepreneurs we would recognize today, to an illegal trader ("interloper"), to a merchant trying his luck, or an out-and-out pirate.

Above all, I hope I have lifted the veil on Elizabeth as a leader: her methods of dominating her men; why her famed use of a woman's prerogative to "change her mind" was in most instances a tactical political weapon, astutely wielded to wrong foot the opposition; and why State-sponsored piracy and plunder was the only way England could survive.

Finally, while I have endeavored to be accurate at all times, if there are any errors, I must assure the reader that they are entirely my own.

SUSAN RONALD,
OXFORD, 2006

Introduction ✣

Bilbao, Spain
Six P.M., Wednesday, May 26, 1585

Master Foster gazed upon Bilbao harbor, feasting his eyes on the fine sight of so many Londoners that had heeded the King of Spain's call for help. Philip II had invited English merchants to send cargoes of corn, and assured the Queen's Majesty that her people would have his very own assurance of safe conduct in these troubled times. Payment for the corn would be made by bills of exchange payable to the City of London in Antwerp at fair-market prices. And so, the *Primrose*, a 150-ton Londoner, had been stocked with nearly twenty tons of corn and several ells of broadcloth, and set sail for Bilbao in Biscay.

Master Foster had heard that the country was starving; that the whole of Iberia had had a harsh winter, though the master of the *Primrose* and his men could be no firm judges of that fact for themselves. Bilbao had been bathed in warm sunshine the past two days in port, and the Spaniards they had seen appeared to have been well fed. Indeed, as Foster took in the near idyllic scene with the sun low in the sky, its rays reflecting lazily on the bay, Bilbao seemed a welcoming voice on the wind as she had always been.

It was then that he noted the soft groan of his rigging. A fine southwesterly was stirring. Foster prayed it would still be blowing the following day when they would weigh anchor and head for home. He hunched over the rail of his ship, leaning heavily on his arms, and looked on as a number of sleek Spanish pinnaces darted between his fellow Londoners. It was one of those rare moments of leisure for the captain of an English merchantman. Perhaps that is why he did not spy the pinnace heading for the *Primrose*. When the watch called out the approach of the Spanish vessel, and that there were seven souls aboard, Foster awoke from his reverie and barked

his orders to the crew, alerting them that a small party wished to board. What the devil could they want at this time of the evening? The *Primrose*'s cargoes had been unladen. It was most unusual for the Spanish merchants to settle their bills of exchange at this hour of the day. Further, the master of the *Primrose* had already settled the matter of loading the Spanish wines for the return voyage the following day.

It was a wary Foster who greeted the corregidor [magistrate] of Biscay. The hale and hearty fellow presented Foster to the six other men as Biscayan merchants, and claimed that they wished to give him a small token of their esteem. They had brought a hamper full of fresh cherries as a gift—a favorite of the English queen, or so they had understood. Master Foster thanked them and ordered that beef, biscuit, and beer be brought to the impromptu gathering in his cabin. Yet before they sat down to eat, four of the Biscayan merchants made their excuses and announced their intention to return to shore aboard the Spanish pinnace. This lack of common civility made Foster truly smell danger.

He ordered his first mate to accompany the Spaniards back on deck, simultaneously giving him the signal that all was not as it should be. It was a well-rehearsed exercise for English merchantmen in foreign waters, and the first mate knew how to alert the crew in secret to be ready for an assault.

The master of the *Primrose* returned to his unwanted guests, laughing and joking with them in broken Spanish and English, noting all the while through the porthole the pinks and oranges of the setting sun, wondering undoubtedly if it would be his last sunset. After some fifteen minutes, the watch called out again that the pinnace had returned carrying more than twenty men and that a larger vessel with perhaps as many as seventy merchants also followed. Foster silently prayed that God would be English this day.

The master bade the corregidor and his men to return to deck to greet the ships, expecting the worst. They were, after all, only twenty-six men against some ninety or more Spaniards. He could only imagine that these Biscayan merchants meant to board the *Primrose*, capture the crew, and, at best, imprison them all. Many a merchantman had been imprisoned before them, and most had fallen foul of the Inquisition. It was a destiny that he could not wish upon his enemies.

Once above deck, Foster's suspicions were confirmed. Turning to the magistrate and his two friends, he said that he could not allow such a group of men to board his small ship, and the corregidor nodded compliantly. Yet before Foster could give his crew the final signal to repulse an attack, he heard the beat of the battle drum from the Spanish ships below and the unmistakable sound of their swords being unsheathed. The thud of the grappling irons and the roar of the Biscayans wrestling alongside the *Primrose* to board her by force drowned out his orders to his men.

The corregidor and his "merchants" seized Foster with daggers drawn at his throat and cried out above the shouts of the melee, "Yield yourself for you are the king's prisoner!"

Foster narrowed his eyes and bellowed back, "We are betrayed!"

The crew of the *Primrose* had fortunately taken the defensive measures that her master had laid down for circumstances such as these. Within seconds, five calivers were fired through the grates from below decks at the Spaniards scuffling above. There were screams from those Biscayans who had legs blown off, and shouts to abandon their action from others. They could not know that it was the only gunpowder and shot that the *Primrose* had on board. But the few seconds of confusion the blast created was enough to turn the tide. Foster prized himself loose from his captors and gave the order to fight to the death. Many of the Biscayans fled back to the boarding vessels, fearing that they would be blown to smithereens, as several of their number had been seconds before. Others stood their ground. Hand-to-hand battle broke out, and the well-practiced English drill of a skirmish at sea ensued. The English, knowing that if they were forced from the ship, they would die a thousand slow deaths, fought like demons possessed with boar-spears and lances, which whipped through two to three Spaniards at a stroke.[1] Yet, despite the heavy carnage on the Spanish side, the outcome of the battle remained in doubt for a time. The only certainty to Foster and his men was that the deck of the *Primrose* was stained red with the blood of the Spaniards and Englishmen.

Some Spaniards were flung overboard; many of them begged for their lives, since they could not swim. The corregidor once again managed to put a dagger to Foster's throat, demanding that his men

cease their fruitless opposition, or Foster would forfeit his own life. The master replied, "Such is the courage of the English nation in defense of their own lives that they would prefer to slay them [the Spanish]."[2] In the heat of the attack, no one had witnessed how Master Foster had freed himself from the corregidor's clutches, and Foster himself never told the tale.

The fighting raged on for another half an hour with many Spanish Biscayans butchered, flung overboard, or drowned before the English could claim victory. Amazingly, only one Englishman, John Tristam, had been killed. Six other members of the crew were injured, but Foster thought they would survive their wounds. He had to presume that his two men, John Burrell and John Broadbank, who had delivered the last of the corn cargo, had been taken into custody ashore. While the master and his crew made ready to set sail, Foster was perplexed why the Biscayan merchants who had escaped in the pinnaces did not bring reinforcements. He could not understand, at the moment of his own victory, why no armed relief for the corregidor had come.

While he decided what should be done with the unfortunates struggling for their lives in the bay, Foster looked out across the harbor for the first time since the assault. All the other Londoners had the King of Spain's flag flying high on their masts. The Spanish treachery was now clear. The English ships had been lured into Spanish harbors for Philip II to confiscate in a master piratical act, and leave England helpless.

As the *Primrose* tacked into the bay, Foster knew that he must reach England in all haste and warn the City of London merchants. He took one last glance down at the Biscayans bobbing upon the water as the *Primrose*'s sails filled with the southwesterly, and spied the corregidor and his "merchants." Foster quickly ordered the crew to fish the Spanish pirates out of the sea.

Once safely away from the Spanish shoreline, Foster demanded that the corregidor and his men be brought to his cabin for questioning. The Spanish officials who had been hale and hearty only two hours earlier now stood trembling and drenched in their bare feet in Foster's quarters. The master ordered the corregidor to answer why he and his men had boarded the *Primrose* and the other

English vessels in harbor—ships that had come in peace at the behest of their king, delivering much needed corn and other sustenance to Spain?

The magistrate replied that it was none of his doing, and that if Master Foster would allow someone to fetch his hose, which were hanging up to dry, the master could see with his very own eyes that he had a commission from the King of Spain himself to seize all ships from "heretic countries."

When the commission was brought back for Foster to read, he scanned the drenched document. While the ink had run somewhat, the words "A great fleet was being prepared. . . . An embargo against foreign shipping is to take place with immediate effect. . . . You must seize all ships in harbor or attempting to come into harbor, and without exception those ships from Holland, Zeeland, Easterland, Germany and England, and any other country not in service of the king, except those ships from France . . . " remained clearly visible. The order had been signed by King Philip II himself in Barcelona a week before.

Foster had the corregidor sent back to the hold with his three "merchants," Francisco de Guevarra, Pedro de Villas Reale, and John de Corale.[3] The crew was ordered to treat their prisoners well, since they may well be worth a ransom. In fact, the corregidor had already offered Foster five hundred crowns to set them free. The master knew they were worth far more than that to the City of London, and that the king's instructions alone would warrant special recognition from the queen herself.

As Foster knew full well, the commission from the King of Spain would be of the greatest interest undoubtedly to the Privy Council. Its discovery might even earn him a place in naval history.

The Desperate Quest for Security

November 1558–November 1568

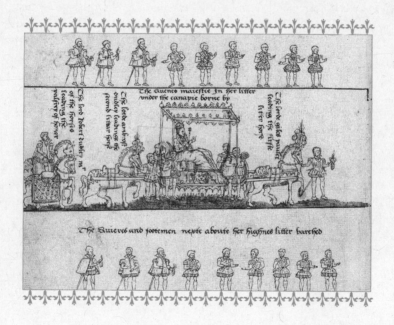

1. The Lord's Doing ✣

November 17, 1558

The dominion of the sea, as it is the ancient and undoubted right of the crown of England, so it is the best security of the land. . . .
The wooden walls [of ships] are the best walls of the kingdom.

—THOMAS COVENTRY, FIRST BARON COVENTRY, 1635

When Elizabeth Tudor inherited the kingdom from her half sister Mary I, in November 1558, England was on the brink of ruin. The feeling of despair among the nobles can only be imagined: not only had the country been torn between the ultra-Protestant reign of Elizabeth's half brother, Edward VI, followed by the fanatically Catholic Mary, but the crown was now proffered to the daughter of the reviled Queen Anne Boleyn. Elizabeth, who had lived her life as an unwelcome reminder of the union of Henry VIII and her mother, would most assuredly have been burned at the stake by Mary without the intervention of the queen's absentee husband, Philip II of Spain. If there was one thing Elizabeth Tudor understood intuitively, it was life on the edge.

Personal security was a luxury of which she must have dreamed as a child and young woman, and barely dared to hope for when her sister was queen. Mary had kept her prisoner, removing the Lady Elizabeth from palace to palace to prevent the next heir to the throne from plotting against her. During Elizabeth's time locked away in the Tower of London, each day could have brought the royal command for her execution, yet each day, the queen hesitated. It was in the Tower that Elizabeth's lifelong devotion to another prisoner, Robert Dudley, blossomed.

Dudley, too, knew life on the edge: his father and grandfather

had been executed for high treason, and it looked highly likely that he would follow them to the scaffold for plotting to overthrow Queen Mary. Dudley's loyalty to Elizabeth had been absolute before their imprisonment, often to the detriment of his own security. After their time together in the Tower, Elizabeth could never doubt his loyalty again. It was the only sure thing in her vulnerable life.

When Mary's latest phantom pregnancy in the spring of 1558 did not produce a child, it was obvious to King Philip, the Privy Council, and the court that the swelling in Mary's abdomen was a tumor and not the heir that the king and queen had so desired. With only Mary Stuart, Queen of Scots, remaining as a potential heir apparent, this left Philip in no doubt as to the course of action to be undertaken: Elizabeth must be set free and named as his wife's heir. If Mary Queen of Scots were to take the throne of England, she would have become queen of Scotland, Wales, Ireland, and England. These titles and kingdoms would have been added to her title as Queen of France, since she had lived in the French court since the age of five and had married the Dauphin Francis earlier in the year. Although Catholic, Philip was not prepared to allow the teenagers Mary and Francis to become the powerful pawns to Francis's mother, Catherine de' Medici. At all cost, he must stop the French crown from trying to abscond with Elizabeth's throne.

Besides, Philip could not promote Mary Stuart's claim to the English throne above his own, since he, too, had a direct claim through his mother, Isabelle of Portugal, a descendant of John of Gaunt of Lancaster. No, Elizabeth was a far better alternative as heir presumptive for Philip despite the fact that he had long known that she practiced the Protestant rites in private. This may have been the most important act of religious tolerance and clemency in the history of his long rule.

While Philip was agonizing over his deliberations and eventually paving the road for Elizabeth to take the crown, the English nobility—Protestant and Catholic alike—had already made up their minds. A mood of desperation had crept over the country. As the autumn of 1558 turned chillier in early November, the roads to Hatfield House in Hertfordshire, Elizabeth's childhood home, were gridlocked with those who had served her half sister,

as well as others who had been exiled from power. All of them were singular in their purpose: to serve the new queen and better their positions.

For the power brokers like William Cecil, who had served faithfully as secretary of state for Mary and Philip, Elizabeth not only represented the only viable successor, but also a fiercely intelligent one with whom he could do business. Others had different viewpoints. Philip's ambassador, Count Feria, who had also made his way to Hatfield, wrote to the king on November 10 that "she is a very vain and clever woman. She must have been thoroughly schooled in the manner in which her father conducted his affairs and I am very much afraid that she will not be well-disposed in matters of religion. . . . There is not a heretic or traitor in all the kingdom who has not joyfully raised himself from the grave to come to her side. She is determined to be governed by no one."[1]

This was no "news" to Philip. During Elizabeth's imprisonment in the Tower, she had written to Mary that "I so well like this estate [spinsterhood] as I persuade myself there is not any kind of life comparable unto it . . . no though I were offered to the greatest prince of all Europe . . . [I would] rather proceed of a maidenly shamefastedness than upon any certain determination."[2] For Elizabeth, who had undergone so many wrongs and near rape at the hands of her uncle, the hapless Thomas Seymour, the future queen had learned all the brutal lessons required of a young, handsome woman that were necessary in the art of sexual politics of the sixteenth century. No man would ever become her master and make her insecure in her position. After all, the Low Countries had eventually become Spanish through the marriage of a female heir. Francis of France was now equally King of Scotland. Moreover, the lessons to be drawn from marriage could never have been very far from her conscious mind with a father like Henry VIII.

While no record remains of her intimate discussions with William Cecil, the Earl of Pembroke, and the Earl of Shrewsbury in the early days of November 1558, these three gentlemen would have "schooled" the future queen in the secrets on the present state of preparedness of England. It was not a pretty picture. To Scotland in the North, the dowager Queen Mary of Guise, who had been ruling Scotland along with the nobles during Queen Mary's

minority, had amassed some twenty thousand French troops on the border of England. Since 1557, the nobles had refused to fight under her banner against England, but the war continued nonetheless. From Elizabeth's perspective, bereft of a standing English army and wholly reliant upon her northern, and mostly Catholic nobles' men, the French troops looked more like an invasion force than a defensive one.

In the West, Ireland refused steadfastly to be subdued—either by England or by her own nobility. The country appeared to be in a state of perpetual tribal warfare, and now that Elizabeth wanted England to become a Protestant realm again, she would risk invasion from the West if the fighting in Ireland united her people against a common English Protestant enemy. It did not take her savant mathematician astronomer, John Dee, to tell Elizabeth that trouble could be fomented in Ireland by other Catholic countries like France or Spain through the provision of men or arms.

On the Continent, Philip had dragged Mary's England into his wars with France in the Low Countries. His action against the French not only drained the English coffers of cash, but the country of able men to adequately defend its borders should Mary of England die as expected. In order to fight his war, not only had Philip impoverished his wife's kingdom, but he had also emptied his own treasury, and was effectively bankrupt for the first time in 1557.[3] Philip's rule in the Low Countries had become downright unpopular, not only because the majority of the inhabitants of the seventeen provinces, or states, were Calvinist; but also due to Philip's style of personal rule. Anything that was not Spanish was inferior for Philip, and the people of the Low Countries found their ancient rights eroded under what appeared to be more and more like a foreign occupation.

Yet it was the loss of Calais that represented the greatest threat to Elizabeth's people. Not only was it catastrophic in terms of the national pride, but, more important, Calais was the primary staple town of all English merchant staple exporters, as it was where they had their wool spun. Since broadcloth was England's principal export, made from the wool spun at Calais, trade was at an all-time low. People were starving, imports were scarce, and death rates soared from war, poor hygiene, and famine. And still, Queen

Mary's pyres of Protestant "heretics" burned, their stench wafting throughout the realm.

In fact, the England Elizabeth was about to inherit was downright poor, torn apart by years of religious strife and war. Not only was she a woman in a man's world, but she had been the "bastard" daughter of Henry VIII, whose dynasty held only the most tenuous claim to the throne of England.[4] When or how Elizabeth had decided on her course of action should she become queen is undoubtedly the culmination of many years of statecraft instilled into her by the very life she led, and her progressive tutor, Roger Ascham. It was no accident of fate that on November 17, 1558, Elizabeth Tudor was standing under the great, ancient oak tree at Hatfield House when the royal messengers rode into the park. It is a scene that has been portrayed in most movies and books about Elizabeth, and was the first act of symbolism in her reign. For ancient oaks equated a nation's strength and durability—the ancient Britons worshipped them. The hearts of these oaks became masts for the tall ships that would come to symbolize the greatness of the Empire by the end of her reign. When Elizabeth took the royal ring that had signified Mary's reign and now her death, and slipped it upon her own finger, the new queen kneeled by that gnarled and storm-struck oak and said, "*A domino factum est mirabile in oculis nostris.*"[5]

This is the Lord's doing, and it is marvelous to our eyes.

2. A Realm Exhausted ✦

Division among ourselves; war with France and Scotland;
The French King bestriding the realm ... steadfast enmity,
but no steadfast friendship abroad.
CSP—DOMESTIC, ELIZABETH, *vol. 1. no. 66*

Within twenty-four hours of Elizabeth's accession, orders had gone out to her newly formed Privy Council. On the day of Queen Mary's death, William Cecil, Elizabeth's principal secretary, wrote and distributed a memorandum with the form of oath to be taken by the privy councillors. The following day, Sir Nicholas Throckmorton wrote to the queen that he had sequestered Cardinal Pole's house and goods on the queen's instructions.[1] Throckmorton also confirmed that he had executed Elizabeth's instructions to the Duke of Norfolk, Elizabeth's uncle Thomas Howard; the Earl of Bedford, John Russell; and Lord Cobham, William Brooke. All ships at port would be confined there until a complete audit of goods, ships, and men could be established.[2] By the time forty-eight hours had elapsed, Cecil had commissions and instructions for the "Lords now beyond the sea" and had orders for Thomas Gresham, the queen's money man and arms dealer in the Low Countries.[3]

Elizabeth's expectations from William Cecil were spelled out clearly in her first public speech from Hatfield on November 20, 1558:

I give you this charge, that you shall be of my Privy Council and content yourself to take pains for me and my realm. This judgment I have of you: that you will not be corrupted with any manner of gift, and that you will be faithful to the state, and that without respect of my private will, you will give me that counsel that you think best, and if you shall know anything necessary to be declared to me of secrecy, you shall show it to myself only. And assure yourself I

will not fail to keep taciturnity therein, and therefore herewith I charge you.[4]

The following day, Count Feria, Philip's ambassador to England who had married Queen Mary's favorite lady-in waiting, Jane Dormer, wrote to the king from Hatfield, "our lady the Queen died."[5] Then in his own private code, Feria continued:

I think your Majesty must have a copy of the will ... as I have written to your Majesty it is very early yet to talk about marriage ...the confusion and ineptitude of these people in all their affairs make it necessary for us to be more circumspect, so as not to miss the opportunities which are presented to us, and particularly in the matter of marriage. For this and other reasons (if there be no objection) it will be well to send me a copy of the [marriage] treaty, which, though it may not be very necessary, will at least serve to post me up as to what would be touched upon, although a new treaty would be different from the last.

The new Queen and her people hold themselves free from your Majesty and will listen to any ambassadors who may come to treat of marriage. Your Majesty understands better than I how important it is that this affair should go through your hands, which as I have said will be difficult except with great negotiation and money. I therefore wish your Majesty to keep in view all the steps to be taken on your behalf, one of them being that the Emperor should not send any ambassador here to treat of this, for it would be inconvenient enough for Ferdinand to marry here even if he took the titbit from your Majesty's hand, but very much worse if it were arranged in any other way. For the present, I know for certain they will not hear the name of the duke of Savoy mentioned as they fear he will want to recover his estates with English forces and will keep them constantly at war. I am very pleased to see that the nobles are all beginning to open their eyes to the fact that it will not do to marry this woman in the country itself.[6]

By the end of November, Elizabeth's Privy Council had been formed save the office of lord keeper, which was eventually taken up by William Cecil's brother-in-law, Sir Nicholas Bacon, in January

1559.[7] A nationwide audit of men and arms was under way for one purpose in mind: to assess how empty the queen's coffers were and how in the devil she could secure her borders.[8]

At the same time, letters were fired off in rapid succession to potential sources of ready cash. On November 27, Cecil wrote on behalf of the Privy Council to London's "lord mayor, Aldermen and Common Council . . . for the sealing of certain bands for the taking up of divers sums of money at Antwerp for the Queen's Majesty by Thomas Gresham, her Highness's Agent there."[9] This was followed up with another letter to the lord mayor, Aldermen, and Common Council to plead for the City of London's merchants in helping to secure funds in Flanders.[10]

No one in England was more acutely aware of the precariousness of her position than Elizabeth herself. For her Catholic population, Mary Queen of Scots held a better claim to the throne as the great-granddaughter of Henry VII through his eldest daughter, Margaret, who was born before Henry VIII. The maternal uncles of Mary Queen of Scots, the powerful French Guise family, ruled Scotland by virtue of the Queen Mother's regency in the name of the French crown, and the common plaint among privy councillors was that Henry II, the French king, was "bestriding the realm, having one foot in Calais and the other in Scotland."[11] This simple fact made the urgency for a religious settlement that could be acceptable to both English Protestants and Catholics essential. Even the Venetian ambassador wrote back to the Doges that the English would be well able "to resist any invasion from abroad, providing there be union within the kingdom."[12]

By autumn 1558 when Elizabeth came to the throne, Philip II and Henry II had begun their peace negotiations. Military operations had ceased, and both realms were determined to make a lasting peace primarily due to their own financial chaos and religious strife in the Spanish-held Low Countries and France. Besides, Philip had wars of religion he was fighting against the Turks in North Africa and the western Mediterranean, and internally, against the Moriscos in Spain. The last thing he could literally afford was to fight a powerful Catholic monarch like the king of France. For Philip, matters of religion always took precedence over temporal matters, and it was essential that Catholic governments unite against the very

real expansionist threat of the Turkish Empire and the spread of Calvinism. Elizabeth and Cecil, who both had known Philip well when he had been king consort of England, did not need to listen to the incessant distortions swirling on the winds to know that the greatest danger they faced would be a Catholic League against a Protestant monarchy in England. What they agreed (though few at the time believed that Elizabeth and Cecil could carry out) was to turn Philip's religious zeal into a concern for his empire, by exploiting the opportunities that came their way—or that they could create—with whatever weapons they could conjure for their English arsenal. The potential threat of an invasion from France, or from the French in Scotland, was very real, and the only way Elizabeth saw to forestall this was to pander to Philip's paranoia.

The scene was now set. The negotiators were united at Cateau-Cambrésis to hammer out a lasting peace, and Elizabeth steadfastly held on to the hope of not ceding Calais, ostensibly due to the loss of England's pride and the commercial staple there. Another and more understandable reason was military; with Calais only twenty-six miles across the Narrow Seas, or Straits of Dover, and the French in control of Scotland, Henry and his belligerent dukes represented a potent threat to England's security. The silent reason for her obstinacy—which would later become one of her trademarks—was simply that she was stalling for time to see how best to play upon the mutual jealousies of the Spanish Habsburg and French Valois kings.[13]

She did not have long to wait. It was Henry II who gave her the first breakthrough. Through an Italian merchant of considerable standing and knowledge of England, Guido Cavalcanti, Henry secretly suggested that if Elizabeth would marry someone "of whose friendship France could feel assured," great amity between their realms would ensue.[14] It was understood that the "someone" was Henry's younger son, Henry, Duke of Anjou (later Henry III). Naturally, the queen made Philip II aware of the offer, thereby guaranteeing the King of Spain's protection against the Valois threats, either expressed or implied.

In the meantime, Elizabeth knew that she needed to rally around her people as well as her noble lords to protect her borders. Both groups would understand the force of arms and the potential threat

that France represented. It was Cecil's job to ensure that word of the threat was whispered into the right ears at the right time. The queen needed money for soldiers' pay and arms, he explained, and she needed it urgently if the French invasion came. But Elizabeth had just heard that the treasury was virtually empty, thanks in large part to Philip. As king consort to Elizabeth's sister he had made use of England's treasury as if it were his own to fight his Continental wars, and had declared his loans "forfeit" to the merchant bankers in Antwerp only the year before. The use of England's exchequer particularly rankled with the parsimonious Elizabeth since Philip had been expecting two treasure fleets from Tierra Firme, or New Spain, in the Americas, with the first treasure fleet due in March 1558 and the second in May of the same year. This made the loss of Calais in January burn more brightly in her mind: England's exchequer had provided the men, money, and arms for the Spanish war machine in the Low Countries, lost Calais in the process, and had failed to secure any reimbursement from the treasure fleet.[15]

When Elizabeth's new lord treasurer, Sir Walter Mildmay, who took up his post at the end of December 1558, reported that the exchequer was, for all intents and purposes, empty, we can only imagine the queen's despair. The year's consignment of gold and silver from the two treasure fleets had arrived and remained in Spain, and there was no offer to replenish England's depleted coffers.[16] Mildmay's report to the Privy Council showed how deeply the queen's sister had embroiled the country in Philip's wars: in her last year as queen, Mary spent unprecedented sums on her navy alone, amounting to £1,073,844 ($401.3 million or £216.9 million today).[17] Certainly most galling of all for Elizabeth was the fact that she now found herself in a position of relying heavily for the country's security on the very man who bankrupted the realm.

But rely on him she did. She, of course, knew of his intentions. Her court was from its earliest days a beehive of espionage and intrigue, and the queen knew that Philip also feared that the French wanted to make England another province of France as Scotland effectively was. With the Spanish king now firmly on her side, all Elizabeth had to do was wait for an opportunity to press home her advantage. As early as March 1559, Henry II was militating with the pope to declare Elizabeth illegitimate and excommunicate her. On hearing

this, the young queen sprang into action, though she hardly needed to prevail upon Philip to impose his will upon the pope to successfully forestall Henry's efforts. Henry retaliated, this time hitting the mark with Elizabeth, by allowing his new seventeen-year-old daughter-in-law, Mary Stuart, Dauphine of France, and his son, Francis, to bear the arms and style of Queen and King of England. While Elizabeth railed against the Stuarts, Guises, and Valoises in a Tudor tirade in England, Philip took more decisive action: he proposed marriage himself to his former sister-in-law. And all this occurred at a dizzying pace, during the peace negotiations at Cateau-Cambrésis in the first quarter of 1559.

Fortunately for Elizabeth, the Count of Feria had the temerity to show his royal instructions to some of the queen's ladies regarding the king's marriage proposal, and Elizabeth knew without doubt from that moment that Philip was a reluctant suitor. Yet she still needed to weigh up the possibility that when she rejected him, Philip, a widower for a second time without an heir to his vast dominions, could well take a Valois bride. This would at a stroke make him England's enemy, and secure a more lasting peace with France. An obvious choice even presented itself: Henry II's daughter, Elisabeth of France.

So, before Mary was cold in her grave, Secretary Cecil and her other councillors were all advising Elizabeth on how she should best play her own marriage card to keep Philip from concluding a Valois pact that would endanger England's very existence. Her first parliament of 1559, on the other hand, was solely urging the queen to marry and have children as was her duty as a woman, thereby putting the Catholic threat of Mary Queen of Scots at one remove from the crown.

Any pretense that Elizabeth had made to marry Philip, or that Secretary Cecil had made on her behalf, was undoubtedly another stalling tactic. The country would not tolerate a return of Philip as their king. The strength of feeling for Elizabeth and against Philip, and even Mary, can best be summed up in a speech believed to have been delivered at York when news of her accession was announced: "Queen Elizabeth, a princess, as you will, of no mingled blood of Spaniard or stranger, but born mere English here among us and therefore most natural unto us."[18] Even setting aside her personal

inclinations to remain a "spinster," the last thing England's young and handsome queen needed was a hated husband. What she did need was time, as well as money, and the only way she could prevent Philip from casting around Valois France for a bride was to pretend she was interested herself. The Count of Feria was thus fed a ripe diet of misinformation, and fortunately for the English, swallowed it with gusto.

Philip was, nonetheless, the most powerful monarch in Europe of the day. His father, Charles V, had abdicated as Holy Roman Emperor, splitting his dominions between his brother Ferdinand, who became Holy Roman Emperor in his stead, and Philip, who took direct control of all the lands and provinces outside the borders of the Holy Roman Empire, from the Americas to the Low Countries and much of Italy. Elizabeth had fortunately charmed him during his brief stint at her sister Mary's side; but, more important, had learned a great deal about how he thought, and how best to handle him. She knew better than any other prince alive that Philip was "more Catholic than the Pope"[19] and would not delegate his authority to anyone. She knew that he had his hand in every act, every letter of the Spanish Habsburg Empire; that he gave each order; oversaw all policy; and above all else was paranoid about the jealousy others felt when he wielded his power. Elizabeth and her councillors had been dealing with Philip for five years in England, and had developed a strategy at the outset to help protect her fledgling rule.

Just as Philip's father, Charles V, had been feared and hated, Philip perceived that the world outside Spain, and his Spanish dominions, was to be mistrusted at the very least, and treated as an enemy given the slightest provocation. His weakest—and yet strongest—ally was none other than the pope himself. His dominions surrounded the Papal States, which also depended heavily upon Philip's Habsburg Sicily for its grain. The sack of Rome in 1527 by Charles V was not allowed to become a distant memory, since Philip himself had ruthlessly used force and threatened to starve out Pope Paul IV in 1556–57 to demonstrate his own might. The popes knew to mistrust Philip's temporal power, and much later he wrote to the pope that, "Most of the misfortunes that have befallen my possessions have occurred because I have tried so hard to defend the church and

extirpate heresy. But the greater these [misfortunes] have become, the more your Holiness has forgotten them!"[20]

For all these reasons, Philip—and Elizabeth's relationship with him and his Spanish Habsburg Empire—would dominate Elizabethan politics and economic aspirations for her entire forty-four-year reign. Elizabeth's government decisions would be dictated by and large throughout her rule by the ever-pressing considerations of security of the realm (defense), revenue generation, official court favor, and court intrigue.[21] Central to that theme in the early years was trade and plunder, and London was the heartbeat and brain of trade.

The City of London merchants made up about 75 percent of the tax revenues, and paid duties to the queen on goods imported or exported. They comprised different "companies" divided into mercers, staplers, goldsmiths, or merchant adventurers dependent on their specific trade and charter. The West Country ports of Plymouth and Bristol were also active contributors to the treasury, and Southampton with the Isle of Wight had already become an important naval outpost, but even when bundled together, they could not touch the powerhouse that was London.

The members of the twelve great livery companies of London comprised the administrative substructure of the city, and citizenship at London—or the freedom of the City—could only be acquired through membership of one of these companies. Membership, in turn, was gained only through a long period of apprenticeship, even if the new entrants were entitled to join by following the trade of their fathers.[22] This meant that London, unlike Antwerp or other great commercial centers, was run by men who had been engaged in business since they were old enough to work, and virtually always by men who belonged to one of the livery companies. The most powerful of these companies at the time of Elizabeth's accession was the Merchants Adventurers, who derived much of their wealth from the export trade in cloth to Antwerp, and the importation of luxury goods from the East and West Indies.[23] And it was the relationship between the Merchants Adventurers and the crown that would dominate government policy for the next several years.

But trade was only one side of the coin. Treasure, irrespective of its

provenance, was the special passport to royal favor, since the queen expected her Merchants Adventurers and other trading corporations and societies to put their ready funds at her disposal for the security of the realm. The same sacrifices were demanded of her gentlemen adventurers at court as well. There was no doubt that Elizabeth's reign was a time when all who wanted power needed to put their money where their ambitions lay, and only then could success be richly rewarded.

And so it was at the beginning of 1559 that the queen found her realm in less than shipshape order. She was literally assailed on all sides and had to unite her country behind her. The first concrete step she took to that end was to set about to create the illusion of power and wealth to dazzle her enemies and give the false impression of a glorious beginning at her coronation in January of that year. It was this illusion that would give the queen her enduring nickname of "Gloriana," and fooled posterity into believing that there had always been some grand mercantile and imperial strategic plan.[24]

But the only "grand plan" that Elizabeth had at that stage was security of the realm. Her vision was clear, and she had the mental acuity and deft touch of a chess grandmaster, always seeing five or six moves ahead of the game, more often than not leading her adversary into the path she wished him, or her, to take. Though she had no money, she had the courage, conviction, advisors, and "stomach of a king" to help her through the task ahead. And at the heart of this illusion in her "grand plan" to save England was the very real world of gentlemen and merchant adventurers, corsairs and pirates. Without them, England could not survive.

3. The Queen, Her Merchants and Gentlemen ⚜

The State may hereafter want such men,
who commonly are the most daring and serviceable
in war of all those kind of people.

— SIR HENRY MAINWARING, ELIZABETHAN PIRATE-TURNED-ADMIRAL

The queen's gentlemen and merchant adventurers—often referred to by England's allies and adversaries alike as her corsairs, rovers, and pirates— were not the stuff of ordinary merchant stock. Indeed, pioneering into new worlds required men who thirsted for knowledge, had tremendous egos, were desperate to make their fortunes, had an acute business sense, and possessed more than a fair portion of intelligence and cunning. Many also claimed a fair degree of patriotism, and all professed undying loyalty to the queen. It was these men who would ultimately save England in ways that no one could begin to imagine in 1559.

Throughout her reign, Elizabeth's court was stuffed to the gunnels with troublesome second sons of gentleman stock, the merchant trades, and the aristocracy. These men had been brought up with "expectations" of wealth, or luxury, but as younger sons they could inherit only the wealth of their wives—should they have the good fortune to marry well— or a portion of their fathers' mercantile enterprises—should their fathers prove generous. If they were unlucky, then they'd have to make their own way in the world, often running foul of strict interpretations of the law and making enemies in their travails and travels. Robert Dudley, John Hawkins, Sir Robert Cecil, Francis Bacon, and Walter Raleigh were some of the most shining examples of Elizabethan younger sons grasping at court power and riches. The jealousy and envy they created was

undoubtedly destructive; their contributions to the mainstay of Elizabeth's court, tremendous.

Then there were the great Elizabethan families who dominated the political, economic, and even the intellectual powerhouses of Elizabeth Tudor's England. They were a heady brew of aristocracy, merchant classes, and poorer segments of society. The political and religious changes that were ushered in by Henry VIII's marriage to Anne Boleyn brushed away the cobwebs of the "old" nobility unwilling or unable to follow the king on his new path, and made way for a fresh rising class of merchant aristocrat, such as the Boleyns themselves. Elizabeth's first lord treasurer, the admirably competent and loyal Sir William Paulet, first Marquis of Winchester, was one of Henry's "new men." The queen's administrative and legal tigers, William Cecil and Nicholas Bacon, while both younger than Winchester, were also cut of the same cloth. While the changes toward "meritocracy" began under Henry for loyalty to the king's desires, under Elizabeth, those who demonstrated loyalty to crown and country by wholehearted dedication to work and wisdom would be richly rewarded irrespective of their social pedigree.

And despite much of what has been written, the lines of Elizabethan power were not necessarily drawn with Protestant pitted against Catholic. Where Edward Fiennes de Clinton, Elizabeth's first lord admiral, who later became Earl of Lincoln, was a staunchly Protestant West Countryman, his successor, Lord Charles Howard of Effingham, Earl of Nottingham, was a Catholic. The Earl of Pembroke and the Earl of Arundel, privy councillors under Mary as well as Elizabeth, both professed Catholic leanings. Robert Dudley and Sir Francis Walsingham were staunch Protestants with strong Puritan inclinations. William Cecil, who later became Lord Burghley, was a Protestant; and he, like the queen herself, believed in moderation in religious politics. Only the queen's merchant adventurers and corsairs were virtually all Protestant, and the trades they plied were always tinged with social, religious, or political hidden agendas.

The men who surrounded the court and queen were united not only in their quest for power, knowledge, treasure, adventure, and England's gathering greatness, but they were frequently closely related or in the same golden circle of good friends. Martin

Frobisher, the corsair who would explore the northern latitudes of North America, was jailed for piracy in the first year of Elizabeth's reign.[1] John Dee, Elizabeth's unofficial astrologer and great mathematician, advised Frobisher and most other adventurers on their voyages of discovery. Dee was himself the son of a "mercer" or textile merchant, and his mercantile connections proved invaluable in Dee's rise to political notice. Both Dee and Elizabeth shared the same tutors: Roger Ascham and Sir John Cheke. Ascham, Cheke, and Sir Thomas Smith, another councillor of the queen, were all Cambridge academics and closely associated with the Dutch humanist Desiderius Erasmus, who was credited with bringing the Italian humanist Renaissance to northern Europe. Cheke was a cherished family friend of the East Anglian merchant, Anthony Cooke, whose daughter Anne had married Sir Nicholas Bacon, the queen's lord keeper, while Cooke's eldest daughter, Mildred, had married Sir William Cecil, the queen's principal secretary, a few years earlier. Cooke and Cecil had been affiliated as well to the much-admired humanist clique cultivated by Queen Catherine Parr (Henry VIII's last wife) and the young Prince Edward.[2] Walter Raleigh was the nephew of Elizabeth's beloved governess and lifelong friend, Cat Ashley. His elder half brothers, Humphrey and Adrian Gilbert, the adventurers who promoted the Northwest Passage route to Cathay and settlement of North America, had been introduced at court by Cat Ashley years before Raleigh himself craved the queen's attention. Lady Catherine Knollys, wife of the privy councillor Sir Francis Knollys, was called Elizabeth's cousin but is now thought by some to have been her half sister, born to Henry VIII and Elizabeth's aunt, Mary Boleyn.[3] Catherine Knollys's brother, Henry Carey, Lord Hunsdon, is also believed to be Henry VIII's son by Mary Boleyn, and he, too, would become a stalwart of Elizabethan England and William Shakespeare's patron. By this yardstick of friends and relations, Elizabeth's world was a small one indeed.

But Elizabeth's men were more than close relations and a fractious lot. Her intellectuals brought the Renaissance to England, advancing society and thought beyond what had been believed possible in Henry VIII's time. John Dee traveled extensively throughout Europe, gathering humanist friends abroad, like the phenomenally gifted mapmaker Gerard Mercator. On his return to England, Dee

preached to Elizabeth's converted adventurers of great wealth and
worlds beyond the horizons that could be theirs for the taking if only
they tried.

From a Spanish perspective, Dee's teachings were anathema. The
world had been divided between the Portuguese and the Spanish
in the previous century, with this division sanctioned by the pope
and enshrined in the Treaty of Tordesillas of 1494. Any voyages of
discovery were the private reserve of the Iberians, and this precept,
coupled with England's economic necessity for survival and security
against Spain, provided the catalyst for England's entry into an
expansionist world power. In fact, the phrase the "British Empire"
wasn't coined in the eighteenth or nineteenth centuries, but by John
Dee in his work *The Petty Navy Royal* in 1577.[4] From Spain's and
Portugal's perspective, empire was the fundamental principle in the
battle to protect Iberian "rights." From an English point of view,
any acts of piracy, trade, or war were the basic ingredients needed
for survival against the great Catholic powers. And these ingredients
would beat at the heart of the clash between Spain, France, and
England throughout most of Elizabeth's reign. Yet it would be wrong
to think that Elizabeth was ever an imperialist. England's place in
history would ultimately be secured by an English Renaissance
in thought, science, and the arts by men like Dee, Marlowe, and
Shakespeare. Yet her right to rule a Protestant England—and sow
the seeds of empire—was secured by her numerous merchant and
gentlemen adventurers through trade, plunder, and colonization.

Two other great contributors to expansionist thought and deed
were the two Richard Hakluyts. Richard Hakluyt, the elder, and
especially the younger Richard Hakluyt, made a lasting record for
posterity by writing down the voyages for all the Elizabethan seamen
they could find, culminating in the younger Hakluyt's *Principall
Navigations*, first published in 1589, and dedicated to Elizabeth's
then principal secretary and spymaster, Sir Francis Walsingham.

Among others who helped the revolutionary trains of thought
to take hold in England was the queen's keeper of the great seal,
Sir Nicholas Bacon, who promoted mass education and funded
scholarships for students at Cambridge.[5] Her principal secretary,
Sir William Cecil, was the vice chancellor of the University of

Cambridge. Sir Thomas Gresham, Elizabeth's ambassador to the Low Countries, "intelligencer," arms dealer, and London merchant, founded the Royal Exchange in 1572 at his own expense for the promotion of international trade. The Corporation of London and the Mercer's Company, to which he belonged, founded Gresham College for popular education with a strong emphasis on practical subjects connected with commerce.[6]

Some of the most influential merchants belonging to the Mercer's Company or the Staplers (who traded in commodities such as wool rather than finished goods like cloth on the Continent) came from gentry stock like Gresham. Others married into the gentry and acquired their wives' estates and coats of arms. Still others founded noble families by royal favor. Merchants and landed gentlemen who were to shine as Elizabeth's adventurers learned over time to act in concert. Trade and plunder were not obvious commercial or political partners at the outset, but with the political movements of the time, they soon became a united cause. Within ten years of Elizabeth's accession, the blurred distinctions between merchants and gentlemen were the accepted norm. The blurring between their legal trading and illicit plundering activities became a way of life as hostilities with Philip II grew, until, finally, it was virtually impossible to tell trade from plunder or piracy. This naturally created a more fluid society, which while still falling well short of a meritocracy, allowed some cream to rise to the top. And a wealth of hidden talent was not found wanting.

While the hub of the jostling for riches and power took place at court and London, a core of fiercely Protestant southwest gentlemen and merchants had already burst upon the world stage of exploration long before Elizabeth had become queen. John Cabot, an immigrant Italian, had sailed from Bristol in the *Mathew* during the reign of Henry VII.[7] John Cabot's son, Sebastian, who claimed the discovery of Newfoundland for himself, thereby eclipsed his father for posterity. The younger Cabot had masterminded the formation of the first joint stock company for exploration, the Muscovy Company, making its voyages independent of the crown, and provided the money with his small group of peers and high officials for the first Muscovy voyages. William Hawkins of Plymouth, the West Country merchant, had

established successful trading with Brazil in the late 1520s, and even brought back an Indian chief aboard ship on his second voyage in 1531 as a sign of the "great favor" that the Indians had shown him. Southampton and Plymouth spawned great adventurers—merchant, gentlemen, and piratical—with such evocative West Country names as Champernowne, Hawkins, Fiennes, Godolphin, Grenville, Gilbert, Killigrew, and Drake.

Yet, the desire for overseas riches that were brought to England by "trade"—whether through legitimate channels or piracy—did not originate with Elizabeth's men. The Tudor courts from Henry VIII's reign simply wallowed in luxury. Luxuries—be they sumptuous clothing, jewels, food, or amusements—were an integral part of Henry's power, and under Elizabeth they became key symbols of her rule. Naturally, her court remained the fashion-setter for the rest of the country, with all the royal status seekers trying to emulate her court in its way of dress, its lavish tastes, and its lust for "the rich trades," or luxury goods, from India and the Orient.

And treasure was the most highly valued prize by the queen herself. It enabled her to pay her bills and spend—carefully—on her aura of wealth, power, and courtly love while, above all else, investing in the security of the realm. Treasure, followed by the rich trades, became the manna of the body politic, attracting royal participation in search of gold.[8] If a lucky adventurer had a cunning plan to find treasure that mitigated risk to the crown, then royal patronage would not be far behind. However, before the queen would commit herself or her ships to dangerous and costly overseas expeditions, she demanded that her men put their own personal fortunes alongside her own at the realm's disposal for most voyages seeking treasure. Even the queen's most cautious ministers of state like Sir William Cecil; Sir Nicholas Bacon; and Sir William Herbert, the Earl of Pembroke, became eager participants in the quest for riches, wagering their own fortunes in the balance. In this way, the precedence was set: anyone wanting royal favor must venture his own wealth for queen and country.

Salaries were notoriously mean, often paid late or not at all, and ministers of state and civil servants alike had to devise ways in which they could serve the realm and earn a good living, while

spending their personal fortunes on behalf of the queen. By modern standards, some conflict of interest was expected in their execution of duties, like adding a percentage onto a bid to cover their costs, but loyalty was always demanded. Cecil's and the queen's answer to the conundrum of how to keep these firebrands under control was to promulgate the sale of patents for sweet wines, alum, tin or copper mining, or salt, or even the sale of royal lands. Probably the most lucrative of these patents, or grants, was the ruling in 1560 that Lord Admiral Clinton (and his successors), in adjudicating cases of piracy as well as complaints against holders of legitimate letters of marque, or letters of reprisal, would henceforth be entitled by law to a one-third interest in goods taken from the pirate or legitimate adventurer.[9]

Yet the secret of Elizabeth's success in dealing with this marauding brood of courtiers, merchants, and close relations vying for power, plunder, and riches remained her ability to fuse the colossal and diverging egos of her gentlemen and merchant adventurers while enforcing her personal will for the protection and security of England. Her security and England's undoubtedly took precedence over their greed, their determination to discover "new worlds," faster trade routes to the Indies, or imperialistic visions of settlement. And this "fusion" is a recurrent theme throughout all aspects of her reign. As queen, she masterminded the internal balance of court power, which was mimicked in her international politics by her interminable and often frustrating use of her dog-eared marriage card; the making and breaking of alliances; her prevarication; and her initial tacit, and later overt, acceptance of plunder and piracy as central to state policy.[10]

The queen's crown—her very person—and the essence of her statecraft would depend on the concept of fusion, or compromise. As a Protestant ruler of a mixed Protestant and Catholic country, overpowered by Catholic giants like Spain and France, Elizabeth was all too conscious of the need to appear to be queen of "all the English." The religious settlement culminating in the Act of Supremacy and Uniformity in April 1559, making Elizabeth supreme governor of the Church of England, was neither a Catholic nor Protestant solution. It pleased no one, but offended few. It

had been carefully crafted to provide a middle ground to keep the nation at peace. Catholics in her realm were allowed to "opt out" of Anglican Church services for a small recusancy fine to practice their preferred religion without fear of being burned at the stake, so long as they did not engage in treasonous acts against the queen or her government.[11] Even the tightrope walk she endlessly engaged in—that of her feigning interest in marriage to make and break international peace accords—was nothing more than a quest for a balance of power.[12]

Above all other considerations, the golden thread that ran through Elizabeth's domestic and foreign policy was security of the realm. The facts speak for themselves. Her grandfather, Henry VII, had seized power, finally ending generations of royal battles between the Yorks and Lancastrians in their seemingly interminable Wars of the Roses. One of her first memories when she was no more than three would have been her father's reign having been seriously threatened by the popular uprising of the Pilgrimage of Grace. The other enduring fact was the execution of her mother and the invisible scars that had been left on her as a result. When Elizabeth had seen her cousin, Queen Catherine Howard—Henry VIII's fifth wife— dragged through the castle by her hair screaming literally for her very life, it is no wonder that the nine-year-old Elizabeth whispered "I shall never marry" under her breath to Robert Dudley.[13]

These invisible scars continually marred her young and turbulent life until she could become queen. The forced estrangement from her young brother, Edward VI, by Dudley's father, the Earl of Northumberland, began her long years of exile from court and mistrust of privy councillors. Her trauma culminated in the final years of suspicion and imprisonment at the hands of her sister, Mary, as Elizabeth herself best described when writing defiantly with a diamond on a window pane at Woodstock, "Much suspected by me, Nothing proved can be, said Elizabeth the prisoner."[14]

It is little wonder that personal security and security of the realm became her mantras, and that all weapons at her disposal to achieve these goals would be used. Elizabeth's overpowering desire to be personally secure and to ensure the safety of her people and realm was the driving force behind her sanctioning of plunder, promotion of

trade, switching allegiances, and eventually giving in to the imperial aims of her intellectuals and adventurers, and creating a nascent British Empire. Piracy and plunder became a vital tool to achieve her goals of security. And yet, for that to become a successful state policy, she would need to successfully "man manage" her merchant adventurers and gentlemen who would make it all possible.

4. The Quest for Cash ✳

*Wherein it may appear that we mean to do to no person
wrong but to provide and foresee how apparent dangers to
our estate may be diverted, and that we might not remain in
this kind of unsurety to have our Calais restored to us . . .*
QUEEN ELIZABETH TO PHILIP II OF SPAIN, SEPTEMBER 30, 1562

By April 1559, the first immediate crises of the queen's reign
had been successfully addressed: the Act of Supremacy and
Uniformity provided a religious solution, and the Treaty of Cateau-
Cambrésis had been agreed. While Elizabeth had ostensibly held
out for the return of Calais, with the treaty providing for the French
to give Calais back to England in eight years' time, or forfeit 500,000
crowns ($186.9 million or £101 million today), there was little doubt
in the queen's or Cecil's minds that Calais was irretrievably lost.[1] Both
the queen and Cecil also understood that the chances of England
ever receiving the forfeit sum entailed in the treaty were slim.

Yet the loss of Calais cut deeper than a loss to Elizabeth's Tudor
pride, as many believe. It had been the home for over a century
to the Staplers, who shipped wool from England to Calais for
spinning and trading on the spun wool. As with all wars, men,
merchandise, money, homes, markets, and confidence were lost
with Calais, too. Furthermore, the security of the realm had
been placed in jeopardy, since without Calais, England no longer
controlled the Straits of Dover, then known as the Narrow Seas,
from both sides of the landmass. This helps to put into perspective,
to some extent, Elizabeth's fixation with regaining Calais, and the
disasters that were to follow as a result of her policy to win her
staple town back.

The treaty of Cateau-Cambrésis merely allowed for the cessation
of hostilities, with a great deal of face saving on both sides. It fell far

short of the ultimate goal of any treaty since it did not eliminate the threat of future wars. The new French king, Francis II, was also by now King of Scotland, and his bride, Mary Queen of Scots, openly defied Elizabeth's personal right to rule by actively claiming the English throne in her own right as a granddaughter of Henry VII.

When Francis's father, Henry II, died from his injuries in a jousting accident in July 1559, things turned from bad to worse for Elizabeth. Even Henry had allowed his son and Mary to sport the insignia of England on their coat of arms, in an overt attempt to goad Elizabeth into premature action against their more powerful kingdom of France. And now that Mary Queen of Scots was also Queen of France, her powerful uncles, the Guises, began actively plotting to put Mary on the throne of England.

At the time, England was by and large rightly regarded as a military and economic backwater by both the French and the Spanish, and there were ample reasons for this perception. What neither crown had yet had the chance to recognize was that Elizabeth Tudor would become the first English monarch adept at playing off one European giant against another in a long game, thereby upsetting the balance of European power and allowing England to step forward onto the world stage. To the north, in France's unofficial vassal realm of Scotland, Elizabeth Tudor warily watched, fearful that it would be only a matter of time before the hostilities between the staunchly Protestant Scottish Lords of the Congregation and the queen dowager, Mary of Guise, would embroil both France and England in their Scottish war. And war was unpredictable and bad for trade.

Any war—aside from the supreme waste of human and economic resources—could not fail to demonstrate, in Elizabeth's eyes, that England was intrinsically weak militarily and economically. The country was simply ill-prepared to face a stronger enemy like France from the Continent, much less a France coupled with Scotland, and potentially Ireland as well. Catholic Ireland had always been viewed as a back door for all Catholic sympathizers, be they French, Spanish, or emissaries from the pope. With a probable war at sea and along the border of Scotland, the thought of having to watch the English flank at Ireland, in addition to the Channel and the North Sea, became a matter for considerable worry. The obvious fact that

armies—or for that matter, navies—needed money that the crown did not have seemed to Elizabeth to be an insurmountable problem. Worse still, the young English queen was unproven as a leader. For her councillors, the specter of war was a regrettable diversion so early in the young queen's reign that could well cost the country its freedom.

Yet despite the expensive diversion of war, it was one that they would have to face up to if England were to remain a Protestant nation. To achieve their goals, Elizabeth and her councillors simply had to tackle the economic health of the realm, while simultaneously keeping England out of a conflict that it could ill afford.

The blow inflicted by the French of the loss of the staple at Calais had already impacted England's fledgling modern economy, though the Staplers had removed their business to Antwerp temporarily in the Spanish Low Countries while searching for another city to use as their main staple town. Meanwhile, Scottish and French pirates were marauding the Channel and the Narrow Seas, and the most powerful group of merchants, the Merchants Adventurers, whose international market was located in Antwerp, were deeply concerned that they would be cut off from their Continental source of wealth. They could, by law, only sell their merchandise abroad, and were only licensed to do so at Antwerp. The English queen knew that her merchants were her best chance at securing loans for the crown, and that a war stood to impoverish her best potential source of ready funds.

It was a dilemma she would need to speedily address. But Elizabeth wasn't given to snap decisions. No matter how she tried to evade the issue, at the end of the day, the nation needed to be able to defend itself, and before any loan could be obtained for arms, the queen needed to understand what she could offer up as security and how she could borrow from English or foreign merchants. To do that, Elizabeth needed to know what she owned; what she was owed; what was missing that could be tracked down and restored; and what could be sold for cash or favors. In the first important months of her reign, the Privy Council wrote letters to "the tellers of the exchequer to send hither a perfect book of the names of all such as are behind within the Queen's Majesty's House of the payment of the last Subsidy granted to the late Queen."[2] An inventory was taken of

the late Queen Mary's jewels, and note made of those items that were missing or had been sold during her lifetime. A committee of the Privy Council was appointed to examine the grants of crown lands made in the last reign.[3] Under the heading "Debts to the Crown," a letter was sent from the Privy Council "to the lord treasurer to cause speedy certificate to be made to the Queen's Majesty of all manner of debts due in the exchequer to the extent [that] the same being known, [so that] order may be given by such as her Highness hath appointed in Commission to see the same answered with all expedition." In December a letter went out to the Court of Wards [Court of Awards] to a Mr. Damsell requesting him to "certify all manner of debts due in the Court."[4]

No individual, dead or alive, was exempt from the quest for cash. Queen Mary's archbishop, Cardinal Pole, who died the same day as his mistress, was a particular target for Elizabeth's men. Within twelve days of taking power, the Privy Council had issued orders to Sir Nicholas Throckmorton "to suffer certain parcels of the late Cardinal's plate which are thought meet by the officers of the Jewel House for the service of the Queen to be brought hither by some of his own folks to the end that, the same being viewed, he may receive the value thereof or of so much of it as shall be thought meet for her Highness' use, and the rest to be safely returned back again unto him, and that they may be bold in her Majesty's name to assure him."[5]

Then the queen and her ministers instructed the sheriffs to put pressure upon such of the "Collectors of the Subsidy" in each county "as were behindhand in their payments. Letters to the sheriffs of the counties of Buckinghamshire, Yorkshire, Gloucestershire, Nottinghamshire, Oxfordshire, Berkshire, Staffordshire, and Warwickshire and [to] the mayors of the towns of Northampton, Derby, King's Lynn and Southampton, [were expedited] to apprehend the collectors of the fifteenth and [the] tenth [taxes] in the said shires and towns behind of [sic] their collections, and to bind them in good bands in treble the sums to make payment of all that is by them due into the exchequer within fifteen days next after the bands taken, &c., according to the minute in the Council Chest."[6]

Before the end of December, the Privy Council reminded Sir Anthony St. Leger, the Irish treasurer, in the name of the queen—and

not for the first time—that the crown must insist on the repayment of the large sums for which he had failed to account during his tenure of office in the treasury in Ireland.[7] Lord Paget received notice that his licence to deal in wine might be reconsidered, and that the Queen reserved the right in the meantime to reasonably demand a share of his profits. Paget was also required to send in an exact statement of the debts due to the late Queen Mary.[8] This was tantamount to an official rebuke, and would have made both St. Leger and Paget unhappy in the extreme. From Berwick in the north to Land's End at the tip of Cornwall, Elizabeth and her privy councillors scoured the country for cash and a true picture of her assets and liabilities. No member of the church or aristocracy, no merchant or yeoman was spared. And most important in this audit of the crown's assets was the queen's navy.

Before March 1559, *The Book of Sea Causes*, the first such register of naval assets and liabilities of its kind, had been compiled by the officers of the queen's navy, giving the names of all the ships, their tonnage, and number of men. It assessed the state of readiness of the queen's navy from the detail of her ships; their state of repair, type and quantity of artillery, the victuals in store, and what would be required at what cost to bring Her Majesty's navy into a fit fighting fleet. The bad-tempered and extremely gifted mariner William Winter, master of the queen's ordnance for the seas and probable main author of *The Book*, also reported on the state of all the ordnance and munitions both aboard ship as well as in the queen's storehouses.[9]

To make matters worse, Scotland's pirates began to make serious inroads into English imports, ravaging the English coastlines from Berwick to Norwich in the East and Carlisle to Liverpool in the West. Even the Spanish king was losing patience with the situation. Elizabeth herself reported to her ambassador in Scotland that the "King of Spain having . . . of late written to us that not only the subjects of the King of Portugal, but also his own of Spain and his Low Countries, are spoiled by pirates, some English, but most Scots, haunting our south and north seas . . . has earnestly renewed the complaint by his ambassador, adding that if the seas were not better preserved under our leagues, he must arm a force himself."[10] Irish pirates also made any passage through Irish waters treacherous, and English smugglers and pirates frequently joined in their escapades.

Then word arrived at court that a significant number of French troops were already garrisoned in Scotland. Invasion from France, where Mary Stuart and her husband, Francis, lived, was feared at any time. Letters poured into the Privy Council begging the queen to fortify the towns of Portsmouth, Southampton, and the towns of the Cinque Ports. The country remained ill prepared for all-out war against France and Scotland, mostly due to lack of funds and trained men to defend the realm. The situation was dire. But not for the first time, nor the last, the dogged English will—whether Catholic or Protestant—to remain independent of a foreign power prevented a civil war, and Englishmen and -women from all walks of life pulled together to defend the country. Scotland's domination by France was a ready example of what could happen in England, and no one wanted a rampaging, invading army to overrun the country and plunder what little they had.

Whether it was luck, or Cecil "making" England's luck on behalf of his queen and country, by April 1559, Scotland's Lords of the Congregation were already engaged in battle against the dowager Queen Mary of Guise's French troops. To the west, Ireland stood steadfastly Catholic and a potential magnet for France, Spain, or even the papacy as a toehold in the British Isles to attack the queen's Protestant England. Elizabeth was undoubtedly wise to see the necessity of preparing England as best she could for war, but without cash, no standing army, a debased coinage that she was in the process of rectifying, and a fleet that was in dire need of urgent repair the prospects of success were bleak.

There is no doubt that the picture was truly grim. Yet despite all the counsel received—both wise and bold—and all the letters issued hastily to better understand the financial state of the realm, it was only the backing of Elizabeth's merchants that gave the queen the breathing room she needed to understand her options and to act upon what she had learned. Sir Thomas Gresham, a member of the Mercers' Company of London and the queen's agent in Antwerp, was the most important of these at the end of 1558 and throughout the early 1560s. Antwerp, which had been on a steady rise in the first half of the sixteenth century, was the hub for all luxury goods for northern Europe. By the spring of 1559, it was easily the northern commercial capital. It was also Gresham's base of operations. Antwerp's other

main attraction was that it was the economic powerhouse for Philip II's Spanish Netherlands, and a source of inestimable intelligence on the Habsburg economy and intentions in the New World. And with the loss of Calais, the Staplers had temporarily retreated to Antwerp while seeking new cities to conduct their business for the spinning of their wool into cloth on a more permanent basis.[11]

And so, it was on Thomas Gresham that the queen relied for help. Elizabeth's sister had borrowed £160,000—£100,000 in Antwerp and £60,000 in London—in the final year of her reign ($59.81 million or £32.33 million today).[12] When Elizabeth had come to the throne in November 1558, £69,069 ($25.83 million or £13.96 million today) were still owed to Flanders merchants.[13] Over the next year, Elizabeth would borrow a further £30,000 ($11.14 million or £6.02 million today) from her powerful traders with Antwerp, the Merchants Adventurers, through Gresham's auspices to pay soldiers' wages, buy arms, and refit ships. It was Gresham alone who took charge of the queen's finances with Antwerp, which was still the northern powerhouse of trade and finance. It was also Gresham who advised the queen on how best to consolidate her debt and rebuild confidence in the pound sterling by removing base coins from circulation.

Undoubtedly, not all of what he did was aboveboard. Customs agents were bribed to allow bullion to be exported from the Low Countries, and not all shipments of armaments were openly declared. Gresham rightly feared that, if the Netherlands regent for Philip II, Margaret of Parma, understood that he was arming England for the conflict ahead, a full embargo on exports to England would be put into force. What Gresham also recognized, as a seasoned Channel traveler, was that the queen's navy needed urgent refitting if the country had any hope of staving off the powers of France, Spain, and the papacy. Stealth and rapid deployment of money and materiel were essential.

It was Gresham's echo of other advice already received from Cecil and his fellow privy councillors that helped spring the queen into early action. The first step toward rebuilding her navy was for the princely sum of £14,000 a year ($4.98 million or £2.69 million today) to be advanced half yearly to Sir Benjamin Gonson, treasurer of the

Admiralty, "to be by him defrayed in such sort as shall be prescribed by him the said lord treasurer with the advice of the lord admiral."

The lord treasurer was to

> *cause such of her Majesty's ships as may be made serviceable with caulking and new trimming to be sufficiently renewed and repaired; item to cause such of her Highness's said ships as a must of necessity be made of new to be gone in hand withal and new made with convenient speed; item he to see also her Highness's said ships furnished with sails anchors cables and other tackle and apparel sufficiently; item he to cause a mass of victual to be always in readiness to serve for 1,000 men for a month to be set to the sea upon any sudden; item he to cause the said ships from time to time to be repaired and renewed as occasion shall require; item when the said ships that are to be renewed shall be new made and sufficiently repaired and the whole navy furnished of sails, anchors, cables and other tackle then is the said lord treasurer content to continue this service in form aforesaid for the sum of £10,000 yearly to be advanced as is aforesaid; item the said Benjamin Gonson and Edward Baeshe, surveyor of the victuals of the ships, shall make their several accounts of the defrayment of the said money and of their whole doings herein once in the year at the least and as often besides as shall be thought fit by my lords of the council.*[14]

The Book of Sea Causes detailed the naval preparedness of the realm. Elizabeth's thirty-four ships consisted of eleven great ships (200 tons and upward), ten barks and pinnaces, and one brigantine, which were "meet to be kept," or in satisfactory condition, while the remaining twelve, among which were two galleys, were to be discarded as "of no continuance and not worth repair."[15] Of all the ships surveyed, twenty-four were between 200 and 800 tons, four barks were between 60 and 80 tons, and there were two pinnaces of 40 tons.

But *The Book of Sea Causes* did not stop at its assessment of the Royal Navy. It noted with considerable interest that there were some forty-five "merchant ships which may be put in fashion for war" and another twenty vessels that could serve as victuallers. The

commissioners estimated that the enlarged fleet of merchant ships and royal ships could be mobilized within two months, providing there was "ready money for the doing thereof." The recommendation at the end of *The Book* was that "the Queen's Majesty's Navy" (this was the first time the term was employed) should be laid up in the Medway and Gillingham Water below Rochester Bridge in Kent, and that Portsmouth on the south coast should be used as an advanced base of operations in the summer months only.

The Book's main author, William Winter, was a colorful rapscallion who would eventually be knighted for his service to queen and country later in Elizabeth's reign. He had been one of the plotters in the Wyatt's Rebellion against Elizabeth's sister, Queen Mary, the leaders of which had wanted to put the Protestant Elizabeth on the throne. While Winter had been sent to the Tower for his efforts, even Queen Mary of England had to recognize his usefulness at sea when England declared war on Valois France with Spain. She was forced to release him for the good of the realm, and, as expected, Winter proved his mettle. He was undoubtedly the best and most able sea officer of his generation, and would soon prove his worth for Elizabeth, too.

By the time Winter was released into action, Elizabeth had already promoted him from surveyor of the navy to master of naval ordnance. There is every indication that he was most likely the decisive voice in the shaping of the new naval program. During the next few years, he oversaw the building of the 1,200-ton *Triumph* and the 1,000-ton *White Bear*. He also arranged for the 800-ton *Victory* to be purchased from its merchant owners. Yet despite these early advances, the poor state of the royal fleet meant that the total number of great ships in operation by 1565 had fallen to seventeen.[16] Winter found this unacceptable, and was undoubtedly one of the first commanders to believe that England's ships were the best "walls" to protect the realm.

Fortunately, Winter's formidable naval talents extended beyond seamanship and surveying. When war with the Queen of Scots and her French Guise relations to expunge the popular Protestant movement became a certainty, Winter was dispatched by Elizabeth in December 1559, the worst possible time of year to engage in a naval battle in the North Sea. His instructions via the Duke of Norfolk, in

charge of the land expedition, were clear: "He [Winter] shall aid the
Queen's said friends and annoy their enemies, specially the French,
without giving any desperate adventure; and this he must seem to do
of his own head as if he had no commission of the Queen or of the
Duke of Norfolk. And that the Queen's friends may be the sooner
comforted the Duke thinks it not amiss that either the said Winter
himself or some of the captains, do forthwith show themselves in the
Firth, leaving the rest behind to receive the said five hundred or 600
harquebusiers to follow."[17]

The high winds and swirling icy tides of the North Sea in
December did not deter the queen's indomitable sea dog. Not only did
he and his fleet of thirty-four ships surprise the French by preventing
reinforcements from landing; but the French were driven back all
the way to the Spanish Netherlands for shelter. Exhausted and glad
to be alive, the French clambered upon the shore, only to be subjected
to pillage from pirates of an unknown nationality. Within a few
weeks, in January 1560, it was a confident Winter who boldly sailed
into the Firth of Forth at Leith, cutting off the French army at Fife.
The French troops almost immediately abandoned their weapons,
and Winter captured two French galleys as prizes for himself, his
men, and the glory of England. When the dispatches reached the
queen at court, Elizabeth could hardly believe Winter's phenomenal
achievement. An order to attack by land as well was issued, and the
courier rode day and night to Berwick to deliver the message. If
Winter could do it, then surely the Duke of Norfolk could follow
suit and beat the French roundly, she reasoned. Winter's successes
had been hailed by the Scottish Lords of the Congregation, and
asked only for England's army to help them reclaim their country
from Mary Queen of Scots's mother, Mary of Guise.

Meanwhile, in Antwerp, Gresham wrote to Cecil at precisely the
same moment that January, declaring, "Here there is very large talk
of the Queen's estate, and the weakness of England, which comes
in very ill time for the accomplishment of the rest of her affairs."[18]
The very real concern for Gresham and his factor, Richard Clough,
who were responsible for getting replacement armaments and
ammunition to the English fleet and armies, was that credit would
not be granted to the queen for a substantial shipment of war materiel
worth between £14,000 and £15,000 ($5.38 million and £2.91 million

today) and release of Her Majesty's ships from harbor in Antwerp. Yet by the close of business on the very day Gresham wrote his worried letter, the Antwerp authorities and foreign merchant princes agreed to allow the loaded English vessels to depart. Gresham and Clough had already shipped enough copper alone for the queen's ordnance makers to manufacture up to forty cannons.[19]

The success in Gresham's negotiations, as well as the superiority against the French at sea, was due in large part to Winter's ability to keep the French at bay and the Spanish under threat of reprisal if they interfered. By his control of the Narrow Seas, England threatened to cut off communication with Antwerp and French interaction with Scotland. It was the first time in what would become the queen's long reign that her ships would provide her with security from invasion, while ensuring that commerce was allowed to continue, albeit at a greatly reduced level. Gresham, while responsible for procuring the weapons of war, also wanted the peace restored as soon as possible, since for every pirate or adventurer able to capture a valuable prize, there were a thousand Englishmen trying to resume England's main export—the cloth trade to Antwerp.[20]

Once the naval and land battles of the short-lived War of the Insignia against the Guises faded, and the war was declared over (mostly due to the unexpected death of Mary of Guise in June 1560), the French king, Francis II, and his queen, Mary Queen of Scots, were forced to abandon their claims to the English throne— at least on paper in the Treaty of Edinburgh. Yet the English malaise remained great, with councillors and the queen pointing out the repeated failings of Norfolk's armies. There were seemingly endless recriminations as to when, why, and where battles were lost. And the government knew that the country had been extremely lucky to come out of its first test relatively unscathed. The only commander to escape their criticism was William Winter himself. William Cecil, secretary of state, wrapped up government appreciation of Winter when he stated, "but of Mr Winter all men speak so well that I need not mention him."[21]

And it looked as if England's good fortune would hold a little longer. Francis II died unexpectedly in December 1560,[22] and his younger brother became Charles IX under the regency of his

omnipotent mother, Catherine de' Medici. Mary Stuart was now a dowager Queen of France, with no power and no presence. While she had never ratified the Treaty of Edinburgh, both France and Spain now wanted peace with England. The near strangulation of trade they had experienced at the hands of Winter and the revitalized English fleet had hardly been expected.

With peace now firmly on the agenda, and the English and French troops out of Scotland, William Winter was once again able to turn his talents to administrative matters. Waste, and more precisely the waste of the queen's exchequer, was a matter dear to Elizabeth's parsimonious heart. Detailed orders regulating the operation of the Navy Board or the "Office of the Admiralty and Marine Affairs" were drawn up based in some part on his advice to tighten up on slack and wasteful accounting, with weekly reporting to the lord admiral or vice admiral instituted. The navy's treasurer had to report monthly as well, giving written accounts quarterly; and the master of naval ordnance was obliged to make a quarterly report from his department. But the real power to spend money on ships, ordnance, and seamen remained in the lord treasurer's hands; and the lord treasurer, the Earl of Winchester, remained at the queen's side in the Privy Council.

The modern naval administration was beginning to take shape. Sir Benjamin Gonson was Winchester's counterpart in the Royal Navy, which disbursed the funds on Gonson's behalf. Gonson, himself a wealthy merchant, had another claim to fame. Within the next few years he would become the father-in-law of the queen's most colorful corsair of the 1560s, John Hawkins.

5. The Merchants Adventurers, Antwerp, and Muscovy ✣

*Our merchants perceived the commodities and wares of
England to be in small request with the countries and
people about us . . . and the price thereof abated . . . and
all foreign merchandises in great account, and their prices
wonderfully raised; certain grave citizens of London . . .
began to think with themselves how this mischief might be
remedied: for seeing that the wealth of the Spaniards and
Portuguese . . . they there upon resolved upon a new and
strange navigation.*

—RICHARD HAKLUYT, *PRINCIPALL NAVIGATIONS*, 1589

Long before and after the wily patriarch of the Hawkins family,
William, had ceded his Spanish trades with Iberia to his two
sons, first Bruges then Antwerp was the center of world trade in the
densely populated north of Europe. Since the last great Dukes of
Burgundy had moved their court to Bruges in the mid-fourteenth
century and aligned themselves to the English crown, the special
relationship between the House of Burgundy and England prevailed
against the common enemy, France. When Marie of Burgundy
married into the Habsburg line around 130 years later, the affinity
between England and Burgundy was automatically transferred to
the House of Habsburg.[1]

The great and powerful London Company of Merchants
Adventurers had profited from the relationship with the House of
Burgundy, then Habsburg, since the late Middle Ages. Its wealth
and power resided not only in maintaining the status quo with
their cloth exports across the Narrow Seas to Antwerp, but also in
keeping ahead of the increasingly cutthroat competition. In the year
before Elizabeth ascended the throne, the foreign merchants of the

north German Hanse towns decided at the Diet of Lübeck to start a commercial war against England, since the Merchants Adventurers were insisting with the crown that Hanse privileges (particularly the waiving of import duties) should be renewed only if the Hanse merchants imported goods solely from their own lands. The value of Hanse imports had already exceeded £200,000 ($73.39 million or £39.67 million today), and so in response, the Hanse merchants gambled that their merchandise from across Europe would mean more to the Elizabethans than the vociferous complaints of her merchant princes.[2]

It was a game played throughout Christendom. The Merchants Adventurers themselves enjoyed special privileges at Antwerp and held similar rights there to the German Hanse merchants based out of the Steelyard in London. So when the English vessels returned to England—importing gems, spices, and other luxuries from the Indies, wines from Italy, or silks—it took little convincing to point out to the queen that it was in her best interests to ensure that they did so on English ships at higher customs duties.[3] But applying diplomatic pressure on the crown wasn't the only way the Merchants Adventurers gained the upper hand against its competition. One of the formidable Hanse towns, Hamburg, had suffered badly from the series of religious edicts made by the pope and Philip of Spain's father, Holy Roman Emperor Charles V, against its predominantly Protestant population. When Elizabeth became queen, her Merchants Adventurers negotiated as trusted Protestant middlemen with the city fathers at Hamburg, and then their queen. The negotiations culminated in the Merchants Adventurers doubling their European market from Antwerp to include henceforth Hamburg. This had the double benefit of also driving a wedge between the northern German cities and contributing largely to breaking up the Hanse trade block.[4]

When Elizabeth ascended the throne, England had been a military and trading backwater compared to Venice, Spain, and especially Portugal. Envy, as well as survival, played an important role in England's premier overseas merchant trading group's quest for alternative markets.[5] The country's Merchants Adventurers had long been the backbone of English export trade, representing

some 90 percent of the cloth exports as well as a strong voice urging the queen against war and Channel piracy. Both were always bad for distribution channels and frequently bad for business. The Merchants Adventurers, like the Hanse merchants, had a great deal to lose if their overseas markets were difficult to reach, or if they themselves were embroiled in a war over which they would have no control. And so, expanding their markets and monopolies made tremendous sense.

They had their own fleet of ships; their own armaments; their own treasury; and their own laws, making them a stand alone, powerful English corporation that could represent an attractive ally to the inexperienced young queen. They engaged solely in foreign trade, and were therefore the greatest receivers of foreign exchange, not to mention foreign intelligence. Strict regulation from "intermeddling" by interlopers was conferred on them by the crown to protect their trading outposts.[6] In fact, their royal decree even engaged the Low Countries in its charter:

> They have full authority as well from her Majesty as from the Princes, States and Rulers of the Low Countries, and beyond the seas, without appeal, provocation, or declination, to end and determine all civil causes, questions and controversies arising between or among the brethren, members and supporters of the said Company, or between them and others, either English or Strangers, who either may or will prorogate the jurisdiction of the said Company and their court, or are subject to the same by privileges and Charters thereunto granted.[7]

Criticism of the court's decision was a punishable offense. Violations of the ordinary rules of the company were always punishable by a monetary fine, with repeated violations often culminating in imprisonment. Any merchant caught "intermeddling" or interloping on the Merchants Adventurers patch often would be both fined and imprisoned.[8]

Yet the Merchants Adventurers were still subject to royal decree, and in order to set sail, export cloth or other commodities, or claim any monopolies over any territory, they, as all of the crown's subjects,

needed royal assent. And the best way for them to get what they needed to grow their interests was to nurture a symbiotic relationship with the crown. Nothing would have made this more apparent to either party than the brief War of the Insignia, where their cross-Channel business was severely disrupted. Since their freedom to trade was at stake as they were all staunch Protestants, they threw their considerable financial weight behind the queen and facilitated loans through Gresham, the queen's factor in Antwerp, in exchange for royal favor.

The merchants, Gresham, the queen, and the Privy Council all knew the importance of their trade to the realm, and that protecting it was essential to England's balance of payments. If their trade faltered, either in export to the Low Countries or the reexport of English kerseys (a lighter and cheaper cloth sold in southern Europe) over the Alps and back to Italy, Turkey, the Balkans, and Persia, then England's fledgling economy would be ruined.[9] By 1560, the queen had already realized that these powerful London merchants—probably no more than one hundred strong—were her stepping-stones into international finance and world prestige. So she let it be known that if they wanted her royal charter and her protection, there would be a reciprocal price to pay.

For better or worse, they had to agree, and the queen set her man Gresham to work on the plan that would launch England on its own road to empire. His work over the next several years would undoubtedly be fraught with difficulties, but above all else, the queen reminded him that failure was not an acceptable outcome. Gresham wisely counseled the queen that before he could work miracles, and she could strut across the world stage, she and her ministers must undertake a rapid stabilization of the pound sterling.[10] Her father, Henry VIII, had in great part enriched the crown with the Dissolution of the Monasteries, pillaging Church treasures and Church lands for himself and his cronies. Still Henry wanted more, and lowered the gold and silver content of English coins. The king had unwittingly wreaked havoc with the Great Debasement of the English monies, which not only undermined confidence in the pound sterling but also made it virtually impossible in a difficult market—like the one in 1560—to fix a viable exchange rate for sterling against other currencies.

Gresham knew from years of experience that the Antwerp money market was extremely sensitive to change depending on supply and demand, and that it was often so unpredictable that rates could change significantly during the course of two Bourse times. This meant that "easy" money was often followed by a period of a dearth of funds, which would only be made available at astronomical rates of interest.[11] In 1560, both conditions prevailed. Gresham's greatest feats of prestidigitation over the next two years would be to enhance the queen's fiscal management reputation by paying Mary's debts, borrowing fresh funds to cover the Scottish war, assisting with the recoining of English currency, and reestablishing confidence in the pound.

The new shilling (twenty making up one pound sterling) was minted, weighing 96 grains and containing 88 $\frac{4}{5}$ grains of fine metal. The mint price was fixed at £2.18s.6d. per pound troy of sterling silver. A pound of "angel" gold was coined into £36 by tale, and a pound of crown gold, which was slightly less pure, into £33 by tale. This meant that the rate between silver and gold was slightly more than eleven to one.[12] Elizabeth proclaimed on December 23, 1560, that the deadline to hand in the debased testoons stamped with a greyhound would be extended to April 1, 1561, in order to handle the volume required by the public. Stringent laws were also brought into effect to increase the penalties for "pinching" or "cutting" coins of the realm in order to siphon off silver or gold for personal use. In the event, Elizabeth nearly met her self-imposed deadline, with the old coins ceasing to be legal tender by the end of April. With the recoinage complete within a year of her announcing it, the queen congratulated herself by stating that she had won a victory over "this hideous monster of the base money."

What made this huge undertaking even more sweet was that the government had minted the new coins at a cost of £733,248 ($261.61 million or £141.41 million today), and paid only £683,113 ($250.62 million or £135.47 million today) for the "base monies," giving it a gross profit of £95,000 ($34.85 million or £18.84 million today). After government expenses, a net profit was estimated at £40,000 ($14.67 million or £7.93 million today).[13]

At last, the queen's merchants could put their faith behind the

English pound, assured of a stable standard of weights and measures for the currency. Wild currency exchange rates became a thing of the past, and the English merchants were again in a position to take advantage of the foreign markets. The downside was that while sterling's exchange rates were again stable, the currency had necessarily suffered some devaluation as well. This presented more problems for the smaller merchants, who were also being squeezed by Spanish wool merchants importing merino wool from the high plains of Iberia. The general public was also unhappy, since there was an acute shortage of ready cash at the existing prices. The Elizabethan chronicler, John Stow, wrote that in the fall of 1561, "the citizens of London were plagued with a threefold plague: pestilence, scarcity of money, and dearth of victuals, the misery whereof we hear too long to write."[14]

Still, the competition was bruising. For each English merchant prepared to carry cloth or other English exports like tin to the Continent, there were at least two "strangers," or foreigners, prepared to take his place in any market. London itself, while it had a number of foreign traders, especially from Italy and the German Hanseatic League, never openly welcomed them in the way that Antwerp did. They were mistrusted as "strangers," with the government and competitors alike keeping a close eye on them, making business and living needlessly uncomfortable and at times claustrophobic. In contrast, the openness of Antwerp allowed the city and the whole of the Spanish Netherlands to prosper from its acceptance of foreign traders, and the city burgomasters welcomed "strangers" in its midst in a way that was as yet unheard of in England. In this welcoming attitude, Antwerp was unique, and the city profited from it.[15]

At the beginning of Elizabeth's reign, there were well over 185 Italian firms in Antwerp alone, with more than that number again in German (from both the Hanse cities and Swabia), Spanish, Portuguese, Danish, Swedish, and English trading houses joining the thriving market. The main reason for this extraordinary commercial bustle was that the "Lords of Antwerp," as the English referred to them, were themselves serious players in the luxury trades and excellent businessmen. This contrasted sharply with London,

where "citizenship" of London would normally be acquired early in life through an apprenticeship to one of the large medieval City corporations (the Mercers, Merchants Adventurers, Staplers, or others), and even then, the proud possessor would be only one rung above the despised "stranger."[16]

Yet by 1561, Antwerp had passed its heyday. While it still flaunted its ancient privileges handed down from the Burgundy dukes as a free city of the Holy Roman Empire, Philip II had already hatched other ideas.[17] The envisaged changes were spurred on by a number of factors, but the first of these would have been the dishonor of his parlous financial state at the time of becoming King of Spain in 1557. His "bankruptcy" of 1557 had devastated a number of the merchants trading in Antwerp—of all nationalities—and made them wary of taking any further sovereign debt. As if this weren't bad enough, other monarchs, including the Portuguese and French governments, repudiated their financial obligations as well, causing a second wave of bankruptcies among the merchants.[18]

Nothing undermines economies more than a lack of confidence, even war. And Philip of Spain, by his inability to pay the huge war debt inherited from his bellicose father and aggravated in his war against France, promoted the decline of Antwerp unwittingly. He was truly dismayed at the anger of the international merchant community; yet as an absolute monarch, he refused all rebuke. He longed for the warmth and comforts of Spain, and took this opportunity to decide that Seville would become the heart of his world trading operations. He resolved that Spain, which he cherished more than any other of his dominions, would become the center of his personal universe and his political empire. Now that his French war was over, his English wife, Queen Mary, soon to be replaced by Elisabeth of France,[19] Philip needed to get on and build his personal dynasty. Fatefully, the only place to do that, in his mind, was Spain. He left the Low Countries in disarray in July 1559, never to return.

Meanwhile, Elizabeth was ready to turn the economic adversity caused by Philip and his misuse of the Antwerp merchants to her advantage. Her first step was to negotiate through Gresham to buy arms and ammunition for the Scottish war. But more important

from Antwerp's viewpoint, Elizabeth sent a clear message through Gresham to reimburse the merchant princes for their loans to her half sister Mary I. At a stroke, Elizabeth of England had set herself above the other monarchs of the time, and especially Philip, by making good her sister's foreign sovereign debt.[20]

Yet despite the queen's ascendancy in Antwerp, England's Merchants Adventurers could not escape unscathed. Philip made his second declaration of "bankruptcy" in 1560, taking down with him some of the top merchant banking families of Europe. Naturally with so many merchants forced to close down operations or tighten their belts as a result of the bankruptcies, there were a number of trades with the English, too, that defaulted. The monumental rise in litigation in Antwerp is a clear indicator of how tricky business dealings had become. English merchants who were not part of the Company of Merchants Adventurers, like the Hawkinses, found that their Spanish and Canaries trades were likewise affected. But most significantly for Elizabeth was if her Merchants Adventurers had dubious royal debtors. In that eventuality, they would be less likely to support her crown with loans in the future unless she could really make it worth their while.

Philip had lost the confidence of his European financiers, relying instead as much as possible in the future on the steady stream of the flota, the Spanish treasure fleet, arriving yearly from New Spain. The Low Countries, and indeed Protestant northern Europe, were proving too great a diversion for him, since the real threat to Spain, or so Philip believed, was the Turkish domination of the Mediterranean, not the heretic English queen. His decision to remove Spanish troops from the defense of the Netherlands against France in the early 1560s was directly linked to his inability to continue to fight European wars on two or more fronts *and* finance them.[21] What Philip had failed to understand was that, at a stroke, he had lost his best chance of taming a young Elizabeth, who, with the Low Countries, would all too soon represent the greatest threat to his empire.

While, the Queen of England took the tough decisions to sort out the "base monies," Elizabeth's Merchants Adventurers had seen all too

clearly from the Spanish king's actions that Spain was not invincible. Long before the king had made his decision to return to Spain, they had decided to try their hand at plying trade themselves to the Indies, or Cathay, cutting out the middlemen from Iberia, the Arabs, or the Venetians—all of whom had long-established business in the region. But unlike the Spanish and Portuguese, England's Merchants Adventurers would approach the Indies from the Northeast and Russia, or Muscovy, as it was then called.

The idea was the brainchild of the Muscovy Company's first governor, Sebastian Cabot, a Merchant Adventurer himself and self-proclaimed "governor of the mystery and company of the Merchants Adventurers for the Discovery of Regions, Dominions, Islands and Places unknown" as early as 1548, the first year of Edward VI's reign.[22] Cabot, whose father had discovered Newfoundland in an expedition financed by Elizabeth's grandfather in 1497, had been a long-distance sea captain and merchant in his own right since 1508. The company's first voyage to Russia set out in 1553 to tremendous fanfare while the adolescent King Edward VI lay dying at Greenwich.

And it was simply a voyage organized on a scale that had never before been contemplated. The "admiral" or flagship was the *Bona Esperanza* of 120 tons, commanded by Sir Hugh Willoughby and carrying thirty-one men with provisions for eighteen months. His "vice admiral" was the *Edward Bonaventure* of 160 tons, sailing under Richard Chancellor, pilot major of the fleet, with thirty-nine men. The third ship in the tiny flotilla was the *Bona Confidentia* of 90 tons, carrying twenty-five men and the master of the fleet. Each vessel had been "new built," that is, repaired with good planking and timbers with their keels sheathed in lead against sea worm. Each ship had its own pinnace, arms, and victuals. And since this was a trading voyage, there were important merchants, Protestant ministers, and musicians who helped to make up the complement of 116 men in all. There were two hundred subscribers—all the great and the good of the land from peers and privy councillors to wealthy City merchants—whose fully paid-up share capital amounted to the staggering sum of £6,000 ($2.78 million or £1.5 million today). Even the lord high admiral, John Dudley, Duke of Northumberland, and his son-in-law, Henry Sidney, were pivotal investors.[23]

Envy of the luxury trades, so long monopolized by the Spaniards and the Portuguese, was the strongest motive for the enterprise. But it was its component backers—from the common seaman to the lord high admiral and City merchants—that set the blueprint for the future of English maritime expansion. The distinction among England's sea dogs, her merchants, and her rulers would become more and more blurred as the Elizabethan age progressed, with maritime exploits and successes becoming the most certain way of rising quickly in society and in wealth.

Even more extraordinary than the armchair admirals backing the voyage was the privation and degradation that the English would suffer until they could at last call success their own in long-distance voyages. This first voyage of discovery to Russia was, in simple terms, a financial disaster with huge loss of life. The ships were delayed by "fickle winds," and Willoughby, who had been chosen to lead the voyage for his "goodly person" overshot landfall and had to turn south to Arzina on the Lapland coast in September, where they decided to over-winter. He had lost contact with Chancellor in the *Edward* and presumed that Chancellor, the less-experienced man, would not survive. Willoughby's journal abruptly ended with that thought. It was found the following summer by Russian fishermen, who had discovered it among the frozen bodies of seventy men.[24]

Meanwhile, Chancellor had found landfall farther north at Vardo, and, having waited a week (as long as he dared in the enclosing gloom of August near the North Pole), sailed on to the White Sea, where he came ashore near the mouth of the River Dwina. Chancellor and his men made their way overland by sled to Moscow and the Russian czar's "golden" court, presenting King Edward's greetings to Ivan IV, later known as "the Terrible." While the descriptions given of the Russian countryside were of an isolated and desolate icebound wasteland, the court of Ivan IV was much admired by Chancellor and his men:

> They go, and being conducted into the Golden Court (for so they call it, although not very fair), they find the Emperor sitting upon a high and stately seat, apparelled with a robe of silver, and with another diadem on his head; our men, being placed over against him, sit down. In the midst of the room stood a mighty

cupboard upon a square foot, whereupon stood also a round board, in a manner of a diamond, broad beneath, and towards the top narrow, and every step rose up more narrow than the other. Upon this cupboard was placed the Emperor's plate, which was so much that the very cupboard itself was scant able to sustain the weight of it. The better part of all the vessels and goblets was made of very fine gold; and, amongst the rest, there were four pots of very large bigness, which did adorn the rest of the plate in great measure, for they were so high, that they thought them at the least five feet long. Then were also upon this cupboard certain silver casks, not much differing from the quantity of our firkins wherein was reserved the Emperor's drink. On each side of the hall stood four tables, each of them laid and covered with very clean table-cloths . . . [25]

Ivan, too, was impressed with the English mariners. A general agreement to commence trading with England was undertaken, and Ivan wrote back to Edward (who was already long dead), saying:

In the strength of the twentieth year of our governance, be it known that at our sea coasts arrived a ship, with one Richard and his company, and said, that he was desirous to come into our dominions, and according to his request hath seen our Majesty and our eyes; and hath declared unto us your Majesty's desire as that we should grant unto your subjects, to go and come, and in our dominions, and among our subjects to frequent free marts, with all sorts of merchandises, and upon the same to have wares for their return. And they have also delivered us your letters which declare the same request. And hereupon we have given order, that wheresoever your faithful servant Hugh Willoughby land or touch in our dominions, to be well entertained, who as yet is not arrived as your servant Richard can declare . . . according to your honourable request and my honourable commandment will not leave it undone, and are furthermore willing that you send unto us your ships and vessels, when, and as often as they may have passage, with good assurance on our part to see them harmless. And if you send one of your Majesty's council to treat with us, whereby your country merchants may with all kinds of wares, and where they

*will, make their market in our dominions, they shall have their free
mart with all free liberties through my whole dominions with all
kinds of wares, to come and go at their pleasure, without any let,
damage, or impediment, according to this our letter, our word, and
our seal . . .* [26]

Chancellor returned to London in 1554 with the relative good news
that the Russians had agreed to trade, and the Muscovy Company
was officially incorporated under Queen Mary by royal charter.
It was granted the monopoly on trade with Russia and all areas
"northwards, northeastwards and northwestwards" which had
been unknown to Englishmen prior to 1553.[27] But the hero of the
Muscovy Company, Richard Chancellor, drowned two years later
in the wreck of the *Edward Bonaventure* after one further voyage
to the White Sea. While Chancellor had given his life for dreams
of adventure (which he certainly had) and wealth (which he never
quite got), the importance of his achievements lay not in the original
discoveries made, but rather in the overall drama of his voyages,
the royal charter, royal embassies, and its cumulative impact on the
English nation. English merchants from the City of London had
taken part and witnessed firsthand the impact of long-distance,
heavily capitalized trade through a joint stock company involving
several strata of society. This made the Muscovy Company the
natural patron of geographical science and enterprise well into
Elizabeth's reign.

And it was not difficult to find replacements for the Muscovy
Company's dead hero. Chancellor's successors were two brothers,
Stephen and William Borough, sons of the Devon navigator John
Aborough. The Boroughs consolidated Chancellor's northern sea
route by turning it into a flourishing commercial highway and
increasing important trade in rope, hemp, and Baltic oak to England.
By the time the Muscovy Company's Governor Cabot died in 1557, it
was believed that the Muscovy trade could travel overland through
Russia in a southerly direction to Persia.

Notwithstanding the Borough brothers' achievements by sea,
the land route southward through Russia to Persia was trail blazed
by a merchant, member of the Mercers' Company, and later royal

ambassador of Elizabeth's: Anthony Jenkinson. Jenkinson began his career as an adolescent training in the Levant, and he traveled extensively throughout the Mediterranean, having received a "safe conduct" permitting him to trade freely in Turkish ports from Suleiman the Great in the early days of Mary of England's rule. On his first journey to Russia, he said his trade with the Tartars was "small and beggarly . . . not worth the writing, neither is there any hope of trade in all those parts worth following."[28]

Still, Jenkinson soldiered southward to Bokhara in tremendous danger from the successive marauding caravans who kidnapped him or molested the trading party. When they reached Bokhara some sixteen weeks later, the city was a huge disappointment, with "beggarly and poor" merchants with so few wares to sell that Jenkinson thought that their stocks hadn't been renewed in two, if not three, years. The way to China, he discovered, would take another nine months overland in the most favorable circumstances; but the road was blocked by war, which happened with alarming regularity. Jenkinson continued on to the Caspian region and eventually sold enough goods to make a small profit. But it was his intelligence on the disruption to trade in the region between Russia, Persia, Turkey, and India by war that would prove the commodity of real value to Elizabeth.

In May 1561, Jenkinson was sent out again on his second Muscovy voyage, carrying letters recommending him to Czar Ivan, the Shah of Persia, and other Circassian princes. The purpose of his journey was to establish firm trade with Russia, and to make another trip to the Caspian region to open commercial trade with Persia. On his arrival in Moscow that summer, Jenkinson was shocked that he was denied access to the czar, and refused leave to travel south. After a six-month delay, under effective house arrest, and at a point of giving up all hope of achieving his goal, the former English ambassador "intervened." At last, Jenkinson would be received at the Russian court.[29] But what sort of "intervention" had the English ambassador made?

In the month prior to Jenkinson's departure from England, the Senate of Hamburg wrote to Elizabeth that "certain princes of the Roman Empire" had informed them that "certain large quantities

of armour and cannon shipped from their town belong to private persons, and is intended for the use of the Grand Duke of the Russians or Muscovites against the Livonians in contravention to the Imperial decree which forbids any ammunitions of war to be sold for the use of the Muscovites. They therefore beg that she will send them an assurance that these arms are intended for her own service."[30]

This complaint was followed two weeks later by a letter from the Senate of Cologne, that wrote on April 30, "Having heard that a very considerable amount of arms, offensive and defensive, were being shipped by her order (especially of the kind required for men-at-arms, such as hand-guns) they were unwilling to hinder the quiet transportation of the same for her service. It having just now come to their knowledge however that certain English traders convey these arms either into Muscovy direct, or to parts from which they may be carried thither, contrary to the interests of the empire."[31]

Elizabeth naturally denied all knowledge of such goings on and wrote back to the Senate on May 6 that "on her royal word" no arms and munitions *had been* shipped in her name from Hamburg.[32] Eight days later, on May 14, Anthony Jenkinson embarked for Russia. Two weeks after that, on May 31, the Holy Roman Emperor Ferdinand wrote to the Queen of England, telling her that he had heard these "rumors" and that the Muscovites are greatly encouraged in their belligerence against Poland and the Germanic states by the provision of "warlike matters." He has therefore given strict orders that no one shall be allowed to transport arms or victuals into Muscovy, and begged the queen to ensure that none of her subjects would go to the country either.[33]

If Ferdinand had heard rumors that the Queen of England was providing Ivan the Terrible with his dark materiel of war, then most likely Ivan, too, would have expected armaments in the English merchants' wares. There is no precise record of Jenkinson's inventory that survives, but in view of the huge delay in Ivan's receiving him, it seems unlikely that whatever war materiel may (or may not) have been provided at the outset was deemed inadequate by the tempestuous czar. The fact that only upon "the intervention" of the former English ambassador was Jenkinson allowed not only

to meet Ivan, but also to become the czar's gem and silk merchant
to Persia, indicates that some favors in the form of weaponry were
most likely exchanged. Ivan made no secret about his "love" of the
English in his struggle against Poland after this, and it is doubtful
that this love would have been as steadfast as it became throughout
the 1560s in commercial and political terms without an English
trade in weaponry.

By June 1562, Jenkinson was finally given a safe conduct from court
and allowed once more to journey down the Volga to the Caspian
Sea, but aside from a sumptuous welcome and friendly relationship
that developed with Abdullah Khan in Shirvan, the trading mission
to Persia proved a disaster. He had once again landed himself in a
war zone on the turn:

> For the Turk's Ambassador being arrived and the peace concluded,
> the Turkish merchants there at that time present, declared to the
> same Ambassador that my coming thither . . . would in great part
> destroy their trade, and that it should be good for him to persuade the
> Sophia not to favor me, as his highness meant to observe the league
> and friendship with the great Turk his master, which request of the
> Turkish merchants, the same Ambassador earnestly preferred, and
> being afterwards dismissed with great honor he departed out of the
> Realm with the Turk's son's head (the rebel Bajazet) as aforesaid,
> and other presents.[34]

Jenkinson was lucky to escape back to England without being made a
"present" himself, and only returned at all through the good auspices
of Abdullah Khan, who persuaded the shah that it would bring bad
luck to kill a stranger "in that fashion." While Jenkinson made five
further voyages to the region, and his voyages were persistently
marred by great misfortune, murder, and failure, the overwhelming
desire to trade directly with Persia and Cathay would become an
English mantra and obsession over the next twenty years. What
Jenkinson's adventures highlighted was that England's strengths lie
not in overland trade, but in somehow dominating the seas.

Trade had become the promoter of new ideas as well as the
generator of economic growth, and helped England to emerge from

its mediocrity into the Renaissance. English merchants, mostly Londoners, learned quickly the refined art of the long-distance business gurus, the Italians, combined with the crucial strategy of controlling the Channel and Narrow Seas. Control of the Channel's shipping lanes meant domination—both economic and political—of Spain's trades with the Low Countries, and this in itself became a goal from the beginning of Elizabeth's reign.

By the end of 1560, the English navy was already evolving into an efficient machine. The country's seamen were putting out to sea to "harvest" from England's enemies (and sometimes her friends) while the English Merchants Adventurers often benefited directly from their forays, though often claiming the reverse.

The country's merchant fleet plying the Channel was not only well protected by the queen's ships, as required, but also by a growing breed of fearless and daring seamen out to take prizes from hostile shipping in payment for shepherding the fleet. In the early 1560s many young English adventurers, dreaming most probably of voyages with the Muscovy Company to Cathay rather than mundane Channel crossings, grew up in the hope that some day, they would cross oceans and take "real" prizes. The exploits of English, French Huguenot, or Scottish pirates were whispered on everyone's lips, and the source of persistent complaint to the Queen of England by her neighbors. Their daring raids in smaller, swifter ships were admired and feared by all. In England, these men were the new "Robin Hoods," seeking to redress the previous years of bloody Catholic cruelty under Mary and dreaming of rich prizes to distribute among their friends. Such men hardly saw their own brand of retribution as Protestant corsairs in the same light. One such dreamer in the thick of the trade with the Low Countries and France—a red-haired junior master on a small bark making the run between the Low Countries and Dover—was the then unknown renegade Francis Drake.[35]

Like hundreds, if not thousands, of other young men, Drake's life and career would be made by "harvesting the sea," teetering perilously at times into piracy, while at other times turning his efforts expansively to the legitimate investments of other merchant princes of the day. His career, perhaps more than any other, came

to symbolize the synthesis of the English seaman from merchant shipping service to defense of the realm to the type of adventurer who would, in Sir Walter Raleigh's words, "seek new worlds, for gold, for praise, for glory."[36]

Frequently in years to come, it would be difficult to discern the legal endeavors of most of Elizabeth's seamen, statesmen, and gentlemen from out-and-out buccaneering. These men—call them pirates, corsairs, rovers, privateers,[37] mariners, sailors, merchants, adventurers, or gentlemen—would drive the rebirth of an isolated England and transform the island nation into a nascent empire. They would also undermine the fortunes of Catholic Europe, and most notably those of Spain and Portugal.

6. The Politics of Piracy, Trade, and Religion ❧

This is a nation of overwhelming audacity, courageous, impetuous, unmerciful in war, warm on first acquaintance, sneering at death, but boastful about it, cunning, and completely given to dissimulation, whether in word or deed; above all they possess prudence, along with great eloquence and hospitality.
— EMANUEL VAN METEREN, ABOUT THE ENGLISH

Before the end of the third year of Elizabeth's reign she had firmly established England as a new force to be reckoned with in the Channel, boosting the country's status and stability, and laying the firm foundations for independence. She had stood up to the troublesome Guise faction in France and Scotland. The whirligig of changing French Valois kings—Henry II, his sons, Francis II, Charles IX— and even their formidable mother, Catherine de' Medici, recognized Elizabeth's achievements and potential danger to France. Philip II admired her and lamented her heresy, and Pope Pius IV wanted her dethroned and even proposed to the Spanish king that he would crown him King of England himself.[1] While the English queen had allied herself with other Protestants in Sweden, Scotland, France, and the Netherlands, she had been careful to maintain a policy of "balance" and "diplomacy" with France, Portugal, the Holy Roman Empire, and Spain. As Philip's ambassador to England so bitterly remarked in April 1562, " . . . now that she has the support of the heretics here and in France, and knows the trouble our affairs are in, in the Netherlands, I am certain that this Queen has thought and studied nothing else since the King sailed for Spain, but how to oust him from the Netherlands, and she believes the best way to effect this is to embroil them over there on religious questions, as I wrote months ago."[2]

Elizabeth did, indeed, keep an intent eye on events in the Low
Countries. She knew that England's wealth, security, and ability to
borrow and generate foreign exchange depended to a large extent
on free trade in the Netherlands. But there were storm clouds on the
horizon. Philip's insatiable need for cash to fight his Mediterranean
war against the Ottoman Turk had led to the States-General
reluctantly agreeing to grant a 3.6 million ducat loan ($326.43
million or £176.45 million today) to their Spanish overlord, but
refused to allow disbursements until Spain recalled her crack *tercios*
troops home. While Philip may have been apoplectic with rage, he
was desperate for the money from the Netherlands to supplement
his fortune in gold and silver sent to Seville twice yearly from the
Americas. And so he agreed to their terms.[3]

As can be expected from a monarch on whose empire the sun
never set, his response to the States-General's economic blackmail
was predictably ugly. Philip worked with the pope in secret on a
plan to redraw the religious map of the Low Countries, fill the
pulpits of the country with his own men of the cloth, and introduce
the Inquisition there. Without warning, toward the end of 1561, the
pope published the plan, naming the new bishops—all of whom had
been personally selected by Philip. Their new primate and cardinal
was none other than Philip's trusty minister, Cardinal Antoine
Perronet de Granvelle, who later tried to persuade the Netherlander
elite that he was one of them. After the first uprisings, he wrote to
Philip that "people here universally display discontent with any and
all Spaniards in these provinces. It would seem that this derives
from the suspicion that one might wish to subject them to Spain
and reduce them to the same state as the Italian provinces under the
Spanish crown."[4]

Naturally, the situation alarmed the Netherlanders as well as
all their trading partners—Protestant and Catholic alike. Unrest
in the Low Countries could only spell disaster for the merchant
classes. The announcement also created havoc in England, since it
was an undisguised fact that two of the most senior Netherlander
officials—William of Orange and Count Egmont—knew nothing
about the redrawing of the Netherlands map.[5]

To compound the gravity of the situation, English merchants in

Spain had been arrested by Inquisition inspectors under royal edict, and the inquisitors destroyed English "Lutheran books" (the Bible) and merchandise. An English pinnace, the *Fleur de Lys*, had been seized in the Canaries in March 1562, and the inquisitors charged her crew with the dastardly crime of "Lutheranism." Even established English factors were imprisoned under the laws of the Inquisition and charged with heresy.[6] Naturally alarmed, English merchants trading with Spain complained to the queen and the Privy Council, demanding royal intervention and a stop to the seizures. As they were unprotected by a "company," like the Merchants Adventurers, and were without a common organization, English traders in Spain were particularly vulnerable. They had no specific representation with city fathers, or the Spanish court. Not only were they being charged with heresy, but unfair levies were raised against them, and the Spanish courts were patently biased. At the end of the day, the use of English shipping was curtailed for "quarrels of matters of religion without cause."[7]

Still, the English were not the only ones singled out for harsh treatment. When the Netherlanders experienced the same abuse, there was an abrupt souring in relations between England and Spain. This new phase in Anglo-Iberian trade was heralded by unprovoked attacks on Spanish shipping on the high seas in response to the "strange and pitiful" treatment of English merchants in Spain.[8] Trade with "Lutheran" heretics seemed to be no longer respected as a legitimate activity in Spanish waters, so the English had nothing to lose and would no longer act respectably. This naturally provoked outrage from Spain, and the English ambassador met several times with the Duke of Alba to outline what Elizabeth was doing against English piracy in Galicia and Andalusia.

The year when these "provocations" occurred was 1562, and some believed at the time that the escalation of "hostilities" between England and Spain may not have been an accident, irrespective of the King of Spain's troubles in the Low Countries. The Queen of England, some ventured, may have chosen her precise moment to flex her newfound muscles.

Two years earlier, the Ottoman fleet ambushed the Spanish fleet at Djerba off the coast of North Africa, capturing six thousand

veteran troops and thirty galleys. Elizabeth chose to believe, rightly, that Philip's withdrawal of the *tercios* from the Low Countries meant that these crack troops were destined for the Mediterranean to replace the captured soldiers, and would be preoccupied in the Mediterranean fighting Islam for some time to come. Her advisors and spies in France had also warned her at the beginning of 1562 that the country was hurtling toward the first of its religious civil wars. The Huguenot commanders, Admiral Gaspard de Coligny and the Prince de Condé were already making overtures to England to help them in their struggle. If she were to take any action against Spain while France was in turmoil, she needn't fear a French reprisal. Trouble in the Low Countries; trouble in France; the confiscation of English merchants, goods, and shipping in Spain; and the restraint of European trade were all important considerations in her decisions. Elizabeth abhorred war. It was a diabolical waste of money and men. If revenge could be had by lightning raids on Spanish shipping, where she could always disown any involvement or tacit approval, then she could keep her dogs of war focused on the enemy at sea, rather than grumbling and troublemaking at home.

There is no doubt that the Queen of England appreciated better than most that Philip's war against the Ottoman Empire had not gone particularly well since Djerba, and in 1562 was at its high tide of danger. Exasperatingly for the King of Spain and the English, Moslem corsairs cruised off the Spanish coast taking any ship they could as their victims—including English vessels at the height of the seizures of English ships by the Spanish themselves! A merchant in Seville reported home, "owing to the Turks and Moors, no ship can come in nor go out."[9] The English ambassador now complained about Spanish and Ottoman depredations, only to be confronted with evidence that English vessels were intruding in Portuguese waters off the Guinea coast of Africa.

Spain and Portugal had long argued against any shipping other than their own being allowed "beyond the line"—that is to say, along the coast of Africa, in the Indies, the Caribbean, the Spanish Main, the Philippines, or Brazil—or for that matter anywhere else where they landed outside of Europe.[10] Now that Portugal had the child king, Sebastian, on its throne, Philip took his duties as the elder statesman protecting their colonies most seriously.[11]

But intrusion by "interlopers" was nothing new to either Spain or Portugal. As early as the 1530s, the Guinea coast had been worried by French and English rovers in search of Ashanti gold and slaves to man the ever-expanding Spanish and Lusitanian empires. The English pirate Thomas Wyndham sailed to the Guinea coast of Africa in 1553—with substantial backing from the City of London— and three ships: the *Primrose*, the *Lion,* and the *Moon.* When their Portuguese pilot fell out with Wyndham, and headed upriver with some gentlemen traders, the crew spat in his face and drew their swords upon his return. The pilot and gentlemen had been blithely trading in human cargo while the crew withered in the "smothering heat with close and cloudy air and storming weather of such putrifying quality that it rotted the coats off their backs."[12] Yellow fever had decimated the crew, and only the *Primrose* returned, with an emaciated crew of a mere forty men. Three-quarters of the men had died, but the ship had over 400 pounds of twenty-two-carat gold in her hold, 36 butts of melegueta peppers, 250 tusks, and the head of one elephant "of huge bigness."[13] Even the queen herself had ventured four royal ships in a failed Guinea voyage in June 1561 as part of a London syndicate.

More worrying to Philip was that he had had reports of English rovers making transatlantic voyages, and demanded that Ambassador Alvarez de Quadra lodge a serious rebuke with the queen. One of the most infamous of these corsairs was a scoundrel called Thomas Stucley, who had been charged with piracy as early as May 1558 for robbing some Spanish ships. Whether Stucley was acquitted due to lack of evidence or the rumor that he was Henry VIII's "base born son" is open to some doubt. Whether Stucley himself started the scurrilous rumor is not beyond the realm of possibility either. Shortly after this incident, Stucley absconded with his own father's property—that is to say, that of Hugh Stucley—and, when those funds ran out, defrauded his four brothers and impoverished his long-suffering wife.

Miraculously, with his past shenanigans, in 1560, Stucley was employed as a tax collector in the county of Berkshire, probably stealing all the money he could get, since a year later he had purchased a captaincy at Berwick. Perhaps more remarkably, Elizabeth more than tolerated the reprobate, and probably attempted to use him as a spy in her "wild" Irish province.

There is no doubt that Stucley was at the heart of a daring plan in
1562 to cross the Atlantic. He had proposed a venture to the Queen of
England whereby he, and the French rover Jean Ribault, the Dieppe
sailor and "western planter" turned pirate who had previously been
in English service, would colonize Florida. Elizabeth was tantalized
by the prospect and agreed to supply at least one ship and artillery.[14]
All that remained was to recruit the sailors and "planters," or
colonists.

There was little that Philip could do, other than protest via
his ambassador while he was preoccupied with his war in the
Mediterranean and unrest in the Low Countries. Legitimate trade
became a precarious way to earn a living in these times, and English
piracy flourished with the tacit approval of the state. There was a
huge increase in letters of reprisal against injustices perpetrated
against English merchants and seamen issued by the Admiralty at
the time with the queen's knowledge.

The letter of reprisal was a long-established and useful tool of
monarchs throughout Europe. Since medieval times, the letter
of reprisal, or *letter de mark*, allowed a merchant, traveler, or ship
owner who had been robbed on foreign territory in peacetime by the
subjects of a foreign prince to recoup his losses. The letter of reprisal
was granted only after the offended party had been unable to obtain
justice in the courts of the foreign country, and was, in Elizabethan
England, granted by the High Court of the Admiralty in cases of
reprisals at sea, and in times of "peace." Peace frequently meant little
more than undeclared war, which was for all intents and purposes
the situation the English found themselves in now.[15]

The letter of reprisal in the hands of England's merchant
navy became a devastatingly blunt instrument. The Channel
shipping lanes became positively choked with would-be aggrieved
Englishmen boarding, ransacking, maiming, and often destroying
any foreign vessel and her crew that they could lay their hands on.
It mattered little if the ships were French, Italian, Netherlanders, or
indeed Spanish. Since the most numerous—and richest—ships in
the Channel were those belonging to Spain and the Netherlands (a
neutral), they became the ripest targets for the holders of the letters
of reprisal to attack. The English used whatever means they could

to obtain their prizes, and we should not doubt their brutality in the exercise of their "duties."[16]

England's seamen were, by and large, a ferocious lot, most of whom had been press-ganged into service. They were rough, undisciplined, and poorly paid. The only thing that sustained many of them and kept them in tow was the promise of prize money or booty—not patriotism or an unswerving loyalty to the authority of the crown, or even their captain—to protect England's shores. Getting wealthy through piracy was their raison d'être, not the icing on the cake. Throughout the 1560s, once pressed into service, these men did not need to be escorted to their ports of embarkation; they went willingly under the command of the recruiting officer and reported for duty wherever they were sent. Their wages were less than fishermen could expect, while the chances of their dying at sea from disease were excellent. Most voyages saw at least half its crew die from disease or starvation. If contact were made with the enemy, then more would die in battle or from infection from their wounds in the weeks that followed. It is little wonder that keeping them in order required excellent leadership skills. As most captains well understood, these men had come for pillage, or, as Drake called it, "some little comfortable dew from heaven."[17] Atrocities carried out by the English were rife. One Spanish crew had even been trussed in their ship's sails and tossed overboard to drown, while their ship—now an English prize—was brought back to an English harbor.[18]

In the words of Captain Luke Ward, a pirate who later became an adventurer of exploration, the English sailor was "great in words and sufficiently crafty, bold as well as hard-working, irascible, inexorable, grasping."[19] The most outstanding of these were the fiercely Protestant West Countrymen like the Hawkinses, the Killigrews, the Champernownes, and the Hawkinses young, and as yet unknown, cousin, Francis Drake, who was trawling the Channel in the early 1560s in a bark that skirted in and out of the waters in the Netherlands, sometimes in legitimate trade, sometimes not. These men represented a new force in English foreign policy, and one that was as unpredictable as it was impossible to resist, or control.

Most significantly, they gave the common folk cause to be proud, and to hope. These "local heroes" were often the difference

between survival and starvation. Harvests were frequently poor, and the winter of 1562-63 was bitterly cold. With Elizabethan local government in the hands of this unpaid gentry or nobility, the local heroes' resourcefulness in the quest for prizes often meant employment and food on the table. Men like the elder Sir Walter Raleigh, vice admiral of Devon; and Sir Edward Horsey, captain of the Isle of Wight, were among the more notorious local robber barons who made a fine art of taking prizes and making English markets for their stolen booty. It is little wonder with such sea dogs unleashed in the Channel that the Spaniards and the Netherlanders put their losses at over 2 million ducats ($11.6 billion or £6.27 billion today) by the end of 1563.

In an attempt to cool the rising temperature between Spain and England, Elizabeth had placed herself in the position of honest broker between Spain and the Low Countries, urging Philip to reinstate the "ancient rights"—meaning to stop the Inquisition and allow freedom of religious practice in the Netherlands. She was also heavily involved with the Huguenot cause in France. Naturally, the Spanish king didn't trust her, as she was abrogating "ancient rights" at the same time in Ireland by enforcing English over Celtic law and had instituted recusancy fines against Catholics in England.[20] He resisted all her entreaties to help in his troubled province, and indeed sent Ambassador de Quadra his orders just to drive his own message into Elizabeth's heart. De Quadra inveigled the brutal Ulster Irish malcontent, Shane O'Neill, to come to his embassy in London to hear a Catholic mass. O'Neill, who had come to England to submit to Elizabeth on the understanding that he would be granted rights as the O'Neill chieftain, couldn't resist the temptation. De Quadra wrote to the regent's advisor and Philip's minister, Cardinal de Granvelle, in the Low Countries that, "Shane O'Neill and ten or twelve of his principal followers have received the holy sacrament in my house with the utmost secrecy as he refused to receive the Queen's communion. He has assured me that he is and will be perfectly steadfast on the question of religion. As to the rest, if His Majesty should intend to mend matters here radically as he writes me from Spain, I think this man will be a most important instrument."[21]

Whether O'Neill intended anything other than reserving his political options is open to debate, but certainly de Quadra's actions would have left O'Neill in no doubt whatever that Ireland had a friend in the King of Spain. Equally certain was that any attempt by Spain to stir up trouble in Ireland would have been very dimly viewed by any Tudor monarch, and in particular by the parsimonious queen, who was spending between £20,000 and £26,000 yearly ($8.33 million or £4.5 million today) to "keep the peace" in the rebellious province, in addition to whatever her governors and lord deputy had to shell out of their own pockets.[22]

Fortunately neither de Quadra nor Philip had realized that England was arming itself—just in case—through Gresham's efforts in the Netherlands, Bohemia, Germany, and Hungary through legitimate trade and foreign finance. By April 1562, Gresham had acquired armaments for which he had paid the staggering sum of just under £140,000 ($50.78 million or £27.45 million today). The purchase of weaponry, gunpowder, and other war materiel had become the chief reason for the crown's borrowings at London and Antwerp, and had begun to raise such suspicion in the Low Countries that Gresham had been obliged to bribe customs officers in order to ship the goods out of Antwerp for London.

But things were about to worsen for trade. France erupted into the first in a series of bloody religious civil wars that dogged the Valois dynasty until its end. At the outset the Huguenot factions maintained control broadly of the north and west of the country under the command of Admiral de Coligny as naval commander, and the Prince de Condé leading the land war. When Philip wrote to de Quadra in London in his secret code that the ambassador must advise Elizabeth of his intention to assist the French crown in its time of need, the alarm in the privy chamber was palpable. The argument raged that if Spain were indeed wooing Ireland, and assisting France, then there would be a real risk that England could be surrounded by the Spanish, invaded by her "postern gate," and lose her independence. Spain simply had to be stopped. Yet it was only when Cecil received a communiqué from the English ambassador Throckmorton in France that matters were acted upon. Throckmorton's April 17, 1562, letter stated:

Cecil must work with his friends at home, and especially abroad, so
that the King of Spain may have his hand full in case he aid [sic]
the Papists in France, for there lies danger. The Queen may make
her profit of these troubles as the King of Spain intends to do . . .
the Queen must not be idle. I know assuredly that the King of
Spain practises to put his foot in Calais. Our friends the Protestants
in France must be so handled and dandled that in case the Duke
of Guise the Constable, the Marshal St Andre and that sect bring
the King of Spain into France, and give them possession of some
places and forts, then the Protestants for their defence or for desire
of revenge or affliction to the Queen, may be moved to give her
possession of Calais, Dieppe, or Newhaven; perhaps all three. This
matter must not be moved to any of them or their ministers, for
it will fall out more aptly of itself upon their demands of aid and
especially when the Prince of Condé and the Protestants perceive
the Papists bring strangers into France, and give the King of Spain
interest in all things.[23]

By June, Admiral de Coligny and the Prince de Condé had proposed
to give the port of Newhaven (Le Havre today) to Elizabeth to help
defend France, and the vital shipping artery of the Channel. The
Privy Council had had time to examine the repercussions and agree
to garrison English troops at Newhaven and Dieppe, with Robert
Dudley leading the "hawk" party for immediate support of the
Huguenots. The queen and Cecil at last relented, more for tangible
security to regain Calais as the longed-after home of the merchant
Staplers than out of Protestant sympathy. For the Admiralty, Calais
was also strategically important to England, since it was its toehold
on the windward side of the Channel. If English shipping could
again be harbored there, then the risk of being locked in port was
eliminated.

Notwithstanding this, once at Newhaven, the Queen of England
categorically refused to allow her soldiers out of the town, since that
could be construed as a hostile act against an anointed king. She was
keen that her motives should not be misunderstood, so she lost no
time in asking her ambassador to Spain, Thomas Challoner, to meet
with Philip to set out her concerns, and why she had been obliged
to intervene in French affairs. Elizabeth was honing her particular

brand of statecraft: wage peace as if it were war. The country could literally ill afford for Philip to turn his heavy guns from his seemingly endless Mediterranean conflicts with the Ottoman Turk onto England.

But before Challoner could arrange the meeting, Elizabeth was struck down with smallpox, and for three weeks lay on what many believed to be her deathbed. She named Robert Dudley as protector of the realm in the event of her death, and the entire country prayed for her survival, remembering with dread the "protectorship" of Dudley's father, Northumberland. The queen knew that Philip's mind had been poisoned by de Quadra, and so one of the first things she did during her recovery was to have a lengthy letter penned to Philip. Her first point made is against the Spanish ambassador:

> *We have been in mind now of a long time to impart to you our concept and judgment hereof, wherein we have been occasioned to forbear only by the mutability of the proceedings of our neighbours in France and for that also we have some cause to doubt of the manner of the report of your ambassador, having found him in his negotiations divers times to have more respect towards the weal of others than of us and our country; we have thought not only to give special charge to our ambassador there resident with you to declare plainly and sincerely our disposition and meaning. . . .* [24]

Challoner's interview took place at last on November 27, 1562, when the queen was already out of danger. His note of the audience to the Privy Council explained that the queen apologized that she had not written sooner, "not from any want of regard towards [the King of Spain], but because she had imagined that these disturbances in France would long since have ended. As she is compelled to move in the matter, Challoner thought it well to send to His Majesty a paper containing the motives which induced her to act as she has done. These reasons are, the hostility of the house of Guise, their efforts to secure the crown of England for the Queen of Scotland, the assumption of the royal arms of England, the refusal of Queen Mary to ratify the treaty, the Queen's apprehension of a descent on her coasts from the seaports of Normandy, and the retention of Calais." [25]

While the queen had been ill, Dudley had masterminded the deployment of some five thousand men and arms to Newhaven with Privy Council approval under the leadership of his brother, Ambrose, the Earl of Warwick, Robert's elder surviving brother. When the Huguenots lost Rouen in October, they blamed Elizabeth, and her impossible order to remain within the city walls. The garrison had been put in an untenable position—defending an indefensible strategy through an exceptionally harsh winter with semihostile allies in the Huguenots, competent enemies in the French crown, and financial support from the Spanish. Further, with income from the Low Countries more and more precarious, and trade through the Muscovy Company still in its fledgling state, the prospects for peace and economic growth grew dim. It was time for the Queen of England to step up a gear and use the best weapon she had in her arsenal to avoid catastrophe—her adventurers. Some armed with the letter of reprisal, some not.

Elizabeth unleashed Stucley and gave the order for him to raise his army of "planters." She also agreed, at long last, to grant the flamboyant West Countryman, John Hawkins, a passport to go on his first Guinea voyage to sell slaves to the Spanish plantations in the Americas.[26]

7. Raising the Stakes ❧

Ships from the Indies have arrived . . . very heavily
laden with divers merchandise and with one million and
eight hundred thousand golden ducats, of which about one
hundred eighty thousand belong to the King, and the rest to
private individuals. They brought with them five ships, part
French and part English, captured by them as corsairs;
but the English ambassador declares that his countrymen
were not corsairs, but merchants . . .

—PAULO TIEPOLO, VENETIAN AMBASSADOR IN SPAIN

With more and more English merchants taken hostage under the draconian legislation of the Inquisition, Elizabeth's resolve to keep her country independent hardened. Every means available to her would be used to that end, and piratical acts and double-dealing by the queen and the Admiralty in the Channel would become some of the sharpest weapons in her arsenal. But there were others, too.

When Elizabeth granted permission to John Hawkins of Plymouth to set sail in October 1562, she was in part responding to the international crisis, and in part to the outcry of her own people for vengeance upon the Inquisition and its perpetrators.[1] In England, popular literature of the day was filled with passionate appeals against the Antichrist, Philip. Pamphleteers depicted the King of Spain as the devil incarnate, while Spanish ballads sung the praises of their king and his undeclared war on the *Luteranos*.[2] In the Inquisition edict published in May 1560, it had been decreed that:

No son or grandson of any person burnt, or reconciled to the Church,
can hold office in the King's household, or at the Court.
If he holds a public office in any place he is to lose it.

> *He cannot be a merchant, apothecary or vendor of spices or drugs.*
>
> *If any of the aforesaid persons has bought gold or silk, the sale of which had been prohibited them, they are to go to the inquisitors to report themselves within six days; otherwise on the expiration of that term, they will be prosecuted with all rigour, and whoever shall fail to accuse them is to be excommunicated.*
>
> *No person of this kind can hold office, such as* maggiordomo, *accountant, carver, or any other charge in the household of any nobleman.*[3]

With such public declarations of steely will from Spain, and public displays of fabulous Spanish wealth arriving in Seville twice yearly from its American colonies, it is little wonder that English envy and revenge were rapidly becoming the motivations behind the new crusade. Still, it is fair to say that both sides shared the blame of religious intolerance rife in that age, and they reaped the consequences that this would bring. Spain had wealth and an empire to protect. England had its Protestant state to uphold and believed it had every right to trade freely in Spanish territories. These reasons, coupled with religious intolerance, fear of foreigners, envy, greed, and revenge were all behind the escalation of hostilities and the rise of piracy.

Yet within England the reasons for raising the stakes fell broadly into three categories. For the queen and the Privy Council, the reasons were political. For the people, it was a matter of religion and pride. And for most merchants, at the outset, it was commercial. Later on, when piratical acts became a safer bet even for legitimate merchants, their reasons wavered into the political.[4]

But which of these reasons was John Hawkins's motivation as he set sail to Portuguese West Africa on the first of his slaving voyages? The loathsome slave trade had been in existence ever since the conquistadores had decimated the Native American population through forced labor and disease some fifty years earlier. African "imports" were seen as a moral solution, relieving the Native Americans from their work burden, and the "imports" were deemed hardy and good workers for the plantations and the gold or

silver mines. A good indication of how the slave business to Spanish America had burgeoned was that, in 1551 alone, no fewer than seventeen thousand licenses were offered for sale.[5] Hawkins, one of the most seasoned English traders in Spain and the Canaries, would have seen the slave trade firstly as an exceptionally good commercial opportunity for any ambitious merchant, and only secondly as a means to curry royal favor.

And what was Elizabeth's motive for raising the stakes? It was obviously economic and political, but was that all? The queen adored symbolic gestures, and sending Hawkins on his first slaving voyage was tantamount to a battle cry that there would be "no peace beyond the lines of amity." The English were simply declaring their right to free trade "beyond the line," meaning in the New World, despite incessant Iberian claims that it was illegal.

Hawkins's backers were enticed into the adventure by the treasurer of the navy, Benjamin Gonson, and the Royal Navy's surveyor and national hero, William Winter. The financial power-houses of the expedition included Londoners like William Garrard, Thomas Lodge, and Lionel Duckett, whose trade had been heavily disrupted by the troubles on the Continent. The undertaking would be purely commercial, thereby allowing the queen to claim loftily in her ambassadorial audiences that it contravened no treaty, and that to the best of her knowledge there was still freedom on the high seas.[6]

Although Hawkins was an excellent navigator, without the benefit of longitude calculations available, accurate maps, and familiarity with the African coast—and later the Caribbean—the voyage could have easily foundered. To ensure success, he needed a competent pilot familiar with the coasts, languages, and people they would encounter. Fortunately, Hawkins's Spanish partner resident in the Canaries, Pedro de Ponte, had provided the wannabe slave trader with this most valuable asset for his long slaving voyage: a Spanish pilot from Cadiz, named Juan Martínez.

Hawkins was intelligent, ambitious, and above all a lateral thinker. The Englishman knew full well that, if he did not plan his voyage diligently, he, like so many others before him, would fail, and possibly die. His greatest strength was that he was a meticulous

planner, and he knew that the unhealthy conditions and long voyage would require "buying" the loyalty of his men and commanding them with a steely will. With this uppermost in mind, he willingly offered higher wages to his sailors and the promise of supplementing their pay with pillage and private trade. To further their mutual good health, Hawkins ensured that there would be adequate water, biscuit, beer, salt beef, fresh beef, Newfoundland salt fish, stockfish, herrings, salt, butter, pease,[7] cheese, and live pets that could later serve as food.

And there was cloth—broadcloth stored in packs of ten for trade in cooler climates as well as wool "cotton" and kerseys from the south of England to trade in the tropics. The ship's equipment of buckets, scoops, grinding stones, compasses, ballast, pulleys, ropes, and rat poison was stuffed into the hold prior to setting off.[8] There were carpenters to repair the ships, cooks, a barber-surgeon, and men who could make and repair ropes and sails. The last essentials of the voyage loaded would be the captain's gold and silver plate, then his company of musicians. Once all were aboard, Hawkins was ready to cast off. No one would accuse him of failing in his slaving mission due to a lack of planning.

It was precisely this planning that attracted his investors at home. Gonson, Winter, Duckett, and Lodge paid to equip the 140-ton *Salomon*, the 40-ton *Jonas*, and the 30-ton *Swallow*, with Hawkins as the *Swallow*'s captain. A young, unknown relation of his on board—Francis Drake—sailed with them on this, the first of his long voyages.[9]

While John Hawkins and his crew began their human harvest in the African waters off the coast of Portuguese-"held" Guinea in the winter of 1562–63, they remained blissfully unaware of the changing political climate at home. Communications between the coast of Africa and England were nonexistent. As Hawkins "hunted" slaves—whether stealing them from Portuguese slave traders who had an established business with Spanish America or by "gathering" slaves in the interior aided and abetted by rival tribes[10]—the Flemish regent, Margaret of Parma, and her chief minister, Cardinal de Granvelle, had written to Philip pleading for him to pay attention to the growing unrest in the Low Countries. The English depredations

against their shipping in the Channel was a cause of great concern, they noted gloomily. Then there was the not insubstantial matter of the English occupation of Newhaven that worried Margaret, particularly as Philip hadn't responded to any of her letters with his action orders in over four months.[11]

Yet before Philip received the plea, "as if by the hand of God" the English garrison was struck down with a virulent outbreak of plague. The French Huguenots turned against their English allies perhaps for the loss of Rouen to Charles IX, or perhaps because they felt that as Frenchmen, their interests would always remain with other Frenchmen. Whatever the precise reason, Warwick's men, both those in France and those who had already returned to England, were dying the most painful and agonizing deaths while infecting thousands of others.

And all the while, Hawkins plied his loathsome trade for over four months in Africa. Guinea (which meant in Berber "the land of the black men")[12] was a huge expanse of land extending over two thousand miles, from Cape Verde in the north, around Cape Palmas to the south, and bordered by the Niger River Delta and the Bight of Benin in the east. Hawkins's slave "harvest" most likely consisted of a twofold plan of attack. The first, and less successful one, was to hunt down slaves in the interior themselves. It didn't take much reflection for a man of Hawkins's resourcefulness to devise a more fruitful means for this vile trade. It would be far easier to identify other Europeans in the vastness of Guinea and take whatever cargo they had already loaded aboard. After all English ships carried far more artillery and ammunition than their Portuguese or Spanish counterparts, and Englishmen were reputed to be fabulous archers as well. So Hawkins changed tack and set about capturing a number of Portuguese vessels and transferring their slaves and other valuable cargo to his English ships. As Hakluyt wrote, Hawkins "stayed some good time, and got into his possession, partly by the sword and partly by other means, to the number of 300 Negroes at the least, besides other merchandise, which that country yields."[13]

All along the African coast, those merchants who survived the English onslaught naturally wrote furious complaints back to their respective courts about the outrages perpetrated by Hawkins and his

men—letters that would take months, if not years, to arrive. Cargoes of ivory, cloves, wax, and nearly four hundred slaves were forcibly obtained, and all merchandise that was deemed unsatisfactory for the Caribbean leg of the journey was returned aboard the smallest ship to England. Among the crew of that ship was a disappointed Drake.[14]

Hawkins, his crew, and his human cargo made the crossing to the Indies in April 1563—the same time that the English occupying force was decimated by plague at Newhaven in France. But the English captain was ignorant of these events, and concerned himself solely with keeping the ship "sweet smelling," his men healthy, and limiting the deaths among his slaves in stinking holds of his ships. But only half the slaves survived the mental anguish and inhumane treatment on their meager diet of beans and water into Caribbean waters. And yet Hawkins had little trouble, at first, in selling the poor wretched souls to the Spaniards to be misused on the Spanish American plantations and in the mines.[15]

Throughout Spanish America the market in slaves at bargain prices was attractive to the Spanish planters. So Hawkins's arrival with his human cargo created a seller's market with brisk trading at Española's ports Puerto de Plata, Monte Christi, and Isabela.[16] Not the first interloper to arrive in the Spanish waters of the Caribbean, Hawkins found a savvy and ready market for his bargain-basement-priced slaves. After all, he had arrived without having been taxed by the Spanish authorities, and his wares represented a significant savings to the colonists. If trading went well there, then Hawkins intended to spread his net wider on future voyages to the Greater Antilles—to Cuba, Jamaica, and Puerto Rico—and beyond to the Spanish Main.[17]

At the region's administrative headquarters, Santo Domingo, rumors and complaints about Hawkins and his methods poured in to the Spanish authorities. It had been claimed that Hawkins had tricked the local governors into trading by a series of plausible lies, coercion, and out-and-out threats. A young and relatively inexperienced officer, Lorenzo Bernáldez, was dispatched to confront Hawkins and halt the Englishman's trading in all Spanish territory—by force, if necessary.

While there had been interlopers for as long as there had been a Spanish empire, it is doubtful that any Spaniard had seen ships bristling with the long and short-range artillery and munitions that Hawkins carried aboard in plain sight. After some bizarre horse-trading, Bernáldez found himself hornswoggled by Hawkins. Violence was avoided when the Spaniard accepted the Englishman's offer of a truce with the receipt of three-quarters of the remaining one hundred forty old or sick slaves, and one of his caravels in exchange for a license to sell the remaining thirty-five slaves and the release of captive Englishmen. An import tax of 7.5 percent was also agreed. The only problem was that Bernáldez hadn't been authorized to grant any license at all.[18]

In spite of all the losses of slaves to death, sickness, and finally ransom, the profits for Hawkins and his backers were phenomenal. His own three ships were so heavily laden with pearls, gold, silver, ginger, hides, sugar, and other trades made with the Spanish colonists in exchange for the unfortunate lives of the West African slaves that he had too much merchandise for the return journey to England. Hawkins, seemingly ever resourceful, chartered two Spanish hulks that were in port and struck a deal for the vessels to take well over fifteen hundred hides and chests of sugar back to Seville. He also gave the captains clear instructions to deliver the goods to the English factor there, Hugh Tipton. While the charter of Spanish ships was depicted as "a bit of luck" by Hawkins, chances are that it had all been prearranged by Pedro de Ponte in the Canaries before Hawkins had left there.[19]

Shipping goods to Spain that the Spaniards classed by virtue of the edict of Inquisition as contraband seems strange, but Hawkins had no choice. The ships (owned by the Seville merchant trading family Martínez) were the only ones available, and Hawkins truly believed that the Spanish authorities would not question the well-established trade of the Martínez family as two of their ships came into port. But Hawkins's luck didn't hold out. A local Basque *licenciado*, Echegoyan, wrote to the Casa de Contractación in Seville about Hawkins's scandalous behavior, finishing with the eye-popping threat, "Tomorrow all this land could become part of England if steps are not taken."[20]

The result was that the Martínez ships and their cargo were impounded, and all Hawkins's men were imprisoned and often tortured under the cruel regime of the Inquisition. Only Thomas Hampton, captain of the first ship to arrive in Seville, managed to escape. The losses—estimated later by Hawkins to be £2,000 ($701,372 or £379,120 today)—were not great when compared with the pearls, other jewels, and luxury goods that had reached England.[21] In fact, though the precise profit was never advertised, shortly after Hawkins arrived back in Plymouth in late summer 1563, he and his backers were already planning their next voyage. William Garrard signed up immediately as a new joint stock backer for the second. He was followed by Sir William Chester, who like Garrard was also a former lord mayor and important merchant in the Canaries. Flattering as their attentions and money were to Hawkins, the big prize came in the form of his powerful new court backers: William Cecil, Lord Admiral Clinton, the Earl of Pembroke, and Robert Dudley.

But they weren't the only ones interested in what John Hawkins had experienced. The queen herself ordered that her quarantine against the plague be broken, and that Hawkins be allowed to join her at Windsor to discuss his journey. It is likely that the queen promised Hawkins the use of the 700-ton *Jesus of Lubeck* for the next Guinea voyage at this time. This was her symbolic gesture that the claim of illegality of English trade "beyond the line" by the Portuguese and Spanish was absurd. The merchant from Plymouth would be able to sail under the queen's colors and reap the benefits that such an honor would entail. But Hawkins was to learn soon that the offer of the *Jesus* was a mixed blessing initially. While the *Jesus* had been deemed as "much worn and of no continuance and not worth repair" in the 1559 *Book of Sea Causes*—it was a public sign of royal approval for both Hawkins and his slaving expeditions.[22]

As if the *Jesus* were not enough, Elizabeth's support for Hawkins was also confirmed by an equally unexpected result of their interview. On September 8, 1563, she wrote to Philip II "in favour of this bearer, John Hawkins . . . our will and pleasure is that your understanding thoroughly the cause, and well-informing yourself of

the equity thereof, do take opportunity to communicate the same in our name . . . and to help and assist our said subject in setting forth his said suit."[23]

Hawkins had been tormented by the imprisonment of his men and the merchants who had helped him to so great a success. So, armed in the knowledge that the Queen of England had implored the King of Spain to hear reason and release his crew, Hawkins traveled to Spain. Yet despite his best efforts to have his crew released and to recover his impounded goods, the Spanish would not relent against the *Luteranos*. In fact, Hawkins's own freedom remained in jeopardy so long as he was in Spain. As to his merchandise, he was informed that it had been sold, and the money sequestered under triple lock and key in the king's personal chest.[24]

By English law, Hawkins's attempt to recover the confiscated merchandise in Spain, as well as lodging an official complaint with the High Court of the Admiralty, would most assuredly result in his being granted a letter of reprisal against Spanish and Portuguese shipping to the value of the goods lost. He was now favored by Her Majesty, and knew that he was at last a man of consequence. On the one hand dejected by his failure in Spain, and on the other emboldened by the queen's support and investment, Hawkins returned to England and prepared to embark on his second voyage, secure in the knowledge that in spite of the Spanish seizures, fortune smiled upon him.

Hawkins's interview with the queen would have alerted him in no uncertain terms to the changing tide of English politics, and the favor with which he was viewed as a new protecting force for the realm. Mary, Queen of Scots, the enchanting widow, was seeking a second and powerful husband. She remained poised for action to claim the English throne and seemingly was, at last, in possession of her own country. Elizabeth was determined that Mary should have that husband, but one who would remain loyal to England. And so she ennobled Robert Dudley to the title of Earl of Leicester, granting him vast swathes of land to make him more attractive to the Scottish queen. Only after Hawkins set sail on his second voyage would Mary announce that she would not have the Queen of England's "master of the horse."

Cecil, who had once feared the royal favorite Dudley, particularly when he had been named as "protector" by the queen when she had smallpox, also knew Dudley was dangerous for his intervention in Newhaven. Dudley, too, was a sworn enemy of the Earl of Sussex, Lord Deputy in Ireland, and he backed the charismatic and violent Shane O'Neill, the Ulster Irish chieftain, against Sussex in a bid to extend his influence throughout Ireland. Dudley also looked favorably upon John Hawkins as a merchant engaged in legitimate trade, and a man in whom he could invest for the future.

But what had become of the pirates in the Channel and elsewhere? And what had happened to Stucley and his Huguenot enterprise? While the French pirate Ribault had successfully established the French colony in Florida, perilously close to Philip's empire, Stucley, who had been supplied with one of the queen's ships in his six-vessel force, sailed around the Caribbean with his three hundred men terrorizing merchants and colonists alike.[25] He had been "well furnished with artillery from the queen," according to ambassador de Quadra,[26] so Stucley's exploits rocked the courts of England, France, and Spain, and his piracy on the high seas became the scandal of the day. Stucley had made Elizabeth a fool in her own eyes, something both Catherine de' Medici and Philip II secretly enjoyed, and which the English queen would never forgive.[27] His attacks on Spanish, French, and Portuguese shipping made the English ambassador to Madrid, Chaloner, "hang his head in shame."[28] Elizabeth hesitated a bit, but eventually disowned Stucley and issued a warrant for his arrest. Her hesitation had as much to do with the usefulness of other questionable adventurers' piratical acts, which helped secure England's borders, as it did with a public admission that Stucley had duped her.

But worse was to yet come for England's queen. De Granvelle, with Philip's tacit approval, decided to close Antwerp and all other Low Countries ports to the English, using the excuse of the plague. Stucley was not the only pirate, or adventurer, who was stealing under the legitimate guise of letters of reprisal, and de Granvelle was out to prove the point. As a result, without any other market of equal status, tens of thousands of yards of broadcloth worth over £700,000

($245.48 million or £132.69 million today) lay in the Thames estuary for six months before the lucrative backbone of English trade could be transferred urgently to Emden in Germany.[29]

Just about the only bright spot on the horizon from the English viewpoint was that the universally reviled Spanish ambassador, Alvarez de Quadra, bishop of Aguila, died in poverty in the English countryside, having initially escaped London and the plague. His replacement, Guzmán de Silva, canon of Toledo, was an intellectual, congenial priest with an iron will and understanding of what made the English tick. Philip had, at last, appointed a worthy emissary to oversee events in England. De Silva's insightful and eventful four-year stint in his London embassy would mark an interesting turn of events for both Hawkins and Elizabeth's England.

8. Cunning Deceits ❧

I am a great servant of the majesty of King Philip,
whom I served when he was King of England.
—JOHN HAWKINS TO GOVERNOR BERNÁLDEZ, APRIL 16, 1565

By the time John Hawkins was ready to set sail on his second slaving voyage, the newly appointed Spanish ambassador, Guzmán de Silva, had tapped into the rich vein of his predecessor's spy network in England. Philip himself had directed him to two particularly good sources of information residing in London— Antonio de Guaras and Luis de Paz, to whom the king referred as "persons of entire trust."[1] At first, the picture they had painted of the Hawkins plan was fuzzy, with some of their port spies declaring that the English admiral was making preparations to lead a squadron of pirates into the Channel to capture Spanish and Flemish shipping. But as more reliable intelligence poured in, it became obvious that Hawkins had a grander enterprise in mind. Whenever he sailed, John Hawkins would be flying the queen's royal standard atop his mainmast, confirming his royal commission. Once his destination was rumored to be the West Indies again, Guzmán de Silva penned a hasty warning to Philip that the Spanish Main would again be in grave danger from the great pirate *Aquinas*, as Hawkins was called.

While this may seem an overstatement, even at the time, de Silva was nonetheless outraged that Hawkins would dare a reprise of his first audacious exploit to the West Indies. After advising the king, he lodged an official complaint with the Privy Council and was promptly told that Hawkins was sailing with the queen's commission, and, in what became a familiar refrain, that the high seas were free. De Silva refused to accept their reply as cast in stone, and wrote directly to the queen, asking her to stop Hawkins from sailing, as he was likely to harm the King of Spain's subjects.

This, too, was a familiar tune. Everyone in a position of power in England knew that "harm to Spanish subjects" was a point dear to the ambassador's heart. Since his arrival, he had been successful in pressing for a royal commission to look into piracy in the Channel in a valiant effort to staunch the tide. Failing that, he aimed to get some compensation from the rogues. After several months hammering away on the subject, de Silva seemed to be making progress. On August 7 the Privy Council dashed off several letters on the express desire of the queen and Lord Robert:

> *to Sir William Godolphin, John Arundel, John Killigrew, Sir John Chichester, and William Lower, esquires, that where a ship was spoiled in that parts appertaining to John de Calvette and others, Spaniards, to take order that they may be restored to their goods, or else the offenders to be bound to appear to answer to the laws according to the quality of their faults . . . [and] to make due inquisition of such goods as appertained to John de Calvette and others, which was spoiled upon the seas by John Fleming and Hamond Gifford, requiring them to make restitution of the said goods unto the complaints, or else to take good bands of them . . .*[2]

Satisfied that the queen was acting in good faith, de Silva wrote to Philip that same month that "the proceedings ordered by the queen with the object of redressing the robberies committed on your Majesty's subjects by her pirates, and other injuries inflicted by reason of money owing etc., are still continuing . . . it appears they are doing their best. The fault is not entirely on the part of the judges, although there has been much remissness, but is largely due to false witnesses, of whom there must be a great number in this country, and notwithstanding this, the judges do not consider the evidence strong enough for them to condemn their own countrymen, and are probably not sorry for it."[3]

In the same encrypted letter, de Silva gave Philip a reasonable running account of his discussions with Elizabeth about her pirates: "With regard to the future I have pressed the queen and her council for some measure of security since, if the sea is not free, there will be forever complaints and troubles."[4]

The Spanish ambassador, fully briefed by his king, had used the very excuse with which the queen had defeated—and would defeat—his own argument: freedom of the high seas. Hawkins was, she claimed, not a pirate, but a gentleman and merchant, and one of considerable means. His sole desire was to undertake honest trade; and since one of her leading countrymen, Elizabeth, her merchants, and her gentlemen backed him in his new adventure. The joint stock company formed for this second slaving voyage read like a *Who's Who* of the day, led by the queen herself. As to harming the King of Spain's loyal subjects, what harm could vibrant trade to the West Indies bring? Elizabeth inquired.

What harm indeed. The queen's arguments in favor of her slave trader were at best disingenuous. What attracted her deep interest in the proposition was the real possibility of enriching her treasury by an expanded trade with the Spanish Indies. It is also tempting to imagine that she never considered the true nature that the "harvesting" of his African victims took, despite having warned Hawkins as early as 1563 that "if any African were carried away without his free consent it would be detestable and call down the vengeance of Heaven upon the undertakers."[5] Above all, John Hawkins and his enterprise represented a "get-rich-quick" scheme that appealed to the queen's parsimonious nature, and the business acumen—if not sheer greed—of her merchant and gentlemen adventurers, particularly in light of the debacle at Newhaven and the remorseless rise in the cost of maintaining the peace in English enclaves and plantations in Ireland.

Her Privy Council couldn't see the harm either—it was for the good of the realm. Even Lord Admiral Clinton and Sir William Herbert, now the Earl of Pembroke, were two of Hawkins's prominent gentlemen adventurer investors. The queen's favorite, Robert Dudley—newly elevated as the Earl of Leicester—was not only an investor but also a primary license holder for the export of undyed cloth, which was being loaded onto Hawkins's ships while the queen engaged the Spanish ambassador in the philosophical merits of her case. Even the cautious William Cecil was actively involved in an administrative and supervisory role in the second voyage. And the queen herself, having ventured the *Jesus*, valued at

£4,000 ($1.45 million or £782,800 today) would have been the largest single investor.[6]

Despite Elizabeth's posturing, there was little doubt that the slaving voyage would do someone harm. Hawkins's new fleet of four ships was, of course, headed by the leviathan 700-ton *Jesus of Lubeck*, and in spite of her advanced years, the *Jesus* couldn't fail to impress. With her fabulously ornate poop, four masts of Baltic oak, and formidable forecastle, the *Jesus* was the ultimate symbol of royal favor. While it was known to be in quite poor repair and of questionable seaworthiness since *The Book of Sea Causes* was published on the queen's accession, the *Jesus* still bristled with heavy bronze and iron artillery. As the admiral of the fleet, it had the sort of devastating firepower that befitted a royal Tudor floating fortress. The second ship in the fleet was the 140-ton *Solomon*, now spruced up and ready for action since its first Caribbean voyage under Hawkins's command. The *Solomon*'s companion ships, the 50-ton *Tiger* and new 30-ton pinnace *Swallow*, completed the fleet. All three of the companion ships belonged to Hawkins. All three were heavily armed, carrying as much artillery and shot as they could accommodate readily for their size, while leaving room for the other essentials of the voyage.

What is staggering is that the entire fleet was manned with a mere 170 mariners—far below the norm for the times. Hawkins, ever the meticulous planner, ensured that there would be ample victuals of biscuits and beef, bacon and beer, peas to help keep scurvy at bay, water, and cider. He had also ordered that their holds be filled with enough beans and peas to feed up to four hundred African slaves. There were cots for the Africans to sleep on, and clothing for them to make themselves "respectable" in the slave markets of New Spain. Every contingency had been provided for.

Still, none of the queen's excuses or Hawkins's preparations interested the Spanish ambassador. De Silva was nobody's fool and an exceptionally able diplomat. Since Hawkins was no pirate, then perhaps, de Silva argued, the queen would support an all-out effort to rid the Channel of "this sea of thieves" and make the lanes safe for merchant shipping of all nations.[7] Elizabeth was trapped by her own words this time. On August 4, she was obliged to publish an

edict ordering all armed ships to return to port and forbade them to set sail again without a license from the queen herself. Such a license could be granted only on giving an undertaking that they would not harm England's allies, including Spain. All well and good, de Silva reasoned, but without a good show of royal strength in Channel ports, Channel piracy would remain a threat to daily life. The ambassador confirmed the exchange of full and frank views with Elizabeth to his king, closing with the remark, "The queen, so far as her words go, shows great rectitude in matters appertaining to justice."[8] This did not, however, mean that she could succeed in subduing—or indeed wholly wished to subdue—piracy. Maritime theft had become more than a national pastime that neatly exported penniless rogues and thieves away from the towns and cities. When, or rather if, they returned, they were frequently financially better off and posed less of a threat to their fellow countrymen. A successful "adventure" spawned new "adventurers," and so it continued. It was little wonder that Channel piracy had become the national obsession.

Philip, for his part, was greatly preoccupied with these Channel matters—both French and English piracy, as well as what action to take with his own rebellious subjects in the Low Countries. Yet he remained powerless to intervene due to his military commitments against the Turks in the Mediterranean. This is what made de Silva's missive stand out as a shimmering hope on an ever-darkening horizon. The States, as Philip himself referred to the Low Countries, were heading toward open revolt against the king's religious intolerance and decrees. The Dutch nobles like William of Orange and Count Egmont claimed that these decrees served only Spain and infringed on the States' ancient privileges. The regent, Margaret of Parma, had warned the king repeatedly that it would be impossible to rule without the cooperation of the Flemish nobles, and unless something was done to remove the odious influence of Philip's man, Cardinal de Granvelle, the States would erupt in revolt.

There is little doubt that de Granvelle was loathed by everyone in power except the king. Since Antwerp had closed its doors to English merchants on his insistence, the great merchant houses of Antwerp found themselves taken by surprise by the tightening of credit on the Bourse and the "deadness of trade."[9] Payments from the Merchants Adventurers, other English merchants—and even

Elizabeth herself—were suspended at that time, benefiting the English and devastating the Antwerp financiers.[10] What had begun as a punishment for English depredations in the Channel and the English adventure at Newhaven (which was seen as meddling in French affairs), was rapidly becoming a threat to Antwerp's very existence as the main northern hub for the luxury trades.

And worse was still to come. Philip had not had word, as yet, that the trade war with England had escalated. A new "vent" for English cloth had been agreed the previous February at Emden, and when the regent found out and sent word to her brother, she was quick to ban all merchants from the States from trading there on Philip's orders. Yet, from over a thousand miles away in Spain, the king couldn't visualize the hardships at Antwerp, nor could he foresee its waning future. He did, however, take great comfort from Spanish intelligence that the main trading cities of the German Hanse refused to trade with the English at Emden that spring, and would continue to do so until their own ancient trading privileges in England were restored to their pre-1552 favorable status. As their ill luck would have it, the autumn harvest was poor, and the Queen of England decreed, in retaliation, a complete embargo on the shipment of grain from England via any means to the Low Countries.[11]

It was against this backdrop that Hawkins prepared his second voyage. Merchants and the queen who might have otherwise repaid their loans at Antwerp saw a good opportunity to invest in his scheme instead. Others, who had been caught in the wrong end of the financial cycle, having recently repaid their loans in the Low Countries, found themselves unable to sell their goods at the spring or summer markets at Emden, or anywhere else on the Continent. Trapped by the political circumstances, these merchants either went bankrupt or sought new credit and new vents of their own. Whatever their individual situation, Hawkins provided new hope to them all.

By August, de Silva had discovered the truth, and he warned the King of Spain that he had been unable to stop Hawkins sailing. His route had been confirmed by Spanish spies at Plymouth as heading for the Canaries, then on to Guinea and then the West Indies. There was ample time for Philip to intervene with a small squadron, either on the Spanish coast or in the Canaries, which were, after all, Spanish

territory. Yet he chose not to do so. For the man who was purported to have the "greatest brain in the world" this was no oversight, but seemingly a cruel calculation.

Philip had not yet become weary of his personal rule—far from it. But he had insisted on ruling his empire from Spain. He saw every missive, every order, every newsletter, and despite his plethora of "councils," the King of Spain handled the details of all correspondence on his own. This meant that instead of direct action, he frequently chose to wield his mighty pen. When the king received word that Hawkins would sail regardless, he speedily wrote to Portugal's boy king, Sebastian, warning him of the voyage to Portuguese-held Guinea. He notified his Council for the Indies in writing—only one of fourteen councils of state in existence at the time—when it met the next morning for its traditional three-hour session. The regent of the Low Countries was informed by letter, as was Cardinal de Granvelle. In fact, it was not uncommon for Philip to dictate and vet more than one hundred letters, licenses, or patents daily in the 1560s, and it was a well-bemoaned fact that no one beside the King of Spain knew for certain what was happening throughout his dominions.[12] Philip often focused down on a single event, and frequently sacrificed the important for the insignificant, as would have certainly been the case concerning Hawkins's fleet.

The Spanish king replied immediately to London to try to stop the voyage at all costs. Philip tempered his request to de Silva, who was, after all, new at his post, by stating that if he couldn't stop Hawkins, the ambassador must at least keep him informed of his efforts at the English court. Interestingly, the intricacies of the financial cycle had dawned on the king. Philip asked de Silva to delve into the queen's finances, and particularly whether she still owed money at Antwerp. On September 4, de Silva penned his reply:

> *I have tried to find out all I could about the finances and the state of the Queen's treasury. She owes to private people in this country lent on her bills 240,000 crowns and in Flanders 200,000 to Belzares and Esquets with whom she ordinarily does business* [a total of $72.41 million or £39.14 million today]. *They tell me that the larger part of this money has been lent to her by the Germans at an interest of 14%, some at 15% and some at 13, according to the value*

of money when the advance was made. The City of London and
certain private merchants guarantee the payment for her.[13]

This was not good news. Philip knew that all the penned protestations he could devise would never carry sufficient weight to stop Elizabeth if she had decided on a certain course. Indeed, what was worrying in the intelligence he was receiving was that Cecil—who had already declared his dislike for the new school of adventure, which risked replacing bona fide trade—had some sort of supervisory role in the Hawkins adventure. It also seemed that Cecil was somehow involved in another adventure undertaken at the same time to Guinea —but with a different purpose—by Hawkins's backer and great London merchant, Sir William Garrard. Robert Dudley, Earl of Leicester, too, had a foot in each camp. If Philip's spies were right, there was a considerable shift in the tide of thinking in England, and Spain would undoubtedly be harmed.[14] Yet still, no direct orders to physically intervene against the English were given.

Whether it was a cunning deceit to allow the English, through Hawkins, to steal from the Portuguese in order to provide Spain with much needed slaves to work plantations and mines in the New World is a rather tempting thought. It was, nonetheless, in many ways, Machiavellian. The Spanish king could not be seen to interfere in Portugal's affairs even though he was second in line for the Portuguese crown. He may have been an heir to its throne, but unless or until he was king of that country, all he could do was covet Portugal's wealth, navy, and territory while professing to be its closest ally. Through his failure to act and send a squadron to stop Hawkins, Philip had the perfect platform to use the English outrage to diplomatic advantage with both Portugal and England.

As for Hawkins personally, he fully expected his competent local governors in the West Indies to dispatch the troublesome captain from Plymouth on the spot. In the unlikely event that his governors failed him, Spain would still benefit from the slave trade; England would be shamed; Portugal would be thankful for his efforts; and a Spanish advantage in the Channel and the Low Countries could be achieved. For Philip, the exploits of a lone sea captain, who had not as yet achieved any measure of greatness, in Africa and the West Indies, was only a mild irritant. His main preoccupation remained Channel

piracy and the cessation of trade to the Low Countries. And it was this cessation of trade that would ultimately prove a catastrophe.

Naturally, the Portuguese king felt differently. Portugal had been defending its "colonies" in Africa from French and English interlopers since the 1520s, with the French becoming particularly active over the past ten years, with more than two hundred Portuguese ships seized by French corsairs in that time.[15] These seized ships were stuffed to the gunnels with more than slaves; the Guinea coast of Africa represented wealth in gold and precious stones as well.

To make matters worse, Portugal's hold on the region was tenuous to say the least. The would-be Lusitanian colonizers had already suffered, as well as profited, from African tribal warfare. The ferocious Sumba tribe from central Africa had been displaced westward to the El Mina and Malagueta coasts of Guinea due to drought, leading to the overthrow of smaller peaceful African tribal kingdoms, and the murder and enslavement of these tribes to the Sumba.[16] When Martin Frobisher, who was already well known for his tall tales, was imprisoned in Sao Jorge (El Mina) in 1555–56 for piracy, he claimed that no Portuguese dared to go more than a mile from the forts without first obtaining a "passport" from the local rulers, the Sumba.[17] Still, King Sebastian of Portugal, who loved more than anything else warring against the African infidel—be he black or Muslim—was more concerned for the time being with the English corsairs, and ordered Aires Cardosso to act as ambassador to London to demand satisfaction from the "heretic" English queen. He also alerted his local governors that Hawkins was on his way.

And so, amid all this animosity brewing and bubbling over in the courts of Spain and Portugal, on October 18, 1564, in the hope of prosperous winds, John Hawkins gave the order to weigh anchor from Plymouth. Yet before they had cleared port, the strong equinoctial gust lashed the *Jesus* around, and one of the ship's officers was killed by the pulley of a sail in a "sorrowful beginning for them all."[18] But after all his planning, Hawkins couldn't allow the incident to dampen his or his crew's spirits, especially as he knew that there was another small fleet of Londoners also heading for the Guinea coast.

Thirty miles out to sea, the Londoners and Hawkins's fleet met. The *Minion*, the *John the Baptist*, and the *Merlin*—captained by David Cartlet, on behalf of the joint stockholders Sir William Garrard, Benjamin Gonson, Sir William Chester, Thomas Lodge,[19] and the Earl of Leicester—were intent on setting up a base in Guinea and mining for gold under the very noses of the Portuguese. Both admirals agreed that the seven ships should sail on together as a "combined" fleet for greater protection against pirates.

After three days of good progress and fair winds, the wind direction and speed changed. Clouds boiled up and the skies blackened, as a true equinox storm suddenly erupted. Waves battered the ships mercilessly for nearly twelve hours, scattering them. When the skies cleared and the sea swells died down, Hawkins saw that his own ship the *Swallow*, and the entire fleet from London, had been lost from sight.[20] Since no obvious debris from sunken ships could be seen, Hawkins hoped that the ships—and especially the *Swallow*— had simply been separated. It is obvious from Hawkins's distress at the time that he hadn't issued any clear instructions to his company with regard to what they should do in the event of separation, and he blamed himself for this serious omission.

According to the chronicler of the voyage, John Sparke—a merchant and future mayor of Plymouth—there was "no small rejoicing" when they luckily stumbled upon the *Swallow*, becalmed some thirty miles north of Cape Finisterre off the northern coast of Spain. They waited for a wind to carry them around the Iberian peninsula and out into the Atlantic for two days, before turning into shore and sheltering in the Galician port of Ferrol, remembered by the men for its "bleak outlook." There, Hawkins summoned the masters of all his ships and corrected his error. Naturally, there was no semaphore code as yet to ease communication between ships, nor any other sophisticated remote means of warning. Hawkins ordered that the smaller ships would lead the *Jesus*, staying up weather of her. Each ship was ordered to communicate with him twice daily on the *Jesus* without fail. If Hawkins raised his ensign over the poop of the *Jesus*—or lit two lights at night—they were to come in straightaway to "speak with her." Three lights meant that the *Jesus* was casting about, and they were to keep the same distance from the lights. If the

bad weather returned, the smaller ships would make a formation tucked in alongside the *Jesus*, or, failing that for whatever reason, alongside the *Solomon*. They were to follow these instructions to the letter until they reached Tenerife. The other ships were also given their own signals: "If any happen to any misfortune, then to show two lights, and shoot off a piece of ordinance. If any lose company, and come in sight again, to make three yaws, and strike the mizzen three times." Finally, Hawkins gave them his benediction order to "serve God daily, love one another, preserve your victuals, beware of fire, and keep good company."[21] It was the same benediction that Elizabeth had given Hawkins on the eve of his sailing.

Hawkins and his mariners had had a narrow escape in the storm. The same cannot be said for the Londoners. Shortly after their arrival in Ferrol, the *Minion* from the Londoners' fleet docked with the dreadful news that the *Merlin* had had an explosion in its powder magazine, burst into flames, and sunk. Only a few mariners had survived in a small boat, and had been towed into port behind the *Minion*. Hawkins quickly added the order to his masters that they would need to put their brigantines astern.[22]

On November 4, the captain mistakenly thought he had reached the Canaries, but he soon realized his error. This was a common enough mistake without the benefit of longitude, even for a reasonably good pilot like Hawkins. Dead reckoning was the only means that Elizabethan sailors had at their disposal to determine longitude, and it would be more than two hundred years before John Harrison discovered an accurate mechanism for its calculation.[23]

Four days later, the fleet arrived at the port of Adeje in Tenerife, finding the *Swallow* awaiting it as Hawkins had previously ordered.[24] After the mishaps in longitude calculation, John Sparke recounted their joy at reaching their first intended port of call with palpable relief. But their happiness soon faded when Hawkins saw that their "welcoming committee" was armed to the teeth and prepared for battle. Hawkins could only assume that they had been taken for corsairs, and called out to the Canarians that they weren't pirates and that he was a good friend of Pedro de Ponte's. Fortunately de Ponte's son, Nicolaso, was one of the armed men, and the confrontation was brought to an end. Hawkins sprang from his landing boat and waded onto the beach to a festive welcome.[25]

After a week of resupplying and making repairs to the fleet—the *Jesus* had sprung its mainmast in the storms and the smaller ships needed minor repairs—Hawkins and his men headed for the Guinea coast. Just north of Cabo Blanco they were spied by several Portuguese fishing boats, which cast about to run ahead of the feared "English pirates." The wind and current were merciless—as it frequently can be near the equatorial coast of Africa—and one of Hawkins's pinnaces capsized. By the time the lookout on the *Jesus* had called out for help, the pinnace was a mile or so back in the admiral's wake, with the English mariners perched unsteadily on its keel. Yet Hawkins kept cool and ordered one of the lifeboats into the sea with two dozen men at oar. Despite the lashing winds and overwhelming currents, the pinnace and her crew were rescued.[26] Hawkins had risked the lives of twenty-four men to save the lives of a handful of others. There is little doubt as to why: he had sailed with few mariners in order to keep his ships "sweet smelling" and avoid pestilence and disease. Each and every soul would be precious in the gathering of his slaves.

While Hawkins was fishing his own men out of the sea, back in England, the queen penned her final reply to the Portuguese ambassador, Aires Cardosso, who had arrived from Lisbon. It mattered not if his arguments had merit, she wrote, the fleet had sailed. Besides, she could see no reason why she should prevent her good subjects from trading in lands subject to the Portuguese, since the two nations had long been allies. Notwithstanding this, she would agree to his demands on the proviso that, "as for sailing into those parts of Africa where the Portuguese king had no more than tacit dominion and where French ships seemed to navigate with impunity, her Majesty finds it not reasonable that she should prohibit her subjects to use their navigation in those parts, otherwise, than the subjects of the French king and other dominions are known yearly to use, offending thereby no dominion, nor country of any Christian prince."[27] Over the ensuing years, this would become Elizabeth's familiar battle cry.

But Hawkins and his men were offending a Christian prince. Having previously been taken for a pirate—and not the honorable merchant he believed himself to be—the queen's adventurer decided

to attack a group of Portuguese fishermen and their Moorish protectors in the harbor of Angela de Santa Ana, south of Cabo Blanco. If they were to treat him as a pirate, he would act like one, he reasoned. Armed only with bows and arrows, the fishermen quickly surrendered when Hawkins fired his heavy cannon. In no time at all, the English were free to take all the provisions they wanted before sailing on.[28]

By the end of November, Hawkins had arrived at Cape Verde and had sent his men into the dense jungle in small raiding parties to hunt for slaves. The richest pickings were at the island of Sambula, where the slaves who were captured had been enslaved by another African tribe, the Samboses, nearly three years earlier. Hawkins congratulated himself on a good beginning. So far, the "harvesting" operation had gone well.

On Christmas Day, after prayers, Hawkins bought two caravel loads of slaves from another group of Portuguese traders. When their dealing was over, the Portuguese kindly suggested that the English go farther along the coast to a town called Bymba, where they could easily buy another hundred "fine specimens" as well as Ashanti gold. The English captain thanked them, and sailed on to Bymba expectantly. All seemed peaceful, so Hawkins took around forty men ashore to set his bargain. Suddenly, shots rang out and there were hails of arrows from the jungle. The English took cover, cursing themselves for having fallen so easily into an obvious trap. They escaped back to their boats, dodging poisoned arrows; when Hawkins was aboard, he was surprised to find that he had ten new slaves. Significantly, he also lamented the wounding of nearly thirty of his mariners. Seven others had been killed in the skirmish, including the captain of the *Solomon*. Worse came later in the day, when some sailors were bathing near the ships. They were attacked and mauled by sharks. Another five men were killed, and the one who survived probably wished that he hadn't. All in all, it was a very bad day for the English.[29]

This incident would become infamous years after Hawkins's return, since the Portuguese claimed through official channels that the Englishmen had stolen wax, gold, ivory, and at least sixty slaves from Sierra Leone. Others wanted restitution for their losses when Hawkins and his men had taken their ships and left their

sailors on the beaches. One merchant even swore that the English had "confiscated and extorted a ship named the *Cola*, loaded with merchandise to the value of 4,000 ducats [$90,511 or £48,925 today] in the river called Caces."[30] There was certainly some truth in the allegations, but how much was never determined, like so many of the complaints heard by the High Court of the Admiralty.

By the time the English adventurers had left the Guinea coast heading for the West Indies on January 29, 1565, they had four hundred slaves in the hold. Where storms had ravaged the fleet in Europe, they found themselves miserably becalmed mid-Atlantic for a long three weeks, suffocating in the hot, humid, still air, and nearly running out of water. But once the wind filled their sails again, their relief was reasonably short-lived. The fleet had made landfall at La Dominica—called the "Island of Cannibals" by the chronicler Sparke. The English still had three hundred seventy of the four hundred slaves living in the stinking holds of their ships, and "Almighty God" had not allowed his "elect" (meaning the English) to perish so far. But there was such a thing as tempting fate, and with the likelihood of encountering cannibals in their weakened condition, the men filled their water casks and sailed away quickly while the wind was good.

At the next island, Margarita, the inhabitants sold the English beef and mutton, but refused to trade for slaves or other wares. Philip's prohibition to trade had reached the West Indies long before Hawkins. The islanders were relieved when Hawkins's fleet proceeded on its way without coming to grief, but they sent word to the viceroy in Santo Domingo that the Englishmen had arrived among them at last. Before Hawkins reached his next port of call at Santa Fe, word had spread like wildfire ahead of them not to trade with the English. Hawkins, meanwhile, had no qualms about his success. He traded with the Indians for chickens, potatoes, pineapples, and maize cakes in exchange for "beads, pewter whistles, glasses, knives, and other trifles" he carried to bargain with.[31] But he had yet to sell one African.

At this rate, Hawkins would be lucky to break even, much less return to England a rich man. It was time to change tactics. If the low-grade trade continued much longer, the ever-present threat of his men mutinying could become reality, for there was nothing

the mariner liked better than plunder. So, on April 3, 1565, when the fleet pulled into harbor at Borburata, and the familiar haggling with local officials began, Hawkins appealed to their better nature. He had been blown off course by contrary winds, he pretended. He sought only legal trade. When he was informed he needed a license, he cajoled the officials that they would surely trade with him while he awaited one from the governor, especially as it might save some of his "lean and sick Negroes." In this way, he'd earn enough to purchase supplies to help the others recover their good health, he reasoned. After three days of bickering, it was agreed to allow the English to sell thirty slaves, but a fair price had not yet been determined. When the governor arrived in town ten days later, Hawkins sensed victory was at hand. He trotted out his well-rehearsed spiel in which he announced he was *el capitán admiral* of Her Majesty, Queen Elizabeth, and that he had been on a mission to Guinea when he was unfortunately driven off course by a devastating contrary wind across the sea. All he wanted to do was sell his slaves so that he—a poor sailor—could pay for supplies and repair his ships before returning home.[32]

Governor Bernáldez (no relation to the officer encountered by Hawkins on his first voyage) wanted to allow Hawkins to trade, but found himself in a serious quandary. The king and the viceroy had ordered that there should be no trading with the *Luteranos*, but his people needed the slaves to keep the plantations running, since the slaves died with alarming regularity. After lengthy discussion with his men and Hawkins, the governor reluctantly agreed to allow the slave trader to proceed with his business after taking several testimonies and on the understanding that he was granting a license only insofar as he had the authority to do so. One of Bernáldez's eyewitnesses swore that he had heard Hawkins threaten to level the entire coast if the governor denied him his trading license. In the event, while the license was issued, the two men couldn't agree on terms, since the governor insisted on the usual royal treasury fee of thirty ducats per slave ($679 or £367 today) and Hawkins refused outright to pay anything. When the license was handed over to the queen's slave trader, he ripped it up, disgusted with the entire proceedings. It was a livid Hawkins who ordered a hundred armed

men ashore threatening to destroy the town if Bernáldez wouldn't agree to his terms. Without heavy artillery or guns, the governor had no choice, and he conceded to all Hawkins's demands. Later, John Hawkins would boast that the governor was one of his best customers—so much so that he ran out of ready cash and had to issue a promissory note for six hundred pesos to Hawkins, payable later at Río de la Hacha.

At long last, Hawkins had struck upon a winning formula with the Spanish settlers in Borburata. When officials at his next port of call, Río de la Hacha, had evacuated the town in fear of their lives, Hawkins, after protestations of his innocence and goodwill got him nowhere, fired off his great cannons at the town. When the locals still wouldn't trade, he landed a hundred men armed to the teeth and marched along the beach, threatening in Spanish to burn their homes. Still, the citizens of Río de la Hacha were ostensibly having none of it. Battle drums rolled behind thirty prancing Spanish horsemen carrying the King of Spain's standard. The local inhabitants apparently wanted to join the English in battle. Without hesitation, the admiral gave the signal, and the English ships fired more heavy cannon at the town, taking care not to hit Hawkins and his mariners. Despite all their sound and fury, the Spanish immediately capitulated. The good folk of Río de la Hacha had suddenly become eager customers, purchasing the remaining slaves and anything else the English were selling. The charade was over. Their eagerness to trade even carried over to placing advance orders for Hawkins's next voyage and providing him with a written testimonial of his fair trading practices and friendly conduct. This would later prove the Spaniards' undoing when the matter was investigated by officials back home. They could only conclude that the whole episode was a sham and the town's leaders were severely punished.[33]

A sad, and often lost, part of this story is that the Africans sold as slaves at Río de la Hacha had drawn a particularly harsh lot. They were destined to become pearl divers. And divers had to learn quickly to hold their breath for astounding lengths of time, or die. Even if they succeeded in this feat, the cold waters or the bends often claimed their lives, for they were rumored to dive to depths of twelve fathoms or more. They worked from dawn to dusk with

nets strapped to their waists or tied around their necks, breaking the water's surface only to catch their breath and, if they were lucky, eat an odd oyster. Then there were, of course, the sharks. Native American Indians had been banned as divers since the Vera Cruz decree of 1558, when African slaves were ordered in their stead as their official replacements. Their life expectancy was measured in days or months, since they were

> *forced to spend their last days in agony, and the nature of the work is such that they perish in any case within a few days, for no man can spend long under water without coming up for air, and the water is so cold that it chills them to the marrow. Most choke on their own blood as the length of time they must stay under water without breathing and the attendant pressure upon their lungs makes them hemorrhage from the mouth; others are carried off by dysentery caused by the extreme cold to which they are subjected.[34]*

Their entire human cargo thus disposed of, Hawkins's fleet sailed directly for Curaçao, where they purchased 978 hides valued at 10 reales of silver each ($363 or £196 today). The terms delighted the seller, who had been sure that the English would simply plunder them.[35] After a failed attempt to drop off a Jamaican captive named Llerena, whom Hawkins had freed in Guinea, the fleet stopped briefly for water on the westernmost point of Cuba.

For the next two weeks, Sparke's chronicle becomes remarkably silent, noting only that they reached the French Huguenot enclave at Fort Caroline on the Florida coast safely. Whether this was a scheduled stop or not, Sparke does not venture to say, but it does seem odd that once loaded with riches for his investors and himself, Hawkins and his men would seek out the French, who were notable rovers. It may have been that part of his private discussions with the queen just before leaving home was to better understand the movement of shipping in the area, or that he had decided to scout about for himself. In any event, they were cordially greeted by the Huguenots, and he sold the smallest of his ships to René Laudonnière, the colony's leader in the absence of Jean Ribault, along with shoes for his men, four cannons, and a good supply of powder and shot.

The road home was not arduous, with the fleet stopping off in Newfoundland for fresh water and fish. On September 20, 1565, after eleven months away, Hawkins brought his ships into Padstow harbor in Cornwall. In his note to Elizabeth, he stated that he had "always been a help to all Spaniards and Portuguese that have come in my way without any harm or prejudice by me offered to any of them."[36]

Despite obvious exaggeration on both sides—in terms of actual harm Hawkins had done, his good or bad conduct, and the value of his trades—there is no doubt that John Hawkins had become a national hero. He had also finally attracted the serious attention of King Philip of Spain.

9. The Gloves Are Off ✦

*We have continued to receive complaints of the Flemish
merchants and mariners of the English robbers, and we
were moved to send many of these letters of complaint to
the Queen of England, both before and after the death
of Bishop Quadra, in the months of August, September,
October, November and December last, begging her to
remedy the evil. . . . Nothing has been done and no answer
given to these letters, and as from day to day the complaints
of people grow, we are now obliged to seek another remedy,
since friendly remonstrance is of no avail.*

—PHILIP II TO AMBASSADOR DE SILVA, FEBRUARY 1565

Despite his protestations of innocence, Ambassador de Silva had no faith in Hawkins's professed honorable mercantile intentions. In an encrypted message to Philip, de Silva claimed, "I do not believe that a ship would be safe, if they were strong enough to take it."[1] Importantly, de Silva added that he was certain that Hawkins had been prowling the Indies during his second voyage for a fortnight to attack the Spanish "plate fleet" known as the flota.

The Spanish ambassador had every right to dread this—as yet—unfulfilled menace. The English had surpassed the French as rovers in the Channel, and were aching to burst out of their financial straitjacket in Europe to trade with Cathay, the Indies, and the New World. The flota was, indeed, an exceptionally vital piece of machinery of state, and the threat to it became the Spanish government's abiding terror throughout the next forty years. Since the beginning of the century the flota had operated as a government monopoly, managed by the Casa de Contractacion—or Commercial House—at Seville. When the fleet sailed up the Guadalquivir River from the coast, the ships anchored at the Toro del Oro, a magnificent round stone tower with huge wooden doors two stories high and

360-degree views of the town. There the ships would off-load their treasure chests onto the gently sloping cobbled quay. Ropes were slid through the three-inch-thick solid iron rings studded into the ironmongery of the oak doors, and the treasure was hauled up onto carriages then on about one hundred yards to the Casa de Contractacion.

Two fleets sailed yearly. The flota of New Spain sailed between Mexico and Spain. From 1564, the more important flota of Tierra Firma brought gold and silver from the Potosi mines of Peru via the Pacific (called the Southern Sea at the time) across the Isthmus of Panama to the Atlantic port of Nombre de Díos. Once loaded, the flota of Tierra Firma would head north along the Yucatán Channel then on to Havana. At Havana, always dependent until the last moment on orders received from the king, the flotas could—and frequently did—link up and make their Atlantic crossing together. It would not be an exaggeration to stress that the combined flotas carried the wealth of the Spanish Empire in their holds. Without these treasures, Philip's Spain simply couldn't continue to dominate the world stage, and what made the situation even more tense was the king's utter awareness of this Achilles' heel.[2]

But the English assaults were nothing new for the Spanish. French corsairs had been attacking the treasure trains for decades in the West Indies, and it was only with the appointment of one of Spain's greatest admirals, Pedro de Menéndez de Avilés, that French operations were mostly thwarted. Menéndez had provided three galleons as a permanent escort to the flotas at his own expense, and he was made captain general of the Indian trade in 1561—at his own "request." As a result, hostilities seemed to have settled down at last between the French and Spanish when Hawkins burst upon the scene.

Menéndez's reaction was predictable. He was determined to make both the French and English understand his intentions for the region once and for all. Less than a month after Hawkins and his men had left Fort Caroline in Florida, Menéndez landed soldiers just south of the French colony and massacred nearly all its inhabitants. Jean Ribault had just returned with some raw recruits and supplies, and they, too, were slaughtered. Menéndez, as a lesson to *Luteranos* everywhere, proudly left a plaque under the lifeless

bodies of his victims, declaring that the colonists had been hanged as heretics by order of the King of Spain.[3] For Menéndez, there could be no compromise. Any foreign colony would be "most damaging to these kingdoms, because on that coast of Florida, near the Bahama Channel . . . they could establish and fortify themselves so as to be able to maintain galleys and other swift war vessels to capture the flotas and other private ships coming from the Indies. . . ."[4]

Meanwhile, back in Spain, the fact that Hawkins had traded successfully with semiofficial status from the Queen of England had made his intrusion into West Indian waters a very serious matter indeed. Philip's sense of self-preservation, coupled with the unshakable belief that all seagoing *Luteranos*—whether French, Dutch, or English—were hateful scoundrels and pirates, created a sense of imminent danger at the Spanish court that was far greater than the threat the English were capable of delivering.

Yet despite all the attention drawn by the English exploits in the West Indies, it was still the veiled hostilities in the Channel that worried Philip the most. Hawkins was an extension of English Channel piracy in the king's eyes, and all the more dangerous since his return to England when the queen bestowed a knighthood on her new hero. The obvious favor that Elizabeth extended to all her adventurers—and particularly Hawkins—was a clear indication to the Spanish king of the queen's hostile intentions. This, coupled with the unfortunate appointment of Dr. John Man as the English ambassador to Spain in 1566, made discussion of "English affairs" at court a very heated matter.

This was the Spanish viewpoint. For Elizabeth and her privy councillors, the situation was entirely different. England had had its lifeblood of commerce snatched away by Spain, and Emden was proving a very poor replacement for Antwerp. Trade between the Flemish and English was still mutually banned when Hawkins pulled into Padstow harbor in September 1565, and the queen was becoming fretful again for her personal security as well as the security of the realm. Both had been jeopardized by a number of events. Economically, poor trade on the Continent, and the failure of the Muscovy Company (in particular Anthony Jenkinson and others) to prove the stunning successes they had promised long ago,

had already led to economic hardship for many. Politically, Elizabeth was weighed down with other grave concerns besides Philip of Spain. The rebellion of Shane O'Neill against colonization in Northern Ireland (Ulster) and the sudden and provocative marriage in the autumn of 1565 of Mary Queen of Scots to the young, handsome, and frequently drunk Lord Henry Darnley had disastrous implications. The Ulster Rebellion proved very costly in human life and hard cash. The Darnley marriage strengthened Mary's claim to the English throne. Mary's actions were also a personal rebuff to the English queen: Elizabeth's choice of husband for the Scottish queen, Leicester, had been spurned as the "keeper of the royal stud." As if this weren't bad enough, Elizabeth's Catholic population reminded her obliquely that failing Mary as queen, Philip II also had a very strong claim in his own right as an heir to the English throne. The only other viable heir, Catherine Grey, was by now locked away in the Tower for marrying without royal consent.

This was the England to which John Hawkins had returned. Security of the realm clung precariously, yet steadfastly, at the top of the Queen of England's agenda, and that security was now seriously compromised by a growing trade war with Spain as well as the constant political machinations of Mary Queen of Scots, who still refused to sign the Treaty of Edinburgh of 1560. Elizabeth's merchant and gentlemen adventurers—whether they were viewed as pirates or not by her friends or foes—represented a private army willing to defend her realm with their wealth and lives, economically, politically, socially, and militarily. And so, she had resolved to nurture them, while appearing to distance herself from their more questionable actions performed in her name.

In most ways, the West Indies was a sideshow. With trade on the Continent in a near shambles, the Holy Grail of riches for Elizabeth's adventurers remained a northeasterly passage to China, or Cathay. No other country had as yet staked a claim to the northeast passage to Cathay, so England was free to maneuver. It was a route that the Portuguese and Spaniards had never frequented. All that remained was to find it. And if the queen's adventurers could find the *northeast* passage—or any other shortcut—to Cathay, the economic wealth of the nation would be preserved.

The Muscovy Company had been founded well over a decade

earlier, and trade with Russia had grown in that time in hemp, cordage, flax, train oil, furs, hides, tallow, and wax. Russian ropes, manufactured by the Muscovy Company's rope makers in Kholmogory and Vologda, supplied most of the crown's naval needs. All these imports were widely used in the burgeoning English merchant navy and were essential in contributing to development of English sea power. The Russians, for their part, were great admirers of English broadcloth, but they were governed by an increasingly unstable Ivan the Terrible. The czar had granted the English privileged trading status, paying no customs duties or tolls, and the English effectively held commercial control over the White Sea for nearly two decades.[5] But for some reason, Ivan had taken a "mislike" of late to Anthony Jenkinson, probably since Jenkinson was trailblazing a path via the Caspian Sea region to Persia, in the hope of opening up a silk trade with the shah.

The czar's "mislike" translated into a high-level personal drama back in England for Sir William Cecil and his protégé, Sir Francis Walsingham. Both were heavy investors in the Russia trade and took an active interest in ensuring that the Muscovy Company prospered. Like many inspired investors since their time, they hadn't viewed Russia as a high-risk investment. Russia was rather an insurance policy for Baltic oak and all the necessities of naval power for the greater good of the English nation. Russia was the first outpost of extra-European trade that had flourished, yet its investors were not reaping real profits.

While Hawkins was establishing his slave trading in the West Indies during his second voyage, Anthony Jenkinson was fighting a rear-guard action with his own Muscovy Company against charges of fraud and misappropriation of funds. To make matters worse for Jenkinson when he had hoped to court royal favor to "scout those seas and to procure to apprehend such pirates as have lately frequented the same," he had angered Elizabeth instead by taking the queen's own ship, the *Aid*, to fulfill this so-called worthwhile task. The hapless adventurer was ordered "in her Highness's name, to repair with the said ship into the river Thames as soon as wind and weather will serve, upon whose arrival Her Majesty will send such smaller vessels thither in his stead as shall be fitter for that service than the *Aid* is."[6]

The *Aid* was, in fact, needed urgently in Ireland, for Sir Henry Sidney, an Elizabethan gentleman adventurer and Ireland's new lord deputy. Sidney had married the Earl of Leicester's sister, Mary, and had been backed by Leicester as a replacement for the Earl of Sussex for the post for some time. Since joining the Privy Council, Leicester had taken a strong, personal interest in Ireland, as he knew that taming the "wild Irish" was the queen's greatest concern for security of the realm and that she remained in constant fear of attack through that "postern gate." Though Sidney had been appointed in the summer, it was October before he was allowed to embark for Dublin to take up his new position as lord deputy.

The intractable problem between England and Ireland had its roots in a papal decree under Henry II, some three hundred years earlier. English plantations that were colonized to replace the power of the church had first begun under Henry VIII when he had dissolved the monasteries. By Elizabeth's reign they had fallen into decay. These plantations were constantly invaded by the Irish clansmen, or septs; and in the North, Shane O'Neill had followed a long-standing Irish tradition and imported Scottish mercenaries, known as "Redshanks," to help him make territorial gains against other Irish septs. To make matters worse, many English colonists, or "planters" as they were called, had gone native, adopting Irish traditions and customs, the most unacceptable of which was "coyne and livery." "Coyne," from the Gaelic *coinmeadh*, meaning the right of the great lord to demand hospitality of whatever nature for his person, had been coupled with the English "livery," by which the lord could demand whatever he needed for his horse. These two demands embodied the worst of both the Irish and English systems and harkened back to the nastiest features of the medieval *droits de seigneur*. It was a uniquely Irish invention, grounded in extortion and intimidation that ran like a sixteenth-century protection racket. The abolition of this pernicious practice became the abiding prime objective of Elizabeth in Ireland.[7] After all, her father, Henry VIII, had made Ireland his own kingdom after his break with Rome, and while the Irish saw matters differently, Elizabeth was determined to colonize the country and tame its wild people. Ireland was in thought and deed the first English colony, and it would become the Queen of England's most spied-on flank—for she feared invasion by

this "postern gate" even more than invasion from France, Scotland, or Spain directly.

By the time John Hawkins had returned to England in September 1565, Shane O'Neill's rebellion in the northern part of Ireland was well under way. Sidney's first task would be to find a way to deal with the man diplomatically, if possible, followed very closely by his attempts to settle the long-standing feud between the Earl of Desmond and the Earl of Ormonde. Thomas Ratcliffe, Earl of Sussex, had been lord lieutenant until 1564, when Leicester succeeded through a whispering campaign in having him removed from Ireland. Still, to Leicester's great displeasure, the queen insisted that Sussex remain on the Privy Council. Sidney readily saw that Sussex's policies were by and large just, and with studious topping and tailing, he had these reiterated as his own in his detailed instructions on Tudor Irish policy. The model colony at Laois-Offaly begun several years earlier was to be supported, with "the building of houses and towns and the setting up of husbandry." By settling the northeast coast of the country, it would be the "surest and soonest way" to handle the Scots and "to inhabit between them and the sea whereby . . . all hope of succour may be taken from them." From depriving O'Neill of his fierce Scottish mercenaries, it was only one short step in Sidney's mind to expelling the Scots from Ireland.[8] The disturbing presence of Catholic Scots in Ireland to the queen cannot be overstated. Nothing, except the meddling of the pope or Spain in Irish affairs, drove the message home more clearly to England's queen that she was surrounded by enemies than by the Scots in Ireland.

But, momentarily, all these troubles were forgotten. While John Hawkins unveiled the treasure trove to his investors, including the queen, ballads were written and pamphlets distributed recounting his daring adventures. Hawkins had become a national hero. To his investors, he presented a 60 percent profit on their initial stake. Though no precise reckoning of the takings was announced, we can get a fairly accurate picture not only of the profits, but also of the purpose of his voyage by the goods he had sold from the record of the royal treasurer in Borburata:

156 slaves, sold at	*11,055* pesos de oro
Textiles:	
Paños *(textiles)*	
115 varas *(kerseys)*	
92 varas londras *(London kerseys)*	
10 varas olandas *(Holland linens)*	
90 varas *and 3* ruanes *(Rouen linens)*. . . *1,473* pesos de oro	
Total . .	*12,528* pesos de oro

Since three *pesos de oro* were equal to one pound sterling at the time, that makes the total value in sterling, £4,176—or $1.51 million or £817,243 today.[9] This receipt shows quite clearly that John Hawkins had only intended for his voyages to open up the slave trade to England. Only 10 percent of the value of the sales were in the traditional export of England, textiles—and even then, most of those came from France and the Low Countries.[10]

It's no wonder that by the time the spoils had been divided, his third voyage was already in the planning. Hawkins should have also not been surprised when Ambassador de Silva took an undue interest in him personally, sidling up to him at court and inviting the new national hero to dinner. De Silva had already warned his king that he believed Hawkins was a danger to Spain, and so during his tête-à-têtes while wine and flattery flowed in equal abundance, the Spanish ambassador tried to "turn" Elizabeth's slave trader and secure Hawkins's allegiance to Spain. There can be little doubt that the mighty mariner sought the advice of William Cecil in the matter, who instructed Hawkins to play along. De Silva's first letter dated October 22, 1565—written in code—recounts their first meeting:

Hawkins, who is the captain, I advised your Majesty had recently arrived from the Indies, conversed with me the day before yesterday at the palace and said that he had been on a long voyage of which he was very tired, and had traded in various parts of the Indies with your Majesty's subjects, but with the permission of the Governors, from whom he brings certificates to show that he has fulfilled the orders given to him by his queen prior to his departure. I said that I should be glad for my own satisfaction and his to see the certificates, and he said he would show them to me. I asked him if it were true

that all the Frenchmen who were in Florida had left, and he said
they had, and that he had sold them a ship and victuals for their
return, as I have already advised. He said the land is not worth
much, and that the natives are savage and warlike. . . . I have not
thought well to take any steps or make any representations about
this voyage until I was well informed of the particulars. I am
promised a detailed statement of the voyage—where he went and
what he did. . . . The truth will be learnt.[11]

De Silva was determined to stop the English in their tracks and curb
their growing passion for roving. Though not as yet as successful,
others had already followed Hawkins's lead. In September 1565,
Vice Admiral William Winter and his brother, George, had prepared
their ship the *Mary Fortune* for a voyage to Guinea, most probably in
the hunt for gold rather than slaves. Within the month, the majority
of the crew had been killed by the Portuguese, with the remaining
few held in captivity in the slave fort at El Mina. Earlier, Thomas
Fenner, described as a "pirate gentleman of Sussex" by de Silva, had
tried to replicate Hawkins's first voyage, but he, too, alas, failed.[12]

If only, de Silva reasoned, he could get Hawkins to serve his
former master, Philip, things might be different. After one of their
more amiable dinners, the Spanish ambassador wrote to his king
that he may have hit upon a solution:

He [Hawkins] is not satisfied with things here, and I will tell him
he is not a fit man for this country, but would be much better off
if he went and served your Majesty, where he would find plenty to
do as other Englishmen have done; he did not appear disinclined to
this. They have again asked him to make another voyage like the
last, but he says he will not do so without your Majesty's license. . . .
It seems advisable to get this man out of the country, so that he may
not teach others, for they have good ships and are greedy folk with
more freedom than is good for them.[13]

Hawkins continued to string de Silva along until February 1566,
claiming that he would like to serve the King of Spain, when word
reached the Spanish ambassador that Hawkins's fleet would be ready
to sail as soon as the weather was right. The game of cat and mouse

continued between the two men for another six months before de Silva finally confronted the queen. Did she not recall her promises that no Spanish subject should be harmed? Did she not also recall that she had given her word that John Hawkins would not be allowed to return to Spanish ports in the Caribbean? Why were her councillors, her gentlemen, and her merchant adventurers financing yet another slaving voyage? he persevered. The queen couldn't deny any of his arguments. She found herself in the position of ordering Hawkins, George Fenner, John Chichester, and William Coke from sailing to "certain privileged places as is planned." Finally on October 17, the Privy Council wrote to the mayor of Plymouth demanding that they

> *cause a ship that is there prepared to be set to the seas by John Hawkins, which is meant to be sent in voyage to the King of Spain's Indias, to be stayed and not suffered in any wise to go to the seas until the matter be here better considered, charging the owner of the said ship or the setter forth of her, in the Queen's Majesty's name, to repair immediately hither to answer unto that shall be objected against him.*

In early November, Hawkins was ordered to pay a bond of £500 in "sound royal English coinage" and that he must forbear to send any of his ships on a voyage to the West Indies, or lose the bond.[14] In fact, the bond went so far as to specifically prohibit Hawkins from sending "at this time into any place or places of the Indias, which are privileged by the King of Spain to any person, or persons there to traffic, And also if the master and company of the said ship, and the master, and company or any other ship, or ships, to be set further in this voyage by the said John Hawkins do not rob, spoil, or evil handle any of the Queen's majesty's subjects, allies, confederates or friends."[15]

De Silva, scarcely able to conceal his glee, was certain he had won. Yet five days later, on November 9, 1566, four of Hawkins's ships—the *Paul*, the *Solomon*, the *Pascoe*, and the *Swallow*—sailed out of Plymouth harbor under the command of Captain John Lovell. One of Lovell's ordinary seamen aboard the admiral ship, the *Swallow*, was Hawkins's "cousin" Francis Drake.

10. Lovell's Lamentable Voyage ✣

Who seeks by worthy deeds to gain renown for hire,
Whose heart, whose hand, whose purse is pressed to
purchase his desire,
If any such there be, that thirsteth after fame,
Lo! Hear a means to win himself an everlasting name.
—SIR FRANCIS DRAKE, 1583

There can be no doubt that Hawkins never intended to travel on what became known as the Lovell voyage. His plan all along had been to marry Katherine Gonson, the attractive eighteen-year-old daughter of Benjamin Gonson, treasurer of the Navy Board, and move from Plymouth to London. The swashbuckling sea captain now saw himself at the heart of power, and while he cultivated court society, his deputies could continue the slave trade on his behalf.

Not much is known about John Lovell, other than that he was an uncompromising Protestant, and no diplomat. No physical description of Lovell survives, unlike the fiery, bearded, redheaded Hawkins of the 1560s, wearing the finest black velvet, bedecked with a bracelet of diamonds and pearls, jeweled scarf, and three gold rings.

Lovell and his crew had been charged with following the tried and tested method of slave trading pioneered by Hawkins, and there had been every expectation that they would succeed. After all, his fellow commanders, James Raunce in the *Solomon*, James Hampton in the *Paul*, and Robert Bolton in the *Pascoe*, were no novices. But things started badly and got steadily worse. In the Canaries, Lovell flaunted his devout Protestantism and scandalized Hawkins's local partner, de Ponte. He even went so far as to claim to an official in Tenerife that "he had made a vow to God that he would come to these islands, burn the image of Our Lady in Candelaria, and roast a young goat in the coals."[1]

Unlike the pragmatic Hawkins, who often masked his Protestantism to suit the occasion, Lovell obviously felt that his mariners, too, must exercise the "true faith" with the same excess that he did. Our only clear glimpse of Drake on the voyage survives, oddly enough, thanks to Spanish torture. In a confession given by a Welshman, Michael Morgan, after he had been captured and tortured by the Inquisition in Mexico City in 1574, we learn that Drake had converted Morgan to Protestantism on the 1566–67 Lovell voyage. The statement was written down by his inquisitor since Morgan was unable to write:

> *He said . . . although at that time he [Morgan] could have found a priest to whom to confess he did not confess but to God in his heart, believing that such a confession was sufficient to be saved, and this he had heard said by Francis Drake, an Englishman and a great Lutheran, who also came on the vessel and who converted him to his belief, alleging the authority of St Paul and saying that those who did not fast should not say evil of those who did, and those who fasted should not speak evil of those who did not, and that in either of those two doctrines, that of Rome and that of England, God would accept the good that they might do; that the true and best doctrine, the one in which man would be saved, was that of England. . . . On the deponent [Morgan] asking the said Drake whether his parents and forefathers would be lost for having kept the doctrines of Rome, he replied 'no,' because the good they had done would be taken into consideration by God, but that the true law and the one whereby they would be saved was that which they now kept in England.*[2]

Drake had taught Morgan "the Paternoster and Creed of the Lutheran Law and he had also learned to recite the Psalms from a book."[3] Francis Drake, the eldest son of Edmund Drake, had learned to hate Catholics from his earliest days in Devon, when, according to family legend, the Drakes had been forced to take refuge in Plymouth harbor before fleeing the wrath of the Western Catholic Rebellion against King Edward. The truth of the matter is somewhat different, as we can now see from the entry in the patent rolls of 1548:

December 21, 1548. Whereas Edmund Drake, shearman, and John Hawking, alias Harte, tailor, late of Tavistock, Devon, are indicted of having on 25 April, 2 Edward VI [meaning second year of Edward's reign], at Tavistock, stolen a horse worth £3, of one John Harte; and whereas William Master, cordyner, and Edmund Drake, shearman, late of Tavistock, are indicted of having on 16 April 2 Edward VI, at Peter Tavy, Devon, in the king's highway (via regia) called "Le Crose Lane" assaulted Roger Langisforde and stolen 21s 7d which he had in his purse.

Pardon to the said Drake, Hawking and Master of all felonies before 20 Oct. last. By p.s. [privy seal][4]

Still, when Drake gave his family history to the chronicler, William Camden, it is doubtful that he knew his own father's dark secret. It would have been easy enough for him to have challenged his father's story, since the Western Rebellion occurred in the summer of 1549, not 1548. This doesn't alter the fact that the West Country was a pretty inhospitable place for those who were staunch supporters of the "new faith" in the late 1540s. King Edward tried to make the Protestant toehold in England resemble a much sterner Lutheran movement. There was no middle ground and no compromise for Elizabeth's younger brother. So when West Country Catholics had resisted Edward's new rulings to remove images from all churches and chapels, withered limbs of one executed Catholic rebel or another adorned the walls of Tavistock. Body parts of those executed for disobeying a royal command were frequently exported around the county to ensure the submission of others. Within the year, the Cornish peasantry rejected the new Prayer Book—egged on by the gentry—and all hell broke loose as they marched into Devon, exercising "the uttermost of their barbarous cruelty." Of course, they were mercilessly crushed.[5]

It was from their new "home" in the hull of a ship moored or beached in the River Medway in Kent, the younger Drake brothers were born and raised until there were twelve surviving sons in all. Edmund earned his crust of bread by preaching to the sailors of the Royal Navy at Gillingham. Francis, as the eldest, was expected to find employment as soon as he was able. Undoubtedly, it was in these mud flats where

the young Francis played, dodging between the king's ships that had been brought in shore for repair. It was in Kent that he absorbed the possibilities of the sea rather than in Devon. It was in Kent that Wyatt's Rebellion to put the Princess Elizabeth on the throne was hatched. It was Kent where the great Londoners passed on their way to the Continent or to Russia or Spain. While Mary's inquisition raged, seizing and burning three hundred innocent mothers, fathers, bakers, butchers, and others of no political significance whatsoever—fifty-four of them were seized and murdered in Kent alone. It is no wonder that Francis Drake hated Philip of Spain, once the king consort of Queen Mary of England.

What is astounding is how his father continued to earn money during the reign of Mary and Philip reading Lutheran prayers to sailors without being counted among those seized for heresy. The family must have lived in constant fear for his life, and their own. What is certain is that Mary's reign would have instilled even greater hatred in Drake for all Catholics. Interestingly, one of the few books Drake carried in his great voyage around the world with him was John Foxe's *Acts and Monuments* from 1563—a history of the Protestant martyrs in the reign of Queen Mary.

While Lovell was sailing on to Guinea, having offended business associates and local officials alike in the Canaries, Elizabeth had other, far more important worries at home. The Queen of Scots had been implicated in the murder of her husband, Lord Darnley, and, it was rumored, had even masterminded the assassination with her lover the Earl of Bothwell. On February 24, 1567, Elizabeth wrote to Mary

> *Madame, My ears have been so deafened and my understanding so grieved and my heart so affrighted to hear the dreadful news of the abominable murder of your mad husband and my killed cousin that I scarcely yet have the wits to write about it. . . . However, I will not at all dissemble what most people are talking about: which is that you will look through your fingers [pretend to ignore] at the revenging of this deed, and that you do not take the measures that touch those who have done as you wished, as if the thing had been entrusted in a way that the murderers felt assurance in doing it.*[6]

There could be little doubt that Mary was plotting again, and that Elizabeth needed to find out what she was up to. Not even de Silva could get the queen's attention in these dark days, so the fate of a small fleet off the coast of Guinea, with no apparent direct investment from the queen herself, would not have hit Elizabeth's radar screen. And so, Lovell sailed on oblivious to the fact that he was of no concern whatsoever to his queen. After two or three months on the Guinea coast "gathering" slaves and merchandise estimated at a value of 30,000 ducats ($10.79 million or £5.83 million) through outright theft, intimidation, or, in a worst case, purchase, Lovell struck out into the Atlantic. Later, the Portuguese would complain that Lovell had attacked the "great ship *Sacharo*, loaded with slaves within sight of the island of Saint James" gravely injuring the captain and slaying many of its crew.[7]

The voyage was not well documented, but it's believed that their first landfall in the West Indies was probably the island of Margarita, off the northern coast of the Spanish Main. Lovell was refused the right to trade, but he was allowed to take on fresh water, wood, and food. At Borburata, on the coast of modern Venezuela, he joined forces with two French pirate fleets that had arrived ahead of him. The more notorious of the pirate captains was Jean Bontemps, with whom Lovell had scraped an acquaintance during his other Hawkins voyages. Bontemps and Lovell sent their agents to Borburata's governor, Pedro Ponce de León, expecting to receive a license to trade as Hawkins had done the previous year. When Ponce de León refused the license, of course under the most strict interdiction from Spain, Lovell sent an armed party ashore. They took two government officials and several other citizens of the town as hostages, and robbed two of the merchants they had kidnapped of the 500 pesos tucked away in their purses.

On reflection, this must have smacked too much of sheer piracy for Lovell, and so the two "robbed" hostages were granted twenty-six slaves in exchange, and everyone was set free. To make everything kosher, the local officials demanded that the merchants—not Lovell or Bontemps—pay a fine to the crown before they would be allowed to take possession of their slaves, thereby settling all tax matters and making everyone happy.[8]

The next we hear of Lovell is on May 18, 1567, when the English fleet—alone—arrived in Río de la Hacha. Again, a representative was sent ashore to ask for a license to trade. The pliable local treasurer, Miguel de Castellanos, who had negotiated the year before with Hawkins, agreed to trade despite Philip's interdiction. But the locals—including de Castellanos's brother Balthasar—refused to trade, since they feared royal retribution from the king. So Lovell simply unloaded around ninety slaves and sailed away in the middle of the night.

When the good citizens of Río de la Hacha had their feet metaphorically put to the fire by the Inquisition a few months later, they changed their tune. One weary inquisitor even commented that he hated to make the colonists testify under oath since they would "only perjure themselves."⁹ According to the new story, Bontemps seemed still to be traveling with Lovell, and had arrived first with his fleet. When the colonists had met the French pirate with armed resistance, he had been driven off. When Lovell arrived, claiming he wanted to trade, and was told that it wouldn't be allowed, the Englishman sent a reply threatening to lay waste to the town and kill all the townspeople. The Spaniards claimed that they had defended the town against the interlopers, and had killed or wounded a number of the English. The slaves whom Lovell had off-loaded a few days later were in fact "old and weak and on the point of dying." Being good Christians, they nursed the slaves back to health, so surely, they argued with their inquisitors, they should be rewarded with them as payment for their admirable defense of the town and obeying the king's orders.¹⁰ The investigation concluded that the colonists had probably bought the slaves in one or more midnight trades, but since they all told the same story, there was little the inquisitors could do about it.

Lovell's voyage is chronicled only once more by the good people of Río de la Hacha, when they claim that he had gone on to Española where he "wrought great evil and destruction."¹¹ If this had been, in fact, true, the voyage would hardly have been largely ignored back home. By the time his fleet pulled into Plymouth harbor in September 1567, Lovell had already been consigned to an anonymous watery history. John Hawkins, on the other hand, had other fish he was frying.

11. The Troublesome Voyage of John Hawkins ✦

An hundred iron pointed darts they fling,
An hundred stones fly whistling by his ears,
An hundred deadly dinted staves they bring,
Yet neither darts, nor stones, nor staves, he fears;
But through the air his plumed crest he rears;
And in derision 'scapes away. . . .
—CHARLES FITZGEFFREY, *Sir Francis Drake*, 1596

While Lovell and his men had been risking life and limb for Hawkins and his investors, the queen had appointed her trailblazing sea captain to the office of clerk of the ships of the Royal Navy, on the condition that his position would be taken up once George Winter retired. Winter understandably clung tightly to his post for another twelve years or so, but the title—and the weight it carried—wielded all the influence Hawkins needed in London's naval society for his next venture.

For this fourth, last, and most impressive slaving voyage, Hawkins's joint stock company investors were even more remarkable than before. The queen; Leicester; the Earl of Pembroke; and Leicester's brother, the Earl of Warwick, were the most prominent from the court itself. But the one astonishing name on the list of investors is that of William Cecil. It seems that even he overcame his habitual "distaste for such ventures" by investing a small sum himself, possibly due to the financial debacle he was facing in his investment in the Muscovy Company.[1] Among the naval backers, the lord admiral, Edward Fiennes de Clinton, invested along with Sir William Winter and William's brother, George. Hawkins's elder brother, William, was a major player, too. The merchants in the syndicate included the usual suspects from the City of London headed by the ubiquitous Sir William Garrard, Sir Lionel Duckett,

and Rowland Heyward. In fact, in the confession of one of Hawkins's captured mariners, Thomas Fuller, he claimed that there were thirty merchants in all investing in the voyage, represented by a dozen or so agents aboard the vessels themselves. The most prominent of these seafaring merchants was Anthony Godard from Plymouth, who was fluent in French and Spanish, and of great value to Hawkins aboard his flagship.[2]

While Hawkins was ordering those who had excelled themselves in the Lovell expedition aboard his ships (and there weren't many) for his new adventure, his officers were also busy scouring the port for all the young and fit hopefuls of Plymouth to press-gang into service. Years later, on his return from the West Indies, a young man named William Cornelius, who had been a mariner aboard sardine ships to Flanders until that fateful day in the autumn of 1567, claimed that "one day as he was going along the street unsuspectingly they fell upon him suddenly and hurried him on board as they were short of people owing to the fact that they were going to Guinea which had a reputation of being an unhealthy country where they would die from fever and that they had taken him as many others."[3]

Once again, the queen's own investment in the new adventure was through her ships rather than ready cash. And again, the *Jesus of Lubeck*—newly refitted since her last voyage at Hawkins's own expense—was the fleet's admiral. The queen also ventured the 300-ton *Minion*; and John Hampton, newly returned from the Lovell voyage, became her master, with John Garrett as his mate. The other four ships in the fleet belonged jointly to John Hawkins and his elder brother, William. The aptly named *William and John* was a 150-ton vessel and had the returning Thomas Bolton as her master with the former captain of the *Solomon*, James Raunce, as the ship's mate. The rebuke in this demotion for Raunce was an unspoken warning to all. The 30-ton pinnace *Swallow*, virtually new when she set out on Lovell's voyage, was still in good condition and was also prepared to sail. The last two ships, the 50-ton bark *Judith* and the 32-ton *Angel*, completed the fleet. At the time of sailing, neither the captain of the *Judith* nor that of the *Angel* had been named. Hawkins had at his command some 1,333 tons of shipping positively bristling with firepower in what was, in all but name, a national undertaking.[4]

Aside from the merchants, admiral, his captains, and crew, the

fleet also carried an orchestra of sorts: a six-man band with at least two fiddlers, a bass viol player, and organist. Entertainment for the captain and all those who shared his table was essential for the gentlemen adventurers—and as essential as their gold plate to eat off of—especially since they would be gone for a year or more.

And so, within a month of Lovell's return, on October 2, 1567, Hawkins was at sea again. This time, though, it was as a captain of a fleet of state with the flag of St. George hoisted atop his mainmast, the queen's colors alongside the national flag; and the queen's commission in his pocket. But Hawkins hadn't obtained these symbols of national honor lightly. In the queen's presence chamber, he once again faithfully, or perhaps faithlessly, promised Elizabeth that his adventure would not offend England's friends and allies, and that he would not harm any subjects of the King of Spain. The charade was more likely to allow Elizabeth to disavow any knowledge of his actions than be believed by England's savvy queen. Certainly de Silva didn't believe it, and he made Cecil swear "a great oath" that the sea dog Hawkins was not heading back to the West Indies.

Yet despite all Hawkins's preparations and the fair wishes of the great and the good, the voyage was doomed from the outset. Within a few days of putting to sea, the fleet was scattered just north of Cape Finisterre, with only the diminutive *Angel* managing in keeping alongside the *Jesus*. The *Jesus*, despite all the repairs carried out after her last voyage, sprung leaks like a massive colander through her ancient timbers. There was one hole in the ship's stern that was so large it needed to be plugged with chunks of baize. While the ships pitched and rolled, and the *Jesus* listed dangerously in the swelling seas, Hawkins had his mariners man the pumps and prayed they would make it through the night.

By daybreak, all were exhausted and utterly soaked through. They held no hope that they could stay afloat and, for that matter, remain alive. Hawkins gathered his crew together to pray one last time. With clasped hands and bowed heads they begged the Lord to preserve them in their hour of need, and keep the *Jesus*—which was after all named in honor of His own Son—from sinking. Emotions ran high after Hawkins's stirring prayers, and later the crew claimed that there wasn't a dry eye on deck. By midnight of October 10, three

days after the storm had started, the winds subsided, and Hawkins knew that the weather was clearing at last. The next morning, with the *Jesus* miraculously still afloat, he led his men in a service of thanksgiving.[5]

Unbeknownst to Hawkins, the tiny *Judith* had sailed on southward in the great storm, and two weeks later Hawkins caught up to her in the roadstead just off Santa Cruz de Tenerife. Still, the *William and John*, the *Swallow*, the *Solomon*, and the *Minion* were missing, feared sunk. To make matters worse, Hawkins had had strained relations with the powers-that-be in Santa Cruz for some time, making it far from the safe haven he needed. When he anchored in the harbor, his great fear was that he was under surveillance, and he couldn't shake the feeling. He was right to be wary. Lovell's shenanigans of the previous year had not been forgotten, and the good people of Santa Cruz feared that they would be attacked by the "thieving English pirates." Nevertheless, it was obvious to the governor that Hawkins's ship had been badly battered in the recent storm, and he was allowed to refit.

Despite being ordered to behave themselves, the confined spaces aboard ship and perhaps their ordeal led two of Hawkins's closest companions, Edward Dudley (captain of the soldiers of the fleet) and George Fitzwilliams, into a violent disagreement. When the men set off to row ashore to fight a duel, Hawkins rushed after them to stop it at once. He wasn't about to allow the Spaniards to have "entertainment" at his men's expense. When Dudley was confronted by his admiral, he struck Hawkins above the eye with his sword in the heat of the moment, and Dudley was clapped in irons on the spot. Striking a senior officer was mutiny even then, and mutiny was punishable by death.

When Dudley heard his death sentence, the hapless captain of the soldiers fell to his knees and begged Hawkins to spare his miserable life. Hawkins told him to say his prayers, and when Dudley babbled to be forgiven yet again, Hawkins helped him to his feet, saying that that would be the end of the matter. The men were relieved, and a thankful Dudley walked away a free, if chastened, man. There would be no rowdiness countenanced on this voyage.[6]

Shortly after this incident, the *Jesus* was finally repaired, and by October 30, Hawkins reached the friendlier southern part of the

island where his partner, Pedro de Ponte, greeted him warmly. There he learned that his missing ships—the *Minion*, the *Swallow*, and the *William and John*—were all safe on the island of La Gomera, just fifteen miles west of Tenerife. The *Judith* was dispatched there, and on November 2, the ships were reunited, and their combined companies held a great celebration, firing off their guns and receiving an official welcome from the Spanish governor of the island. Meat, jugs of wine, and fresh oranges were brought on board as a gift from the town of San Sebastian.

Nonetheless, later, the Spanish would complain about "outrages" perpetrated against the Church during Hawkins's sojourn. They may have been right. For whatever reason, this voyage held a strong anti-Catholic bias. There were reports of burning images of the saints, burning the doors to the hermitage at Playa de Santiago, overturning a cross, and shooting at the church and chapel of Santa Cruz. Protestantism had well and truly overshadowed the ethos of the crew. Still, despite their acting like ruffians and pirates, Hawkins and these men thought they were gentlemen and merchant adventurers. They saw themselves as holding a simple, yet burning, piety, often praying three times daily aboard ship. Their adventure was for the good of their realm and queen, in an increasingly hostile world. It never occurred to them that they played a very real role in that increasing hostility.

For that matter, no one had as yet realized that these voyages would change England and, eventually, the world. As they increased over time and in success, their goals would become ever more commercial and, in later years, colonial. They would fundamentally change the very fabric of English society. England's mariners were in a high risk, high reward game. The ships' companies knew that perhaps as many as half of them wouldn't return, but they all calculated that if they did, they would do so as wealthy men. Their adventures would mark the beginning of a new way of expression in the English language, expanding horizons for those more, or perhaps less, fortunate, who stayed at home.

The mariners' diaries are bathed in their workaday chores, the boredom of the Doldrums, the swell of the sea, the stench and the horror of battle, and tales of vast wealth and booty. This was the time when sea shanties were first sung to help pass the long hours at

work or while waiting endlessly on a glassy sea for the wind to fill their sails. Their language was rich with the religious fervor of the day and showed their daily hopes and aspirations, their triumphs and their tribulations. And it is their very own words that help us to understand how terrifying, expanding, and exciting the world seemed to them. They themselves were often indentured in some way or another, and suffered greatly just to stay alive. For them slavery was not the heinous crime that we know it to be today, but a means for them to take one step up the social ladder by acquiring the "wealth" that slavery and these "trading" adventures brought.

These were the pioneers who—willingly or not—followed John Hawkins on his fourth slave trading voyage. At Cape Verde, they plundered Portuguese ships for African slaves already "harvested." When this wasn't fruitful enough, he ordered his men to "gather" slaves by direct assaults on their villages. The assaults were a disaster. In one midnight attack, Hawkins and twenty of his men were wounded by poisoned arrows the natives fired at them. Seven or eight of the mariners contracted an illness that may have been lockjaw (tetanus) and died. Considering that they captured only nine slaves, it was a terrible result.

Hawkins and his men couldn't put the Cape Verde Islands behind them quickly enough after this debacle. While they sailed along the Guinea coast, they encountered some French pirates who had taken a Portuguese ship. Hawkins "impounded" the Portuguese *Gratia Dei* (Grace of God) and gave Francis Drake his first command as her captain.

After this, for a while, Hawkins's voyage seemed to be improving. Along the Sierra Leone coast, where numerous rivers flow into the sea, the men set to work in shallow draft, swift ships, and, by the end of November, near Cape Roxo, captured the slaves aboard six Portuguese vessels. But events soon soured again when Drake led an expedition up the Cacheo River, capturing Portuguese ships—which had no slaves. Four Englishmen were killed, and 250 mariners and soldiers were engaged in the fruitless action.

Finally, in January 1568, Hawkins, with the help of the Sapi people, who were the native enemies of the Conga, stormed an indigenous fortified town on the island of Conga off the coast of Sierra Leone. Until that point, the queen's slave trader had "gathered" only 150

slaves despite numerous raids. Through fierce fighting that amazed
the English, the town was captured and handed over to the merciless
Sapi, and the English "harvested" 250 more slaves. By February,
the count had risen to 400, and Hawkins felt he could sail on to the
West Indies. He had lost under a dozen men to battle, a few more to
disease, and two to drowning when a hippopotamus rammed their
ship.[7]

Their Atlantic crossing bode well for the trade ahead, and the
English fleet made landfall at Dominica on March 27, where they
took on fresh water and wood without incident. At his next port of
call, the island of Margarita, the English found the town abandoned
and sacked "in a manner all spoiled and burned" with "the walls of
a house scrawled in charcoal with the phrase in the French language
Vengeance for La Florida."[8] What remained of the town's population
had escaped into the interior. Hawkins sent a party after them "in
peace," and it was soon confirmed that the town had suffered a violent
reprisal by the French for the murder of their colonists in Florida
three years earlier. Neither Hawkins nor the Spanish had known that
the Florida Indians had virtually destroyed the remaining Spanish
outposts in Florida by early 1568.[9] Ever the crowd-pleaser, Hawkins
vowed to apprehend the French corsairs, after which their Spanish
hosts were so grateful that nine days of friendly trading (linen for
gold) and feasting followed.

Shortly before Easter, the fleet reached Borburata, only to find that
the French had beaten them to it and laid waste to the town. Houses
and the church had been destroyed, and most of the inhabitants
had fled inland. Soon Hawkins learned that Ponce de Léon and
his family had been attacked in Coro, too, the local seat of Spain's
government. The Spanish Caribbean had changed for the worse
in the two years Hawkins had been absent. But he wouldn't allow
French depredations to stop him. As resourceful as ever, Hawkins
bribed two men with the reward of an African woman if they could
entice the colonists back to town.

Sure enough, the townspeople trickled back in small groups, and
a makeshift trading emporium was set up on the beach. Some of
the wretched slaves were off-loaded and kept under guard from
running away from the Spanish, and probably also from the French.

It did not bode well for a brisk trade, but Hawkins wrote off to governor Ponce de Léon in any event for his license to trade sixty slaves only. Naturally, he hauled out his usual patter that he had blown off course when he wrote that:

> *This voyage on the which I was ordered by the Queen's Majesty of England, my mistress, another way and not to these parts, and the charges being made in England, before I set sail the pretence was forcibly overturned. Therefore I am commanded by the Queen's Majesty my mistress to seek here another traffic with the wares I already had and Negroes which I should procure in Guinea, to lighten the great charges hazarded in the setting out of this navy.* [10]

While he awaited his answer, he ordered his ships to be careened and trimmed. Hawkins even tried to bribe the local bishop to help him get his license by the gift of two Africans and twelve silver spoons. When they were returned at the same time as the negative reply from Governor Ponce de Léon, which said, "before my eyes I saw the governor my predecessor carried away into Spain for giving licence to the country to traffic with you at your last being here, [is] an example for me that I fall not in the like or worse." [11]

The settlers who had been lured back to town to trade now fled again. Hawkins sent a party of sixty men headed by his favorite henchman, Robert Barrett, to bring them back, but Barrett returned only with stolen chickens. The English remained in port, though, hopeful that furtive midnight trades might turn into something more profitable. But when trading didn't pick up enough by the beginning of June 1568 to warrant prolonging their stay, the fleet weighed anchor and headed for Río de la Hacha.

Drake was sent ahead in the *Judith* together with the *Angel* under his command, while Hawkins took on victuals for the fleet at Curaçao. This is the first mention of Drake as captain of an English ship in Hawkins's fleet. But, according to Job Hortop, one of Drake's men:

> *The Spaniards shot three pieces at us from the shore, we requited with two of ours, and shot through the Governor's house: we*

weighed anchor and anchored again without shot of the town,
where we rode five days in despite of the Spaniards and their
shot. In the mean space there came a carvel of advice from Santo
Domingo, whom with the Angel *and the* Judith, *we chased and*
drove to the shore: we fetched him from thence in spite of 200
Spanish harquebusiers' shot, and anchored again before the town . . .
'till our General's coming, who anchored, landed his men, and
valiantly took the town, with the loss of one man, whose name was
Thomas Surgeon.[12]

It was only by killing the defenders of Río de la Hacha, burning
half the town, and letting his men loose to plunder that the local
treasurer allowed the English to "trade." The same modus operandi
was used at Santa Marta, the next port west—though at Santa
Marta, the town was taken by "mutual agreement" when a pretense
was instigated to land 150 mariners and "shoot out of the ships half
a score shot over the town for a color [a charade]."[13] Though trade
was brisk, Hawkins still had a number of unsold Africans. And so
he headed to Cartagena.

Where Santa Marta had no hope of resistance, Cartagena was
well fortified and, as a major trading port, well endowed with both
European goods and slaves. There was a heated exchange of views
between Hawkins and Cartagena's governor as well as plenty of
gunfire, but the result remained the same. Cartagena was having
none of the queen's slave trader. The English fleet weighed anchor
on July 24, just before the beginning of the hurricane season. Despite
all their difficulties, the adventure had been a financial success.

They set sail for home and entered the Florida Channel. It
was there that the men claimed they could "smell" the hurricane
coming. Powerless, they watched the clouds darken and swell. As
the winds whipped up to hurricane force, they hoped against hope
that they could outrun the storm. But on August 22, the storm hit
and battered the fleet for several days, threatening to shipwreck
them. As if experiencing déjà vu from the beginning of the voyage,
Hawkins watched the *Jesus* begin to break up. She was "not able to
bear the sea longer, for in her stern on either side of the stern post
her planks did open and shut with every sea [swell], the seas being

without number, and the leaks so big as the thickness of a man's arm, the living fish did swim upon her ballast as in the sea."[14]

This was by far more dangerous than the first storm. Hawkins barked his orders to have the forecastle and the raised poop of the *Jesus* demolished. Anything to make the ship lighter in the turbulent sea. Mariners constantly manned the pumps, while others stuffed anything—and everything—into the gaping holes between her rotted planks to keep the sea at bay. Hawkins thought of giving the "abandon ship" order more than once, but was determined to hold out as long as he possibly could. The disgrace he would face back home for abandoning a royal ship at sea was too much for him to bear. Then, when the hurricane was at its most vicious, he saw that the *William and John* had disappeared, presumed sunk. They tacked round and scoured the coastline for her, and as they did, they also searched for a decent berth for themselves. When the wind died down, their worst fears became reality. Unless the *Jesus* had urgent major repairs, she would not be bringing them back home.

To make things worse, the fleet was running hopelessly short of food and water. They sailed on in light breezes for days on end, lost at sea. None of their pilots had been to these waters, and none knew the geography. It was on September 11 that they realized that they had entered the Gulf of Mexico and were drifting to some reefs off the Yucatán. It was a desperate situation.

Then, as if their prayers had been answered, two Spanish ships were spotted in the distance. Drake was sent in the *Judith* with the *Angel* to overtake them. The faster, sleeker English pinnaces outran the Spaniards with comparative ease, and despite one of the cargo ships escaping Drake's clutches, the other one fortunately was carrying wine and, importantly, a captain who knew the waters well. The Spaniard was questioned and said he was heading for San Juan de Ulúa, the port of Veracruz, the main port in all the Gulf of Mexico. On the one hand, it was lucky that such a major port was within two hundred miles of them; on the other, it was two hundred miles in the wrong direction.

Still Hawkins had no choice, and set sail for San Juan de Ulúa. On their approach, he ordered the flag of St. George to be hauled down three miles from port. The queen's colors on the *Jesus* and the

Minion were so faded and fouled by the weather that they seemed a blank canvas. When the Spaniards realized their mistake in letting the Englishman approach, they immediately banished the tattered English fleet to an island offshore in the harbor. Hawkins tried to be indignant, but as he soon learned, the flota was expected at any moment.

They hadn't long to wait. At first light on September 17, the lookout atop the *Jesus* called down that three sails were nine miles distant. It was the flota's advance guard. By the time the flota was nearing the harbor, its commander, General Francisco de Luxan, could see readily enough that the *Luterano* corsair was blocking the roadstead. What made matters worse was that de Luxan had on board the newly appointed viceroy, Don Martín Enríquez de Almansa. The viceroy ordered that the ships be halted where they were so that the remaining ten ships of the flota could catch up to them while he pondered their predicament. Meanwhile, he arranged for his young son, a gentleman-in-waiting, a horse, and some of his valuables to be taken ashore out of sight of the English rovers.[15]

The situation was potentially explosive and put Hawkins in a "great perplexity of mind." He was powerless to act as he usually did against such a force while his ship slowly sank. And yet his heart must have leapt—along with the hearts of his men—at the thought that the flota carried at least £2 million in riches in gold, silver, and precious gems. Equally well, Hawkins's fleet had its own treasure to protect, and he dared not risk the queen's wrath in such a weighty affair. But there was no time to mull things over. Like his queen, his first thought was of self-defense, and he ordered the Spanish soldiers on the island to sail back into port along with their African slaves. The last thing he wanted was for the "locals" to be at their backs while they faced off the flota. He then ordered the captain of the guard, Anthony Delgadillo, to advise the Spanish fleet of their honorable intentions, and that they simply needed around three weeks time to repair their ships before they could sail home. For once, Hawkins truly *had* been blown off course and was unable to maneuver. Delgadillo was sent like a dove from the ark to deliver the Englishman's ultimatum: let the English fleet stay for repairs, and the flota will be allowed into harbor.

When Enríquez learned from Delgadillo that it was Hawkins who occupied the port, he was incandescent with rage. How dare this rover order *him* around? Hadn't Delgadillo known that Hawkins had "committed serious ravages on these coasts and was . . . little better than a pirate and a corsair on whose word scant reliance could be placed?"[16]

Still, Delgadillo respectfully reminded the viceroy, the English fleet was bristling with heavy guns, demiculverins, and harquebuses, and each ship held the feared English archers in their rigging. There was no doubt that Hawkins had ordered his men to their battle stations. Enríquez agreed that it was an impressive array, and he decided to handle the matter as his king would have done. The flota needed to dock, load, and reach Spain before the weather deteriorated further.

When Delgadillo returned to Hawkins with the viceroy's query as to what he proposed to do to unblock the stalemate, the Englishman was stunned. It was the first he had heard that Philip's representative himself was on board the flota. He quickly clarified his terms:

The first was that we might have victuals for our money, and license to sell as much wares as might suffice to furnish our wants.

The second, that we might be suffered peaceably to repair our ships.

The third, that the island might be in our possession during the time of our abode there.

In which island, our General, for the better safety of him and his, had already planted and placed certain ordnance; which were eleven pieces of brass. Therefore he required that the same might so continue; and that no Spaniard should come to land in the said island, having or wearing any kind of weapon about him.

The fourth, and last, that for the better and more sure performance and maintenance of peace, and of all the conditions; there might 12 gentlemen of credit be delivered of either part, as hostages.[17]

Delgadillo carried on the shuttle diplomacy between the viceroy and the Englishman, and when Enríquez learned for certain about the sheer mass of arms the English carried, he knew that he had to agree

to the "pirate's terms," despite his fury. After some twenty-four hours of tinkering around the edges of Hawkins's ultimatum, ten hostages were exchanged, a buoy was set afloat to mark the line beyond which neither party should go on pain of death, and the English agreed to pay a fair market rate for any goods or provisions received.

Hawkins played it straight, selecting gentlemen adventurers for the hostage exchange. Christopher Bingham, John Corniel, George Fitzwilliams, Thomas Fowler, William de Orlando, Michael Soul, Richard Temple, and John Varney were chosen for the honor. They were brought out to the Spanish fleet by Delgadillo on Saturday, September 18, at the same time that Enríquez and de Luxan perpetrated their fraud. The Spanish hostages would be random seamen who had been told to draw lots, and then were dressed up "as their betters."

The viceroy, of course, had no intention of allowing a corsair who had ravaged the coasts of New Spain to dictate terms to him. And he certainly would not surrender ten of his gentlemen. But he needed to be in port to do something about the situation. It was only on the following Tuesday that the winds changed and allowed the flota into harbor. An audiencia was held on the Wednesday, and 10,000 *pesos de oro* ($1.19 million or £643,133 today) was handed over to raise an army to fight the *Luteranos*. Spanish horsemen rode up and down the coast, spreading the word to gather all able-bodied Spaniards, African slaves, and Indians to defeat the English upstart. Oblivious to the danger, Hawkins and his men busied themselves with their repairs.

When Hawkins awoke on Thursday, September 23, there was a whiff of treason in the air, as he later wrote, "The treason being at hand, some appearance showed, as shifting of weapons from ship to ship, planting and bending of ordnance from the ships to the island where our men warded [lived], passing to and fro of companies of men more than required for their necessary business, and many other ill-likelihood which caused us to have a vehement suspicion."[18]

Hawkins sent his henchman Barrett to find out what was going on, and went below decks to have breakfast. The Englishman looked out of his cabin window and saw that a Spanish hulk was closing in on the *Minion*, crossing the line of separation marked by the buoy.

He sprang to his feet and saw that the other ships of the fleet were moving as well, and before he could do a thing, warning was given to the flota to attack.

The chaos of a full-scale battle in port ensued. An estimated three hundred Spaniards tried to board the *Jesus*, while others leapt across from the *Jesus* to the *Minion*, and grappled with the English in hand-to-hand combat. An order was given to cut the *Minion*'s head cables so that she could float free from the quayside. The *Minion*'s gunners struck the Spanish vice flagship with her first shot. The next shots ripped through the flagship's broadside, shattering timbers just above the waterline. Seconds later, the ship exploded, taking twenty men with her to the bottom of the harbor. The Spanish vice admiral was in flames. It looked as though God would be Protestant that day.

But it was not to be. Two Spanish ships had grappled aboard the *Jesus* while quite a few of her crew desperately struggled to cut the admiral's cable from the capstan. After nearly an hour, both the *Jesus* and the *Minion* had slipped free of their moorings and turned to fight. Amid the cannon fire, chaos, din, and stench of war, the English inflicted more than sixty direct hits, pummeling the Spanish fleet.

But as reinforcements from the island poured in, the tide of battle turned. The *Angel* was sunk, the *Swallow* and *Grace of God* (the captive Portuguese caravel) were overrun, and the *Jesus* was listing dangerously. Under heavy shore fire, the crew of the *Jesus* transferred as much of its plunder and treasure to the *Minion* as possible. Hawkins hastily ordered in Drake in the *Judith* to take on some of his men, slaves, and other goods. The order was then shouted to abandon ship. The Spanish fire ships were already in the English fleet's midst, separating the *Minion* and the *Judith* from the *Jesus*. Hawkins was the last to climb aboard the *Minion*, only to turn and see the *Jesus* finally sink with much of her treasure still aboard.

To make matters worse, when the fog of battle cleared and the *Minion* had gone beyond the reach of the Spaniards, Hawkins noticed for the first time that the *Judith* had vanished. But that was the least of Hawkins's problems.

England was well on the road to war with Spain.

⊰c **Part Two** *ↄ⊱*

Harvesting the Sea

November 1568–May 1585

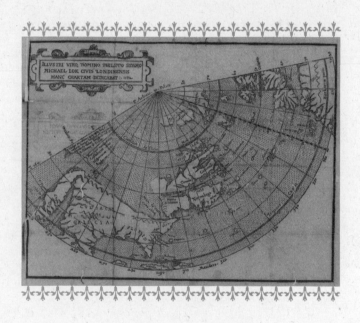

12. The Queen and Alba's Pay Ships ❧

Her Majesty commands all and every, her justices and
officials within her towns, cities, ports, and other places
under her government, to take steps to detain and arrest
with all their goods, chattels, and ships, all subjects born
in the dominions of the King of Spain, in order that they
may be held as security and pledges for the damages and loss
received, without just or apparent cause, by the subjects of
Her Majesty, and for other reasons which may appear. . . .
—ELIZABETH R, ROYAL PROCLAMATION OF JANUARY 1569

Before San Juan de Ulúa, while Hawkins was languishing in the Caribbean waters around Borburata, his world back home had changed dramatically. In May 1568, Mary, Queen of Scots, and her fellow fugitives from Scottish justice stole across the border into England at Solway Firth, fleeing the wrath of their lords of the covenant. With the murder of Shane O'Neill in Ireland a year earlier in June 1567, after nearly two years of a marauding war against the English—and nearly a decade of Shane's deeply humiliating treatment of Elizabeth's government there—the importation of Scottish mercenaries to Ireland had ceased temporarily with Shane's death. In fact, it seemed to many that the Catholic Scottish threat to both England and Ireland—for the time being—was at a standstill.[1] Elizabeth entered her tenth year as England's queen with secure borders at both her "postern" gates, even if the situation with the Low Countries and Spain looked set to explode.

William of Orange and his brother, Louis of Nassau, were both in exile from the States at the head of ineffective mercenary armies, while their maritime supporters—the Sea Beggars—were plundering Spanish shipping at sea. France's Huguenot insurgents held La Rochelle as their base, with the dual result of keeping

Henry III busy in a semiperpetual state of civil war and preventing the French king from becoming interested in foreign affairs. The Huguenots also helped promote English trade inadvertently when, under the pretence of violence against the English wine fleet at Bordeaux, Sir William Winter accompanied the fleet for security— and also ran secret weaponry and victuals ashore to keep supplying France's rebels.[2]

Even Elizabeth's captain of state, William Cecil, saw the benefit of exploiting these improved conditions for England abroad. As long as they lasted, England—and her queen—could breathe easier, and perhaps reflect on the new order, in relative security. While Mary's sudden exile in England was a very tricky matter to handle for myriad reasons, Cecil's calm statecraft in conjunction with Elizabeth's keen desire to see Scotland's rightful monarch restored to the throne saw this as an opportunity to mediate between the Scottish queen and her Protestant lords. So long as Mary—who still had the best claim as heir to the English throne—remained a pawn in Elizabeth's power to play as she willed, the English queen and her councillors held an unexpected trump card against the Catholic League that threatened from Spain and, especially, Rome.

Pope Pius V—as his predecessors Paul IV and Pius IV—had been itching to excommunicate the Queen of England from the fold. To date, it was only Philip's intervention that had stopped the popes from acting in haste. As odd as it may seem, it quite suited Philip in a Machiavellian way to have Mary trussed up in a castle in England. The very last thing that he truly wanted was for her to seize the English throne, which he felt he had almost as good a claim to.[3] Philip knew that there was little doubt that the Scottish queen remained a pawn of her powerful French Guise uncles, and would keep him from recovering his "lost" kingdom, England.

While Elizabeth had become more than a mild irritant, the Spanish king still held out hope that she would marry his cousin, the Austrian Archduke Charles, or another Catholic prince, and at least become subject to her husband's will. That Elizabeth had successfully navigated these waters without finding herself ensnared in a marriage to any prince—Catholic or otherwise—was becoming a serious worry to the Spanish king, and indeed to Elizabeth's parliaments and Privy Council.

Philip's consternation was compounded by the fact that Spanish intelligence had been found woefully lacking. The Spanish ambassador de Silva had claimed that he had the situation under control, that he "understood" Hawkins, and that he had the power to stop the next planned West Indian incursion. De Silva also claimed that he, as spymaster, was "controlling" the renegade Thomas Stucley, who was again throwing his weight around in Ireland by the middle of 1568, unsettling the fragile peace. When the Butlers and the Desmonds renewed their territorial disputes in an open war, Stucley bamboozled de Silva into believing that he could deliver Ireland with just a few thousand men and horse into Spain's eager hands.

All the Spanish ambassador's assertions that he had the situations "under control" couldn't have been further from the truth. So when it was discovered that Hawkins and his fleet had undertaken yet another slaving voyage, Philip glowered with rage at Guzmán de Silva's gullibility and Hawkins's cunning deceits. Something had to be done to improve Spain's intelligence. Since the ambassador had been pleading poverty and wished to return home, the easy solution was at hand. While Hawkins was heading toward the Florida Channel, Philip decided to remove de Silva to a "safer" haven, appointing him ambassador to the signory in Venice.

De Silva's replacement, Guerau de Spes, proved another kettle of fish altogether. Described by his contemporaries as a "fire-eating Catalan soldier," he lacked the finer points of diplomacy so necessary in a good ambassador. Interestingly, Elizabeth's own ambassador to Spain was hardly any better. Dr. John Man had been booted out of Madrid around the same time for calling the pope "a canting little monk" at a dinner party.[4]

But it was the daily bad news from the Channel and the States that continued to preoccupy Philip most. The previous year he had loosed the finest commander of any army in Europe on the Flemings— Don Fernando Álvarez de Toledo, Duke of Alba. Alba had been appointed as general governor of the Low Countries in retaliation to the Flemings' rebellion, called the Iconoclastic Fury. Back in the spring of 1566, the Netherlanders had rioted and destroyed more than four hundred churches and desecrated countless smaller shrines. More than two hundred thousand men had taken up arms against Spain, and when news reached Philip, he shook his head wearily,

reportedly saying, "in truth, I cannot understand how such a great evil could have arisen and spread in such a short time."[5] Even when he abolished the Inquisition, the riots continued, and so he rescinded his previous order. Naturally, the Flemings were having none of it.

Alba left Spain in April 1567 and gathered a force of ten thousand crack *tercio* Spanish troops as he marched toward the Low Countries. They crossed the Alps in June and entered Brussels without a fight on August 22, 1567. Today, it is difficult to imagine that this "bloodless" military action was a turning point in northern European history. For the next eighty years, Spain would try to keep trade and communications open to the Spanish Netherlands; whereas the Netherlanders and Spain's enemies would try by any means possible to keep Spain out. The result of the conflict (known as the "Eighty Years' War") would be the United Provinces of the Netherlands and the birth of the Dutch Empire.

In the spring, the Venetian ambassador in Spain wrote to the signory that the Queen of England had written

> to complain of the proclamation published at Antwerp, whereby all English merchants were compelled either to live according to [the] Catholic religion or to abandon commercial pursuits and the country . . . but the King would neither receive the Ambassador nor the letters, and indeed has given the ambassador to understand that if he wishes to remain here, he also must live like a good Christian. . . . I do not know whether his Majesty has lately had any cause for taking this action against the Queen, or whether the result proceeds from his excellent nature . . . the King has told him [the Nuncio] with great distinctness that he may assure the Pope that all the subjects of his Majesty's states must either believe what his Majesty believes, or be utterly destroyed and ruined . . . [6]

By the autumn of 1568, Alba's troops had swollen to over fifty thousand mercenaries. They had been gathered from Italy, Switzerland, Germany, and Spain, and represented a formidable fighting force. It was against these professionals, led by the ruthless Alba, that Elizabeth's merchant and gentlemen adventurers would pitch their lives, fortunes, and wits.[7]

The immediate effect of Alba's arrival was the implementation

of the worst excesses of Philip's religious schemes, including a quasi-Inquisition, known by the Spanish as the Council of Troubles. The Flemings called it the "Council of Blood." He pledged to Philip that he would "create a New World" in the troublesome provinces, and there is little doubt that he did, though not in the sense that he had intended.[8] For the Queen of England, and especially Cecil, Alba's arrival shattered the rosier picture from the beginning of the year. A highly disciplined Spanish army was now within a hundred miles of London across a short stretch of the Narrow Seas. De Spes, informed by exiled English Catholics and tutored against the English queen by the Count of Feria, looked increasingly like a fifth column rather than an open avenue for diplomatic discourse. Even William of Orange's resistance was crumbling before Alba's onslaught.

Then, in late November, God became Protestant again. The Channel weather had been appalling, delaying William Winter and the wine fleet at London. On the southern coast, Huguenot rovers had chased four small Spanish ships into port at Falmouth, Plymouth, and Southampton. The customs officers were advised that the ships carried treasure for the Duke of Alba—it was the gold to pay his troops. According to de Spes:

> *Up to the present two cutters and one other vessel have arrived safely in Antwerp, and for the rest of them, Benedict Spinola asked me to intercede. At the same time that I received news of them I requested audience of the Queen, which was granted on the 29th, and the Queen consented to give me a passport for the money to be brought overland, or to lend one of her own ships to convoy the vessels in safety, of which I gave notice to the duke of Alba, from whom I have received no answer. . . . I warned the captains of the vessels not to move, and had letters from the Queen sent to the officials of the ports, ordering them to defend the ships, which was highly necessary as, although in the cases where the ships could get shelter near to the towns, they have done so, the pirates have attacked them, and some of our men have been killed defending their vessels, with a greater loss still on the part of the corsairs. . . . Many people have advised the Queen to seize the money, and the vice admiral has written to this effect from Plymouth. I am in hourly expectation of the Duke's order. . . .[9]*

The Council naturally agreed to the safe conduct overland to Dover, while the queen herself offered a naval squadron to escort the Spanish ships by sea. De Spes dared not decide without Alba, and still awaited word. It is significant that this letter to the king was sent through their usual channels, in Spanish, and certainly not in code. Of course, it was intercepted. Cecil naturally wanted to speak to Benedict Spinola, the great Italian merchant banker residing in London, but he had to tread carefully. Yet little did Cecil know, Spinola had news for Cecil, too.

The merchant had heard through his reliable correspondents in Spain that some great evil had befallen the Hawkins expedition in the West Indies, and that they had all been massacred. Since Spinola had been an investor in the second Hawkins voyage as well as the last one, *and* he was the source of the treasure aboard Alba's pay ships, he had spread the alarm quickly to Sir William Winter, who was guarding Spinola's wine fleet bound for La Rochelle. The last thing Spinola wanted was further losses. When the terrible news reached Winter, he immediately put into Plymouth to protect the treasure ships until some sense could be made of the combined disasters. While he was there, he felt compelled to tell John Hawkins's elder brother, William, the bad news. The date was December 3, the day after the queen had signed the safe conduct for the treasure.

The elder Hawkins lost no time in writing off to Cecil, conveying the dreadful intelligence. He pleaded that Spinola be questioned about the truth of the matter. While de Spes wrangled with the governor of the Isle of Wight (Edward Horsey, a notable rover in his own right) to get the Spanish treasure away from him under the safe conduct dated December 2, Hawkins and Sir Arthur Champernowne, vice admiral of Devon, were battening down the hatches in the West Country. If John Hawkins and his men had been slaughtered, the King of Spain's treasure would make some small recompense under a "letter of patent."

Meanwhile, in London, Spinola and Cecil met at last. Both had reasons for a friendly and frank discussion. The Italian merchant banker told Elizabeth's leading councillor that the treasure had been a loan to the Spanish king, and even told him the terms at 10 percent payable in Antwerp. The queen was consulted forthwith, and it was agreed with Spinola that a loan to the Queen of England was just as

advantageous for the Italian, and far less risky, in the circumstances, than a loan to Philip of Spain. Once their transaction was agreed, and sealed, the treasure was brought from its various points on the south coast to the Tower, and locked up securely. When counted, it amounted to a staggering £85,000 ($30.34 million or £16.4 million today).

De Spes was beside himself, sending a panicked missive to Alba on December 21:

> *As Benedict Spinola had put his own money in safety, he has been slack in the dispatch of these other ships, although he was authorised to spend a thousand pounds sterling in the transit. He thought this was inadequate, and sent for authority to spend a larger amount; which authority, he said, he expected hourly, although I believe it has been nothing but a subterfuge. I am now sending to give an account of the matter to the Queen and shall ask for audience in conformity with her reply. . . . It is not for me to advise you but to follow your orders, but I do not like this way of beginning here, and it is my opinion that all English ships and merchandise should be at once seized in the States, and particularly in Antwerp, news of it being also sent swiftly to Spain as there are valuable English ships at Bilbao and Laredo.[10]*

This was followed shortly after by another letter penned by de Spes—also not in code and also panic-stricken—and was received days later at Alba's headquarters:

> *The Queen has taken possession of the boxes of money brought by Lope de la Sierra's ship and 64 boxes from the cutters in Plymouth. She is going to do the same with the other two cutters in Falmouth, notwithstanding her promise and letters, besides the passport she gave. The duke of Alba has ordered all English ships and property to be seized, and informs me thereof in his letter of the 29th ultimo, which was brought by a special courier, who, however, was careless, as with him came four others dispatched by the English. . . . They also tried to raise the mob against foreigners, but the aldermen and constables acted well and took possession of the streets, so that the matter has ended in the seizure of property of Flemish and other*

subjects of your Majesty. All the Spaniards came to my house at
night, where most of them still remain. The ports are closed and
orders have been issued that no post-horses are to be given to anyone.
Cecil was here during the disturbances and returned next day to
Hampton Court, where councils are still being held, but nothing
yet has been said to me. . . . These heretic knaves of the Council are
going headlong to perdition, incited by Cecil, who is indescribably
crazy in his zeal for heresy. . . .

The sloops that these pirates have taken are four, with a Spanish
ship, all very valuable. They (the English Government) have also
seized the property of Portuguese. I send this enclosed in a letter from
the French ambassador, with a letter for the Duke and another for
Don Francés de Alava. . . . They [the Council] are in consultation
every day, and I know not how it will end. . . . [11]

Alba, the great soldier if not the great governor, followed de Spes's
ill-conceived advice, though not entirely without reflection. His
soldiers hadn't been paid in months, and Alba sensed mutiny in the
air. If his men knew why there was further delay, it might stem the
tide a while longer. And so, on December 19, 1568—the same day
that de Spes officially demanded restitution of the treasure from the
queen—Alba ordered all English property in the Low Countries
sequestered. This flew in the face of all existing treaties with Spain,
where it was clearly stated that no reprisals could be enforced without
a distinct refusal or unreasonable delay in returning seized goods.[12]

Elizabeth and Cecil—for once—couldn't have been more
delighted. Alba and de Spes had made a serious tactical error that
would cost Philip dearly. In retaliation, the queen decreed,

Any merchants born or living under the allegiance of the King
of Spain who may be found in towns, ports or other places under
suspicion of hiding or disguise, or in any manner of fraud in order
to prevent the detention of themselves and their goods, shall be
called to account by the officers of justice of such places with the
help of all justices of the peace, who shall inquire and examine
the said merchants by all legitimate methods and cast them into
prison, no matter to what nation they belong, including all those

who may abet or help to hide those who practice such fraud . . .
and especially those who may have concealed such persons or their
property.

 Her Majesty having also learnt from trustworthy sources that it
was the intention to detain her subjects beyond the sea, under the
pretext that the Queen had detained in one of her ports a certain
ship and three or four small boats in which were certain sums of
money, Her Majesty thinks fit to declare briefly the facts of the
case, by which it will be seen that the detention of her subjects was
unjust and without due cause.[13]

With de Spes now under house arrest, Alba recognized that he would
have to make the first move to defuse the situation. In early January
1569 he sent an emissary, Dr. Christophe d'Assonleville, who was a
member of the Flemish Council of State, to mediate. Elizabeth had
him arrested, too, since he had arrived without proper credentials
from his king.

 The country was in an uproar against the Spanish knaves. There
was a rising murmur of war or retaliation on everyone's lips in
the streets. The merchants—sickened by the unending stream of
disruptions to trade—longed for new markets, passages to Cathay,
and a world without a dominant Spain.

 A few days after the public erupted with indignation, on January
20, toward evening, the small weather-beaten 50-ton *Judith* limped
into Plymouth harbor, alone. Francis Drake, overloaded with men
from the *Jesus*, without an ample store of water or victuals, and with
no order given for a rendezvous by Hawkins before he had been
separated by a northerly gale from the *Minion*, had resolved to try to
bring his ship and his men home safely.

13. The Cost of Failure ❧

If all the miseries and troublesome affairs of this sorrowful
voyage should be perfectly and thoroughly written, there
should need a painful man with his pen, and as great a time
as he had that wrote the lives and deaths of the Martyrs.

—JOHN HAWKINS, COMPARING HIS VOYAGE TO FOXE'S ACCOUNT OF
PROTESTANT MARTYRS UNDER MARY I, MAY 1569

Five days later, the *Minion* careened into harbor at Mounts Bay
in Cornwall. John Hawkins and a fraction of the crew had
survived the nail-biting Atlantic crossing. Once out of danger from
the Spanish fleet, it was a despondent Hawkins who headed for
England. With the ship leaking badly and so dangerously overloaded,
there was no way any of them could live to tell their tale, he believed,
let alone return home. The English admiral had no choice but to
take drastic action. More than a hundred men were set ashore in the
Gulf of Mexico, never to be seen again. He then tried to head north,
but sailed straight into the jaws of a tropical storm in the Bahamas
Channel. As he plodded northward, Hawkins watched helplessly
as his starving men grew sick and died, one by one. Nearly every
rodent, dog, cat, parrot, or monkey aboard ship had long ago been
eaten, and while they were still thousands of miles from home, their
only sustenance was their leather fittings and abundant salt water.[1]
By the time they reached the coast of Galicia in Spain, they were
desperate men. Hawkins, dressed in his finest scarlet cloak and
doublet, edged with silver and wearing a great gold chain, told the
port officials that if they didn't allow him to buy food and wine,
he would simply take what they needed without paying. Provisions
were, of course, handed over at once, but not without a further
cost. The starving mariners were unable to control themselves,
and gorged themselves on the fresh food. The result was a spate of

further deaths from gluttony. To cover up, Hawkins ordered their emaciated bodies thrown overboard in the dead of night with stones tied to their feet.[2]

When, at long last, they reached port in Mount's Bay in England, word spread like a brushfire that the admiral and some more of his men had returned. In fact, there were only twelve mariners accompanying Hawkins, out of an original complement of four hundred men. William Hawkins, relieved, and fighting fit, quickly wrote off to Cecil demanding the queen issue "letters of reprisal" against the Spanish. Armed with his brother's letter, John Hawkins set off for London. The residue of his entire takings from the West Indies was loaded onto a mere four packhorses for the journey.

But the queen and her councillors refused to be dragged into Hawkins's personal vendetta against Spain. Indeed, though Francis Drake, too, pleaded for "justice," the government was more deeply concerned—and rightly, too—with primary matters of state, which included, among other matters, granting asylum to a huge influx of Protestant refugees from the Netherlands; declaring of a "safe haven" for William of Orange's Sea Beggars at Dover and other southern ports; trying to restore Mary Queen of Scots with some constraints onto Scotland's throne; reconciling the French king to his Huguenot insurgents; negotiating with Alba over the standoff on Spanish and English seizures; fighting the "universal" rebellion in Ireland and the Northern Rising of the Catholic lords Northumberland and Westmoreland in England. Hawkins's timing was, to say the least, poor.

Nonetheless, he persevered. He knew better than anyone else that, with each passing day, the hundreds of Englishmen captured or abandoned in the West Indies were being put to the most brutal torture that the Inquisition had to offer. By March 1569, he and many of the other survivors—save Francis Drake—made their declaration before the High Court of the Admiralty, outlining what had happened.

Drake's reunion with Hawkins had taken place a month earlier, and though no specific record of that encounter survives, it could not have been an easy one. Drake had no formal education, no social standing, no social graces, no previous oceangoing experience as a

captain, and no money. But he had proved to both Hawkins and himself that he was one hell of a captain and navigator. Besides, Drake's obvious "excuse" for heading home was a lack of clear orders from Hawkins to rendezvous somewhere. Drake's first duty at that point had been to save as many men and goods as he possibly could. Still, it is intriguing to wonder why Drake never used this argument publicly in his defense. Hawkins, in the end, tempered his criticism of the clearly superior navigator and new captain by reporting only that "the *Judith* . . . forsook us in our great misery."[3]

By the time the High Court of the Admiralty met in March and April, Hawkins had compiled a detailed claim against the Spaniards for the treachery at San Juan de Ulúa, in the hope of negotiating for a letter of reprisal, and for the release of his men from Spanish captivity. His monetary claim was listed as:

1. First, the specified ship, called the *Jesus of Lubeck* With its equipment and accoutrements as sent out from England **£5,000**

2. Item instruments of war, or guns of bronze and iron, which were part of the accoutrements, equipment, and munitions installed in the same ship called the *Jesus* and sent out from England **£2,000**

3. Item gun powder, iron balls, arms and other instruments or guns installed in the same ship and dispatched from England **£2,000**

4. Item two anchors and three anchor lines, called cables, from the equipment of the ship called the *Minion*, which were lost when the said ship escaped from forcible seizure by Spaniards **£200**

5. Item the specified ship called the *Swallow* with its equipment, accoutrements, and munitions sent out from England, and the victuals and seamen's goods carried in it **£850**

6. Item the specified ship called the *Angel*, with its equipment, accoutrements, and munitions sent out from England, as well as the victuals and seamen's goods carried in it **£180**

7. Item the specified ship called the *Grace of God*, with its equipment, apparatus, and munitions, as well as the victuals and seamen's goods placed in it **£400**

8. Item in the specified ship called the *Jesus*, and the three other ships, or some of them, 57 black Ethiopians, commonly called Negroes, of the best sort and stature each of whom is worth gold pesos in the region of the West Indies **£9,120**

9. Item in the said ship called the *Jesus* and the other three ships, or some of them, 30 bales of linen cloth, each worth 3,000 reals **£2,250**

10. Item in the said four ships, or some of them, 1,000 pieces of dyed cloth, each of which is worth 15 shillings sterling **£750**

11. Item in the said four ships, or some of them, 400 pounds of that kind of merchandise commonly called margaritas [trinkets], each pound of which is worth 5 shillings sterling **£100**

12. Item, in the said four ships, or some of them, 300 pounds of pewter, each pound of which is worth 2 shillings sterling **£30**

13. Item, a bale of cambric commonly called taffeta, containing 40 *varas* [ells] **£40**

14. Item four bales of woolen cloth called hampshires and northerns, each of which is worth £8 sterling **£340**

15. Item six bales of cottons **£90**

16. Item a chest containing 30 swords decorated in gold **£120**

17. Item 12 quintals of wax **£120**

18. Item seven tons of manillios, commonly 7 tons of arm and wrist bands [manacles] each of which is worth £50 **£350**

19. Item in the said ship called the *Jesus* a little sack of gold and silver containing 600 pesos of gold and silver **£2,400**

20. Item in the said ship a chest containing various pieces of silver work, commonly called silver plate **£200**

21. Item in the said ship silver called currency **£500**

22. Item in the said four ships, or some of them, twenty jars of Cretan and Spanish wine, commonly 20 butts of malmseys [sweet wines] and secs [dry wines] **£300**

23. Item, in the said four ships or some of them 36 containers of flour, commonly 36 barrels meal, each of which is worth £4 **£144**

24. Item in the said four ships or some of them, other victuals and necessaries to the value of **£150**

25. Item in the said ship called the *Jesus* clothing belonging to the said John Hawkins and other things brought for his personal use **£300**

26. Item in the said ship called the *Jesus* chests and trunks of seamen's belongings **£900**

27. Item in the said ship called the *Jesus* a bale of 20 mantles, commonly called a pack of 20 cloaks, each of which is worth £4, **£80**[4]

The accounting made for a claim of £28,914 ($10.27 million or £5.55 million today). The glaring losses relate to the prime motivation of the voyage, with £9,120 being the loss of the value of 57 "Ethiopians," £320 for their seven tons of manacles, and probably the sterling receipts of £2,400 (600 *pesos de oro*) representing the value of slaves already sold.[5] When the value of the armaments and munitions are added—the very tools required for "harvesting" the Africans—a total of £21,900, or 76 percent, relates directly to so-called losses sustained relating specifically to the slave trade.

Yet this "reckoning" omits the losses of human life. The Africans themselves were doomed either to a curtailed life in misery or an agonizing death from the moment of their capture. Their deaths were never counted. The English sustained losses of 130 dead in the San Juan de Ulúa attack, with a further fifty-two taken prisoner. Hawkins abandoned around 100 more in the Gulf of Mexico, and a further forty-five or so were lost to starvation, disease, or their gluttonous meal on arrival in Galicia.

But still, the High Court of the Admiralty refused to issue a letter of reprisal late in the summer of 1569. According to the French ambassador residing in London at the time, La Mothe Fénélon, "the affairs of the Queen of England are in a condition of peace which appears to be bordering upon war, because the great majority of the English expect to have war. . . . "[6]

The government had bigger fish to fry than the granting of an inflated letter of reprisal to Hawkins. The Northern Rising of two of the country's most prominent Catholic dukes had been quashed— but not without implicating trusted Catholic councillors like the Earl of Pembroke. And to top it all, Spanish forces were gathering a head of steam in the Netherlands. Trade had been suspended between England and Spain, the Netherlands, and Ireland. To make matters worse, Cecil had uncovered a Privy Council–led faction—headed by Leicester—to have Mary Queen of Scots marry the Duke of Norfolk, the queen's cousin.

So when La Mothe Fénélon reported that " . . . money is being raised in every possible way; all the merchandise of Spain is to be sold; new angels are being coined in the Tower in order to pay foreigners, and cash payments to private individuals are being stopped, so that no money is in circulation . . . in truth . . . the queen receives hardly any revenue."[7]

What had started as a promising year had become an *annus horribilis* for the queen. And the only way out, as far as she was concerned, was to wage peace as if it were war.

For that, she needed the services of men like Francis Drake.

14. Undeclared Holy War ❧

I am so keen to achieve the consummation of this enterprise,
I am so attached to it in my heart, and I am so convinced
that God our Saviour must embrace it as His own cause,
that I cannot be dissuaded. Nor can I accept or believe the
contrary.
—PHILIP II TO THE DUKE OF ALBA, SEPTEMBER 14, 1571,
ON THE INVASION OF ENGLAND

It was obvious to the Privy Council and the queen that Hawkins
had not only exaggerated his losses, but also that he had intended
to shout his dubious tactics in the West Indies from the rooftops,
in an attempt to embarrass the government into action. Hawkins
had resolved to make a clear record of the Spanish "treachery,"
oblivious to the fact that he was hurting his own case for a letter of
reprisal. While Hawkins was preparing his "True declaration of the
troublesome voyage of M. John Hawkins to the parties of Guinea
and the West Indies, in the Years of our Lord 1567 and 1568" in May
1569, Francis Drake had simply vanished. Reprisal was on everyone's
lips, and Hawkins's pamphlet outlining in graphic terms the wrongs
done to the English was whipping up the general population onto a
war footing.

Meanwhile, back in the West Indies, Spain's new viceroy to
Mexico, Don Martín Enríquez de Almansa, gave the order to
fortify all ports and towns. He sent word to Philip, detailing quite a
different picture to the one painted by the aggrieved Hawkins. He,
and virtually all of Philip's governors in the West Indies, had become
strong proponents for a fleet of galleons to patrol their waters to stop
the interlopers before they could come ashore.

Yet while these belated preparations were under way, the Spanish
had precious little to fear from the English in 1569. It was the Sea

Beggars and the Huguenots in the Narrow Seas, as well as the Huguenots in the West Indies, who had become active. Instead, England was marshaling its naval resources to protect trade to France (again in a state of civil war) and Germany, bringing troops to and from Ireland, and carrying men and weapons to the north. Still, the rumor machine persisted. "They tell me too," La Mothe Fénélon wrote after citing the movements of the queen's navy, "that Hawkins is pushing forward the armament of seven other good men-of-war, but they want to make me believe that they are for a new voyage he is undertaking to the Indies."[1]

The truth of the matter was that the entire navy—both royal and merchant vessels—was on alert against a potential invasion that had been urged by de Spes, the King of Spain, and lately the pope. In the dark days of the autumn of 1569, Elizabeth knew that the time for prevarication was over. A general muster had been called, and every available man was pressed into service. Ever the wily stateswoman, she also drew upon the services of the fugitive Sea Beggars to help protect England's shores. Their action was particularly appealing to England's parsimonious queen: they defended England, and she bore no expense.

While Hawkins and his personal squadrons were reported in dispatches many times for their activities safeguarding the realm, the only sure sighting we have of Drake in the year was his marriage at St. Budeaux's Church on July 4 to Mary Newman, daughter of seaman Harry Newman, "a great Lutheran who spoke much against the Roman Church and argued for Protestant doctrines" and who had served aboard the *Jesus* in Hawkins's last slaving voyage.[2] Nonetheless, Drake himself claimed to have made a reconnaissance mission back to the West Indies for a future mission with the *Swan*, and he reported that he continued to serve in the queen's navy to his "great advantage."[3] With the Elizabethan penchant for talking in riddles, there may well have been some truth in his boast.

While the queen and her men were protecting the realm from its foes, the Duke of Alba made a pivotal decision. He had no desire to replace Elizabeth with Mary, and he couldn't understand Philip's inclination to replace good military strategy with royal will or religious fervor. Rather than invade England, where Alba ran

the double risk of losing his grip in the Netherlands and possibly not succeeding with an invasion force, he resolved to blockade the recalcitrant island nation instead. The wine fleet bound for La Rochelle had been hopelessly delayed at London, and the wool fleet was desperate to sail to Germany. La Mothe Fénélon hit the nail on the head when he claimed that there was a shortage of cash. Without fresh sales of merchandise and healthy international trade, the country's economy would collapse.

So it is entirely likely, that a fabulous navigator and daring captain like Drake would have been among the volunteers in the squadron to protect England's number-one export—wool. It is also likely that Drake, aboard whatever ship he captained, would have been double counted among the forty or so ships roving in the Channel and the Narrow Seas, snapping up the Spanish and Portuguese shipping foolhardy enough to come within his sights.[4]

The ferocious defense of England's shores came as no surprise to Alba, who, alone among Philip's governors and generals, understood and admired the fearlessness of the English. Five months after the Catholic-inspired Northern Rising failed, Pope Pius V at last took measures that had been mooted on the queen's accession—he published the *Regnans in excelsis*, excommunicating England's heretic queen on February 25, 1570. The papal bull radiated from Rome like wildfire and was published throughout Europe. Alba ensured that it was published in the Netherlands in March, especially in the ports for all who dealt with England to see. The main clause that so shocked the queen and her Privy Councillors stated,

We declare the said Elizabeth heretic and fautress [patroness] of heretics, and her adherents, to have fallen under sentence of anathema, and to be cut off from the unity of the Body of Christ, and her, Elizabeth, to be deprived of her pretended right to the said realm and of all and every dominion, dignity and privilege; and also the nobles, subjects and peoples of the said realm, and all else who in any manner have made oath to her, to be for ever absolved from such oath, and all duty of liege-fealty and obedience, as by the authority of these presents We absolve them, and deprive the said Elizabeth of her pretended right to the realm and of all else aforesaid,

*and lay upon all and singular nobles, subjects and peoples, and
others aforesaid, our injunction and interdict, that they resume not
to yield obedience to her, or her admonitions, mandates and laws;
otherwise We involve them in the like sentence of anathema.[5]*

The effect that the papal bull had on the English—both loyal
Protestants and Catholics—was the decided awareness that the
powers of Rome had declared war on England. For Drake, it
was the declaration of war that he had long awaited. Since Good
Queen Bess had come to the throne, the Spanish and Portuguese
had regarded the English as Lutheran smugglers, interlopers, and
pirates—even if their sole intention had been to engage in legitimate
trade. Elizabeth—now faced with war at home, in the Netherlands,
in France, and in Ireland—had been branded as a common criminal
by the pope, with the hefty price of papal sanction to rebel put on the
queen's head.

It was nothing less than religious imperialism from Pius V. He
hadn't even consulted Philip of Spain, or the man whom he expected
to carry his Catholic arms into war with England, the Duke of Alba.
In fact, by the time the dastardly deed had been pinned to the door
of the Archbishop of Canterbury's residence in London, Lambeth
Palace, that spring, it had become an open invitation for anyone with
a plan to assassinate the English queen.

Certainly, Drake, and in particular all of his fellow West
Countrymen, were having none of it. The age of hostile commerce
under Hawkins was over. The age of Drake's war had dawned.

15. Drake's War ✦

*As there is a general vengeance which secretly pursues
the doers of wrong and suffers them not to prosper . . . so
is there a particular indignation engraffed [inset] in the
bosom of all that are wronged, which ceases not seeking, by
all means possible, to redress or remedy the wrong received.*
—SIR FRANCIS DRAKE, QUOTED FROM *Sir Francis Drake Revived*

There is an old military adage, "Time spent in reconnaissance
is seldom time wasted." Drake claimed long after the event
that he had spent part of 1570 in the Caribbean on reconnaissance,
and while there is scant surviving evidence to support his claim,
there is no particular reason to disbelieve him. It was a relatively
quiet year in the West Indies, and since the Spanish interchanged
the term *Luterano* freely for either Huguenots or Englishmen, it
is impossible to know for sure whether Drake featured among
the five or so corsair-related incidents on the Spanish Main in that
year. In many ways, the Spaniards were right to mix up the two
peoples. Despite their very different backgrounds, languages, and
countries, English gunners and crossbow archers had long served
aboard Huguenot rovers.[1] What is noteworthy is that until the
arrival of Drake, no Englishman had ever entered the Spanish
colonies of the Main or West Indies intent solely on revenge and
plunder.[2]

But even a reconnaissance mission is not without its rewards.
According to a contemporaneous account entitled *A Summary
Relation of the Harms and Robberies Done by Fr. Drake an Englishman,
with the Assistance and Help of Other Englishmen*:

*In the year 1570, he went to the Indies in a bark of 40 tons, with
whom there went an English merchant of Exeter called Richard*

*Dennys and others, and upon the coast of Nombre de Díos they
did rob divers barks in the river Chagres that were transporting
merchandise of 40,000 ducats [$3.52 million or £1.9 million today]
of velvets, and taffetas, beside other merchandise, besides gold and
silver in other barks, and with the same came to Plymouth where it
was divided amongst his partners.*[5]

It is generally assumed that the amount stolen was exaggerated. Yet,
this account brings us tantalizingly close to Drake, almost as if we
are reading about his daring escapades in a dispassionate newspaper
article. Here we see a glimpse of Drake, not as yet in full possession
of the cunning that would make him "world famous." Though he
was greatly admired by his friends—and even his enemies—he was
nonetheless little more than a pirate hell-bent on revenge.

And no man was better suited to the task. Drake had an uncanny
genius for sensing his enemy's weakness and, without the need for
huge numbers of men and artillery, was able to achieve his nefarious
aims. What's more amazing, as with any real genius, he made it all
look so easy. San Juan de Ulúa had been etched into his soul and the
resultant hatred for Philip, the ignominy of the encounter, and the
fire against Catholic injustice in his belly would be stoked by further
perceived wrongs until the day he died.

Still, Drake hardly needed excuses or popish threats against
England to fulfill his personal quest. The flota had been within his
grasp at San Juan de Ulúa, but in following a defensive rather than
offensive course—due only in part to circumstances—the English
fleet had been well and truly trounced. That flota had belonged to
Philip of Spain. Ergo, Philip had humiliated him and his fellow
mariners. What's more, Philip had made, in Drake's eyes, a call to
arms through the pope against his queen, Elizabeth, by virtue of the
excommunication bull. So Drake went to war to protect her, enrich
himself, and spread the glory for the realm of England.

While Hawkins, Winter, and Drake's fellow West Countrymen
under Devon's Vice Admiral Sir Arthur Champernowne scoured
the Narrow Seas in the company of Orange's Sea Beggars, preying
on Spanish shipping, Drake headed back to Spanish America. He
had seen at firsthand the fabulous wealth there, and his mouth

watered at the prospect of Spain's vulnerability. Yet the clear answer to one simple question seemed to elude him. How had the Spanish succeeded in bringing the wealth of its empire back to Seville for over fifty years virtually unscathed?

The reply was obvious. No one had dared to attack the treasure trains or *trajín*. Where San Juan de Ulúa provided a safe haven for the Mexican flota, the treasures of the Spanish Main were brought to Nombre de Díos for transshipment to Seville in a series of complex maneuvers. To reach Nombre de Díos, the gold, silver, pearls, and precious gemstones from Peru, Chile, and Bolivia (all called "Peru" at the time) were first brought to the Pacific by mule train, loaded onto frigates, and shipped northward to Panama City.

From there, another mule train of up to six hundred animals threaded its way through the dense jungle to the isolated settlement of Venta Cruces. In this humid, remote outpost—no more than a wharf and a warehouse rather than a settlement or colony—the bulk of the treasure train was loaded onto shallow draft barks and brought down the Chagres River to Nombre de Díos. The Spanish bullion continued overland from Venta Cruces by mule train to Nombre de Díos. Once there, all the king's riches would be locked up securely in his treasure house, where it awaited the arrival of the flota, which would carry it back to Spain. Without this shipment of gold and silver each and every year, Philip's credibility with his European bankers would evaporate, and so would his funds to keep his empire in a virtual state of perpetual warfare.[4]

Yet, despite its incredible importance, Nombre de Díos was at significant risk of attack. There was no regular garrison stationed there; there were no fortifications to speak of either. It sat a mere twenty-three leagues—around eight miles—across rugged jungle terrain from the Pacific Ocean, and hundreds of miles from anywhere in the Caribbean. It seemed to languish in the stifling equatorial heat, coming to life only when the flota docked. "The treasure house of the world," as Drake called Nombre de Díos in *Sir Francis Drake Revived*, was a ramshackle collection of wooden buildings, a warehouse, a wharf, and the king's treasure house. Its only true defense was its utter isolation.

And so, in late February 1571, Drake had returned. This time, as captain of the tiny forty-ton *Swan*, he anchored off the clear blue coast at Nombre de Díos, timing his arrival to give himself as long as possible for raiding before the hurricane season brewed up again. The information available to Drake prior to these voyages was at best incomplete, and mostly inaccurate. But through studious observation of Panama's coastline and harbors, interrogation of any Spanish prisoners—whom he appeared to have released unharmed—and, most important, the friendship of the *Cimarrones*, or escaped black slaves, Drake garnered an entirely different picture.

The *Cimarrones*, called Cimaroons in sixteenth-century English, were a crucial factor in Drake's ultimate success in the Americas. Only a year earlier, the bishop of Panama had complained that they represented a real threat to Spanish settlements in the area when he wrote to the king that "the human tongue cannot relate the ignominies which both the French and the *cimarrones* [sic] have this year inflicted here on all sorts of persons; and of a thousand Negroes who arrive annually, three hundred or more escape to the wilds."[5] They had the inside knowledge of how the Spanish settlements worked. They knew Spanish habits and ways. They were the ones who confirmed to Drake that the settlements were weakly garrisoned, and frequently fell victim to the depredations of French rovers.

So when Drake's men attacked a vessel from Cartagena traveling to Nombre de Díos in late February at the small port of Pontoons, it is hardly surprising that the Spaniards aboard should have resisted capture. Drake had left the *Swan* safely tucked away in a nearby harbor with "a fine bay . . . safe . . . for all winds,"[6] while he and fifteen or so of his men approached in a pinnace and hailed the Spanish frigate for a "parlay." The English had two small culverins threatening the Spaniards from its bow, and the men were armed to the teeth with swords, crossbows, and harquebuses. According to Spanish accounts, two of the men had their faces powdered with "war paint"—one black, the other red.

The Spaniards never stood a chance. Four were killed, including one African slave, before they cut their own cables and tried to outrun Drake and his men. The frigate inevitably ran aground, and the

Spanish—desperate to escape—waded ashore waist-deep through a mangrove swamp to safety. The frenzied plundering of the first ship was interrupted by the delightfully unexpected capture of a second Spanish frigate. Again its crew fled through the mangrove swamp to shore and watched helplessly. When the Spaniards finally regained the vessel the next day, the English had left a note: " . . . Done by English, who are well disposed if there be no cause to the contrary: if there be cause, we will be devils rather then [sic] men."[7]

While the Spanish were counting their losses, Drake and his men headed up the Chagres River and the fabled route of Spanish gold. Unlike all previous rovers, Drake reached Venta Cruces, and seized 100,000 pesos ($10.55 million or £5.7 million today) worth of clothing and other goods from the wharf as well as three barks. They sank the ships so that the news of their exploits couldn't overtake them. For the next three months, Drake and his men operated between Nombre de Díos and Puerto Bello along the coast, intercepting vessels to and from the mouth of the Chagres, gaining more and more information about the flota each time. In all, around twelve vessels were captured laden with valuables estimated at 150,000 pesos ($17.59 million or £9.51 million today), not including the two prize vessels, slaves, and clothing. These were estimated at another 80,000 pesos ($9.38 million or £5.07 million today).

Drake's next prey was a royal dispatch frigate out of Cartagena, carrying the king's correspondence for the colonies of Panama and Peru. This time, Drake's pinnace was armed with twenty-three men, and the capture took place around May 8, 1571. The ship's owner and another seaman were killed before the prisoners were put ashore on an uninhabited island nearby. Philip's correspondence was tossed irreverently into the sea, and the ship set adrift. When the hapless Spaniards were rescued, tales of "stripping and abusing a friar" identified the new corsair as an unknown *Luterano* pirate from England.

Three expeditions had been sent out to capture the daring Englishman at a cost of 4,000 pesos ($469,110 or £253,573 today) without success. Officials in Panama wrote to Philip on May 25 that this Drake was "so fully in possession of the whole coast of Nombre

de Díos, Cartagena, Tolu, Santa Marta and Cabo de la Vela, that traffic dares not sail from Santo Domingo thither, and trade and commerce are diminishing between the windward islands and this Main."[8]

Drake's private war had raked in officially £66,000 ($23.22 million or £12.55 million today) in three months.[9] While the legality of Drake's venture cannot be sustained remotely either morally or in law, it heralded the end of the age of Hawkins's aggressive commercial and illicit trade in the Caribbean. It also meant that Philip II and Sebastian of Portugal would need to redouble their efforts in defending the monopolies they claimed in Africa and the Americas if they were to keep their empires safe from Drake and the new breed of Elizabethan seamen.

16. The Dread of Future Foes ⚜

The doubt[1] of future foes
Exiles my present joy
And wit me warns to shun such snares
As threatens mine annoy.
For falsehood now doth flow
And subjects' faith doth ebb,
Which should not be if reason ruled
Or wisdom weaved the web.

—POEM BY ELIZABETH I, C. 1571[2]

The year 1572 was one of those turning points in history that was comprised not of one momentous event, but of many. The Ridolfi plot to kill Elizabeth and put Mary on England's throne had been uncovered in time, thanks to the astute intelligence work of Sir Francis Walsingham. Implicated in the plot were not only the Duke of Norfolk and his men, but also Mary, Queen of Scots, the Pope, Philip II, Thomas Stucley, and, of course, its author, the Florentine merchant banker Roberto Ridolfi. If Walsingham hadn't communicated the list of all "strangers" arriving from Rome to William Cecil (elevated to the position of lord treasurer and created Lord Burghley in 1571), the machinations of a well-oiled Catholic espionage network could have feasibly succeeded.[3] Elizabeth reacted with notable calm in the middle of the international maelstrom, but still fired off a stinging rebuke to Mary on February 1, 1572, "to consider that it is not the manner to obtain good things with evil speeches," she admonishes her cousin, "nor benefits with injurious challenges, nor to get good to yourself with doing evil to another."[4]

The loss of the Duke of Norfolk, Thomas Howard, as an ally was devastating for Elizabeth in several ways. As her second cousin on the Boleyn side, he was one of her closest surviving family relatives. But more devastating was the fact that since the Northern Catholic

Rising in 1569, Norfolk was the senior noble of the realm. He was also an important Privy Councillor, and a gentleman adventurer whose wealth had been invested in a number of ventures from those of the Muscovy Company to the Hawkins slaving voyages. Yet the most crushing blow to the queen was that only a short time previously, key members of her own Privy Council, led by none other than her favorite, the Earl of Leicester, were behind a marriage negotiation between Norfolk and Mary of Scots. While the earlier negotiation had not, of course, included plans to supplant Elizabeth on the throne, it cast a long shadow of doubt over the motivations of such stalwarts as Leicester, Sir Henry Sidney, and the ever-trusty Earl of Pembroke in these dark days.[5] Pembroke had been implicated previously in the Northern Rising by the Catholic Earls. The possibility that these three most trusted and loyal servants could have been in league to promote the secret marriage plans of the Queen of Scots to Norfolk, which formed the basis for the future Ridolfi plot, was too grotesque for Elizabeth to contemplate. Only when Pembroke protested, "God forbid I should live the hour, now in my old age, to stain my former life with one spot of disloyalty," was the queen's mind put to rest. To prove her confidence in him, Pembroke was put in charge of the queen's personal guard at Windsor.[6]

Norfolk was speedily tried, convicted of treason, and sentenced to death. Meanwhile, his fellow plotters Ridolfi and Stucley had escaped the country. By the time Elizabeth had granted a temporary stay of execution in March 1572, Ridolfi had made good his escape to Rome. Stucley, the queen's former gentleman adventurer in the 1560s, had become one of Philip's heroes in the great battle of Lepanto in October 1571 where the Turkish navy was crushed by the united papal and Spanish forces. Already a resident at the Spanish court, and a great favorite of Jane, Duchess of Feria, former lady-in-waiting to Elizabeth's sister Mary, Stucley remained a wild card in the pack of knaves. Neither the queen nor Lord Burghley knew where he would tip up next, or what forces he would bring to bear on the realm. Stucley's claim on the seneschal [governorship] of Wexford had failed two years earlier, and he was forced to relinquish any claims to plantations in Ireland to his archenemy, Sir Peter Carew. Naturally, this "hand over" didn't pass off smoothly, so Stucley was detained "at Her Majesty's pleasure," imprisoned in

Dublin Castle, until he saw the error of his ways. On the promise of an honorable return to England, Stucley was released, but he fled to Spain instead, much to the embarrassment of Elizabeth's lord deputy, Sir Henry Sidney. Naturally, his escape counted as another black mark on Sidney's record.

And so it came to pass that Stucley, since the time of Ridolfi, had become Philip's "loyal" client. In a joint proposal to the King of Spain and the pope, Stucley had urged, "That there be given him four well equipped ships and a foist and two barks and therewith 3,000 foot and five hundred horse, where he will undertake to raise without for the present any payment on that account; and with that force he will go to Plymouth and burn and take the fleet of Hawkins and thence he will go to Ireland and make himself master of Waterford and Cork."[7]

Though Stucley had personally betrayed Elizabeth, it was the greater Catholic League against her, her troublesome "province" Ireland, and ultimately the defeat of the Turks that truly worried the English queen and Burghley in international politics. These were particularly harsh years for queen and country. Years of upheaval in trade in the Low Countries, the Northern Catholic Rising in England, failed plantations in Ireland coupled with the James Fitzmaurice Fitzgerald and Edmund Butler tribal war there, the loss of "favored nation status" in Ivan the Terrible's Russia for the previous three years, no successful northerly route as yet to Cathay for the growth of the luxury trade to the Orient, Barbary pirates and Spanish wars in the Mediterranean, the papal excommunication and absolution of English subjects from obeying Elizabeth, and the ultimate failure of Hawkins's slaving expeditions all combined to make the early 1570s a time of particular penury and dissatisfaction.

Still, there were, seemingly, some bright rays on the horizon. Peace, though an illusion, had reigned in the more heavily populated, predominantly Protestant south for fifteen years. A compromise had been etched in stone between Protestants and Catholics, and the country was poised to enter a new era of prosperity, if only the rest of the world would let it happen. Some adventurers had dedicated much of their efforts to improving matters at home, despite nursing a penchant for raiding foreign shipping in the Narrow Seas and

beyond. Sir Lionel Duckett, master of the Mercers' Company in 1572 and lord mayor of London in that year, was determined to maintain "good order" in the capital by curbing excessive debauchery, drinking, and feasting, despite being labeled a killjoy. He also instituted the system for the issue of writs of habeas corpus to be restricted to cases against those who disturbed the peace. Where Duckett indirectly condoned "lawlessness" at sea through his private investments, he was particularly proud—with good reason—of his efforts at curbing criminality and venal behavior at home.[8]

Sir Thomas Gresham, who would remain the queen's royal factor at Antwerp until May 1573, had found his role increasingly difficult to maintain since the seizure of the Duke of Alba's pay ships. Gresham witnessed the delicate series of negotiations for the return of the money (long ago spent) between the Genoese bankers, the queen and Burghley, and the king's representative, Tomasso Fieschi, but was powerless to contribute positively to talks that were by and large handled at Privy Council level.[9] To complicate matters further, Gresham's great friends were Balthazar and Gaspar Schetz, with whom he often stayed. Life must have been decidedly uncomfortable for the queen's factor since Gaspar was also the King of Spain's royal factor.[10] All of these complications paled into insignificance, though, when, as a result of Philip's naval war against the Turks and his requirement to enhance protection of his colonies, the King of Spain declared bankruptcy in Antwerp yet again in 1572.

And Gresham was unstoppable. He had already turned his attention to a different and positive project. Plans were under way for the pinnacle of his personal achievement. His vision for England's future would become a monument that all merchants and traders could appreciate and enjoy. With Sir Lionel Duckett's able assistance, Gresham began building the physical representation to England's economic future—the Royal Exchange in the City. Modeled on the Antwerp bourse, it was to be Gresham's legacy to the nation, built in large part with his own money.[11]

Yet trade with Antwerp, the greatest pillar of foreign exchange, had long been reduced to a low water mark by international circumstances. Customs and excise duties on imports were at an all

time low at the time of building, making the Royal Exchange seem
to some like Gresham's great folly. Merchant adventurers had been
reduced to becoming "adventurers" harvesting the seas in order to
make a living. Naturally, any merchandise brought into port without
the proper paperwork—including a "letter of reprisal"—would
have been confiscated. And so smuggling became rife everywhere.
The result was that most of the crown's receipts now came from the
sale of crown lands rather than foreign exchange or excise duty.

Something needed to be done. Sir Thomas Smith, Elizabeth's
principal secretary in 1572, had agreed with the Merchants
Adventurers stance that, ultimately, only continued trade with the
Netherlands could guarantee Anglo-Spanish amity.[12] Perhaps it was
for his outspoken, if correct but unpopular, views that Smith was sent
to Paris on the embassy with Sir Philip Sidney in 1572 for Henry of
Navarre's marriage to the King of France's sister, rather than to the
Low Countries to continue the negotiations for the "return" of the
money taken from Alba's pay ships in November 1568.

Burghley urged his queen that something had to be done about
the international situation if England were to grow and occupy a
position of importance in the world. Elizabeth agreed. She knew
full well what she would have to do to placate the King of Spain
and Alba, and so long as it cost her very little in real financial and
face-saving terms, it would seem to show a great willingness on
her part to patch things up with the kings of Spain and Portugal.
After consultations with Burghley and other Privy Councillors, the
queen resolved, firstly, to cease the Guinea and all slave trade;[13] and,
secondly, to make a concerted effort to stop Channel piracy. The first
of these was handled readily enough through proclamation, though
neither Iberian king believed that Elizabeth was sincere. Nor did
they believe, rightly, that the Privy Council and the Admiralty
could stop privateers from interloping in Spanish and Portuguese
colonies.

As to Channel piracy, the ready solution was for the queen to
expel Orange's Sea Beggars from their safe haven at Dover. But was
this newfound cooperation with Spain all it seemed to be? Or was it,
as with so many things with Elizabeth, a masterstroke or "answer
answerless" to an intractable problem, another of her gossamer webs

that when held up to the lightest of breezes turned round upon itself and became nothing more than broken silken threads?

Captain La Marck, Orange's most robust mariner, had made Dover and the creeks and bays along the south coast his home with his fellow Sea Beggars for several years. English seamen swelled his ranks in the certain expectation that they would share in La Marck's plunder. But La Marck, his men, and even the English who served under or alongside him were expendable in the game of cat and mouse that the Queen of England played with Philip of Spain. They were a cheap and easily disavowed means of making unofficial war. But meanwhile, she persisted—until the spring of 1572—in renewing safe conduct after safe conduct for La Marck and his men. As the Queen of England, it was the only course open to her to show her defiance of Spain. As the patron of these pirates, Elizabeth would never allow their expulsion to mean their extinction.[14]

Alba's view remained skeptical. The Sea Beggars were rebels and pirates, baptized by Elizabeth as Orange's soldiers, but pirates nonetheless.[15] Interestingly, little has been made of the fact that Philip had engaged willingly in the same practice of harboring rebels—but in his case, rebels from English justice. After the collapse of the Northern Rising, the Earl of Westmoreland, Lord Dacre, and others had escaped to the Netherlands and lived comfortably under the protection of the Spanish government *and* on Spanish pensions.[16] These very men would become the backbone for Philip's "Enterprise of England" in 1588. Their activities could not, would not, be tolerated by the queen or her Privy Council without a fight.

And so, in what appeared to the uninitiated to be an act of munificence—the expulsion of Orange's Sea Beggars from England's shores—Elizabeth had, in fact, struck a lethal blow against the King of Spain; she was pulling back the olive branch from his outstretched hand. What followed was vintage Elizabeth.

The expulsion orders handed down from the commissioners of the Cinque Ports on the grounds of "plundering ships belonging to the merchants of the Steelyard and others, and seizing their ships and the goods they had taken or uttered 'to the slander of the realm and impeachment of the haunt and traffic of merchandise'" was only one of the long list of complaints against the Dutch rebels.[17] On March 25, they were ordered to quit Dover and, indeed, England.

When La Marck was still seen hovering off the south coast, Sir John Hawkins was sent with his fleet to ensure La Marck's retreat. A month later, La Marck's fleet landed at the Isle of Wight to sell their captured prizes for victuals. Three days later, they successfully captured one of two deepwater ports in the Netherlands, Brill.

At last, Orange had his toehold on home ground. Brill had been seized by La Marck, but Flushing, the other deepwater port, was beyond his reach. In July 1572, Sir Humphrey Gilbert, Elizabeth's hardened gentleman adventurer fresh from his wars in Ireland, and Gilbert's uncle, the vice admiral of Devon, Sir Arthur Champernowne, led some eleven hundred "pressed" volunteers to capture Flushing and Sluys. Above all, it was Gilbert's duty to ensure that the French would not be able to occupy these ports. There is no doubt that he had the tacit support of the queen and the Privy Council for an undertaking like this: when he failed to take Flushing by November, he returned to England in a feigned "disgrace."[18] Then, in a most transparent effort to prove her good credentials in combating piracy in 1572, Elizabeth refused to grant Sir Richard Grenville a license to voyage into the Pacific since it would "annoy the King of Spain."

Yet even the cunning deceits of the Queen of England were to be outdone in 1572 by another queen—the dowager Queen of France, Catherine de' Medici. In that year Catherine was in the middle of negotiating a marriage between her son, Francis, the Duc d'Alençon, and Elizabeth. She was also responding to the clear and present danger closer to home that the Huguenot leader, Admiral de Coligny, represented. Coligny had, in her eyes and those of the Guises, supplanted Catherine's influence with the weak King Charles, her son. In the summer of 1572, the eyes of the great nations of Europe were on Paris for the wedding of Henry, King of Navarre, to Marguerite de Valois, Catherine's daughter, and sister to King Charles. It was a match that had been championed by Coligny. After years of civil war, Coligny—in an act of conciliation—had become a close advisor of the king, and had been instrumental in the negotiations.

Queen Catherine whispered in her son's ear that as the king of Navarre was a Protestant, she feared the capital could become

a killing field if the population were allowed to go about armed. Naturally, Charles concurred, and he issued a royal proclamation forbidding arms and the molestation of any foreigner or Navarre follower. Protestants throughout Europe, and especially in France, took this for a great act of kindness and reconciliation, and they flocked to Paris for the ceremony.

The stark facts were precisely the contrary. The Guises, uncles to Mary, Queen of Scots, along with Queen Catherine, believed that Coligny represented too great an influence on the weak-minded king. Coligny simply had to go. And what better time to assassinate Coligny than when Paris was *en fête* and filled to overflowing with Protestants?

On the morning of Friday, August 22, 1572, after a week of festivities celebrating the elaborate wedding of Henry to Marguerite, Admiral de Coligny wended his way back to his lodgings in the rue de Béthisy. He was returning home from watching the king play Guise at tennis at the Louvre. A would-be assassin fired three shots from a third-floor window as Coligny turned into his street. The first blew off most of Coligny's right-hand index finger. The next lodged in his left arm, and the third missed altogether. The king was notified, and his personal physician was sent to tend to the admiral. Coligny's wounds were not considered grievous, and the Huguenots who had gathered to stand vigil in the street below the admiral's lodgings rejoiced "to see the king so careful as well for the curing of the admiral, as also for searching out of the party that hurt him."[19] Bearing this out, the king and his brothers were so solicitous that they and their mother visited the convalescing admiral.

Yet Henry of Navarre and the Prince de Condé smelled danger in the air. They tried to calm their Huguenot supporters by confirming that Coligny would recover completely. But when the man hired to assassinate the admiral was caught, one Maurevert, it was also discovered that the man who had held the horse for Maurevert's quick getaway was a veteran servant of the Duc de Guise. Maurevert's weapon, a harquebuse, had been "borrowed" from the Duc d'Alençon's armory. And the Duc d'Alençon was the English queen's intended bridegroom.

There was only one option left open to the scheming Valoises

and Guises to keep the truth from coming out: exterminate the Huguenots. At four in the morning, the Duc de Guise and his Swiss mercenaries forced their way into the admiral's lodgings. Coligny was already on his knees in prayer. While he knelt, the mercenaries stabbed him repeatedly then tossed his bloodied body out the window. Meanwhile, throughout the capital, Huguenot houses were attacked. Men, women, and children were slaughtered, their bodies thrown into the streets or the River Seine. Huguenots to whom King Charles had granted asylum at the Louvre were murdered, their two hundred or so corpses piled high in the splendid palace courtyard. According to the Spanish ambassador to France, Zuñiga, fanatics had entered the English embassy where Sir Francis Walsingham, Elizabeth's ambassador, resided, and where other English notables like Sir Philip Sidney and Sir Thomas Smith hid along with the ambassador from the mob. Only after the danger had passed had the Duc de Nevers stationed the royal guard outside Ambassador Walsingham's home. In the first blood orgy on St. Bartholomew's Day, conservatively over two thousand Huguenots were slain.

It was the first such massacre of Christian against Christian. Its suddenness, viciousness, and ferocity stunned all who witnessed it and all who heard about it. Elizabeth, after long, hard reflection, wrote to Walsingham in December 1572:

We are sorry to hear, first, the great slaughter made in France of noblemen and gentlemen, unconvicted and untried, so suddenly (as it said at his [the king's] commandment), did seem with us so much to touch the honor of our good brother as we could not but with lamentation and with tears of our heart hear it of a prince so well allied to us . . . we do hear it marvelously evil taken and as a thing of a terrible and dangerous example; and are sorry that our good brother was so ready to condescend to any such counsel, whose nature we took to be more humane and noble.

But when was added unto it—that women, children, maids, young infants, and sucking babes were at the same time murdered and cast into the river, and that liberty of execution was given to the vilest and basest sort of the popular, without punishment or revenge of such cruelties done afterwards by law upon those cruel

murderers of such innocents . . . And now since it doth appear by
all doings, both by edicts and otherwise, that the rigor is used only
against them of the religion reformed . . . that his : . . intent doth
tend only to subvert that religion that we do profess and to root
it out of this realm. At least, all the strangers of all nations and
religions so doth interpret it, as may appear by the triumphs and
rejoicing set out as well in the realm of France. . . .[20]

No wonder Elizabeth called off wedding negotiations with Alençon
further along in this same letter. What's more, Elizabeth, from that
moment, questioned who other than Burghley and her merchant
and gentlemen adventurers she could count among her friends and
allies.

A faint smile must have fleeted across her lips when she thought
back to the spring of that year. The most audacious of her adventurers,
Francis Drake, had set sail from Plymouth on Whit Sun Eve, May 24,
1572. He hadn't merely been allowed by the queen and Admiralty to
return to the Spanish Main to ransack the treasure house of the King
of Spain. He was fulfilling her grand plan. Elizabeth of England had
blessed him, and all others like him, in their quests for treasure and
their annoyance of Catholics everywhere who would dare to steal
her crown.

17. Drake at the Treasure House of the World ❧

Some think it true to say he did it in the Devil's name,
And none ever since could do the like again;
But those are all deceived, why should they doubt it,
They know each year there's some that go about it.
— ANONYMOUS, VERSE TO DRAKE C. 1619

It is well nigh impossible for us to imagine how brave, or foolhardy, Drake and his men were—sailing thousands of miles without reliable charts or accurate measurement of longitude into a vast ocean where, on the other side, only hostile forces of the King of Spain awaited them. It is even more impossible to imagine how this voyage eventually led to the hopes of England's becoming a world power.

Nonetheless, as Drake's two small ships left Plymouth Sound that balmy May evening, hope and expectation filled the air. Seventy-three mariners and boys had boarded the 70-ton *Pasco*[1] and the 40-ton *Swan*, each and every one of them a volunteer. Only one sailor was over fifty years of age. The rest were all under thirty. Some, like Drake's younger brother, John, had invested their life savings—in John's case, some £30 ($10,554 or £5,705 today). Aboard the *Pasco*, stored in precut sections, were three pinnaces for shallow, inshore work. Victuals and other provisions for a year were divided between the two ships. "Artificers" (carpenters) with their tools, musicians, and weapons for any eventuality Drake could then imagine were the final necessities added to their complement. Significantly, the *Pasco* had been registered as a Hawkins ship, and word was out that the queen's slave trader had buried the hatchet with Drake and was an investor in the voyage.[2]

According to Drake, they were favored with a "prosperous wind from God" and reached the island of Guadeloupe in twenty-five days, on June 28. On July 12, Drake's ships approached Port Pheasant, the secret cove he had "found" in 1570–71. It was here that Drake had left tools and provisions for his return. Yet as his ship pulled into the cove, a wisp of smoke rose above the treetops near the site of his encampment the year before. Since Drake thought Port Pheasant was uninhabited, he led a small party of heavily armed men ashore at the ready to retake it, only to discover the remains of a smoldering campfire. Nailed to a tree trunk nearby was a lead plaque with its warning etched into it, especially for Drake's eyes:

> *Captain Drake, if you fortune to come to this port, make haste away, for the Spaniards which you had with you here the last year have betrayed this place, and taken away all that you left here. I departed from hence, this present 7 of July, 1572. Your very loving friend John Garret.*[3]

Garret was a fellow West Countryman and ex-slaver like Drake. Obviously, he and doubtless many others had chosen Port Pheasant to emulate Drake's first solo raid. But Drake sloughed off the warning. He ordered his men ashore with the pinnaces and set his carpenters to work on their assembly. His mariners felled trees and erected a huge stockade around their camp for added security—just in case Garret was right.

The following day, three small craft sailed over the horizon. The men were ordered to their battle stations, but they were soon stood down. The admiral, only a bark, had the flag of St. George hoisted on her mainmast, and her captain was none other than James Raunce— the captain of the *William and John*—which had been separated from the Hawkins fleet just before San Juan de Ulúa. Raunce had brought with him two Spanish prizes—one a tiny shallop, the other a caravel called the *Santa Catalina*. He was sailing, he explained to Drake, one of Sir Edward Horsey's barks out of the Isle of Wight in search of treasure. The captured Spanish prize was the *aviso* bound for Nombre de Díos, whose purpose was to bring correspondence and news between the colonies. Raunce lost no time asking Drake

if they might not join forces. His old friend was welcomed, Drake said, especially since they had in mind to capture Nombre de Díos and the king's treasure house.[4]

Raunce's captives, some poor slaves who were being freighted across the Spanish Main, happily told Drake and Raunce that they had heard reports that "certain soldiers should come thither shortly, and were daily looked for . . . to defend the town against the Cimaroons."[5] While their intelligence was welcome, their news could not dissuade Drake from his course. He ordered the slaves released, since he wished to "use those Negroes well."[6] Drake had no way of knowing that the slaves' information was false.

By July 28, the three pinnaces—now baptized the *Lion*, *Bear*, and *Minion*—were ready to sail. It was agreed that Raunce would guard their position and keep his bark and the *Santa Catalina*, the *Pasco*, and the *Swan* with him. Drake and his seventy-three men sailed on in the three pinnaces and the shallop toward Nombre de Díos, heavily armed with six shields, six fire pikes (that could double up as torches by night), twelve pikes, twenty-four harquebuses, six spears, sixteen bows with arrows, two drums, and two trumpets. All Drake's men had been briefed. They would sail to Nombre de Díos and attack at dawn.[7]

At the fringes of the bay, Drake and his men lay in wait. They had been drilled and trained for what Drake imagined lay ahead. Nevertheless, they began to fidget and worry about the outcome while they were under strict orders to watch quietly and listen until dawn. Drake was a great observer of nature and men, and he knew that if he waited for daybreak, many of his men would lose their nerve. Fortunately, at some time between two and three in the morning, the clouds cleared, revealing a brilliant full moon. It cast silvery shadows from the masts and rigging onto the deck as if dawn had come early. For Drake it was a clear sign from God. Without hesitation, he gave the order to attack, claiming that dawn was upon them. Once on the move, their mutterings stopped.

As they stole out into the harbor, they saw a wine ship from the Canaries anchored in the bay. Its crew, meanwhile, had already spotted Drake's men skulking in the shadows. Without hesitation, the Spaniards lowered a boat to warn the town, but Drake cut them off and drove them across the bay, where they could do no immediate

harm. Drake landed without further skirmishes, and seized the battery of six guns that defended the port. Its sole defender saw Drake approach and ran hell for leather to the town, saving his own life but risking the lives of his fellow Spaniards.

Drake's success would depend solely on the element of surprise, and especially on the Spaniards' belief that they were being attacked by several hundred men rather than several dozen. A few mariners were left in port to guard the pinnaces to secure their retreat, while Drake divided his other men into three groups to storm the town. John Drake and John Oxenham were each given sixteen men to go around the left and right flanks. Drake himself would advance along the main road with the rest. As they marched forward, Nombre de Díos began to stir. The lone sentinel from the battery had raised the alarm. The church bell pealed its anxious cry to the townspeople. Drums beat out an assembly order. Shouts in Spanish called out for every man to defend their town, while the women were begged to hide with their children.

In the midst of all this confusion, Drake advanced steadily, his fire pikes held high, their fierce glow dancing eerily along the walls of the settlement. His drummer and trumpeter heralded his arrival as if he were a caesar, at the head of a huge army. The *alcalde* had already grouped together his nervous militia at the southern corner of the market square when Drake came into view, and ordered his men to fire on the English corsairs. One bullet killed his trumpeter straightaway, the other struck Drake in the leg. All the other shots hit the dust in front of Drake and his men. Then Drake smiled and gave the order for his mariners to attack. The English lunged forward ferociously, waving their pikes, screaming a battle cry, and firing their own shots back at the Spaniards in among a hail of arrows from their crossbows.

Simultaneously, John Drake and John Oxenham arrived in the square with their company of men, brandishing their weapons and firing shot and arrows, too. Terrified, the Spaniards broke ranks and fled, many of them hurling their weapons to the ground behind them.[8] With only one fatality, the English commanded the town. But the Spaniards would soon figure out that they had been duped and would mount a counterattack. As they regrouped in the market square, Drake interrogated some Spanish prisoners, asking for them

to lead Drake and his men to the governor's home. If they were intent on trickery, they would not live to tell the tale, he warned. While Drake had come to empty the King of Spain's treasure house, the simple fact of the matter was, he couldn't be exactly sure how best to approach it from shore. The governor would be the most reliable source of that information, Drake had decided. Besides, it may be that the governor himself would be in possession of treasure, too, he reasoned.

Drake would not be disappointed. When the door was pushed open at the governor's house, a candle was lit at the top of the stairs and he saw:

> a fair jennet [small Spanish horse] ready saddled, either for the Governor himself, or some other of his household to carry it after him. By means of this light, we saw a huge heap of silver in that nether room; being a pile of bars of silver of, as near as we could guess, seventy foot in length, of ten foot in breadth, and twelve foot in height, piled up against the wall. Each bar was between thirty-five and forty pound in weight. At the sight hereof, our captain commanded straightly that none of us should touch a bar of silver, but stand upon our weapons, because the town was full of people, and there was in the King's Treasure House, near the water side, more gold and jewels than all our four pinnaces could carry; which we would presently set some in hand to break open.[9]

As they were deciding if they should trouble with the silver or head onto the king's treasure house for the gold, an escaped Negro slave, named Diego, rushed forward, begging to be taken on board with Drake and his men. As proof of his good faith the escaped slave claimed that their pinnaces were in danger from the king's soldiers who had been sent to protect the town from the Cimaroons. Drake could ill afford to ignore the warning, and he sent his brother and Oxenham to check. While his cohorts secured the pinnaces, Drake started back into the town toward the king's treasure house, which stood at the westernmost end of the settlement.

Just as they started out, the skies opened in a torrential, tropical, summer thunderstorm, and by the time the main force reached

the treasure house, they were soaked through. Worse still, their gunpowder was sodden, and the strings on their crossbows were too wet to use with any degree of accuracy. There was nothing left for them to do but wait. When the rain eased, John Drake, who had rejoined them from securing the pinnaces, was ordered to break down the treasure house door, while Francis and his men held the market square. But as their captain stepped forward, he swooned, and it was then that Drake's men saw for the first time that he had been wounded in the earlier face-off. Blood streaked his footprints in the sand, and the lower part of his leg was stained crimson.

His men gathered around him and decided that they had to get their captain to safety. There would be other opportunities to get treasure, someday. So they bound his leg with one of their scarves and carried him back to the pinnaces, where they made good their escape to the Bastimentos Islands, or Isles of Victuals, about a league west of the town. Still, just so they wouldn't leave empty-handed, they took the Canaries wine ship with them.[10]

Meanwhile, the *alcalde* of Nombre de Díos counted his losses. Thirty-two were dead, according to one eyewitness,[11] though the official complaint to the Queen of England two years later claimed a death toll of eighteen. More worrying to the *alcalde* were his wounded. Had these pirates used poisonous arrows? He needed to know the answer to this, and who these savages were. How else could he make an accurate report to the governor and the king? Since the English had only escaped to a nearby island, the *alcalde* sent a gentleman envoy to Drake to find out the answers to these questions. The English captain proudly told the Spaniard that they had come for the King of Spain's treasure, that they were English and would never use poison arrows, and that his name was Francis Drake. Then, "he advised the governor to hold open his eyes, for before he departed," and Drake nodded at him, "if God lent him life and leave, he meant to reap some of their harvest, which they get out of the earth, and send into Spain to trouble all the earth."[12]

With the "niceties" of the Spaniard's mission completed, Drake ordered that the envoy be "burdened with gifts" as a sign of their personal goodwill.

18. From a Treetop in Darien ❧

We came to the height of the desired hill . . . about ten of
the clock; where the chiefest of these Cimaroons took our
Captain by the hand and prayed to him follow him if he
was desirous to see at once the two seas, which he had so
longed for. Here was that goodly and great high tree . . .
and from thence we saw without any difficulty plainly
the Atlantic Ocean, whence now we came, and the South
Atlantic,[1] so much desired
—*Sir Francis Drake Revived*

While Drake was recovering from his wounds during the course of the next few days, he certainly hatched a plan for his next raids. During this time, he became friendly with the former slave, Diego, who had begged to join their company when he warned them that the pinnaces had been in danger. Drake listened and learned from Diego. The plan was to involve the Cimaroons in their attacks, since they knew the jungle and the Spaniards so well. It took no time at all for Drake to grow to admire Diego greatly. The English and the Cimaroons had, according to Diego, common cause in their hatred for the Spanish, and he was sure that these former slaves turned raiders would prove stalwart allies with important local knowledge.[2]

By the time they left the Isle of Victuals to rejoin forces with Captain Raunce, the terrified *alcalde* of Nombre de Díos had spread the alarm as far as Cartagena, Santa Marta, and Honduras. Earthworks were thrown up at great speed on the beach, and a new battery of heavy guns was installed to command the headland. The *alcalde* was certain that *El Draco*—the Dragon—or Drake would return. While Drake and his men had left Nombre de Díos virtually empty-handed, in Spanish eyes it was an audacious coup. No pirate had ever come to rob the King of Spain's treasure in its repository.

It struck terror into the hearts of strong men to think that the gold that kept the empire afloat could have so easily been stolen by a mere *Luterano*.[3]

Raunce, on the other hand, was not amused. He decried Drake's antics, fearful that the Caribbean would be crawling with Spanish soldiers in no time at all. When he told Drake that he had had enough, Drake was more than happy to let him go. If Raunce were not made of sterner stuff, he would add nothing to the equation.

Again aware that Raunce's departure might renew grumbling among the ranks, Drake suggested that he and his remaining men should strike while the iron was still hot, and attack the shipping at Cartagena. Though the town itself wasn't particularly well protected, it did have a fortified tower and heavy gun battery in harbor. There would be risks. The crew agreed to give it a whirl, and they set sail. But word had already reached Cartagena that there was an English pirate in the vicinity, and the shipping had moved to the inner harbor. That is, saving one.

This lone ship lay at anchor out of range of the town's great guns— a 240-ton vessel still laden with her cargo of munitions. According to the Spanish complaint two years later, Drake pillaged the prize and burned it.[4] While the attack terrorized the town, it showed Drake that word did indeed travel fast in that part of the world. It also demonstrated that the Spaniards, with all their guns and bluster, remained powerless to stop well-equipped, swift English pinnaces cruising inshore to pillage.

Despite the fact that Drake had sailed with Hawkins, it was rapidly becoming apparent that both he and his men not only valued and liked Diego, treating him as one of their own, but recognized that they were relying heavily upon his local knowledge for the ultimate success of their mission.[5] Diego was his fellow traveler, his friend, who had been sorrowfully mistreated at the hands of the Spanish, and who seemed to sense that Drake was the answer to not only his own, but also the *Cimarrones*' prayers for revenge.

And yet, so far, the voyage had not been a success. Diego was certain that the *Cimarrones* would help Drake. They were, after all, fellow travelers, too. But it was only in his long talks by the campfire with Diego, John Oxenham, and John Drake, that Drake finally thought through a daring scheme where his partnership with the

Cimaroons would benefit them both. Since the Spaniards knew they were there, and were expecting them to raid the towns along the Spanish Main, the English could still have the element of surprise if they attacked the king's treasure *before* it arrived at the treasure house at Nombre de Díos. Drake shared his thoughts with Diego, Oxenham, and his brother, and they all thought it was a brilliant idea.

But they would still need to wait awhile until Spanish vigilance lapsed. And so, Drake dug in for the long haul, allowing the Spaniards to drop their guard over time. With the invaluable assistance of Diego, his men were taught to build shelters and stockades, to make safe havens and depots in which to hide extra provisions along the coast. They would lay low, trim and careen their ships, and gather food and other provisions to place in their storehouses. Meanwhile, John Drake went with Diego to contact the *Cimarrones* in the jungle to ask for their help. It was agreed that they should meet Francis Drake personally, since they had already heard so much about his daring.

On September 14, they met aboard the *Pasco*, and two weeks later, a second group of blacks joined them to seal their bargain "to their great comfort and our content, they rejoicing that they should have some fit opportunity to wreak their wrongs on the Spaniards, we hoping that now our voyage should be bettered."[6]

The *Cimarrones* eagerly told the English that the plan could work by attacking the treasure trains in the middle of the Isthmus of Panama. After all, they had been evading Spanish capture for years in the jungles, and they knew each trail, each tree, and each hazard as their own home. The treasure, they informed the English, always moved after the rainy season, resuming only when the flota was either in port or approaching the port of Nombre de Díos. Drake reckoned that that gave them five months to prepare. He must have also realized at that point that the treasure house at Nombre de Díos had been empty when he first tried to rob it! Drake was always a good judge of men, and he immediately agreed to add the former slaves to his trusted inner circle of "Plymouth lads." They shook hands on a deal and celebrated their partnership aboard the *Pasco*, while they plotted Spain's downfall.

The *Cimarrones* helped Drake and his men to establish a forward base, just to the east of Nombre de Díos, where they built a fort in just over two weeks. Drake, meanwhile, left for Cartagena with two of the pinnaces to try to get more intelligence, victuals, and prizes, leaving his brother John in charge. Throughout October 1572, Francis Drake terrorized the city of Cartagena and nearly blockaded its port. He chased dozens of ships, seized others, taunted his pursuers, and always escaped unharmed. His impudence knew no bounds.

But Drake had had enough fun. They were in dire need of food and had to return to their base with enough to feed their swelling "army." At last, fortune smiled on them when a 90-ton victualing Spaniard came across their path, and Drake found "her laden with victual well powdered and dried, which at that present we received as sent as of God's great mercy."[7]

But their luck didn't hold out. When Drake returned to base, he was told that his brother John had been killed in a skirmish with a Spanish ship. Two months later, his younger brother, Joseph, was the first to die of a mysterious disease that ripped through his crew like no other pestilence they had known before. When the epidemic was over, some 40 percent of the company had perished of yellow fever, and the English had renamed their haven Slaughter Island. While they tried to put their troubles behind them, bury their dead, and keep themselves alive, the *Cimarrone* scouts ran into camp one day to say that the flota had docked at Nombre de Díos.

Drake, seventeen of his remaining men, and thirty *Cimarrones* headed straightaway toward Panama. The dark and murky jungle floor was lit only by the occasional macaw on the wing or the tropical sun filtering through the canopy of trees. Sounds of their footsteps swishing through the undergrowth became their daily companion, while they kept on the lookout for poisonous snakes, anacondas, and lizards. Their aim was to cut off the *trajín*—or treasure train—near Venta Cruces, where the treasure was divided between the barges and the mule train. But something miraculous happened on their fourth day in the jungle. The leader of the *Cimarrones*, Pedro, pointed to a huge tree and asked Drake to go aloft. The captain and Oxenham

exchanged quizzical looks, but he complied. High above the tropical rainforest in the Bay of Darien, in the company of an escaped black slave named Pedro, Drake became the first Englishman to see the massive expanse of the Pacific as he turned his head to the west, and the Caribbean that he knew so well as he wheeled around to the east. Separating the two was a mere twenty leagues of rain forest. We can only imagine Francis Drake's mind clicking into gear, the elation in his heart, and the foundations for his greatest adventure being laid. Later, Drake said that at that moment he "besought almighty God of his goodness to give him life and leave to sail once again in an English ship in that sea."[8]

19. Success at a Cost ❧

*The realm is at the present moment so terrified, and the
spirits of all so disturbed, that we know not in what words
to emphasize to your Majesty the solicitude we make in this
dispatch. . . . These English have so shamelessly opened the
door and a way by which, with impunity, whenever they
desire, they will attack the pack-trains traveling overland
by this highway.*

—MUNICIPAL COUNCIL OF PANAMA TO PHILIP II, FEBRUARY 24, 1573

Drake knew from experience that a surprise assault was critical
to their success. They laid in wait, crouching by the side of
the jungle path for what must have seemed an eternity before the
tinkling of mule bells rang sweetly in their ears. Suddenly, the gallop
of a lone horse coming from the wrong direction warned Drake that
all was not as it should be. Before the rider could be stopped he had
alerted the muleteers to head back, and that the pirate Drake would
pounce on them any moment.[1] The Spanish cleverly separated out
the silver shipment from the more valuable gold—estimated at some
£35,000 ($12.32 million or £6.66 million today)—and sent the mules
carrying the silver on into Drake's arms. Realizing that they had
been discovered, Drake and Pedro decided that it would be too risky
to return to base the same way they had come, and opted instead to
boldly take Venta Cruces. The raiding party marched through the
town, burning and pillaging as they went. Any casualties incurred
were in defense of property, not in brutal murder, according to
reports both Spanish and English. Drake had also ordered his men
that the women must remain "inviolate," and he even entered homes
to reassure the women personally that none of them would be raped.[2]
While there is no excuse for the terror Drake and his raiders inflicted
on their victims, this level of humanity in the sixteenth century—let
alone in the twentieth or twenty-first—is remarkable.

Now that he had made his strike, Drake once again lay low, hoping to trick the Spaniards into believing that he had left the Caribbean with his paltry treasure. While his good "Plymouth lads" grumbled about the heat, humidity, and their ill-luck, the *Cimarrones* tended the sick and injured and made moccasins for the foot-sore rovers. Drake marveled at their strength, their courage, and above all their loyalty. "Yea many times when some of our company fainted with sickness or weariness," Drake wrote later, "two *Cimarrones* would carry him [the sick] with ease between them two miles together, and at other times (when need was) they would show themselves no less valiant than industrious and of good judgement."[3]

After their retreat, there was little else to do than plan their next raid for the spring of 1573, and capture a prize that would hopefully keep them well provided in victuals and water. Then, nearly a month after they had rejoined their ships following the Venta Cruces raids, a large French ship bore down on them just off Cativas Headland near Nombre de Díos. Her captain, who had been looking for Drake for some five weeks, was none other than the Huguenot corsair Guillaume le Testu. Le Testu was no ordinary pirate. He had been the personal protégé of Admiral de Coligny, and was captaining a ship for the merchant adventurer Philippe Strozzi.[4]

Le Testu was well known to Drake. After all, Le Testu had taken part in the French colonial adventure to Brazil, and Drake admired the French challenge in South America to the Spaniards.[5] So when the Frenchman asked for water, and explained some of his men were ill, Drake ordered provisions to be sent aboard; then he asked Le Testu to follow him to one of his storehouses so that they could be fully replenished. When they finally anchored, the Huguenot captain gave Drake a gilt scimitar that had been a gift of his dear, now butchered, leader, Admiral de Coligny. This devastating news, and the carnage that had ensued in France, shocked and angered Drake, making the gift all the more dear.[6]

The two men had already respected each other before they ever met, but once in the same cabin together, that respect grew into mutual admiration. Le Testu showed Drake his invaluable folio atlas of fifty-six maps that he had drawn based on his own experiences, and which had been dedicated to Coligny some years earlier. This treasure of experience would have driven home the fact to Drake of

how poor English knowledge of the seas had truly been. Le Testu had been a royal pilot at Le Havre, and had been born and bred with the sea coursing through his soul like Drake. The main difference between the two was that Le Testu had high-level contacts in Coligny and, lately, André Thévet, Catherine de' Medici's chaplain. Drake had to make his own way through hard graft. What is striking from this encounter of great "pirates" is that Le Testu would have not been a corsair or outlaw if he had adhered to the Catholic faith.[7]

Naturally, Drake and Le Testu fell in together, and agreed on how to mount another raid on the *trajín*. Le Testu believed that if they attacked closer to Nombre de Díos, after the gold and silver shipments had been separated at the Chagres River, the soldiers would be more relaxed as their journey was nearing its end. It would be easier to box them in or, preferably, disperse the mule train's defenders more easily, he ventured. Drake agreed.

On March 31, 1573, the combined *Cimarrone*, English, and Huguenot forces stole into the jungle. Cimaroon scouts edged forward in the night, returning to their positions before daybreak. The *trajín* had nearly two hundred mules in all and an escort of around forty-five poorly armed, barefoot soldiers.

The assault was rapid and deadly. The Cimaroons led the charge. Within the first few seconds, a Negro harquebusier fired at Le Testu, wounding him in the stomach, and killing a Cimaroon. The attackers surged forward regardless, shouting fierce battle cries and shooting off their weapons. The Spaniards quickly recognized that if they stayed and defended the *trajín*, it would be a turkey shoot, and they would be the turkeys. While they turned tail and ran, the raiders leapt onto the baggage and prized open the chests. The mules were carrying more than 200,000 *pesos de oro* ($23.24 million or £12.56 million today). What made the prize sweeter was that 18,363 *pesos de oro* ($2.13 million or £1.15 million today) personally belonged to the King of Spain.[8]

The fifteen tons of silver looted was hastily hidden in burrows made by land crabs, or under fallen trees. They had to be quick about it, though, since again, they were only two leagues from Nombre de Díos. Half of the gold was loaded back onto the mules and carried to the mouth of the Francisca River, where their pinnaces were waiting. But Le Testu was mortally wounded, and he knew it. He told Drake

to go ahead and leave him, that he would guard the silver until they could return. The last thing Le Testu wanted was for Spanish soldiers to cut off their retreat to the sea, and Drake reluctantly agreed. Two of his men volunteered to keep him company, while the others marched laboriously away.

Two days later, after yet another torrential downpour in the jungle, the raiders arrived at their rendezvous. But instead of their own pinnaces, they found Spanish shallops. Had the pinnaces been captured? How would they escape back to their pirate's haven? the men asked. Had the Spaniards wrecked the *Pasco* and dashed their hopes of returning home? Drake knew from experience that action would keep these worries from overpowering his men. As ever ingenious, he instructed them to make a raft from fallen trees, binding the trunks together and using a slashed biscuit sack for its puny sail. It wasn't pretty, but it just about floated. After the Spaniards rounded the headland, Drake and three men waded out in their ludicrous tree raft, at times sailing waist high in seawater, before they spotted the *Bear* and the *Minion*, nestled in a safe harbor nearby. As Drake boarded the ship, he broke into a sudden smile and brought out a quoit (disc) of gold from his shirt. Their voyage had been made.

After his men had been brought safely on board, the *Cimarrones* came forward with the sad news that captain Le Testu had been killed. Drake said a prayer for the Frenchman's soul and gave the order to weigh anchor. It was unsafe to return for the silver. Their voyage had been made, thanks in large part to the Cimaroons and the Huguenots, with whom he gladly shared their prize. They had been away for more than a year, and more than half of them were dead, including Drake's two brothers.

In an incredibly swift and uneventful crossing of only twenty-three days, Drake and his remaining crew pulled into Plymouth harbor on Sunday, August 9, 1574. All the good men and women of the town were at prayer in St. Andrew's Church, listening to their vicar's sermon, when a murmuring among the parishoners grew into a roar. Drake had returned, they whispered to one another. One by one they left, until finally the entire flock deserted its preacher and raced to the waterfront to welcome home their heroes.

20. Dr. Dee's Nursery and the Northwest Passage ⚜

*I did conjecture the . . . star in Cassiopeia appearing anno
1572 to signify the finding of some great treasure of the
philosopher's stone . . .*
—DR. JOHN DEE, 1582

From the moment Drake returned in August 1574, the floodgates
burst open. Adventurers had been champing at the bit for years
to explore the western reaches of the globe in search of treasure and
a shorter way to the East Indies. Now Drake had returned—not
once but twice—with his holds filled with treasure. It mattered little
that it was plunder. That he hadn't looked for the fabled Northwest
Passage to Cathay meant that there was still vast scope for others to
join in the adventures. Soon, it was rumored at court that Drake had
seen both great oceans from one vantage point in the high treetop
above Darien. Surely, they speculated, this sighting by Drake proved
the existence of the passage, and that North America was no more
than a trifling obstacle to attain its Holy Grail of Cathay.

They were right certainly about Drake if not the passage. He was
interested purely in "singeing the King of Spain's beard" through
plunder. He was a man who understood results only. And the result
that preoccupied his every waking hour was to execute his private
war against Philip of Spain, righting the wrongs perpetrated against
all Protestants everywhere. Before Drake had reached his anchorage
in Plymouth harbor, the kernel of his most daring exploit had already
been hatched.

For the greater West Country public, to say that Drake had become
even more famous is absolutely true. But to say that his name was on
the lips of very Londoner would still be an exaggeration. This had

little to do with Drake's adventure or the boldness of his actions, and everything to do with his timing on returning to England. While he had been plundering the Spanish Main, the Duke of Alba had at last persuaded Philip to come to terms with Elizabeth, and shortly before Drake anchored at Plymouth, the Convention of Bristol of 1574 provided for a settlement over the Spanish pay ships confiscated by the queen in 1568. By mutual agreement neither England nor Spain would harbor aliens who were hostile to the other; and significantly, from the queen's viewpoint, Philip promised to restore the "ancient liberties" previously enjoyed by the Netherlanders. Spain also agreed that the Inquisition would be prevented from harming English sailors on Spanish territory.[1] Nonetheless, since the terms of the Bristol Accord had only been agreed weeks before Drake's return, it is tantalizing to think that the Queen of England could have repaid Philip with her share of the phenomenal booty only recently captured by Drake in the West Indies.

While timing from the queen's perspective may have been a tad bit embarrassing publicly, privately Drake's adventure was the talk of those in the know. He had been singled out by Leicester and Walsingham as an ingenious and handy man to have in a pinch, and Drake was packed off to Ireland to help Walter Devereux, first Earl of Essex, in his Ulster plantation scheme. It was a brilliant coup on their part to distract Drake in the "bog" of Ireland. Leicester knew, probably as one of Drake's backers, that the stout and hardy West Countryman had earned his spurs in the Caribbean. Still, his loyalty to the crown had yet to be proven. When Leicester advised England's most dangerous mariner that the queen had her personal money invested in Essex's Irish venture—£10,000, no less, or some $34.67 million or £18.74 million today—Drake would have readily spotted the opportunity to curry royal favor, and done all he could to ensure Essex's success. Not only would Drake be useful in "the great bog" of Ireland, Leicester reasoned, but also it would keep the dazzlingly bold captain from "annoying the King of Spain" at a time when Elizabeth had become shortsighted again, and was particularly desirous of appeasing the Spanish monarch. But that did not mean that Drake's projects, or indeed others contemplated by a range of adventurers for attacking Spain, had stalled. Though diverted for now, Drake would use his time in Ireland wisely.

And so he planned, and planned. To undertake the greatest voyage of his life, Drake would need powerful and wealthy patrons. John Hawkins and his other West Country backers wouldn't have sufficient resources to back his scheme on their own. Walter Devereux, Earl of Essex, on the other hand, did. Essex was married to the queen's cousin, Lettice Knollys, daughter of the Privy Councillor Sir Francis Knollys, and would recommend Drake to the court if he served the Earl well. Also serving under Essex was Christopher Hatton, a rising star at court. Drake was aiming his sights directly at the queen's personal favorites, and he wanted to prove himself to Leicester, Essex, and Hatton as a capable general at sea.[2]

Ireland had long been the place where an adventurer's fortunes were made, or swallowed up whole, since the time of Henry VII. It was also a vast proving ground for many of the West Countrymen like Drake—most of whom had had some education in Dr. John Dee's nursery for budding adventurers. The most staunchly Protestant West Countrymen like Richard Grenville, Sir Humphrey Gilbert, Walter Raleigh, Sir Peter Carew, and Sir Arthur Champernowne had all served devoted "hard time" in Ireland. The lord deputy of Ireland's son and Renaissance man, Philip Sidney, had engaged in the intellectually stimulating military chatter around the table in Dr. Dee's library at Mortlake near London. And Sir Henry Sidney had come to rely increasingly on Philip's advice during his tenure as Ireland's lord deputy, not only for the geographic and navigational knowledge that Dr. Dee had imparted to England's dogged mariners, but also for his insights into abstract mathematics and science, and how it related to military strategies.[3]

But they were not the only adventurers flocking to Dr. Dee's doors. As early as February 1563, Dee had written to Lord Burghley from an inn in Antwerp aptly named the Golden Angel. Dee had already become a great friend of the Flemish master cartographer Gerard Mercator.[4] Another of his great friends was Abraham Ortelius, a generation younger than Mercator and a brilliant mapmaker in his own right. Dee had known Mercator since his days at Louvain in 1547, when Mercator described him as a "tall, slight youth, looking wise beyond his years, with fair skin, good looks and bright color."[5] Back then, Dee was only nineteen.

By 1563, Dee had come to an "arrangement" with Cecil that in

exchange for important information, Cecil and others in positions of power would help him grow his expensive and rare library relating to mathematics, cosmography, astrology, geography, the scientific mysticism of the Cabala, and the writings of the ancients. A voracious reader and devoted correspondent with his Continental friends and luminaries, Dee had already proved to the Privy Council that he could provide them with the crux of a fledgling yet well-oiled espionage network. For Dee, espionage was only one of the end results of the codes and ciphers—a gift from the magical scientific principles of the Cabala—upon which he worked. It was the bigger code, or the unraveling the universe's mysteries for man's understanding, that enthralled him. Espionage was a means to an end, providing him with cash to pursue his travels, to meet more men of thought, to protect the recent Protestant rise, and, above all, to purchase more books.

Dee also accepted government research projects to earn his daily crust. In 1570, Christopher Hatton and Leicester commissioned Dee, through Edward Dyer, to write a "state of the nation" paper. The resulting *Britannicae Republicae Synopsis* is one of the most perceptive and helpful overviews of the realm's political institutions, economy, and defenses.[6] This document clearly identifies the problems besetting Elizabeth's England, from urban degeneration to a declining textile industry, currency debasement to decline in trade, religious strife to unemployment and vagrancy. What is significant, though, is Dee's use of the word "republic." He was emphasizing the ancient need to engage the people in a newfound patriotism, as part of a "common weal" or commonwealth. His philosophy was neoplatonist in approach, and he urged philanthropy from those who could afford it in good works at home in order to promote public prosperity.

But this was not Dee's sole or, indeed, his most important use to the queen. Elizabeth also used Dee's services to interpret signs. He had been hastily summoned to Windsor to explain the sudden appearance of a new star in the constellation Cassiopeia. Surely, it forebode something of great import—either for good or evil, Elizabeth asked. And if there was some means by which evil for the realm could be turned to good, Dee was the only person the queen trusted to tell her how that might best be achieved. Elizabeth had

long believed in her own royal "magic," and her highly rated divine royal touch was said to prove her legitimate claim to the throne.

Of course, Dee had already been called to cast her horoscope for the most propitious date for her coronation back in 1559. By this time, Elizabeth had long accepted his advice on the geography, cosmology, or astrology relating to maritime expansion. Dee had read every rare book imaginable on these subjects, and he was increasingly aware of "signs" in the heavens, based on his knowledge of the Hermetic tradition, which blended principles of the ancients with Cabala, early Christianity, and Egyptian philosophical religions. When Dee predicted that the new star was a portent of her rise in the world—in economic, political, and religious terms—the queen was grateful, and pacified.

But Elizabeth was never one to rest on her laurels. She knew that the only way in which Dee's prediction would come true was through shedding her isolationist tendencies, expanding trade, and exploring the new worlds beyond the equinoctial. Burghley was alarmed by the implications of Dee's advice, where the likes of Leicester, Walsingham, Christopher Hatton, and Philip Sidney were entranced.

So when Richard Grenville, the former "sheriff of Cork" in Ireland, had petitioned the queen as well as Lord Admiral Clinton on March 22, 1574, with a proposal to sail to the northwest rather than the northeast to find a passage to Cathay, the paper seemed as if it had surely been written in consultation with Dr. Dee. Grenville's proposed plan, entitled "The Discovery Traffic and Enjoining of Lands South of the Equator Not Already Possessed or Subdued by Any Christian Prince," was at great pains to deny trespass upon any Spanish- or Portuguese-held lands. The expedition's main purpose, Grenville claimed, would be to explore Terra Australis Incognita. At the behest of the lord admiral, who may well have been an investor, the queen granted a letter patent for Grenville to set sail. The 200-ton *Castle of Comfort* was purchased jointly with John Hawkins, and preparations for the voyage began.

Whether Elizabeth heard, or suspected, that Grenville's real objective was to emulate Drake's escapades in the West Indies, is difficult to say. But the new Spanish ambassador, Bernardino de

Mendoza,[7] had certainly had wind of it, and he reminded Elizabeth of how hard they had all worked to bring about this new era of peace. On reflection, the queen, in one of her aggravating "second thoughts," cancelled the letter patent to Grenville and forbade the adventurer from sailing on his first transatlantic voyage. The *Castle of Comfort* was leased out instead to the Prince de Condé for his Huguenot roving, with Grenville and Hawkins receiving a share of any profits.[8] Within the year, Grenville received his knighthood for "services to Ireland," perhaps to assuage his bruised ego.

It would only be in 1579, when John Oxenham was tortured by the Inquisition after his capture in Panama two years earlier, that the true purpose of the Grenville expedition was known. To avoid any further agony, Oxenham avowed that the project was "to come and found a settlement on the River Plate and then pass the Strait [meaning the Magellan Strait] and establish settlements wherever a good country for such could be found."[9] But how would Oxenham have come by that information? Drake is the most likely answer.

The Grenville petition had angered the Muscovy Company, too, which had been granted an exclusive license to explore the Northeast Passage to Cathay. The queen's Letter Patent was an infringement on their rights. And while the lord admiral had supported Grenville, Francis Walsingham, a major shareholder in the Muscovy Company, did not. It wasn't the first time that the company had objected to "interlopers" seeking royal approval. Humphrey Gilbert had run afoul of the Muscovy Company in the 1560s when he had initially mooted a voyage to Cathay via the northwest. He soon realized that he'd have to give up the idea, or undertake his enterprise as a mere servant of the company.

But all this would soon change. A new type of adventurer was appearing on the scene. They were essentially pirates—with little education, and fewer manners still. They were ruthless, hotheaded, and, at heart, fairly unpleasant men. But they often had the backing of the queen's gentlemen adventurers, since they had been rovers for decades. Martin Frobisher was just such a man.

Frobisher was a corsair-turned-merchant adventurer who had spent time in jail in England and Guinea for his roving activities. The nephew of Sir John Yorke, one of the Muscovy Company's leading

lights and a steward at the Tower of London and the mint, was
a pioneer himself in the now defunct Guinea trade. It was Yorke
who had arranged for the fourteen-year-old Frobisher to go on
Wyndham's ill-fated Guinea voyage. Frobisher was one of the few
lucky ones to have survived. A year later, he had returned as part
of the Leicester-backed adventure to establish a fort on the Gold
Coast. Soon Frobisher fell out with his uncle, but he was clever
enough to know that in order to conquer vested interest of any of
the "companies," he needed a powerful champion.[10]

Ambrose Dudley, Earl of Warwick and Robert's older brother,
was just that man. By the end of 1574, the Muscovy Company was
forced to bow to Warwick's pressure with the queen, and stood aside
while Frobisher was granted a license, along with the merchant
adventurer Michael Lok, to explore the eastern coast of North
America for a Northwest Passage to Cathay. Lok, a London member
of the Mercers' Company, had previously been agent of the Muscovy
Company. When he agreed to provide personal loans of more than
£800 cash ($277,382 or £149,936 today) to the expedition, the Letter
Patent was granted again.[11] Lok thereby became the major promoter
of the voyage. Having traveled widely himself in the services of the
company, Lok considered that he was an amateur cosmographer,
and he became an avid student at the Dee nursery.

At a meeting in Mortlake with the experienced Muscovy pilot
and former Dee pupil Stephen Borough, Lok agreed to a deal with
the queen's cosmographer to instruct his partner and fleet captain,
Martin Frobisher, in the art of navigation. Dee moved into Muscovy
House and began at once to teach Frobisher and his ship's master,
Christopher Hall, the navigational experiences of Columbus, and
how to keep proper records. He also gave Frobisher, who was after
all a novice to transatlantic crossings, a grounding in the importance
of frequent depth soundings, how to take and calculate readings for
latitude and longitude, how to deal with the natives, and how to
ascertain if ores might be valuable. But Frobisher and Hall were, by
and large, ignorant, and were unable to understand the importance
of the simplest mathematical exercise.

Nonetheless, Dee prevailed as best he could, despite the widely
held view that mathematics was "without convenient practise at sea."
Where Frobisher found it difficult to see the importance of calculations,

the mathematics in Lok's accounts of the Frobisher voyages reveal in wretched detail the huge expectations for success from 1576 to their utter failure to live up to those high hopes in 1579.[12]

While the first voyage was meant to leave England for the east coast of America in 1575, subscribers were like the illusive gold dust they sought on an ill wind, and the expedition had to be delayed. At the end of the day, Lok's and Frobisher's expectations had to be scaled down, and the voyage was limited to two small barks and a pinnace instead of the three larger ships originally contemplated. When Frobisher was looking around later for people to blame, Lok told him that potential investors' reluctance to invest was due to Frobisher's reputation as a pirate. Whatever the truth of the matter, it was Lok's salesmanship that stressed the varied luxury commodities that the road to Cathay might yield, the English woolens the natives might purchase, the precious metals its shores certainly possessed, and the train oil that its oceans held that finally clinched the share purchases. But despite Lok's enthusiasm, the total cash raised was a mere £875 ($303,387 or £163,993 today). Since costs for the expedition had already come to £1,613 19s. 3d. ($561,697 or £303,620 today), Lok had to make good on the rest from his own pocket. Out of the eighteen shareholders, Lord Burghley, Sir Francis Walsingham, Philip Sidney, Thomas Randolph (ambassador to Scotland), and the Earls of Leicester, Warwick, and Sussex were the most prominent, having invested £50 each.

Sir Lionel Duckett was also an active promoter, and it was he who paid for Dee's time and expenses in the technical planning. The Mercator map was provided to Frobisher in place of the Ortelius map that had been favored by Gilbert in the 1560s, but as neither one had any real degree of accuracy, the results could only be based on a fiction. Both maps showed the North American coast at the same latitude as the British Isles, with the legendary Strait of Anian separating Asia and America. During the preparation stage, Lok thought it would be useful for the adventurers to meet with Sir Humphrey Gilbert and arranged the meeting. Naturally, Gilbert expounded on the virtues of the 1564 Ortelius map over the 1569 Mercator map, and the importance of the fabled islands in the North Atlantic called Friesland and Estotiland.[13] It was a case of the blind leading the blind.

Still, at Dee's insistence, the Mercator map prevailed. Dee also ensured that they carry a brass *horologium universale* and an *armilla ptolomei*, among other instruments, to help the mariners get their bearings. Alas, these were better suited to Dee's library than to a transatlantic voyage, particularly in the hands of men like Frobisher and Hall. Dee's influence can also be seen by the library aboard Frobisher's 30-ton bark, *Gabriel*, by the inclusion of André Thevet's *Cosmographie universelle* (in French, of course) and his *New Found World or Antartctike* alongside Pedro de Medina's *Regimiento de Navegación* (in Spanish), Cunningham's *Cosmographical Glasse*, and Robert Recorde's *Castle of Knowledge*. The great navigator, William Borough—who later fell out with Dee publicly—wished Frobisher well by presenting him with an astrolabe, but he still refused to invest in the voyage personally.[14]

Despite all the unpromising financial omens, Frobisher set sail at last from a rainy London in the *Gabriel* with Christopher Hall, and Nicholas Chancellor (son of explorer Richard Chancellor) as his purser on June 7, 1576. There were seventeen men who crewed the ship as well. On the *Michael* (also a 30-ton bark), there was a crew of twelve, and the expedition's unnamed 7-ton pinnace had a crew of three.

The bad omens continued. Before leaving Deptford, the pinnace struck another vessel, losing its bowsprit. The fleet assembled on the Thames in front of Greenwich Palace, and let off its demiculverins in salute to the queen. "Her Majesty," Christopher Hall recorded in the ship's log, "beholding the same, commended it, and bade us farewell, with shaking her hand at us out of the window."[15]

Following Mercator's map, they headed west by north, expecting to land smartly across the Atlantic at the mouth of the Strait of Anian. In the Shetland Isles to the far north of Scotland, the *Michael* began to leak badly, and the ships had to put into shore for repairs. From there Frobisher sent a letter to "the worshipful and our approved good friend, M. Dee," assuring him that "we do remember you, and hold ourselves bound to you as your poor disciples."[16]

Though they had made the crossing in two weeks, of course they couldn't find the strait. In fact, they thought they had landed at the mythical island of Friesland, since Greenland was much farther to the north. (Naturally, it was Greenland.) They had entered the

unknown, the far northerly region that Dee called "Thule," being neither land, sea, nor air. As they passed through sheer, spectacular towers of ice, an amazed Frobisher christened them "Dee's Pinnacles" in honor of the teacher he had once shunned.

But nothing had prepared them for the harsh weather, the ice, the thick arctic fogs and snows in mid-summer. By the middle of July, a "great storm" raged, and the pinnace was sunk. The *Michael* stole away from the *Gabriel* and headed straight home for England. The skipper claimed on his return that the *Gabriel* was feared lost in the arctic gales, too. But Frobisher was made of sterner stuff than the *Michael*'s captain. Despite the *Gabriel* capsizing—saved only by Frobisher's "valiant courage" in ordering the mizzen mast to be hacked away while he untangled the rigging and the sails filling with icy water—the ship sailed on. Drenched in freezing saltwater, alone in the desolate heaving sea, Frobisher sailed on for two days more before sighting land.

Where Columbus first sighted sugar sand beaches and swaying palms in his new world, Frobisher spied "a land of ice of marvelous great height." This was "Meta Incognita"—the Limit of the Unknown. To Frobisher, it was Atlantis, the fabled Lost Continent. It was, in fact, the southern tip of Baffin Island. Threading their way through soaring icebergs, frozen seas, and heavy fogs, at around 63 degrees they found an inlet, and sailed into what is known today as Frobisher Bay. For another eight days the *Gabriel* wended its way through the ice blocks unable to see beyond the next bend or the towering ice floes. Finally, Frobisher went ashore, and claimed that,

> *there he saw far the two headlands at the furthest end of the straits and no likelihood of any land to the northwards of them and the great open [sea] between them, which . . . they judged to be the West Sea [the Pacific] whereby to pass to Cathay and to the East India.*[17]

While this picturesque scene may not have struck a familiar note to Elizabethans, with the benefit of four hundred odd years and twenty-twenty hindsight, Frobisher had intended his claim to rival that of Drake.

But this voyage bore little resemblance to Drake's escapades. They would turn endlessly back on themselves along the Canadian coast of North America with only the mysterious loss of five of his men and one hostile encounter with Inuit kayaks to show for their efforts. Frobisher had also lost two of his boats in the episode (one known to be sunk) and rightly felt that with a story as grand as Drake's—that he had *seen* the passage to Cathay with his own eyes—his investors wouldn't much notice that the only "riches" they were bringing back was the captured Inuit tribesman and a large hunk of black rock given to him by one of the missing mariners, Robert Garrard. At least the unusual rock proved they had hit land.[18]

Frobisher was no Drake, but he knew what he was doing in bringing back the Inuit. The first North American to be paraded ignominiously through London made for great theater with the Elizabethans, who loved their theater. Their "strange man and his boat . . . was such a wonder onto the whole city and to the rest of the realm that heard of it, as seemed never to have happened the like great matter to any man's knowledge."[19] Frobisher was delighted that the Eskimo's Tartar features were suggestive of the Orient, and that Lok and others had made the connection without too much prompting. But it was the mysterious black rock that would eventually cause the greatest stir.

Lok had it assayed by three different experts, each and every one of them declaring that it contained no metal or minerals of note. Finally, in January 1577, the determined Lok took it to an Italian goldsmith in London, who claimed (though how is not clear) that the stone was rich in gold ore. The "secret" of the ore was revealed to Elizabeth by Lok in a letter. When Walsingham replied on the queen's behalf that it seemed odd, since none of the queen's assayers had found any gold, Lok remained adamant that they had discovered gold in the frozen wastelands of Meta Incognita. Even Dee seemed to agree. When no arrangement had been made with the crown for a follow-up expedition, after three more months of negotiations, in March 1577, Frobisher's and Lok's news "bafflingly" leaked out. There was "the hope of more of the same gold ore to be found," they declared, and that this "kindled a greater opinion in the hearts of many to advance the voyage again. Whereupon preparation was

made for a new voyage against the year following, and the captain more specially directed by commission for the searching more of this gold ore than for the searching any further of the passage."[20]

Frobisher's fiction—that he had seen the Pacific Ocean from the shores of eastern North America—had brought gold fever to London, and would soon bankrupt his friend and business partner, Michael Lok.

21. Dark Days at Rathlin Island ❧

Great Framer and Preserver of Things, O God, . . . Free
the country and kingdom most especially from all assault of
war; keep us exempt from the internal and domestic tumults
by which a good part of the Christian world is
now disturbed . . .

—PRAYER BY ELIZABETH I, C. 1578

While Michael Lok and Martin Frobisher were attempting to entice the great and the good of England to invest in their next Northwest Passage venture, Francis Drake was finishing his harsh service in Ireland under the erratic Walter Devereux, Earl of Essex. Devereux's "plantations" were, like all Tudor projects in Ireland, bogged down in guerrilla warfare. Resistance this time was led primarily by the powerful lord of Tyrone, Turlough O'Neill. But the Scots who had been imported for decades as mercenaries to fight the English were also in revolt. They had decided to stay, and settled in the Glens of Antrim in lands that the O'Neill called their own. Their putative head, Sorley Boy MacDonnell, was the son of the Lord of Islay and Kintyre in Scotland, and had dug in against the English on the jagged L-shaped rock of an island called Rathlin, four miles long by three miles wide. This storm-swept rock in northeastern County Antrim was an oasis for seabirds— razorbills, cormorants, guillemots, puffins, and gulls. The avian population outnumbered the people sheltering there by at least a thousand to one. But its days as a wildlife sanctuary were numbered. In a land that abounds with legend, even a small, craggy outcrop like Rathlin had its moment in ancient lore. It was said that the great Scots king, Robert the Bruce, had centuries earlier taken refuge from the English in the stone castle there. Now, Sorley Boy MacDonnell had followed in the Bruce's footsteps, and he brought his chiefs and their families to Rathlin and to safety.

Strategically, it was a sound move. Rathlin was only thirteen miles from the Scottish coast, and only three from Ireland. The waters surrounding the island had been notorious for centuries for their sudden whirlpools and deadly currents. Rathlin's cliffs remain legendary for attracting shipwrecks over four hundred years on. It is no wonder that when Sorley Boy and his chiefs had retreated to Rathlin with enough food, seed, and animals to last them years, he had every reason to think that he was untouchable. But he hadn't reckoned with Devereux and his new admiral, Francis Drake.[1]

Devereux had made a petition entitled "My Opinion for the Reformation and the Government of Ulster to the Privy Council" in 1574 to provide him with ships for just such an eventuality. Ireland's coast is littered with thousands of safe havens and coves that can be approached only by an invading force by sea. It was Burghley who drafted the Council's reply to Essex in his document "Doubts to Be Resolved by the Earl of Essex," in which the fifteenth item listed queries, "What is to be thought requisite for the having of any shipping upon the sea, besides victuallers, to keep out the Scots, for that no mention is thereof made in the plot [plan]. . . ."[2]

Devereux gave his answer in early 1575, mentioning Drake as the cause for his change of tactic:

> *The shipping was not mentioned in the plot, but yet not unthought of, for I wrote unto my agents to write to my lord admiral [Clinton], that the shipping now here might be converted to buy certain frigates which one Drake brought out of [the] Indies whereof one is in possession of Mr Hawkins [and] one of Sir Arthur Champernowne They were bought at easy prices. . . . They will brook a sea well and carry 200 soldiers, as I am informed, and yet they draw so little water, as they may pass into every river, island or creek where the Scottish galley may flee, and are of better strength [and] stowage than others, for the galleys are made more slight and thin than the wherries upon the Thames. No shipping therefore [is] so good for this purpose in my opinion as the frigates. . . . Good choice must be made of mariners for these boats, for ordinary sailors love not to pull at an oar.*[3]

Essex's reply lifts the veil of history momentarily. On his return from the West Indies, Drake had evidently sold on his Spanish prizes to Hawkins and Champernowne, who tried immediately to flog them on to Devereux. But ships without a daring captain would only partially fulfill Essex's needs. He had heard of Drake, through the Leicester and Sidney connection, but hadn't the means to attract him into defense of the Irish plantations. After all, Ireland was not Drake's cause célèbre.

Fortunately for Essex, Leicester also took an active interest in Ireland and its affairs. Further ships were bought or leased, and by May 1575, Essex had a squadron with Drake as its admiral. Drake came to Ireland with his own ship, the *Falcon* (probably a frigate), and a pinnace. There were also eighteen mariners, a master, a pilot boatswain, a steward, a carpenter, and a gunner. His thirteen-year-old cousin, also named John Drake, joined the crew as its "boy." Though Drake was the fleet's commander, both he and a Captain James Sydae drew a salary of 42 shillings a month ($690 or £373 today). For the next four months, Drake saw active duty of a kind that was unlike any other he had experienced before. While he commanded the sea operations, he had little to do with land battles, and presumably he didn't like what he saw.

In May 1575, Essex wrote to Burghley, "If the frigates come there shall not be a boat that remain in the Rathlins, or the Glens, or come up that coast."[4] He clearly intended for his fleet to cut off the supplies and communications to Rathlin Island by using Drake. The frigates were ordered to assemble at Carrickfergus, while the Earl mysteriously withdrew toward the Pale around Dublin. Captain John Norris, veteran of the Huguenot civil wars in France, had volunteered with his three hundred foot soldiers and eighty horse to take the island by storm. Where Drake had already become known for his fair treatment of the enemy, and had even gone out of his way to protect the women at Ventas Cruces, Norris had earned a well-deserved reputation as a ruthless soldier who took no prisoners.

But why had Essex withdrawn before Norris had launched his attack? Had his experience of Ireland taught him that the wind had eyes, and that by his sleight of hand, the Scots wouldn't be alerted to the attack? Or was he afraid that whatever brutality Norris would

mete out to the Scots might fetch some sturdy rebuke from the queen? Whatever the truth of the matter, Norris ordered Drake to take his army across to Rathlin on July 20.

True to its legend, the winds at Rathlin whipped up and the sea swelled almost immediately, dispersing the fleet. It was two days before they had regrouped and made the three-mile crossing, landing on the eastern side of the island. The troops were disembarked and marched northeasterly toward the castle with such speed that many of MacDonnell's followers had been caught outside. In the inevitable skirmish, one of Norris's men was killed before the Scots reached sanctuary. While Norris and his soldiers pursued them, Drake and his mariners landed two siege guns and brought them within firing distance of the castle. After three days pummeling the castle walls, they finally breached the Scots' defenses. Yet despite this, and an attempted storming of the castle, it took another two days before the Scots asked for a "parlay."

Meanwhile, Drake and his sailors were kept very busy blockading the island from relief vessels or escaping Scots. During the siege of the castle and the next few days, Drake captured and burned eleven Scottish galleys. Any survivors were taken aboard Drake's ships, to be exchanged against English prisoners at a later date. What Drake didn't know was that there would be no exchange.

At the castle, Norris was told by the surrendering Scots that they wanted only to return to Scotland. In the circumstances, their lives, they knew, would depend on Norris's mercy. But they had put their lives into untrustworthy hands. Norris claimed that he would grant clemency to the constable of the castle and his family (who was the son of an Irish chieftain), but that for the Scots, their lives would depend entirely on the "courtesy of the English soldiers," to use the euphemism of the day. What followed was the worst bloodbath in forty years since the Pardon of Maywood in 1535, when English soldiers butchered the garrison at Dengen after its surrender.[5]

Every man, woman, child, and baby on Rathlin Island was slaughtered. More than one hundred horses, three hundred cows, and three thousand sheep were confiscated or killed, and the crops burned, and enough corn to feed two hundred men for a year confiscated. For days the English scoured the island looking in every cave, on every cliff face, in the ditches or undergrowth for any

survivors. Several hundred more Scots were brutally slaughtered where they were caught in the days following the surrender.

And yet, when the massacre was reported back to the Privy Council, there was no word of rebuke against Norris or Essex. In fact, the Privy Council congratulated Essex on a successful campaign. Still, it is strange; Elizabeth had expressly warned Essex when he set out for Ireland that he mustn't shed blood unnecessarily. Drake's official reaction is also unrecorded. Where Drake had shown his enemy compassion in the heat of battle, Norris had shown unabated cruelty. It most certainly wasn't the way Drake would have handled things. But the admiral was not without power, as it happened. The events that followed tell their own tale.

When Sir Henry Sidney—a distant relation of Drake through Drake's godfather, the Earl of Bedford—was brought across to Dublin for his renewed tenure as lord deputy, it was Francis Drake who piloted his ship. What words were exchanged between them we can only imagine. Sidney landed on September 7, and the entire English naval squadron in Ireland was disbanded twelve days later. Only Drake remained on the payroll until the end of the month. Essex raged at Sidney's incompetence. After all, Rathlin could be occupied again. In support of Essex, and in a move that was tantamount to mutiny, John Norris complained to the Privy Council that

> my Lord Deputy that now is presently upon his landing there discharged the frigates which the Scots having intelligence of and of their departure, upon the last voyage that the aforesaid hoy made for the revictualling of the castle, on their return assaulted, took and burnt her. My humble suit to your Honours is not to put this loss upon me ... for had I not been assured by the Earl of Essex that he understood by certain [of] Her Majesty's letters to himself, her pleasure was the frigates should not have been discharged as long as the place was retained, I would more sufficiently have provided for the safety of the passage.[6]

Before the end of the year, Sidney ordered the English garrison at Rathlin to be abandoned. The forty soldiers who had remained there had been reduced to eating their own horses for food due to the Scottish reprisals. And without Rathlin, there was no need for a

naval squadron. Essex and Drake returned to England, where they both received rewards from the court. By the summer of 1576, Essex had been sent back to Ireland as its earl marshal, but he died within weeks of dysentery, with dreams of yet more bloodshed thankfully unfulfilled.[7]

Drake had shared his own dream from the treetop high above Darien with the earl before his death, as well as his new friend, a gentleman named Thomas Doughty, who had served Essex well as a secretary. Doughty vowed to accompany Drake on his next great voyage, and to help him in any way he possibly could at court.

22. Drake's Perfect Timing ❦

He was sent for unto Her Majesty by Secretary
Walsingham, and she told him that she would gladly be
revenged on the King of Spain for divers injuries and that
Drake was the only man that might do this exploit . . .
— SIR FRANCIS DRAKE, *Sir Francis Drake Revived*

The reappointment of Sir Henry Sidney as lord deputy in Ireland put that troubled province back into a safe pair of hands from the Privy Council's perspective. There was no further need for an Irish navy, and hence no need for Drake to squander his maritime brilliance there.[1]

Where Drake's timing had been decidedly poor on his return from the West Indies, his return from Ireland was blessed in every way. For years, Sir John Hawkins had had an eye on his father-in-law's position as treasurer of the navy, and indeed Benjamin Gonson was grooming him for that post. In February 1577, Hawkins claimed the sums of £100 and £950 from lord treasurer Burghley: the first sum was for clearing "the coast of pirates" and the second, for his provision of ships and losses incurred in Essex's Irish "plantation" scheme. He even listed the £150 costs for recovering his captured mariners from the King of Spain's clutches in sending George Fitzwilliams to meet the king in 1571.[2] In light of what followed, it is fairly clear that Burghley connived with Hawkins in making these demands.

Hawkins's "reasonable suits," so Burghley stated, included information garnered from Gonson's naval accounts as well as discussions with Elizabeth's two master shipwrights, Peter Pett and Matthew Baker. Not satisfied simply to have his losses covered, Hawkins went on to accuse the Winter brothers and the Navy Board of feathering their own nests and avoiding their blindingly obvious inability to deliver a better, sleeker, more efficient navy for less money. The

Winters' annual costs were £6,000 ($2.09 million or £1.13 million today), and Hawkins claimed that a "far better" navy could be maintained for £4,000 yearly. To build seven ships had cost nearly £5,000 in the previous year, and Hawkins predicted that the current year would see a doubling of that sum. His claim, entitled "Abuses in the Admiralty Touching Her Majesty's Navy Exhibited by Mr Hawkins" went on to allege that new ships were being built for £800 too much ($274,658 or £148,464 today) and wood provided for £400 per load too much ($137,329 or £74,232 today). These were serious charges indeed—particularly against a national hero like Sir William Winter—and could not go unaddressed.[3]

The accusation made, Hawkins could only wait out the results of the hornets' nest he had stirred up against the Winter brothers. Though Hawkins had Burghley's trust, the Lord Admiral Clinton, aging, but not without substantial influence, weighed in on the side of William and George Winter. Nonetheless, Hawkins was eventually appointed as the new "treasurer for marine causes," to replace his father-in-law on November 18, 1577. "I shall pluck a thorn out of my foot," an evidently relieved Gonson warned him, "and put it into yours."[4] Hawkins's appointment is a demonstrable change of direction, and an important one in English naval history. Because of, rather than despite, his merchant pirating of the 1560s, a redesign program would be undertaken in his tenure that produced precisely what he had sought: sleeker, swifter, more heavily armed, more efficient ships that would run circles around the Spanish and Portuguese.

Drake's return from Ireland also coincided with the outburst of "gold fever" at court, introduced by Michael Lok and Martin Frobisher. The air was filled with expectation that the gold that had so long filled Philip of Spain's coffers might justly come to England, too, through Frobisher's mining exploits. The only cloud on Drake's horizon was the strong possibility that English merchants—if they knew what he had in mind—could veto his own plans for the future.

Some merchants had already turned to illicit trade and plunder, while others clung precariously to the "old ways" of the merchant companies and government-granted monopolies. But it was the

"newer" aggressive English traders who, little by little, had been gnawing away at the fringes of Spain's empire. Yet miraculously, while English depredations against Spanish shipping had been steadily on the rise, so trade with Iberia had risen, too. English trade with the Barbary Coast (largely in the control of the Portuguese or Moors) amounted to some £17,775 ($6.11 million or £3.3 million today) by 1576. England's trade with Portugal in the same year was £8,758 5s. 4d. ($3.01 million or £1.63 million today). While trade had been higher in previous years, there were still some 4,361 English officially resident in Portugal (there were only 7 Portuguese in England in the same period). The treaty of 1572 had also finally come into effect opening trade to the Barbary Coast. All this "progress" led the merchants to hope widely that the English would no longer be viewed as interlopers.[5] It was a slender thread to cling to.

Elizabeth, meanwhile, was never one to pass up a great opportunity to slyly knife Philip in the back. English shipping had once again begun trading in the Mediterranean after the defeat of the Turks at Lepanto, but the war of Cyprus (1570–73) had crippled trade with Venice anew. With Antwerp's trade in chaos since 1569 and the arrival of Alba, the 1570s became a decade of plunder, piracy, and underhanded dealing. A veritable tidal wave of piracy swept the Italian and Iberian peninsulas, with English rovers leading the pack along with the French, Barbary, and Turkish mariners. By the latter part of the decade, the deadly combination of Leicester and Walsingham granted a monopoly to Acerbo Velutelli, a Luccan merchant, to freight imports of currants from the eastern Mediterranean to England aboard English ships. Among the ship owners were Sir John Hawkins, Oliver and Nicholas Stile, Simon Lawrence, and Thomas Cordell.[6]

Still, the most important of the Levant traders would be Sir Edward Osborne. According to Hakluyt,

> *Sir Edward Osborne and M. Richard Staper seriously considering what benefit might grow to the common wealth by renewing of the foresaid discontinued trade, to the enlarging of Her Majesty's customs [duties], the furthering of navigation, the venting of diverse general commodities of this Realm, and the enriching of*

the City of London, determined to use some effectual means of re-establishing and augmenting thereof. Wherefore about the year 1575, the foresaid R.W. [Right Worshipful] merchants at their charges and expenses sent John Wight and Joseph Clements by way of Poland to Constantinople, where the said Joseph remained 18 months to procure a safe conduct from the grand signory for Mr William Harborne, then factor for Sir Edward Osborne. . . . The said Mr Harborne the first of July 1578 departed from London by the sea to Hamburg, and thence . . . traveled to Leopolis in Poland . . . he arrived at Constantinople the 28th of October.[7]

Elizabeth was desperate to foster good relations with the Porte (the Sultan's government in Constantinople), as a counterbalance to Spain's open animosity and France's invariable spoiling tactics. Harborne's embassy to Constantinople was not merely a new commercial venture to Spain's old enemy; it was a matter of considerable interest to the state, with state sanction. Walsingham's memorandum to the queen from 1578, entitled "A Consideration of the Trade unto Turkey," sets out how to use this new and important market "to great profit" through direct access to the Levant. He also urged the queen to look at the political advantages to an Anglo-Ottoman entente, thus beginning the long and lucrative chapter in England's history of trade with the Middle East.[8]

It was as if all these excellent signs for his project were conspiring to raise Drake's expectations. But there was more. The single most important development in English thinking of the period, attributable to Dr. John Dee, was about to be published. In August 1576, Dr. Dee wrote his first draft of the incredibly insightful paper "A Petty Navy Royal," which would change English thought on the island nation's relationship to the sea forever. It might have also been aptly entitled "In Defense of the Realm," and it was made available to the public as part of his *General & Rare Memorials Pertaining to the Perfect Art of Navigation*, in 1577.

Dee logically laid out a thirteen-point plan for the development of a standing navy for England's defense. He urged for a navy of seventy-five or more tall ships, well provisioned with supplies to patrol England's coasts, not only to fend off any threat of invasion

from her neighbors, but also from Spain and the pope, who had already shown their true colors through the Ridolfi plot and the bull of excommunication. Dee is the first to refer to the "British Empire" and to England's shores as part of a greater Britain. He covers all skills required in such a defensive force from mustering the men to what tasks they would need to be trained to perform ranging from piloting skills in harbor and recognizing landmarks to the greater "art of navigation" and every shade of expertise in between. It is obviously written with an eye to presentation to Elizabeth, since his point 5 lays claim to the intractable problems of vagrancy and crime when he writes, "How many hundreds of lusty and handsome men would be, this way, well occupied, and have needful maintenance, which now are either idle, or want sustenance, or both; in too many places of this renowned Monarchy?"[9]

Not pirate nor prince nor potentate would dare attack a realm so strong, Dee continues, adding that pirates of "good character" would desire to be employed in such an instrument of national pride. Foreign fishermen guilty of invading England's shores for decades could be rebuffed by a standing navy, thereby ensuring enough fish stocks for the common good. But Dee, as an experienced intelligencer, added that humble fishermen may not be fishermen after all:

> And this sort of people they be, which otherwise by colour [under cover] and pretence of coming about their feat of fishing do subtly and secretly use soundings and searchings of our channels, deeps, shoals, banks, or bars along the sea coasts, and in our haven mouths also, and up in our creeks, sometimes in our bays, and sometimes in our roads, etc.; taking good marks, for avoiding of the dangers, and also trying good landings. And so, making perfect charts of all our coasts round about England and Ireland, are become almost [more] perfect in them, than the most part of our masters, leadsmen or pilots are. To the double danger of mischief in times of war; and also to no little hazard of the State Royal, if maliciously bent, they should purpose to land any puissant army, in time to come.[10]

Dee concludes his thesis with the correct assertion that "this Petty Navy Royal is thought to be the only Master Key wherewith to open all locks that keep out or hinder this incomparable British Empire

from enjoying . . . such a yearly revenue of Treasure . . . with so great ease to . . . yield the like to either king or other potentate . . ."[11]

The timing of Dee's publication was no accident. Frobisher had already left on his second voyage, and adventurers of all sorts were beating a path to his door. Several years earlier, he had presented the queen with his view of the state of the realm that clearly demonstrated that something had to be done to alleviate the perpetual state of near-war abroad so that the people could enjoy their long-earned peace at home. Protestants everywhere—especially in Flanders and the Dutch provinces—were under siege by either the pope, Philip II, or Charles IX of France.

Crucial to this exposé was the simple fact that Elizabeth trusted Dee implicitly. Like Leicester, he was affectionately called her "eyes." While she paid him little by way of money, he was always welcomed at court. His near neighbor, Sir Francis Walsingham, was also a great admirer of his, as was Leicester himself. It would be these three men who would form the core support for Drake and his fellow adventurers, both at court, and in the realm generally. Burghley, on the other hand, had made his views known with regard to partaking in plunder, preferring the integrity of investments through the guise of a joint stock company like the Muscovy Company instead. Though he turned his nose up at booty as a means to become personally wealthy, Burghley welcomed it nonetheless into Elizabeth's purse for the realm.

And now, the final factor came into play to clinch Elizabeth's favor for Drake. Again, Burghley had been urging Elizabeth quite strongly to act at once and marry Francis, the Duke of Alençon. It was the last chance, he thought, for the queen to have a child. There was an edginess at court while power shifted again subtly in favor of Leicester and Walsingham, and away from Burghley. Christopher Hatton had joined ranks with Leicester, and it was their violent opposition to the marriage that won out in the end, temporarily unseating Burghley from pole position.[12]

All this happened just as Drake made his appearance in court. He knew that Grenville had recently presented his own scheme for sailing into the Pacific to Burghley, and he also knew that, although Grenville was regarded as a renegade with little sea experience to cope

successfully with the difficult conditions in the Strait of Magellan, he talked a very good game. Drake's old ship's master, John Oxenham, had recently embarked, too, in April on a small voyage of his own—to carry a pinnace across the Isthmus of Panama and raid the Pacific. Oxenham had no means of garnering government support; and if Grenville did, Drake's chances for a major plundering exploit would be at an end.[13]

But the time "wasted" in Ireland had been worthwhile in finding him patronage among the gentlemen adventurers at court as his backers. It had cost him dearly, however, in being the second Englishman ever to reach the Pacific.[14] What Drake had been temporarily unaware of was the delicate change in court power that wafted on the air. When Drake delivered his letter of introduction from Walter Devereux, Earl of Essex, to Sir Francis Walsingham, his timing proved superb.

What followed is shrouded in secrecy, as were all reports that later referred to Drake's voyage of circumnavigation. Walsingham and Leicester were, however, his first and greatest promoters. This "triumvirate" embodied Philip II's most entrenched enemies, and cleverest foes. Drake put up £1,000 ($341,621 or £184,660 today) himself to prove that he believed in his plan. John Hawkins followed with £500 ($170,811 or £92,330 today). William Winter, not to be outdone, contributed £750 ($256,216 or £138,495 today), along with the Lord Admiral Lincoln, Sir Francis Walsingham, the Earl of Leicester, and Christopher Hatton. George Winter, like Hawkins, invested £500. It was now up to Walsingham and Leicester to argue Drake's case before Elizabeth.[15] From the makeup of his investors, it would certainly have been evident to the queen that Drake's voyage had anti-Spanish—and not trading or imperialistic—motivations. In fact, when she met with Drake, she agreed to the captain's terms,

> that it might please her Majesty to grant . . . her ship the Swallow with her tackle, apparel, and only four culverins, with two falcons of brass [that] might be left to the said ship with the ordnance afore named might be valued by indifferent [independent] persons and that sum which the same shall amount unto her Highness to bear

*such portion as she shall like, and for the rest, the same to be born
by the parties that shall be thought . . . Upon good assurances to be
given to the Exchequer . . .*

*. . . that the Queen's Majesty may be made privy to the truth of
the voyage, and yet the color [cover] to be given out to Alexandria,
which in effect is ready done by a licence procured from the
Turks.*[16]

Burghley, though, worried Walsingham and Leicester. If he got
wind of an expedition bent on plunder, he would surely persuade
the notoriously fickle queen against "annoying the King of Spain."
And so, the solution to subvert Burghley was to put about—in a
very convincing manner—that Drake's destination was Alexandria,
since trade to the eastern Mediterranean had been reopened once
more. The queen herself was certainly in the know, for no pen was
ever put to paper to confirm the nature of the highly provocative
escapade other than what she wrote above, and she engaged Drake
in the subterfuge by agreeing to invest on condition that Drake
understood her "special commandment that of all men, my lord
treasurer Burghley should not know about it."[17]

Finally, in July 1577, the queen decided. Drake could go to
"Alexandria." Had John Dee seen into the stars to tell her that the
moment was right? Since Drake's greatest voyage had begun as a
state secret bent on plunder—and ended as a state secret for the
achievements he made—we will never know. Only a remnant of
Drake's instructions and how he readied his fleet survive. The rest is
lost in the fog of history.

What we do know is that on November 15, 1577, his tiny fleet
comprising the 100-ton bark, *Pelican*; the 80-ton *Elizabeth*; the
store ship *Swan;* the puny merchantman, *Marigold*; and the fleet's
scout and messenger ship, *Christopher*, set sail in Plymouth Sound.
Drake and his crew of 164 men were sent almost like "doves from
the ark" to perform miracles. The first miracle was to somehow
beat the King of Spain in his own empire. The second was setting
themselves against the vast and unknown expanses of sea. Despite
being beaten back into harbor virtually straightaway, Drake waited
out the Channel storms, and set sail again on December 13, 1577 on
the historic voyage.

Elizabeth was no fool, and she knew that nothing could be kept a secret for long from Burghley, as he ran his own spy network within court. But she could hope that the dark secret that she, Drake, Leicester, Walsingham, and her main courtiers were going to raid Spanish shipping in the Pacific just might elude him for a time. By then, hopefully, Captain Francis Drake would have returned from the Pacific with his holds filled with gold. England was emerging— whether Elizabeth liked it or not—as the political leader of European Protestants, and a fledgling world power, fighting "old" Catholic Europe with any tools she had at her disposal. And Drake was the sharpest tool in the box.

23. The Northwest and the Company of Kathai ✳

Ensnared by the enticements of this world or burning with
a desire for riches . . .
—DR. JOHN DEE, C. 1560

Drake's success and his ability to fund his South Seas project was in small part due to the gold fever that had swept the court and London after Frobisher's voyage. But who was the "leak" that began gold fever in the first place? There were many possibilities, with Michael Lok and Martin Frobisher at the top of the list. Fifty years after Elizabethan England, the Dutch suffered from Tulipomania, when a single rare tulip could fetch more than a fine home. While it's expedient to blame Lok or Frobisher, their investor list for the second expedition—excluding Elizabeth and Burghley—would not have been above suspicion as perpetrators of the act. The likes of the Earls of Leicester, Warwick, and Sussex, any of the West Countrymen, or Walsingham himself could have been involved to a greater or lesser extent.

Whatever the truth of the matter, gold fever did hit London and the court—hard. Anyone who was anyone clamored for shares in the new joint stock company that Lok was rumored to be setting up. "Frobisher . . . has given it as his decided opinion," wrote Sir Philip Sidney to his old friend and courtier Hubert Languet, "that the island is so productive in metals, as to seem very far to surpass the country of Peru, at least as it now is. There are also six other islands near to this, which seem very little inferior."[1]

In response, a grateful Lok launched a new joint stock company in March 1577, called the Company of Kathai, or Cathay Company, to manage the discovery and exploitation of gold in North America.

Its chief subscribers were Elizabeth and her court, with a total investment of £5,150 ($1.77 million or £955,737 today). The queen also ventured her 200-ton *Aid*.[2] Unlike the earlier voyage, it was truly a royal expedition with Edward Fenton, the Earl of Warwick's handpicked man, as captain of the *Gabriel*, and Gilbert Yorke, the lord admiral's choice, commanding the *Michael*.[3] Frobisher's lieutenant, George Beste, was Christopher Hatton's representative. The chronicler for the expedition was Dionyse Settle, who was the secretary of George Clifford, the Earl of Cumberland.[4] The admiral, the *Michael*, carried 134 men in total, including 11 gentlemen, 3 "goldfiners" [gold refiners], 20 soldiers, 8 miners, and a number of convicts from the Forest of Dean, brought along as "expendable" colonists for Frobisher to land on the imaginary Friesland. Life in the bleak winter landscape was deemed a reprieve for criminals, and a way for them to redeem themselves back into society. This was the first hint of a policy of "transportation" that would blight the English Empire for forty years of the nineteenth century. Frobisher's instructions regarding these poor souls was to land them on Friesland, and then —if possible—"to speak with them on your return." Fortunately for them, Frobisher off-loaded the convicts at Harwich, claiming that his ship was overloaded.

The orders received in the name of the queen to Frobisher and the other shareholders in the Cathay Company were quite clear:

> *To have regard that there be no spoil of the provisions taken in the ships.*
>
> *To dismiss, before departure or on the way, any that are mutinous.*
>
> *To depart before 12 May and make way north or west to Meta Incognita and the Countess of Warwick's island and sound in the Straight, which we name Frobisher's Strait, having been discovered by yourself two years since. So to order your course that the ships do not lose each other, and if any wilfulness or negligence appear in any person in charge, to punish such offender sharply, to the example of others.*
>
> *On arriving at the Countess of Warwick's island and sound, to harbor your vessels, and repair to the mines and minerals where*

you wrought last year, and set the men to work to gather the ore, seeing they are well placed from danger and malice of the people and any other extremity.

If you find richer mines than those whence you had your last year's lading, you shall remove and work them if convenient.

To search for and consider of an apt place where you may best plant and fortify the 100 men you leave to inhabit there, against the people and all other extremities.

To leave with Capt. Fenton the 100 persons, with orders to keep a journal of proceedings, noting what part of the year is most free from ice, and with him the Gabriel, Michael, *and* Judith *with provisions &c.*

To instruct all the people in any conference with the natives, to behave so as to secure their friendship.

After you have safely harbored your ships, set your miners to work, &c; if time permit, you are to repair with the two barks to the place where you lost your men the first year, to search for mines, and to discover 50 to 100 leagues further westward, as the opening of the strait by water will lead, that you may be certain you are entered the South Sea, called Mer de Sud, *and in your passage to learn all you can; but not to tarry long, that you may be able to return in due time.*

To consider what place is most convenient to fortify for defence of the mines, and possessing of the country, and to bring home perfect notes and maps thereof, to be kept in secret and so delivered to us.

Not to suffer any vessel laden with ore to set sail unto the day fixed in the charter party, except you see good cause, but keep all together till your arrival in the Thames . . .

We chiefly desire to know the temperature of these northwest parts, therefore you shall write an account of how any further discovery of the lands of seas lying within 200 leagues of the place fortified for our people may be achieved . . .

No person is to make an assay of metal or ore in Meta Incog. But those to whom the office is assigned, except yourself, your lieutenant-general, and substitutes; nor is any person to take up or keep for his private use any ore, precious stone &c. found in that

land but deliver the same to you or your lieutenant, on pain of
forfeiting treble the value out of his wages, and other punishment.

To keep a record of all ore and minerals found, as also specimens
thereof in boxes, and the localities of discovery . . . the boxes to be
delivered to the treasurer of the company of Merchant Adventurers
for northwest affairs on your return . . .

To bring back 800 tons or more if possible of the said ore, and
return into the Thames . . .

You shall have power to punish treason, mutiny, or other disorder
among the persons employed.[5]

Sailing on May 31, 1577, Frobisher once again reached the southern
tip of the mythical island of Friesland, but was unable to make
landfall due to the weather, rough seas, and ice. He plowed on in the
icy waters to Little Hall's Island and the southern tip of Frobisher
Bay, where some highly unsatisfactory ore samples were taken. The
voyage was beginning to look distinctly unpromising. Since his first
Inuit captive had created such a sensation in London, Frobisher had
in mind to bring others back home; and though it was clearly not
a stated purpose of the journey, it would certainly deflect attention
away from the possibility that they might not find gold. Despite Dr.
Dee's instruction, the statements and audit undertaken after the
voyage show that neither Frobisher nor his gentlemen adventurers
had the remotest inclination or understanding of how good relations
with a native population could have helped make the expedition a
success.

Tentative steps were made to capture some native or other by
what is often called "silent trade" where one group lays down gifts
on the ground and goes away then the other does the same, and so it
continues until they feel confident enough to meet face-to-face. The
English were the first to do this, and the Inuit followed suit. After
several such exchanges, Frobisher and his second in command,
Hall, entered the clearing unarmed. Again the Inuit followed
their example. Presents were exchanged. Then Frobisher, in an
act of unwarranted and cold-blooded treachery, signaled to Hall
to pounce. But the Inuit were too quick and escaped their clutches.
Their kinsmen surged forward from the shadows firing their arrows

and shouting. They chased Frobisher and Hall back to the boats, but in the skirmish, Frobisher justly received the ignominious wound of an arrow in his backside.[6]

His pride had been grievously wounded, and the Inuit were cast as a "base, cruel and man-eating people." When Frobisher was able to fight again, the English mounted a "counterattack" and captured an Inuit male. But Frobisher's blood was up, and nothing short of a proper victory could assuage his ill temper. While ostensibly searching for their five abandoned seamen, they attacked another group of Inuit, brutally slaying several, and capturing a young woman and her baby. The babe had been wounded in the incident, yet there is no record of viewing this as either wrong or of any significance. Still, the three prisoners' behaviors were observed by the expedition's resident artist, probably John White, who would achieve fame later for the Roanoke voyages. White made a series of realistic sketches of the three of them, and they were significant in that they were the first English sketches of native North Americans.

With these three prisoners under his belt, Frobisher had well and truly proved to his fellow adventurers that they had conquered these "crafty villains" in the name of the Queen of England. The mining operation was gaining pace by now, and over 140 tons had been laden onto the *Aid*. They had been away quite long enough, and with winter threatening, Frobisher announced that they had achieved the first two aims of their expedition. What had become of the abandoned English from the earlier voyage, they never asked, and they never learned.[7]

They returned to Countess of Warwick Island, where they finally set up their mining operations after preliminary assays showed that the ore there was "favorable." But they had already squandered four weeks of the arctic summer and, after mining only 140 tons of the black rock, headed smartly home.

As Frobisher expected, the Inuit captives caused a great stir, and at first, the court remained expectant of a windfall. But when the Tower's assayer pronounced that the ore held no gold, Lok had it retested several times until, at last, a Dr. Burchet's opinion had been purchased to state that it was worth at least £40 per ton.[8] Many of the shareholders began to query who Burchet was, and why it had taken so many assays to ascertain the ore's value, so Frobisher and

Lok geared up quickly for a major mining expedition and third voyage. But even before it set sail, the ore's estimated value began to plummet.

Nonetheless, Frobisher and his fleet of fifteen ships sailed on May 31, 1578—exactly one year after the second voyage had set out—from Harwich on what became his last voyage of discovery to the north of America. Sailing northward around the British Isles to the Orkneys, then west past Greenland, the fleet sighted Meta Incognita (the peninsula on Baffin Island) through thick fog. Frobisher and his men were swept into an unknown strait farther to the southwest by the current, prevented from taking any readings whatsoever due to the fog. But, in the confusion, they discovered another "strait" that Frobisher claimed to be the Frobisher Straits of the second voyage. This "Mistaken Straits"—better known today as the Hudson Strait—was undoubtedly Frobisher's greatest discovery. While at first Frobisher pretended that it had been the same strait as he had previously found, Beste wrote in his diary:

> And truly it was wonderful to hear and see the rushing and noise that the tides do make in this place, with so violent a force that our ships lying a hull were turned sometimes round about even in a moment after the manner of a whirlpool, and the noise of the stream no less to be heard afar off then the waterfall of London Bridge.[9]

It was July 7, 1578, when the fleet entered the "Mistaken Straits." Three days later, four ships were separated from the advancing fleet in the freezing fog, and decided to turn back. Frobisher and those ships still following him pressed on another estimated sixty leagues between never-ending skyscrapers of ice, whose summits remained perpetually shrouded in the arctic fog. Finally, after nine more days, with no immediate end in sight, he gave the order to return back through the strait, since he "both would and could," Frobisher boasted, "have gone through to the South Sea" if he hadn't had the entire responsibility for the welfare of his fleet and the expedition as a whole to consider.[10]

Frobisher rightly reasoned that it was time to resume the main purpose of the voyage—gold mining. And so they returned to

Friesland (Baffin Island) where the gold mining "colony" was set up by the end of July. Yet it hadn't been smooth sailing through to Baffin. When they were approaching, Baffin was still clogged with ice floes, and after some considerable grinding of wooden hulls against ice, with gentlemen adventurers manning the capstans like common sailors, offering sound advice based on their better education, they finally made landfall. Frobisher trudged across the ice and theatrically raised the flag of St. George, officially claiming the land for England.[11]

But a short while later, the *Dennys*, a 100-ton bark, was struck by an iceberg and sank within sight of the entire, stunned expedition. Fortunately her crew was spared, but the prefabricated "winter" house that had been brought from England partially assembled was lost with the *Dennys*.[12] Instead, stone (partially from ballast) and wooden structures were erected for shelter, and the adventurers settled into their mining operations at long last. What had begun two voyages earlier as the quest for a lucrative trade route to the East Indies and Cathay had clearly become a settlement in its own right searching for gold. By the end of August, over 1,370 tons of ore had been mined and loaded, and they headed for home.

Like Drake on his return from the West Indies, Frobisher had come back to a different England in September than the one he had left in the late spring. Michael Lok had been obliged to submit his accounts for an audit in August, and when the results regarding the value of the ore were other than those desired by Frobisher, he ordered a second official audit to be undertaken. Costs for the three voyages had risen to £20,345 ($6.96 million or £3.76 million today) with two-thirds of that attributed solely to the third voyage and the gold refinery built at Dartford. This was equivalent to one tenth of the national budget. Yet the investors had stumped up only £17,630 6s. 8d. ($6.03 million or £3.26 million today). The list of unpaid subscriptions read like a *Who's Who* of Elizabethan England: Lord Burghley; Lord Admiral Clinton; the Earl of Sussex; the Earl of Warwick; Henry Carey, Lord Hunsdon; Sir Francis Knollys; the Earl of Pembroke; Philip Sidney; Edward Dyer; Anthony Jenkinson; Dr. John Dee; and Thomas Randolph, to name just a few.

It wasn't until January 1579 that the wages for the mariners and others involved in the voyage were settled, leaving an outstanding

deficit of £3,658 14s. 3d.—that is, until the refined gold could be sold. Frobisher distanced himself from Lok, rounding on him that he was a fraud, a knave, and a bankrupt. "I daily instructed him," Lok ventured in his defense, "making my house his home, my purse his purse at his need, and my credit his credit to my power, when he was utterly destitute both of money, credit and friends."[13]

Even more damning was Lok's description of his business partner after the initial ore discovery, while gold fever still swept the court: "Frobisher grew into such a monstrous mind that a whole kingdom could not contain it but already, by discovery of a new world, he was become another Columbus."[14] Though Lok was putting up a spirited defense, the debts kept piling in, with claims from the ship owners mounting. When William Boroughs demanded £200 for his ship loaned to the Company of Kathai for the last voyage, and Lok was unable to pay, he was left no alternative but to declare bankruptcy. This had the effect of throwing the Company of Kathai into receivership—pending the sale of the ore—not to mention Lok's spending a spell in the dreaded Fleet Prison as an undischarged bankrupt.

The only problem in selling the ore was that from the haul of well over a thousand tons of black, gleaming rock from North America, the total amount of gold that was extracted remains imbedded today in the sealing wax appended to the report that it was completely worthless. The entire gold extraction could be placed upon the head of a pin.

24. In the Shadow of Magellan ❧

*And now, my masters, let us consider what we have
done. We have now set together by the ears three mighty
princes, as first Her Majesty [then] the Kings of Spain and
Portugal, and if this voyage should not have good success,
we should not only be a scorning or a reproachful scoffing
spoke unto our enemies, but also a great blot to our whole
country forever . . .*

—FRANCIS DRAKE, PORT ST. JULIAN, AUGUST 1578

Frobisher was preparing for his third voyage when Drake sailed
November 15, 1577. Within days the queen's favorite, Christopher
Hatton, had been knighted for his services to the queen. Aside from
his known courtly duties as the head of her guard, Hatton had also
contributed the *Pelican* and the *Marigold* to Drake's journey. The
Christopher was named after him.

As far as hugely historic voyages go, Drake had made a rather
inauspicious beginning. In the days between his initial and final
sailing from Plymouth, Drake accused James Sydae, who had served
with him and Thomas Doughty in Ireland, of provisioning the ships
poorly for the months at sea that lay ahead. This was a famous trick
of many ships' masters, when they underspent on their budget for
victuals, substituting poorer quality foodstuffs or providing less, and
pocketing the surplus. Doughty muttered his unhappiness to the crew
that Drake had dismissed an "essential member" of their company,
and that their hotheaded captain might even dismiss him, Doughty,
who had been instrumental in ensuring that the voyage happened
in the first place. When Doughty found he had a ready audience,
he even claimed that Drake had been ordered to consult him at all
times by their investors, and that he shared Drake's authority. None
of Drake's men told him while they were still on English soil what

Doughty had been getting up to. If they had, matters may have turned out differently.

They were past the entry to the Mediterranean before the mariners learned that Alexandria was not their intended destination. Naturally there was grumbling, like, "Mr. Drake had hired them for Alexandria," one mariner complained, "and if he had known that *this* had been Alexandria, he would have been hanged in England rather than have come on this voyage."[1] But still, Drake recorded no incident in his own narrative up to this point, despite the fact that he must have been on his guard for malcontents among his men.

As they steered past the Cape Verde Islands, Drake held up the old English tradition of plundering the coast. A pinnace was sent in hot pursuit after a ship off Santiago and captured her. The *Santa Maria*, as she was then called, was filled with fresh victuals, fresh fruit, other everyday necessities, an astrolabe, and the most valuable commodity yet—a Portuguese pilot named Nuño da Silva, who was the proud owner of several nautical charts of the coasts and ocean between Europe and South America. Nuño da Silva, Drake resolved, would pilot their way to South America.

Drake rechristened the prize ship the *Mary*, after his wife, and appointed his good friend Doughty as her skipper. Soon after Doughty came aboard, there was an argument with some of the men, and two contradictory stories of that dispute survive. The first supporting Doughty's actions has it that Drake's brother, Thomas, was found rifling through the Portuguese booty, and Doughty threatened to report it to the commander. When Drake was told, he flew into a rage against Doughty, accusing him of undermining his authority. The second version, from the ship's preacher, Francis Fletcher, puts an entirely different slant on the matter. Though Fletcher could be considered a "hostile witness" for Drake, he claimed that it was Doughty who was stealing some of the prize goods. Drake looked into it—since fisticuffs about booty often ended in injury or death among sailors, and always ended in discord. He found that Doughty had indeed some Portuguese gloves, a ring, and some Portuguese coins upon his person. Doughty explained this away, claiming that it was the Portuguese prisoners who had given these tokens to him for preferential treatment aboard ship. Drake considered this to be

a plausible explanation, but he thought it wiser to remove Doughty from the crew, who might readily slit his throat in his sleep. And so, Drake made Doughty captain of the *Pelican*—the admiral ship.

Only Drake knew the probable length of their voyage, and the ability of any commander to keep the peace among rough men at sea was always a risky business. No one knew better than Drake how much his sailors looked for "some little comfortable dew from heaven," and how his mariners "rejoiced in things stark naughty, bragging in sundry piracies."[2] Transferring Doughty seemed the most sensible and amicable course, but Drake hadn't bargained on Doughty's colossal ego.

Doughty had been well educated, had powerful connections at court, and was an insufferable snob—all things that Drake was not. It rankled with him that Drake, and men like Hawkins and Winter, used their sea captaincies as a means of stepping up the social ladder. Little else can explain his path to self-destruction, even his later assertion that he was secretly in the pay of Lord Burghley. He couldn't fathom Drake's strict discipline with his lawless mariners, nor why he, Doughty, had to abide by the same rules and play second fiddle to an uneducated sailor like Drake. But even Drake's prisoners saw the point, and they remarked on the special relationships he had with his men. In a statement to Don Martín Enríquez from Drake's former prisoner Francisco de Zátate, "He treats them [his men] with affection, and they treat him with respect."[3]

With Doughty aboard the *Pelican* and Drake now captaining the *Mary*, Thomas Doughty's ego inflated beyond his ability to use any tact in his accusations against Drake. John Doughty, Thomas's younger brother, boasted that both he and his brother could summon up the powers of witchcraft, and bring "the Devil to bear down upon the ship's company" as a bear or a lion, if they so desired. The superstitious seamen were evidently in fear of their lives and dared not, at first, to tell their captain. But matters came to a head when Thomas Doughty sent a mysteriously threatening missive to Drake that he would shortly "have more need of me than I shall have of the voyage."[4]

Drake finally snapped. He sent his trumpeter John Brewer, Hatton's faithful servant, to fetch Doughty back to the *Mary*.[5] When Brewer delivered the general's message, Doughty started a scuffle and

refused. Brewer returned, eventually, without the reprobate in tow, so Drake beat the *Mary* round to join the *Pelican*, calling Doughty aboard. While Doughty climbed the ladder, Drake exclaimed "Stay there, Thomas Doughty! For I must send you to another place."[6] The oarsmen were commanded to remove Doughty to the fly boat, the *Swan*, and he was compelled to go. Doughty complained bitterly to the *Swan's* captain, John Chester, that he was being treated as a prisoner, but Chester—like Drake—made no reply.

With Doughty under wraps, the fleet slowly headed across the vast Atlantic on its southwesterly route. They would spend sixty days and nights without the sight or smell of land until on April 5, 1578, they breathed in the familiar "very sweet smell" at 31°30' south. At last, they had reached the coast of Brazil. They sailed straight past the well-trodden trading posts surrounding the River Plate, while Drake concentrated on the main task at hand—consulting Nuño's charts and comparing them to the coastline. Only one European ship had ever passed through the Strait of Magellan before— fifty-eight years earlier—and Magellan, its captain, was killed before the circumnavigation voyage had been completed. Whether or not Drake had seriously intended to go around the world at this stage has been a subject of hot debate, but what was in no doubt was that he was planning to bring his personal war against Philip of Spain to the Pacific. Understanding Nuño's charts, how the currents worked, the reversal of the magnetic pole in the Southern Hemisphere were all critical not only to Drake keeping himself and his crew alive, but also to eventual success.

As the Southern Hemisphere's autumn gripped the tiny flotilla in its clutches, the seas swelled, and the likelihood of finding fresh supplies dwindled. The fleet was scattered, but Drake had appointed a rendezvous with Nuño's help. When Drake's ships reassembled at Bahia Nodales (Argentina) at 47°57' he learned that Doughty was still making mischief. One of Drake's men, John Saracold, bluntly remarked to the commander in front of Doughty that there "were traitors aboard" and that Drake would do well to deal with them as Magellan had done, as an example to the others. Doughty cried out that Drake had no authority to hang him, or even put him on trial. But since Doughty had made it clear to the gentlemen adventurers aboard the *Swan* that mucking in alongside rough sailors was beneath

them, he left Drake with little choice as to the outcome. Mutiny was only a short step away.

Drake gave the order to break up the *Swan* to consolidate the fleet, ordering the Doughty brothers aboard the *Christopher*. When they refused to go, Drake cut their dramatics short by telling his men to hoist them aboard with the ship's tackle. It was obvious to Drake that the men were beginning to take sides, and unless Doughty changed his ways immediately, his disobedience could no longer go unpunished. With the seas continually swelling the farther south they sailed, Drake realized that he would need to scuttle the *Christopher* as well, or else they would lose the weather, wasting time waiting to reassemble the fleet. He boarded the *Elizabeth* and warned his men that "a very bad couple of men" would be sent to them, "the which he did not know how to carry along with him . . . Thomas Doughty is a conjuror, a seditious fellow . . . and his brother . . . a witch, a poisoner and such a one as the world can judge of. I cannot tell from whence he came, but from the Devil I think."[7] Then he reminded his men that they were on a quest for treasure beyond their wildest dreams. He could only hope they would remain focused on the last part of his message.

Not far north of the Strait of Magellan stood a ghostlike relic of doom and foreboding—the fifty-eight-year-old wooden scaffold erected by Ferdinand Magellan when he hanged one of his men for mutiny. Whether or not the eerie sight of Magellan's gallows stirred Drake into action as they finally entered the harbor of Port St. Julian was never recorded, but the fact remains that at Port St. Julian, Thomas Doughty would be put on trial at last. But first Drake needed to secure their anchorage, for shortly after they arrived, a fatal skirmish with the local Indians saw two of Drake's men killed. To avoid further attacks by the hostile natives, the Englishmen were ordered to pitch their tents on a rocky island in the harbor. And still, in the midst of grave danger, Doughty continually criticized their commander. The following day, they were all summoned before Drake. He was mightily fed up. Thomas Doughty would be tried for mutiny and witchcraft.

Doughty, a clever, trained lawyer, claimed that Drake had no jurisdiction to put him on trial and that he would answer only to the "Queen's court" in England. He was, strictly speaking, right. Unless

Drake could produce a written commission signed by the queen herself, he had no authority to act *in loco reginae*. But how could Drake produce such a document when Elizabeth had sworn him to secrecy, even from Burghley? He, like so many "spies" and agents provocateurs before and after him, had no papers for the express reason that the queen could disown their actions if they were captured. All Drake carried with him was his written instructions, unendorsed by queen or council. Doughty must have known this, and his claim that Drake did not have a royal commission almost had the proceedings go his way.

Drake blustered that Doughty had poisoned the Earl of Essex, that he was poisoning his men against him, too. Doughty, instead of staying on strong ground, allowed himself to get diverted into a shouting match with Drake, claiming that he was in the pay of Lord Burghley, who had knowledge of the voyage from none other than Doughty himself. "Lo, my masters," Drake declared, "what this fellow hath done! God will have his treacheries all known for Her Majesty gave me special commandment that of all men my lord treasurer should not know it, but to see his own mouth hath betrayed him!"[8]

Now it was made generally known to the sailors that Burghley disapproved of plundering and would have stopped their voyage from setting sail if he had known their true purpose. Drake produced some papers for his men, presumably his written instructions. They were, after all, now sworn in properly as jurors of the kangaroo court. Eventually, Drake prevailed, and they supported him in his assertion that he had the queen's blessing. Witnesses for and against Doughty were heard. Then, Drake set out the alternatives to the jurors once all the evidence had been heard for and against Doughty:

> And now my masters, consider what a great voyage we are like to make, the like was never made out of England, for by the same the worst in this fleet shall become a gentleman, and if this voyage go not forward, which I cannot see how possible it should if this man live, what a reproach it will be, not only unto our country but especially unto us, the very simplest here may consider of. Therefore, my masters, they that think this man worthy to die, let them with me hold up their hands.[9]

The choices were stark. If they returned home to have Doughty tried, they would incur the wrath of the queen, who Drake maintained to his men, had ventured a thousand crowns. And that was before their other powerful backers like Hatton, Walsingham, and Leicester sank their teeth into them. To send Doughty back home with a ship, and in the company of some men (for Doughty was no sailor), would weaken the expedition too much and put their own lives at risk. To leave Doughty at Port St. Julian would guarantee him a slow and lingering death at the hands of hostile natives. The men voted unanimously to execute Doughty.

In the end, Doughty met his maker with great courage befitting an Elizabethan gentleman. He chose to die by the axe, and made his will. He shared the sacrament with Drake, and then they had a last dinner together. At the end, they had a few moments together, but their conversation was never recorded. He begged all the men to forgive him, and Drake promised that there would be no further reprisals—specifically against Doughty's younger brother, John. Doughty's head was severed in one blow then held aloft by Drake as the head of a mutineer.

Drake reminded his men of the huge task ahead of them. There would be no arbitrary class distinctions between them any longer. Each life would depend in future upon the goodwill of the others. Old wounds from the Doughty business could not be allowed to fester, and they must all work together for queen and country. If they failed to sail on, "what triumph it would be to Spain and Portugal, and again the like would never be attempted." Having said his piece, Drake begged the men to take a vote on whether or not they wanted to continue. He had been relying on promise of Spanish treasure and plunder, of riches beyond their wildest imaginings, not upon any twentieth century notion of patriotism. They agreed to follow their commander to the ends of the world.

And so, on August 17, 1578, nearly two months to the day after they reached Port St. Julian, that desolate site of two executions for mutiny, Drake and his men burned the *Mary* to reduce the squadron to just the *Pelican*, the *Elizabeth*, and the *Marigold*, and sailed into the unknown.

25. Into the Jaws of Death ❧

But escaping from these straits and miseries, as it were
through the needle's eye . . . we could now no longer
forbear, but must needs find some place of refuge . . . thus
worn out by so many and so long intolerable toils; the
like whereof, it is supposed, no traveler hath felt, neither
hath there ever been such a tempest, so violent and of such
continuance since Noah's flood. . . .

—SIR FRANCIS DRAKE, OCTOBER 1579

Three days later, the ships were confronted with the Cape of Virgins some four leagues off, rising sharply as sheer, gray peaks in the distance. These were the sentinels that guarded the entry to the Strait of Magellan "full of black stars against which the sea beating, showed as it were, the spoutings of whales."[1] It was a terrifying and solemn moment, and breathtakingly momentous for Drake and his men. The seas swelled and rocked them off their feet, as if in warning that they should not dare to enter the forbidden territory. The moment of awe had to pass if they were to become masters of their destiny, Drake's instinct told him, so he ordered the fleet to strike their topsails in homage to their Sovereign Lady, Queen Elizabeth. Then in remembrance of Christopher Hatton, the *Pelican* was rechristened The *Golden Hind*.[2] With Doughty's demise still fresh in his mind, it was a necessary demonstration of respect for his patron.

The ceremonies had the desired effect of whipping up the men's lust for plunder and glory. But until they were favored with a good wind from the northeast, entering the straits would be impossible. And so they waited in the shadows of the Cape of Virgins beating back and forth against the current. And then they waited more. Finally, two long days later, the ships entered the yawning mouth

of the Strait of Magellan, which must have seemed biblical to the preaching side of Drake, reminding him of Jonah and the "great fish." No one aboard any of the ships—including their Portuguese pilot, Nuño da Silva—had ever passed through the forbidding straits before. No one even knew that it was a three-hundred-mile-long twisting waterway. All charts were hopelessly inaccurate. All they knew is that it was riddled with false trails and turns and had claimed the lives of hundreds of sailors before them. They also knew—falsely, as it turns out—that the Strait of Magellan was the channel between the tip of South America and "Terra Australis." They could only pray that the winds would remain at their backs, and the currents run steadily from east to west by northwest.

Drake ordered that they keep to midchannel to avoid any unknown shoals, which at first was relatively easy, for "the ebbings and flowings [there] being as orderly as on other coasts."[3] The shores to either side were flat and low at this point, but the general knew better than to breathe any sighs of relief. On August 24, St. Bartholomew's Day, they "fell with three islands bearing triangle-wise one from another; one of them was very fair and large and of fruitful soil, upon which, being next unto us and the weather very calm, our general with his gentlemen and certain of his mariners, then landed, taking possession thereof in Her Majesty's name, and to her use, and called the same Elizabeth Island."[4] They christened the other two islands St. George, after England's flag, and St. Bartholomew, to mark the day. Since the weather was so good, Drake gave the order to reprovision and scavenge for food and wood. The discovery of a human skeleton on St. George's drove home to them again the dangerous nature of their expedition.

Their main source of fresh food was penguins, described as having a "body less than a goose and bigger than a mallard." An estimated three thousand inhabited the islands before the arrival of the Englishmen, when several hundred were bludgeoned and stored aboard ship. After reprovisioning, Drake ordered them to sail on while the weather and wind remained with them. "From these islands to the entrance into the South Sea," Drake later remarked, "the fret is very crooked, having many turnings, and so it were shuttings up, as if there were no passage at all, by means whereof we were often troubled with contrary winds, so that some of our

ships recovering a cape of land, entering another reach, the rest were forced to alter their course and come to anchor where they might."[5]

As they progressed, the land to both sides soared again to dizzying heights, like gray basalt columns of glass covered in snow. Drake remarked that to the northerly side of the straits lay the continent of America, and to the south and east "nothing but islands, among which lie innumerable frets or passages into the South Seas."[6] Until now, the current had by and large been with them, but when the winds varied, the sea was whipped up into eddies and whirlpools and it became impossible for Drake to sound for depth or too dangerous or deep to anchor. When they found anchorage, the rock face was so jagged that it frayed the hemp cables. The landscape was foreign and difficult to describe. Drake later called it a land of "congealed cloud" and "frozen meteors."

Then, about 150 miles into the channel, as they wended their way to the northwest, through the myriad islands scattered in the straits, the wind swung around to a strong gusting westerly. It funneled between the mountains, howling a gale and churning up the sea. For the next 150 miles, they battled the weather emerging, in only fourteen days, on September 6, 1578, into the South Seas. It had taken Magellan thirty-seven.[7]

But Drake had no time to rest on his laurels. His instructions ordered him to head along the Chilean coast to Peru. Consulting the charts again, they turned northwesterly, but after two or more days of good progress, all they could see from every horizon was the stunning blue sea. The charts, he reasoned, had to be wrong. And so, with heavy hearts, they luffed around and headed back to where they had been disgorged into the Pacific. The Chilean coast had to lie to the north, not to the northwest. This, too, was a significant geographical discovery, though not the purpose of the voyage.

Terrible weeks ensued. Instead of finding the Chilean coast where they expected to, they mistakenly reentered the Strait of Magellan. Screaming winds and torrential rain remorselessly pummeled the ships, threatening hourly to crash them upon the rocks. When it wasn't raining, it was so foggy they could barely see the bow of the ship, much less between ships, and all they could hear was the eerie roar of the waves echoing as they broke on the rocks. At times they beat southwesterly toward the open sea between South America and

Antarctica; at other times they simply clawed their way along the northern shore of the straits. Finally, at some time toward the end of September, the *Marigold* was lost with all twenty-nine hands on board. Drake pretended for a time that they had merely lost sight of her, but he couldn't deny the "fearful cries" they had all heard the night she vanished.

They were most likely within reach of Cape Horn when Captain Winter, aboard the *Elizabeth*, had had enough and turned his ship back to England. He later claimed that he had no choice in the "fog and outrageous winter" if he were to avoid shipwreck. The fact remains that Winter and his men reentered the Magellan Strait, found shelter for a few weeks to recover from their ordeal, then knowingly, willingly sailed for England. Winter disclaimed authorship of the idea, but his men insisted that the decision had been his and his alone.[8] When the *Elizabeth* anchored in Ilfracombe, Devon, in June 1579, it was the first news that Plymouth and the court had had of Drake and his successful passage into the South Seas. The important question that Winter was unable to answer though was if Drake had survived the storms that had made them turn back.

Of course, Drake had survived. He had also made his second great geographic discovery. The Strait of Magellan was not the tip of South America. And he was the first European commander to sail around the southernmost tip of South America from the Atlantic into the Pacific.[9] But Drake was not an explorer. His mission was to plunder the western coast of Spanish America, and to bring the treasure back to England.

26. The Famous Voyage ✣

You will say that this man who steals by day and prays
by night in public is a devil. . . . I would not wish to take
anything except what belongs to King Philip and Don
Martín Enríquez. . . . I am not going to stop until I collect
two millions which my cousin, John Hawkins, lost at San
Juan d'Ulúa.

— FRANCIS DRAKE, NOVEMBER 1578

While Drake was turning north toward the Chilean coast into the vast unknown, Elizabeth was facing a greater enemy at home. Men like Drake were rare, and while most of her courtiers and other adventurers rallied round to the greater threat imposed by an ever-stronger Spain, few had the daring and bravado to get under Philip's skin in the way *El Draco* did. And none other than Drake understood the element of surprise. The queen had come to the realization that her adventurers were her only defensive and offensive weapons of any importance, and there were precious few of them. England's merchant navy was small, with fewer than twenty ships above 200 tons. "Officially" between 1578 and 1581, they would snaffle no more than ten Spanish ships in the entire world. And Drake alone took at least twelve of them.[1]

Europe teetered once again on the brink. In the Low Countries, Alexander Farnese, the Duke of Parma and Philip's nephew, had been appointed to execute the King of Spain's will with intolerable brutality and cruelty against the Dutch. While the Spanish Fury raged in the Low Countries, Henry of Guise, uncle to Mary, Queen of Scots, had become Philip's puppet and had the ear of the French king. As if the neutralization of France wasn't bad enough, Walsingham's and Burghley's spies reported that something was afoot in Munster again, this time backed by the pope. And while King Sebastian of Portugal had been killed along with the ubiquitous Thomas

Stucley in the Battle of the Three Kings at Alcazar in Morocco, his uncle Henry d'Evora, the sickly, elderly cardinal and head of the Inquisition in Portugal, was crowned Portugal's new king. Worse still, Philip of Spain, according to Henry, had the next best claim to the Portuguese throne on his death. If Spain united with Portugal, all hope of checking Philip's pernicious anti-Protestant influence against Elizabeth would be lost forever.[2]

This was the queen's view of the tempests brewing in Europe. Of the Pacific and Drake, she could only wonder how they were faring, if she thought of them at all. Still God hadn't abandoned them, in Drake's words. After fifty days of a raging storm that had cost him his tiny fleet, the commander headed toward the rendezvous at 30° south and anchored twelve fathoms off the island of Mocha. But Drake had misjudged the animosity of the natives against the Spanish. As they rowed ashore, they were met with a shower of darts and arrows whistling directly at them, forcing them to retreat, while the natives splashed through the waves in pursuit. Drake was struck twice in the head, with one arrow narrowly missing his right eye. Their barber-surgeon was dead. Two of his best masters had been captured and butchered by the time Drake reached the *Hind*. They had been mistaken for Spaniards, clearly, and it was a salutary lesson to Drake for the future.[3] They were left with little choice but to weigh anchor, and abandon all further hope of meeting up with the *Elizabeth*.

Four days later, on November 30, they came across an Indian in a canoe and cajoled him into becoming their pilot along the coast of Chile in exchange for trinkets. He led them to Valparaiso, where the *Captain of Moriall*, admiral of the fleet of the Solomon Islands, was moored in harbor. They certainly saw the windswept, barnacled ship pulling alongside, for they drummed her in as a sign of welcome. Despite the fact that they didn't recognize the ship or her colors, it didn't matter—there were no strangers in the South Seas—also affectionately called the Spanish Lake. It was only when the *Captain of Moriall* was boarded that the truth finally became apparent.

The Spanish were herded into the hold, barring one who jumped overboard and swam toward shore to raise the alarm. He needn't have bothered. Drake loaded two boats with his men armed to the

teeth and captured the town without a shot being fired. All the inhabitants had abandoned it, fearing for their lives. In their first encounter against Spain's "forces," the English had been triumphant. As their reward, they ransacked the port of Valparaiso in an orgy of looting.

They had resolved to take along the Spanish ship's pilot, naturally hoping that he would be useful in sailing farther north. The *Captain of Moriall* had also been laden with alcohol and "a certain quantity of fine gold of Baldinia, and a great cross of gold beset with emeralds," the memoirs of the voyage tells us, and "we spent some time in refreshing ourselves, and easing [plundering] this ship of so heavy a burden on the 8th day of the same month [December] having in the meantime sufficiently stored ourselves with necessaries, as wine, bread, bacon, etc., for a long season."[4]

Drake and his men loaded four chests containing an estimated 25,000 *pesos de oro* worth of gold ($3.46 million or £1.87 million today), as well as some fine Spanish wine.[5] The port's warehouses and homes provided them with food, and its church with some silver. As they said their good-byes to Valparaiso, it was undoubtedly a grateful crew who bathed themselves in the glory of their first real prize in over a year at sea. All of Drake's promises could be believed, and the hardships they had endured were worth it. They were already wealthy men.[6]

But Drake knew that this was only the beginning, providing he could stay ahead of the news announcing his arrival in the South Seas. If word reached Lima before he did, then Spanish shipping would scatter at sea, and an offensive would be mounted against their lone ship. Still, the immediate problem he had to cope with was to see to the repairs the *Golden Hind* so desperately needed, mounting the full complement of her heavy guns, and building the pinnace they had brought along for their plundering and inshore work.

Drake still hoped against hope that he might find the *Elizabeth* and perhaps even the *Marigold*, and he decided to start work on the *Hind* near the appointed rendezvous at 30° south. On December 19, 1578, a party of Spanish horse and foot attacked a dozen of his men who were working onshore collecting fresh water. One Englishman was killed before the rovers were rescued by boats launched hastily

from the *Hind*. The dead man, Richard Minivy, had his heart carved out and was beheaded in full view of the general and crew. The rewards of their labors might be high, but so were the risks.

They moved on to Salada Bay, near Coquimbo, where they completed their preparations to raid the treasure fleet from Peru, which had been Drake's long-held dream since Darien. A pinnace large enough to take forty men and a culverin in its bow was built, while essential repairs for leaks and the full complement of the *Hind*'s heavy guns were mounted. As they headed north toward Lima, two more barks were taken with forty odd bars of silver "the bigness and fashion of a brick bat" and each weighing twenty pounds, not to mention the thirteen bars of silver from a Spaniard asleep on the beach valued at 4,000 ducats ($338,217 or £182,820 today). Fortunately for the Spaniard, he was a sound sleeper, though poorer when he awoke.[7]

At Arica, on February 9, 1579, the English corsairs fell upon another bark in the middle of loading thirty-seven bars of silver and a chest of silver coin that they simply had to help themselves to, followed shortly after by another bark laden with fresh linen and wine. It was too tempting a prize for men who had been at sea for fifteen months to ignore.[8] Still, it was a rather disappointing haul, since Arica was the port for the legendary Potosi mines.

But worse was yet to come. After Arica, they headed to the small port of Chule, where they took on a little water. They soon learned that the news of their piracy had traveled fast—two hours before they had anchored, a bullion vessel had left fully loaded. The locals jeered at them from the quayside, hurling verbal abuse and laughing at them for being so slow. The element of surprise had been squandered on meager prizes, while overland messengers carried the word that *El Draco*—Drake, the dragon—had found his way into the South Seas. The time for pinpricks to Spain's empire was at an end.

Drake set the prize ships adrift and released all his prisoners, save two Spanish pilots who set their course for Callao, the port for Lima. More prizes were taken en route, more with a view to intelligence than capturing gold, and at last Drake was rewarded for his diligence. There was a silver vessel bound for Panama at Callao and another

ship, *Nuestra Señora de la Concepción*—irreverently rebranded the *Cacafuego* or "Shitfire"[9] by her crew—that had just left Callao for Panama. The Spanish captain thought that the *Cacafuego* was richly laden with silver, and had overheard that she would be stopping at several ports to take on consignments of flour.

The problem for Drake was both ships had silver and not gold, making his choice of which one to go for more difficult. Callao was nearest, so he plumbed for the port, reasoning that the overland couriers hadn't reached there yet. Quite late in the night of February 15, 1579, Drake snuck into the harbor of Callao between the island of San Lorenzo and the mainland. The port was full of sail, and all seemed quiet. He ordered his pinnace to steal between the ships at anchor and have his men see if they were laden with treasure, and he was disappointed to learn that all of the ships had not as yet taken their cargoes on board. Rather than attack the customs house carrying an estimated 200,000 pesos in silver and risk word leaking out to Lima quickly, he gave the order to cut the cables of all the ships and hack down the main masts of the two largest vessels in harbor, escaping only with some silk and a chest containing some Spanish *reals*.[10] They would instead, he resolved, give chase to the *Cacafuego*.

But while they were amassing their plunder, another ship sailed innocently into harbor. The *San Cristobal* had arrived from Panama with her merchandise for Peru. The customs officials boarding the *San Cristobal* first noticed the activity aboard the *Hind*, and rowed across, hailing to her to identify herself. A Spanish voice replied from the *Hind* that she was Miguel Angel's ship from Chile (the one that had made a narrow escape in Arica). As the customs officer hauled himself aboard, he stared directly into the mouth of an English brass culverin. He immediately realized his mistake, fell back into his boat, and rowed as fast as he could to save his life. The crew of the *San Cristobal* saw—and, importantly, heard—what had happened, but before they could do anything, Drake's pinnace had captured her. Her crew either swam to safety, or escaped in lowered boats, allowing Drake's rovers to invade and take control.

The *Hind*'s sails filled and she tacked about. While the militia was being raised in the town, witnesses could see the *San Cristobal*

in the distance being plundered by the pirates. But before they could attack, Drake and his pirates had sailed after the *Cacafuego*. All along the coast northward, they had news of their prey. From their next prize they learned that she was three days ahead of them. When they raided the port at Paita, the *Cacafuego*'s lead had been cut to two days. Their next two vessels attacked brought the rovers gold, silver, food, and new ships' tackle that its owner later valued at 24,000 *pesos de oro* ($3.31 million or £1.79 million today).[11]

A golden reward was offered to the first mariner to spot the *Cacafuego* on the horizon. On March 1st at around three in the afternoon, young John Drake, aloft in the crow's nest, claimed the gold chain, spying their prey around four leagues to the south. Naturally, the *Cacafuego* had no knowledge whatsoever of the danger she was in. In order not to scare her into flight, it would be impossible to strike the sails, so Drake ordered pots to be filled with water, tied to ropes, then thrown astern. This would put a great drag on the *Hind* and lull the *Cacafuego* into believing that the *Hind* was just a small merchantman on the same heading, and moving at a normal speed for a Spanish ship.

The Spanish ship's owner and captain, San Juan de Anton, spied the *Hind* and thought at first she might be from Chile. According to Drake's plan, they gained slowly on the *Cacafuego* without her taking fright. By nine in the evening, when the *Hind* was virtually alongside, her captain rang a salute, but there was no answer from the strange vessel. Anton came over to the side to investigate. But by then it was too late.

The English were already grappling alongside from the pinnace. Drake's drum and trumpet sounded the attack from the opposite side. After this, Drake's narrative reports that:

> what seemed to be about sixty harquebuses were shot, followed by many arrows, which struck the side of the ship, and chainballs shot from a heavy piece of ordnance carried away the mizzen [mast] and sent it into the sea with its sail and lateen yard. After this the English shot another great gun, shouting again, "Strike sail!" and simultaneously a pinnace laid aboard to port and about forty archers climbed up the channels of the shrouds and entered [the]

ship while, at the opposite side, the English ship laid aboard. It was
thus that they forced San Juan's ship to surrender . . . they seized
him and carried him to the English ship where he saw the corsair
Francis Drake, who was removing his helmet and coat of mail.
Drake embraced [him] saying "Have patience, for such is the usage
of war," and immediately ordered him to be locked up in the cabin
in the poop.[12]

And what a prize she was! Much needed fresh fruits, conserves, sugars, meal, and other victuals were pounced upon by Drake's ravenous men. The general himself, with his masters, went immediately below to see the reason for the *Cacafuego*'s slow sailing. There was "a certain quantity of jewels and precious stones, 13 chests of *reals* of plate, 80 pounds weight in gold, 26 tons of uncoined silver, two very fair gilt silver drinking bowls, and the like trifles, valued in all at about 360,000 pesos."[13] This represents $49.62 million or £26.82 million today. An estimated half of the prize had belonged to Philip of Spain. It took them six days to secure the booty aboard the *Hind*, before leaving San Juan de Anton and his crew behind to beat a path to Panama to sound the alarm.

Drake knew that he hadn't fooled any of the Spaniards into believing that he would be stupid enough to return along the South American coast through the straits to home, but he tried to dissemble with them anyway. What the Spaniards hadn't realized was that Drake had promised the queen, Hatton, Leicester, and Walsingham that he would search for the western entry to the fabled Strait of Anian, mark the entry to the Northwest Passage, and, if possible, head back to England that way. But Drake knew better than anyone that if he hugged the coast, it would mean suicide. So his first move was to strike out to sea again, heading in a northwesterly direction "by guess and by God." But by the time they had reached somewhere around modern Vancouver they had been so engulfed in icy fogs and fierce northwesterlies that the *Hind*, squatting badly on the seas with her spectacular treasure, began leaking. They had been at sea again for fifty days, and food and fresh water were once more running low. There was no alternative but to turn back. Finally, they reached a haven somewhere between 38° and 48° north.[14]

The *Hind* was finally hauled ashore for careening and trimming around June 5, 1579. The natives, immediately friendly toward the Englishmen, were obviously intrigued by their vessel, clothing, trinkets, and skin color. Evidently, it was their first encounter with Europeans. On June 29, 1579, the tribal chief came down the mountain, followed by hundreds of men and women all dancing and singing in celebration, and bearing gifts for the English. The chief bade them all to be silent while he made a speech, which, of course, Drake and his men were unable to understand, but they surmised that "it was their intent, the king himself, with all the singing a song, set a crown upon his [Drake's] head, enriched his neck with all their chains, and offering unto him many other things, honoured him by the name *Hyóh* . . . because they were not only visited of the gods (for so they still judged us to be), but the great and chief God was now become their God, their king and patron. . . . "[15]

Drake, duly crowned God, was now expected to speak. And so, he raised his newly hewn scepter and proclaimed this land New Albion, on behalf of Her Most Excellent Sovereign Majesty. After that, they begged their new God, Drake, to heal their sick or infirm with his "royal touch." All the English could do was to apply the same balms they ministered to themselves, and from that day until their last ashore, in what many assume to be modern day Drake's Bay, their devoted "subjects" rarely left them.

Before leaving the coast, Drake says that a "plate of brass" was struck and "fast nailed to a great and firm post whereon is engraven her Grace's name, and the day and year of our arrival there, and of the free giving up of the province and kingdom, both by the king and people, into Her Majesty's hands."[16]

On July 23, 1579, Drake struck out into the vastness of the Pacific Ocean, singularly ill prepared for the voyage ahead in the *Golden Hind*, which was after all a tiny ship measuring no more than a hundred feet in length and twenty in the beam, and heavily laden with fabulous treasure. While their number had dwindled to about sixty-five, the bare minimum Drake believed necessary to attempt a voyage around the world, he was certain it was the only course left to steer. His men had become well disciplined under his strict command, and they wanted only to get home safely to enjoy their new wealth. But Drake was no fool, and he realized

that the length of time they might spend out of sight of land could lead to anything. The charts and sailing directions he had purloined showed him that the distance was greater than any shown on any map that had been made available to him previously. He therefore provisioned the ship for a longer voyage to stave off any privation or talk of mutiny, and kept his discovery to himself. Drake was thus able to avoid the problems that beset Magellan.

For sixty-eight days they sailed west, out of sight of land or man. Fortunately the winds and seas were favorable. Yet all they could hear was the swishing of the bow as it plowed through the ocean, the creaking of the *Hind*'s rigging and timbers, and the steady whir of the wind in its sails. The English made landfall in Micronesia, somewhere in the Carolinian archipelago on September 30, 1579. Naturally, they were glad to see land again, and apparently relieved at the "friendly" reception that awaited them. Hordes of natives in their dugout canoes paddled out to greet them, chattering and smiling, then clambering aboard the *Hind*. But all was not as it seemed. Soon they began arguing among themselves, taking the Englishmen's possessions when they refused to trade with them. Drake fired a warning shot, but that only scattered them temporarily. Though he was saddened and ashamed by it, he was compelled to fire directly at an approaching canoe, and blew it and its occupants to smithereens. Meanwhile, the order had been given to tack about, and the *Hind* and her men sailed away from the isle that Drake had already named the "Island of Thieves."[17] It was the ancestors of these same natives who had killed Magellan.

They next touched briefly at Mindanao in the Philippines, and sailed on to the legendary Spice Islands of the Moluccas. We can hardly imagine the tremendous sense of accomplishment Drake felt as he reached the Far Eastern frontier of the Spanish and Portuguese empires, for in that single moment, he had fulfilled the dreams of all explorers and navigators since Columbus more than eighty years earlier.

All his Spanish maps were now utterly useless. This was Portuguese territory, and Spain had relinquished her claim to the precious Spice Islands fifty years earlier. It also meant that Drake should change his tactics, especially if he wanted to create a toehold for his queen in the East. Fortunately for Drake, the bulk of the rich

trade in cloves was in the hands of the Sultan of Ternate when he arrived. And the sultan had not been enamored with the Portuguese. Drake was assured of a warm welcome by the sultan's emissary.

The sultan was true to his word. The English were met with tremendous pomp and ceremony, with the *Hind* being towed into the best anchorage by the sultan's galley. The sultan himself, Babu, accompanied by three galleys rowed by eighty oarsmen each and soldiers lining the decks armed to the eyeballs, boarded the *Hind* to extend his personal welcome to Drake and his men. Babu, statuesque and imperious, bedecked in cloth of gold and red leather shoes with jewels strewn about his person, greeted the sea weary, stocky redheaded West Country Englishman as an equal. Drake ordered some of their treasure on deck so that he could show Babu that they truly were in possession of a fortune. The formalities at an end, Drake followed Babu to his fortress, where an agreement was hammered out for England to expel Portugal from the area if Babu would concede his trade in cloves to the Queen of England. In exchange, Drake gave his word that within two years "he would decorate that sea with ships for whatever purpose might be necessary . . . and gave [Babu] a gold ring set with a precious stone, a coat of mail, and a very fine helmet."[18]

Drake, of course, had no power to commit the queen to such an undertaking and the complications in international diplomacy it could unleash, but it did "buy" him six tons of top quality cloves that were laden into the *Hind*. Still, Drake certainly didn't trust Babu's effusion, nor did Babu completely trust Drake.[19] Three days later, with even more treasure—this time spices—in its hold, the *Hind* set out into the Indian Ocean. Somewhere off the northeastern coast of the Celebes, they found an uninhabited island with abundant wood and water, and all the victuals they could want. There Drake left three Negroes, including a woman named Maria, who had been brought from South America and had conceived a child aboard ship. By the narratives, and contrary to Drake's many detractors' theories, it seems that they wanted to establish a colony there, since it was "rich in all the necessities of life." Drake's faithful friend, Diego, of course, remained at his master's side.

As they sailed around into the Celebes Sea, the warm green waters hid the last great danger that Drake would have to face—a long, steep,

coral reef only seven feet below the surface. The winds were driving them southward rather than west, and soon they found themselves lost in a maze of shallows and islands along the fingerlike east coast of the Celebes. Without any charts, maps, or personal knowledge, they had to navigate their way through—constantly beating back and forth—with "extraordinary care and circumspection."[20] Then, on January 9, 1580, at nine P.M., the unmistakable and spectacular grinding of the ship's wooden hull against the reef rocked the *Hind*. She had run aground and was listing perilously on the rocks.[21] In that single moment, all could have been lost, and no one was more acutely aware of that fact than the commander. Drake and his men began bailing the water out of the hold to inspect the damage. Somehow, most of the timbers were still intact and able to be repaired, if only they could work the ship loose from the reef. Drake took soundings, and only a single length away from the ship, the sea was so deep that he could find no sea floor. There was, however, no safe ground for the men to stand upon to haul the *Hind* off, and the nearest land, by their reckoning, was almost twenty miles away. Their pinnace could take only a third of their crew.

In the morning, Drake took his soundings again with no better results. Then he prayed, and his recalcitrant preacher Fletcher gave them the sacrament. The only alternative left to them, Drake said, was to lighten the *Hind*'s load. Three tons of cloves, victuals, ammunition, and two pieces of artillery were eventually tossed overboard, yet still the ship held fast. Then, as if by divine will, in the late afternoon the wind changed, and the *Hind* slid like an ungainly whale into deep water.[22]

Understandably, the next leg of the *Hind*'s voyage is not easily decipherable since the geography was completely unknown to Drake. Nonetheless, the *Hind* found itself at sea again, and was able to refit and recover from their ordeal at an island, avoiding the Malacca Strait, somewhere south of Java. Drake, despite the Portuguese presence in the region, was the first European to navigate successfully Java's southern coast, proving it was an island, separate from Terra Australis.

From the tip of Java, Drake and his men sailed out into the Indian Ocean on March 26, 1580, reaching the Cape of Good Hope in June. By the time they made landfall along the western coast of Africa

at Sierra Leone, their water supplies were dangerously low, with only a half a pint to share between three men. Amazingly this 9,700-mile stretch of the voyage—from the tip of Java to Sierra Leone—is barely documented, though it must feature among Drake's greatest achievements, for even in the eighteenth century, it was "a thing hardly to be credited, and which was never performed by any mariner before his time or since."[23] His navigation of these waters in the tiny *Hind* without a safe base or any reliable map is tantamount to being launched to the moon out of a cannon, orbiting without instruments or ground control, then returning safely home.

Sierra Leone was no less spectacular a place to them than New Albion. The Englishmen were delighted and overawed at the sight of their first elephant, and the fabled "oyster tree" (the mangrove) of travelers' tales. More important, fresh water abounded, as did lemons and other fruits. Though it would be nearly two hundred years more before citrus fruits would be credited with staving off the deadly swelling, extreme muscular distension, and weakness of scurvy, Drake intuitively knew that it was keeping him and his men healthy. There were no recorded deaths from scurvy on his voyage.

From Sierra Leone, the Cape Verde Islands were only a stone's throw away comparatively speaking. As they headed on the final leg of their journey, Drake could but wonder if Elizabeth still was queen, or if Philip of Spain had at last succeeded in planting Mary Queen of Scots upon the English throne. Had the queen married? he wondered. Was the country at peace or at war? After all they had been through, he worried at last about what kind of reception they might receive at home.

On September 26, 1580, some local fishermen in the Channel spied a small, weather worn, heavily lying ship making her approach past them into Plymouth Sound. A stocky man with curly red hair hailed them and asked, "Is Elizabeth still queen?" Later they recalled that they thought it was a very odd question for an Englishman flying the flag of St. George to ask. One of them piped up proudly though in reply, "Aye, and in fine health, too!" Little did they know that they had been the welcoming party for one of the world's greatest adventures ever recorded.[24]

27. The World Is Not Enough ✦

Non sufficit orbis
— CONCEIT COMMEMORATING PHILIP II'S EMPIRE

When Captain Winter had returned in June 1579 with the *Elizabeth*, there was more than a fluttering of butterflies' wings at court and in the City of London. The country, then Europe, was thrown into utter disbelief. Bernardino de Mendoza, the Spanish ambassador to England, had been caught completely unaware. "The adventurers who provided money and ships for the voyage," he blustered in a report to Philip, "are beside themselves for joy, and I am told that there are some councillors amongst them. The people here are talking of nothing else but going out to plunder in a similar way."[1] Only Burghley remained calm. What else could he do? The expedition had left without his express knowledge of its final destination, and whatever his relationship with Doughty had been, that was at an end as well.

Three weeks before Drake returned, news reached the City from Seville merchants trading with London in the new Spanish Company that Drake had captured several prizes and taken 600,000 ducats ($50.47 million or £27.28 million today). The investors in the voyage—including Elizabeth—waited expectantly, hoping for an enormous windfall. The Portuguese ambassador had already petitioned the queen for restitution to Nuño da Silva for his losses, and in June 1580 the lord admiral, an investor in the expedition, too, ordered that goods "piratically taken on the seas by Francis Drake and his accomplices to be restored to the Portuguese."[2] But the only person guilty of the crimes and capable of any restoration at that point was Captain Winter, who had returned to England, abandoning his commander.

But Philip II knew more than he was letting on to others. In August 1579, the letters began arriving, and they did not stop for over a year. The South Seas colonies had been ravaged by "the boldness of this low man." The "Spanish Lake" that cosseted Philip's western empire, he knew, had become a vast Pacific Ocean where any corsair could become "lost" from reprisals. Still, putting things into perspective, Drake's thefts, though huge, were insignificant in the greater scheme of things. What mattered was that the navigational feat was colossal, and would not fail to inspire others. All Philip could do was to wait and see the extent of the damage before acting. In the meantime, he felt justified in the shift in his grand strategy by creating a Catholic League against England's heretic queen.

Drake, too, waited. Plymouth had had an outbreak of the plague, and he was deeply unsure how matters would stand with the queen. All he could hope was that the vastness of the treasure would please her. He remained ignorant of any changes in the political, social, or economic landscape that might affect his reception, and until John Brewer, Sir Christopher Hatton's trumpeter who had accompanied them on the voyage, returned, there would be no certainty. Drake's wife, Mary, and the mayor of Plymouth, John Blitheman, rowed out to the *Hind*, but whether they had a grasp of international affairs, or the queen's present frame of mind, is doubtful. And so Drake wrote to Leicester, Hatton, Walsingham, and the other backers to tell them he had safely returned with riches.

When Elizabeth learned that her pirate had returned with fabulous treasure, a quorum of privy councillors was immediately convened, but only the lord admiral was among the five members present who openly supported Drake. Burghley and Sussex concluded that Drake's booty should be registered at the Tower of London in preparation for its return. When the restitution order was put before Leicester, Walsingham, and Hatton, they refused to sign it. Why should they lose a fortune to please Philip of Spain? And so, while the gentlemen argued, Elizabeth quietly sent word to Drake that he needn't fear. She was summoning him to court and asked him to kindly bring her some samples from his great adventure.

Drake sprang into action, loading several packhorses with some gold and silver, and all of the precious jewels. When he arrived at

court at Richmond, he was admitted immediately to the queen's privy chamber, where they remained quite alone for six hours. What was said between them was never recorded in full, but certainly the queen told Drake about the dreadful turn of events in Europe, while he pledged to do as she wished to help.

In 1579, the queen most likely explained, Philip had backed the papal expedition to Munster to foment an Irish uprising against England. An English expedition to Munster was under way, but the outcome remained uncertain. Charles IX of France had died, and his brother Henry was now King Henry III. The French king was under the influence of Henry of Guise who was both the uncle of Mary, Queen of Scots, and the puppet of Philip of Spain. Worse still, in January 1580, King Henry of Portugal had died, and Philip was claiming his right as heir to the Portuguese crown. The Portuguese wanted the natural nephew of King Henry, Dom Antonio de Crato, as their king, but Philip had successfully invaded Portugal both by land and by sea in the summer, and had declared himself king in Antonio's place. The Spanish and Portuguese empires were now one, and Philip was king of the largest empire that the world had ever known. In a sound bite that Drake could readily comprehend, Philip now had twelve oceangoing galleons from the Portuguese Royal Navy, doubling the size of his Indian guard and ocean fleet. The total combined shipping that he now held exceeded 250,000 tons—over six times that of England—and his great admiral, the Marquis of Santa Cruz, had branded Elizabeth "the pirate queen."[3]

In these circumstances, Drake's adventurous tales and evident vast plunder would have been like "heaven's dew" to the beleaguered queen. The Elizabeth Islands in the Strait of Magellan, New Albion in the South Seas, and a trade agreement with the Spice Islands would have made her recognize that there was no going back, no handing over, and certainly no abandoning her renegade captain. No matter what, Drake would not suffer, for he had served her loyally and extremely well.

While Drake left for home with orders to register the treasure aboard the *Hind* with Edmund Tremayne, clerk to the Privy Council and a former Member of Parliament for Plymouth, the court was electric with anticipation around him. Mendoza was outraged that

the queen had received the pirate. Would the queen send him to the Tower? Or would she reward him? Rumors of the spectacular hoard grew, and soon all London knew about the great adventure.

Back in Plymouth, Drake did as his queen had requested. He took £10,000 ($3.42 million or £1.82 million today) for himself and £14,000 ($4.72 million or £2.55 million today) for his men, though it is entirely likely that he took more. Then Tremayne and his assistant began the arduous task of counting the treasure for registration and eventual transportation by land to the Tower. Tremayne's orders in the queen's hand, "To assist Francis Drake in sending up certain bullion brought into the realm by him, but to leave so much of it in Drake's hands as shall amount to the sum of £10,000, the leaving of which sum in his hands is to be kept most secret to himself alone" were carried out with part of the treasure remaining in custody in Plymouth, and the vast majority shipped overland to the Tower.[4]

In London, Elizabeth categorically refused to grant the Spanish ambassador an audience, writing instead to the outraged Mendoza that she had made a personal investigation of Drake's voyage and had determined that no harm had been done to the King of Spain. While the victims of Drake's depredations had begun submitting the dossiers relating to their losses, the alleged amounts pillaged skyrocketed. Many Spanish merchants had tried to avoid duties by shipping unregistered cargoes and blaming Drake for fictitiously high losses. English merchants in the new Spanish Company pressed the queen for restitution, fearing reprisals against their own businesses. Burghley complained bitterly to the queen that Drake had committed several acts of war. Elizabeth replied that so had Philip and Pope Gregory XIII in invading Ireland. The massacre of the papal troops at Smerwick had shown that Philip was garnering support against her, and she would not placate him by returning the treasure.

But why? Elizabeth was never so steadfast toward anyone except Leicester before this. The answer is simple really. After years of near-war with Spain, of balancing Spain's power against that of France, of weighing the possibilities of one marital match against another to protect England, of protecting England's borders from Scotland and Ireland while helping to support the Netherlanders in

their bid to return to their ancient rights, the queen's coffers were emptying too rapidly for the continued security of the realm. Wars were "easily begun, but not so soon ended," to use one of her favorite expressions, and yet for the millions that the queen had poured into securing the realm, it was all she could do to tread water and not drown. And now Drake—coupled with Antonio de Crato, who had brought her the fabulous Portuguese crown jewels to help pay for an English expedition to reclaim his country—offered the parsimonious queen a real opportunity to stop handling by half measures the most dangerous situation she faced. Spain needed to be checked, and by restoring Drake's plunder, she would only succeed in limiting her possibilities to maneuver.[5]

And, to add to the mystery, there were literally tons of swag that had not been registered either at Plymouth or at the Tower of London. Tremayne's official report of what had been sent to the Tower from Plymouth's Saltash Castle shows "forty-six parcels of treasure average over two hundred-weight each," or almost five tons. This was, of course, after Drake had siphoned off the £24,000 for himself and his men. Another account in Burghley's State Papers states that there were ten tons of silver bullion delivered.[6] What of the twenty-six tons of uncoined silver alone that Drake himself claimed to have taken?

Then there were the Royal Warrants for coins refined. In this manner, Sir Christopher Hatton received £2,300; Sir Francis Walsingham, £4,000; and the Earl of Leicester, £4,000 in newly minted coins. A further £29,635 was refined into "clean ingots" in their names.[7] The truth of the matter is that the backers were happy to admit to a windfall profit of 4,700 percent on their investment, but, officially, millions went unaccounted for.

Unofficially, it has been estimated that the queen's share exceeded a full year's expenditure for the entire realm. This is backed up by the fact that she gave over £100,000 to Francis, now Duke of Anjou, and again a suitor for Elizabeth's hand, to help the Dutch in their struggle against Spain shortly after Drake's return. By early 1581, Leicester had accompanied Anjou to the Low Countries with hundreds of courtiers as a sign of the queen's goodwill, and also negotiated with Francisco Rodriguez (a former victim of Hawkins's thefts) for the

pawning of some of the finest of the Portuguese crown's diamonds.[8] Without Drake, Elizabeth simply would have been unable to support the Dutch or defend the realm in full measure as she would do over the coming years. Harvesting the sea was beginning to have its distinct attractions.

Still, the Queen of England could never admit in official circles that this was the case. She dissembled with Philip as she had done with Mendoza, feigning disbelief at his "*Memoria de los Cossarios Ingleses que han hecho robas en las Indias*" ("Memorandum concerning the robberies of the English Corsairs in the Indies").[9] Her "engagement" to Anjou neutralized any French action against her, and effectively made Anjou her puppet in the Low Countries. Her sweet talking Antonio de Crato was to keep possible invasion of Portugal open as an option in the event of a full-fledged war with Spain. And the agreement hammered out by William Harborne in Turkey ushered in a new era of legitimate trade with Sultan Murad III and the beginning of the Levant Company through its special Charter of Privileges.

Coded messages to her enemies were the golden thread stringing all her disparate foreign policies together. While the queen's enemies and her more conservative advisors like Burghley may have been dismayed at her behavior, she had read the mood of the nation perfectly: the country was puffing out its chest with pride at Drake's exploits. England would no longer kowtow to Spain's demands that she ignore the sea.

And so, on April 1, 1581, the queen decided to give her enemies the key to her cipher. The *Golden Hind* had made the voyage from Plymouth to Deptford to show her to the queen, as requested. Naturally, much of London rushed to the quayside to glimpse a view of the ship that had given them hope for the future. The throng was huge, with a hundred or so well wishers collapsing the plank across which the queen had walked to climb aboard the *Hind* moments earlier. They scrabbled in the mudflats below, uninjured, and entertaining other onlookers with their antics in trying to escape. The queen was entertaining, too, losing one of her garters, which was fetched back to her by Monsieur de Marchaumont, the French ambassador. It was purple and gold, and Elizabeth raised her skirts,

placing it upon her leg in front of the crowd, promising, like the coquette she was, that she would send it on to the ambassador as a keepsake when she had finished with it. After the royal banquet on deck, Drake was made to stoop before her. She mused aloud to the assembled audience if she should strike off his head with her gilded sword she held aloft. Naturally, there were defiant howls of "NO!" The queen smiled, lowering her eyes and nodding to her people, then passed the golden sword to de Marchaumont and asked him to kindly perform the ceremony of knighthood. The queen now had France, and Sir Francis Drake to protect her realm and harvest the seas.

As if to prove her right, Drake ordered a present of 1,200 crowns to be divided among the queen's officers aboard the *Golden Hind*, and presented a large silver tray with a diamond frog to Elizabeth herself, to symbolize their understanding with France.[10]

28. Elizabeth Strikes Back in the Levant ✂

One must be a fox in order to recognize traps, and a lion to frighten off wolves.

—NICCOLÒ MACHIAVELLI, *The Prince,* 1531[1]

Until the early 1580s, foreign policy was underpinned by the three-legged stool of trade, plunder, and, in the case of Ireland, settlement. This period experienced a metaphorical tug-of-war between bona fide merchants seeking fresh outlets for legitimate trade, Elizabethan corsairs looking to get rich, and the new imperialists like Walter Raleigh, who had a vision to make colonization enrobe and dominate trade and plunder. Elizabeth, despite what her detractors may say, was not an imperialist. But like Drake with Doughty, she, too, had had enough poking and prodding by the pope and the King of Spain. Her difficulty remained in controlling the various factions at home to the benefit of England abroad.

Elizabeth's deeply Protestant—even puritanical—party, led by Leicester and Walsingham, wanted her to protect the Dutch, at almost any cost. By agreeing to finance the Duke of Anjou's elected rule in the Low Countries, her commitment was clear, and her risks were small.[2] Trade had been so erratic in the previous decade that the Low Countries had ceased to be the powerhouse it had been twenty years before, and had become instead a symbol of Spain's might or religious freedom or persecution, depending on the point of view. But the queen was adamant, the Netherlands was not a colony or province of England, nor would it ever become one. To go down that weary road would mean all out war with Spain. Indeed, William of Orange paid dearly for welcoming Anjou as their leader in 1582 by an assassination attempt on his life funded by Philip of Spain. What did interest Elizabeth were the opportunities to renew trade

in places that had been a blank canvas until recent years, like the Levant. Walsingham, too, saw the merit of trade and recommended that

> *the first thing that is to be done to withstand their fines [customs duties] is to make choice of some apt man to be sent with her Majesty's letters unto the Turk to procure an ample safe conduct, who is always to remain there at the charge of the merchants, as agent to impeach the indirect practises of the said Ambassadors, whose repair thither is to be handled with great secrecy, and his voyage to be performed rather by land than by sea.[3]*

William Harborne was just the man whom the leaders of the Levant Company, Osborne and Staper, identified for the job. He could promise precisely what the Turks wanted, and what the pope had forbidden as an export from Christendom—munitions. By allying herself with the Ottoman Empire, Philip's main enemy, and contravening an edict from the pope, Elizabeth knew she could not only reap the rewards of the Levant trade but also annoy her two main enemies while adopting her favorite stance: feigning innocence. In May 1580, Harborne succeeded in procuring a complex charter of privileges from Sultan Murad III, which took the form of a unilateral treaty. It offered fabulous trading privileges merely for the friendship of the English queen. The reason for his munificence was, of course, a complete work of fiction. But it wasn't all smooth sailing.

In April 1581, shortly after Drake had been knighted, an English ship called *Bark Roe* had been blissfully unaware of the importance of the new entente with the sultan and, after spending some time with Harborne at Chios, seized and plundered two merchantmen belonging to Greek subjects of Murad III. Harborne was arrested and locked up for piracy, and all English privileges were summarily withdrawn. Two months later, the queen was obliged to humbly apologize, and she offered to send a permanent ambassador to Constantinople to avoid such terrible misunderstandings of their amity.[4]

Harborne was released and, after a brief sojourn in England, returned as the queen's ambassador from 1583 to 1588. In that time,

he set up a network of consulates in Egypt, Syria, Algeria, Tunisia, Lebanon, and Libya. One of the Levant Company's most forward thinking traders, John Newbery, set up trading posts stretching from Aleppo in Syria to India. English traders plied the Mediterranean freely bringing back Turkish carpets, Persian silk, sweet oils and wines, currants, and other delicacies from the Levant. They also traded in pepper, and other rare spices like cloves, nutmeg, ginger, and cinnamon, cutting out the middlemen between the Levant and England. England had more choice at cheaper prices in its luxury markets. The Levant Company at last fulfilled the trading aspirations that so many other trading companies, including the Muscovy Company, had simply failed to do. Undoubtedly Newbery, more than any other merchant so far, understood how the system in the Middle East worked. His journal took account of commodity prices, customs duties, cultural differences, transport costs, local caravan trading routes and much more.[5] And the more he succeeded, the angrier Philip II became. But the king was not the only one.

The temptation to link the Middle East to the East was huge, particularly since Newbery had been so successful in setting up his trading posts as far as India. In Newbery's 1583 voyage to the East, he not only carried the queen's letters of introduction to Akbar the Great and "the king of China," but sailing with him in the *Tiger* were the merchants Ralph Fitch (who would later become famous for his involvement in the East India Company), Ralph Allen, John Eldred, William Shales, and William Skinner, along with a jeweler, William Leeds, and a painter named James Story. The queen herself had "lent" 10,000 pounds in weight in silver to Osborne, Staper, and their partners for the journey—silver certainly looted from Spain's empire by Drake. While all the merchants except Fitch and Newbery were to be left at Baghdad and Basra to set up their trading posts, Newbery, Fitch, the jeweler, and the painter went on to India. But why?

India was, until the mid-eighteenth century, the only place where diamonds of any quality could be found. It was also where rubies, emeralds, and pearls abounded along with gold. John Dee had been consulted by Newbery before leaving London, and it was evident that the intention of their reconnaissance into India was to acquire

"great quantities of diamonds, pearls and rubies, etc. to which end they brought with them a great sum of money and gold, and that very secretly."[6]

In August, within ten days of setting up their trading post in Hormuz, Newbery and Fitch were arrested and shipped to prison in Goa. According to Newbery, "there were two causes which moved the captain of Hormuz to imprison us and afterwards to send us hither. The first was because Michael Stropene had accused us of many matters, which were most false. And the second was for that Mr Drake at his being at Moluccas, caused two pieces of his ordinance to be shot at a galleon of the king of Portugal. . . . "[7]

While it was all well and good for the Portuguese—who had been governing Hormuz and Goa for nearly eighty years—to allege offense at Drake's actions, Newbery was probably aware of the queen's fascination with Dom Antonio de Crato (and even more aware of her fixation on acquiring his crown jewels), and her surreptitious support for him. Undeterred, he disavowed any dealings with either Drake or Antonio de Crato, and he blamed his imprisonment on the Venetian Stropene, who, Newbery claimed, "did presently invent all the subtle means they could to hinder them [the English]: and to that end they went unto the Captain of Hormuz . . . telling him that there were certain English men come into Hormuz, that were sent only to spy the country; and said further, that they were heretics."[8] What hadn't occurred to either Newbery or Fitch was that the middlemen whom they were cutting out of the Levant trade with England were the Venetians.

Fortunately for the hapless English merchants, two Jesuit priests and a Dutch trader intervened on their behalf, and they were released after three desperate weeks in the Goan prison. The lesson was salutary but unfortunately wasn't automatically transferable between adventurers. Like children, Elizabeth's adventurers rarely learned from the mistakes of their brothers. It would be at least another fifty years before English traders realized that if they didn't know the local system and understand the politics, legal trade would be virtually impossible.

29. Katherine Champernowne's Sons Take Up the American Dream ❧

Brother, I have sent you a token from Her Majesty, an anchor guided by a Lady as you see, and farther Her Highness willed me to send you word that she wished as great good hap and safety to your ship as if herself were there in person. . . .

—WALTER RALEIGH TO SIR HUMPHREY GILBERT, MARCH 18, 1582

Closer to home, the gentlemen adventurers fared better, at least in terms of the political upheavals of Elizabeth's reign. Humphrey Gilbert had been a soldier of fortune since 1562, first at Newhaven in France, then, from 1566 in Ireland, involving himself in myriad plantation schemes. Between his stint at Newhaven and his time in Ireland, he had proposed to the queen that he set out and search for the Northwest Passage.

But Ireland was where he would make his name. His uncle, Sir Arthur Champernowne, embroiled him further in that unfortunate country with his personal vision for Irish "plantings" in Ulster and Munster between 1566 and 1572. Gilbert even became involved with Sir Thomas Smith, Elizabeth's secretary of state, in his privately financed plantation schemes in Ulster from 1571 to 1575, and led English "volunteers" as their hardened military commander in the Low Countries in 1572. Knighted for services to the crown in Ireland in 1570, Sir Humphrey Gilbert was of that breed of highly volatile younger sons of gentle birth in Elizabethan England who saw gold in colonization, rather than in piracy.[1]

The queen, for her part, needed Gilbert and men like him to extend her authority in Ireland. Allowing her gentlemen to pillage and spoil the land of its rich natural timber resources and prolific fishing grounds was the only pay she could afford to give. Still Gilbert, much like his much younger half brother, Walter Raleigh, seemed expert

at snatching defeat from the jaws of victory. The eldest Gilbert was Sir John, followed by Sir Humphrey, then Adrian. Walter Raleigh and his elder brother Carew were their half brothers by their mother's marriage to Walter Raleigh senior. Never before had five sons from one gentlewoman dominated foreign expansion. But such was the lot for Katherine Champernowne's sons. They had each been introduced in their turn at court by their aunt, Cat Ashley, Elizabeth's faithful governess. For each, their early days held tremendous promise, but they were ultimately destroyed by their own arrogance, poor judgment of their courtly rivals, scant knowledge of the lands they wanted to explore, and, in Walter's case, an inability to assess the situation dispassionately and roll with the tides of change.

Gilbert's early successes as a brutal military captain in Ireland fed his vision of transplanting Englishmen to foreign shores. Unlike Drake, Gilbert delighted in inflicting massive casualties in as vile a manner as possible. Deliberately killing as many women and children along with their men, his particular specialty was to lay waste to the land, cut off his victims' heads, and use them as markers forming a gruesome path to his tent. He brought "great terror to the people when they saw the heads of their dead fathers, mothers, sisters, brothers, children, kinsfolk and friends lie on the ground before their faces." Gilbert himself boasted to Sir Henry Sidney that "after my first summoning of any castle or fort, if they would not presently yield it, I would not afterwards take it of their gift [accept their surrender], but won it perforce, how many lives soever it cost, putting man, woman and child of them to the sword."[2]

For some reason, Humphrey Gilbert thought that his fearsome conduct in Ireland qualified him to go in search of the Northwest Passage, as if this perilous sea voyage of discovery was a natural extension to his previous credentials. When the Muscovy Company refused to allow Gilbert to "interlope," he continued to build on his knowledge base for North America, reading everything he could find on the subject and consulting with the Hakluyts and Dee. By concentrating his energies on the colonization of America, he believed that he would be in the forefront of what would become, at some point, a necessity to England's survival. On the plus side of his highly volatile character, Gilbert's enthusiasm for North American colonies was infectious and spread to young Walter (sixteen years his

junior). It would be their spectacular failures that would pave the way for the seventeenth-century successes.[3]

With the assistance of both the Richard Hakluyts and John Dee, a huge body of correspondence and firsthand accounts of life in the Americas was building up, and Humphrey Gilbert had access to most of it. He conjectured that the failure of the Company of Kathai, and Drake's secret departure on his voyage of circumnavigation, meant the time was right to press the queen for a royal patent for Norumbega—that swathe of North America between the Hudson River and Cape Breton in Newfoundland.

Since Gilbert was so well connected, and had Leicester's support to search for the Northwest Passage and settle America, Elizabeth granted a royal patent on June 11, 1578, "to discover and inhabit some strange place not actually possessed of any Christian prince or people."[4] It is tantalizing to hope that the queen did not want such a violent adventurer to wreak havoc on any people, but this was hardly her worry. Her limitation on the patent to a term of six years in which to settle Englishmen in these lands in order to retain the title from the crown was, however, a stroke of genius. Elizabeth could appear to comply with his scheme, while not venturing a penny herself, and if the venture came to nothing, then she would have lost nothing.

While Gilbert's own substantial family of brothers and uncles involved their fortunes in the undertaking, Gilbert himself understood the benefit of royal patronage, and tried to enthuse others at court, including Elizabeth, with the prospect of discovering gold. But he found that Lok and Frobisher had tied up the wafer-thin royal investment market with their final voyage, and his pleas fell on deaf ears. Only young Henry Knollys, son of Sir Francis Knollys, treasurer of the queen's household and cousin to the queen, became a major participant. While Sir Humphrey was gathering together his fleet for the Norumbega expedition, he talked of rescuing Oxenham from Panama; capturing all the shipping of France, Spain, and Portugal; fishing at the Newfoundland fisheries; and eventually seizing the whole of the West Indies for England. He wrote off memorandum after memorandum trying to enlist the same level of support Drake had done so successfully, but to no avail.

While the word "madness" springs to mind for this as well as other Gilbert projects, in his defense, these rantings fit more into the realm

of trying to make dreams come true. Most of the queen's western adventurers were facing the complete unknown, with Spanish America their sole compass for "how things worked." And if Spain could fashion an empire from nothing and become wealthier than any other European nation could imagine, then so could England . . . if only the queen would back *their* voyages of exploration to North America.

But before the expedition sailed from Plymouth, Gilbert and Henry Knollys fell out, and Knollys set off with three of the ten ships in the expedition to capture "rich prizes" through opportunistic piracy. Gilbert, meanwhile, with his brothers and half brothers set off in the seven remaining ships for North America. Before they were past Ireland, the fleet was dispersed by heavy squalls and storms. Gilbert alone made landfall there. That was the closest he would get to America.

His half brothers, Carew and Walter Raleigh, however, each in command of his own ship, fared only slightly better. Walter's navigator was the exiled Portuguese pilot, Simon Fernandez, who would play an important role in Raleigh's own dreams of settlement. After the storms, Fernandez argued that it would be best to head south instead of north by northwest to the Canaries, taking the more familiar route favored by Hawkins and Drake.[5] They made it as far as the Cape Verde Islands, where they had a "confrontation" with some Spanish and Portuguese ships and escaped back home, with the *Falcon*, a leased ship from John Hawkins, now badly in need of repairs. Understandably, any plunder taken in the fracas was shared out with the ship owner.

In one sense, their timing was fortunate. The court and Privy Council had no time to immediately address issues of gentlemen adventurers engaging in piracy. The proposed French marriage with Alençon was "on again" in 1580–81, consuming all of the court's energies, and forcing all of the queen's gentlemen to take sides. Burghley, a proponent of the match, was in disfavor, and Walsingham with Leicester, on the rise. Whose patronage a gentleman followed would determine which side of the argument he would be on. Walter Raleigh was the exception. Originally under the patronage of the vituperative Earl of Oxford, Raleigh "jumped ship" and made his search for a new patron. He wrote to the Earl

of Leicester, declaring that "I will be found as ready and dare do as much in your service as any man you may command."[6] Of course, Raleigh hadn't recognized that Leicester's heir, Sir Philip Sidney, was being groomed as the earl's younger replacement for the queen's affections, and if for any reason Sidney failed, Leicester's stepson, Robert, Earl of Essex, would most assuredly do well. Despite Raleigh's brief encounter with the sea, remembered by many as a dubious chapter in his young career, by 1581, he had already shown great promise as a soldier in Munster. And Leicester wanted to keep him there, out of court, and out of harm's way.

In the meantime, the tenacious Spanish ambassador, Bernardino de Mendoza, was unrelenting in trying to get recompense for the piracy in which Knollys, and later Raleigh, had been engaged during the failed first Gilbert voyage. But the queen was not minded to hear the pleadings of Philip's servant in England until such time as he came forward with a reasonable explanation or apology for the king's financing the papal mercenary troops in Ireland. He had invaded her sovereign soil and committed a clear act of war, she argued. Mendoza's position had been so severely compromised that no one dared to speak to him. When he walked along the street, children hooted and stoned him. In his audience with the queen in October 1581 at Richmond, he lashed out at Elizabeth that whatever she might think of Spain, she had brought these tribulations upon herself; that she was extending herself far too much to the Portuguese pretender, Dom Antonio de Crato; and that if she didn't change tack, "cannons would bring her to reason."[7]

Elizabeth was livid. She told Mendoza that he need "not think to threaten or frighten her, for if he did, she would put him in a place where he could not say a word." He was within an ace of being expelled, and he knew it. He had gone too far, and he tried to appease the English queen with flattery, telling her that she was "a lady so beautiful that even lions would crouch before her."[8] Elizabeth answered that she would ignore the Spanish ambassador's pleas for restitution from her gentlemen adventurers, including Drake, until the King of Spain could answer for his invasion of Ireland.[9]

Yet despite the heated exchange, when Gilbert requested another passport to go to his "lands" in America, the queen forbade him to sail, claiming that he was "noted of not good hap by sea" as his recent

voyage clearly showed. Disgruntled, Humphrey Gilbert sold part of his "concession" of lands north of the fiftieth parallel in Norumbega to Dr. John Dee.[10] After all, he had "by his former preparation [been] enfeebled of ability and credit to perform his designments . . . whereby his estate was impaired." He had been left no alternative but to dispose of "certain assignments out of his commission to sundry persons of mean ability desiring the privilege of his grant, to plant and fortify in the North parts of America about the river of Canada."[11]

Gilbert assigned rights to a Southampton merchant, Edward Cotton, to exploit whaling in the Gulf of St. Lawrence; but his venture soon ended in failure, too. Then in 1581, Gilbert took advantage of a change in the political atmosphere with the first Throckmorton assassination attempt on Elizabeth's life and subsequent clamping down on Catholics and recusancy fines. He agreed on a deal to grant rights of settlement to some 8.5 million acres to Catholics led by Sir George Peckham and Sir Thomas Gerrard to offset some of his losses.[12]

When the Spanish ambassador got wind of the Catholic "transportation" scheme, which would effectively export all opposition to Protestant policies in England, he set in motion a campaign to discredit both Gilbert and the Peckham/Gerrard undertaking. It would be disastrous for Spain's designs on England if Gilbert and his Catholic subtenants overcame the odds stacked against them.[13] Gilbert predictably ignored the Spanish threat and formed his own Southampton-based company called "The Merchant Adventurers with Sir Humphrey Gilbert," which would be imbued with the exclusive rights of trade with Gilbert's North American colony. The new company included all of Katherine Champernowne's five sons, thirty-nine Southampton merchants, and, notably, Francis Walsingham, who ventured £50.[14]

Prior to this, in preparation for Gilbert's own second expedition, Simon Fernandez was sent to the New England coast in an 8-ton frigate, the *Squirrel*, on a reconnaissance mission. On his return, Hakluyt, Gilbert, Dee, and Peckham all met at Dee's Mortlake home to discuss Fernandez's findings. But myths, not hard facts about terrain, the native Americans, and threats to settlement generally abounded. In their desperation, an Englishman named David Ingram, who had been put ashore in the Gulf of Mexico by John Hawkins back in 1568, was also interrogated by Gilbert and his

partners. Ingram had miraculously walked across North America to Newfoundland, where he was eventually picked up and returned to England. Still Ingram's tale was so fabulous to the adventurers that they were unable to decipher his facts from fantasy.[15]

Predictably, money began to dwindle, as always in these costly expeditions, and many of Peckham's backers pulled out when it became apparent that the queen would still demand the vast recusancy fines from her Catholic subjects even if they emigrated to America. Still, the lack of enthusiasm for the project can be largely attributable to Francis Throckmorton, who had initially been arrested in 1581 for plotting against the queen. In early 1583, he was unexpectedly taken into custody again.[16] Walsingham, who may have invested in the Catholic venture to North America to get to know his "enemies" better, had had Throckmorton seized as one of "the chief agents of the Queen of Scots," and who was also in the pay of the King of Spain. Seditious pamphlets published abroad were found in his possession, and he was put under excruciating torture for six months before he finally confessed all.

Meanwhile, Mendoza had been expelled to Paris in 1582, after the first Throckmorton affair, and had instigated this second and far more dangerous plot in 1583.[17] The assassination plots translated into draconian measures by the crown, and a waning willingness on the part of Catholics to poke their heads above the metaphorical parapet of English politics for any risky venture.

Finally, and mysteriously, Walsingham's stepson, Christopher Carleill, seemed to redeem the situation somewhat for Gilbert. He had interested the city of Bristol in Gilbert's plans, and in the spring of 1583, the Bristol merchants agreed to give 1,000 marks ($153,550 or £83,000 today) and a bark to be captained by Carleill.

Even better news was yet to come. Walter Raleigh had somehow stepped forward from the mass of young men itching to grab the queen's attention at court. He not only grabbed her attention, but he retained it. Since Gilbert was the "new favorite's" brother, the voyage now seemed to have a royal seal of approval.

After all the delays, a small fleet of five vessels set sail at last. On this second voyage, Gilbert commanded the admiral ship, the *Delight* (120 tons), that was part-owned by William Winter and his brother John. Other ships in the fleet were the *Golden Hind* (40 tons), owned

and captained by Edward Hayes; Raleigh's *Bark Ralegh* (200 tons); the *Swallow* (40 tons), belonging to a Scottish merchant; and the *Squirrel.* The voyage of 1583 was taken for one reason only: to retain Gilbert's six-year patent and thus prevent its expiry. But this voyage, too, to recoin Elizabeth's own words, was of "little hap." Within two days, the *Bark Ralegh* had returned to Plymouth, presumably due to disease. The *Swallow* split off from the rest of the fleet during their seven-week voyage to Newfoundland, in search of plunder. Yet somehow the fleet regrouped in St. John's harbor, where, despite the presence of thirty-six other ships with Spanish, Portuguese, and French flags hoisted proudly aloft their mainmasts, Gilbert claimed the land for the queen with great ceremony.

Yet, in their two weeks at St. John's prospecting for gold, disease spread like a brushfire among the men. So many had died and others were too ill to work that Gilbert was reluctantly compelled to order the *Swallow* to return to England with the sick and dying. The few who weren't sick refused to carry on, and Gilbert knew he was beaten. He claimed that the following spring he would send out two new fleets, one for the north of America, and the other for the south, and that "Her Majesty will be so gracious, to lend me 10,000 pounds."[18]

Then in a storm near Cape Breton Island, the *Delight* was shipwrecked. Eighty of her crew were killed, and, of the twenty survivors, only a handful ever saw England again. Gilbert was aboard the *Squirrel*, and on Monday, September 9, "the frigate [the *Squirrel*] being ahead of us . . . suddenly her lights were out, whereof as it were in a moment, we lost sight, and withal our watch cried, the General was cast away, which was too true."[19]

The first patent granted for North America had ended in fiasco. Humphrey Gilbert and his youngest brother, Walter Raleigh, had thought of their colonization schemes as a good means to injure Spain and enrich themselves and England. Carleill, and probably Peckham, until the issue of recusancy fines loomed large again, viewed it as an economically sound colonial enterprise. None gave any thought to the indigenous population of America. And Elizabeth herself thought of it as a sideshow to the pressing requirements for containing Spain, and getting more gold quickly.

Still, Walter Raleigh would persuade his queen that America would be worth another try.

30. The Defeats of 1582–84 ❧

*Tell me what has become of Drake and what you
hear of arming of ships. . . . It is most important
that I should know all this.*

—PHILIP II TO BERNARDINO DE MENDOZA

Drake had made good use of his time since he returned from his
around-the-world voyage. He had become mayor of Plymouth
in 1581 and began a major infrastructure project to bring a fresh
water supply to the town. The queen and Leicester had ensured
that he received just reward and standing for his phenomenal
accomplishment that had to remain a state secret, due to its very
nature. A proposal was put forward by Leicester that Drake should
head a company as its life governor to search for new territories, and
to spearhead a fruitful trading relationship with the Moluccas. Most
important for Sir Francis, he would never again sail as a rover. From
1580 onward, he would always have the queen's commission.

Drake was the most famous, most feared mariner in the world.
Everyone everywhere wanted to know him. And as the most
accomplished seaman of his day he was nicknamed "The Fortunate"
by popular acclaim. Even royalty sought Drake out, and Antonio
de Crato, the dethroned king of Portugal, was no exception. Where
Drake had been dubbed "The Fortunate," Antonio was called
"The Determined." It was Antonio's determination, his theft of
the Portuguese crown jewels, and his ability to embroil men and
women of greatness in his affairs that prevents him from being a
mere footnote in history.

Antonio, hearing of Drake's successes, and counting on the long-
standing friendship of Portugal and England, entrusted much of the
Portuguese crown jewels in pawn to Elizabeth to try to win back
his kingdom through the back door of the Azores. He should have
known better than to believe that Elizabeth would involve herself in

certain war with Spain. After all, she had by and large ignored his earlier plea for help when Spain overran the Portuguese mainland in 1580.[1]

But Drake was of another mind altogether. He carried grudges for his lifetime. Philip had invaded sovereign English territory in 1580 through the papal troops who ended up massacred on the southwest coast of Ireland at Smerwick. Any action he might take with or on behalf of Antonio would be justifiable retaliation for that act of war by Spain. Antonio's plan was to have a combined English and French fleet sailing under Antonio's flag to Terceira in the Azores, with Drake as his general. The plan was discussed at the highest levels of government with Leicester, Walsingham, Hawkins, Winter, and with the ailing Lord Admiral Clinton. Frobisher and Edward Fenton were named by the politicians as possible vice admirals for Drake. The financial deal was that the English would receive 75 percent of the Spanish prizes, and keep any Portuguese ships that refused allegiance to Antonio de Crato.[2] Naturally privileged trading status would also be on offer to England if they succeeded.

Still, to put out to sea without the queen's commission, the Privy Council would need to agree to these terms. Elizabeth and Burghley quickly vetoed Antonio's demand that the fleet would also need to intervene on mainland Portugal in the event that "the Kingdom of Portugal needs succouring." From that moment on, the proposed voyage was doomed. Munster was still in rebellion, and Elizabeth rightly feared that Philip might send more troops to her rebellious province Ireland in retaliation for any overt support for Antonio's cause. The fact that she had already financed Anjou's rule in the Low Countries conveniently escaped her view. A Portuguese invasion was too risky a business for her. Voyages of exploration, while treacherous for their mariners, could always be disowned. And nothing could prevent her from obfuscating about her involvement in the future as she had done so adeptly in the past.

Yet Drake believed that part of the plan might still be worth resurrecting. If the English fleet accompanied Antonio back to the Azores, and waited there to intercept the Spanish flota on its return, there would be no need to attack the West Indies later. Leicester and Walsingham agreed that money, or, more precisely, the lack of it, was the King of Spain's weak point. Any attack on his treasure trains

would wound Philip more deeply than any other exploit they could undertake. His incessant wars, the costs of subduing the rebellious Dutch, the annexation of Portugal, had meant that his solvency relied increasingly on every single treasure ship making a safe return to the Casa in Seville.

The plan made sense, but all they could hope for from a watchful queen who had just been told that there was yet another plot against her life (the second Throckmorton plot) was an "indirect" participation. Even then Elizabeth made England's involvement reliant on the joining in, too. If Catherine de' Medici, who had also been a claimant to the Portuguese throne, would not agree, then neither would the Queen of England. Drake, Hawkins, and Leicester were called to meet with Burghley, where the lord treasurer laid down clearly the queen's objections. The mission, in its present form, would need to be scuttled. Unbeknownst to them at the time, Philip had written to Mendoza only a week earlier that any voyage sailing from England undertaken on behalf of Antonio would be considered an act of war.

Yet Drake, ever the man of action, appealed to Leicester for another mission—a braver and more dangerous one, but one that would bring them all great wealth. Drake had pushed the door ajar to the East in his dealings with Babu, and now proposed a trading mission to the East Indies. Leicester, Walsingham, Hatton, Christopher Carleill, and Lord Admiral Lincoln agreed to the idea along with the Muscovy Company and adventurers like Frobisher. Drake himself invested £666 13s. 4d. ($211,805 or £114,489 today). As the voyage's inspiration and advisor, not to mention the only man who had actually sailed those seas, Drake was instrumental in the nitty-gritty of navigation, mapping out the best watering holes, planning how to victual the ship (including the provision of fresh fruit) and determining how to keep the ships "sweet smelling" to preserve health on board. More than a dozen of his own men agreed to join the expedition. Even Drake's young cousin, John, would sail in the 40-ton *Bark Francis* belonging to Sir Francis.

While the planning was meticulous by the standards of the day, the ultimate choice of captain was a disaster. Martin Frobisher, somehow relatively unscathed from the Northwest Passage debacle,

was mooted as the expedition's general. But Drake, at least, had the foresight to veto his selection on the grounds that he was too cantankerous a man to command a voyage that required both naval cunning and diplomatic prowess. Instead, Edward Fenton proposed himself as a replacement for Frobisher. Frobisher was more senior, but Drake's earlier point having been taken meant that Fenton eventually had himself accepted by the gentlemen adventurers. Fenton's vice admiral was the seasoned veteran Captain Luke Ward. The fact that Drake had been outvoted in the Council on these choices mattered little at the end of the day. He remained confident that he could inspire and educate the commanders adequately for the task that lay ahead, especially since many of his own highly skilled men were also participating.

When Drake blew in to Plymouth to give his final encouragement to the fleet, he saw immediately that the ships were light on tackle, and he ordered more to be delivered straightaway to the admiral with his compliments, along with some wine. Drake had been promoted to a position of standing and power, but there were—at least on this voyage—no more "Drakes" to replace his ingenuity, bravado, and flair in mastering the sea.

Fenton, who had proved himself a soldier of fortune only on land, was quite simply not up to the task. Virtually all others taking part in the expedition were better sailors and knew the sea better than he. His motivation for putting himself forward as commander of the fleet was to "get rich quick" and to advance to the place that Drake already occupied. The result was disastrous. In the vast expanse of the Atlantic Ocean, Fenton became alienated from his men and reality. As the Atlantic winds became unfavorable for sailing around the Cape of Good Hope, as originally planned, his professional mariners demanded that Fenton toss away his instructions and make for the Strait of Magellan to plunder Peru as Sir Francis had done. Powerless to resist, Fenton complied but not without ample bluster. Only some of Fenton's fleet reached the Brazilian coast, where they made a frenzied attack on three Spanish ships, sinking one. Trade was refused to them by everyone they encountered, and they were forced to return home to England none the richer, and none the wiser. Fenton, by now leading an uncontrolled crew, demanded that they

take the island of St. Helena, where he would be crowned "king," and from which they would plunder all ships passing to and from the Cape of Good Hope. The loneliness of command and the sea coupled with the demands of the voyage had made him lose the touchstones that grounded all men to their daily life ashore. Doubtless, Fenton had experienced some sort of mental breakdown.

By the time the fleet returned to England in June 1583—thirteen months after sailing—Fenton had lost most of his men and ships. He discovered that his vice admiral, Luke Ward, had reached England before him and had reported to the backers, and therefore the better part of the Privy Council, about Fenton's wanting to become "King of St. Helena." When his crazed attack against William Hawkins became common currency, Fenton was dealt with judiciously and told to retire to obscurity or face the consequences. Sadly, Sir Francis's young cousin, John Drake, had been captured near the River Plate, where the *Bark Francis* was shipwrecked and never returned to England.[3]

This was the nadir of the English maritime expansion. To make matters worse, Sir John Hawkins and Sir William Winter were at each other's throats, each claiming that the other was lining his pockets and that other naval officials were misappropriating funds. When Hawkins complained to Burghley that "the officers have taken courage and hardness to oppose themselves against me . . . divers [sic] matters have been omitted, delayed and hindered by many subtle practises," the queen ordered Burghley to set up a commission to investigate. The five commissioners were Lord Howard of Effingham (a Catholic and lord chamberlain at the time), the Earl of Lincoln (lord admiral), Sir Walter Mildmay, Sir Francis Walsingham, and, of course Burghley himself.[4] Four members of the Navy Board were to assist them in their deliberations: William Winter, surveyor of the ships; John Hawkins, treasurer; William Borough, clerk of ships; and William Holstocke, comptroller of ships. The master shipwrights, Peter Pett and Matthew Baker, were also called upon to assist the commissioners in their inquiries.

Elizabeth knew that each and every one of these men was vital to the navy, and that no fault must be discovered against any of them. Burghley had been ordered to investigate thoroughly, resolve

their differences, and make certain that they knew that she wanted this to be the end of the matter. But the facts spoke for themselves. Hawkins was right. The ships were being repaired with inferior products at inflated prices. Unseasoned oak was used for planking causing excessive leaking and time in dry dock. All the ships had at last been put in good order since 1578, but at a price. All ships built at Woolwich, Chatham, or Portsmouth seemed to be clear of the inflated charges against the ships built at Deptford. This laid the blame squarely on Matthew Baker, though the inspectors were most careful to omit his name from any documentation. Pett signed the report signifying his agreement to its findings, whereas Baker did not. Nor did Winter or the other Navy Board members.[5] As if to rub salt in their fresh wounds, Hawkins went on to offer the Privy Council a shipbuilding program that would not only be systematic, but would also include all ordinary and extraordinary repairs at an annualized savings of £3,200 ($956,968 or £517,280 today) to the crown. The proposal would eventually be accepted by mid-1585, when war with Spain had become inevitable.

In the interim, Philip's naval forces had gone from strength to strength. His brilliant admiral, the Marquis of Santa Cruz, annihilated any Portuguese resistance in the Azores, crushing forces loyal to Antonio in July 1582.[6] At the same time, Alba's troops in Portugal solidified Philip's stranglehold on his new dominion. In the Low Countries, the Duke of Parma's vicious campaign against the Dutch insurgents went on unabated, despite Elizabeth's support for Anjou's puppet government. In 1583, Parma retook Nieupoort and Dunkirk on the North Sea, establishing his Spanish naval squadron there as a bridgehead to an invasion of England. Still, these were not deepwater ports, and only ships of up to 200 tons could dock from Spain there.

Inevitably, Anjou had been routed from the Netherlands, and died a month later on May 31, 1584. Two months after that, William of Orange was assassinated in his own home. And Philip's flotas continued to pour gold, silver, and precious gems into his coffers unabated, while Elizabeth sold her crown lands, took part in risky maritime adventures, and prayed for deliverance. She must have feared on more than one occasion that God had become Catholic

again. Pope Gregory XIII had already reinforced the point with the adoption of the Gregorian calendar in October 1582. Naturally, the queen refused to adopt it (despite its being more accurate) from an institution that called her "the patroness of heretics and pirates." From 1582 until 1751, England would lag ten days behind the Catholic empires.

There was only one option left in 1584 to the queen and England. The country must recover from its nadir, and it would have to call upon the resources and tenacity of her adventurers.

31. Water! ❧

Whosoever commands the sea commands the trade;
whosoever commands the trade of the world commands the
riches of the world, and consequently the world itself.
—SIR WALTER RALEIGH

Clearly something needed to be done to reverse the tide. The old tried-and-true methods of daring plunder didn't seem to work any longer. Unless Elizabeth gave up all hope of peace, and surrendered to the horror of war with Spain, she could see no clear way through the impasse. Spain or the papacy would continue to fund assassination plots until one day, Lord forbid, they would succeed. Over £3.3 million ($1.11 billion or £600 million today) had been shipped from the Americas to Philip's coffers in the ten years between 1570 and 1580. That figure, unbeknown to Elizabeth, would rise nearly sixfold to £18.7 million ($5.42 billion or £2.93 billion today) by 1590.[1]

While the King of Spain's financial affairs were a closely guarded state secret, the obvious benefit he enjoyed from his American colonies was difficult to disguise. Now that he had successfully overrun Portugal and subsumed its navy into his own, it seemed to most minds of every persuasion that the King of Spain was unstoppable. That is to most minds except the great commanders of the past like Drake, Hawkins, and Winter. Sharing their point of view was the new adventurer of the future, Walter Raleigh. The queen's great political mainstays Leicester, Walsingham, and Burghley were also unwilling to look at the situation through defeatist eyes. Even Burghley had overcome his aversion to plunder, since to date it had been the only effective weapon against Spain. If England were to remain Protestant, ruled by their Virgin Queen, then it required the queen to be realistic and see that war was already inevitable.

Though she never openly admitted that they were right, Elizabeth would agree by the autumn of 1584 to give financial and military assistance to the Dutch rebels. The top priority was to try to save Antwerp from extermination at the hands of Parma. And with Parma now in charge of two Low Countries' ports, capable of making rendezvous with a larger invasion force from Spain, Walsingham's spy network clicked into high gear.

It is no wonder that with war looming heavily upon the horizon Elizabeth, now aged fifty-one, would find such pleasure in the sweet and lilting banter of the charismatic Walter Raleigh. His strong sense of power, his almost Machiavellian energy in his quest of fortune, mesmerized the aging queen. While Elizabeth had sent him packing to Ireland in 1582, on his return a year later with hard proof of his "better experience in martial affairs" for his role in the massacre at Smerwick, the dashing, handsome, and well-spoken Raleigh radiated that confidence and courtly eloquence that the queen so admired.[2] Within the year, she had given him the first of his nicknames, "Water," and pretended to die of thirst every time he left her sight. Soon her "Pug" Walter would follow—her lap dog—giving her courtly love and the intellectual stimulation she so craved.

After the nicknames came the showering of wealth. Elizabeth gave her new favorite Scotney (Bletching Court) at Lydd in Kent and Newlands Farm in Romney Marsh, Hampshire, recently received from All Souls College Oxford.[3] The medieval pile Durham House, in London, followed; and though it was in dire need of remedial work, Raleigh's position with its commanding view over the Thames could not leave anyone wondering about his commanding position in the queen's affections. To help with his upkeep, and his necessarily ruinous court expenses, Elizabeth granted him by royal patent, a license for the farm of wine. This provided him with a basic income of somewhere between £700 and £800 annually (approximately $222,000 or £120,000 today). In the spring of 1584, he was also granted a number of profitable licenses from the queen for the export of broadcloth without any of the standard statutory restrictions, making him a perceived enemy of the Merchants Adventurers, the Levant Company, the Spanish Company, and the Muscovy Company combined. Extensive plantations in Ireland would come later, as

would the estates belonging to the Babington Plotters. He had become the Member for Parliament for Devonshire, vociferously defending royal prerogatives. Indubitably, the impoverished youngest son of Katherine Champernowne had finally arrived. But it still wasn't enough for the ambitious West Countryman.

Elizabeth was clearly entranced by him. Leicester, Walsingham, Burghley, and all her merchants and other adventurers were licensed by his colossal ego and the sway he held over the queen. No other favorite, aside from Leicester himself in the 1560s, had been shown such preferential treatment. Leicester's own chosen successor to the queen's heart through poetry and courtly deeds, Sir Philip Sidney, had been more or less spurned, though Elizabeth had made him Master of the Ordnance of the Tower in recompense. And so, Leicester resolved, probably with the connivance of both Walsingham and Burghley for a time, to supplant the upstart Raleigh in the queen's affections with his own stepson Robert, Earl of Essex. But timing, as Leicester knew, was everything, and for now, he would allow Raleigh his moment of glory.[4]

Raleigh was nothing if not monumentally ambitious. Like his friend, John Dee, he saw colonization and a British Empire spanning all the world's seas and continents as the queen's, and by extension, his rightful place in the world. His half brothers Adrian and Sir John Gilbert were eager to retain Sir Humphrey's grant of lands in the north of the North American continent, while the lands sold to Peckham and Gerrard were adjoining these to the south in modern New England. That only left Raleigh the "Mediterranean" coast north of Florida, which was far more to his personal liking in any event. This preference wasn't only driven by the hazards of the voyage and climate. Raleigh, like Dee before him, believed that gold only "grew" in warmer climates.

On March 25, 1584, Raleigh's application to take over some of his dead half brother's patent was granted by the queen. He "owned" exclusive rights to control the settlement and access to land in North America within six hundred miles to the north and south of any plantation he could establish and maintain within the next six years.[5]

Raleigh wouldn't make the same mistake that his half-brother had made, and prepared two barks to sail from the West Country

on a reconnaissance voyage to the east coast of North America the moment the patent was granted. His servants, Philip Amadas and Arthur Barlow, captained the two ships, with Simon Fernandez as their pilot.[6] Raleigh edited Barlow's narrative with an exceedingly heavy hand prior to its publication, yet the excitement Barlow felt on first sight of America remains breathtaking today:

> We viewed the land about us, being, whereas we first landed, very sandy and low towards the water's side, but so full of grapes as the very beating and surge of the sea overflowed them of which we found such plenty, as well there as in all places else, both on the sand and on the green soil on the hills, as in the plains, as well on every little shrub, as also climbing towards the tops of high cedars, that I think in all the world the like abundance is not to be found.
>
> We passed from the sea side towards the tops of those hills next adjoining, being but of mean height, and from thence we beheld the sea on both sides. Under the bank or hill whereon we stood, we beheld the valleys replenished with goodly cedar trees, and having discharged our harquebus-shot, such a flock of cranes (the most part white) arose under us, with such a cry redoubled by many echoes, as if an army of men had shouted all together.[7]

Three days after making landfall at Hatteras on the Carolina Outer Banks, their first contact with Native Americans was made by three men rowing a canoe. They communicated through the use of sign language, with one of the Native Americans receiving presents of food, drink, a hat, and a shirt. He returned a short while later with a boatload of fish for the Englishmen. Soon, brisk bartering took place. The English exchanged their pots, pans, tools, and weaponry for skins, furs, and pearls. Fresh meat, vegetables, and fruit were brought as gifts. Some of the food in the cornucopia of delights, like potatoes, had never been tasted before. It was on a clear summer's day that Barlow remarked their "maize" that was "very white, fair and well tasted."[8]

Their friendship thusly sealed, the Englishmen were shown the way to Roanoke, an island lying between the reef and the shore near the mouth of the Albemarle Sound. There, the tribal village of "nine houses, built of cedar, and fortified round about with sharp trees, to

keep out their enemies, and the entrance into it made like a turnpike very artificially" greeted them. Their hosts were "kind and loving people," the likes of which "there can not be found in the world."[9]

Barlow omitted all reference to their other encounter—that time with hostile natives, where some of the English were certainly killed and possibly eaten. Instead, he depicted the natives as "very handsome and goodly people, and in their behaviour as mannerly and civil as any of Europe . . . void of all guile, and treason, and such as lived after the manner of the golden age."[10]

The ships returned to England in September, with two Native Americans named Manteo and Wanchese from Roanoke in tow along with their Indian wares. Raleigh was presumably informed of the full details of the expedition by Barlow, Amadas, and Fernandez—from the tricky crossing in the Florida Channel to the difficult navigation around the Outer Banks. But Raleigh was the most expert Elizabethan salesman to date, and knew that all of the negative and more truthful remarks would need to be crossed out of any account of the voyage outside of their inner circle if he were to succeed in funding and forming a colony. Perhaps by the time his settlers had been recruited he actually believed that "Virginia" was indeed the land of milk and honey, but, more likely, he had his eyes firmly focused on the need to get official and royal backing for the voyage that lay ahead.

Raleigh doctored the Barlow narrative, redesigning it to attract the greatest support possible among the people who would ultimately be his settlers, but also in large measure to assure royal backing. With his poetic ability and rosy picture of a promised land, he by and large achieved his wishes. Where five years earlier the court had been gripped with gold fever, it now saw the merit—despite its general and strong dislike for the swaggering Raleigh—of his Western Plantation scheme.

The queen was truly excited about the new possibilities Raleigh's scheme offered after an era of prolonged ignominious failures. When his bill was passed by the House of Commons to confirm his title to the appropriately named "Wyngandacoia" (the Native American expression for "you wear good clothes"), Elizabeth knighted Raleigh in January 1585, authorizing the change of name for his lands to the also appropriate moniker, "Virginia."[11]

There was nothing more to lose. Any vestige of the old amity between Spain and England was in tatters, and for the queen, attacking Spain "beyond the equinoctial," where she stood a good chance of enriching herself without risking outright war, somehow held out a perverse hope for the future. It also had the merit of being consistent with her foreign policy since the 1560s.

For Raleigh, it meant that he could better anything Drake had achieved so far.

32. Roanoke ❧

No, no, my Pug, though Fortune were not blind,
Assure thyself she could not rule my mind.
Fortune, I know, sometimes doth conquer kings,
And rules and reigns on earth and earthly things,
But never think Fortune can bear the sway,
If virtue watch, and will her not obey.[1]

—ELIZABETH I TO WALTER RALEIGH, C. 1587

R aleigh had manipulated the Elizabethan propaganda machine into working overtime. At his behest and specific commission, Hakluyt published his *Discourse of Western Planting* in 1584 in support of Raleigh's Virginia project for the queen's and Walsingham's eyes only. His conclusion that "a brief collection of certain reasons to induce her Majesty and the State to take in hand the western voyage and the planting there" was clearly aimed at garnering crown support for the Raleigh scheme.[2] Hakluyt, as a practicing clergyman, doubtless wanted to save souls that had no hope of salvation through Christianity (the beginning of the misplaced British colonial philosophy of "White Man's Burden"). Yet Hakluyt's not-so-hidden message urged the queen to merge entrepreneurial activity with state sponsorship, harnessing her adventurers' apparent boundless energy for the good of the realm.

What both Raleigh and Hakluyt failed to notice was that Europe was again in crisis, and where the crisis following the St. Bartholomew's massacre in 1572 ended in peace, the crisis of 1585 would most assuredly end in war.[3] Elizabeth had to amass her ever-dwindling resources to address the Spanish threat closer to home. Naturally, Raleigh had her emotional support, and she gave him authority to impound shipping, supplies, and men in Devon, Cornwall, and in the Bristol Channel, but he would need to make

his own way in financing and provisioning his expedition.[4] Still, fortune smiled on the sweet-talking Raleigh, and his subscribers were drawn from the likes of Sir Francis Walsingham; the new lord admiral following Clinton's death, Lord Charles Howard; Thomas Cavendish; and Sir Richard Grenville. His second expedition to Virginia would be the best-equipped voyage to North America so far.

In the end, the queen ventured her 160-ton ship the *Tiger* and ordered Sir Philip Sidney to release £400 ($119,510 or £64,600 today) worth of gunpowder from the Tower's stores. Four other ships with two pinnaces for inshore work under Grenville's command carried six hundred men in all. The seasoned Irish commander Ralph Lane was granted leave from Ireland to lead the soldiers who would form the mainstay of the Virginia settlement. Raleigh, of course, would be their armchair admiral, for the queen simply disallowed any talk of her favorite accompanying his men on their dangerous mission. Raleigh knew he was more than fortunate to have this level of support, given his jealous enemies at court. With the threat that loomed in the Low Countries (despite his political arguments in Hakluyt's treatise that he could inflict a major blow against Spain with his colony), Raleigh was lucky to attract any finance at all.[5]

He threw himself into the enterprise both financially and intellectually. His London home, Durham House, was turned into an alternative center of naval excellence to Dee's Mortlake home, and Raleigh was rumored to have also put over £3,000 ($919,450 or £497,000 today) of his personal fortune toward the venture. But even this staggering sum meant little to the vastly wealthy Raleigh. The queen had been remarkably generous to her new favorite, and his income from various appointments far exceeded his lavish spending. Described as "very sumptuous in his apparel . . . he is served at his table [with] silver with his own [coat of] arms on the same. He has attending on him at least 30 men whose liveries are chargeable [paid for by Raleigh], of which half be gentlemen, very brave fellows, [with] divers having chains of gold."[6]

From his vantage point high atop his turreted study overlooking the Thames, Raleigh and his disciples plotted the voyage and

eventual settlement of Virginia. They pored over the existing sea charts, discussed the navigational aspects, and gleaned new ideas on how effectively to begin a nascent civilization. Anyone who Raleigh thought might be able to contribute to the body of knowledge to make the colony a success was called upon, irrespective of race or religion. Dutch émigrés were welcome, as were Jews and Catholics. In a largesse that was uncharacteristic of the age, Raleigh stressed that what mattered was their intellect and facts or skills at their disposal, not their beliefs. Foremost among Raleigh's "savant disciples" was Thomas Hariot—a "white wizard" or conjurer expert in mathematics and algebra. Unlike Dee, Hariot didn't dabble in the occult, but like Dee, he saw the world as a complex mathematical equation that held the secrets of God's great design. [7]

Whether Raleigh subscribed to Dee's emphasis on mathematics, or felt that he had "reinvented the wheel" with Hariot's system, matters little. Hariot, with the benefit of Raleigh's munificent salary, threw himself into his work with vigor. He was responsible for teaching the mariners the art of navigation while Raleigh read anything he could relating to the Spanish conquest of America. Fortune smiled on him once again, since in the previous year *The Spanish Colonie* had been translated into English and published. It detailed the killing machinery of the conquistadors.

But for Raleigh, his first hurdle would be against time: the longer he waited to sail, the greater the risk would be of the queen changing her mind in light of the deteriorating political scene in Europe. The ships were well victualed (not only with meats and fish that could be stored for longer periods, but also with livestock), and ample supplies of ciders, beers, wines, and aqua vitae bought and loaded for the colonists' unquenchable thirsts. Seeds for planting were stowed away carefully in the holds, and Raleigh and his captains prayed that the victuals would last until the first crops came in.

But Raleigh was naïve if he thought his adventure had escaped the ever-watchful King of Spain. Mendoza—even from his enforced exile in Paris—had managed to slip a spy in among the dockworkers, and he sent a factual and copious report to Philip relating the number of ships, victuals, guns mounted on deck, and mariners.

Again, Fortune played her part: Mendoza had wildly overestimated the number of ships and underestimated the number of men. This misinformation led the King of Spain to the slightly false conclusion that the primary purpose of the expedition was plunder.

And so, on April 9, 1585, Raleigh's squadron sailed at daybreak of a fine spring morning. Ten days out to sea, the sky to the west darkened, and the sun was reduced to a thin sliver. The superstitious mariners hadn't seen an eclipse before, and muttered that it was an omen of evil. Luckily, Hariot had accompanied the voyage, and he explained that it wasn't an evil omen, but a near total eclipse of the sun, a natural and recurring phenomenon. Across the Atlantic in Virginia, though, the Native Americans at Roanoke saw a total eclipse, and definitely viewed it as the foreshadowing of a great disaster.

Then a storm blew up near the Canaries and the *Tiger*'s pinnace sank. Grenville tried to keep his squadron together, but in vain. Unlike Hawkins's ill-fated voyage, Sir Richard had appointed a rendezvous at Puerto Rico for his dispersed ships, and spent no time looking for them. The crossing to the warm, welcoming waters of the Caribbean took only twenty-one days. But their victuals had become infected with weevils in the tropical heat, and the humidity encased most of the food in a thick, stinking, furry mold. They had failed to take on fresh fruits or food that had kept Drake's men healthy on much longer voyages, and by the time they reached the rendezvous harbor at Guayanilla Bay in Puerto Rico, they had to go ashore—into hostile Spanish territory—to find food and clean water, or perish. The experienced soldier and future governor of the first Virginia colony, Ralph Lane, ordered a vast battlement to be built to protect the men, while they waited for the other ships to arrive. By the time the *Elizabeth* appeared over the horizon several days later, they were predictably fending off an attack of Spanish horsemen.

When the Spanish governor saw the second ship, he asked for a "parlay" which, thanks to Grenville's arrogance, turned into a dangerous standoff. Despite this, the Spaniards promised to return with food, but when they failed to appear at the appointed time, Grenville ordered the men to cast off and sail. He smelled a trap, and

he was right. All they could do to relieve themselves from starvation and dehydration was to sink into piracy, and so they fell upon the first two prize ships they could master to relieve their plight. Nonetheless, other problems beset them. Lane's and Grenville's command structure was badly frayed, with Lane complaining of Grenville's "intolerable pride and insatiable ambition." Thomas Cavendish, captain of the *Elizabeth*, and Captain Clarke of the *Roebuck* agreed.[8] But things would deteriorate even further.

Toward the end of June, the fleet made landfall at the Carolina Outer Banks. When the *Tiger* tried to navigate her way through into the inner channel, she ran aground and was damaged. Much of the stores for the colony were destroyed by the seawater gushing through her torn planks. The ship's master, Simon Fernandez, should have known better, since he was the expert navigator who knew those waters. What neither Grenville nor Lane had come to realize as yet was that Roanoke simply did not afford a safe anchorage for ships the size of the *Tiger*.[9]

Repairs to the damaged queen's ship began, while the rest of the squadron pressed on with their settlement plan. By the end of July, the four ships and pinnace anchored at Port Ferdinando on Hatarask Island, opposite Roanoke. The two Native Americans whom Barlow had brought back to London, Manteo and Wanchese, returned with the second expedition acting as their interpreters. After the statutory exchange of gifts and other trading formalities were finished, the English were granted the right to build a fort and cottages at the northern tip of the island. Lane ordered that one hundred men make their settlement there while he and the others explored up-country for food and fresh water sources before winter closed in.

Sir Richard Grenville, to the palpable relief of the colonists, departed back to England in late August with a letter from Lane to Richard Hakluyt that belied any notion of hardship or friction:

If Virginia had but horses and [their] kind in some reasonable proportion, I dare assure myself being inhabited with English, no realm in Christendom were comparable to it. For this already we find, that what commodities soever Spain, France, Italy, or the

*East parts do yield unto us in wines of all sorts, in oils, in flax,
in resins, pitch, frankincense, currants, sugars and such like, these
parts do about with it growth of them all, but being Savages that
possess the land, they know no use of the same. And sundry other
rich commodities, that no parts of the world, be they West or East
Indies, have, here we find great abundance of.[10]*

Raleigh couldn't have written a better piece of propaganda himself.

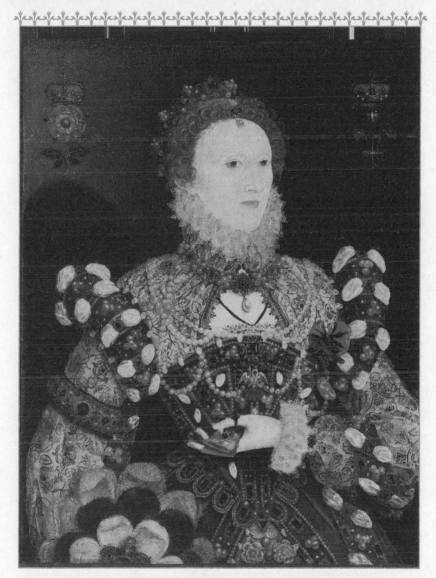

Elizabeth I in *The Pelican Portrait*, thought to be painted by Nicholas Hilliard, c. 1578. The pelican is a symbol of purity, but given the year of painting, it could also have been a symbolic and secret tribute to Sir Francis Drake, who was circumnavigating the globe aboard the *Pelican*, later renamed the *Golden Hind*.

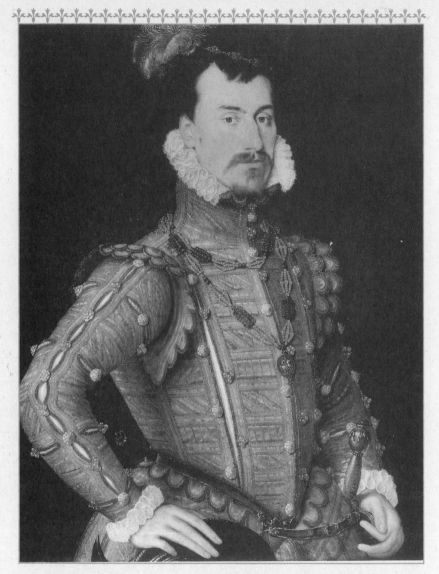

Robert Dudley, Earl of Leicester, painted roughly the same time as Elizabeth's *Pelican Portrait* opposite.

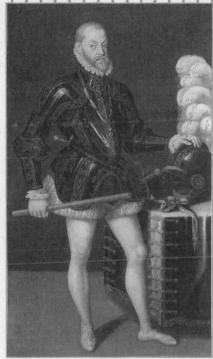

King Philip II of Spain, who had a sneaking admiration for Elizabeth, despite being her nemesis for over forty years.

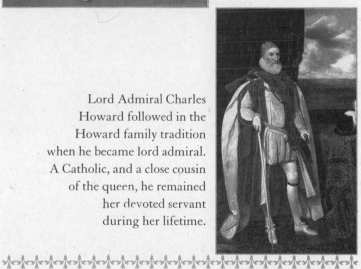

Lord Admiral Charles Howard followed in the Howard family tradition when he became lord admiral. A Catholic, and a close cousin of the queen, he remained her devoted servant during her lifetime.

Map of the Gulf of Mexico and the Caribbean by Jacques Dousaigo that was available to Philip's Spanish navigators, and stolen by Elizabethan adventurers.

An Elizabethan chart of the Virginia Coast.

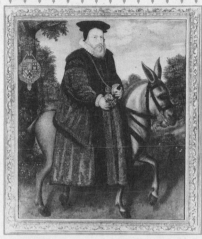

Sir William Cecil, Lord Burghley, the queen's lord chancellor and longest-serving minister, famously riding his donkey.

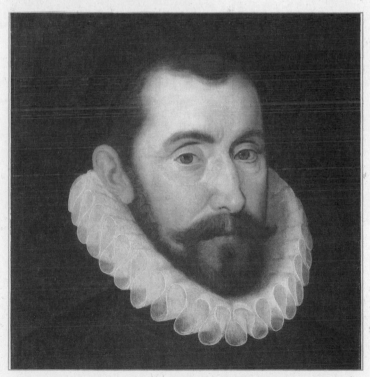

Sir Francis Walsingham, Elizabeth's loyal spymaster.

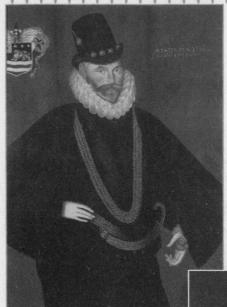

Sir John Hawkins, Elizabeth's slave trader and later treasurer of the navy. Hawkins had a vision of making England a world power by elbowing his way into the Spanish American Empire through trade.

Sir Francis Drake was Elizabeth's most gifted and audacious mariner. While his ship was the second to circumnavigate the globe, it is unlikely that this had been his original intent. The lure of American gold and rich prizes from Spanish vessels were most likely his target, but to bring these home safely, his only hope of eluding Spanish capture was to strike out across the Pacific. Fortunately for Drake and his men, he also captured valuable Spanish charts and a Portuguese pilot who knew the Pacific.

Martin Frobisher, like Drake, was essentially a pirate, though he lacked Drake's navigational and strategic abilities. Frobisher's Northwest Passage venture ended in failure, with his business partner and many gentlemen adventurers financially ruined.

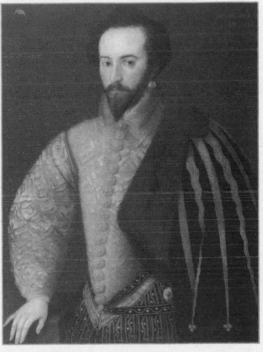

While Sir Walter Raleigh was highly favored by the queen, and granted his half brother's lands in North America—over a million acres of "Northern" and "Southern" Virginia—he failed to make a viable settlement work in Virginia and dreamed of the gold of "El Dorado." On Elizabeth's death, he was implicated in a plot to put Arabella Stuart on the throne instead of James Stuart and, after many years in the Tower and a doomed expedition to "El Dorado," was executed for treason.

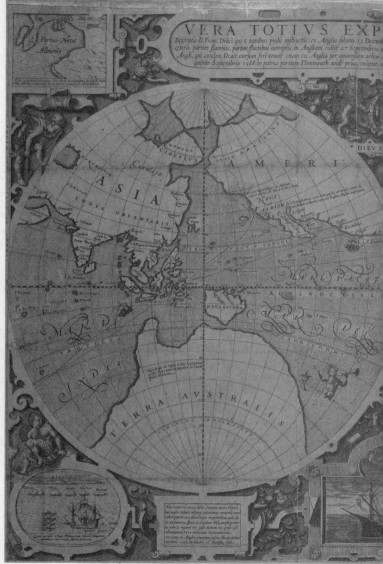

Drake's map of his voyage of circumnavigation. This was the first world map drawn by an English navigator, and it became the world view for Elizabethans.

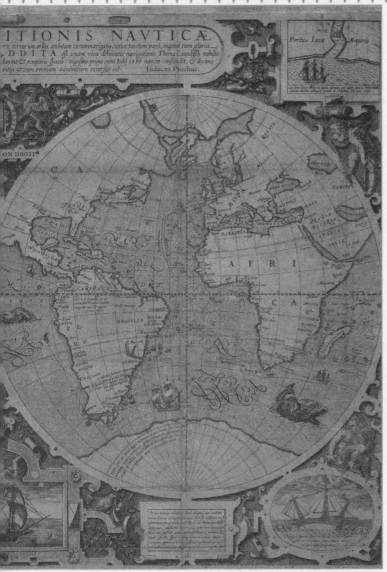

Robert Devereux was Robert Dudley's stepson. After his time in Holland, and throughout his campaigns in Ireland, he grew a beard and apparently cared far less about his personal appearance. He was willed Philip Sidney's "two best swords" and was a patron of the arts and a friend of Shakespeare. Devereux, despite being one of the queen's favorites, masterminded an ill-fated rebellion in London and was beheaded as a traitor.

The Deed of Grant for Virginia to Sir Walter Raleigh from Elizabeth. Note that the official Privy Seal is still attached.

This is how the Thames looked at Greenwich from Elizabeth's reign through to the 1630s.

An artist's impression of troops arriving for the Siege of Antwerp. The city fell and was razed to the ground in what became known as "the Spanish Fury."

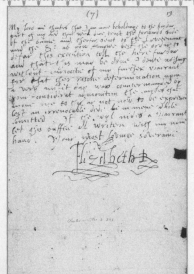

A letter written in Elizabeth's own hand around two A.M. to Sir William Cecil, demanding a stay of execution for her cousin, Thomas Howard, who had been found guilty of treason and of plotting to marry Mary Queen of Scots, against Elizabeth's will. The letter has little of Elizabeth's exceptionally fluid penmanship, and her agitated state of mind is reflected in her handwriting.

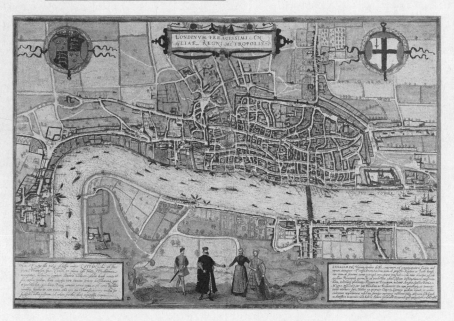

A map of London and the Thames to the Tower of London showing the detail of the river and streets.

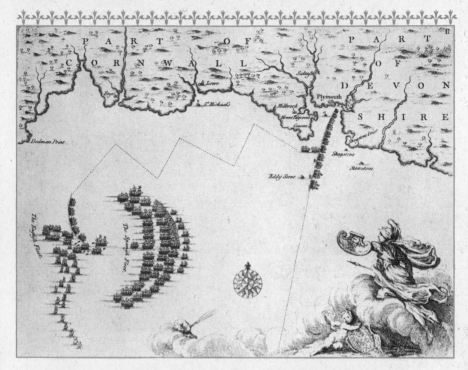

The original Flemish-made Armada Tapestry hung in the Houses of Parliament at Westminster but was destroyed by fire in the nineteenth century. This is a copy made to commemorate the single most important battle in British history, and is historically accurate.

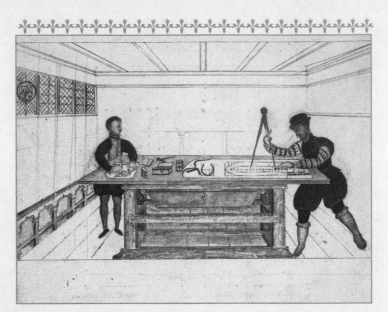

Matthew Baker, one of Elizabeth's most trusted shipwrights, is designing a ship.

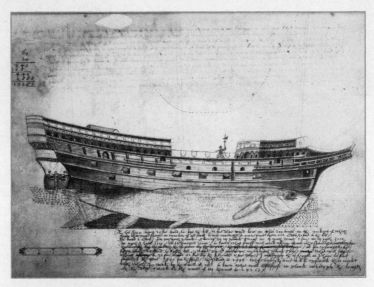

The cod in the belly of the ship depicts the ideal design for one of Baker's ships.

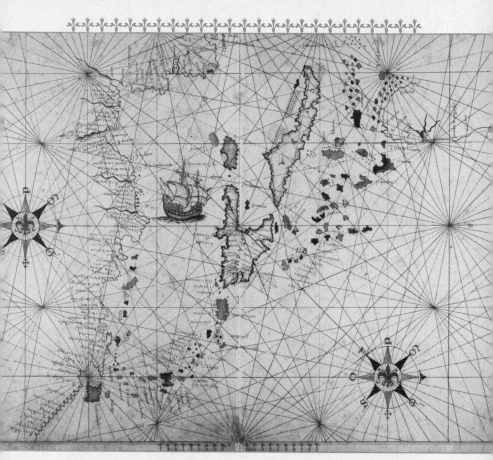

A contemporary chart of the North Atlantic, Newfoundland to
Brazil, by Angelo de Conte Freducci. It shows the challenges that
navigators faced in sailing on the eastern seaboards of North and
South America.

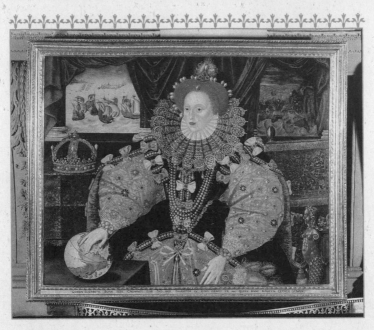

The Armada Portrait of Queen Elizabeth I is the most iconic image of England's naval strength from her reign. Her hand is placed on the globe, she is wearing the de' Medici pearls that had been given as a wedding present to Mary Queen of Scots by Catherine de' Medici, and her English navy, flying the flag of St. George, has just defeated the Spanish Armada. There are three "Armada Portraits," but it is believed that the one in the Duke of Bedford's collection is the first to have been painted by the artist.

⇜∘ **Part Three** ∘⇝

The Spanish War

And if you suppose that princes' causes be veiled covertly
that no intelligence may bewray [reveal] them, deceive
not yourself: we old foxes can find shifts [cracks] to save
ourselves by others' malice, and come by knowledge of
greatest secret, specially if it touch our freehold.
—ELIZABETH I, JULY 1585

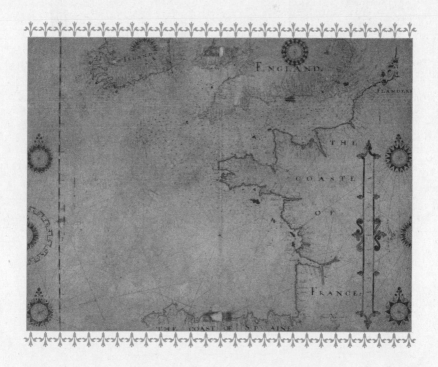

33. The Queen Lets Loose
 Her Dragon ⚔

*With this corsair at sea in such strength, we cannot protect
any island or coast, nor predict where he may attack, so it is
not clear what we can do to stop him.*

— BERNARDINO DE ESCALANTE FROM SANTO DOMINGO TO PHILIP II

Since the autumn of 1583, Philip had been plotting and planning
the "Enterprise of England" that had been urged for so long by his
admiral, the Marquis of Santa Cruz, and other mariners. But it was
only in the spring of 1585 that most of the pieces on the chessboard
had been moved into place. Parma's merciless war of attrition
against the Dutch rebels was entering its endgame. Antwerp would
buckle. The powerful Guise faction in France was in the King of
Spain's pay, and had mounted another failed attempt on Elizabeth's
life in 1583, increasing the pressure on the heretic queen by stoking
the fires of Catholic discontent at home with her harsh retaliatory
measures. The year 1584 progressed Santa Cruz's scheme through the
assassination of William of Orange, along with the rout and death of
Anjou. Still, Philip was nervous. There had been little, if any, news
of Drake. What was he up to? What was the she-devil Elizabeth
planning? Since the expulsion of Mendoza in 1582, he had to admit
that the quality of his intelligence had suffered dramatically.

Mountains of official papers littered his desk, among them Santa
Cruz's plan for the Armada. Though well advanced in age, nothing
happened anywhere in Spain's empire without Philip reviewing it
on his gigantic desk. Into the small hours of the morning, the King
of Spain pored over his papers, looking for alternative strategic
plans. As he rustled through them with his arthritic hands, he hoped
fruitlessly to discover a panacea for the Queen of England's dragon,
Drake, hidden somewhere in their texts. All he needed to do was to

give the order. And yet he waited. Santa Cruz must be ready. Or was he? How could he allow Santa Cruz to sail from Lisbon with the Armada without backup from Parma in Holland? Surely it would be useful to make a two-pronged attack to include the Duke of Parma? But Parma was slow in subduing the Dutch, and Antwerp had not as yet fallen. What would the Queen of England do about her Dutch Protestant brethren? Philip worried these issues whether strolling in his gardenia fragranced gardens at the Escorial, or by candlelight among his masses of dispatches. Still, a clear and divine reply would not answer his myriad questions.

But he needn't have worried long. Word soon reached Philip that Elizabeth had suspended trade with the Spanish Netherlands. It was a small sign, but a sign nonetheless of her intentions. It is easy to imagine the wily king smiling to himself at her poor timing. A plea for help had gone out to provide food for his people who had had yet another year of failed harvests followed by a harsh winter. The French, English, and many countries that had Baltic ports had responded generously with grain shipments. But with the number of English ships in Spanish-held harbors, Philip could take much of Elizabeth's merchant shipping, and weaken any response she might make to him back home. Philip believed the time was ripe to flex his muscles, and he gave the order to seize all foreign shipping.

But he hadn't reckoned on the escape of the *Primrose* in May, or her master's seizure of two of his henchmen in Galicia. They were, of course, interrogated by Walsingham's finest men and sang like canaries. Not only did they sing, but they also held a copy of the king's orders. When these were shown to Elizabeth, endorsed personally by the King of Spain, her rage must have been felt throughout the court. She had dithered about war since, in Machiavelli's words, "it was a gamble," but she could no longer shy away from its inevitability.

The Privy Council discussed little else over the coming weeks, and when the Dutch envoys appeared at court begging for the queen and her men to send relief hurriedly to Antwerp, she agreed. She also invited Philip's "thorn," Dom Antonio, to return to England in June. Drake had suggested—not for the first time—that they take the battle to Spain and invade first, and the thought no doubt titillated the queen and many of her adventurers.[1] But her courtiers knew that

Drake's entreaties wouldn't be heard. The Queen of England almost never acted rashly or decisively, and yet, at least this time, she had acted. While she negotiated suitable terms to support the Dutch, she unleashed Drake along the Galician coast to try to recover as many Englishmen and ships as he possibly could. Her royal commission was signed on July 1, 1585, granting him and any merchants who had experienced losses in the latest treachery the "right of reprisal." It was a royal warrant to plunder—not only along the northern coast of Spain—but anywhere, anytime, and against anyone on Spanish territory.

Meanwhile, Philip had perhaps realized his error in acting so hastily. By August, the Treaty of Nonsuch was signed for the English to relieve the beleaguered Dutch, but by then it was too late for Antwerp. Parma had razed the once great city to the ground in what became known quickly as the Spanish Fury. Virtually every nobleman in the realm put together their own forces under the queen's banner in the month that followed, and over three hundred noble gentlemen adventurers led thousands of their troops into the Low Countries and war by the end of the year.

Drake, for his part, had devised a calculated, ambitious plan that—if successful—could rip apart the Spanish Empire. He planned to attack the Galician coast of Spain, then head into the West Indies, and capture Santo Domingo, Cartagena, Nombre de Díos, Río de la Hacha, and Santa Marta before heading north to Raleigh's new colony of Virginia to ensure that the "western planters" wanted for nothing. Not only would he bring well over twenty-three hundred men with him, but he also planned to free around five thousand Cimaroons from their Spanish overlords to fight alongside his own men.[2]

Drake's first task was to raise money for the joint stock company that would fund his exploit, and ensure that the stockholders would understand that the mission had more than the purpose of plunder at its heart. The queen needed money to finance the Netherlands war, and Drake had undertaken to provide it with his adventure. In doing so, he would also deprive Philip of his American treasure. Leicester thought it was a splendid plan, and he told Burghley "that

is the string that toucheth him [Philip] indeed, for whiles his riches
of the Indies continue, he thinketh he will be able with them to
weary out all other princes. And I know by good means that he more
feareth this action of Sir Francis than he ever did anything that hath
been attempted against him."[3]

Drake's fleet would be the largest England had ever sent to foreign
waters. Its ships were evidently on a fully sanctioned royal mission,
comprising:

Ship	Captain	Owner
The *Elizabeth Bonaventure*	Sir Francis Drake	Elizabeth I
The *Aid*	Edward Winter	Elizabeth I
The *Talbot Bark*	*	Earl of Shrewsbury
The *Galleon Leicester*	Francis Knollys	Robert, Earl of Leicester
The *Sea Dragon*	*	Sir William Winter
The *White Lion*	James Erisey	Lord Admiral Howard
The *Bark Bond*	Robert Crosse	William and John Hawkins
The *Hope*	William Hawkins	William and John Hawkins
The *Bark Hawkins*	William Hawkins, younger	William and John Hawkins
The *Galliot Duck*	Richard Hawkins	Richard Hawkins
The *Bark Bonner*	George Fortescue	Richard Hawkins
The *Thomas Drake*	Thomas Moone	Francis Drake
The *Francis*	*	Francis Drake
The *Elizabeth Drake*	John Varney	Francis Drake
The *Tiger*	Christopher Carleill	City of London
The *Primrose*	Martin Frobisher	City of London

In all, some twenty-five ships and eight pinnaces made up the fleet. Sir Francis's lieutenant general, Sir Christopher Carleill (Walsingham's stepson), was a professional soldier and had fought valiantly in Ireland. While the military contingent aboard was unseasoned, Drake was glad to leave their training in Carleill's capable hands. Though Frobisher had had more "experience" at sea, and remained as cantankerous as ever, he bowed graciously to Carleill's superior position, unlike Leicester's upstart brother-in-law Knollys. Drake had no time for prima donnas aboard ship, and demanded that his gentlemen make themselves useful in the same everyday chores as his lowest mariners.

On September 14, 1585, the same day that Drake managed to rid himself of Sidney and his entourage, he hastily set sail, though the ships hadn't been fully victualed, and one of his captains had to be hustled aboard to avoid missing the sailing. Drake knew his queen well enough to know that Sidney might have blighted the entire mission, and that Elizabeth, in a fit of pique, might recall the fleet at any moment. This, of course, was an unacceptable risk for Sir Francis, but they still needed the food they had been compelled to leave behind. As he sailed away, Drake also knew in his heart that it would be unsafe to finish his victualing at any English port.

Incredibly, Drake's phenomenal good luck held, and within the week he came upon a Biscayan ship laden with fish. Three vessels from the English fleet pursued her and, with their weatherly design, had no trouble in snaring her. It was Carleill who won the game, and he snatched the prize for the fleet. Once brought aboard there was

* There was some last minute confusion regarding these captains with the unscheduled, and unwanted, arrival of Sir Philip Sidney, Sir Fulke Greville, and their entourages—including Dom Antonio. Sidney insisted that Greville be made captain of the *Hope*. Sidney was trying to escape to America, angered by Elizabeth's failure to agree to acknowledge him as governor for Flushing. He and Fulke Greville tried to sail with Drake, but were outwitted by the admiral, and ordered to return to London. The *Tiger* should not be confused with the queen's ship *Tiger*, which had just returned home from Virginia under Greville.[4]

now enough food for the fleet to run to Spain and take shelter at the mouth of the Vigo River and replenish their stocks with clean water.

Once safely ensconced at anchor, Sir Francis sent word to the local governor at Bayona asking if Spain was at war with England, and why the King of Spain had impounded the English merchant fleet. Don Pedro Bermudez, Bayona's hapless governor, could not have mistaken the intent of the Englishmen, and was undoubtedly overawed. He took a thousand Spanish horse with him to personally confront *El Draco*. Meeting face-to-face midriver in a tiny rowboat, Bermudez told Drake that they were not at war with each other; that Philip had recently released the impounded vessels; and that if Drake left Bayona and Vigo alone, he would give them all the water and food they needed. And so it was agreed.

By mid-October, the English left Spain, having had an unusually friendly and hospitable exchange with the Spanish. Meanwhile, Philip fulminated at the Escorial. But things could have been much worse for the King of Spain. Drake had narrowly missed capturing the *flota* as it returned from the West Indies. It had passed within twelve hours of Drake while the fleet was sailing off the Portuguese coast, just out of sight over the line of the horizon.[5]

After plundering the Cape Verde Islands, most likely in retaliation for an old complaint by William Hawkins as well as resupplying the fleet, the English headed west across the Atlantic, only to be stricken with a virulent disease (possibly typhus) on their voyage. Somewhere between two and three hundred men died within days, and hundreds of others were left weak and debilitated. When landfall was made at St. Kitts (then uninhabited), the mariners who could went ashore so that the sick could recover, and the fetid ships be cleaned and fumigated. Where Drake had so successfully kept his men healthy in his voyage of circumnavigation by keeping the numbers down, on a military adventure like this, it simply was not possible. After a few weeks ashore recovering, the fleet plowed through the green-fringed Caribbean waters to Santo Domingo, the oldest city in the New World.[6]

Its elegant whitewashed buildings spoke of its ancient pride, though a closer glimpse revealed that it was merely faded glory. Santo Domingo was no longer on the bullion route, and, while rich

in sugar and cattle, it had by and large become an administrative center for the Audiencia, or high court of the region.

While closing in on the town, Drake and his men took three frigates also heading for its port. Drake's luck was almost uncanny, since one of these carried the letters from King Philip warning the Audiencia that *El Draco* was heading in their direction to destroy them. Naturally, the town was metaphorically caught sleeping, despite a lone fisherman describing an impressive fleet in the waters off the island. The English attacked on New Year's Eve. Santo Domingo was theirs on New Year's Day 1586, but not before a cannonball crashed through the side of the *Elizabeth Bonaventure*, and another fell on deck and rolled between Drake's legs while he paced back and forth with Carleill and Frobisher.[7]

The English overran the once great city, plundering and pillaging at will. Still, Drake's estimates of vast mountains of plunder and gold were hopelessly optimistic: all the fleet had to show for their capture was sixteen thousand hides, victuals, wine, vinegar, and oil. The cash they found was so insignificant that it was not even specified. Their only alternative was to "ransom" the city itself.

Twelve days later, the high sheriff met Drake to negotiate their release. Drake asked for a million ducats (the amount at which he had originally valued the plunder). The *alcalde* muttered that such a sum was impossible, that there wasn't that much money in the whole of his jurisdiction. So Drake told him that they would be compelled to burn the town down, building by building, until his demands were met. At this point, the king's factor, García Fernández de Torrequemada, took over the negotiations while Santo Domingo burned. In the end, Drake was forced to compromise on the not so paltry figure of 25,000 ducats, raising their total takings to £11,275 ($3.27 million or £1.77 million today). Nonetheless, the figure was still disappointing to Sir Francis and his men.

Afterward, Fernández de Torrequemada wrote to Philip, "Drake is a man of medium stature, blond, rather heavy than slender, merry, careful. He commands and governs imperiously. He is feared and obeyed by his men. He punishes resolutely. Sharp, restless, well-spoken, inclined to liberality and to ambition, vainglorious, boastful, not very cruel."[8] Considering that Drake had ordered the destruction

of over a third of Santo Domingo—from the lowliest houses to its churches, monastery, and castle—this was high praise indeed. While Torrequemada watched the English fleet weigh anchor leaving behind the smoldering ruin of the New World's oldest settlement, he couldn't help but wonder aloud that "this thing must have had Divine sanction as punishment for the people's sins."[9]

While the fall of Santo Domingo sent an aftershock through the Caribbean and beyond, Grenville was counting his cash back in London. After he had sailed from Roanoke on August 25, 1585, he had had the good fortune to fall in behind the flota and give chase. Of the thirty-three ships that had left Havana in July, only the 300-ton unarmed *Santa Maria* straggled behind the rest, squatting heavily on the rolling sea cradling treasure in her hold. The English pirate adventurers had long ago uncovered the unmistakable and ungainly gait of a ship laden with treasure, and gave chase. When the *Tiger* overcame her, the *Santa Maria* had no alternative but to surrender to the faster, sleeker vessel bristling with firepower, flying the flag of St. George, and the queen's colors.

Once aboard his Spanish prize, Grenville could hardly believe his good luck. He held up the passengers at gunpoint and ordered them to pass across their valuables. The ship's manifest confirmed that a rich cargo of gold, silver, and pearls, calf hides, sugar, ginger, and cochineal was stowed aboard. In all, it was valued at 120,000 ducats—roughly £30,000, or $8.70 million or £4.7 million today. Grenville ordered the treasure to be removed to the *Tiger*, while he captained the prize back to Plymouth. Not only was the ship worth a great deal more, but there was also the good possibility of ransoming his hostages. The first voyage to colonize North America had been made, not by a "western planting" but by plunder. Grenville knew, as did any good sea captain in Elizabeth's reign, that his duty was not only to accompany the colonists to safety on foreign shores, but also to ensure the financial aspects— profit to the joint stockholders—remained uppermost in their minds. And plunder was the surest way of making exploration pay quickly. On their return to Plymouth on October 18, 1585—one month after Drake's fleet had sailed—Elizabeth was said to have

been so delighted with the quality of the pearls that she kept a whole cabinet filled with them for her own use.[10]

In the closing months of 1585, while Sir Richard Grenville basked in the glory of his haul in the comfort of an excited London, Ralph Lane and his 107 settlers were toiling to try to make their colony work. Lane, an exceptionally strict disciplinarian who had recommended keelhauling as punishment on the outbound voyage, was not above meting out the harshest sentences imaginable on land to keep his "riff raff" in check.[11] There were carpenters, metallurgists like the German Jewish expert Joachim Ganz, former soldiers from Ireland, "drones and grumblers" masquerading as gentlemen, and a few who knew how to till the soil, though they weren't specialist gardeners or farmers. Lane wrote that most "had little or no care for any other thing but to pamper their bellies," then adding, "Because there were not to be found any English cities, nor such fair houses, nor at their own wish any of their old accustomed dainty food, nor any soft beds of down or feathers, the country was to them miserable."

Of his second in command, Philip Amadas, Lane extolled rare praise when he said "he was the gentleman that never spared labour or peril either by land or water, fair weather or foul, to perform any service committed unto him." Thomas Hariot had accompanied Lane as the chief mathematician, but his observations pale into insignificance (as do Lane's) when compared to the amazing body of drawings provided to posterity by the expedition's accredited artist, John White. White had already made his name in England for his stunning portraits of the Inuit tribesmen on Baffin Island during Frobisher's 1577 voyage, and his drawings in Virginia remain our most poignant reminders today of that ill-fated colony.[12]

The critical task ahead, aside from staying alive, was to find a better natural harbor than the one Roanoke afforded. Their "scouts" Manteo and Wanchese suggested exploring to the north, where they believed the ideal harbor existed. Lane and a small party of settlers discovered Chesapeake Bay and spent part of their first American winter inland there, making friends with the Chesapeake tribe. Lane reported that "a good harbor being found to the northward . . . you shall clear yourself from all those dangers and broad shallow sounds . . . and gain within four days travel into the heart of the Main

200 miles at the least . . . the territory and soil of the Chesepians was for pleasantness of seat, for temperature of climate, of fertility of soil and for the commodity of the sea . . . not to be excelled by any other whatsoever."[13]

In the spring, Lane took another expedition to the west, exploring the Albemarle Sound. From there, they headed north again, this time up the Chowan River, where they met the Chowan "king," who showed them samples of his "wassador"—a metal deemed by Lane to be copper, or perhaps a different quality of gold. The Chowan chief also told Lane that there were pearls to be had in plentiful supply at the Chesapeake Bay. Lane did not question the Native American "king" and informed his settlers that their firm intention should be to remove themselves to the better harbor at Chesapeake, as soon as relief finally arrived from England. "The discovery of a good mine," Lane remarked, "by the goodness of God, or a passage to the South Sea, or some way to it, and nothing else can bring this country in request to be inhabited by our nation."[14] But he could do nothing until his English support arrived. On more than one occasion, Lane must have asked himself, where in the blazes was their relief from England?

That was the spring of 1586, when Drake's name rang throughout Spanish America and Catholic Europe like a death knell. In England, the Low Countries, and other Protestant nation-states, it brought cascades of joy. Rumors, most based on the incredible truth, abounded with Drake said to have liberated twelve thousand slaves on Hispaniola. Some said he had been defeated at Havana, others that he had taken the flagship of the Peruvian flota and 300,000 ducats booty. But these rumors were at variance with the truth.

The Spanish colonies in the New World were thrown into terror, confusion, and disarray by the news of Drake's fleet and the ransoming of Santo Domingo. While the cash prize for the city was miniscule to Spaniard and Englishman alike, the catastrophic blow to Spain's prestige was irrecoverable. Though ill-prepared to mount a defense against the faster, more weatherly, more heavily armed, and more brazen English fleet, they had little choice. Either defend Spanish America, or lose it entirely. Their greatest dilemma was, however, to answer the burning question: Where would Drake strike next?

During the night of February 9–10, Sir Francis landed Carleill with around a thousand men near the fort of La Caleta, where Cartagena's battery guns were located. Carleill's men had to pick their way through the darkness, carefully avoiding the poisoned stakes driven into the path by the Indians. The Caleta's defenses were not strong, but they could inflict serious damage on the English fleet if Carleill were unable to overcome them. Unlike sleepy Santo Domingo, Cartagena—as all of Spain's important cities and towns in the New World now—was on high alert. While Carleill and his men advanced, the three hundred Spanish soldiers and two hundred Indians tried to ambush the advancing English but, when they failed, scurried for cover. Around an hour before dawn, Carleill and his men had snaked their way within reach of the Caleta. The attack order was given, and as the English sprang forth from the brush on the far side of the fort from the harbor, the Spaniards opened fire roaring, "Come on, heretic dogs!" Galleys in the port fired high, but as Carleill was out of range, their shot was useless. Also on the far side of the fort, the wall had been ravaged by poor maintenance and time, and all the English had to do was to kick in the flimsy thirty-foot-wide wine-butt barricade that had been erected in haste to keep them out. After the briefest pike battle, most of the Spaniards fled to the town, hotly pursued by the English.[15] In the meantime, two galleys ran aground as they attempted to escape, and the order was given by their admiral to destroy them at once so Drake could not benefit from the disaster. But Drake was never one to come up empty-handed. He had already seized the *Santa Clara* and the *Napolitana*, as well as the few remaining vessels in harbor.[16] And so, a day later, Sir Francis Drake was master of Cartagena.

Drake turned his attention to the business of administering his prize while also trying to stave off the unwelcome reappearance of the "fever" in his fleet. Fresh wells were dug for clean water; "Frenchmen, Turks and Negroes"—to a man Spanish prisoners—were released and ordered by Drake to be treated with the greatest civility. The Turks were so thankful that more than one hundred of them begged to accompany Drake's fleet back to England. Sir Francis, of course, complied.

The business of ransom was undertaken with decorum on both sides. Sir Francis demanded 5,000 ducats ransom for Alonso Bravo

to cover the preservation of his home and neighborhood ($362,138 or £195,750 today). When he heard that Bravo's wife was terminally ill, Drake agreed that the Spaniard could return home to keep her company for as long as necessary and until the agreed ransom was paid. When his wife, Elvira, died, Drake and his men attended her funeral, and provided the pomp and ceremony at which the English so excel, with their muffled drums, flags drawn up high, and a proper military volley shot off as befitted a brave soldier's wife. As he had demanded a further 3,000 ducats for the priory where Elvira was buried, in an incongruous act of generosity, Sir Francis reduced the demand to a nominal 600 ducats, and a promise to Bravo that no one would disturb Elvira's final resting place.

As negotiations progressed for the release of Cartagena, Drake's initial demand for 400,000 ducats ($28.97 million or £15.66 million today) was whittled down. After 248 homes were destroyed by arson, a ransom of 107,000 ducats was finally secured in early March 1586. This brought the total yield for Cartagena to 113,000 gold ducats ($32.75 million or £17.7 million today), including the ransom paid by Bravo, the priory, and another small estate. But this small gain was offset by great personal loss. Half of the men who had survived the voyage of circumnavigation with him had lost their lives at Cartagena. Men like Thomas Moone and John Varney who had been with him from the beginning, had fallen. A hundred more men had died of the "fever," including George Fortescue. Only seven hundred men remained fit for service—an attrition of sixteen hundred men from the original complement. Even Drake had to admit it was a grossly inadequate force to attack Havana. Notwithstanding this change in plan, there was no time to linger. Drake knew he was late in supporting Raleigh's colony, and since the pickings were hopelessly poorer in the West Indies than anticipated, he did not want to fail in that important task as well.

At Cuba, they dug wells for fresh water, with Sir Francis mucking in with his sailors "up to his armpits" carrying the barrels of clean water aboard ship. Once replenished, the fleet sailed along the east coast of Florida to St. Augustine, Spain's oldest city in Florida. Sir Francis called a "war council," and Carleill and Frobisher agreed that the Spanish watchtower there posed a severe threat to Raleigh's

settlement. The next day, after a few bullets were fired (that hit nothing) Sir Francis and his men took the town. To their delight, the governor had deserted so quickly that he fled without the £2,000 worth of money brought to the fort for safekeeping ($579,420 or £313,200 today). By May 29, two days after their siege, the town and fort were utterly destroyed.

Though Lane had no idea where Drake was—or even if it was Drake who had been still designated to come—and Drake was uncertain where to find Roanoke since Grenville hadn't returned before Drake had left (thanks to the Philip Sidney incident), Sir Francis supposed that the colony lay at about 36° north. Amazingly he found Roanoke on June 9, and immediately saw that it didn't offer any safe anchorage within the Outer Banks. Drake and a party of his men rowed ashore, to Lane's immense relief. Relations between the Native Americans and the inept, unskilled settlers had deteriorated dramatically over the issue of the Englishmen badgering the natives for both food and water. Grenville had failed to return with fresh provisions at Easter, and now the natives were literally starving them out. Sir Francis offered that all of the settlers were welcome to return to England with the fleet, but Lane demurred. He wanted to stay. So Drake offered him the *Francis* and some small boats and food for four months and a hundred men to navigate the ships. Lane agreed to the second proposal and preparations began at once. But a huge June thunderstorm bubbled up and raged on for three solid days, driving the *Francis*, the *Sea Dragon*, the *White Lion*, and the *Talbot* out to sea.

Now, all Sir Francis could offer Lane was the *Bark Bonner* and whatever food he could spare. But Lane realized that the *Bark Bonner* could never bring them all to safety. It was as if the heavens were sending Lane a message, and he announced after consultation with his colonists that he had changed his mind and wanted to return home. The colonists stampeded to get aboard the ships that had rowed into the shallows to rescue them, upsetting maps, books, and detailed accounts of their story. The three colonists who had gone up-country in search of food and an alternate settlement site were abandoned, never to be seen again. Finally, on June 18, 1586, Sir Francis Drake had embarked

the Roanoke settlers and sailed for England. Five weeks later, on July 27, they anchored safely at Portsmouth.[19]

Two weeks after that, Sir Richard Grenville returned to Roanoke, finding it abandoned. He searched the country surrounding the settlement and explored the coastline in the vain hope of finding the men he had come to relieve. He was "desolate yet unwilling to lose possession of the country," and so he landed fifteen men on the "Isle of Roanoke," plentifully provisioned for two years, and sailed away. Grenville, of course, left them to certain death.

34. The Camel's Back ✦

*Considering that the English have done so much damage in
so short a time to the merchant men trading in these waters,
it is likely that they will do the same to the India fleets;
accordingly it would be as well to give orders that at least
two more ships besides the Captain and the Admiral should
be armed in each fleet . . . all these preparations are directed
solely against the English fleet. . . .*

— MARQUIS OF SANTA CRUZ TO PHILIP II

I n January 1585, the pope published another bull against Elizabeth,
giving Philip of Spain 1.8 million crowns annually ($1.15 billion or
£623 million today) over a five-year period to eradicate the "heretical
state" of England. Effectively, the pope agreed to forfeit papal
concessions to the crown of Spain. Proceeds would be collected in
special chests at the mint in Madrid for the king's use to rid himself
of the demon Elizabeth. He raised an additional 900,000 crowns for
his enterprise.[1]

Philip had tired by the end of 1585 with English meddling in the
Low Countries. Had he not had William of Orange assassinated to
bring the Netherlands back under control? And what for? So that
Robert Dudley, Earl of Leicester, should become its effective king!
Little did Philip know that Dudley's rise to a quasi-kingship offered
by the Dutch had stirred almost as much consternation at Elizabeth's
court as it had at Philip's. The queen was so angry that she wrote a
personal letter to Leicester and had it brought to him by Sir Thomas
Heneage in the Low Countries. She intuitively knew that Leicester's
actions drove England ever closer to the final confrontation. Her
stinging words to Leicester (though not the finest she had written)
were these:

We hold our honour greatly touched by the said acceptation of that government, and least as we may not with our honour endure, or that it carries a manifest appearance of repugnancy to our protestation set out in print, by the which we declare that our only intent in sending him over to those parts was to direct and govern the English troops that we had granted to the States for their aid and to assist them with his advice and counsel for the better ordering both of their civil and martial courses, as is contained in the late contract passed between us and their commissioners that were here, so as the world may justly thereby conceive . . . [that] a minister [of] ours sent thither to execute and hold such a course of government as was contained in the said contract—should without our assent be pressed to assent to accept of more large and absolute authority over the said countries than was accorded by virtue of the said contract, especially seeing that we ourself, being oftentimes pressed by their commissioners to accept of the absolute government, did always refuse the same. . . .[2]

Despite the rebuke, Leicester, never a great commander in the field, didn't stand a chance against the superior Spanish troops honed into a crack fighting force by Parma. At the end of 1586, Leicester, and what was left of his army, had been brought back to England, defeated. Sir Philip Sidney, along with thousands of others, had been killed in a fruitless, chaotic attempt to free the Dutch from the yoke of the Spanish.

Then, in February 1587 at the Earl of Shrewsbury's home, Fotheringhay Castle, the final act in the twenty-year drama between the two British queens was played out. Despite having been thrust into the rarified atmosphere of the French and Scottish courts her entire life, Mary had allowed her heart to rule her head. Now she would lose even that. Her execution for her role in the Babington plot would serve as a symbol for all Catholics that "stubborn disobedience . . . Incitement to insurrection . . . against the life and person of her Sacred Majesty" would end in a guilty verdict for high treason and death. When Mary's auburn wig and head were held aloft for the executioner to utter the customary words for traitors, "Long live the queen," in Elizabeth's name, all-out war was inevitable.

Or perhaps not. Elizabeth always made a good show of saying what she didn't mean, and meaning what she didn't say. She lashed out at her Councillors, singling out Walsingham, for tricking her into signing Mary's death warrant. Her former agent in the Low Countries, William Davison, now one of her secretaries, was judged to be the most culpable and was thrown unceremoniously into the Tower through its notorious Traitor's Gate. Yet, for Davison, the Traitor's Gate swung both ways, and he was later released upon a bond of £10,000. For now Elizabeth had written the script, and for the time being, Davison would need to be sacrificed for the good of the realm. Elizabeth, meanwhile, put on the best performance of her life to avoid any backlash from Scotland. She wailed for a solid three weeks, then wrote a heartfelt letter of apology and explanation to the King of Scotland, James, blaming her secretary and begging the King's personal forgiveness. James was no fool and felt he was a step closer to becoming Elizabeth's heir. If the queen asked forgiveness he would comply. With the throne of England dangled in front of his nose, how could he refuse?[3]

When the dramatic news reached the King of Spain on March 23, Philip recognized that he, too, could dither no longer. Aside from Mary's Calvinist son, James VI of Scotland, he believed (as did Mendoza, by his genealogical chart showing Philip directly descended from Edward III) that he had the best claim to England's throne, and would need to seize it for Catholicism.[4]

Orders were sent out to Don Alvaro de Bazán, the Marquis of Santa Cruz, to prepare the fleet for the "Enterprise of England" he had so long wanted to undertake. Santa Cruz's estimate was for 150 great ships, which included all Spain's galleons and most of her merchantmen. Over forty *urcas*—round tublike freighters used for provisions—would also be required. Some 320 dispatch boats and cruisers would also be needed, bringing the total estimate to 510 sail, along with 30,000 mariners and 64,000 soldiers. The naval ordnance alone would cost around 3.8 million ducats ($4.20 billion or £2.27 billion today). Such a force was as far beyond Philip's reach as it would have been beyond Elizabeth's. And so, the king came up with an alternative plan for Santa Cruz to meet up with Parma's troops in the Low Countries and for them to invade England together. It was a perfect solution for the armchair strategist: marry his premier

naval commander with the ruthless and skilled Parma.[5] But as preparations progressed through the spring of 1587, costs soared, making Philip feel literally ill. Spending rose to 10,000,500 *reals* per day for his officers' commissions alone ($1.06 billion or £570,322 million). Yet Santa Cruz required another 3 million *reals* in gold urgently.[6]

Almost as bad as the financial strain that the Enterprise was putting on Spain's coffers were the blithe remarks from his officers that an invasion of England would be a dawdle. *Disparo!* (Nonsense!) Philip scrawled on these papers before he would toss them aside, or into the fire. After all, *he* had been King of England, and he knew something of English stubbornness and character. The uncertainty of the outcome of the Enterprise weighed heavily on his conscience. But as Mendoza wrote to Philip and later shared his thoughts with the Pope, "since God in His wisdom has ordained otherwise [than for Mary to rule England], He will raise up other instruments for the triumph of His cause. . . . So it would seem to be God's obvious design to bestow upon your majesty the crowns of these two kingdoms."[7]

Yet Philip's "Enterprise of England" was the worst-kept secret in Europe, and Elizabeth, too, was left no alternative but to try to cut it off at the knees. She would unleash Drake again, and pray.

35. Cadiz ⚜

I've Singed the beard of the King of Spain
—SIR FRANCIS DRAKE

Philip II had been in his sickbed crippled by gout and self-doubt for the past six months. Though ill, he knew decisive action had to be taken that spring to hold out any palpable hope to be rid of his great demons—Elizabeth and Drake—once and for all. More recently, Raleigh and his Virginia colony troubled his aching mind. The man Davis had already made two voyages in search of the Northwest Passage, and would soon undertake a third! And now he had been advised that a certain Thomas Cavendish had sailed for Peru in his ship the *Desire*.[1] Desire . . . it was a word that haunted him. He now desired peace. Even Aranjuez, his oasis of calm, could not provide him with the balm to soothe his troubled thoughts. The undeclared war against "that Englishwoman" continued to escalate despite his best efforts. Still, he often wondered how things had degenerated to such an impasse. How had he gone from brother to would-be suitor to her persecutor in twenty-eight years? But when the nostalgia cleared, Philip remembered that Elizabeth often claimed no knowledge of her adventurers' undertakings, while simultaneously counting her third of the cash they plundered.

The king was, as ever, well informed. Since 1585, her firsthand knowledge of the two hundred vessels sailing each year carrying out her business of piracy and plunder had made her, at the very least, an accessory. The rules of these naval engagements had been well defined by the English Admiralty: the queen received a one-third share of the registered plunder, the investors a third, and the crew a third. The Admiralty would get a 10 percent slice off the top, after customs officials (who also paid out to the queen and her councillors) were paid on the ships' arrivals into harbor.[2]

What good were all the riches of the world, Philip asked his councillors, if none of his Indiamen reached Spanish or Portuguese ports? He knew full well that not one treasure ship had docked in Spain the previous year, and prayed that the Queen of England's intelligencers had not been informed. Her sailors would be the ruin of him. Yet Elizabeth had been her own worst enemy, and left him with no alternative once she had eliminated the Queen of Scots.

And so, it had been with some reluctance that Philip gave the order to his great admiral, Santa Cruz, to press ahead with a Spanish Armada to invade England to claim the throne for Spanish interests. It was a matter of self-defense, a matter of national pride. It was also an economic necessity.

While Philip II shambled through the perfumed gardens in the afternoons of April 1587, he mused repeatedly, "Clearly God must be allowing her waywardness on account of her sins and unfaithfulness, so that she will be lost." As ever, the Spanish monarch sought the financial—as well as spiritual—support from Pope Sixtus V for his enterprise against England. However, this time, the pope's offer of a million ducats was conditional on the successful invasion of England, ordering that "your Majesty would not maintain the throne for yourself." When the pope—through his own spy network—learned about Philip's plan to keep England as part of his enlarged empire, Sixtus fulminated against the king with threats of divine vengeance unless he "repented of his great sin, and obeyed the Vicar of Christ."[3]

Meanwhile, Elizabeth, of course, knew everything. Drake begged to be allowed to sail and attack Philip on his home territory. Walsingham and Leicester agreed. A plan was hatched to use Antonio, the dethroned Portuguese king, as their decoy, and Walsingham spread as much disinformation as he could to keep the object of Drake's mission an utter secret.[4] For the job ahead, Drake was given six of the queen's ships: her four best galleons—the *Elizabeth Bonaventure*, the *Golden Lion*, the *Dreadnought*, and the *Rainbow*—and two of her swiftest pinnaces. Elizabeth personally authorized Drake to "obtain as many ships as would join him from the London merchants," and the lord admiral offered his own galleon and pinnace. Drake invested four of his own ships in the

venture.[5] By March 27, 1587, Drake had obtained a total of forty-two vessels for his secret mission.

To help keep Philip's spies off the scent, Drake stayed behind in London for twenty-four hours for an unrecorded meeting with his great friend, Sir Francis Walsingham, before joining the Londoners at Dover and boarding the *Elizabeth Bonaventure* with his wife, Lady Elizabeth.[6] Walsingham then leaked the latest disinformation to Philip's newest spy—the English ambassador in Paris—Sir Edward Stafford. As an excellent spymaster, Walsingham knew that Stafford had accepted 8,000 crowns from Philip only weeks earlier, and he chose specifically to leave the traitor in place so that he could better serve the English crown by his treachery. Stafford did not disappoint him.[7]

Mendoza was told immediately, and he penned an urgent advice to Philip that "the Queen of England's secretary writes to the new confidant [Stafford] telling him to be careful what reports he sends from here ... the Queen had not decided anything about sending out the fleet, as the intelligence sent by her ambassador here had cooled her."[8]

Ten days later "true advices from England" were received by Mendoza that proclaimed:

On the 27th March proclamation was made in London ordering the instant embarkation of the crews and troops of the 10 ships with Francis Drake. Of these 10 ships, four belonged to the Queen, their burden being respectively 400, 300 and 120 tons; very well armed with bronze guns. The others are merchantmen, the largest 200 tons, but most of them 120 to 150 tons, with iron pieces. The queen's flagship took out 200 men ... Drake went on board near Dover, and sailed with the ships to Plymouth, where the fleet was to rendezvous. Off the Isle of Wight he was joined by 12 merchant ships which had been sent by the Queen, and they all proceeded together to Plymouth. They take victuals for over four months ... Drake took orders for the ships which might be in the Western ports, or at sea with letters of marque [letters of reprisal], to accompany him ... so that altogether they hoped to enter Spanish waters with 60 sail and about 3,000 men, besides those who might be in the

298

ships bearing the letters of marque . . . they are going to prevent the junction of his Majesty's fleet in Spain, destroying a portion of it, as it will have to be fitted out in various ports. Others say the design is to intercept the Indian flotillas, and this seems the most probable.[9]

But it was too late. *El Draco* had set sail two weeks before with his fleet to "singe the beard of the King of Spain." It was an exercise that Drake embraced with relish, as he did every opportunity for retribution in his personal war. As had become her custom, Elizabeth set about to publicly disassociate herself from Drake's secret mission, despite the fact that she had just sent him out with sealed orders "to impeach the purpose of the Spanish fleet and stop their meeting at Lisbon, distressing their ships within their havens, and returning to England with the plunder."[10]

By now Drake knew that the queen's decisions could be transitory, and for this reason he fled London with the Portuguese pretender, literally riding on his coattails, begging to come along. But Drake knew that it was no time to get diverted by Antonio's wild assertions that all of Portugal would rise up behind him. Sir Francis and his combined fleet set sail on April 12, 1587, from Plymouth, leaving the Portuguese pretender to kick his heels in the West Country of England.

It did not take Drake's naval genius to know that the rumors of Philip's Armada were true, and that the time for diplomacy had passed. As prime defender of the Catholic faith, Philip had had his hand forced with the swing of the Queen of Scots' executioner's blade, and everyone—including his vacillating queen—knew that England was already at war. Elizabeth's counter-orders, written in her own hand, to "forbear to enter forcibly into any of the said king's ports or havens, or to offer violence to any of his towns or shipping within harboring, or to do any act of hostility upon the land. And yet, notwithstanding this direction, her pleasure is that both you and such of her subjects as serve there under you should do your best endeavour (avoiding as much as may lie in you the effusion of Christian blood) to get into your possession such shipping of the said king or his subjects as you shall find at sea" were rushed out to the admiral on one of her finest remaining pinnaces.[11]

It was vintage Elizabeth. And it encapsulated her desire to have her cake and eat it, to wage peace as if it were war, and to try to lull her enemies into believing that she would not knowingly take up arms against them. Yet, the amended order was sent out a full nine days after Drake had sailed. Her intended subterfuge now complete, all Elizabeth—and the country—could do was wait and pray. Walsingham tried to throw oil on troubled waters by claiming that Drake was heading for the West Indies to "harry" the West Indies fleet of Spain. The queen herself enhanced the misinformation when she dismissed these rumors as fantasy, confirming to the Venetian ambassador that Drake had not "left London for Plymouth to gather a powerful fleet with a view to meeting and fighting the Peruvian flotilla, but had sailed instead for Constantinople."[12]

While Philip tried to enjoy his fragrant garden, Elizabeth, in her turn, rambled through her chilly palace at Whitehall, more ill-tempered than usual. Only her daily horseback riding and hunting brought her some relief from the tension. Perhaps she had acted rashly? Had she played her cards well? Would Drake let her down? She was both empowered and powerless. Elizabeth was now fifty-four. All she had worked for her entire life was in play. Worst of all, she hated being backed into a corner almost as much as she loathed war.

Drake, in the meantime, was making good progress. Aside from a storm off Finisterre, where at least one ship was lost, the voyage had gone swiftly and smoothly, and Drake had arrived off the coast of Cadiz within eighteen days without alerting the Spaniards. The bulk of the flotilla still lagged badly behind the *Elizabeth Bonaventure* due to the Finisterre storm when Drake called in his seasoned second in command, William Burroughs, to his cabin for a council of war. Cadiz lay just over the horizon ahead, Drake pointed, and the flotilla at the horizon behind them. Burroughs waited before replying. Unbeknown to Drake he had become his lieutenant general at Burghley's specific request. Drake explained that the time to attack was now. Burroughs was of the opinion that their number was dangerously low, and it was best to wait for the fleet to catch up to them before attacking the Spanish port. First thing in the morning would be better. Drake railed at him that it

was tactically wrong to lose the crucial element of surprise, and categorically overruled Burroughs. The order for attack was given at four P.M. on the afternoon of April 29.

At precisely that moment, Philip was shambling through his sweet-scented gardens at Aranjuez, ignoring the urgent dispatch from Mendoza in Paris. It warned the king that Drake "was to try to prevent the junction of your Majesty's fleet, which had to be equipped in various ports, and if they succeed in breaking up a portion of it, then to proceed on the Indian route and encounter the flotillas. To this end they had let out a few words to Drake about Cadiz being a good port to burn the shipping in, if a good fleet were taken thither."[13] Even if Philip had read the urgent message, he would have been unable to stop Elizabeth's admiral.

As the favorable winds blew Drake's fleet within view of Cadiz harbor, its inhabitants were enjoying some street players performing a comedy in the large central town square. A tumbler measured his muscles against the comedians', to the general amusement of the crowd, while the surrounding shops burst to breaking point with customers who had had too much to drink. Someone pointed to the approaching ships. It must be the valiant fleet of Juan Martínez de Recalde and his Biscayans, another replied. Only when the ships were counted did the people of Cadiz begin to think that it could be their enemies, the *Luteranos*, perhaps even *El Draco*.

Despite the relaxed atmosphere, the harbor was not unguarded. Six galleys of the Spanish fleet had docked from Gibraltar a few days earlier, and had spread themselves across the upper bay, in the shadow of the old castle. Their commander, Don Pedro de Acuña, drew these ships across the entrance to the bay, oars glinting in the late afternoon sunlight, in preparation for the attack. Another ship broke ranks and, with its harquebusiers and pikemen at their battle stations in the forecastle, prepared to stop the hostile fleet. Drake's long-distance guns struck them midships in response. The English banners were broken out, and Drake's trumpets and drum hailed their presence from the quarterdeck of the *Elizabeth Bonaventure*.

The townspeople watched in utter disbelief. Whispers of *El Draco* became shrieks of "Drake, the Dragon!" in no time. Orders were shouted for the women, children, and the aged to take refuge in the castle. Pandemonium broke out as the people of Cadiz fled

for their lives. Fearful of the terrified "mob" running toward him, the captain of the guard in the castle shut his gates to the panicked crowd. Twenty-five women and children were trampled to death before he came to his senses and let them in.

Meanwhile, the men of the town formed themselves into companies to defend the port in the event of Drake landing, but without adequate harbor defenses they couldn't have held out much hope of winning. Murmurs between the frightened men claimed that the formidable galleys of the Spanish empire were superior to Drake's sailing ships. But the Spanish galleons were huge hulks, with forecastles overflowing with soldiers and short-range cannon, unable to maneuver swiftly in rolling seas or close combat. What they had not appreciated was that any of Drake's seven heaviest sailing ships could heave more firepower at them in a single broadside than all of the Spanish galleons put together—and that they could heave it much more accurately and a great deal further. Even if their number had been greater, the Spaniards could never have beaten the more technically advanced, more heavily armed English vessels. Hawkins's redesign of the English fleet would stand up admirably to the battlefield conditions.

The Spanish galleys limped into anchor between the old fort of Cadiz and St. Mary's Port, some four miles to the northeast of Cadiz harbor. There the waters were shallow, and the defenders regrouped and mounted skirmishes against the plundering English throughout the night. The Spanish shore guns pounded the harbor waters, with not an Englishman nor English ship injured. Excuses for this appalling lack of force were later said to be due to the fact that Spanish gunpowder was expensive and unreliable, and the men firing the weapons were inexperienced.

Even in these threatening circumstances, and against direct orders from the queen, Drake did not seek to destroy the remaining merchant vessels in harbor. Instead, he huddled the ships together and had most of the sixty vessels boarded to take their cargo as plunder. Evidently, it was hard to break old habits. Some of these cargo ships were destined to join the Armada at Lisbon, including five *urcas* fully laden with wine and biscuit, and a number of Dutch hulks. The Dutch vessels had been confiscated by the Spanish and pressed into Philip's service for his great invasion force. There were

also ships waiting to join the fleet sailing for the Americas. Instead, Drake ordered his men to remove the Xerez wine (sherry) from the ships as well as all the other provisions they could load.

Throughout the night the Spanish took aim at Drake's fleet, but cornered only Burroughs's ship, the *Golden Lion*, when a cannon ball hit her hull. Drake sent the *Rainbow* with six merchantmen and his own pinnace to protect her and bring her to safety, cursing Burroughs for his "treachery." By morning, the wind had died away, leaving Drake and his men pathetically becalmed and in real danger. At midday, the Duke of Medina Sidonia and his men arrived to rescue Cadiz. For twelve hours he tried with fire ships to pierce Drake's defenses, but to no avail. Then the wind picked up again shortly after midnight, and Drake's fleet sailed from the harbor with the Spanish in pursuit. Drake turned and lay anchor, and again, despite heavy fire from the Spaniards, the *Elizabeth Bonaventure* remained unscathed. At dawn, prisoners were exchanged, Medina Sidonia gave the English admiral a present of wine and sweetmeats, and Drake sailed off in the direction of Cape St. Vincent and the Azores.[14]

An estimate prepared by the Duke of Medina Sidonia, for Philip's eyes only, listed twenty-four vessels lost, valued at 172,000 ducats, including their cargoes ($11.90 million or £6.43 million today). "The loss," Philip said, "was not very great, but the daring of the attempt was very great indeed." Drake believed that he had sunk thirty-seven ships. But even this estimate doesn't tell the full story.[15]

Sir Francis's solemn vow to Elizabeth was to defeat the Spanish fleet and to reward the private investors and crew through plunder. Until this point, neither had really been achieved. Although the Spanish estimated some twenty-four ships destroyed—including an impressive fighting galleon belonging to the Armada commander, the Marquis of Santa Cruz—some sixty ships remained seaworthy at Cadiz. Considering that the English looted, burned, and sank the ships at will, it remains a mystery why Drake didn't destroy the entire fleet. If only he had scuttled them . . .

So why did Drake flagrantly disregard his commitment to Elizabeth? Surely Drake had learned in Cadiz that the *urcas* and the other merchant ships were there to join the rest of the Armada

in Lisbon before sailing to England. Why did he not destroy these ships, too? Like so many skirmishes clouded by the fog of war, the answers remain unclear. Most likely, it was because Drake had a sniff of greater glory to come. He had learned from his prisoners that Juan Martínez de Recalde, Spain's most able naval officer after the great Santa Cruz himself, was somewhere off Cape St. Vincent with a squadron half the size of Drake's. And so, after ten days in an orgy of plunder in and around Cadiz, Drake's fleet sailed west toward Recalde and glory. It was a unique opportunity for Sir Francis to face off the legendary Recalde with the odds stacked in his favor and perhaps seize the flota he was rumored to be accompanying. Yet even if the flota hadn't sailed under Recalde, if he could neutralize the talented Spaniard, Drake must have thought that the threat imposed by Spain later would be greatly reduced.

Since Cape St. Vincent was not on the strategic map for the naval campaign agreed with Elizabeth, Burroughs objected strongly to Drake's disobeying the queen's orders. Drake countered accusing Burroughs of mutiny and treason, and ordering him put under arrest on the *Golden Lion*. But in an exceptional turn of events, Burroughs's men mutinied against Drake, and released their captain, who hightailed it back to London in the queen's ship. While sailing southward to Cape St. Vincent, Drake had him tried in absentia for desertion and treason, sentencing him to death. But by the time Drake would catch up with Burroughs again in London, Burghley had ensured that his man was well beyond Drake's wrath.

At Cape St. Vincent, the English fleet destroyed fishing boats and coasters bringing barrel staves for the Armada's water barrels. From a twenty-first century vantage point, this may seem petty; yet it was the most successful portion of the Spanish raid in strategic terms. Without the staves to hold the water barrels together, it was impossible to store water and food for any long voyage. Through this single act of piracy, Drake had ensured that the Armada would be doomed to yet another lengthy delay, and escaped Elizabeth's promised retribution.

Yet where was Recalde? While waiting for his answer, Drake wrote to Walsingham: "I assure your honour the like preparation

[at Cadiz] was never heard of nor known as the King of Spain hath and daily maketh to invade England. . . . I dare not almost write of the great forces we hear the King of Spain hath. Prepare in England strongly and most by sea!"[16]

Drake's tendency to lawlessness had always been overlooked because of his sheer brilliance as a commander. Cadiz was the first time the English lower, sleeker ships had been used against the Spanish vessels in "skirmish" tactics. It was also the first time that smaller ships had outgunned the towering Spanish galleons. But even Drake knew that unless he could bring back chests of swag, he would *be* history, rather than finding his place in it.

As luck would have it, by the time Drake sailed from Cadiz, Recalde had already anchored in Lisbon harbor. Drake pursued him, sailing north along the Portuguese coast, and landed unopposed at Lagos. Columns of Spanish horsemen shadowed the English invaders and opened fire, and the English made a dash to the rather unimpressive Sagres Castle and captured it. Drake probably never realized that it was the castle of Prince Henry the Navigator, the first royal ever to promote maritime exploration. Nonetheless, he wrote in his ship's log that day, "continuing to the end, yields the true glory."

Then, as ever, his luck changed. On June 1, the whole fleet weighed anchor, and ships carrying Drake's dispatches and diseased or disabled turned northward, while the fleet sailed south for the Azores. Drake had had news that the king's own carrack, the lumbering *San Felipe*, was homeward-bound from Goa with its annual cargo of spices, jewels, and other oriental goods that were fruits of Portugal's eastern empire.

By now Philip II was apoplectic with rage at Drake's ignominious escapades along the Portuguese coast and Cadiz. He already feared that *El Draco* had heard of the approaching *San Felipe* from caravels in the Guinea trade before the bad news had reached him. After all, the *San Felipe* was the vessel worth 3 million *reals* that Philip needed badly to fit out the Armada in its final stages. Most of all he needed her treasure.

On June 18, at São Miguel in the Azores, the *Elizabeth Bonaventure* "engaged" Philip's carrack and easily seized her. The *San Felipe*'s

guns were so jammed with precious cargo that she was unable to use them against the English marauders. The carrack was stuffed with pepper, cinnamon, cloves, calicoes, silks, ivories, gold, silver, and caskets of jewels. The total value was £114,000 ($32.01 million or £17.3 million today) and three times the value of all the ships' cargoes he had sunk, seized, or burned in Cadiz Bay. Considering that the queen's ship, the *Elizabeth Bonaventure*, could be provisioned for £175 monthly, and that £40,000 put an entire army in the field, this was a colossal booty—even for Drake.

Its capture also meant that Sir Francis needed to set sail immediately for England to save his prize, forfeiting all the unfinished goals set by his queen back home. The loss of the *San Felipe* would aggravate Philip's precarious financial position and lead him to make ever more desperate deals with his enemies and allies alike in order to launch his Armada. While Drake, as admiral, had not destroyed the Armada fleet, he had so confused and disrupted Spanish and Portuguese shipping that he had bought Elizabeth's England another year to prepare for the enterprise. In Drake's own words, "there must be a beginning of any good matter."[17]

36. The Plundering of the Spanish Armada ❧

If the late Queen would have believed her men of war
as she did her scribes, we had in her time beaten that
great empire in pieces and made their kings kings of
figs and oranges as in old times.
— SIR WALTER RALEIGH

The country was in an uproar when Drake returned with the treasure from King Philip's carrack. Not only was Drake's name on everyone's lips, in every pamphlet, and blessed in every church in an exultation of joy, but he had provided a boost of confidence to the court and the people. The queen was delighted with her portion of the takings, but again threw the court into dismay against her when she steadfastly refused to prepare for the inevitable war. Drake cajoled and begged Elizabeth, having written to Walsingham while still in pursuit of Recalde and the flota: "I dare not almost write unto your Honour of the great forces we hear that the King of Spain hath out. . . . Prepare in England strongly, and most by sea. Stop him now, and stop him ever."[1]

From that moment until the time he was finally let loose, Drake sang the same song, over and over. He longed to capture the fleet, in port, at Lisbon while it was still assembling its victuals and forces. "The advantage of time and place," Drake wrote to the queen on April 13, 1588, "in all martial actions is half the victory."[2] He had certainly convinced Lord Admiral Howard that his tactics were right, but the queen remained unmoved. England possessed the most sophisticated mobilization system of the age, and could muster and load men and supplies aboard ship in weeks, as opposed to the Spanish method that seemed to take years. Though she didn't want to let on to Drake, his latest escapade had done more damage than the taking of the *San Felipe* and the destruction and plundering of

ships and critical supplies. Philip had been obliged to suspend the silver fleets for 1588 and, in addition to his astronomical papal loans, borrow money from the merchant banking houses of Fugger and Spinola.[3] The blow to Spanish pride had been colossal.

Yet the queen knew that her own system, while finely tuned, was also fragile. Unlike Philip, her borrowing capability was restricted to small sums and for short periods of time. Parliament had voted an increase in her expenditure to £72,000 a year at the beginning of 1588, and, thanks to her parsimonious nature, she still had a further £154,000 in her reserves ($41.94 million or £22.67 million today). Considering that the first year of Dutch financial assistance had cost her £160,000, and that the navy's best estimate for a partial naval mobilization would cost £15,000 a month, Elizabeth simply couldn't afford the luxury of granting Drake his "advantage of time and place" until—possibly—the very last second.[4] Her parsimony has been blamed for much of what went wrong in the preparations for the Spanish Armada battle, but even with all the money in the world, it would have been unwise to prepare and man the fleet. It was virtually impossible to keep ships manned for combat at sea for any length of time without sickness—scurvy or dysentery—ravaging the crews. The lack of funds, in this case, saved English lives.

In addition to her financial woes, the queen also had to assuage any number of bruised egos in the formation of her fighting force. Her dear "Water" had been begging to send relief to his second group of colonists newly installed in Virginia, but she dared not allow any of her expert captains to sail with men and provisions for such a task. England needed all its resources to hand. Raleigh also could not understand why his West Country cousin had been selected as the lieutenant general of the fleet when *he* was the queen's obvious favorite! Frobisher, too, cut up rough when she had selected Drake as Howard's second in command, but he was swiftly reminded of his numerous failures at sea and Drake's phenomenal successes to keep him in check. William Burroughs, too, had been offended by Drake's appointment, especially as his "case" had not as yet been settled by the High Court of the Admiralty. Henry Knollys had taken a dislike to the upstart Drake after their run-in during the 1585 West Indies voyage, and he let his feelings be known as well. The only naval man not to make his ego felt was Drake himself, who never made any

reference to the Lord High Admiral Howard's having no sea battle experience whatsoever.[5]

Philip, too, had a number of worries beyond the obvious financial double whammy of no fleets arriving with treasure, combined with past depredations coupled with the threat of future ones. Then, of course, Santa Cruz had done the unthinkable. He died. It was with an extremely heavy heart that Philip named the soldier and "hero" of Cadiz, Medina Sidonia, as Santa Cruz's replacement. Medina Sidonia was the next most high-ranking peer of the realm, and, as such, his appointment was "God's obvious design." Philip may have been obliged to make him admiral of the fleet, but he was not obliged to trust him. Medina Sidonia made his lack of confidence in the undertaking clear to his king, and all Philip could urge was, "sail . . . sail." Parma, too, had lost any enthusiasm for Philip's hybrid scheme devised to save money, since it would most likely lose lives. Like Elizabeth, the King of Spain had no conception of how wars were actually fought at sea, and the difficulty that his generals would have in meeting up with the English baying at their heels. No practical suggestions were forthcoming either as to how Parma's forces could board from their two hundred or so skiffs onto the Spanish galleons without being attacked by the Dutch, who still controlled the deepwater ports. Above all, Spanish mutinies could be brought on by lack of prompt pay. This would mean that the Armada would need to travel with treasure for her mariners, and keep them loyal.[6]

Philip also had to play a treacherous double game—persuading Protestant nations of the north of Europe (and thereby ones which could inconveniently intervene in his battle plan) that his invasion of England was strictly political, while reassuring the Catholic countries that his motivations were purely religious. Such conceits could be kept "secret" for only a short period. Time was, as a result, his enemy as well.[7]

And so, through a series of half-measures, concessions on the part of the monarchs and their nobility, and the disparate voices of their adventurers, Elizabeth and Philip prepared to have their fleets meet in what would become the first modern naval battle in history. Pitted against the imperious, high-castled Spanish galleons

were Hawkins's smaller, sleeker, more heavily armed warships and pinnaces. Yet the notorious English weather conspired against each of them, preventing Medina Sidonia from reaching England until the end of July and keeping Drake and Howard from sailing out beyond France to attack Lisbon. It would become an engagement simplistically remembered by history as won by "a great wind." It was, in fact, no such thing.

The formation of England's fleet was divided into seven types: the queen's ships; merchant ships serving "westward under Sir F. Drake"; those "set forth and paid for by the City of London"; merchant ships and barks in the queen's pay; coasters under the lord admiral paid for by the queen; coasters under Lord Henry Seymour; and volunteers that joined the fleet after the attack by the Armada.[8] In all, some 182 ships and 15 victualing ships. Six ships only were 300 tons or more—the *Galleon Leicester*, the *Edward Bonaventure*, the *Merchant Royal*, the *Roebuck*, the *Hercules,* and the *Sampson*. Another twenty were between 200 and 300 tons, and proven fighters, like John Watts's *Margaret and John*, a merchant ship from the City of London. Also on England's side was a superior naval efficiency in victualing and in repairs, with the long established royal dockyards at Deptford, Woolwich, and Chatham.[9]

Spain, amazingly, had no royal dockyards, which made their preparations ponderous and extremely inefficient. Through attrition, by the time the Spaniards reached the Channel, their fleet had already lost over twenty ships. While the 127 vessels sailing toward England were slightly fewer than the total English contingent, they were dramatically impressive in their tightly knit crescent formation, and vastly outweighed the English ships. Twenty were warships, or armed merchantmen of considerable stature and force. Four of these were galleasses (mixed oared and sail vessels that had helped Philip to win at Lepanto over sixteen years earlier). All the rest were transports, the tubby *urcas* for victuals or small craft for communications and distribution. In the spring storms that drove them back to Corunna in May, they had lost four other galleys.

When Medina Sidonia finally sailed again from Corunna on July 12, 1588, with his remaining 131 vessels manned with 7,000 mariners and 17,000 soldiers, he had a fraction of the 510 ships and 35,000 men demanded by Santa Cruz. Philip's plan was to have Medina

Sidonia "join hands" with Parma from Dunkirk and Nieuwport, and invade England. Parma's assault force was around seventeen thousand men, whom he would somehow embark on the fly boats and skiffs to join Medina Sidonia.[10] If for any reason the "joining hands" did not succeed, the Spanish fleet was to take the Isle of Wight, secure it, and communicate with Parma from there for an alternative plan.[11]

Elizabeth has frequently been criticized by many strategists and historians for her intrusive, and at times contradictory, orders to her fleet. In part, this is because Drake finally persuaded her (with the active connivance of Howard) that it was foolhardy to divide the English ships, with Howard guarding the Narrow Seas, and Drake the entry to the Channel at Plymouth, called the Western Approaches. Yet after the order had been given in the spring to attempt to catch Philip sleeping in Lisbon, the queen's "interference" was minimal, particularly in comparison with the King of Spain, who had an alternative plan for nearly any contingency. If there was one thing the Queen of England did at this point, it was to trust her commanders once they had put out to sea. Burghley, now quite old and gnarled with gout and arthritis, wrote gloomily at the time, "a man would wish, if peace cannot be had, that the enemy would no longer delay, but prove (as I trust) his evil fortune."[12] The wait was getting to everyone.

But Burghley was always a pessimist. Sir William Winter wrote, "Our ships doth show themselves like gallants here. . . . I assure you, it would do a man's heart good to behold them." Lord Admiral Howard, too, remained confident, boasting, "I have been aboard of every ship that goeth out with me and in every place where any may creep, and I thank God that they be in the estate they be in, and there is never a one of them that knows what a leak means. . . . "[13]

The entire country prepared for war in its own way. Across the south coast, bonfires were erected on all the high peaks leading from Land's End to London and manned around the clock. At the first sight of the Spaniards, the order to light the first beacon would be given from a salvo let off at Plymouth, and it would take under fifteen minutes for the torchlight warnings to carry the news to court. It was a tried and tested method used since ancient times, and it would be used again and again until the advent of telecommunications.[14]

Then, suddenly, on the morning of July 19, 1588, a seaman named Captain Thomas Fleming was cruising with his ship, the *Golden Hind,* off the coast at the Lizard when he spied a massive line of ships in the distance off the Isles of Scilly with their sails struck, as if in wait for more ships. It must have been an incredibly impressive sight. Despite a royal warrant for his detention as a pirate, Fleming headed into port to warn the fleet at Plymouth.

Legend has it that Drake was playing a game of bowls on Plymouth Hoe when Fleming broke the news, and that he allegedly said that there was more than enough time to finish the game and beat the Spaniards. There is no evidence from any English source at the time or later that anything of the sort happened. After fifteen months of waiting to engage the enemy, it is highly unlikely that Drake, in particular, did anything other than scramble his men to their ships and their battle stations, while ordering the beacons to be lit to carry word to London. While, strictly speaking, Fleming should have been clapped in irons, since a warrant had been issued for his arrest for piracy, it is more likely that he had, in fact, been engaged by Howard and Drake to act as their scout.[15]

The Armada made for a formidable sight. The Spanish ships ranged two miles in breadth, and with their huge fore and after castles towered over the English. In the six battles that followed, the history of naval combat evolved into the modern era. Gone forever were the days of oarpowered ships over sail. Grappling and boarding, too, was replaced by superior firepower and long-range weaponry. The death knell was also tolled for the English crossbow archers as the country's most lethal fighting force aboard ship.[16]

Yet despite superior maneuverability and firepower, the English made little, if any headway, on the first day of battle (July 20). The next day, though, the English got lucky. One of the Spanish warships, the *Nuestra Señora del Rosario*, was lost. The *Rosario*, a colossal 1,150 ton *nao*, a multipurpose ship armed for war with fifty-two guns and a crew of over four hundred men, lost its bowsprit, foreyard, halyards, and forecourse after a series of collisions in the fleet due to their tight formation. Her commander, Don Pedro de Valdes, fired off his guns to let Medina Sidonia know his plight, but all efforts to save her failed. Valdes watched helplessly as the Armada slowly

pulled away to the east, leaving him to his destiny. This was a huge blow to the Spaniards, since she was one of the largest ships in the Armada, and carried a third of the treasure taken along to pay the mariners and soldiers.[17]

While the English had seen that the *Rosario* had been left behind, at their council of war that night, Howard gave the order to keep their formation and follow the main body of the Spanish fleet. It was Drake's turn to lead the watch that night, and so his poop lantern was lit at his stern for the other ships to follow. Nonetheless, Watts's Londoner, the *Margaret and John*, broke formation and ranged alongside the *Rosario*. His arrows and muskets at close range met with the ferocious reply of several Spanish guns, and the *Margaret and John*'s captain replied with a broadside. They were so close that they could hear the Spaniards whispering after the crash of the cannonball into the *Rosario*'s hull. Though disabled, she was still over four times the English ship's size, and the men voted to return to the English fleet.[18]

Meanwhile, Howard blithely followed the lantern, unaware that all was not as it should be. The lookout had lost sight of Drake's lantern, and instead of advising the admiral, who had gone below, he waited and strained his eyes into the dark distance before he saw the lantern again, but this time much farther forward than expected. Fogs suddenly bubbled up all the time in the Channel, and so the watch thought nothing more of the episode until morning. Drake, meanwhile, had sailed away. His own watch aboard his ship, the *Revenge*, had reported that there were three or four ships sailing abreast of them. Could it be the Spaniards working to windward in the dark? Drake ordered his lantern extinguished to surprise the ships that dogged him, and to avoid taking the whole of the fleet on a wild-goose chase, and lose the Armada.

His prey turned out to be German freighters, and Drake claimed to be rejoining the fleet when he spied the *Rosario* and pulled up alongside her. He summoned her captain to surrender, and when the Spaniard asked for terms, Drake replied that he had no time to parlay, but that they had the word of Sir Francis Drake that they wouldn't be harmed. Twenty years later, when Drake's heirs were arguing over his estate, testimony from his sailors that night reported:

The said Sir Francis entertained the said Don Pedro in his cabin, and there, in the hearing of the deponent, the said Sir Francis did will his own interpreter to ask the said Don Pedro in the Spanish tongue whether he would yield unto him or no and further to tell him if he would not yield he would set him aboard again. Whereupon the said Don Pedro paused a little while with himself, and afterwards yielded unto the said Sir Francis Drake and remained with him as a prisoner.[19]

The Spaniards were transferred to the *Revenge* and her sister ship, the *Roebuck*, while the *Rosario*'s treasure was lowered into the *Revenge*, where Drake could keep his eye on it. It is believed that the haul amounted to some 55,000 ducats ($3.74 million or £2.02 million today) as well as jewels, silver plate, and fine apparel, though no one knew for sure how much was truly there. When the treasure passed into the lord admiral's hands, only half that sum was counted. When Frobisher later learned of the incident, he was incandescent with rage. Frobisher's rescue by Drake near the Isle of Wight was a even more bitter pill to swallow.

But on that day, Drake hadn't returned as yet by dawn, and it was only when Howard came above decks that he quickly saw that he hadn't been following Drake's poop lantern after all, but the one of the Spanish Armada instead! The English account of how he extricated himself and what, if anything, he said to Drake when he rejoined him is ambiguous. All we know for sure is that Drake did rejoin, Howard did take possession of the treasure, and that Drake was again on several occasions entrusted to act as lead ship with his poop lantern alight to guide the fleet.

That same day, Howard himself peeled off from the fleet and picked up the *San Salvador*, which was sinking after an explosion in her gunpowder stores ripped through the ship. She should have been scuttled, but Howard ordered instead that Captain Fleming (the pirate who gave the first alert) should bring her into harbor at Weymouth, Dorset.[20]

After the first two battles, the Spaniards were already very low on powder and shot. The gunpowder magazine's explosion aboard the *San Salvador* spelled further disaster. Frobisher in the largest English ship, the *Triumph*, was nearly cornered at the Isle of Wight,

but rescued at the end of the day by Drake's sharp maneuvering. By the time the Armada had reached the Calais Roads, it was seriously depleted of food and water as well. The English had learned from their battles to stay just out of gun range while the Spaniards tried to sink them. English rates of fire were only one or one and a half rounds per gun per hour, where the Spanish managed only one to one and a half rounds per day. With its superior firepower, the English ships slowly made inroads into the invincible Armada. But it was Philip's strict order to Medina Sidonia not to make any independent landing without Parma that committed the Spanish Armada to failure—not the English fleet.

Parma had too few armed vessels to protect his army sailing out of harbor to meet the Armada, and he knew he and his soldiers would be sitting ducks for the Dutch, who had now joined the English side. On the Sunday night, the English loosed eight fire ships into the tightly packed Armada and watched the Spaniards grapple themselves free while they stood out to sea. Despite incredible Spanish courage, the elements were against them. A great storm brewed up, allowing the English to herd them toward the Zealand Banks—shallows that could shipwreck the entire fleet.

Then as Tuesday dawned, the wind changed direction to southward, allowing the entrapped Armada to escape to the north. No one believed that it would be the end of the action. In fact, Howard wrote to Walsingham, "Their force is wonderful great and strong, yet we pluck their feathers by little and little. I pray to God that the forces on the land be strong enough to answer so puissant a force."[21]

But it was the end. The Spanish Armada sailed around to the north of the British Isles, and west again around Ireland, with several of their galleons shipwrecked there. At least one-third of the men were dead, and half of those who returned were sick or dying. Only Recalde landed safely in Ireland with a small squadron, and got away to tell the gruesome tale of the Armada's destruction on Ireland's western coast. But even the great Recalde fell victim to sickness on his return to Spain, dying within weeks, it was claimed, of a broken heart. Spain fell into deep mourning, for the loss of the Armada was a national catastrophe. The loss of her men was irreplaceable. The

loss of the treasure and the ships was barely considered in the public psyche. Where Spain mourned, England rejoiced. Even at the time, there were many who claimed that the defeat of the Armada was the moment when Spanish maritime expansion ceased, and the English were on the rise.

For the Queen of England, it was a vindication by God of all she represented. In the ten days that the Spanish Armada threatened England, God had smiled down on His Protestant queen.

37. America Again . . . and Again? ✳

> *As Salomon said, "Riches are a stronghold, in the*
> *imagination of the rich man." But this is excellently*
> *expressed that it is in imagination, and not always in fact.*
> —SIR FRANCIS BACON, *Essays*, NO. 34 "OF RICHES"

Raleigh's role in the Armada campaign was largely supportive, even selling the *Ark Ralegh* to the queen to use as the renamed *Ark Royal* for Admiral Howard. After it was all over, he somehow was charged with selling the captured Armada wines as agent to his half brother, Sir John Gilbert. While it must have been a highly profitable transaction for both men, Raleigh's real interest was with the casks. "I must also pray you to set aside twenty-five tons of the iron hooped cask for me," he asked Sir John, "priced in such reasonable sort as you may, for I shall have great use of them. And if my Lord of Cumberland or any other make means to have them, you may answer that they are priced and sold, or that Her Majesty has given them to me. . . . "[1]

Cumberland and any other adventurer would have probably figured that Raleigh needed so many casks for his wine trade. This was not the case remotely. Raleigh earnestly put about the fact that having been prevented from reprovisioning his colonists (who had sailed to Virginia in April 1587), due to the Armada threat, he was absolutely determined to ensure their safety—and his grant of twelve hundred miles of North America—by supporting them with fresh supplies in 1588–1589.

Virginia was, after all, his best opportunity to find his own gold supply. And so, while Frobisher and the other disgruntled commanders from the Armada fleet argued with the Admiralty over the prizes and ransoms to be obtained for ships and men, Raleigh rose above the petty squabbling and stepped up his efforts for Virginia.

Raleigh had set up an innovative scheme to attract settlers in the third Virginia colony by offering them five hundred acres of land to farm on the strength of their signing up for the adventure. If they invested funds, then they would get more again. His Virginia company, unusually, was organized as one enjoying the right of self-government under their own officials, with representatives in England to ensure the chain of supply until they could provide for themselves in America.[2] Raleigh's chosen governor and his twelve assistants were granted their charter on January 7, 1587, as "Governor and Assistants of the City of Raleigh in Virginia." The charter did not delegate powers to the colonists, but merely made them paid servants of Raleigh and any other adventurers or promoters residing in England. After all, Raleigh's planters were markedly "middle class." Their only claim to any aristocracy, whatsoever, was the false coat of arms that Raleigh had bribed the chief officer of arms, William Dethick, to bestow upon White and each of his twelve assistants.[3]

What Raleigh didn't know, of course, was that all was not well. Only he would continue to employ Simon Fernandez, nicknamed "the swine" by other adventurers. Fernandez's interest was plunder, and, as a former pirate, the temptation to revert to his old trade was far too great. Raleigh's simple instructions to collect plants and water in the West Indies, then to purchase livestock for the colony, resulted in Fernandez going after Spanish prizes and ignoring the 110 men and women in his charge. If their captain acted like this in the West Indies, then how would Fernandez carry out his further orders to pick up the fifteen-man contingent left by Grenville at Roanoke in 1586, then drop the settlers off at the more fertile landing and good harbor of Chesapeake? Evidently this wasn't a question that had occurred to Raleigh's appointed governor, John White. White was undoubtedly a splendid artist but, as it turned out, a truly dreadful leader of men. Instead of asking himself some basic questions, White harangued and shamed Fernandez until they finally sailed north to Virginia.[4]

By the time they reached Roanoke, Fernandez was spoiling for a fight. While White equipped a pinnace with forty of his best men to go search for the fifteen men Grenville had left behind, Fernandez hailed them from the *Lion*, shouting orders that he prepared to

abandon them. All the colonists were hastily ordered ashore. Only White and two or three others were allowed to return to the *Lion* to make the necessary arrangements to offload provisions.[5] Amazingly, White, though angry, was not unhappy. He knew Roanoke very well and, with anglicized Manteo as Raleigh's personal representative at his side, most likely felt that they could not come to any harm. After some haggling, White finally agreed with Fernandez that the *Lion* should return shortly to take aboard the men left by Grenville, and that, in the interim, Fernandez would ensure that the fly boat carrying the rest of the "planters" would be able to disembark in safety.

Thus at the end of July the planters were reunited in Lane's abandoned fort, having found no trace of Grenville's men. When Manteo, recently converted to Christianity and dubbed Lord of Roanoke and Dasemunkepeuc, returned with the news from his own people at Croatoan that Grenville's men had been driven off Roanoke by the hostile mainland tribes, razing the earthworks and fort in the process, White did nothing. A short while later, one of White's assistants was ambushed while fishing for crabs. And still White did nothing.[6]

Trusting that all would somehow be all right, White tried to make amends for the wrongs that Lane had committed, and to correct the label the previous planters had acquired of "stealers of corn." When White failed to get the mainland chiefs and elders to come to some sort of accommodation with his settlers, the planters mistakenly ambushed the friendly Croatoans in their village, killing one native.[7] Relations between the Native Americans and planters were still strained when, on August 18, Virginia Dare, a healthy baby girl, became the first child born to Europeans in North America. She was also White's first grandchild.

Meanwhile, Fernandez had returned and remained within sight of the colonists two miles from shore, waiting. Fernandez's hovering offshore frankly unnerved the colonists. His sinister actions, combined with the repeated native attacks, made them doubt their ability to withstand the winter and the wisdom of planting any fields at Roanoke to harvest in the spring. Chesapeake had become a perceived haven in this hostile land in the colonists' eyes, and White's

resistance to any move there utterly undermined his authority. After a number of discussions, White was at last compelled to go by his assistants, and, on August 25, was given a certificate asserting that he had been selected to "the present and speedy supply of certain our known and apparent lacks and needs most requisite and necessary for the good planting of us, or any other in this land of Virginia."[8]

And so Raleigh's governor left eighty-four men, seventeen women, and eleven children with Manteo and his assistant, Towaye. White understood that they intended to move fifty miles or so farther up into the mainland, where the land was fertile and the risk of hostile natives was lower. To this day, we are unsure if it was to the mouth of the Chesapeake or the Albemarle Sound. What we do know is that a pinnace and some boats were left behind with them. On August 27, White was allowed to board the fly boat, leaving behind his daughter, Elenora; her husband, Ananias Dare; and baby, Virginia, with the rest of the planters entrusted to his care. Before they had sailed over the horizon, a disastrous accident at the capstan injured most of the crew. Many died, and others became ill with fever and the bloody flux, reducing their number so dramatically that they couldn't sail beyond Smerwick in southwest Ireland, where Raleigh had first made his name. White alone continued to London, arriving only in early November, three weeks after the *Lion* had returned from its fruitless privateering voyage.[9] Even White could not help noticing that the country was on a war footing, and that the queen wouldn't allow any ships to sail that might weaken the defense of the realm.

For Raleigh it was a double disaster. He could not possibly lose face and do nothing. To do nothing would be to abandon his fellow "adventurers" who had invested their money alongside him. Yet all he could muster on behalf of White and the planters was for two pinnaces to sail—the 30-ton *Brave* and 24-ton *Roe*—from Grenville's home port of Bideford. But the Atlantic was teaming with pirates, adventurers, and Spaniards all aching for a brawl, and the *Roe*'s captain decided to break off and join in. Alone now, the *Brave* was attacked by a Huguenot ship out of La Rochelle, and by the end of May 1588, White was back in Bideford. Raleigh tried time and time again to get Grenville to sea on his behalf to provide support for

the fledgling colony, but he was overruled by the Privy Council. It was this harsh and necessary decision in the face of the real threat to England that sealed the colonists' fates.[10]

Richard Hakluyt, in the meantime, had published his *Principall Navigations* at the beginning of 1590, stinging Walter Raleigh with his bitter preface that "the plantations were founded at the charges of Sir Walter Raleigh, whose entrance upon those new inhabitations had been happy, if it had been as seriously followed, as it was cheerfully undertaken."[11] The threat of the Armada had passed, yet throughout 1589, Raleigh, who himself had men-of-war in the Atlantic, made no effort to rescue his planters. His attention, like thousands of other adventurers, had been grabbed by the real chance for riches beyond even his greedy dreams, and the destruction of Spain's empire. The casks that he had written to his half brother Sir John about would serve just as well aboard his men-of-war. The planters would simply have to wait.

38. The Last Gasp of the Early Roaring '90s ❧

Tis England's honor that you have in hand,
Then think thereof, if you do love our land.
The gain is yours, if millions home you bring,
Then courage take, to gain so sweet a thing.
The time calls on, which causes me to end,
Wherefore to God, I do you all commend . . .
That Philip's Regions may not be more stored,
With Pearl, Jewels and the purest Gold.

— HENRY ROBERTS, ADVENTURER POET, *The Trumpet of Fame*

The only ones who could afford to continue the war against Spain were Elizabeth's adventurers. Where they dreamed of riches and empire, Elizabeth longed to consolidate her England, and stop her ruinous expenditure in Ireland. Little did she realize then that the 1590s would see her spend £2 million ($480.63 million or £259.8 million today) in the defense of her postern gate. She had built her image of Gloriana on the peace and security of the realm, and continually hoped for the day when the myth would become a reality. It was precisely these desires that the adventurers pandered to throughout the 1590s. Under the guise of a new nationalism they would enrich themselves, leading the queen to believe that only by destroying Spain's wealth could England ever find peace. But the queen was no fool. The death of her beloved "Robin," Earl of Leicester, a month after the Armada was defeated in 1588 had left her personally rudderless. The advice of the equally aging Walsingham and Burghley may have seemed faint as the younger generation energetically pressed itself forward first at court, then in the Privy Council. Certainly, years of loyal service had worn them out. So when the queen's spymaster, Sir Francis Walsingham, died in

April 1590, Elizabeth simply relied more heavily on Lord Burghley, and his chosen successor and second son, Robert Cecil. Only the two Cecils had the overview in the same way the queen had, and only *they* now shared her most intimate strategies. Cecil's "hold" over the old queen became the source of tremendous friction between him and Robert, Earl of Essex, and Cecil's appointment would prove to be one of the more controversial appointments Elizabeth would make.

But Robert Cecil did not necessarily mean "bad news" for the queen's adventurers. When Sir John Hawkins came to the Council with his brilliant plan for a Silver Blockade of Spain, Cecil not only listened to him, Cecil believed he was right. The Hawkins plan was simple and cheap. Six major galleons would need to be maintained between Spain and the Azores, and kept at sea for four months. At the end of that time, they would be replaced with another fleet of the same strength. England had proved that it could keep ships at sea—so long as they were not heavily manned—in reasonable condition and "healthy and sweet-smelling" for that period. Young Cecil was still an unknown quantity beyond the dizzying heights of the queen's personal company, despite his rapidly growing power. Perhaps it was for that reason that Hawkins had made no statement about commercial gain possible in his scheme. Whatever his reasons, the plan was, alas, never fully enacted. More is the pity, since it made complete sense. The best way to level the playing field would be for Philip to have access to the same amounts of gold—or preferably less—than Elizabeth. Only her adventurers could achieve that task, and both the queen and Cecil knew it.

There is also the possibility that the plan was put on hold with the first failure ever of Sir Francis Drake as commander of his own fleet. In 1589, Drake undertook to land Dom Antonio in Portugal to reestablish him on the throne, investing £1,000 himself in the adventure ($268,250 or £145,000 today) and "setting himself forth with twenty men and muskets."[1] The soldiers were led by the brutal veteran of the Irish and Dutch campaigns, Sir John "Black Jack" Norris, and the exuberant rising star Robert, Earl of Essex. Drake should have known better than to be associated with either, but he had had little choice. He also should have known better than to believe that the Portuguese would rise up spontaneously

for Dom Antonio after living peacefully under Philip's rule for nine years. Notwithstanding all this, the 1589 voyage was doomed to failure for the same reason that most adventuring voyages in the 1590s failed: Elizabeth had sent adventurers to do the job of a professional, government-controlled Royal Navy, blurring her "war aims." Granted, the queen did not have the money to develop a true Royal Navy, and so private adventurers who invested in ships and manpower for the queen (with their own commercial plans for plundering) ruined Drake's chances along with Antonio's overinflated view of his people's love for him.[2] For Drake, the result was an apparent fall from favor.

Drake would spend the better part of the next six years in what many called his "disgrace." But the term is inaccurate. A disgraced general is not constantly called upon by his political superiors for his advice and handling of matters ashore as Drake had been. By November 1590, the Privy Council commissioned Sir Francis as a justice of the Admiralty to help resolve regular episodes involving the plundering of neutral ships by English adventurers, and making an inventory of their proceeds. Since the bulk of adventurers or pirates were West Countrymen, and the lord admiral received a portion of all registered prizes, this was a position of extreme importance. Drake was also responsible for the safe stowage of the loot until the case could be heard in the High Court of the Admiralty. The job of recovering, securing, and handling the accounting for questionable cargoes and examination of these "foul outrages" became the mainstay of his work until 1596.[3]

And while Drake built up his fortunes ashore, Philip rebuilt his navy. English spies reported the king's naval strength from Spain in 1591:

At Ferroll: thirty-two sail, ready, small and great.

At Santander: Eight new galleons, the least eight hundred tons. Four already launched, four to be launched within a month.

At Bilbao: ten ships pressed for the king.

At the River of Portugal [Lisbon]: Nine new galleons and ships. Four about one thousand tons, the rest from eight hundred to seven hundred tons each. Eight already launched, the other to be launched in a month.

324 ❧ The Pirate Queen ❧

At Passages: Fifteen great ships of which thirteen were in the Armada of three hundred to five hundred tons.
In all about seventy-five to rendezvous at Ferrol.[4]

Raleigh, meanwhile, was back at his plantations in Ireland, making mansions for himself at Youghal and Lismore. Among his frequent houseguests were the out-of-royal-favor poet and neighbor Edmund Spenser, and Raleigh's cousin Sir George Carew, who was also Ireland's master of the ordnance. Unlike the queen, Raleigh saw adventuring only in terms of empire. And while in Ireland, he had taken to building his own personal empire, thanks in no small part to the queen's extreme generosity of 42,000 acres of prime farmland at a rent of £233 6s. 3d. ($62,583 or £33,829 today) annually after the first three rent-free years.[5]

At Youghal he introduced novelty crops as early as 1595, planting potatoes and tomatoes—from the New World—around the same time. While it had been Drake who brought the first tobacco back to England from the West Indies (and Ralph Lane, an officer of Drake's at the time, who would teach Raleigh how to smoke), it would be Raleigh who would popularize the habit of social smoking while drinking mugs of ale. An invitation to smoke and drink ale with Raleigh was the most welcomed of private male gatherings in the 1590s.[6]

Even so, while his smoking parties took place primarily at his London home, Durham House, Ireland remained the main source of his revenue. He had grand plans to import New World foods on a large scale and to commercialize the planting of tobacco. Still, as with so many things in Raleigh's life, plans were all they would remain.

Elizabeth had also allowed Raleigh to muster an extra company of cavalry to help protect his intended "planters" there. But as in England, he quickly gained the reputation for being full of himself, falling out with Ireland's lord deputy, Sir William Fitzwilliam, through an unnecessary lawsuit against Lady Stanley, wife of Sir William Stanley the traitor, but nonetheless a vastly popular figure in Catholic Ireland. Raleigh continued to alienate those around him who viewed him as a "pushing and selfish adventurer."[7] In a typical

fit of pique, Raleigh complained in a veiled threat to George Carew that, "if in Ireland they think I am not worth respecting, they shall much deceive themselves."[8] And while Raleigh played in Ireland, his ships still sailed under the command of his masters, enriching their owner.

It was said at the time by the queen's intelligencers that "traitors murderers, thieves, cozeners, cony catchers, shifting mates, runners away with other men's wives, some having two or three wives, persons divorced living loosely, bankrupts, carnal gospellers, Papists, Puritans, and Brownists," all flocked in droves from England to Munster. In the hundred years between 1580 and 1680, over a hundred thousand English—though not all reprobates by a long shot—emigrated to Ireland. It naturally attracted those who had nothing to lose and pure adventurers. All of them were looking to pluck a prime piece of land from the Irish for themselves in the same way that frontiersmen of America did.[9]

At sea, the English adventurers were led by the queen's "rogue" George Clifford, third Earl of Cumberland, off the Azores in 1591, in what became known as the Islands Voyage. Cumberland and his squadron cruised that summer in the Azores aboard the queen's *Victory*, plundering dozens of ships and netting tens of thousands of ducats (official reports varying wildly). Still, their aim wasn't a blockade as Hawkins had suggested. It was a plunder mission. Had they adopted the Hawkins plan, they could have probably captured the passing Portuguese carracks laden with gold and precious gems, as well as several West Indiamen. Nonetheless, Cumberland was happy with his takings, and remained at sea through September when the queen sent out Frobisher with a small squadron to reconnoiter Seville and Lisbon. Frobisher took four prize ships, much to his own delight, but the bulk of the flota had arrived in port safely.

Yet, as expected, this did nothing to deter Philip in his determination to rebuild his fleet to use against England again. To make matters worse, a more concerted effort to blockade Spain had failed in 1590, with the East Indiamen this time eluding twelve of the queen's ships under the joint command of Frobisher and

Hawkins. Reprisal ships still abounded, with John Watts's ships in the West Indies making a killing in understated loot to avoid taxation.

Gold and silver was flowing into the queen's and Admiralty's coffers, but still, Philip's rebuilding program remained on track. By the spring of 1592, Lord Admiral Howard finally managed to launch a squadron back to sea to meet up with other adventurers, including Cumberland. While details of their mission have not been preserved, it seems that suffered too from the double-headed coin of plunder to pay for the voyage while ensuring state security. Elizabeth certainly knew Philip well enough by now to be acutely aware that he would not take the defeat of the "Invincible" Armada lying down. What she didn't know is that Don Alonso de Bazán's fleet had been relaunched in the hope of catching John Watts's fleet as it returned from its plunder operation in the West Indies.

The King of Spain had ordered that all Spanish ships remain in the West Indies until further notice, but, unknown to Philip, many had already stolen homeward and lay at anchor near Terceira in the Azores and cursed the English corsairs repeatedly for their misfortunes. Frobisher, Hawkins, and his son Richard were all under sail in different squadrons, all trying to encircle the Iberian coast like a school of sharks. And Philip was unable to send gold or reinforcements to Parma in the Netherlands. At last the English blockade seemed to be working.[10]

Still, Elizabeth wasn't convinced. Reluctantly, she sent Lord Admiral Howard with Sir Richard Grenville as his lieutenant to Spanish waters. The Earl of Cumberland planned to join them to lead the "jackal" squadron that roved tightly against the Iberian coast. They were lucky in taking a Lubecker off the Finisterre coast with £10,000 worth of masts and timber ($2.41 million or £1.3 million today) destined to provision Philip's new fleet.[11] Their prisoners told them that the Indian fleet they were looking to plunder had arrived some weeks earlier at the Azores, and were out of their reach by now.

Howard wasn't having any of that! The Lubecker was sent back to England while he headed the ships belonging to the queen and Raleigh to the Azores. Back home, the queen had received alarming reports of the Spanish king's new naval strength, and the possibility of

a new Armada. Raleigh was ordered to hasten down to Plymouth to organize a fleet, while Cumberland sailed quickly out to rendezvous with Howard.

When Cumberland met up with some of his cruising ships along the Spanish coast, his worst fears were confirmed. The Marquis of Santa Cruz's brother, Don Alonso de Bazán, had sailed to accompany the Indian fleet to safety from the Azores. Howard was in mortal danger. But with the luck of "the gifted amateur" that England spawned throughout its rise to empire, Howard remained blissfully unaware of the danger, claiming that he was "almost famished for want of prey, or rather like a bear robbed of her whelps."[12] Fortunately, a squadron of sixteen ships (including the *Bark Raleigh*) had met up with the lord admiral before he could come to harm. Don Alonso, however, was closing in with his fifty sail—thirty of which were great ships and galleons. Nonetheless, the English fleet was caught by surprise reprovisioning with water at Flores.

Orders were shouted to "heave ho!" by the English, but the Spaniards blocked the roadstead as their sails began to fill with wind. Still, Howard's luck held, and despite most ships slipping their cables, they sailed away. That is, all except Sir Richard Grenville aboard the *Revenge* who resolved to stay and engage the enemy. It was an act of sheer madness. The *Revenge*, the queen's pride and joy as her prototype for a sleeker, more yar vessel, was lost after twelve long hours of battle, and Grenville with many of his men were needlessly killed. All others were spared.

The loss of the *Revenge* was a harsh blow for the queen—until now (or *ever*, for that matter)—it was the only royal ship to be lost in the Spanish War.[13] "Sir Richard utterly refused to turn from the enemy," Walter Raleigh wrote in a scathing verbal attack against Grenville, "alleging that he would rather chose [sic] to die, then to dishonor himself, his country, and Her Majesty's ship, persuading his company that he would pass through the two squadrons [of Spaniards] in despite of them: and enforce those of Seville to give him way."[14] But Raleigh had other motives for being so angry at the needless loss of life and property aboard the *Revenge*. Grenville was dead, and so were Raleigh's dreams of sending him to Virginia to rescue his colonists.

Raleigh knew that he had to concentrate on either his quest for gold or his colony in Virginia, and so he agreed to terms with the London merchants Thomas Smythe and William Sanderson to send nineteen new colonists to Roanoke. In exchange for their investment of money, shipping, victuals, and so on, Raleigh relinquished some of his rights of trade. It seemed an ideal solution to the Elizabethan entrepreneur. When John Watts, the London merchant and greatest owner and promoter of adventuring ships, was involved by Sanderson, it looked as though White's "lost colonists" would at last be rescued. But this was a false hope, since in the end the three ships were not allowed to sail, as the Privy Council expected yet another Armada.[15] Undaunted, Raleigh used his famous charm with Elizabeth, and succeeded in obtaining a license for another private ship, the *Hopewell*, to sail with John White aboard, together with some more "western planters" and provisions.

When they anchored at last off Hatarask on August 15, 1590, they found the Roanoke fort three days later, deserted. Carved into one of the trees marking out the former fort was the word CROATOAN and another tree had "CRO" etched into its trunk. This was the agreed signal between the planters and White for his return. If the word of their destination also had a Maltese cross beneath, then that would mean that they had decamped under duress. White was overjoyed at finding "a certain token of their safe being at Croatoan, which is the place where Manteo was born, and the Savages of the land our friends."[16]

The captain of the *Hopewell* began his run south to Croatoan but was taken by surprise in what must have been the beginning of a hurricane. They were unable to recover their water casks, and lost two anchors trying to clear the Outer Banks. With only a single cable and anchor, few victuals, and no pinnace in vastly deteriorating weather, the captain decided, with White's consent, to head for the West Indies and outrun the storm. A few days later, after a further pounding, the *Hopewell* was forced to turn east toward the Azores and home. It proved to be the last real attempt to rescue the colonists at Roanoke.

By the time Howard and Cumberland were planning their mission against Spain, Raleigh had engrossed himself in his new role as the leader of Elizabeth's adventurers, organizing Atlantic plunder on a

gigantic scale. Yet he never gave up hope of finding treasure in the New World, and had long dreamed of "El Dorado," the mythical golden kingdom whispered in Indian folklore. In Hakluyt's *Discourse of Western Planting*, he describes a tract of twenty-one hundred miles that "is neither Spaniard, nor Portuguese, nor any Christian man, but only the Caribs, Indians and savages. In which places is great plenty of gold, pearl and precious stones."[17] For years he had been querying explorers returning from South America about El Dorado, and particularly French corsairs who had traveled up the Amazon. He was so hungry for real knowledge about El Dorado that Raleigh exchanged with these men the intelligence they craved about Raleigh's own difficulties in establishing colonies in Virginia for facts about Patagonia and the Spanish Main.[18]

But Raleigh's inquisitiveness and hopes to launch an all-out investigation of the region were interrupted with the sudden discovery by Elizabeth that he had secretly married her lady-in-waiting, Bess Throckmorton. Their son, Wat, was living proof of their relationship, yet Raleigh lied and bluffed about his involvement with the queen's lady. When Raleigh was finally compelled to confess, Elizabeth thundered at him in rage and unceremoniously packed him off to the Tower to cool his silken heels for a while. The queen had to approve all court marriages by law, and Raleigh should have known better. After all, he followed Leicester's own public debacle in secretly marrying Lettice Knollys, Walter Devereux's widow, by a number of years, as well as Robert Devereux's (second Earl of Essex) own crime two years earlier.

Elizabeth's efforts in the early 1590s were also absorbed by Philip's change of tactic. Henry of Navarre had inherited the French throne, and as the Protestant king of predominantly Catholic France, this made his efforts in the Spanish Netherlands even more futile. That is, until the Spanish took Calais. Now Henry, financed as well by Elizabeth, was fighting a rear-guard action, trying to keep the Spanish from fanning out from the Pas de Calais and beyond. For her part, Elizabeth did what she could by sending Essex and his volunteers to relieve Rouen at the French king's side, but her frayed purse strings were near breaking point. It is intriguing to speculate if her lack of capital might have been the main reason why she had allowed the adventurers out to sea in the vast numbers that she did at

the time. A percentage of their takings—even after pilferage by the crews and hangers-on at port—was better than absolutely nothing. She had become bitter that things had come to such an impasse, for if there was one thing above all else that Elizabeth loathed, it was being backed into a corner.[19]

It seems odd that Drake was the only great adventurer who was not at sea, and may well have held a warmer place in her heart as a result. He, at least, was making an attempt to capture the ill-gotten gains of her pirates and adventurers. Even more interesting is that Elizabeth used his wondrous reputation to full advantage, often claiming within earshot of the Venetian ambassador that Drake was due to sail with fifty ships. Here we can still see the young queen teasing and taunting her enemies, and telling lies as if they were truths.[20]

No longer fettered by Elizabeth as her indispensable favorite, Raleigh along with Cumberland came up with a scheme to capture the Isthmus of Panama in reprisal for the loss of the *Revenge*. The plan appealed to the queen's devious side, and it was a way for Raleigh to show his allegiance. Without too much cajoling Elizabeth ventured two ships and £3,000 in cash ($720,890 or £389,670 today). Raleigh contributed the *Roebuck* and money he said was his own, but many think it had really been borrowed from his friends. In the event, they never made it past the Azores. There Captain Crosse (who was a Drake veteran mariner) in one of Cumberland's ships took the Portuguese carrack *Madre de Díos* after a hard fight. It was the largest ship afloat at the time, with seven decks and a cargo in gold, spices, and precious gemstones worth a staggering £150,000 ($36.08 million or £19.5 million today).[21] At least that was the official figure.

But by the time the treasure was brought back to England, much had been pilfered along the way. Stories of disorderliness among the English sailors filled the official and popular press. Drake himself heard how the swarm of English pirates (for he could describe them as nothing else) ran wild with excitement, rummaging through the passengers' cabins, breaking open chests with their weapons, and running off with much of what belonged by law to the adventurers' ship owners and the Admiralty. He spent much of his time taking depositions of how Cumberland's mariners were literally at one

another's throats, staving off sailors from the other adventuring ships and keeping them from partaking in their ecstatic orgy of booty.

Still, that wasn't the end of the affair. London jewelers clamored aboard diligences and rushed to Plymouth where the sailors disembarked. Every cutpurse and thief gathered around the pier in the hope of something to steal while the treasure was unloaded. "We cannot look upon anything here," the harassed receiver of customs, Thomas Middleton, opined, "except we should keep a guard to drive away the disordered pilfering bystanders that attend but a time to carry away somewhat when any chest is opened." It took Drake and several other commissioners several weeks to gain control of the situation—restoring order, taking witness statements, examining mariners, taking inventory, and finally, thankfully, sending £141,000 worth of the cargo to London.[22] Drake had yet again more than proved his weight in gold.

The taking of the *Madre de Dios* had a devastating effect on Philip's reputation. The gossipy Venetian ambassador in Spain wrote in cipher to the doges that "the King must be relieved from the weight of so many debts . . . he has debts of about thirteen millions [ducats] in gold . . . in the air as they say." And it was true that "the West India fleet has never at any time of its history been so harried by the English and exposed to such danger of capture as at this present moment."[23]

But in truth, enough gold and silver made its way to Philip's coffers, and his rebuilding program continued unabated. There would be another Armada.

❧ **Part Four** ☙

Dawn of Empire

I myself will venture my royal blood; I myself will be your general, judge, and rewarder of your virtue in the field. I know that already for your forwardness you have deserved rewards and crowns, and I assure you in the word of a prince you shall not fail of them. . . .

— ELIZABETH I, ARMADA SPEECH AT TILBURY, AUGUST 9, 1588

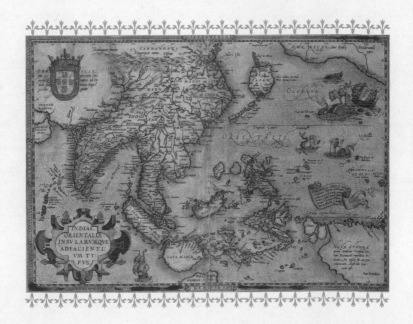

39. The Alchemy That Turned Plunder into Trade ✺

Ambition is like choler, which is an humour that maketh men active, earnest, full of alacrity, and stirring if not stopped So ambitious men, if they find the way open for their rising, and still get forward, they are rather busy than dangerous . . .

—SIR FRANCIS BACON, *Essays, Of Ambition*

By the mid-1590s, Spain's naval rebirth was not only rumored, but also evident from the turning tide of her adventurers at sea. While Philip's health continued to deteriorate, his anger against England remained hearty. Drake had been a landlubber for six years, and he longed to feel the boards beneath his feet, the stiff sea breezes in his face, and the thrill of the attack again. The ghost of Thomas Doughty had finally been laid to rest, though his younger brother, John, still rotted in prison for his attempt on Drake's life.[1] Now in his mid-fifties, with the help of his cousin, Sir John Hawkins (in his sixties himself), the two veteran sea dogs persuaded the queen to allow them a nostalgic revival of their "troublesome" 1568 adventure, but this time the purpose was to capture Panama. If Hawkins's blockade couldn't stop the silver shipments, surely their landing at Panama would. The queen allowed them to go, wanting to believe in them more than *truly* believing. Perhaps this was why she wanted them to adopt the tactics that had been so successful in their youths—the surprise smash-and-grab raids that had so inspired her younger, ambitious adventurers. And so, after much preparation, they set sail with the old queen's blessing.

The result was catastrophic. When the two former pirates heard that a great silver carrack had been crippled in Puerto Rico, they naturally attacked. It had been over ten years since Drake had last

seen the West Indies, and in that time, Spain's fortifications against the return of *El Draco* proved more than effective. Hawkins was killed by a direct hit in November 1595. Two months later, in January 1596, Drake had his stool shot out from under him while eating dinner. But his luck would not hold this time. Within weeks, he was dead of the bloody flux, probably brought on by an infection of his wounds.[2] Starved of the threat of *El Draco*—whether real or imagined—all looked lost to the despondent queen.

But just as this devastating news reached court, worse was yet to come. Henry IV of France had decided that "Paris was worth a mass" and converted to Catholicism, ending decades of civil war. The effect on Elizabeth was profound since Henry had been her hope for a Protestant, and thereby benign, France. In reply to this, she urgently sent Gilbert Talbot, seventh Earl of Shrewsbury, to obtain Henry's oath to observe the conditions of their league against Spain and to invest him in the Order of the Garter. "And by this means you will shade if not cover my error," she wrote to Henry, "if such I may call it, who was the first to present to you my faith, assuring you that if all pacts were as inviolate as this one will be on my side, everyone would be astonished to see such constant friendship in this century."[3] Her words still ring true today. Catholic France and Catholic Spain would assuredly form a league against England, the queen feared. Time was of the essence if Philip, France, the pope, and any other takers of her crown were to be stopped.

Elizabeth knew that her only alternative was to continue to prosecute her war against Spain, and so she agreed to send out an expedition from Plymouth bound for the Spanish coast and bent on capturing and destroying as many ships as it could at Cadiz, then Lisbon.[4] Leading the voyage was the lord admiral himself with the queen's charismatic favorite, the handsome, hotheaded Robert, Earl of Essex. Raleigh, freshly returned from his Guiana voyage (which had not been successful in finding the mythical El Dorado, nor had it been of any real significance as a voyage of discovery), had been asked to join the fleet as its rear admiral. Funding for the expedition came directly from the queen, with Howard and Essex as her joint shareholders. A stunning fleet of around 150 sail with 18 of the

queen's ships among them, along with 18 Dutchmen and 12 outsized Londoners all bristling with the latest firepower. A landing force of ten thousand soldiers of England's "choisest men" was mustered and taken aboard. They would be led by Essex, Vere, Blount, Gerrard, and Cumberland.[5]

As with Drake nine years earlier, Cadiz was miraculously caught sleeping. Two of the king's galleons were destroyed and two others captured. When the town surrendered to the swashbuckling Essex for an agreed ransom of 125,000 ducats ($7.59 million or £4.1 million today) the best terms they could get from the English was to allow all but the top 150 citizens of the town leave, along with all the women, before the sack began. In addition, the Spaniards had to leave all their worldly possessions behind.[6] As soon as the women left town the queen's soldiers sacked it, in an ecstatic, raging free-for-all lasting two weeks. So far as they were concerned, their voyage was made.

Incredibly, while the sack of the town was taking place, the lord high admiral and his men did not have their eyes on the richly laden India fleet in port. To prevent them from stealing it and using the proceeds against Spain, Don Luis Alfonso Flores, the admiral of the flota, ordered the ships to be destroyed. The estimated value of the ships' cargoes alone amounted to around 4 million ducats ($240.32 million or £129.9 million today) according to Medina Sidonia, but the Spanish merchants would later claim 12 million ducats in losses.[7] As to personal effects of the townspeople and churches, no accurate estimate of either the value, or the inventory of what was taken or destroyed, survives. Loot was, after all, how all nations paid their soldiers for the risks they took.

What had originally been intended as an act of war with strict instructions by the queen was again sidetracked by private interest and plunder. The lord admiral had persuaded the queen that a mission entirely funded by her as a royal expeditionary force, and not as a joint stock company, would stop the increasing lawlessness of her mariners and achieve her war aims. Indeed, his instructions ordered, "by burning of ships of war in his [the King of Spain's] havens before they should come forth to the seas, and therewith also destroying his magazines of victuals and his munitions for the arming of his navy, to provide that neither the rebels in Ireland

should be aided and strengthened, nor yet the king be able, of long time, to have any great navy in readiness to offend us."[8]

Still, it was Essex's shining hour—a brilliant, magnificent knight at the head of an army defeating the queen's greatest foe. He was like a fire-breathing dragon in the face of the enemy, demanding the council of war to hold on to the port of Cadiz to stop trade from the Mediterranean and both the East and West Indies, "whereby we shall cut his [Philip's] sinews and make war upon him with his own money."[9] More is the pity that he was overruled by "wiser" heads since by occupying the port—even for a short period of time—all shipments by sea could have been halted, turning the thorn in Philip's side into a massive bellyache. This was Essex's first and best moment as a soldier. Even his great rivalry with the disgraced Walter Raleigh (who famously cried *Entramos!* while attacking the town) showed Essex to be an inspirational leader of men at Cadiz, while Raleigh was shown to be a great talker at them.

Yet this "great" victory did not achieve Elizabeth's aims. The Indies fleet was in harbor—some forty to fifty vessels fully laden and ripe for the plucking—but while the soldiers ravaged Cadiz, the Spanish captains were given all the time they needed to destroy the fleet themselves to prevent an English capture. To compound their error, no attempt was made to take Lisbon or any other Iberian port, and no thought was given to try to intercept the incoming treasure fleet. Essentially, the "famous victory" pointed up in red-letter terms that soldiers were not mariners, and that Lord Admiral Howard was no sailor. To make matters worse, their booty was embezzled by underlings at the cost of the adventure's promoters. The queen, naturally, was left distinctly unamused, despite the fleet's returning to England with two new Spanish warships, some 1,200 Spanish pieces of ordnance and £12,838 in gold, plate, sugar, hides, silks, and jewels ($3.09 million or £1.67 million today).[10]

She was all the more angry since her spies reported that the next Armada was now ready to sail from Lisbon. But no one seemed to know for certain if the plan was to reach England, or to land a force to fight and meddle in the continuing troubles in Ireland. Half of her advisors felt that Philip could not let the defeat of the "Invincible" lie, especially as it was compounded by the ignominy of Cadiz for a second time. Other voices were certain that the King of Spain meant

to attack her at her rebellious postern gate. Then, mercifully, word came through that the fleet had sailed from Lisbon, but had been shipwrecked by Atlantic storms off Finisterre that October. Again, the weather seemed to conspire in England's favor, at least for a little while.

Essex, never one to miss a fresh rush of blood to the head, felt invincible himself after Cadiz. In a quickly cobbled together action, he embarked his forces to meet the remnants of the failed second armada—the "Invisible"—scattered along the coast at Ferrol and Corunna. But Essex was essentially a soldier and not a sailor—a common error in thinking among Elizabethan fighters—and he had paid little attention to the time of year for launching such an ill-conceived attack. Naturally, the weather had turned again, and Essex's army was driven back to Plymouth by the autumn equinoctial storms, his ships battered and troops dreadfully seasick.

※

The year 1596 was another watershed in the prosecution of the war against Spain: there was Essex's role as national hero, taking over Drake's position, the end of France's wars of religion by the conversion to Catholicism by Henry IV, and Philip's second failed Armada attempt. Nonetheless, it was apparent that England could not deliver a knockout blow to Spain unless it had a base in the heart of the enemy's territory. And England's last chance of doing this ended when Essex was overruled by his own council of war at Cadiz.

Yet in many ways, it was probably the right decision to abandon Cadiz. The unruliness of the soldiers and seamen fighting seemingly endless years of war had produced an expectation of mountains of plunder as their just payment for serving their country. This expectation in turn had created an underclass of English seaman who, when viewed through the eyes of their superior officers, did not make a pretty picture in the light of day. "They rejoiced in things stark naughty, bragging in his [sic] sundry piracies." The only thing that kept their officers safe from attack was a strict disciplinarian regime. Whipping at the capstan, keelhauling, or hanging were always options. Drake hanged a man for sodomy, and Cumberland a member of his crew for rape. Crews of less well-regimented vessels were not above murdering their own masters for victuals or casting

their captains adrift to die in despair—as happened later to the explorer Henry Hudson.[11]

From the sailors' standpoint, however, they deserved better. "What is a piece of beef of half a pound among four men to dinner," one seaman asked, "or half a dry stockfish for four days in the week, and nothing else to help withal: yea, we have help—a little beverage more than pump water. We were pressed by Her Majesty's press to have her allowance [take her pay], and not to be thus dealt withal— you make no men of us, but beasts."[12] Still, the better ships allowed the men to swim and play music to help wile away the lonely hours in healthy undertakings rather than drinking and gambling. Music became part of the daily routine to help the men perform their chores, and their sea shanties had begun to be sung ashore in taverns.

What emerged as the Royal Navy then was a group of men who were not born to the gentleman class, serving alongside gentlemen and noblemen of the realm. For those lucky enough to survive, and wanting to better themselves socially and financially, the navy was their respectable "leg up" into the higher echelons of society. For those who thought only of plunder and swag—irrespective of their social standing—their place was frequently found lashed at the mizzen mast or clapped in irons before being killed or escaping into out-and-out piracy. Above all, there was evidently truth on both sides of the argument.

The harsh reality was that there were no more Drakes after 1596. Instead, private interests investing in joint stock companies continued to dominate not only Elizabethan foreign trade but also Elizabethan adventuring. Though still alive, the ailing William Cecil, Lord Burghley, had by now ceded most of his duties to his intelligent younger son, Robert. Unlike his father, the ambitious Robert Cecil was a strong proponent of adventuring; and he, like the queen, was as guilty as the seagoing adventurers in hoping that treasure would come his way. As a younger son, Cecil, like all adventurers, was looking to build up his personal fortune, and he succeeded admirably.[13] Elizabeth was trying to keep the country afloat, praying (as it turns out in vain) to avoid the further sale of crown lands. Both Elizabeth and Cecil invested heavily in the Earl of Cumberland's adventures of 1589 and 1593, but it was their support

of the lord admiral and the Admiralty that brought them their most lucrative source of income.[14]

The Admiralty, under Charles Howard, had turned plunder into quite a business. Not only did it receive 10 percent on all registered prizes—and it is estimated that only 10 percent of prizes were registered—but the High Court of the Admiralty sold reprisal letters to adventurers, took bonds from them, sold plundered goods in order to make "cash restitutions," and levied and collected customs. Its officers, from the admiral to its high court judge, Sir Julius Caesar, to the individuals in charge of every department or activity, were all involved in adventuring. In this way, the queen's navy had become a navy of private interests that encouraged Elizabeth to invest in plundering expeditions whenever her navy was not engaged in defense of the realm.[15] And whenever a matter of particular interest to "Mr. Secretary Cecil" came before the High Court of the Admiralty, Lord Howard was quick to dash a note off to Sir Julius Caesar reminding him of Cecil's personal interest. It was an exceedingly well-oiled machine, with Sir Julius Caesar taking a "twentieth" of the lord admiral's "tenth." [16] Still, these men who made the Admiralty work should not be judged too harshly. By the standards of the time, they worked efficiently and honestly, taking what was expected by way of recompense since salaries were often not paid at all, or paid late. When compared to Spain's naval administration, England's Admiralty was a paragon of virtue.

In truth, by the late 1590s, it had become so difficult to discern the machinations of the Admiralty that it was left to Cecil to oversee its activities on behalf of the Privy Council. The "pirates" were dealt with harshly by the High Court of the Admiralty, and usually forced to give restitution for a portion of what had been stolen. In 1600 alone, there were eighty-nine cases of men arrested as pirates. It mattered little if they were the lowly Captain Diggory Piper (of the famed galliard) or a peer of the realm. Only Sir George Carey, governor of the Isle of Wight, and heir to Lord Hunsdon and future patron of William Shakespeare, seemed to escape unscathed. But then again, he was the lord admiral's brother-in-law. What mattered were the

circumstances of the seizure, and whether the so-called "pirates" could bribe their way out of trouble.[17]

Sir Julius Caesar, too, had a position of unprecedented power. It was he who sat at the High Court of the Admiralty and issued the letters of reprisal, often accepting fiction as fact. It was said that Drake's adventures had "inflamed the whole country with a desire to adventure unto the seas, in the hope of the like good success," and it was Caesar's duty to ensure that they could. Reprisal ships usually accompanied "royal" missions, though others chose to sail independently if the queen's expeditions seemed too tame for their needs. The 1590s were therefore the decade where John Hagthorpe's statement that there were "never less than two hundred sail of voluntaries and others on Spanish Coasts" has generally been accepted. Even if it were an exaggeration, there were probably never any less than a hundred English ships of reprisal sailing on the seas at any one time in the whole decade. And most of these ships went "unregistered" for a fee, thanks to Sir Julius and the Admiralty officers. Others were logged in at low values for their cargoes.[18]

Taking the Admiralty, merchants, and the adventurers as "the queen's adventurers," it is easy to see why the queen's share of the purse in pure percentage terms continued to dwindle. But it wasn't the unfair distribution of the spoils that strained the economy. It was Ireland, as well as the war with Spain, that was ruining her. Each year, more and more crown lands needed to be sold to keep "Battleship England" afloat, and the old queen was reduced to finding as many creative ways as possible, assisted by her "elf" (also called her "pygmy") Cecil, to plug the leaks. Raleigh, somewhat unkindly but nonetheless truthfully, accused the queen of not recognizing the power of her "private navy."

Still, even the outspoken Raleigh hadn't recognized that the real power had almost imperceptibly shifted from the gentlemen adventurers back into the hands of the queen's merchant adventurers. These men, like John Watts of London and alderman Paul Bayning with his *Golden Phoenix*, worked at times for the queen, and at other times, strictly for their own commercial interests. Any joint stock companies that they engaged in had clear objectives, and these were cast in stone. Heavily armed for defensive and offensive action, the

Londoners in particular who specialized in building and owning ships that could double up for "warfare" were awesome weapons. There was no longer any room on their ships for the amateur adventurer, or the queen's objectives when they were engaged in trade. These were businessmen in the modern sense. Friends were friends, but business was business.

There were still smaller vessels hankering for plunder, too. These were usually owner captains, much as young Drake had been aboard his bark plying the Channel ports. Often they grouped together, sharing expenses and creating small squadrons, especially when they ventured farther afield like the West Indies. Those who had done well sometimes lent money to the great adventures of Drake, Raleigh, Essex, and Cumberland, but, by and large, they knew their place among the second rung of merchant adventurers, combining trade and plunder when they could.

And yet the "trade" of plunder consumed many more fortunes and lives than it made. "The numbers of sailors and seamen," Admiral Monson complained, "are increased treble by it [plunder] to what they are in the navigations of peaceable voyages."[19] True pirates became the more respectable "adventurers" thanks in no small part to the lining of Sir Julius Caesar's pockets. Often a peaceful voyage would deteriorate into an exercise in piracy as a result. Naturally, this made foreigners reluctant to trade with the English, never quite knowing their real intentions. And, in turn, it created a trade depression that compounded the intractable problem of unemployment and poverty to a level unknown since the Wars of the Roses a century earlier. The 1590s became known as a decade of high inflation, failed harvests, renewed bouts of plague in London in particular, and the decade where the aging queen (now in her sixties) seemed to be losing her tight grip on her divergent factions at court. It is no wonder that the reputation Englishmen gained abroad was as a rambunctious lot of pirates.

But Elizabeth hadn't by any stretch of the imagination "lost the plot." She, and of course Robert Cecil, encouraged pamphleteers singing the praises of her seafaring men. Adventuring writers like Henry Roberts became more popular than Shakespeare. Nationalism and patriotism were attributed to the acts of daring-do by the queen's

adventurers, and the average Englishman swelled with pride that their tiny country had seen off the greatest empire in the world—not once or twice, but three times, with the third armada attempt meeting the same fate as the second.

Spain's economy had suffered, too. Not so much from the direct plundering of ships but more from the secondary and tertiary effects of the English (and by now to a lesser extent the French) and Dutch depredations. Ships lost added enormously to the cost of maintaining the flow of treasure. Increased fortifications in the West Indies and elsewhere consumed real time, money, and men. Lives of Spain's finest soldiers and mariners were lost, with their number severely depleted after the failed "Invincible" campaign of 1588. Scurvy (the plague of the sea), ships sunk at sea, poor wages, and poorer campaigns of attack meant that Spain's men were dying in droves. Its population began to slump. Defense of the Atlantic had to be added to the price tag of trying to reconquer the Netherlands in its unrelenting rebellion. Famine and plague at home also took their toll, in part caused by private fortunes being wasted on protection of their West Indian plantations and mines. Others began to feel that the Atlantic trade was too risky and sought other ways of making a living.

And still, England's merchants continued their onslaught. Talented captains like James Lancaster successfully raided Pernambuco in 1595, with Watts, Bayning, and other former merchants of England's Spanish Company joining forces with him. The arms trade to Morocco flourished, as did the sale of metals for weaponry to the Ottoman sultans. Robert Cecil was a particularly active backer of Mediterranean plunder, and he became involved with Thomas Cordell's and William Garraway's plundering operations there, while also investing with the lord admiral's own reprisal fleet.

The outports of England suffered if, like Bristol, they didn't possess ship owners who had built vessels for the purposes of war, trade, and plunder. The ports of Plymouth, Weymouth, and Southampton fared better than most with their merchant and gentlemen adventurers, who frequently put their ships to sea under the queen's banner either on the Continent or in Ireland. Yet while

the great merchants and the adventurers were not inflicting the long-hoped-for "knockout blow," they were amassing gigantic personal fortunes. Watts, Bayning, Thomas Smythe, and Thomas Middleton all cast around for how best to turn those gigantic fortunes into monumental ones. To do that, they had to ensure a steady flow of merchandise of extreme worth and high quality, and a buoyant home market to sell it in. That would mean fishing in new grounds. These men had refined the skill of trade and plunder to a new art form and could engage in either or both at will. And so, without a strictly fixed idea as to which of their activities would prevail, they turned their eyes from the Atlantic eastward.

The East Indies had always been their Holy Grail, after all.

40. Essex, Ireland, and Tragedy ❧

Eyes of youth have sharp sights, but commonly not so
deep as those of older age. . . . I see as in a crystal the right
figure of my folly . . . foreseen haps breeds no wonder;
no more doth your short-returned post before his time.

—ELIZABETH I TO ROBERT DEVEREUX, JULY 1597

Robert Devereux, Earl of Essex, like so many adventurers and courtiers of the younger Elizabethan generations, began his military career in the Low Countries at Leicester's side. It was there that he inherited two of Sir Philip Sidney's "best swords" and made his most steadfast friends in combat. With Sidney's death, Essex became the queen's favorite on his return home in 1587, and took Sidney's place as well as darling of the court's literati. The other "pretender" to both those titles, Walter Raleigh, would remain his bitter enemy for the duration of their lives. When Raleigh had himself painted with pearls under a crescent moon, Essex replied with Hilliard's *Young Man among Roses*. Poetry, too, became a weapon of choice, as did—nearly—swords. With the loss of his own heir, Sir Philip Sidney, in the Low Countries, Leicester himself had encouraged their rivalry from the outset, seeing his stepson Essex as his natural successor for the queen's heart over the upstart West Countryman Raleigh.[1]

And Leicester's wishes, during his lifetime, were never ignored. Essex's rise was meteoric. Within the year, he was a knight of the Garter, had been given the attainted Sir Francis Englefield's lands, and the smashing London pad York House (which he'd rename Essex House). The young Earl's servants boasted that even into the small hours of the morning "my lord is at cards or one game or another with her [the queen], that he comes not to his own lodging until the birds sing in the morning."[2] When Leicester died unexpectedly

on September 4, 1588, Essex took over his offices as lord steward and master of the horse. Elizabeth, deeply bereaved without her Leicester, saw him again daily in his stepson, Essex, and soon would not be parted from the young man. Though undoubtedly charismatic and brilliant, he had become the young Robert Dudley in Elizabeth's eyes, lavishing gifts and appointments on him as she had done for Dudley in their youth. Even Leicester's farm on sweet wines became Essex's, and remained his until October 1600.

Yet, despite all the promise and all the love and gifts Elizabeth showered upon him, Essex's worst enemy remained himself. His arrogance was colossal. He would do as he wished, and he would bring the "old" queen to heel. Possessing the pride of a man whose nature refused to be ruled would prove his epitaph.

Well aware of the queen's disfavor for "secret" marriages among her men and women at court, Essex nonetheless contracted to marry Philip Sidney's widow, Frances Walsingham Sidney, sometime in 1590. While Elizabeth's attachment to Essex meant that her fury soon subsided, his constant string of women—from her maid of honor Elizabeth Southwell to the Countess of Derby—stretched the queen's patience more than once to breaking point. The queen frowned upon overt infidelity as it reflected poorly on her court. But the queen's feelings mattered little at the end of the day to Essex. While his wife had given him an heir, she lacked the money that the queen's most ostentatious courtier craved and demanded. And with Sir Francis Walsingham now dead, there was nothing to keep him in check. Essex found himself boasting "overly grandly" how he would handle matters, while plotting to make daring adventures in the hope of plunder and the position he believed he deserved.[3]

But Essex was a transparent boy compared to Robert Cecil, and he could never plumb the depths of Cecil's Machiavellian thoughts and deeds. Essex's own impatience and desperate wishes always seemed to interfere. So when he shined like a brilliant gemstone at Cadiz, and still did not get his way, he suffered a deep depression for the first part of 1587. The only thing that pulled him out of it was Elizabeth's approval for him to take part in the Silver Blockade scheme devised by Hawkins. Instead of cruising off the Spanish coast, Essex and his men sailed for the Azores in the hope of catching the flota, despite

his criticism that this kind of expedition was "idle wanderings upon the sea" only a year before.[4] Disgrace followed, when, on his return home, he discovered that the Spaniards had nearly succeeded in launching their fleet in an assault on Falmouth in Cornwall. And despite these setbacks, it never once dawned on Essex that he was a soldier of fortune and adventurer, not a naval commander.

Essex was sworn in as a privy councillor before the end of 1593, an honor that eluded Raleigh altogether. He threw himself into his work on the council in the vain hope that he could take over Burghley's role as the queen's chief advisor, since it was rumored that "their chief hour glass [Burghley] has little sand left in it."[5] As if to prove his unswerving loyalty, Essex wrongly accused, and had convicted, the queen's physician, Roderigo Lopez, of plotting to assassinate the queen in 1594. Still, whenever the queen ridiculed him (as she derided all her councillors) for his flights of fancy or other pretensions, he would shut himself away in his rooms for days on end, like a spoiled child, until she made a gesture to show her favor. He lived in the mistaken hope that, on Burghley's death, Elizabeth would choose his counsel over that of Robert Cecil.

By 1598, Essex had become known as a "man of great designs." Elizabeth had become weary of his constant haranguing and demands for more gifts, more favors, more power. To boot, Essex had made powerful enemies—Burghley, Cecil, Nottingham, Cobham, and Raleigh—all of whom had been strengthened by their own successes. As if that were not enough to count against him, he insisted on trying to make peace between his mother and Elizabeth, whose "mislike" for her cousin Lettice (who had secretly married Leicester) had not lessened since Leicester's death. Again and again, he taunted the queen, famously turning his back on her in her presence chamber, dumbfounding all onlookers. The incident in which he drew his sword on the queen had been smoothed over, but it was not entirely forgiven or forgotten.

He angered Elizabeth, yet moments later could make her laugh. No other subject had treated her in this way, but an explanation for the queen's remarkable patience was that she saw in him the rambunctious Robert Dudley instead of the prideful Essex, and felt somehow that she couldn't live without him at her side. When Essex became highly critical of all previous campaigns in Ireland—

including his dead father's—his bluff was eventually called, and despite the queen's hesitation at putting such a man at the head of her army there, she at last relented. The Privy Council agreed that he should prosecute the war against the rebellious Hugh O'Neill, Earl of Tyrone, and bring the Irish troubles to an end. His instructions clearly stated that he should head for Ulster after landing at Dublin, and defeat Tyrone.

Crushing Tyrone would be Essex's greatest challenge. Ireland had been in "revolt" in one form or another for most of Elizabeth's long reign, with Tyrone's own uncle, Shane O'Neill, being massacred at the hands of the English. The Earl of Ormond had been the queen's staunchest ally though, for a long while, he was wrongly viewed as treacherous to England by the machinations of the Earl of Desmond, and the misinformation that Hugh O'Neill himself had sown among English nobles. Sir Henry Sidney claimed that he had "bred" the young O'Neill (at the time the third Baron of Dungannon) "from a little boy, then very poor of goods, and full feebly friended" between 1556 and 1559. In 1567, Sir Henry brought the young Dungannon to court along with other sons from other Irish noble houses to fully educate them in the English ways. He had gone from having no chance of inheriting the title of the "O'Neill" as the third defenseless son of the man deprived of his inheritance by Shane O'Neill, to the all-powerful Earl of Tyrone, who used his knowledge of England and its customs against itself to his own ends.[6]

The situation in Ireland was desperate. When the English hadn't been trying to dominate the Irish chieftains, the chieftains themselves warred endlessly with one another. Cattle raids, scorched-earth policies, rape, murder, and tribal allegiances dominated the country. The only constant was the Catholic religion, which after Henry VIII's break with Rome meant that Catholic interests viewed it as a launch pad into England. The more Protestant England fought to retain its "Irish plantations" (confiscated, of course, from dissident Irish chieftains) and its Irish sovereignty, the more the Irish revolted.[7]

When Tyrone returned to Ulster in 1585, it was with the single purpose to make himself master of his own lands yet again, then to free Ireland from England's yoke. He was a consummate general and, unusually for the times, had oodles of patience. For the next ten

years, he honed his Ulster guerrilla raids into a well-run rebellion, until at last in 1595 open warfare was declared. These tactics had been the undoing of Sir John "Black Jack" Norris, returned from the Low Countries and Cadiz to give the Irish yet another drubbing. The current lord deputy, Sir William Russell, too, had been confounded by Tyrone. When Russell was replaced by Lord Burgh in 1597, Elizabeth hoped that at last she had found the military and administrative combination to bring Ireland to heel. Within eight months, both Norris and Burgh were dead.

Nothing and no one seemed capable of stopping Tyrone. He leveled one English plantation after another, and the queen feared that even the Pale surrounding Dublin might be in jeopardy. Other parts of the country were beginning to adopt Tyrone's tactics, and no matter what forces or commanders the queen threw at them, the Irish were victorious. Tyrone's famous victory against Sir Henry Bagenal at Yellow Ford gave heart to all Ireland, and created a number of other uprisings around the Pale in Leinster and in Munster in the Southwest. Walter Raleigh's own vast forty-two-thousand-acre plantation was washed away in a sea of blood. As if this wasn't bad enough, what Elizabeth truly feared with considerable dread was that Tyrone was expecting assistance at any moment from Spain or the pope, not only to take her troubled province from her realm, but also to invade England itself.[8]

It was into this tricky situation that the new lord lieutenant, the hotheaded Essex, arrived in April 1599. Instead of following the queen's directions to head at once for Ulster, Essex attacked Munster, in the Southwest, claiming that he needed to make the South safe first against possible Spanish support. With each passing week, the queen wrote more and more vitriolic letters to her new lord lieutenant. Ireland was bankrupting her. Why wasn't he meeting Tyrone's forces in Ulster? Finally, she snapped, and on July 19, 1599, wrote to Essex:

> *We have perceived by your letters to our Council brought by Henry Carey, that you are arrived at Dublin after your journey into Munster, where though it seemeth by the words of your letter that you had spent divers days in taking an account of all that have*

passed since you left that place, yet have you in this dispatch given us small light either when or in what order you intend particularly to proceed to the northern action. Wherein if you compare the time that is run on and the excessive charges that is spent with the effects of anything wrought by this voyage (howsoever we may remain satisfied with your own particular cares and travails of body and mind), yet you must needs think that we that have the eyes of foreign princes upon our actions and have the hearts of people to comfort and cherish—who groan under the burden of continual levies and impositions which are occasioned by these late actions—can little please ourself hitherto with anything that hath been effected.[9]

Against the queen's specific command, instead of engaging Tyrone's troops in the North, he proceeded to make peace with Tyrone, who had after all been Essex's good friend at court. The English had been decimated by disease and fruitless war in Munster thanks to Essex. When the two old friends met, talking midstream so that they wouldn't be overheard, their horses belly-deep in the fast-flowing current, the history of Ireland would be changed forever. At the end of their half-hour talk, Essex came away feeling that he had made an honorable peace. He believed that his Irish friend had agreed to lay down his arms. Tyrone, meanwhile, reported back to Spain that he had nearly persuaded Essex to turn against Elizabeth![10] It is one of the more mysterious chapters in the history of the two countries since what happened next doesn't clearly follow, and proved a tragedy to both sides.

Elizabeth's letters continued to arrive—each one angrier than the last. No longer trusting his written word to calm her, Essex was certain that his detractors—of which there were many—were poisoning the queen against him. Only a personal appearance at court could make her see that he had, in fact, acted for the good of her realm. And so, again, the prideful Essex ignored royal commandment, left his post as lord lieutenant without leave, and hastened to Nonsuch, where on September 24, he barged in on the old queen, who was not fully dressed. To say that his demeanor startled her is more than an English understatement. Elizabeth felt distinctly threatened by her soldier, still muddy from his travels and carrying his sword in his

hand. She famously sweet-talked him, asking him to give her leave to dress before they spoke in earnest. She begged him to go wash the dirt from his travels from him, and rejoin her later in the day. By afternoon, her sails had filled with a good head of wind again, and she blasted him as only Queen Elizabeth could do, in front of the entire Council. It would be the last time that they would ever see each other.

Essex was confined to his chambers before being sent to Essex House under house arrest. He was in a state of near mental and physical collapse. Treason charges were drawn up against him, and perhaps for the first time, he realized that his short life could end in total failure, though by now his paranoia was near complete. He was, however, in one way fortunate: his breakdown did spare him a judgment by the Star Chamber at the end of November 1602 since it was believed Essex would die of his malady. If, after all, he would die, then why make a martyr of him, the Star Chamber argued.

And yet, Essex did recover, though he never fully in strength or sound reasoning again. Though disgraced, a number of young and disaffected noblemen flocked to his side, like the heartthrob Henry Wriothesley, third Earl of Southampton; while others, Sir Francis Bacon being the most notable, deserted and betrayed him. Eventually, Elizabeth settled on the best solution: allow Essex his freedom, but continue to bar him from court. His political career was at an end, but she would not otherwise harm him.[11]

Had she left matters like that, then things might have turned out differently. In the end, though, the queen's pride and parsimony got the better of her. When Essex's sweet wines farm came up for renewal in October 1600, she refused to renew it. From her vantage point, it was an extremely valuable royal gift, and one that had continually shown exceptional royal favor since it was first bestowed in the 1560s onto Robert Dudley. How could she allow a man who had failed to tame Tyrone or even fight him to retain this treasure?

Essex's reaction was predictably harebrained. He wrote to James VI of Scotland pleading for help. James, the only child of Mary, Queen of Scots, had been Elizabeth's putative heir since the time of

Mary's execution—so long as no one pushed the English queen into making it official. Naturally, the queen's "intelligencers" knew all. Essex had naturally been put under constant surveillance. Finally, in February 1601, Essex and his followers had hatched a scheme to take over control of court and oust Essex's enemies by denouncing them to the queen. But their plans were preempted by a summons to appear before the queen on Saturday, February 7. On the one hand, they panicked, resolving to throw themselves on the mercy of the City. On the other, they sought refuge in a final act of defiance, and paid Shakespeare and his players to put on a specially commissioned performance of *Richard II* at the Globe Theater, instead of responding to the summons.

The following morning, Essex led around three hundred men, all wearing their swords and doublets but no armor, on a march into the City. Some of the men carried firearms. Notable among them were the Earls of Southampton, Rutland, Bedford, Sandys, Cromwell, and Monteagle, as well as Sir Christopher Blount. When Essex's march came to the house of the sheriff of London, Sir Thomas Smythe, they soon realized the folly of their action. Smythe and the lord mayor had ordered the City gates shut, and Essex's support evaporated. By nine P.M., Essex had surrendered, spending the night as a prisoner at Lambeth Palace (the archbishop of Canterbury's London home) before being transported to the Tower through Traitor's Gate.

Ten days later, Essex and Southampton were tried for treason. Southampton's sentence was commuted to imprisonment, but Essex was to die on the scaffold, thanks in no small part to the testimony of his former intimate friend, Sir Francis Bacon.[12] It could be claimed that Essex, more than any other adventurer, lost everything in Ireland. He certainly lost his father to the interminable Irish wars, and may have lost his sanity in the guerrilla warfare so expertly practiced by the Irish rebels. Still, at the end of the day, Robert Devereux, Earl of Essex, had ideas beyond his station in life. He was no Leicester. He was no Francis Drake. He was no Burghley, nor even a Robert Cecil. But if wishing made it so, he had all their cunning and fortunes rolled into one, and the ability to make himself the queen's master where all the others had failed.

And what of Tyrone and Ireland? Tyrone's insistence that Ireland could only free itself completely from England's rule with the help of the Spanish proved a tremendous weakness in his otherwise fine strategy. The notorious contrary winds between Spain and England in the Bay of Biscay shipwrecked Philip's last two armadas. When the third armada landed at Kinsale with four thousand men, under the leadership of Don Juan de Aguilla, instead of on Ulster's shores, Irish hopes for a Gaelic Ireland were dashed. In a country full of myth and legend, they claim that early modern Irish had thirty-two words that meant fool, idiot, moron, or imbecile. That is until Tyrone began his insults against Aguilla: "that misbegotten son of a tree stump . . . that baboon's droppings . . . that, that *Spaniard!*"[13]

It must be said that Essex's desertion was another blessing for England and curse of Ireland at the end of the day. For Essex was replaced by the unbelievably tenacious Charles Blount, Lord Mountjoy, who proved to be the right man—at last—for the job of taming the "wild" Irish. Through Mountjoy's phenomenal energy and generalship (not unlike Wellington's two centuries later), Tyrone's plans were anticipated, and he was stopped at every turn. Raleigh's cousin, Sir George Carew (also Essex's mortal enemy), was put in charge of settling Munster, which he did with diplomacy and tact more than by force of arms. New forts at Derry near Lough Foyle provided a base camp near Tyrone's own lands, from which Sir Henry Docwra could tackle the disaffected O'Neills, Maguires, and O'Donnells for the English as Carew had done in Munster, and Mountjoy had done in Connaught.

Tyrone's epithets aside, when the Spaniards finally landed their four thousand crack infantrymen at Kinsale in September 1601, it was too late. Naturally, with Tyrone's strength in the North, there was no chance of victory. The Munster Irish and Tyrone's supporters were already depleted by Mountjoy's tactics, and the combined Irish and Spanish forces faced a complete rout. De Aguilla made an honorable surrender in January 1602, while O'Neill fled to Spain. Tyrone was eventually captured in March 1603, and with him died the expectation of Irish independence for nearly a century and a half.[14]

Though there are many who would disagree, England's conquest of Ireland wasn't entirely bad for the country. It extinguished tribal warfare on the island, making blood feuds, murder, and cattle raiding illegal. In conquest came the birth of the Irish nation, rising like the phoenix from its ashes. Pride in being Irish, as opposed to an O'Neill or O'Toole, with the accompanying patriotism against the archenemy England, swelled in its people as a whole, and was allowed to take hold and flourish.

41. Raleigh, Virginia, and Empire ⚬

A maze wherein affection finds no end
A ranging cloud that runs before the wind
A substance like the shadow of the sun
A goal of grief for which the wisest run.
—SIR WALTER RALEIGH, "Farewell False Love," 1588

Raleigh's income had been severely curtailed as a result of the Munster uprising in the wake of Tyrone's guerrilla exploits. He had acquired the largest seignory in the country through the English conquest of the Irish chieftains, and had spent a great deal of time in 1589 renovating his mansion and plantation near Youghall. To his friends, he claimed he was retreating "from Court . . . to take order for my prize."[1] The vast forests there provided much of the wooden staves for barrels, which was one of his main trading businesses, selling to the Admiralty and other shipowners. When his estate fell victim to the same scorched earth policy as others had done in the rebellion, the pinch he felt was most certainly real. After Tyrone's supporters had laid waste to his lands, he was lucky to sell them to Sir Richard Boyle, secretary for Munster, for £1,500 ($360,750 or £195,000 today).

Other than Essex, Walter Raleigh was only other courtier vying for the perfect vision of courtly love at the sunset of Elizabeth's reign. Essex had been born into the new nobility, and was the handsome portrait of the highly educated, suave, hot-tempered, quick-tempered, and arrogant nobleman until his premature death on the scaffold. Raleigh, too, had bagfuls of arrogance and charm, was quick to anger and slow to forgive. He had been educated at Oxford, but he came down to London without obtaining a degree. Yet Raleigh, despite his pretensions, was only a West Countryman of gentle birth, and he spoke his whole life with a thick West Country

accent. And accents in England, until recently, determined one's place in society.

Both were adventurers in the true sense of the word—Raleigh earned a fortune several times over from his escapades, while Essex lost his principal capital. Aside from these main points of their lives, Raleigh and Essex would share the reason for their deaths, too: treason.

But that is for the future.

Elizabeth could not live without either of them. Some believed that when Essex was executed, much of the life, vigor, and good humor went out of her. She sank into what can only be described as a deep depression, where even her "Water" could not quench her thirst and bring her back to life. While Raleigh continued to live high on the hog, his expenses far exceeded his income. After Essex's execution, when the queen didn't give Raleigh any new and beneficial grants to relieve his often-bemoaned penury, it was clear that Raleigh would not profit from Essex's demise.[2] The thought of tightening his belt and living within his means was not an option that Raleigh could stomach. And so he fell back again on his adventuring with renewed passion.

He had planned a campaign with Cumberland and Frobisher to capture the West Indies flota in 1592. Yet, shortly before setting sail with the impressive fleet, Elizabeth recalled him to London. Raleigh ignored the order and accompanied his ships until he could give his orders to his new commander Sir John Burgh, at sea. Frobisher was to keep guard on the Spanish coast, while the rest of the adventuring fleet were led by Cumberland to the Azores. There, Cumberland encountered two Portuguese East Indies carracks, the *Santa Cruz* and the *Madre de Díos*. The *Santa Cruz* was burned after her richly laden cargo was taken, while the *Madre de Díos* was sailed back to England.[3]

This "campaign" became known as the Islands Voyage to the Azores. Under normal circumstances, Raleigh stood every chance of making good his losses in Ireland and Virginia, and by normal calculations should have cleared around £80,000 for his troubles ($19.24 million or £10.4 million today). Instead, this would be the queen's ransom. To his abiding anger, it was not meant to be. After

the shares of the spoils were divided, Raleigh complained bitterly to Lord Burghley that

> *the City of London is to have £6,000 profit by Her Majesty's order. Then they are to have Her Majesty's allowance of £2,000 upon all and £4,000 profit as well out of our principal. By that means we are to lose £4,000 of money disbursed. . . . The Earl of Cumberland is allowed £36,000 and his account came but to £19,000, so he has £ 17,000 profit, who adventured for himself, and we that served the Queen and assisted her service [fitting out her ships] have not our own again. Besides I gave my ship's sails and cables to furnish the carrack and bring her home or else she [would] have perished. . . . I was the cause that all this came to the Queen and that the King of Spain spent £300,000 [in] the last year. And I lost in the last year in the voyage of my Lord Thomas Howard, £1,600, besides the interest of £11,000 which I have paid ever since this voyage began.*[4]

All of the figures, and certainly reference to his being solely responsible for the expenditure of the King of Spain, are incorrect. Raleigh's summary of woe is right, however, when he states that he earned very little from England's largest adventuring haul. The reason for this was simple: in between the time when Raleigh had initially intended to sail on the voyage and the date of the final accounting in January 1593, Raleigh had been committed to the Tower for lying to the queen about his secret marriage to Bess Throckmorton and the birth of his son Wat.

Still, it is difficult to feel sorry for the man. He was immensely talented, a great strategist, a gifted poet and historian, and he had other varied sources of income. He was an Admiralty officer, and earned a great deal from his declared—as well as undeclared—dealings in this professional capacity. He advised other, more sea loving, admirals and captains about where to go in search of plunder, and duly received his fair portion for his trouble. While vice admiral for both Devon and Cornwall since 1585, his undeclared earnings would have been huge.

Then there was the not insubstantial matter of the Virginia grant.

Some adventurers had pointed out to the Privy Council that Raleigh's patent of 1584 had expired since no colony had been successfully established within six years. Raleigh argued, with the support of Richard Hakluyt, that they were wrong. There was no evidence that his colony at Roanoke had perished, only that they had moved to Croatoan. Indeed, two children—Virginia Dare and a boy to the Harvies had been born in Virginia.[5] So long as he could argue that point successfully (which he did), then the twelve hundred miles of prime North American coastline belonged exclusively to him. Still, the fact remained that there were no documented voyages to Virginia in the decade between 1591 and 1602, and certainly Raleigh appeared to have abandoned Virginia in favor of adventure and the quest for gold.

Indeed, Raleigh spent the 1590s busily looking for the fabled El Dorado. Virginia, according to his surveyors and experts, held no gold. And if England were to become the great empire to supplant Spain, Raleigh argued, it was gold that the country needed. It would also be the only salvation for Raleigh's dwindling resources. In order to exploit any gold deposits or mines that he may be fortunate enough to find during his voyages of exploration in the 1590s, Raleigh needed to promote the concept of colonies and empire strongly. Without the manpower to take charge of these new lands, there would be no means of extracting, protecting, or shipping the gold back to England.

Yet, as hard as he tried, after his 1595 voyage to Trinidad and the Orinoco, where no concrete sign of El Dorado had been discerned, it remained impossible for Raleigh to attract finance to his proposed adventures. Other adventurers like Sir Robert Dudley, the "base-born" son of Leicester and Lady Douglas Sheffield, searched as well, but they did not join in Raleigh's expedition. Even Raleigh's *Discoverie of the Large Rich, and Beautiful Empire of Guiana*, published in 1596, failed to renew the gold fever at court that had prevailed at the time of Frobisher's attempts at finding the Northwest Passage.[6] When this was followed a year later with his *Of the Voyage for Guiana*, outlining his proposed methods for settlement, and the attributes of converting the "heathens" to Christianity, few realized what an insightful work it was. Even Hakluyt's preaching in intellectual

circles and at court produced no result for him. It was a pity, but the country wasn't ready for an all out push into the great unknown while Ireland remained in revolt, and Spain continually—or so it seemed—sent out repeated armadas through the 1590s. *Of the Voyage for Guiana* set out clearly—and for the first time—the foundations necessary for the development of a tropical colony, arguing at length about how to use the local population to advantage, while importing English settlers to bring in the rule of English law and mastermind the export of goods and supplies back to England.[7]

Despite Cecil's agreement to send out two ships to Guiana to look for El Dorado, the level of interest in the region in the late 1590s was exceedingly limited. In addition to the Irish and Spanish problems (Spain had taken Calais and threatened Rouen), France had a Catholic king again with the conversion of Henry IV. The queen could die at any time, and the succession was not assured. The tropical jungles of the Orinoco or the Amazon were too far away and too dangerous for anyone to venture their money in when matters in Europe remained so unsettled.

Then a new adventure happened to refresh Raleigh's interests in Virginia, though he had no part in the expedition. In 1597, a separatist Puritan sect, mistakenly called Brownists by the Privy Council, asked for a license to emigrate to the St. Lawrence region of North America. The queen agreed, providing that they never returned to England while still practicing their faith. She deeply mistrusted Puritans, as did Cecil. But Raleigh would have preferred they attempt to settle in Virginia, and cleverly wrote to Cecil "not to meddle with the state of Ireland (where Cecil had substantial holdings) nor that of Guiana. There is under our noses the great and ample country of Virginia."[8]

The letter continued, urging Cecil to advise the queen that if they proceeded to make a colony in Virginia, "if upon a good and godly peace obtained, it shall please the Almighty to stir up her majesty's heart to continue with her favourable countenance . . . with transporting of one or two thousand of her people . . . she shall by God's assistance, in short space, work many great and unlooked-for effects, increase her dominions, enrich her coffers, and reduce many pagans to the father of Christ."[9]

But the "Brownists" sailed under the auspices of two London

merchants, Alexander van Harwick and Charles Leigh, for the island of Ramea on the St. Lawrence River. The *Hopewell* and *Chancewell* set out in April 1597 but, on their arrival, were confronted by hostile Breton and Basque fishermen who had already laid claim to the territory. In the end, Leigh, who led the expedition in the *Hopewell*, had to return to England with his pioneers still aboard due to French and Spanish resistance to the formation of an English colony at the site of their fisheries.[10]

Finally, in 1602, Raleigh sent two ships and a pinnace under Captain Samuel Mace to renew trade with North America. Mace was under strict orders that if the "lost colonists" had survived, then he must bring some of them back to England. They would be his best instruments for selling his ideas of empire at home after all. But while Mace worked up the coast of North America to Cape Fear, there was no serious effort to find the "lost colonists" of 1587. Instead, Mace loaded sassafras wood and china root (sarsaparilla). While sarsaparilla had no medicinal value despite reports to the contrary, sassafras fetched 3s. to 20s. for a pound weight in London (between $7 and $240 or £20 to £130 today) and was the new "miracle" cure for "the French pox" or syphilis.[11]

At the same time, Bartholomew Gosnold, Bartholomew Gilbert, and John Brereton sailed a small expedition to the New England coast in the hope of establishing a trading settlement there. As frequently happened in these early voyages, though, food was in short supply, planters were poorly advised, and, as a result, serious arguments threatening survival broke out. In the end, within three months, on June 18, 1602, they had all sailed again for England, anchoring at Weymouth three weeks later.

Significantly, Raleigh was there to meet them that July 1602—hopping mad. It seems that the first he had heard of their voyage had been after they left. Since he held the exclusive rights to settle and trade in that part of North America—or so he believed—he was not prepared to abide their interloping. Still, it wasn't his plantation rights that truly concerned him: if Bartholomew Gilbert and his partners sold their sassafras on the open market, it would become flooded, wiping out the considerable profit that Raleigh himself had intended to claim from his own earlier shipment. The hapless merchant agreed that this would not be any good for either of them,

and so Raleigh sent him to Cecil in London with a letter warning, "I have a patent that all ships and goods are confiscate that shall trade there without my leave. . . . Gilbert went without my leave, and therefore *all* is confiscate . . . [yet Gilbert] shall have his part again."[12]

Raleigh was acting with pure economics at the heart of his argument. He merely wanted to control market flow and ensure that there would not be a glut. There were obviously no hard feelings since the group later dedicated their *Brief and True Relation of the Discovery of the North Part of Virginia*, published shortly after, to Raleigh.

Economics even ruled Raleigh's head in the quest for the "lost colonists," too. His interest in their survival was twofold: to protect his exclusive patent and to tempt others to follow in their footsteps. Yet, Raleigh would not be remembered for his callousness toward his "western planters." He would be credited with far greater things: the "introduction" of tobacco and potatoes to England (both false); the embodiment of chivalry and courtly love; and the founding of Virginia.

It was an appropriate way for the queen's favorite adventurer to be remembered. Still, it would have been more appropriate perhaps if he had been more widely seen for what he had really been: a promoter of empire and a poet. Interestingly, nearly the last surviving letter of Elizabeth's reign is from Raleigh: it was the first piece of direct spin doctoring to attract planters to the American colonies in the early days of the seventeenth century.

42. The East and the East India Company ✦

*I cannot tell you where you should look for me because I
live at the devotion of the winds and seas.*

— SIR JAMES LANCASTER TO THE GOVERNORS OF
THE EAST INDIA COMPANY, 1603

When Thomas Cavendish sailed up the Channel in the
autumn of 1588—his mariners sporting silken doublets and
his topsails trimmed with gold—a new era in maritime adventuring
was ushered in, though no one knew it at the time. Cavendish, the
second Englishman to circumnavigate the globe had also returned
home with treasure, some £100,000, in fact ($2.41 billion or £1.3
billion today).

No sooner did he step ashore than Cavendish wrote to his old
friend, the lord chamberlain, Lord Hunsdon, "I sailed along the
islands of the Moluccas where our countrymen may have trade as
freely as the Portuguese if they themselves will."[1] Not only had he
reiterated Drake's message of eight years before, but he also proved
that the size of ship or fleet no longer mattered. Nor, indeed, did
the pope's division of the world between Spain and Portugal of a
hundred years earlier.

Yet what did matter was the machinery of state that had been put
in place for the queen's adventurers to serve the crown. Elizabeth
held the ultimate sanction to allow her mariners to sail. As a result,
England's merchants had been taking a backseat to the queen and
her gentlemen adventurers for the past eighteen years while affairs
of state intermingled with their trading aims.

In those heady days after the defeat of the "Invincible," a huge
shift in overseas trade would take place, much to the queen's
satisfaction. The better-maintained fleets belonging to the
merchants doubled up as men-of-war to serve the queen. When
security of the realm allowed for them to be employed by their
owners in the single objective of trade, they were phenomenally

successful in most adventurers that they undertook. In turn, their vast wealth garnered from those years of freebooting and trade created their moment to reemerge as the premier economic force of the country. Whenever their trading ships anchored at faraway ports in the aftermath of July 1588, sultans and potentates were uniformly impressed to meet the men who had put Philip of Spain in his rightful place.

By the late 1590s, Londoners realized that there was no longer any need to rely solely on mariners of varying skills and honesty, or on seas that could dash their fortunes without warning. Cavendish's second voyage in 1591, Richard Hawkins's in 1594, followed by Dudley's, Chidley's, and Wood's had all ended in disaster. No, the merchants agreed. Their thrust would be different. Their undertaking would resemble the colony "forts" of Portuguese India. The foreign rulers now wanted to trade with them, in part as protection against Spain, in part, to make more money. The London merchants envisaged huge emporia—cities and towns— from which they could turn their fortunes into a power that the world had not as yet seen. The time had come to seize the Holy Grail: trade with the East Indies.

Sir James Lancaster, a former merchant and English factor who had lived in Lisbon until the union of Portuguese and Spanish crowns in 1580, made a reconnaissance mission lasting from 1591 to 1594 to the East in the *Edward Bonaventure*—the same Levant Company ship he had captained during the armada campaign. He was shadowed by the Dutch fleet reconnoitering the same waters to develop the Netherlands' spice trade; and where their voyage was a phenomenal success, Lancaster's was a financial disaster. Yet despite this dismal beginning, it was by watching and drooling over the Dutch successes that the London merchants thought that they must seize their chance at once or their last opportunity to enter the spice race would be squandered. They were determined not to lose out again—this time to the Dutch, who England had saved from Spain.[2]

The rivalry between Dutch and English merchants came to a head when the Dutch petitioned Elizabeth in July 1599 to purchase a number of English ships for their Eastern colonization purposes.

The Londoners protested angrily. It was a matter of national interest to hold on to its own spice trade, they argued. Then, on September 22, 1599, 101 London merchants signed a petition promising a total of £30,133 6s. 8d. ($7.23 million or £3.91 million today) "to venture in the pretended voyage to the East Indias,"[3] and set it before the queen for her consideration. Within weeks, the demand came back from court that their venturing must be suspended at once—and that the company should not be formed under any circumstances.

It seemed that Robert Cecil had finally penetrated the queen's deep mistrust of the Spaniard, and had begun peace talks. From Elizabeth's and Cecil's viewpoint, the formation of a company to plunder the rich East Indies could only bring bad news to those negotiations. Philip II had died the year before, as had Lord Burghley, but it was feared that Philip's son and heir, Philip III, harbored a venomous loathing for the English, too. After de Aguilla's failed invasion of Ireland, naturally, these talks failed.

In the meantime, the London merchants argued their case compellingly, producing vast lists and maps of cities and towns occupied by the Portuguese, and even greater lists and maps of places where "no Christian prince" had a fort or trade. Still, they didn't fool the old queen. She knew full well that the Portuguese were far more than "merchants" in the East—the *Estado da India* controlled huge trading forts in Mozambique, Hormuz, Goa, and Malacca, and had fended off Arab and Venetian traders there for nearly a century.[4]

Nonetheless, the merchants were right to stress the vast gaps in Portugal's dominance between Indonesia and China. Where the Portuguese were strongest was, of course, from the western coast of India, encompassing Ceylon (Sri Lanka) to the Persian Gulf. But the Dutch, too, had consulted their maps and drawn the same conclusions. They knew that the eastern Portuguese trading empire was vulnerable. Their voyages to Bantam and Java were so successful that several new Dutch companies were formed to exploit the spice trade. There was widespread agreement among the queen's merchants: if the English Levant Company merchants could not make the queen budge from her position, then England's access to spices and the other rich trades was in jeopardy.

Elizabeth was tempted, but it was only when the talks with Spain were truly at an irrevocable impasse that she consented to allow their plan to go ahead. It was an ever-familiar pattern of "stop start" that dogged Elizabeth's reign, at times caused by her natural caution for security of the realm, while at other times caused by lack of funds.[5] Still, the Londoners remained tenacious. By New Year's Day 1600, the 101 names had grown to 218 merchants, incorporating as the "Company of London Merchants trading to the East Indies." One of the leading merchants, Alderman Paul Bayning, headed the committee, and his close colleague, Thomas Smythe, became the new company's governor. The only "titled" member they had was George Clifford, third Earl of Cumberland.

While most gentlemen adventurers had not as yet realized that their day had passed and that the future would need to be won by hard work and cunning rather than plunder, Cumberland and the London merchants were well aware of the changes in the world. Protestantism had spread; Spain had lost its terrier Philip II; and the Dutch with their States General had set themselves up as an alternative government to Spain's, and they had taken control of their destiny. It was right that trade should change as a result, and the Londoners would remain single-minded in their eastern undertakings, agreeing universally not to muddle affairs of state with their trading objectives. Or so they thought.

The company charter of 1600 allowed the company a monopoly to the countries beyond the Cape of Good Hope and Strait of Magellan for a period of fifteen years, subject to the usual exclusion of places possessed by any Christian prince. Exceptionally, they were also allowed to export silver to a value of up to £30,000 annually ($7.22 million or £3.9 million today) to facilitate their trading activities. This was an incredible concession for a crown that scrimped to find cash at the best of times. The £30,000 represented an astounding sixth of the queen's annual purse for the realm. Conversely, it demonstrated clearly to all participants in the new company that it had Elizabeth's seal of approval.

But the Londoners would not allow the queen's "seal" to keep them from running their company as they saw fit. They categorically refused one of Essex's soldiers, Sir Edward Michelbourne, to

command the first venture, opting instead to continue backing James Lancaster as their commander. There remained a mistrust of gentleman adventurers' ability to distinguish trade from plunder, whereas they knew that Lancaster would obey his orders and maintain trade as his primary concern.

Lancaster's flagship, the 600-ton *Red Dragon*, had been recently purchased from the Earl of Cumberland (formerly called the *Malice Scourge*) at the inflated price of £3,700 ($889,092 or £480,590 today). The 240-ton *Susan*, which had belonged to Paul Bayning; the 260-ton *Ascension*, built for William Garraway (Cecil's partner); the 300-ton *Hector*, and the 120-ton *Gift* comprised the rest of the fleet.[6] The *Red Dragon* would set the standard for all subsequent English East Indiamen—a real man-of-war bristling with firepower (thirty-eight guns in all), large yet sleek, weatherly, and, importantly, graced with a large cargo hold. She was as much a warship as a trader.

Each ship also had its merchants aboard. John Middleton, John Havard, and William Brund were the main factors aboard the *Hector*, *Susan*, and *Ascension*, respectively. Lancaster had a crew of two hundred, but the entire fleet had around five hundred men for 1,520 tons of shipping. Importantly, Lancaster's chief pilot, the veteran of three arctic voyages, John Davis, had been to the East Indies before—sailing with the Dutch commander Cornelius Houtman van Hoorn, after whom Cape Horn is named.

A prerequisite of the voyage by Lancaster was that the ships be provisioned with enough lemon juice until they made landfall at the Cape in South Africa. He demanded that three spoonfuls of lemon juice be doled out to the men of all ranks daily to avoid the "plague of the sea"—scurvy. By the time they reached the Cape six months later, all men had remained "in rude health."[7]

The *Red Dragon* and her squadron were off the coast of Madagascar on Christmas Day 1601, only anchoring off Achin (Sumatra) the following June. Here was the major source of pepper, and a people hostile to Portugal. But pepper wasn't the spice they sought: nutmeg and cloves fetched the highest prices in London, and that was what they intended to bring home. So they pressed on

to Bantam, where they were allowed to trade freely, and left several of their factors there, thereby founding the first English "factory" in the East.[8] But this did not bring the members of the company their Holy Grail, at least not yet.

After a fifteen-month outward bound journey, several months in the Far East, and a seven-month return stretch, Lancaster only reached England in September 1603, with his cargo that consisted, despite all his efforts, primarily of pepper.

The England he returned to was not the same place he had left, as Drake had found before in his time.

Plague ravaged the realm, and the queen was dead.

*

Many had believed that it was Essex's tragic end that brought on the queen's depression in 1602. But was Essex's life worth more than that of Burghley, Walsingham, Hatton, Drake, Winter, Hawkins, Hunsdon, Knollys, or her most beloved Leicester? There were perhaps no more Drakes, but Drake, like so many Elizabethans, would be an anachronism in the seventeenth century. There was no more Philip II either. Protestantism had taken root and flourished at last, and Elizabeth knew that she had been instrumental in ensuring that its new shoots hadn't withered.

In the third week of March 1603, the queen became progressively more reflective, standing for long hours simply staring out the window. She had been at her privy chamber window embrasure for two solid days, refusing food, running her index finger along her sore gums, staring. The sixty-nine-year-old Elizabeth, queen for over forty-four years, by the grace of God, turned, so it's believed, to listen to the entreaties of her advisors to lie down and rest. Worn out from the burdens of office, illness, and age, and especially the loss of all those she had loved and who had died before her, the old queen made to turn and collapsed.

In the gray hours of Thursday, March 24, 1603, Tudor England expired with Elizabeth. On her deathbed, too weak to talk, she communicated with her privy councillors by signs. They read out the names of her possible successors, and when the King of Scots's name was uttered, she slowly brought her hand to the crown of her head and nodded. James VI of Scotland, son of Mary Queen of Scots, would become James I of England. Having at last made her choice

of successor official, Elizabeth Tudor allowed herself to slip away quietly.[9]

Given her symptoms, medical historians suggest that she died of septicemia caused by extensive tooth and gum decay, perhaps brought on by her great penchant for candied cherries, lovingly brought back from warmer seas by her adventurers to please their pirate queen.

Epilogue ❧

*France and England cannot be debarred from meddling
with the aforesaid trade and navigation: their power is
great, their seamen many, their seas large, their merchants
with their captains and soldiers over greedy of money and
booty and their subjects and servants never trusting. . . .*

—PHILIP II'S INSTRUCTIONS TO HIS SON, PHILIP III, IN 1596,

BEFORE SLIPPING INTO A COMA AND DYING

Though forbidding any formal naming of her successor, or even any discussion of the matter, from the moment Elizabeth wrote to James VI of Scotland after the execution of his mother in 1587, King James had always been treated as her heir. It wasn't a perfect or tidy solution, but for Elizabeth it was the only one. She had been right to believe that in choosing an heir, the seeds of destruction would be sown. Where Tudor statecraft had raised England from little more than a tribal community in her grandfather's time, Elizabeth's talent, perseverance, and skill had honed England into the beginnings of the nation state we recognize today. Though not officially united for another hundred years, the United Kingdom of Great Britain and Northern Ireland found its roots in her time. Much of our treasured English language and literature flourished—despite or perhaps because of censorship—in Elizabeth's England. In James Stuart, an intelligent but untrustworthy pair of hands, Elizabeth had inadvertently sown the seeds of the English Civil War and a century of upheaval.

Robert Cecil went on to become the great Jacobean statesman, elevated in James's reign to the title of Earl of Salisbury. Sir Francis Bacon's betrayal of his good friend Essex was soon forgotten. By 1621 he had risen to become Lord Verulam Viscount St. Albans. King James treasured him, giving him a knighthood in 1603, then ultimately promoting his rise to Privy Councillor, lord keeper

and, finally, lord chancellor in 1618. Bacon was, of course, also the accomplished Jacobean writer and philosopher. Both the Cecils and Bacons, along with many other great Elizabethan aristocratic families like the Stanleys, Herberts, and Sidneys, remain influential in Britain today.

Elizabeth died knowing that the Earl of Tyrone, who had cost her so dearly in lives of her adventurers and hard cash, had been captured, though fortunately she did not live to see his fate. King James I ultimately pardoned and restored him to power in 1607, but Tyrone fled to Rome, where he lived out his life peacefully until its end in 1616.

Walter Raleigh, though, did not fare as well. No sooner had James reached London than he was advised by none other than Robert Cecil that Raleigh was championing a scheme to put James's cousin Arabella Stuart on the throne of England. Raleigh once again found himself incarcerated in the Tower and was found guilty of high treason. Though initially slated for execution, at the pleading of James's wife, Anne of Denmark, and eldest son, Prince Henry, Raleigh's sentence was commuted. It was in these dreary days that Raleigh wrote his *History of the World* and some of his best poetry, including "The Lie." Desperate to restore his fortune and favor at court, Raleigh was given one last chance by the king to find El Dorado. The voyage naturally failed, with Raleigh also losing his eldest son Wat in the escapade. The sixty-three-year-old adventurer returned to England a broken man, and readied himself for the scaffold that awaited him, famously pronouncing as the axe touched his neck, "Tis a sharp remedy, but a sure one for all ills."

James naturally had revoked any claim that Raleigh had to the "country of Virginia." In 1607 the colony of Jamestown was founded. In 1609 the Virginia Company was granted its new charter by the king, with funding by many of the London merchants and their heirs who had also been involved in the East India Company. Its governor, John Rolfe—the husband of the Native American princess Pocahontas— began the exploitation of tobacco for sale back in London in 1612. But the Virginia Company's government was too rigid, and despite a revamping of its operations in 1616, company control of the enlarged Virginia colony was never adequate to ensure its survival. Though Raleigh lived long enough to hear of its expansion before his death,

he never saw Virginia again. Also, the Virginia Company was never profitable like the East India Company, thus dooming it to failure. After an attack by the natives in 1622 that wiped out Jamestown, the Virginia Company was dissolved in favor of a royal government.

A few years earlier, the self-imposed exiles, the Brownists of Elizabethan England, had returned from Leiden in the Netherlands after a lifetime abroad. Better known today as the Pilgrim Fathers, these Puritan Separatists chartered the 180-ton merchant ship *Mayflower* used in the wine trade from a London adventurer, settling in December 1620 in Massachusetts Bay. While only thirty-seven of the colonists were "Leiden Separatists," there were an additional sixty-five passengers plus crew who hopefully had the varied skills required for success in northern Virginia . The closely knit religious community founded on the Puritan work ethic prospered where nearly all other religiously motivated attempts at colonization had failed.

The Catholic "transportation policy" originally envisaged for northern Virginia (Norumbega) headed farther south, where the "great city" of Baltimore was founded as a Catholic enclave promoting Catholic ideals under Lord Baltimore in Charles I's reign. The state of Maryland was named after Charles I's queen, Henrietta Maria, the youngest child of Henry IV of France and a staunch Catholic.

As for the plea for Catholic toleration in England, the aversion to having Catholics in power never faded. The Gunpowder Plot to kill the king and all of Parliament failed in November 1605, and ruined any potential for religious toleration or the restoration of Catholicism to the crown. By the end of the seventeenth century, it became "illegal" for the reigning monarch to be Catholic after James II's enforced abdication. England preferred to import other Stuart cousins—William III and Mary II—from the Netherlands as their new monarchs over James II, their rightful Catholic king.

And the East India Company? After a very shaky start in violent competition with the VOC, or the Dutch East India Company, the Honourable Company, as it was frequently called, more than fulfilled the Londoners' most fanciful dreams. It was the Netherlands' time first for its Golden Age and empire built on the fortunes of the VOC, and throughout the first half of the seventeenth century the

Honourable Company had only a few hard-fought successes. Yet through their tenacity, as much as their cunning and wit, the East India Company ruled over what later became the English colonies or spheres of influence from India through to China, and its efforts, trials, and tribulations evolved into the British Empire spanning two-fifths of the world's landmass. Had Britain not made the mistakes it did in its "western plantings"—the United States—its empire would have been substantially larger.

What had begun as a means of survival in what some today might call state-sponsored terrorism, England's "wooden walls" were, in fact, the only means left open to the country to stay independent and financially solvent. Had Philip II allowed trade with his colonies, perhaps things would have been different. Perhaps not. In any event, it didn't happen. What did occur, though, was a series of events over decades that made Elizabeth and her adventurers fundamental to the formation of the British Empire.

Appendix I ✢

Doctor John Dee.
The Petty Navy Royal.

(extract from *General & Rare Memorials*, published in August 1577)

Whom also I have heard often and most heartily wish, that all manner of persons passing or frequenting our seas appropriate, and many ways next environing England, Ireland, and Scotland, might be in convenient and honourable sort, at all times, at the commandment and order, by beck or check, of a Petty Naval Royal of three-score tall ships or more, but in no case fewer; and they to be very well appointed, thoroughly manned, and sufficiently victualled.

The public commodities whereof ensuing are, or would be so great and many, as the whole commons, and all the subjects of this noble Kingdom would for ever bless the day and hour wherein such good and politic order was, in so good time and opportunity, taken and established: and esteem them not only most worthy and royal Councillors, but also heroical Magistrates, who have had so fatherly care for the commonalty; and most wisely procured so general British security,

1. That, henceforth, neither France, Denmark, Scotland, Spain, nor any other country can have such liberty for invasion, or their mutual conspiracies or aids, anyway transporting, to annoy the blessed state of our tranquillity; is either they have in times past had, or else may have whensoever they will forget or contemn the observing of their sworn or pretended amity.

2. Besides that, I report me to all English merchants, said he, *of how great value to them, and consequently to the public weal of this Kingdom, such a security were? (a) Whereby, both outward*

and homeward, continually their merchantlike ships, many or
few, great or small, may in our seas and somewhat further, pass
quietly unpilled, unspoiled, and untaken by pirates or others in
time of peace. (b) What abundance of money now lost by assurance
[marine insurance] given or taken, would by this means also, be
greatly out of danger?

3. And thirdly, (a) how many men, before time of urgent need,
would thus be made very skilful in all the foresaid seas and sea
coasts; in their channels knowing, in soundings all over, in good
marks taking for avoiding dangers, in good harbors trying out, in
good landings essaying, in the order of ebbs and floods observing,
and all other points advisedly learning, which to the perfect Art
of Navigation are very necessary: whereby they may be the better
able to be divided and distributed in a greater Navy, with charge of
Mastership or Pilotage, in time of great need. (b) They of this Navy
should oftentimes espy or meet the privy sounders and searchers of
our channels, flats, banks, pits &c.; and so very diligently deciphering
our sea coasts, yea, in the river of Thames also; otherwhile up to the
station of the Grand Navy Royal. (c) And likewise, very often meet
with the abominable thieves that steal our corn and victuals from
sundry our coasts, to the great hindrance of the public plenty of
England. And these thieves are both subjects and foreigners; and
very often and to to [far to] evidently seen, and generally murmured
at, but as yet not redressed; for all the good and wise order by the
most honourable Senate of the Privy Council taken therein.

4. Fourthly, how many thousands of soldiers of all degrees, and
apt ages of men, would be, by this means, not only hardened well
to brook all rage and disturbance of sea, and endure healthfully
all hardness of lodging and diet there; but also would be well
practised and easily trained up to great perfection of understanding
all manner of fight and service at sea? So that, in time of great
need, that expert and hardy crew of some thousands of sea soldiers
[Marines] would be to this realm a treasure incomparable. And
who knoweth, not, what danger it is, in time of great need, either to
use all fresh water soldiers; or to be a fortnight in providing a little
company of omni-gatharums, taken up on the sudden to serve at

sea? For our ordinary Land Musters are generally intended, or now may be spared to be employed otherwise, if need be.

5. How many hundreds of lusty and handsome men would be, this way, well occupied, and have needful maintenance, which now are either idle, or want sustenance, or both; in too many places of this renowned Monarchy?

6. Moreover, what a comfort and safeguard will it, or may it be to the whole Realm, to have the great advantage of so many warlike ships, so well manned and appointed for all assays, at all hours, ready to affront straightway, set on and overthrow, any sudden or privy foreign treachery by sea, directly or indirectly, attempted against this Empire, in any coast or part thereof. For sudden foreign attempts (that is to say, unknown or unheard of to us, before their readiness) cannot be done with great power. For great navies most commonly are espied or heard somewhat of, and that very certainly while they are in preparing; though in the meanwhile, politically, in divers places, they distribute their ships and their preparations appertaining.

7. And by reason of the foresaid Petty Navy Royal, it shall at all times, not only lie in our hands greatly to displease and pinch the petty foreign offender at sea; but also, if just occasion be given, on land to do very valiant service and that speedily: as well against any of the foresaid foreign possible offenders, as also against such of Ireland or England, who shall or will traitorously, rebelliously, or seditiously assemble in troops or bands within the territories of Ireland or England; while greater armies, on our behalf, shall be in preparing against them, if further need be. For skilful sea soldiers are also on land far more trainable to all martial exploits executing; and therein to be more quick-eyed and nimble at hand strokes or scaling; better to endure all hardness of lodging or diet; and less to fear all danger near or far: that the land soldier can be brought to the perfection of a sea soldier.

8. By this Navy also, all pirates—our own countrymen, and they be no small number—would be called, or constrained to come home. And then (upon good assurance taken of the reformable and men of choice, for their good abearing from henceforth) all such to be

bestowed here and there in the foresaid Navy. For good account is to be made of their bodies, already hardened to the seas; and chiefly of their courage and skill for good service to be done at the sea.

9. *Ninthly, Princes and potentates, our foreign friends or privy foes, the one for love and the other for fear, would not suffer any merchant or others, subjects of the Queen's Majesty, either to have speedy wrong in their Courts; or by unreasonable delays or trifling shifts to be made weary and unable to follow their rights. And notwithstanding such our friends or privy foes, their subjects would be glad most reverently to become suitors and petitioners to the royal State of this Kingdom for just redress, if, any kind of way, they could truly prove themselves by any subject of this realm injured; and they would never be so stout, rude and dishonourably injurious to the Crown and Dignity of this most sacred Monarchy as, in such cases, to be their own judges, or to use against this Kingdom and the royal chief Council thereof, such abominable terms of dishonour as our to to great lenity and their to to barbarous impudency might in a manner induce them to do. And all this would come to pass through the Royalty and Sovereignty of the seas adjacent or environing this Monarchy of England, Ireland, and (by right) Scotland and the Orkneys also, very princely, prudently, and valiantly recovered (that is to say, by the Petty Navy Royal); duly and justly limited; discreetly possessed; and triumphantly enjoyed.*

10. *Should not Foreign Fishermen (overboldly now, and to to injuriously abusing such fishings about England, Wales and Ireland) by the presence, oversight power and industry of this Petty Navy Royal be made content; and judge themselves well apaid to enjoy, by our leave, some great portion of revenue to enrich themselves and their countries by, with fishing within the seas appertaining to our ancient bounds and limits? Where now, to our great shame and reproach, some of them do come in a manner home to our doors; and among them all, deprive us yearly of many hundred thousand pounds, which by our fishermen using the said fishings as chief, we might enjoy; and at length, by little and little, bring them (if he would deal so rigorously with them) to have as little portion of our peculiar commodity (to our Islandish Monarchy, by GOD and Nature assigned) as now they force our fishermen to be contented*

with: and yearly notwithstanding, do at their fishing openly and ragingly use such words of reproach to our Prince and realm, as no true subject's heart can quietly digest. And besides that, offer such shameful wrongs to the good laboursome people of this land, as is not by any reason to be borne withal, or endured any longer: destroying their nets; cutting their cables to the loss of their anchors, yea, and often-times of barks, men and all.

And this sort of people they be, which otherwhile by colour and pretence of coming about their feat of fishing, do subtly and secretly use soundings and searchings of our channels, deeps, shoals, banks, or bars along the sea coasts, and in our haven mouths also, and up in our creeks, sometimes in our bays, and sometimes in our roads; &c.; taking good marks, for avoiding of the dangers, and also trying good landings. And so, making perfect charts of all our coasts round about England and Ireland, are become almost perfecter in them, than the most part of our Masters, Leadsmen, or Pilots are. To the double danger of mischief in times of war; and also to no little hazard of the State Royal, if, maliciously bent, they should purpose to land any puissant army, in time to come.

And as concerning those fishings of England, Wales and Ireland, of their places, yearly seasons, the many hundreds of foreign fisherboats yearly resorting, the divers sorts of fish there taken, with appurtenances: I know right well that long ago all such matter concerning these fishings was declared unto some of the higher powers of this Kingdom, and made manifest by R[obert]. H[itchcock]. another honest gentleman of the Middle Temple, who very discreetly and faithfully hath dealt therein; and still travaileth, and by divers other ways also, to further the weal public of England so much as in him lieth.

But note, I pray you, this point very advisedly. That as by this Plat [tract] *of our said fishing commodities, many a hundred thousand pounds of yearly revenue might grow to the Crown of England more than now doth, and much more the commons of this Monarchy also; besides the inestimable benefit of plentiful victualling and relieving of both England and Ireland; the increasing of many thousands of expert, hard, and hardy mariners; the abating of the sea forces of our foreign neighbours and unconstant friends; and contrariwise; the increasing of our own power and force at sea; so*

it is most evident and certain that principium *in this case is,* Plus quam dimidium totius, *as I have heard it verified proverbially in many other affairs.*

Wherefore, the very entrance and beginning towards our Sea Right recovering, and the foresaid commodities enjoying at length; yea, and the only *means of our continuance therewith, can be no other; but by the dreadful presence and power, with discreet oversight and due order, of the said Petty Navy Royal; being— wholly sometimes, sometimes a part thereof—at all the chief places of our fishings; as if they were Public Officers, Commissioners, and Justiciers, by the supreme authority royal of our most renowned Queen Elizabeth, rightfully and prudently thereto assigned.*

So that this Petty Navy Royal is thought to be the only Master Key wherewith to open all locks that keep out or hinder this comparable British Empire from enjoying by many reasons, such a yearly Revenue of Treasure, both to the Supreme Head and the subjects thereof—as no plat of ground of sea in the whole world else, being of no greater quantity—can with more right, greater honour, with so great ease and so little charges, so near at hand, in so short time, and in so little danger, any kind of way, yield the like to either King or other potentate and absolute Governor thereof whosoever. Besides, the Peaceable Enjoyment to enjoy all the same, for ever; year, yearly and yearly, by our wisdom and valiantness duly used, all manner of our commodities to arise greater and greater; as well in wealth and strength as of foreign love and fear, where it is most requisite to be: and also of Triumphant Fame the whole world over, undoubtedly.

Also this Petty Navy Royal will be the perfect means of very many other and exceeding great commodities redounding to this Monarchy; which our fishermen and their fisher-boats only, can never be able to compass or bring to pass: and those being such as are more necessary to be cured for presently [instantly] than wealth.

Therefore, the premise well weighed, above and before all other, this Plat [plan] of a Petty Navy Royal will, by GOD's grace, be found the plain and perfect A.B.C., most necessary for the commons and every subject in his calling to be carefully and diligently musing upon, or exercising himself therein; till, shortly, they may be able in

effect to read before their eyes, the most joyful and pleasant British histories by that Alphabet only deciphered, and so brought to their understanding and knowledge that ever to this or any kingdom in the whole world else, was known or perceived.

11. *Furthermore, how acceptable a thing may this be to the Ragusyes* [Argosies], *Hulks, Caravels, and other foreign rich laden ships, passing within or by any of the sea limits of Her Majesty's royalty; even there to be now in most security where only, heretofore, they have been in most jeopardy: as well by the ravin of the pirate, as the rage of the sea distressing them, for lack of succour, or good and ready pilotage! What great friendship in [sic the] heart of foreign Prince and subject! And what liberal presents and foreign contributions in hand will duly follow thereof, who cannot imagine?*

12. *Moreover, such a Petty Navy Royal, said he, would be in such stead, as though (a) one [fleet] were appointed to consider and listen to the doings of Ireland; and (b) another to have as good an eye, and ready hand for Scottish dealings; (c) another to intercept or understand all privy conspiracies, by sea to be communicated; and privy aids of men, munition or money be sea to be transported; to the endamaging of this kingdom, any way intended (d) another against all sudden foreign attempts: (e) another to oversee the foreign fishermen: (f) another against all pirates haunting our seas: and therewith as well to waft and guard our own merchant fleets as they shall pass and repass between this realm, and wheresoever else they may best be planted for their ordinary marts' keeping; if England may not best serve that turn. And also to defend, help, and direct many of our foreign friends, who must needs pass by or frequent any of those seas, whose principal royalty, undoubtedly, is to the Imperial Crown of these British Islands appropriate.*

One such Navy, said he, by royal direction, excellently well manned, and to all purposes aptly and plentifully furnished and appointed; and now, in time of our peace and quiet everywhere, yet beforehand set forth to the foresaid seas *with their charges and commissions (most secretly to be kept from all foes and foreigners) would stand this common wealth in as great stead as four times so many ships would or could do; if, upon the sudden and all at once, we should be forced to deal for removing the foresaid sundry*

*principal matters of annoyance: we being then utterly unready
thereto, and the enemy's attempt requiring speedy, and admitting
of no successive, defeating.*

13. *To conclude herein. This Petty Navy Royal undoubtedly will
stand the realm in better stead than the enjoying of four such forts
or towns as Calais and Boulogne only could do. For this will be
as great strength, and to as good purpose in any coast of England,
Ireland, or Scotland, between us and the foreign foe, as ever Calais
was for that only one place that it is situated in; and will help to
enjoy the Royalty and Sovereignty of the Narrow Seas throughout,
and of other our seas also, more serviceable than Calais or Boulogne
ever did or could do: if all the provisos hereto appertaining be duly
observed. Forasmuch as we intend now* peace only preserving,
*and no invasion of France or any enemy on that main inhabiting;
toward whom by Calais or Boulogne we need to let in our land
forces &c. Much I know may be here said,* Pro et Contra, *in this
case: but GOD hath suffered such matters to fall so out; and all to us
for the best, if it be so, thankfully construed and duly considered.*

*For when all foreign Princes, our neighbours, doubtful friends,
or undutiful people, subjects or vassals to our Sovereign, perceive
such a Petty Navy Royal hovering purposely here and there, ever
ready and able to overthrow any of their malicious and subtle secret
attempts intended against the weal public of this noble Kingdom in
any part or coast thereof: then every one of them will or may think
that, of purpose, that Navy was made out only to prevent them, and
none other; and for their destruction being bewrayed* [betrayed]
*as they would deem. So that not one such foreign enemy would
adventure, first, to break out into any notable disorder against us;
nor homish subject or wavering vassal, for like respects, durst, the,
privily muster to rebellion, or make harmful rodes* [inroads] *or
dangerous riots in any English or Irish Marches.*

*But such matter as this, I judge you have, or might have heard
of, ere now, by worshipful Master DYER; and that abundantly:
seeing* Synopsis Reipublicae Britanicae, *was, at his request, six
years past* [i.e., in 1570] *contrived; as by the methodical author
thereof, I understand. Whose policy for the partings, meetings,
followings, circuits &c., of the ships (to the foresaid Petty Navy*

Royal belonging) with the alterations both of times, places, and numbers &c., is very strange to hear.

So that, in total sum of all the foresaid considerations united in one, it seemeth to be almost a mathematical demonstration, next under the merciful and mighty protection of GOD, for a feasible policy to bring and preserve this victorious British Monarchy in a marvellous security. Whereupon, the revenue of the Crown of England and Wealth public will wonderfully increase and flourish; and then, thereupon, sea forces anew to be increased proportionally, &c. And so the Fame, Renown, Estimation, and Love or Fear of this British Microcosmus, *all the whole and great World over, will be speedily be spread, and surely be settled, &c.*

It is most earnestly and carefully to be considered that our herring fishings, against [over] *Yarmouth chiefly, have not (so notably, to our great injury and loss and been traded, but from Thirty-six years ago hitherward.)* [This fixes the commencement of the Dutch herring fishery on the English coasts about 1540.] *In which time, as they have in wealth, and numbers of boats and men, by little and little increased, and are now become very rich, strong, proud, and violent; so, in the race* [course] *of the selfsame time running, the coasts of Norfolk and Suffolk next to those fishing-places adjacent, are decayed in their navy to the number of 140 sail, and they* [of] *from threescore to a hundred tons and upwards* [each]; *besides Crayers and others. Whereupon, besides many other damages thereby sustained publicly, these coasts are not able to trade to Iceland, as in times past they have done; to no little loss yearly to the wealth public of this kingdom.*

But the Herring Busses hither yearly restoring out of the Low Countries, under King PHILIP his dominion, are above five hundred.

Besides 100 or such a thing, of Frenchmen.

The North Seas fishing, within the English limits, are yearly possessed of 300 or 400 sail of Flemings [Dutch]; *so accounted.*

The Western fishings of Hake and Pilchards are yearly possessed by a great navy of Frenchmen; who yearly do great injuries to our poor countrymen, Her Majesty's faithful subjects.

Strangers also enjoy at their pleasure the Herring fishing of Allonby, Workington, and Whitehaven on the coast of Lancashire.

And in Wales, about Dyfi [the Dyfed] *and Aberystwyth, the plentiful Herring fishing is enjoyed by 300 Sail of strangers.*

But in Ireland, Baltimore [near Cape Clear] *is possessed yearly, from July to Michaelmas most commonly, with 300 Sail of Spaniards, entering there into the fishing at a Strait* [passage] *not so broad as half the breadth of the Thames against* [over] *Whitehall. Where, our late good King EDWARD VI's most honourable Privy Council was of the mind once to have planted a strong bulwark* [fort]; *for other weighty reasons, as well as His Majesty to be Sovereign Lord of the fishing of Millwin and Cod there.*

Black Rock [co. Cork?] *is yearly fished by 300 or sometimes 400 sail of Spaniards and Frenchmen.*

But to reckon all, I should be too tedious to you; and make my heart ache for sorrow, &c.

Yet surely I think it necessary to leave to our posterity some remembrance of the places where our rich fishings else are, about Ireland. As at Kinsale, Cork, Carlingford, Saltesses, Dungarven, Youghal, Waterford, La Foy, The Band, Calibeg [Killibegs] *&c. And all chiefly enjoyed, as securely and freely from us by strangers, as if they were within their own Kings' peculiar sea limits: nay rather as if those coasts, seas, and bays &c., were of their private and several purchases. To our unspeakable loss, discredit, and discomfort; and to no small further danger in these perilous times, of most subtle treacheries and fickle fidelity.*

Dictum, Sapienti sat esto.

Appendix II �֎

*S*ince much of the book is spent in discussion of the flota and the treasure it carried, I thought the reader would be interested to see what a typical (though not large) flota from New Spain brought back to Seville, according to the Venetian Ambassador. This is what arrived at the *casa* in the same year as Drake's plundering of the *San Felipe*.

Report of all that the *Flotilla of New Spain* brings with it, August 1587

For the King

Eight thousand bars of silver.
Twelve cases of gold.
Three hundred thousand reals.
Twenty cases of pearls.
One case of emeralds.

For Private Individuals

Five millions of fused silver.
One thousand five hundred marks of pearls.*
A great case of emeralds.

From San Domingo

Thirty-five thousand pieces of stamped leather.
Two hundred cases of sugar.
Twenty-two thousand quintals of ginger.
Four thousand quintals of guaiacum (lignum vitae).
Fifty quintals of sarsaparilla.

Forty-eight quintals of cassia.
Sixty-four cases of linen.

From New Spain

One million nine hundred thousand pesos of silver for the King.
Two millions for private merchants.
One thousand one hundred marks of gold.*
Five thousand six hundred cases of cochineal.
Sixty-four thousand pieces of stamped leather.
Twenty-five thousand pounds of indigo.

The value of the above, sixteen millions [ducats] in gold.

 ($4.42 billion or £2.39 billion today)

**1 mark = 8 ounces*

Endnotes ❧

Abbreviations:

AI	Archivio de Indias, Seville, Spain
APC	*Acts of the Privy Council*
BL	British Library
CPR	*Calendar of Patent Rolls*
CSP	*Calendar of State Papers*
DNB	*Dictionary of National Biography*
FSL	Folger Shakespeare Library, Washington, D.C.
HMC	Historic Manuscripts Commission
KL	Kervyn Lettenhove, *Les Relations des Pays Bas et L'Angleterre*
NA	National Archive
OED	*Oxford English Dictionary*
SP	State Papers

Introduction

1. Richard Hakluyt, *Tudor Venturers* (London, 1970), p. 201
2. Ibid., p. 200.
3. SP 94/2 fol. 78, 100.

Chapter 1. *The Lord's Doing*

1. *CSP—Spain*, vol. 1, p. 334.
2. Simon, Schama, *A History of Britain* (London, 2000), p. 285
3. G. Parker, *The Grand Strategy of Philip II*, (New Haven, 2000), p. 2; also see, J. Denucé, *Lettres Marchandes d'Anvers*, (Brussels, 1961), Chapter 9, pp. 164–168
4. Owen Tudor, grandfather of Henry VII, was the second husband of Queen Katherine, the widow of Henry V and mother of Henry VI, the last Lancastrian king in the Wars of the Roses. Victorian historians claimed that there was never any proof of their marriage, but this

has since been refuted. See S. B. Chrimes, *Henry VII* (New Haven, 1999).

5. Simon Schama, *A History of Britain*, p. 285.

Chapter 2. *A Realm Exhausted*

1. Throckmorton was soon to be appointed as the queen's ambassador to France. This particular news would have given Elizabeth great pleasure, since it was Cardinal Pole who had been her nemesis throughout Mary's reign, and it was he who had carried out an Anglicized version of the Spanish Inquisition in the previous five years.

2. *CSP—Domestic*, vol. 1, p. 115, nos. 2, 4.

3. Ibid., no. 5.

4. National Archives, SP Domestic, Elizabeth 12/1/7.

5. *CSP—Spain*, vol. 1, p. 1.

6. Ibid.

7. The office of lord keeper (of the privy seal) was one of extreme trust. The lord keeper kept the queen's seals required to engross an act into law and made the signatory personally responsible for the contents of any document under seal. Nicholas Bacon is most noted as a solid stalwart of early Elizabethan rule, as he set about modernizing the legal system to make it more just and was a firm believer in universal education (for men).

8. *CSP—Domestic*, vols 2, 3, pp. 120–129

9. *APC*, p. 9, no. 38.

10. Ibid.

11. National Archives, SP Domestic., Elizabeth I/77.

12. R. B. Wernham, *Before the Armada* (London, 1966), p. 240; also see *CSP—Venice*, vol. 6, 1049.

13. R. B. Wernham, *Before the Armada*, p. 245

14. Ibid.

15. AI, Indice General de los Papeles del Consejos de Indias, p. 128.

16. *CSP—Foreign*, vol. 1, p. xvi.

17. *CSP—Domestic*, p. 118.

18. *CSP—Foreign*, vol. 1, p. ix.

19. A repeated complaint of all popes between 1558 and Philip's death in 1596. It is found time and time again in the *CSP—Rome*, *CSP— Spain*, G. Parker's *The Grand Strategy of Philip II* (New Haven, 2000), and many other sources.

20. G. Parker, *The Grand Strategy of Philip II*, p. 7.

21. Ibid., p. 14.

22. G. D. Ramsay, *The City of London* (Manchester, 1964), p. 34.

23. I refer to them by their correct name and not Merchant Adventurers as is commonly the case today, in order to avoid any confusion with "merchant adventurers" (a generic term) and the Merchants Adventurers, the specific corporation.

24. Kenneth R. Andrews, *Trade, Plunder & Settlement*, p. 16.

Chapter 3. *The Queen, Her Merchants and Gentlemen*

1. DNB Biographical sketch on Martin Frobisher

2. R. Tittler, *Nicholas Bacon: The Making of a Tudor Statesman* (London, 1966), pp. 48-50.

3. See bibliographical sketches in the DNB for further details.

4. Benjamin Woolley's recent biography of Dr. John Dee, *The Queen's Conjurer* (New York, 2001) makes for riveting reading.

5. Robert Tittler's *Nicholas Bacon* is the best biography of this exceptionally egalitarian man dedicated to the law and justice.

6. Kenneth Andrews, *Trade, Plunder & Settlement* (Cambridge, 1999), p. 32.

7. John Cabot's voyage of discovery in 1497 had been funded by Elizabeth's grandfather, Henry VII, who had refused money to Columbus for his "West Indies" expedition only five years earlier in 1492.

8. Kenneth Andrews, *Trade, Plunder & Settlement*, p. 14.

9. Lord Admiral Clinton and later Lord Admiral Howard became accomplices before and after the fact in many instances of piracy by virtue of this ruling. They took a keen interest in who would be issued with letters of reprisal, or "letters of marque," making the bearer a bona fide mariner seeking reprisal granted from a head of state at the beginning of Elizabeth's reign. Yet as the years rolled on, virtually anyone requesting a letter of reprisal was granted one. They became direct beneficiaries of the pirates' prosperity. Please note that the term "privateer" did not exist in Elizabethan times, and was used only from the eighteenth century onward.

10. Ibid.

11. Again, this is an area that has been explored very well by Susan Brigen in *New Worlds, Lost Worlds* (New York, 2001). The recusancy fines were tolerated by Catholics, but increased significantly after 1570 when the pope sent out a communiqué that all Catholics were exempt from any loyalty to the "heretic queen."

12. This is the topic of many books on Elizabeth, and I could never do the subject justice here. It was an important tactic in her international politics that she would use as long as she decently could (until the early

1580s), but not something she probably seriously entertained in light of her childhood traumas, desire to rule in her own right, and deep devotion to Robert Dudley. Despite all the protestations of "courtly love" and a long list of admirers and scandalous behavior, Elizabeth only ever loved Robert Dudley, and never seriously entertained any marriage—except perhaps in old age—to the Duke of Alençon. With Robert Dudley disgraced by the inconvenient and suspicious "accidental" death of his wife, Amy Robsart, any chance Elizabeth could have had in marrying him had ended. In fictional works there are hints that William Cecil could have been behind a plot to murder Amy and thereby ruin Robert's chances with the queen. The theory is historically possible, perhaps even probable, but there is no proof.

13. Derek Wilson, *Sweet Robin* (London, 1981), pp. 81–87.

14. John Foxe, *Foxe's Book of Martyrs* (London, 1888), 1714; also Raphael Holinshed, *Chronicles of England, Scotland, and Ireland* (London, 1808), vol. 3, p. 1158; and *Elizabeth I Collected Works*, L. S. Marcus, J. Mueller, and M.B. Rose (eds.), p. 48.

Chapter 4. *The Quest for Cash*

1. *APC*, 1558–1559, p. 1. Note that the documents are silent on whether these are Continental crowns or English crowns. One Continental crown was equal to 4 English crowns, and there were 5 shillings to a crown, or 4 crowns to a pound. I have taken the crowns as being Continental crowns since it was a payment due from France, or 2 million English crowns.

2. *APC*, p. 38, January 5, 1559.

3. Ibid., p. 28.

4. Ibid.

5. Ibid., p. 11, no. 15.

6. Ibid.

7. Ibid., pp. 14–15.

8. Ibid., pp. 22, 25, viii, ix.

9. *CSP—Domestic* 1559, p. 126, nos. 44 and 45. The use of the word "cause" in this instance means a fact or condition of matters or consideration moving a person to action [OED].

10. *CSP—Scotland*, p. 546, no. 1008.

11. Staplers were those who had the wool woven or spun into cloth or another finished product. A staple was the market town for its sale.

12. *CSP—Spain*, vol. 1, p. ix.

13. Raymond de Roover, *Gresham on Foreign Exchange* (Cambridge USA, 1949), p. 26.

14. M. Oppenheim, *A History of the Administration of the Royal Navy, 1509–1660* (London, 1896), p. 112.

15. N. A. M. Rodger, *Safeguard of the Sea* (London, 2004), p. 229.

16. Ibid.

17. *CSP—Foreign*, 1559–1565, p. 313, no. 623.

18. Ibid., pp. 308–310.

19. Ibid.

20. N. A. M. Rodger, *Safeguard of the Sea,* p. 196.

21. Ibid., p. 230.

22. When the Bishop of Ross, Confessor of Mary Queen of Scots, was interrogated after the Babington Plot was uncovered, he claimed that Mary had poisoned her husband, Francis.

Chapter 5. *The Merchants Adventurers, Antwerp, and Muscovy*

1. Margaret of York, sister of Edward IV, was the third wife of Marie's father, Duke Charles of Burgundy. While the marriage was childless, it was also a further bond.

2. W. E. Lingelbach, *The Merchant Adventurers of England: Their Laws and Ordinances with Other Documents* (New York, 1971), p. xxix.

3. Kenneth Andrews, *Trade, Plunder & Settlement* (Cambridge, 1999), p. 6.

4. W. E. Lingelbach, *The Merchant Adventurers of England*, p.xxix.

5. Kenneth Andrews, *Trade, Plunder & Settlement*, p. 63.

6. W. E. Lingelbach, *The Merchant Adventurers of England*, pp. xvi, 6.

7. Wheeler, *Treatise of Commerce* (London, 1601), p. 25.

8. W. E. Lingelbach, *The Merchant Adventurers of England*, p. 6.

9. G. D. Ramsay, *The City of London* (Manchester, 1964), pp. 6-7.

10. Raymond de Roover, *An Elizabethan Manuscript: Text of Gresham on The Understanding of Foreign Exchange* (London, 1949), p. 22.

11. Ibid., pp. 8-9. See also Chaloner to Cecil, August 31, 1559 and KL, II, 8–9.

12. Ibid., p. 68.

13. Ibid., p. 69. See also Albert Feavearyear, *The Pound Sterling* (Oxford, 1963), p. 79.

14. Ibid.

15. The key to Antwerp's commercial success was the atmosphere of tolerance that had been guaranteed as an ancient right. Europe's oppressed peoples, like the Jews, flocked there and rebuilt their fortunes.

16. Kenneth Andrews, *Trade, Plunder & Settlement*, p. 68. Also see William Cunningham, *Growth of English Industry and Commerce*, vol. 2 (Cambridge, UK, 1882), p. 136, n. 2.

17. Baron Kervyn Lettenhove has calendared the State Papers of the Low-Countries in *Les Relations des Pays Bas et l'Angleterre*, which shows in fine detail the erosion of these privileges of tolerance.

18. J. Denucé, *Les Lettres des Marchands d'Anvers* (Brussels, 1961), pp. 267–268

19. Philip II's "proposal" to Elizabeth shortly after her accession was at best halfhearted. The defender of the Catholic faith, and according to Gregory XIII, "more Catholic than the pope," could barely bring himself to issue the offer of marriage to the heretic Queen Elizabeth.

20. At the time of Mary's death, her debt was £65,069; this was much more than existed in England's exchequer. This equates approximately to £10.09 million or $18.66 million today.

21. Philip also rightly believed that by marrying Elisabeth of France that the French threat against the Spanish Netherlands had naturally receded.

22. W. E. Lingelbach, *The Merchant Adventurers of England*, p. xviii.

23. Richard Hakluyt, *Principall Navigations*, vol. 2, pp. 212–214; Kenneth Andrews, *Trade, Plunder & Settlement*, p. 64.

24. Kenneth Andrews, *Trade, Plunder & Settlement*, p. 65.

25. Ibid., p. 68.

26. Richard Hakluyt, *Discoveries of Muscovy*, London (1589 edition), pp. 26–32.

27. Ibid.

28. Kenneth Andrews, *Trade, Plunder & Settlement*, pp. 19-20.

29. Ibid., pp. 68, 81.

30. *CSP—Foreign*, p. 59, no 112, April 14, 1561.

31. Ibid., p. 90, no 156, April 30, 1561.

32. Ibid., p.102, no 184, May 6, 1561.

33. Ibid., pp. 126–127, no. 217

34. Richard Hakluyt, *Principall Navigations*, vol. 3., p. 38.

35. Julian A. Corbett, *Drake and the Tudor Navy* (London, 1988), pp. 71-72

36. Raleigh quoted from A. G. Lee, *The Son of Leicester: The Story of Sir Robert Dudley*, (London, 1964), p. 61.

37. The term "privateer" was not invented until the eighteenth century. Despite the trend since the nineteenth century to use it to describe Elizabethan seamen, I try to avoid it for a more accurate historical depiction.

Chapter 6. *The Politics of Piracy, Trade, and Religion*

1. G. Parker, *The Grand Strategy of Philip II* (New Haven, 2000), p. 150.

2. *CSP—Spain*, vol. 1, 1558–1567, p. 234, no. 158. Bishop Quadra to Cardinal de Granvelle, London, April 2, 1562.

3. G. Parker, *The Grand Strategy of Philip II*, p. 118

4. Ibid., p. 117. See also Groen van Prinsterer, *Archives*, 1st series, I, 152, Granvelle to Philip II, March 10, 1563.

5. G. Parker, *The Grand Strategy of Philip II*, pp. 120–123.

6. Ibid.

7. G. D. Ramsay, *The City of London* (Manchester, 1964), p. 137.

8. Ibid.

9. Ibid. c.f. SP 70/39/200. Tipton to Chaloner, July 4, 1562.

10. The "lines of amity" meant European waters. While the pope had divided the world between Portugal and Spain in the previous century, successive Tudor monarchs had never bought into the idea that all other nations, and especially England, should not be allowed to trade in Portuguese and Spanish waters.

11. This becomes more comprehensible when we consider that Philip II had the best claim to the Portuguese throne should Sebastian die childless. Also see, G. Parker, *The Grand Strategy of Philip II,* p. 123.

12. Nick Hazlewood, *The Queen's Slave Trader* (New York, 2005), p. 53

13. Ibid.

14. *CSP—Foreign*, 1562, no. 18.

15. N. A. M. Rodger, *Safeguard of the Sea* (London, 2004), pp. 199-200.

16. Ibid., p. 195.

17. N. Hazlewood, *The Queen's Slave Trader* (New York, 2005), p. 199.

18. N. A. M. Rodger, *Safeguard of the Sea,* p. 198.

19. Ibid.

20. R. B.Wernham, *Before the Armada* (London, 1966), p. 279.

21. *CSP—Spain*, vol. 1, p. 322 (de Quadra to Philip)

22. G. D. Ramsay, *The City of London,* p. 116.

23. *CSP—Spain*, vol. 1, p. 239, no. 31.

24. National Archives, SP Foreign, Elizabeth, 70/41/503, fols. 239r-241r. Written in Cecil's secretary's hand, though definitely Elizabeth's words. Postscript written by Cecil.

25. *CSP—Spain*, vol. 1, 1558–1567, p. 234, no. 158.

26. Ibid.

Chapter 7. *Raising the Stakes*

1. N. Hazlewood, *The Queen's Slave Trader*, p. 54.

2. J.A., Corbett, *Drake and the Tudor Navy* (Aldershot, England, 1988 Centenary imprint), p. 71.

3. *CSP—Venice*, vol. 2, pp. 207–208.

4. J.A. Corbett, *Drake and the Tudor Navy*, p. 75

5. Ibid., p. 79.

6. N. A. M. Rodger, *Safeguard of the Sea* (London, 2004), p. 322.

7. "Pease" were dried lentils made into porridge. The nursery rhyme, "Pease porridge hot, pease porridge cold, pease porridge in the pot, nine days old," may well have had its origins among the sea shanties that were sung at this time.

8. N. A. M. Rodger, *Safeguard of the Sea*, p. 198.

9. Ibid., p. 199.

10. Nick Hazlewood, *The Queen's Slave Trader* (New York, 2005), p. 54.

11. G. Parker, *The Grand Strategy of Philip II* (New Haven, 2000), pp. 117–119.

12. Nick Hazlewood, *The Queen's Slave Trader*, p. 53.

13. Richard Hakluyt, *Principall Navigations* (London, 1598), p. 522. Also see H. Kelsey, *Sir John Hawkins* (New Haven, 2003), p. 12.

14. Ibid.

15. Slave trading, begun and heavily taxed by the Spanish and the Portuguese, was considered not only a legitimate but also humane activity to replace the Native American populations decimated by war, famine, and disease. For a brilliant account of the reasons for conquest of southern America by the Spanish, read Jared Diamond's Pulitzer Prize-winning book, *Guns, Germs and Steel* (New York, 1997).

16. Kenneth Andrews, *Trade, Plunder & Settlement* (Cambridge, 1999), p. 117.

17. Nick Hazlewood, *The Queen's Slave Trader*, p. 57.

18. Ibid.

19. H. Kelsey, *Sir John Hawkins,* p. 15. See also N. Hazelwood, *The Queen's Slave Trader*, pp. 50–51. Agreed taxes in Corbett, *Drake and the Tudor Navy*, p. 88.

20. *CSP—Foreign*, no 1136, pp. 497–498.

21. H. Kelsey, *Sir John Hawkins*, p. 17.

22. William Monson, *Sir William Monson's Tracts* (London, 1625), vol. 2, pp. 247–248.

23. Kenneth Andrews, *Trade, Plunder & Settlement*, pp. 107–108. See also *CSP—Foreign*, 1562, no. 18.

24. H. Kelsey, *Sir John Hawkins*, p. 16.

25. *DNB* (biography on Stucley).

26. *CSP—Spain*, vol. 1, p. 322 (de Quadra to Philip).

27. *CSP—Spain*, vol. 3, p. 349.

28. *CSP—Foreign*, 1564–1565, p. 272.

29. G. D. Ramsay, *The City of London*, chapter 8 relating to Emden.

Chapter 8. *Cunning Deceits*

1. *CSP—Spain*, vol. 1, p. 352.
2. *APC*, p. 146.
3. Ibid., pp. 373–374.
4. Nick Hazlewood, *The Queen's Slave Trader* (New York, 2005), p. 91.
5. Julian A. Corbett, *Drake and the Tudor Navy* (Aldershot, England, 1988 Centenary imprint), p. 84.
6. *CSP—Spain,* vol. 1, pp. 373–374.
7. Ibid.
8. G. D. Ramsay, *The City of London* (Manchester, 1964), p. 238.
9. See Ibid., chapter 8, pp. 251–283.
10. *APC*, pp. 154–156. There were eight securities that were "canceled" by the queen, some of which were on behalf of the City of London. At the time of cancellation, the queen owed well in excess of 800,000 Fl, or £200,000 ($6.87 billion or £4.04 billion today) or a year's entire exchequer receipts.
11. *APC*, pp. 157–158.
12. G. Parker, *The Grand Strategy of Philip II* (New Haven, 2000), p. 28. This grew to over 2,000 by the 1590s.
13. *CSP—Spain*, vol.1, pp. 383–384. The sums owed by the queen far exceeded what de Silva had gleaned, but the rates of interest did not exceed 10 percent.
14. J.S. Corbett, *Drake and the Tudor Navy*, pp. 84–85. See also N. Hazlewood, *The Queen's Slave Trader*, pp. 94–95.
15. John W. Blake, *West Africa, Quest for God and Gold—1454–1578* (London, 1977), p. 107.
16. Ibid., p. 138.
17. BL, Lansdowne MS 171, ff. 148–9.
18. Nick Hazlewood, *The Queen's Slave Trader*, p. 95 as quoted from Richard Hakluyt's *Principall Navigations* (London, 1598).
19. Lodge had been caught at the wrong end of the financial cycle in Antwerp, and had been propped up by the queen herself to join in on this expedition in the hope of avoiding bankruptcy.
20. Nick Hazlewood, *The Queen's Slave Trader,* p. 97.
21. H. Kelsey, *Sir John Hawkins* (New Haven, 2003), p. 20.
22. Ibid. The brigantines, small light craft, usually carried explosives and other highly flammable and unstable stores at sea, and were used for close onshore work in unfamiliar harbors since they had a very shallow draft.

23. See Dava Sobel's fabulous book *Longitude* (London, 1998). On page 14, she explains for the uninitiated "dead reckoning" better than anyone else when she writes, "The captain would throw a log overboard and observe how quickly the ship receded from this guidepost. He noted the crude speedometer reading in his ship's logbook, along with the direction of travel, which he took from the stars or a compass, and the length of time on a particular course, counted with a sandglass or a pocket watch. Factoring in the effects of ocean currents, fickle winds, and errors in judgment, he then determined his longitude. He routinely missed the mark."

24. H. Kelsey, *Sir John Hawkins*, p. 20.

25. Ibid., p. 21.

26. In Richard Hakluyt's *Principall Navigations*, see John Sparke, "Voyage Made by the Worshipful J. Hawkins," p. 523.

27. H. Kelsey, *Sir John Hawkins*, p. 22.

28. H. Kelsey, *Sir John Hawkins*, p. 23.

29. Ibid.

30. *CSP—Foreign*, pp. 15–20.

31. Ibid., p. 24. See also National Archives, MS SP 70/99, fols. 4–5v.

32. In Richard Hakluyt's *Principall Navigations*, see John Sparke, "Voyage Made by the Worshipful J. Hawkins," p. 523.

33. H. Kelsey, *Sir John Hawkins*, p. 26. See also letter from Hawkins to Alonso Bernáldez dated April 16, 1565, AGI Justicia 93, fol. 88v.

34. Ibid. See also John Sparke, "Voyage Made by the Worshipful J. Hawkins," in Richard Hakluyt's *Principall Navigations*.

35. Ibid., p. 28. See also N. Hazlewood, *The Queen's Slave Trader*, pp. 122–130 for a detailed account.

36. Nick Hazlewood, *The Queen's Slave Trader*, p. 127–128.

Chapter 9. *The Gloves Are Off*

1. J. S. Corbett, *Drake and the Tudor Navy* (Aldershot, England, 1988 Centenary imprint), p. 89.

2. Ibid., p. 90.

3. Nick Hazlewood, *The Queen's Slave Trader* (New York, 2005), p. 139.

4. Kenneth Andrews, *The Spanish Caribbean* (London, 1978), p. 91.

5. Kenneth Andrews, *Trade, Plunder & Settlement* (Cambridge, 1999), p. 76.

6. *APC*, October 11, 1565, p. 267.

7. C. Brady, *The Chief Governors of Ireland* (Dublin, 2004), pp. 6–7.

8. Ibid., p. 118. See also Henry Sidney's *Articles*, May 20, 1565, SP 63/13/46.

9. Kenneth Andrews, *The Spanish Caribbean*, p. 109.

10. James Williamson's *Sir John Hawkins* (Oxford, 1927) believes that the goal was for a less reprehensible trade in textiles. Many experts believe that Professor Williamson's slant on matters could be colored by the fact that he is a descendant of Hawkins's.

11. *CSP—Spain*, vol. 1, p. 494.

12. Nick Hazlewood, *The Queen's Slave Trader,* p. 145.

13. Ibid., p. 148.

14. Ibid., pp. 152–153.

15. H. Kelsey, *Sir John Hawkins* (New Haven, 2003), p. 39. See also, SP 12/40/99, f.211.

Chapter 10. *Lovell's Lamentable Voyage*

1. H. Kelsey, *Sir John Hawkins* (New Haven, 2003), p. 41.

2. John Sugden, *Sir Francis Drake* (London, 1996), p. 19. See also, Conway Papers Manuscript, "Confession of Michael Morgan, January 1574." Add MS 7235.

3. Ibid., p. 20.

4. *CPR*, Edward, Second Year of his Reign, No. 893. Dated Westminster. 18 Dec 1548.

5. H. Kelsey, *Sir John Hawkins,* p. 43.

6. L. S. Marcus, *Elizabeth I Collected Works*, *c.f.* SP Scotland, Elizabeth 52/13/17, f. 30r (copy of the French original).

7. H. Kelsey, *Sir John Hawkins*, p. 44.

8. Ibid.

9. Ibid., p. 45. See also N. Hazlewood, *The Queen's Slave Trader* (New York, 2005), pp. 157–158.

10. Ibid., p. 46.

11. Ibid.

Chapter 11. *The Troublesome Voyage of John Hawkins*

1. John Sugden, *Sir Francis Drake* (London, 1996), p. 23.

2. In the testimonies of the captured sailors given before the Inquisition, Godard frequently appears as "Antonio Tejida," since he was a dealer in woollen cloth, or *tejido*. Most of the Englishmen who were captured, or of whom the prisoners spoke, had their names corrupted through Spanish transcription. Aside from the obvious Juan Aquinas—John

Hawkins—there were names like Juan Brun (easily identifiable as John Brown) and the more esoteric Enrique Quince (Henry Quin) and Jorge Fizullens (George Fitzallen).

3. Nick Hazlewood, *The Queen's Slave Trader* (New York, 2005), p. 181.

4. Kenneth Andrews, *The Spanish Caribbean* (London, 1978), pp. 122–123.

5. There are so many great accounts of this incident. See N. Hazlewood's *The Queen's Slave Trader*, p. 185, for the most detailed account. Also see H. Kelsey's *Sir John Hawkins* (New Haven, 2003), p. 57 and J. Sugden's, *Sir Francis Drake*, p. 24. It is also recounted in Richard Hakluyt's *Principall Navigations* (London, 1598).

6. In N. Hazlewood's *The Queen's Slave Trader*, pp. 188–189. In J. Sugden's *Sir Francis Drake*, pp. 24–25.

7. John Sugden, *Sir Francis Drake*, pp. 26–27.

8. N. Hazlewood, *The Queen's Slave Trader*, p. 214

9. Kenneth Andrews, *The Spanish Caribbean*, p. 101. Although Hawkins and the Spanish didn't know about the Spanish being massacred in Florida, the French under Dominique de Gourgues certainly did. De Gourgues left the message behind at St Johns, "je ne fais ceci comme aux Espagnols, ni comme aux Marranos, mais comme aux traitres, voleurs et meurtriers." (I am not doing this either to Spaniards or Marranos, but to traitors, thieves and murderers.)

10. Nick Hazlewood, *The Queen's Slave Trader*, pp. 215–216.

11. Ibid., p. 217.

12. Richard Hakluyt, *Principall Navigations*, vol. 9, p. 449. See also Kenneth Andrews, *The Spanish Caribbean*, p. 124.

13. BL, Cotton MSS, Otho E. VIII, f. 36. Otho E VIII is the most fabulous source of West Indian exploits of the 1560s.

14. Nick Hazlewood, *The Queen's Slave Trader*, pp. 233–239.

15. Ibid.

16. Ibid., p. 240. See also Kenneth Andrews, *The Spanish Caribbean*, pp. 125–126.

17. Ibid., p. 241. See also, Julian Corbett, *Successors of Drake* (London, 1900), pp. 56-133.

18. Ibid., p. 246. See also Kenneth Andrews, *Elizabethan Privateering* (Cambridge, UK, 1964), pp. 32–34.

Chapter 12. *The Queen and Alba's Pay Ships*

1. Shane O'Neill had been importing Scots mercenaries known as "red-shanks" to populate the northeast coast of Ulster and fight alongside him. So long as Mary remained on Scotland's throne, this represented a double danger to England's borders.

2. Julian A. Corbett, *Drake and the Tudor Navy* (Aldershot, England, 1988 Centenary imprint), p. 121.

3. Philip II did, in fact, have a very legitimate claim to the English throne. His next ambassador, Bernardino de Mendoza, penned a rather over-zealous defense of Philip's claim as a direct descendant from John of Gaunt, which did nothing to endear either of them to Elizabeth or her Councillors.

4. G. Parker, *The Grand Strategy of Philip II* (New Haven, 2000), pp. 120–122.

5. *CSP—Spain*, vol. 2, p. 29.

6. *CSP—Venice*, vol. 3, p. 423, dated May 7, 1568.

7. R. B. Wernham, *Before the Armada*, pp. 290–292.

8. G. Parker, *The Grand Strategy of Philip II*, p. 123. (Alba to Philip II, January 6, 1568).

9. *CSP—Spain*, vol. 2, p. 83.

10. Ibid., p. 90.

11. Ibid., p. 95.

12. Julian A. Corbett, *Drake and the Tudor Navy*, p. 124.

13. *CSP—Spain*, vol. 2, p. 99–100.

Chapter 13. *The Cost of Failure*

1. AGI Patronato 265, Ramo, 13, fol. 25v. Testimony of Juan de la Torre, February 28, 1569.

2. J. Hawkins, *Troublesome Voyadge,* fol. B. vii.

3. J. Hampden (ed.), *Francis Drake Privateer*, (London, 1972), p. 45. Hawkins's reasons for tempering his criticism by not mentioning Drake by name are many. It is tempting to hope that one of them was that for Drake's silence about Hawkins's lack of clear course of action to follow in the event of attack, the young Drake again found favor with his more "experienced" cousin. This early stain on Drake's record, however, stuck, and was trotted out many years later by both Martin Frobisher and William Borough as an alleged "proof" of cowardice. Drake's subsequent record speaks volumes for itself.

4. SP 12/53, f. iv-7. See also printed version in E. Arber's *An English Garner*, (London, 1903), pp. 104–126.

5. Hawkins, naturally, exaggerated his losses in several ways. The most glaring and provable of which is the fact that the *peso de oro* was exchanged at 3 to the pound sterling, not 25p to the pound, as he accounts here.

6. *CSP—Foreign*, vol. 5, p. 436.

7. Ibid., pp. 437–438.

Chapter 14. *Undeclared Holy War*

1. J. Corbett, *Drake and the Tudor Navy* (Aldershot, England, 1988 Centenary reprint), vol. 1, p. 148.
2. J. Hampden (ed.), *Sir Francis Drake Privateer*, (London, 1972), p. 46.
3. J. Corbett, *Drake and the Tudor Navy*, vol. 1, p. 126.
4. Ibid., pp. 126–127.
5. *CSP—Rome*, vol. 1, p. 328.

Chapter 15. *Drake's War*

1. J. Corbett, *Drake and the Tudor Navy* (Aldershot, England, 1988 Centenary reprint), vol. 1, p. 146.
2. John Sugden, *Sir Francis Drake* (London, 1996), p. 45.
3. MS Ashmole 830, unnumbered folio. See also Irene A. Wright's *Documents Concerning English Voyages to the Spanish Main 1569–1580* (London, 1973) vol. 1, docs. 5-13. In Kelsey's biographical sketch in the *DNB*, he claims that this voyage was funded by William Winter and his brother, George. Sugden believes it was Hawkins. In light of this original manuscript, coupled with Irene Wright's meticulous translations in *Documents*, and Drake's mini-celebrity status in Plymouth at the time, there is little reason to disbelieve that Richard Dennys and other Devon merchants backed this relatively inexpensive voyage. Taken into consideration with Drake's dubious reputation on his return in 1569, it makes sense.
4. John Sugden, *Sir Francis Drake*, pp. 45–46.
5. J. Hampden (ed.), *Sir Francis Drake Privateer*, (London, 1972), pp. 46–47.
6. John Sugden, *Sir Francis Drake*, (London, 1996), p. 48.
7. Ibid., p. 50.
8. Ibid., p. 51. See also Irene A. Wright, *Documents Concerning English Voyages*, vol. 1, docs. 31–35.
9. It is safer to take this estimate rather than the sum of the other estimates provided earlier in the chapter by Drake, and also the estimate of £100,000 provided in the *DNB*. The lord admiral, Customs & Excise, and Drake's crew and partners received their shares based on the £66,000.

Chapter 16. *The Dread of Future Foes*

1. "Doubt" in this instance, per the *OED*, means "dread."
2. FSL, MS V.b. 317, fol. 20 vol. 1. It is assumed that this poem was written on the discovery of the Ridolfi plot, the betrayal by the queen's cousin, the Duke of Norfolk, and Mary's involvement from her castle prison.

3. *CSP—Rome*, pp. 337, 379.

4. BL, MS Cotton Caligula, C. III, fol. 145r.

5. A. Stewart, *Philip Sidney*, (London, 2004), p. 200.

6. *DNB*, William Herbert, Earl of Pembroke biography. He had been an investor in Hugh Willoughby's northeast passage adventure in the 1550s, the Hawkins voyages, and was a principal shareholder in the mines royal and mineral and battery companies. Note that later, Sir Henry Sidney's daughter, Mary, would become the second wife of the Earl's son and heir.

7. *CSP—Rome*, p. 374.

8. *DNB*, Sir Lionel Duckett.

9. Raymond de Roover, *Gresham on Foreign Exchange*, (Cambridge, USA, 1999), p. 27.

10. Ibid.

11. Ibid. See pages 22–25 for an explanation of the Gresham accounts. His accounts hadn't been audited for the eleven years prior to his retirement as the queen's factor, and were estimated to be £10,000 ($3.4 million or £2 million today) understated. In order to get around the potential problem of reimbursement—since the money had already been earmarked for the Royal Exchange—Gresham cleverly approached the queen through Leicester during her Kenilworth visit in the summer of 1573, where the queen magnanimously (and uncharacteristically) wrote off the amount.

12. R. B. Wernham, *The Making of Elizabethan Foreign Policy* (Berkeley, 1980), p. 33.

13. England voluntarily abandoned all Guinea trade and slave trade from 1572 until it was resumed in 1650.

14. A. F. Pollard, *History of England 1547–1603*, pp. 305, 331–332.

15. C. W. Previté-Orton (ed.), *The English Historical Review*, vol. XLVI, 1931, "Queen Elizabeth, The Sea Beggars, and the Capture of Brill, 1572," p. 38.

16. Ibid.

17. Ibid., p. 39.

18. *DNB*, sketch biography of Sir Humphrey Gilbert.

19. A. Stewart, *Sir Philip Sidney* (London, 2004), p. 84.

20. BL, MS Additional 30156, fol. 437r-440r.

Chapter 17. *Drake at the Treasure House of the World*

1. The *Pasco* is sometimes referred to as the *Pascha*.

2. Whether his investment took the form of giving the *Pasco* to Drake, or in the fitting out costs, is unclear.

3. J. Hampden (ed.), *Sir Francis Drake Revived* (London, 1954), p. 55.

4. Ibid., p. 57. Also see J. Sugden, *Sir Francis Drake* (London, 1996), p. 55.

5. John Sugden, *Sir Francis Drake*, p. 55.

6. Ibid., pp. 55–56. Drake always treated his hostages and prisoners as well as possible, but there is no doubt that he felt truly badly for the lives that the Negro slaves were made to endure, as evidenced by his subsequent behavior.

7. Ibid.

8. J. Hampden (ed.), *Sir Francis Drake Revived*, pp. 60–61. Drake's wound was most likely a flesh wound, but he did lose a large amount of blood.

9. Ibid., p. 64.

10. Ibid.

11. John Sugden, *Sir Francis Drake*, p. 58. The testimony of the eyewitness García de Paz is generally now thought to have been exaggerated.

12. Ibid., p. 65.

Chapter 18. *From a Treetop in Darien*

1. The Pacific Ocean was interchangeably called the South Atlantic, West Sea, the Southern Sea, the South Sea, or even the Spanish Lake, but never, as yet, the Pacific.

2. J. Hampden, (ed.), *Sir Francis Drake Revived* (London, 1954), p. 64. Diego is mentioned more in J. Hamden's *Sir Francis Drake Revived* than anyone else, save the captain himself and his brother, John.

3. John Sugden, *Sir Francis Drake* (London, 1996), p. 59.

4. Ibid., p. 62, quoted from J. Hampden's *Sir Francis Drake Revived*.

5. Ibid., p. 64, quoted from J. Hampden's *Sir Francis Drake Revived*.

6. J. Hampden (ed.), *Sir Francis Drake Revived*, p. 85. The momentous date was February 11, 1573. While the Spaniards and some Portuguese had long known the significance of the Isthmus of Panama, this "open secret" hadn't been seen by any other European before this date.

7. Ibid.

8. Ibid.

Chapter 19. *Success at a Cost*

1. John Sugden, *Sir Francis Drake* (London, 1996), p. 68. The rider had seen one of Oxenham's men, a fellow named Robert Pike, stand up in the undergrowth. Pike had allegedly drunk too much neat aqua vitae the night before.

2. J. Hampden (ed.), *Sir Francis Drake Revived* (London, 1954), p. 91.

3. Ibid., p. 92.

4. J. Corbett, *Drake and the Tudor Navy* (Aldershot, England, 1988 Centenary reprint), p. 184. Also see J. Sugden, *Sir Francis Drake*, p. 71. Strozzi was more than a "mercenary soldier" as depicted in these texts. The family had been merchant princes for at least a hundred years, and the Strozzi were bankers to Henry III, who succeeded Charles IX as King of France. See S. Ronald, *The Sancy Blood Diamond* (New York, 2004), pp. 48, 62, 87, 88, 92, 93.

5. Kenneth Andrews, *Trade, Plunder & Settlement* (Cambridge, 1999), p. 131.

6. John Sugden, *Sir Francis Drake*, p. 72.

7. Ibid.

8. Ibid., p. 73.

Chapter 20. *Dr. Dee's Nursery and the Northwest Passage*

1. John Sugden, *Sir Francis Drake* (London, 1996), p. 79.

2. Sir Francis Knollys held a position of great trust with Elizabeth. Married to her beloved cousin, Catherine, he had been chosen to guard Mary, Queen of Scots, when she fled to England in 1568. His daughter, Lettice, married Robert Dudley, Earl of Leicester, shortly after Walter Devereux's death. It was an open secret that Lettice, reputed to be the greatest beauty at court, and Leicester were lovers while Essex was bogged down in Ireland.

3. B. Woolley, *The Queen's Conjurer* (New York, 2001), pp. 97–123. The entire chapter relates to Dee's position within the adventurer community and how important his influence was.

4. The Mercator Principle is still used by NASA today.

5. N. Crane, *Mercator* (London, 2003), p. 164. Cf. R. Deacon, *John Dee Scientist, Geographer, Astrologer and Secret Agent to Elizabeth I* (London, 1968). Nicholas Crane's *Mercator* is a marvelously good read, even for those bored by geography.

6. BL, MS Cotton Charter XIII, art. 39.

7. Ambassador de Spes had been recalled hastily in January 1570 since he had failed miserably as an "ambassador" in England. Whether this was to protect him from his reported involvement in the Ridolfi plot or not is open to interpretation.

8. *DNB*, biography on Richard Grenville. Interestingly, Grenville's father was the master aboard the *Mary Rose*, which sank in July 1545 as she was launched in the Solent, and had been built as Henry VIII's greatest battleship.

9. Kenneth Andrews, *Trade, Plunder & Settlement* (Cambridge, 1999), p. 140.

10. Ibid., p. 168. Walsingham had most likely been an investor since 1562, when he married Anne Carleill, daughter of Sir George Barnes, who was one of the founding counselors in 1555, the year the Muscovy Company was founded. Anne's first husband, Alexander Carleill, held stock in the company in his own name prior to his death, and these shares, along with any that Sir George Barnes would leave to her, would have been controlled by Walsingham.

11. *DNB*, biography of Michael Lok.

12. R. Collinson, Stefansson and McCaskill, *The Three Voyages of Martin Frobisher* (London, 1938), vol. 2, pp. 215–223, Cf. State Papers E/351. Also see B. Woolley, *The Queen's Conjurer*, pp. 102–103.

13. Kenneth Andrews, *Trade, Plunder & Settlement*, pp. 169–170.

14. Ibid., p. 171.

15. B. Woolley, *The Queen's Conjurer*, Cf. E. G. Taylor's *Tudor Geography*, (London, 1930), p. 97.

16. Ibid., p. 105. Cf. *Tudor Geography* (London, 1930), document ix, pp. 262–263.

17. Kenneth Andrews, *Trade, Plunder & Settlement*, p. 172. Cf. R. Collinson (ed.), *Three Voyages of Frobisher*, p. 83.

18. The passage does exist, but is iced over most of the time. In 1845, the best-equipped expedition to date set out, and all its mariners died in the attempt. It was successfully navigated only between June 13, 1903, and August 26, 1905, by Norwegian explorer Roald Amundsen, in a small fishing boat, *The Jonah*, along with a crew of seven men.

19. Ibid., p. 173. Cf. R. Collinson (ed.), *Three Voyages of Frobisher* (London, 1867), p. 87.

20. Richard Hakluyt, *Principall Navigations* (London, 1598), vol. 7, p. 283.

Chapter 21. *Dark Days at Rathlin Island*

1. C., Brady, *The Chief Governors of Ireland* (Dublin, 2004), pp. 259–260.

2. BL MS Additional 48015, f. 319–320.

3. Ibid., f. 329.

4. NA SP63/51, f. 19, 20.

5. John Sugden, *Sir Francis Drake* (London, 1996), p. 85.

6. NA SP 63/54, f. 126.

7. When Essex died so rapidly and so violently on his return to Ireland, many whispered that Leicester had somehow perpetrated the heinous crime—just as he was alleged to have killed his first wife, Amy Robsart. Nothing was ever proven, and history has not given Essex's death any nefarious postmortem.

Chapter 22. *Drake's Perfect Timing*

1. Elizabeth had been deeply wounded by Leicester's affair with Lettice Devereux, née Knollys, and had most likely heard the rumors spread at court by Mendoza, the Spanish ambassador, and others, that Lettice had had two illegitimate children by Leicester during Devereux's first term in Ireland. I haven't been able to find that Devereux himself had made any such discovery. It is, however, significant that after the two failed French matches (with Henry III of France and his younger brother Francis), which Leicester opposed, the queen should be extremely jealous of his attentions wandering elsewhere. Lettice Devereux, Countess of Essex, and Robert Dudley, Earl of Leicester, were married in 1580, and she gave birth to Leicester's first legitimate male heir in April 1581.

2. H. Kelsey, *Sir John Hawkins* (New Haven, 2003), pp. 150–152. Interestingly, the episode with Fitzwilliams shows how Hawkins misled the very man who had been sent to do his bidding with Philip II, giving us great insight into how loyalties in Elizabethan England were subject to the prevailing wind.

3. BL MS Lansdowne 113, no. 14, f. 45–47. The manuscript is undated, but describes repairs made in 1577.

4. H. Kelsey, *Sir John Hawkins*, p. 153.

5. V. M. Shillington and A. B. W. Chapman, *Commercial Relations of Portugal* (London, 1907), pp. 140–144.

6. Kenneth Andrews, *Trade, Plunder & Settlement*, pp. 88–89.

7. Richard Hakluyt, *Principall Navigations* (London, 1598), vol. 5, pp. 168–169.

8. Kenneth Andrews, *Trade, Plunder & Settlement*, p. 90.

9. John Dee, *A Petty Navy Royal* (printed version from E. Arber's *An English Garner* [London, 1903]), p. 47.

10. Ibid., p. 49.

11. Ibid.

12. Derek Wilson, *Sweet Robin* (London, 1981), p. 224.

13. John Sugden, *Sir Francis Drake*, pp. 93–94.

14. Magellan's master gunner was English, and John Oxenham would have preceded him.

15. Derek Wilson, *Sweet Robin*, p. 94.

16. John Sugden, *Sir Francis Drake*, pp. 95-96.

17. Francis Drake, *Sir Francis Drake Revived* (London, 1954), pp. 112–113.

Chapter 23. *The Northwest and the Company of Kathai*

1. S. A. Pears (ed.), *Correspondence of Sir Philip Sidney* (London, 1845), p. 144.

2. Kenneth Andrews, *Trade, Plunder & Settlement* (Cambridge, 1999), pp. 174–175.

3. It is probably significant that the names of the ships were the *Michael* and *Gabriel*, both of whom were, of course, archangels. By this time, Dr. Dee's occult experiments had already progressed, and both names would become increasingly important to his work in the ensuing decades.

4. George Clifford, third Earl of Cumberland, was affectionately referred to by Elizabeth as her "rogue."

5. *CSP—Domestic*, 1547–1580, pp. 536–538, no. 81, undated but presumed to be March or April 1577.

6. Kenneth Andrews, *Trade, Plunder & Settlement* (Cambridge, 1999), p. 175.

7. As part of local folklore, the Inuit verbally passed down from generation to generation that the Englishmen built themselves a kayak, and rowed away.

8. Dr. Burchet is a figure of some mystery. His name is spelled in very different ways—even for Elizabethans—and some believe that he may not have even existed.

9. Richard Hakluyt, *Principall Navigations* (London, 1598), vol. 7, 284–286. Also see E164/35.

10. Ibid., vol. 7, p. 334.

11. Ibid., vol. 7, p. 336. Frobisher had been accused at the time of never reaching the coast of North America. The remnants of the Frobisher expeditions were found in the 1861–2 expedition of American explorer Charles Francis Hall, though the artifacts Hall found have since vanished. Hall also documented an Inuit legend handed down from generation to generation that the five lost Englishmen built themselves a boat, and sailed away. See Kenneth Andrews, *Trade, Plunder & Settlement*, p. 177, note 26.

12. G. Beste, *A True Discourse of the Late Voyages of Martin Frobisher . . .* (London, 1578), p. 236.

13. *CSP—Colonial*, p. xii.

14. Ibid., p. 58, no. 142.

Chapter 24. *In the Shadow of Magellan*

1. Samuel Taylor Coleridge, *More Light on Drake* (London, 1907), p. 150, report of Robert Winter, June 2, 1579.

2. N. A. M. Rodger, *Safeguard of the Sea* (London, 2004), p. 322.

3. J. Calvar Gross, *La Batalla del Mar Océano* (Madrid, 1988), I, p. 155.

4. John Sugden, *Sir Francis Drake* (London, 1996), p 104. C.f. W.S.W Vaux, *The World Encompassed by Sir Francis Drake* (London, 1854), p. 173.

5. Trumpeters had special functions aboard ships. All ships that Drake was on had a drum, fife, and at least one trumpeter. The trumpeter "should have a silver trumpet, and himself and his noise to have banners of silk of the admiral's colours. His place is to keep the poop, to attend to the general's going ashore and coming aboard, and all other strangers or boats, and to sound as an entertainment to them, as also when they hail a ship, or when they charge, board or enter her . . . " Cf. William Mason, *Sir William Monson's Tracts,* vol.4, p. 57.

6. John Sugden, *Sir Francis Drake*, p. 104.

7. Ibid., Cf. W. S. W. Vaux, *The World Encompassed by Sir Francis Drake* (London, 1854), p. 199.

8. Ibid., p. 110.

9. Ibid., pp. 113–114.

Chapter 25. *Into the Jaws of Death*

1. Francis Drake's account in *The World Encompassed* (London, 1628), p. 150.

2. Ibid. The hind was in the family crest of the Hatton family. There is an interesting aside I would like to make here. The beautiful portrait of Elizabeth known as *The Pelican Portrait* was painted c. 1576. It is possible, according to the Liverpool Museum of Art, that this was painted the following year. If this is, in fact, the case, then I would argue that the queen—the greatest lover of symbolism of her age—had this portrait painted as a symbol of purity, while she had sent Drake forth in the *Pelican* to plunder the King of Spain.

3. Ibid., p. 152.

4. Ibid.

5. Ibid.

6. Ibid.

7. John Sugden, *Sir Francis Drake* (London, 1996). It was the fastest time through the straits that century. Loyasa took four months, Thomas Cavendish forty-nine days, and Richard Hawkins forty-six days.

8. Ibid., pp. 116–117.

9. It was William Cornelius Shouten Van Hoorn who would name Cape Horn in 1616.

Chapter 26. *The Famous Voyage*

1. J. Calvar Gross, *La Batalla del Mar Oceáno* (Madrid, 1988), vol. 1, pp. 319–320. During this same period, on his voyage of circumnavigation alone, Drake took a minimum of eleven ships by the time he plundered the *Cacafuego*. It is difficult to estimate the exact number, since in the harbor of Callao there were between nine and thirty ships, depending on which account you read. For the purposes of simplicity, I am counting *all* the ships in Callao harbor and Paita harbor as one ship in each of those ports. This, of course, means that the original State Paper source from Spain clearly underestimates Drake's depredations and any possible undocumented English piracies in the Channel.

2. S. Ronald, *The Sancy Blood Diamond* (New York, 2004), pp.76–79.

3. John Sugden, *Sir Francis Drake* (London, 1996), p. 120.

4. F. Drake, *The World Encompassed*, p. 164.

5. According to Sugden, the exchange rate between the GBP and the *peso de oro* was 8 shillings 3 pence (prior to decimalization). This rounds off to .4075 pence today. Since rates of exchange vacillated then, as now, the rate of exchange between foreign currency and sterling had changed too.

6. F. Drake, *The World Encompassed* (London, 1996), pp. 165-166.

7. Ibid., p. 167.

8. Drake refers to the vessel as the *Cacafuego* in his narrative, and so I call it that, too, in mine to obviate confusion. Apparently after she was taken, one of the Spaniards renamed her the *Cacaplata*—or the "shits plate," meaning gold.

9. John Sugden, *Sir Francis Drake*, p. 125.

10. Ibid.

11. For the last of these prizes, Drake agreed with the Spanish owner that he would only take the cargo since the ship was all he had.

12. F. Drake, *The World Encompassed*, additional notes, p. 213.

13. Ibid., p. 170. While this formed the vast majority of the booty, it wasn't all.

14. The huge debate over whether this was San Francisco or not is not discussed here. The controversy rages on, and there are many scholars who are better placed than I to pronounce on this point. What I would say is that this mooring was most likely within the boundaries of what is today the continental United States.

15. W.S.W. Vaux (ed.), *The World Encompassed*, p. 237.

16. F. Drake, *The World Encompassed*, p. 184.

17. John Sugden, *Sir Francis Drake*, pp. 136–138.

18. Ibid., p. 140. Cf. Henry Wagner, *Sir Francis Drake's Voyage Around the World* (Mansfield Center, CT, 2005), p. 180.

19. According to Spanish sources like Antonio de Herrera's *Historia General de Mundo* (Madrid, 1606), Babu had plotted to kill Drake since he had traded without his permission.

20. Ibid., p. 141.

21. Zelia Nuttall (ed.), *New Light on Drake* (London,1914), pp. 383–384.

22. Julian Corbett and Henry Wagner both feel that the incident probably took place near Tomori Bay or Vesuvius Reef nearby.

23. Zelia Nuttall (ed.), *New Light on Drake*, p. 142.

24. Ibid., p.143. Cf. W. Anderson, *The Whole of Captain Cook's Voyages* (London, 1784).

Chapter 27. *The World Is Not Enough*

1. *CSP—Spain*, vol. 2, pp. 694–695.

2. Zelia Nuttall (ed.), *New Light on Drake*, pp. 385–386. Of all those who claimed money back from Drake, Nuño da Silva alone met with Drake privately, and dropped any claims he had against the commander following on that meeting. Drake clearly gave credit where it was due, and he treated his former captive with generosity.

3. J. Calvar Gross, *La Batalla del Mar Oceáno* (Madrid, 1988), vol. 1, no. 395.

4. *CSP—Domestic*, the queen to Tremayne, October 25, 1580, no. 30.

5. S. Ronald, *The Sancy Blood Diamond* (New York, 2004), pp. 74–81, for a brief financial history of the takeover of Portugal by Spain and Elizabeth's reaction.

6. J. S. Corbett, *Drake and the Tudor Navy* (Aldershot, England, 1988 Centenary reprint), pp. 408–409.

7. Ibid.

8. S. Ronald, *The Sancy Blood Diamond*, pp. 82–105. Also see J. S. Corbett, *Drake and the Tudor Navy,* p. 332. After completing the book, I found specific references in the de Lisle papers regarding Leicester's mission while accompanying Anjou to the Low Countries.

9. J. S. Corbett, *Drake and the Tudor Navy,* p. 402.

10. The knighthood of Sir Francis Drake is recounted in all his biographies, and in film. My favorite "rendition" is J. Corbett's in *Drake and the Tudor Navy*, pp. 315–318, followed by J. Sugden's *Sir Francis Drake*, pp. 150–151. It's vintage Elizabeth.

Chapter 28. *Elizabeth Strikes Back in the Levant*

1. *The Prince* was, of course, in Elizabeth's personal library. It is also the only book besides the Bible I know of that has never been out of popular print since it was first published 500 years ago. Dedicated to

the Magnificent Lorenzo de' Medici, it was published posthumously. Machiavelli, who had no formal education as a child due to the family's extreme poverty, died in 1527.

2. Francis, Duke of Anjou, had been the Duke of Alençon until his brother, King Charles IX, died. On Henry of Anjou's accession to the French throne as Henry III, Francis dropped the title of Alençon and became Francis, Duke of Anjou.

3. Kenneth Andrews, *Trade, Plunder & Settlement* (Cambridge, 1999), p. 90. Cf. Walsingham's memo headed "A Consideration of the Trade into Turkey."

4. Ibid., pp. 91–92.

5. S.A. Skilliter *Harborne* (London, 1977), pp. 159–200. Also see Richard Hakluyt's *Principall Navigations* (London, 1598), vol. 5, pp. 189–191, and *CSP—Foreign*, p. 781.

6. Kenneth Andrews, *Trade, Plunder & Settlement,* p. 94.

7. Richard Hakluyt, *Principall Navigations*, vol. 5, p. 459.

8. Ibid., vol. 5, p. 507.

Chapter 29. *Katherine Champernowne's Sons Take Up the American Dream*

1. D. B. Quinn, *Ralegh and the British Empire* (London, 1973), pp. 36–37.

2. Kenneth Andrews, *Trade, Plunder & Settlement* (Cambridge, 1999), pp. 184–185. Cf. Thomas Churchyard, *Churchyard's Choice* (London, 1587), p. 128, and Richard Chope, *A New Light on Grenville* (London, 1918), p. 214.

3. D. B. Quinn, *Ralegh and the British Empire*, p. 38.

4. Ibid.

5. Kenneth Andrews, *Trade, Plunder & Settlement*, p. 187.

6. D. B. Quinn, *Ralegh and the British Empire*, p. 39.

7. BL, Harl. 6993, f.5. Letter from Walter Raleigh to the Earl of Leicester from Lismore, August 26, 1581.

8. *CSP—Spain*, vol. 3, pp. xxxiii, 186.

9. Ibid.

10. Ibid., pp. xxxiv, 193.

11. Kenneth Andrews, *Trade, Plunder & Settlement*, p. 190.

12. Ibid., Cf. D.B. Quinn, *Sir Humphrey Gilbert* (Liverpool, 1983), pp. 49–53.

13. D. B. Quinn, *England and the Discovery of America* (London, 1974), pp. 364-397.

14. Ibid.

15. Ibid.

16. Ibid., p. 217.

17. A. Beer, *Bess: The Life of Lady Ralegh* (London, 2003), pp. 45–47. This plot did indeed involve Mary Queen of Scots, and was a vicious attempt on Elizabeth's life. Burghley and Walsingham put in place a set of draconian laws that were intended to safeguard the queen, but only punished her Catholic subjects. Though the Babington Plot, for which Mary lost her life, was barely anything more than entrapment, she certainly had acted to kill the Queen of England in the Throckmorton Plot. Francis Throckmorton's cousin, Elizabeth Throckmorton, would later become Walter Raleigh's wife.

18. Richard Hakluyt, *Principall Navigations* (London, 1598), vol. 8, pp. 34–77.

19. Ibid., p. 77.

Chapter 30. *The Defeats of 1582–84*

1. S. Ronald, *The Sancy Blood Diamond* (New York, 2004), pp. 87–88.

2. John Sugden, *Sir Francis Drake* (London, 1996), p. 165, also pp. 166–168.

3. John Drake was captured and brought to Lima where he was "interrogated" and tortured by the Inquisition. Seven years later, it is presumed that he was made to walk in the *auto-da-fé* at Lima, repenting his Lutheranism, since another eighty-eight-year-old John Drake was made to walk another *auto-da-fé* at Cartagena in December 1650.

4. H. Kelsey, *Sir John Hawkins* (New Haven, 2003), p. 166.

5. Ibid., p. 168.

6. N. A. M. Rodger, *Safeguard of the Sea* (London, 2004), p. 246.

Chapter 31. *Water!*

1. N. A. M. Rodger, *Safeguard of the Sea* (London, 2004), p. 248.

2. A. Latham and J. Youings (eds.), *The Letters of Sir Walter Ralegh* (London, 2001), p. 13.

3. D. B. Quinn, *Ralegh and the British Empire* (London, 1973), p. 17.

4. D. Wilson, *Sweet Robin (London, 1981)*, pp. 272–273.

5. D. B. Quinn, *Ralegh and the British Empire*, p. 52.

6. Ibid., p. 53.

7. Ibid.

8. Ibid., p. 54.

9. Ibid.

10. Richard Hakluyt (ed.), *Virginia Voyages*, pp. 8–12.
11. D. B. Quinn, *Ralegh and the British Empire*, p. 61.

Chapter 32. *Roanoke*

1. This is a portion of a poem reply to Raleigh's poem from BL, MS Add. 63742, f. 116r, oddly included in a vellum-bound tome described as *Letters from Henry, fourth Earl of Derby*. Pug was another of Elizabeth's nicknames for Raleigh.

2. E. G. R. Taylor, *Writings of the Hakluyts* (London, 1935), p. 326. Also see Charles Deane (ed.), *Discourse on Western Planting* (London, 1877).

3. R. B. Wernham, *The Making of Elizabethan Foreign Policy* (Berkeley, 1980), p. 55.

4. Kenneth Andrews, *Trade, Plunder & Settlement* (Cambridge, 1999), p. 205.

5. D. B. Quinn, *Ralegh and the British Empire* (London, 1973), p. 59.

6. G. Milton, *Big Chief Elizabeth* (London, 2000), pp. 46–47.

7. Dee was the first to systematically use the mathematical signs of equals, plus, minus, divide, and multiply, and he wrote a treatise on using these universally in the 1560s.

8. Ibid., p. 103.

9. Kenneth Andrews, *Trade, Plunder & Settlement*, p. 205.

10. Richard Hakluyt, *Virginia Voyages* (London, 1888), pp. 22–23.

Chapter 33. *The Queen Lets Loose Her Dragon*

1. G. Parker, *The Grand Strategy of Philip II* (New Haven, 2000), p. 175.

2. D. Loades, *The Tudor Navy* (Aldershot, England, 1992), p. 234.

3. John Sugden, *Sir Francis Drake*, p. 178. Cf. *CSP—Foreign*, pp. 330–332.

4. Ibid., pp. 178–181.

5. Ibid., p. 182.

6. Ibid., p. 186.

7. Ibid., p. 187.

8. Ibid., p. 189. Cf. *García Fernández de Torrequemada's Letter to the Spanish Crown 4th February 1587*, Irene A. Wright, ed. (London, 1951), pp. 200–205.

9. Ibid., p. 190. Cf. *Rodrigo Fernández de Ribera to the Crown*, in Wright, *Further Voyages to Spanish America* (London, 1951), pp. 178–180.

10. D. B. Quinn, *Ralegh and the British Empire* (London, 1973), p. 68.

11. See G. Milton's *Big Chief Elizabeth* (London, 2000), for a description of the character and recruitment criteria for the first colonists, pp. 83–92.

12. D. B. Quinn, *Ralegh and the British Empire*, pp. 70–71. The White drawings are at the British Library and can be seen in the two-volume set, *The American Drawings of John White*.

13. Richard Hakluyt, *The Virginia Voyages*, pp. 33-34.

14. Kenneth Andrews, *Trade, Plunder & Settlement*, p. 208, Cf. Richard Hakluyt, *Principall Navigation* (London, 1598), vol. 8, p. 331.

15. John Sugden, *Sir Francis Drake* (London, 1996), p. 194. There were two examples of great courage by the Spaniards: Captain Alonso Bravo, a captain of the infantry, was taken prisoner only after six wounds had been inflicted; and the Spanish standard bearer stood his ground until Carleill himself had to kill him.

16. Ibid., p. 196.

17. Ibid.

18. Ibid., p. 198.

19. Richard Hakluyt, *The Virginia Voyages*, pp. 42–45.

Chapter 34. *The Camel's Back*

1. S. Ronald, *The Sancy Blood Diamond* (New York, 2004), p. 95.

2. L. Marcus, J. Mueller, and M. B. Rose, *Elizabeth I: Collected Works* (Chicago, 2000), pp. 268–272.

3. G. Mattingly, *The Defeat of the Spanish Armada* (London, 1959), pp. 17–28 carries the full account.

4. S. Ronald, *The Sancy Blood Diamond*, pp. 100–101.

5. G. Mattingly, *The Defeat of the Spanish Armada*, pp. 72–74. This book is the most compelling one written about the Armada in my opinion, putting it beautifully into historical context and making the characters of Philip and Elizabeth blaze with life. Though first published in 1959, it is still in print.

6. Ibid., p. 78.

7. *CSP—Spain*, vol. 4, p. 61.

Chapter 35. *Cadiz*

1. The *CSP—Spain* and *Venice* carry numerous references to Philip's torment about Drake, Elizabeth, Raleigh, Leicester, and the newer generation of seaman "explorer" like Raleigh and Cavendish. For a good overview of Cavendish's accomplishments and voyage, see Derek Wilson's *The Circumnavigators* (London, 1989).

2. R. W. Kenny, *Elizabeth's Admiral* (Baltimore, 1970), pp. 38–42.

Endnotes 413

3. *CSP—Spain*, vol. 4, pp. xix-xx.

4. John Sugden, *Sir Francis Drake* (London, 1996), pp. 204–205.

5. SP 12/193, F. 26-28, 42.

6. Drake's first wife, Mary, had died several years earlier. His second wife was Lady Elizabeth Sydenham, whose father was a wealthy Somerset merchant.

7. *CSP—Spain*, vol.4, p. 62, no. 62, In Stafford's defense, he had been complaining of penury for quite some time, begging the queen to give him a financial reward commensurate with his position. Elizabeth naturally demurred.

8. Ibid.

9. Ibid., p. 65, no. 65, and p. 69, no. 67.

10. BL, MS Cotton Otho E, VIII, 192–195.

11. BL, MS Cotton Vespasian, CVIII, f. 207.

12. *CSP—Venice*, vol. 8, p. 254–258.

13. *CSP—Spain*, vol. 3, p. 368.

14. G. Mattingly, *The Defeat of the Spanish Armada* (London, 1959), pp. 91–106.

15. Ibid.

16. Ibid.

17. Ibid.

Chapter 36. The Plundering of the Spanish Armada

1. J. S. Corbett, *The Spanish War*, p. 109. Cf. *A Letter from Sir Francis Drake to Sir Francis Walsingham*, April 27, 1587.

2. J. K. Laughton (ed.), *State Papers Relating to the Defeat of the Spanish Armada* (London, 1898), vol. 1, p. 148.

3. N. A. M. Rodger, *Safeguard of the Sea* (London, 2004), p. 260. Also see J. Corbett, *The Spanish War*, p. 280.

4. R. Wernham, *Before the Armada* (London, 1966), pp. 377–378. Cf. SP12/143, f. 20.

5. N. A. M. Rodger, *Safeguard of the Sea*, pp. 260–261. Also see G. Mattingly, *The Defeat of the Spanish Armada* (London, 1959), pp. 107–109; J. S. Corbett, *The Spanish War*, pp. 277–280; W. T. MacCaffrey, *The Shaping of the Elizabethan Regime* (Princeton, 1908), p. 299; R. B. Wernham, *The Making of Elizabethan Foreign Policy* (Berkeley, 1980), p. 59; and Dietz, *The Exchequer under Elizabeth* (New Haven, 2000), pp. 100–103.

6. G. Parker, *The Grand Strategy of Philip II* (New Haven, 2000), pp. 182–84. Also see N. A. M. Rodger, *Safeguard of the Sea* (London, 2004) pp. 258–259.

7. N. A. M. Rodger, *Safeguard of the Sea*, p. 259.

8. J. K. Laughton (ed.), *State Papers Relating to the Defeat of the Spanish Armada*, vol. 2, pp. 324–331.

9. N. A. M., Rodger, *Safeguard of the Sea*, p. 263–264.

10. Kenneth Andrews, *Trade, Plunder & Settlement* (Cambridge, 1999), p. 233.

11. F. Duro, *Armada Invencible* (Madrid, 1884), vol. 2, pp. 5–10.

12. N. A. M. Rodger, *Safeguard of the Sea*, p. 264.

13. J. K. Laughton (ed.), *State Papers Relating to the Defeat of the Spanish Armada*, vol. 1, pp. 79–81.

14. Bonfires play an important part in British military and social history. There is a great book about them called *Bonfires to Beacons* by Nick Kumons (London, 1990).

15. See J. Sugden, *Sir Francis Drake* (London, 1996), pp. 234–235, for details.

16. Ibid., pp. 238–239. Also see Kenneth Andrews, *Trade, Plunder & Settlement*, pp. 232–233.

17. J. Sugden, *Sir Francis Drake*, pp. 241-246. Also see N. A. M. Rodger, *Safeguard of the Sea*, pp. 265–266.

18. J. Sugden, *Sir Francis Drake*, p. 246.

19. Ibid., pp. 243–244. The National Archives has the depositions ref. E 133/47. The lawsuit related to the Drakes of Esher being dissatisfied with their share of the family spoils and their lawsuit against Drake's heir, Thomas Drake.

20. G. Mattingly, *The Defeat of the Spanish Armada*, p. 288.

21. N. A. M. Rodger, *Safeguard of the Sea*, p. 270. Cf. G. Mattingly, *The Defeat of the Spanish Armada*, vol. 1, p. 341.

Chapter 37. America Again . . . and Again?

1. A. Latham and J. Youings (eds.), *The Letters of Sir Walter Ralegh* (London, 2001), pp. 45–46, dated September 13, 1588, from court. My Lord Cumberland to whom he refers is George, third Earl of Cumberland.

2. D. B. Quinn, *Ralegh and the British Empire* (London, 1973), p. 89.

3. G. Milton, *Big Chief Elizabeth* (London, 2000), p. 203.

4. For a splendid profile of White and his colonists, read G. Milton's *Big Chief Elizabeth*.

5. D. B. Quinn, *Ralegh and the British Empire*, p. 92.

6. Kenneth Andrews, *Trade, Plunder & Settlement* (Cambridge, 1999), pp. 216–217.

7. D. B. Quinn, *Ralegh and the British Empire*, p. 93.

8. Ibid., p. 94.

9. Kenneth, Andrews, *Trade, Plunder & Settlement*, p. 217.

10. Ibid., p. 218.

11. Richard Hakluyt, *Principall Navigations* (London, 1598), p. 4.

Chapter 38. The Last Gasp of the Early Rouring '90s

1. Kenneth Andrews, *Elizabethan Privateering* (Cambridge, 1964), p. 206.

2. Ibid., pp. 236–239. For the best account of the 1589 voyage, see J. Sugden, *Sir Francis Drake* (London, 1996), chapter XX, pp. 263–284.

3. John Sugden, *Sir Francis Drake* (London, 1996), pp. 300–301.

4. J. S. Corbett, *Drake and the Tudor Navy* (Aldershot, England, 1988 Centenary reprint), vol. 2, p. 340. Cf. SP Spain, xxix, no. 2.

5. D. B. Quinn, *Ralegh and the British Empire* (London, 1973), pp. 109–114.

6. D. Akenson, *An Irish History of Civilization* (London, 2005), vol. 1, pp. 160–162.

7. J. S. Corbett, *Successors of Drake* (London, 1900), p. 27.

8. D. B. Quinn, *Ralegh and the British Empire,* pp. 114–115.

9. D. Akenson, *An Irish History of Civilization*, vol. 1, p. 160.

10. J. S. Corbett, *Drake and the Tudor Navy*, pp. 350–351.

11. Ibid., p. 357.

12. Ibid.

13. Kenneth Andrews, *Trade, Plunder & Settlement*, p. 242.

14. Ibid., p. 240.

15. Ibid., p. 219.

16. Ibid.

17. D. B. Quinn, *Ralegh and the British Empire*, p. 126.

18. Ibid.

19. Ibid., p. 131.

20. *CSP—Venice*, vol. 9, no. 121, pp. 53 54.

21. J. S. Corbett, *Drake and the Tudor Navy* (Aldershot, England, 1988 Centenary reprint), vol.2, pp. 366–369.

22. J. Sugden, *Sir Francis Drake*, pp. 302–303.

23. *CSP—Venice*, vol. 9, no. 153, pp. 67–68.

Chapter 39. The Alchemy That Turned Plunder into Trade

1. Corbett goes into some significant detail on how poor John Doughty,

on his return from the voyage of circumnavigation, first tried to have Drake brought to trial for the murder of his brother, and, when that failed, he attempted to kill him. He was thrown into jail unceremoniously—without trial—and the last we see of him is a letter to the Earl of Leicester, Robert Dudley, begging for his release. He undoubtedly died a dreadful and agonizing death in the most undemocratic way repugnant to all great democracies.

2. Kenneth Andrews, *Trade, Plunder & Settlement* (Cambridge, 1999), p. 241.

3. BL, MS Additonal 24023, f.1 [in French in Elizabeth's hand] with the date provided by MS Additional 48212, f.13 as September 13, 1596.

4. Kenneth Andrews, *Trade, Plunder & Settlement*, p. 241.

5. J. S. Corbett, *Successors of Drake* (London, 1900), pp. 89–90.

6. Ibid., pp. 100–101.

7. Ibid., pp. 102–103.

8. N. A. M. Rodger, *Safeguard of the Sea* (London, 2004), p. 284.

9. Ibid., p. 285.

10. Ibid.

11. Kenneth Andrews, *The Elizabethan Seaman* (London, 1982), p. 322.

12. M. Oppenheim, *A History of the Administration of the Royal Navy* (London, 1896), p. 384.

13. By 1596, Elizabeth had entrusted much of her government's workings to Robert Cecil, her hunchbacked "Elf." Cecil, like many Elizabethan children, had a spinal deformity: as a result of the constant taunting he endured while growing up, he was more Machiavellian than any other of the queen's Privy Councillors. See his entry in the *DNB*.

14. By the end of Elizabeth's reign, Cecil's farm of "silks" netted him £7,000 annually—$1.77 million or £909,200 today. His "takings" through his adventures with Charles Howard amounted to significantly more.

15. R. W. Kenny, *Elizabeth's Admiral* (Baltimore, 1970), pp. 37–40.

16. Ibid. Also see Hatfield MSS 4:358, 375.

17. N. A. M. Rodger, *Safeguard of the Sea*, pp. 343–344. Also see Kenneth Andrews, *Trade, Plunder & Settlement*, p. 245, and K. R. Kenny, *Elizabeth's Admiral*, pp. 67–87.

18. Kenneth Andrews, *Elizabethan Privateering* (Cambridge, 1964), pp. 32–34.

19. William Monson, *Sir William Monson's Tracts* (London, 1625), vol. 4, p. 21.

Chapter 40. *Essex, Ireland, and Tragedy*

1. *DNB*, Robert Devereux biography, p. 4.

2. FSL, L.a.39.

3. For details, see *DNB* biography.

4. BL, MS Additional 74287, f.13v.

5. Salisbury MSS, 4, 116.

6. *DNB*, Hugh O'Neill biography, p. 1.

7. G. R. Elton, *England Under the Tudors* (London, 1993), pp. 379–385.

8. Ibid., pp. 386–387.

9. FSL, MS V.b.214, f.229v–230v.

10. *CSP—Spain* vol.4, p. 685.

11. *DNB*, biography, p. 18. One of Essex's many rows with the queen was over the appointment of Bacon as attorney-general. The queen steadfastly refused.

12. D. Akenson, *An Irish History of Civilization* (London, 2005), vol. 1, pp. 165–166.

13. G. R. Elton, *England Under the Tudors*, pp. 388–389.

Chapter 41. *Raleigh, Virginia, and Empire*

1. A. Latham and J. Youings (eds.), *The Letters of Sir Walter Ralegh* (London, 2001), pp. 50–51, no. 33.

2. Elizabeth's final illness was more complex than that, and was as much due to old age and depression at the loss of so many of her contemporaries, poor understanding of medical matters, and the feeling that she had served her time on earth.

3. D. B. Quinn, *Ralegh and the British Empire* (London, 1973), pp. 134–135.

4. A. Latham and J. Youings (eds.), *The Letters of Sir Walter Ralegh* p. 87, no. 56.

5. D.B. Quinn and A.M. Quinn, *The First Colonists* (Raleigh, NC, 1982), p. 108.

6. D. B. Quinn, *Ralegh and the British Empire*, p. 149.

7. Ibid., p. 151.

8. Ibid., p. 158.

9. Ibid.

10. Ibid., p. 157.

11. *HMC Salisbury* (London, 1888), vol. 9, p. 311. Also see A. Latham and J. Youings, *The Letters of Sir Walter Raleigh*, pp. 240–241, letter no. 161.

12. Ibid.

Chapter 42. *The East and East India Company*

1. G. Milton, *Nathaniel's Nutmeg* (New York, 1999), p. 41.

2. This is a distinctly English perspective, I'm sure, though not without foundation.

3. Kenneth Andrews, *Trade, Plunder & Settlement* (Cambridge, 1999), p. 256.

4. J. Keay, *The Honourable Company* (London, 1993), pp. 10–13.

5. There were other reasons as well for Elizabeth to hesitate as she did: it was a favorite game to wrong-foot her courtiers, at times pandering to one faction or another, as well as a way of keeping her enemies (foreign ambassadors and unseen traitors in her midst) guessing as to her true purpose. Sometimes she would change her mind simply for the fun of it. But when it came to matters of national or international importance, she invariably hesitated for one of the two reasons I give.

6. Kenneth Andrews, *Trade, Plunder & Settlement*, pp. 258–259.

7. Ibid., p. 263.

8. J. Keay, *The Honourable Company*, pp. 14–15.

9. S. Ronald, *The Sancy Blood Diamond* (New York, 2004), p. 137.

Glossary ⚜

Sources for this glossary were provided primarily by the *Oxford English Dictionary*, Kenneth R. Andrews's *The Spanish Caribbean*, N. A. M. Rodgers's *The Safeguard of the Sea*, and David Loades's *The Tudor Navy*. My sincerest thanks to them all.

abeam, (adj.) at right angles to the ship's center line.

admiral, 1. the officer commanding a squadron of ships; 2. the Lord (High) Admiral, an officer of the crown in charge of Admiralty and naval affairs; 3. a flagship in a fleet (16th and 17th centuries).

adviso, announcement.

afore, same as fore.

aft, abaft, towards the stern or rear of a ship.

aftercastle, the tower or fighting platform built at the stern of a ship from the 13th century.

agreeing, (as in climate), becoming acclimatized.

alcaide, Spanish governor.

aloft, 1. relating to the masts and rigging upwards, or 2. on deck.

amidship(s), relating to the middle or centerline of a ship.

anatomy, a skeleton or mummy.

ancient, 1. an ensign or standard; 2. an ensign or standard-bearer.

annoy, injure.

appointed, equipped or armed.

armada, any fleet of warships, or if large enough, a single warship. Used in this book solely for Spanish warships.

arquebuse (also harquebuse), a portable fire-arm with a box-like fire lock of variable size, but usually a large, cumbersome kind of musket.

artificial, skillful, workmanlike.

ashore, towards or on the shore.

assay, assault. (Term "at all assays," meaning "in any attack," or "any danger.")

astern, behind the ship, in the direction from which she is moving.

astrolabe, a navigational instrument used for measuring the altitude of heavenly bodies and thereby the ship's latitude.

asiento, a Spanish commercial contract or licence.

audiencia, the high court of a region within Spain's jurisdiction.

back, 1. to trim sails so that they catch the wind from ahead; 2. (of the wind) to change in a counter-clockwise direction.

ballast, stones, gravel, or other weight stowed low in a ship to improve her stability.

banquet, dessert; sweetmeats and wine.

bar, a shoal across the mouth of a tidal estuary.

Barbary, from the northwest coast of Africa (as in barbary pirate, or barbary trade).

barbican, a man-made structure defending the gate of a castle.

barge, an oared sailing vessel used for war and trade (14th–16th centuries).

bark, any seagoing sailing ship of moderate size (16th century).

barrel, 1. a cask of specified capacity, usually between 30–34 gallons; 2. the muzzle of a gun.

base, a very small cannon, probably firing a six-ounce shot.

basilisk, a type of long heavy gun, usually breech-loading (15th–16th century).

battery, 1. the broadside guns mounted on one deck or the side of the ship; 2. a group of guns mounted ashore to fire on ships.

beach, to run a ship aground or ashore.

beam, 1. the width of the ship; 2. the direction at right angles to the center line of the ship; 3. a timber running from side to side of the ship to support the deck.

bear, 1. to enter names in the ships book as part of the ship's company; 2. to lie or point in a certain direction; 3.—**away,** to bear up or turn downwind; 4.—**room,** to bear up (16th–17th century); 5.—**up,** to turn downwind.

beat, (of a ship), to work windward by several tacks (turnings).

behoveful, advantageous.

bill, halberd (see *halberd*).

block, a pulley.

boatswain, 1. a ship's officer responsible for sails, rigging, and ground tackle; 2. boatswain's mate, the petty officer assisting the boatswain.

bolt, a short arrow fired from a crossbow.

bonaventure mizzen, see mizzen.

boom, 1. a light running spar, especially one at the foot of a sail; 2. a floating barrier protecting a harbor.

bow, verb, 1. to bend; 2. to cant a broadside gun as far forward as possible (16th century).

bowline, a line or tackle led forward from the leach of a square sail to haul the weather leach taut when beating to windward.

bow-shoot, bow-shot, a distance of about 240 yards.

bowspirit, a spar projecting over the bows, spreading various riggings and one or more sails.

brave, beautiful, fine, decorated.

Brazil, a wood used for dyeing cloth. (Brazil was named after its wood.)

breach, the breaking of the sea on the shore.

breech, the inner or rear end of a gun.

breeching, a rope attaching the breech of the gun to the ship's side to restrain the recoil or movement of the gun.

brigantine, a small vessel equipped for sailing or rowing, swifter and more easily maneuverable than large ships, frequently used for piracy, espionage, or reconnoitering.

brow, a portable bridge for crossing from dockside to the ship or from ship to ship

brownbill, a burnished axe.

brustling, crackling, rustling, roaring.

buff, buffalo.

buskin, a boot reaching to the calf or the knee.

by and by, at once.

cable, 1. a thick long rope, particularly the anchor cable; 2. a measure of distance originally 120, then later 100 fathoms or one-tenth of a nautical mile.

cabrito, goat (Spanish).

cacique, an Indian chieftain.

caliver, a long, light musket.

cannon, the English cannon was probably a 7-inch gun firing a 40 pound round of shot. The Spanish cannon was larger, firing a 50 pound round of shot.

cant, to turn or change the heading or direction of the ship.

capitana, Spanish flagship.

caravel, a small, light, fast lateen-rigged ship, originally a Portuguese type.

carvel, adj. Of the "skeleton-first" method of shipbuilding in which a frame of timbers is clad with planking laid edge to edge.

cargason, cargo, bill of lading.

carrack, a large "round ship" used as a merchant ship, (merchantman) with a high superstructure fore and aft (15th–16th century) particularly to transport cargo from the East Indies.

castle, 1. a structure erected forward (forecastle) or aft (aftercastle).

caulk, to make seams watertight on a ship.

cause, causeway or raised roadway across water.

chamlet or camlet, presumed to be a type or mohair or camel hair cloth mixed with wool, silk, or cotton (*A Handbook of English Costume in the Sixteenth Century*).

chamber, a detachable breech containing the explosive charge of a gun (15th–16th century); 2. the inner end of the bore of a muzzle-loading gun which is bored to a smaller diameter than the rest to accept a reduced charge.

chargeable, responsible, expensive, or troublesome.

charged, high or having tall castles fore and aft.

chase, the bow of a ship.

chirurgeon, surgeon.

Cimarróne, Cimarroon, a runaway slave.

Cipango, Japan.

clift, split wood.

clinker (clench), a system of shipbuilding where the hull is made of overlapping strakes of planking built up from the keel with light frames inserted later for stiffening.

close-hauled, steering as close to the wind as possible.

cock-boat, a small boat or dinghy.

cod, pod

cog, a type of merchant ship with a flat bottom and high freeboard rigged with a single mast and sail.

commodious, convenient, advantageous or profitable.

composition, agreement, treaty, compromise.

conceits, ideas or fancies.

contagious, foul.

contractátion house, a commercial exchange center.

cooper, 1. a skilled repairer of casks; 2. a rating employed to assist the purser to dispense beer and other liquids.

cordovan skin, fine leather from Cordova, Spain, or in the style of Cordova.

corinths, currants.

corregidor, a magistrate or sheriff.

coxswain, a petty officer in charge of a boat's crew.

crossbar, cross-shot, cannon shot in the form of a bar or a cross.

cross-staff, an instrument for observing the altitude of the sun or star in order to fix latitude. John Dee made vast improvements to the cross-staff.

cruet, a small vessel holding wine or water for the celebration of the Eucharist.

crumbs, to gather up or pick up strength.

culverin, the longest range gun in use in the 16th century. A long, muzzle-loading smooth bore gun, usually firing a round of shot of about 17 pounds in weight. The demi-culverin shot was about half that weight at 9 pounds.

cunning, skillful or clever.

customer, a customs house officer.

cut out, to take as a prize a ship from its fleet.

daw, to revive, bring back to consciousness.

dead reckoning, the captain would throw a log overboard and observe how quickly the ship receded from this guidepost. Noting the speed reading in his ship's logbook, along with the direction of travel, which he took from the stars or a compass, and the length of time on a particular course, he then determined his longitude. He routinely missed the mark.

defend, to forbid.

deliver, quick to, active, or nimble.

demurrage, a payment made by a shipper to the ship owner in compensation for unreasonably detaining the ship on her voyage.

detract, to withdraw from.

dight, dressed, dressed up, or decorated.

disbock, to flow out of or into.

draft, chart.

drake, a short gun of the culverin type.

drumbler, a small fast vessel used as a transport or a fighting ship.

ducat, a Spanish coin worth about 5 shillings and 10 pence in Elizabethan times.

Easterland, the territory of the Hanse merchants on the Baltic.

elchie, ambassador.

ell, 45 inches, the standard width of cloth.

equinoctial, of the equator.

factor, an agent for a merchant or monarch in a foreign country.

factory, trading station for the factor.

falchion, a broad curved sword (as used by the Turks and Barbary pirates).

falconet, a gun about 6½ feet long firing a 1½ pound shot.

fat, cask.

fencible, easy to defend.

figu, plantain banana.

fine, end.

firkin, a small cask containing between eight to nine gallons.

fish, to mend a mast or spar by binding it to a splint.

flead, fleane, flayed, or skinned.

flux, dysentery.

fly-boat, fast sailing vessel usually traveling between ships in a squadron with provisions and messages.

foist, a small light galley with 18-20 oars aside and two masts.

foot, foot soldiers, infantry.

freeboard, the minimum height of the ship's side above the waterline.

frumenty or furmenty, a dish of wheat boiled in milk and seasoned to taste.

furicane, hurricane.

furniture, equipment.

gable, cable.

galleass, a large long sailing vessel with a flush deck, auxiliary oars, and broadside guns.

galleon, a sailing warship of fine lines, with high upperworks aft and a galley bow with heavy battery of chasers (16th century).

galley, 1. a type of warship propelled by oars; 2. the kitchen aboard ship.

galliard, a kissing dance.

galliot, a small galley.

gallizabra, a type of Spanish sailing warship that was small, fast and equipped with oars.

general, 1. commander of any expedition, either maritime or military; 2. a flagship.

glass, gloss.

goose-wing, "one of the clews or lower corners of a ship's mainsail or foresail when the middle part is furled or tied up to the yard" (*SOED*).

grave, v. to clean a ship's bottom by burning off the accretions and paying it over with tar while aground on a beach or placed in a dock (*SOED*).

groat, an English four penny piece.

grommet, an Elizabethan apprentice seaman.

guards, stripes (blue and green).

Guinea, Coast of, the west coast of Africa from Sierra Leone to Benin where the Portuguese had initially set up slaving forts.

gunwale, a heavy timber forming the top of the ship's side.

halberd, a kind of spear approximately six feet long with a head that could be used either for cutting or thrusting.

handy, easily maneuverable.

hardly, with difficulty.

harquebus, see arquebus.

harping iron, harpoon.

hawser, a large rope or tackle.

hold, fort.

horse, cavalry.

hound, projection at the mast-head.

hoy, a flat bottomed sailing vessel.

ingenio, sugar mill.

intend to, to attend to.

jealousy, suspicion, mistrust.

jennet, a small Spanish horse.

jut, a push or knock.

kemb, comb.

kern, v. to make into grains, to granulate.

kintal, see *quintal*.

larboard, now known as the port side.

large (of the wind), on the quarter.

lateen, 1. a fore-and-aft rig where triangular sails are bent to yards which are set so that the foot is made fast on deck and the middle hoisted to the masthead; 2. a triangular sail rigged ship.

latitude, a position lying on a line around the earth parallel to the equator.

league, approximately three miles.

leese, lose.

letters patent, a document under the Great Seal of England appointing the person(s) to act on behalf of the Crown.

lewd, unprincipled, vulgar, evil, foolish.

ligier, resident ambassador or commercial representative.

list, strip, edging.

longitude, a position lying on a line around the earth from pole to pole.

lowbell, a small bell used in fowling.

luff, to bring the ship closer to the wind.

maguey, American aloe.

main, mainland.

main to, v., to lower sails.

mammee, a large tropical tree bearing huge yellow fruit when ripe.

mankind, male stags.

mark, thirteen shillings and eight pence in Elizabethan money.

mart, market.

master, 1. the commanding officer of a merchant ship; 2. an officer responsible for the navigation and pilotage of a warship.

match, a slow burning fuse for firing guns.

mean, moderate or medium.

mess, a group of seamen.

millio, millet.

mizzen, 1. the foremost mast of a ship; 2. bonaventure—, the fourth and aftermost mast of a great ship of the 16th century.

morse, walrus.

musket, a breech-loading gun in a swivel mounting (16th century).

occupy, 1. to follow one's occupation; 2. to have sexual intercourse.

open, in view of.

overseen, mistaken.

painful, diligent.

pantofles, overshoes like slippers.

part, partisan.

partisan, a kind of spear approximately nine feet long with a broad blade.

patache, "a small boat used for communications between the vessels of a fleet" (*SOED*).

peason, peas.

peso, a piece of eight, worth about four shillings and three pence in Elizabethan money.

pilled, pillaged.

pilot, navigator.

pine, pineapple.

pinnace, a small ship or boat, usually with oars as well as sails and fairly fast. It is able to navigate in the shallows.

pintado, a cloth painted or printed in colors.

pipe, (of wine or water for example), a very large cask, about half a ton.

plant, v., to colonize.

plantano, plantain.

policy, crafty device, strategem, trick.

politically, craftily, falsely.

pompion, pumpkin.

posy, a short inscription or motto.

purchase, capture, plunder, or prize.

purveyance, the sovereign's right to obtain supplies for the royal household at a fixed price.

quintal, a one hundred pound weight.

race-built ship, a ship built low in the water designed for speed.

real of plate, a Spanish coin, worth about six and a half pennies of Elizabethan money.

receipt, capacity.

reckoning, 1. a calculation of a ship's position; 2. dead-, an estimation of the ship's position without the benefit of observations, by calculating course, speed, and drift from a known point of departure.

regiment, rule or government.

road, anchorage or port.

roan cloth, a kind of linen made at Rouen.

rowbarge, a small oared warship (16th century).

royal of plate, see real of plate above.

rude, untutored, barbarous.

rummage, v., to stow cargo or clean a ship thoroughly.

St. Laurence, island of, believed to be Madagascar.

seron, "a bale or package of exotic products (such as almonds cocoa)

made up from an animal's hide" (*SOED*).

shallop, a small, sleek cruising warship in the 16th century.

shift, v. to change clothes.

sith, sithens, since.

sleeveless, useless.

sodden, boiled.

sort (of files), a number of different kinds.

span, approximately nine inches.

spend, v., to lose (as a mast, etc.)

spoiled, despoiled, pillaged.

states, men of importance.

stead, help.

stirk, a young bullock or heifer.

stock, the crossbar of an anchor.

stone bow, a kind of crossbow or catapult for shooting stones (*SOED*).

success, fortune, either good or bad.

suckets, fruits preserved in syrup or candied.

sumach, a preparation used in tanning or dyeing leather.

swimmer (of a fish), a dorsal fin.

tabard, a surcoat bearing the arms of the wearer or his lord.

tables, pictures, flat surfaces.

tack, 1. to shift tack or go about, to turn into the wind and so onto the opposite tack; 2. to beat to windward by successive tacks.

tally, an accounting device, usually a notched stick or note recording a sum of money owed.

target, shield.

tierce, one third.

towardly, promising.

trade, trail, footprints, tread.

trajín, the portage of Spanish treasure across the isthmus of Panama to Nombre de Díos, a trap for catching wild animals, a decoy, a snare.

troterro, a messenger.

tuberones, sharks.

turkey, turquoise.

turnout, to launch a ship.

twelve tide, the twelve days of Christmas.

unstocked (of an anchor), without a crossbar.

utter, 1. outer; 2. to offer for sale, to sell.

utterance, sale.

vail, v. to go down stream with the tide.

victual, v., to provide good and drink for a ship or the navy; n. good and drink.

waft, v. 1. to beckon; 2. to wave something as a signal; 3. to protect a convoy of merchant ships (16th century).

want, mole.

warp, 1. to tow a ship with boats; 2. to move a ship by hauling on warps to make fast to shore.

watchet, light or sky blue.

weatherly, (of a ship) tending to drift little to leeward when close-hauled.

wood, mad.

worm, snake, serpent, dragon.

zabra, a small vessel used off the coasts of Spain and Portugal (*SOED*).

Zeilan, (Ceylon) Sri Lanka.

Zocotoro, Socotra.

Select Bibliographical Essay and Suggested Reading ✦

Abbreviations:

BL British Library

DNB *Dictionary of National Biography*

MS Manuscript

Manuscripts

The handwritten and printed manuscripts of the British Library, the Guildhall Library, The Caird Library at the National Maritime Museum, and the National Archives in London, as well as those at the Archivio de Indias in Seville, Spain, and Folger Shakespeare Library in Washington, D.C., have formed the crux of my original research.

From the British Library, the most useful manuscripts were Titus B XIII and MS 48015 relating to Ireland. Harleian MSS 168, 398, 598, 1546, 1877 and 6990; Lansdowne MSS 14, 16, 26, 113 [Burghley papers] and 43 [regarding Spain]; Additional MS 33,271; 11405; 33592, 36316; 36317; Egerton 2541; Sloane MSS 1786, 2292, 3289; Titus F I and Titus 107/46; Caligula C, II relating to English affairs were essential reading. Cotton Ortho VIII; Stowe 303; and Tiberius D VIII relating to the adventurers and the Turkey/Levant Company were indispensable; Cotton Galba B, XI; Cotton Galba D; Additional MSS 12497; 12503; 12504; 28,702 and 28,357 regarding relations with Spain were particularly useful. Stowe 159 relating to Portugal made fascinating reading, too.

From the National Archives, I relied heavily on the State Papers pertaining to Spain, Ireland, and the Low Countries, with the most helpful documents being SP 43 [English adventurers against Spain]; SP 12/78, 12/3, 12/7, 12/12 [Elizabeth's reign]; SP46/16, SP46/17, SP46/27, SP 941 [relating to Spain]; SP 94 [Walsingham's spies]; SP 84/4, 5, 6, 7, 8, 9, 10 [the Dutch Revolts]; and SP 99 [proclamations to pirates].

From the Archivio de Indias I found the testimonies contained in the manuscripts *Justicia* 908, Indiferente General 742, 1866 and the Casa de Contratacion 5109, 5110 illuminating.

At the Folger Shakespeare Library the most helpful original manuscripts were MS V.a. 197, L.d. 66; L.d. 406; L.d. 403; L.d. 483; L.b. 516; V.b. 142 [Ireland], x.d. 200 [victualing] and L.d. 612. The printed

manuscript DA. 35089, representing a collection of state papers for the Tudor children's reigns, edited by Samuel Haynes (London, 1740), was also useful.

From the Caird Library at the National Maritime Museum, Samuel Purchas's *Purchas His Pilgrims,* vols. 1–2 (Glasgow, 1905), Sebastian Cabot's *Memoirs* and Philip Barbour (ed.), *The Complete Works of Captain John Smith,* vol. 1 (Chapel Hill, 1986), were my primary sources.

General

I have also relied on the *Calendar of State Papers—Spain,* vols. 1–4, Martin A. S. Hume (ed.); *Rome,* vols. 1–2, J. M. Rigg (ed.) (1926); *Venice,* vols. 7–9, R. Brown and H. Brown (eds.) (London, 1890-1894); *Foreign,* Joseph Stevenson (ed.) (London, 1865-1870) and *Foreign,* Allan James Crosby (ed.) (London, 1871–1895). R. B. Wernham was the editor for the years 1596 until the end of Elizabeth's reign. *The Calendar of State Papers—Scotland,* vols. 1–2, Joseph Bain (ed.) (Edinburgh, 1898); *Ireland,* 8 vols., H. C. Hamilton (ed.) (London, 1877) and E. G. Atkinson (ed.) (London, 1885–1903); *Colonial,* vol. 1; and *Domestic,* vols. 1–3, Mary Anne Everett Green (ed.) (London, 1867–1870). These State Papers, as well as the *Acts of the Privy Council,* J. R. Dasent (ed.) (London, 1886–1900), all were exceptionally valuable in increasing my understanding of the fears and diplomacy of the time, as well as in discerning Elizabeth's true motivations—but frequently, when read in juxtaposition with one another (for example, by cross-referencing the same incident in three or more of the calendars, a different image would emerge than from reading a certain ambassador's report to his king). All proved fascinating reading, particularly in relation to the growing concerns about English piracy, and putting these into context with the piratical acts of other nations.

The works of Richard Hakluyt, and in particular his *Principall Navigations* (London, 1598) in 26 volumes, gave clarity to the main voyages during Elizabeth's long reign.

I found the works of Kenneth R. Andrews—*Trade, Plunder & Settlement: Maritime Enterprise and the Genesis of the British Empire 1480–1630* (Cambridge, 1999), *The Spanish Caribbean* (London, 1978), *Elizabethan Privateering: English Privateering During the Spanish War 1585–1603* (Cambridge, 1964), *The Elizabethan Seaman* (Mariner's Mirror, 69, London, 1982), and *Ships, Money & Politics* (Cambridge, 1991)— illuminating, fun, and essential reading. N. A. M. Rodger's *The Safeguard of the Sea* (London, 2004) was both invaluable and reliable, and could hardly be considered a secondary source. Michael Oppenheim's *A History of the Administration of the Royal Navy and Merchant Shipping in Relation to the Navy* (London, 1896); the six-volume *Sir William Monson's*

Tracts by Sir William Monson (London, 1625); Richard Hakluyt's *Fighting Merchantman* (1927 printed edition) and his *Elizabethan Adventurers upon the Spanish Main* (1912 printed edition) were equally core sources. Without the fabulous groundbreaking (though now in parts somewhat out of date) work of Julian S. Corbett in his *Drake and the Tudor Navy* (Aldershot, England, 1988 Centenary reprint of vols. 1–2 of 1888) and his *Successors of Drake* (London, 1900), I would have undoubtedly had to dig much harder.

For general accounts and understanding how commerce worked, H. S. Cobb (ed.), *Corporation of London Records Office—The Overseas Trade of London: Exchequer Customs Accounts* (London, 1990); R. R. Sharpe (ed.), *Calendar of Letter Books Preserved Among the Archives of the City of London*, 11 vols. (London, 1899–1912); *Calendar of MSS Marquis of Salisbury*, 18 vols. (London, 1883); C. M. Clode (ed.), *Memoirs of the Merchant Taylors' Company* (London, 1875); *Accounts for the Merchant Taylors' Company* (London, 1875); Victor van Klarwill (ed.), *The Fugger News-letters: Second Series* (London, 1926); Henry Machlyn's *The Diary of Henry Machlyn, Citizen and Merchant Taylor of London* (J. G. Nichols, ed.) (London, 1848); John Wheeler's *A Treatise on Commerce* (London, 1601); William of Orange's *A Discourse Consisting of Motives for the Enlargement and Freedom of Trade* (London, 1645), and Dudley Digges (ed.), *The Compleat Ambassador* (London, 1655) proved invaluable.

For Spanish sources, I widely consulted Irene A. Wright's translations of original Spanish papers in *Documents Concerning English Voyages to the Spanish Main 1569–1580*, vol. 1 (London, 1932); J. Calvar Gross (ed.), *La Batalia del Mar Océano: Génesis de la Empressa de Inglaterra de 1588*, vol. 1 (Madrid, 1988); and Geoffrey Parker's *The Grand Strategy of Philip II* (New Haven, 2000), as well as *The Dutch Revolt* (London, 2002). I also referred to the *Archivio de Indias* in Seville, the *Legajos* from the *Casa de Contratacion* 5109, 5110; *Justicia* 908; the *Indiferente General* 742, 1866; Panama 44, 45; and Santo Domingo 15, 51, 73, 81, 129, 184, and 186. In addition, I found Andrew Wheatcroft's *The Hapsburgs* (London, 2004) fascinating reading.

Specific to the Low Countries, the works of Baron Kervyn de Lettenhove *Les Relations des Pays Bas et l'Angleterre*, vols. 1–4 of 11 volumes (Brussels, 1882) is equivalent to the Calendar of State Papers relating to English affairs for the period. John Stow's *Survey of London* (London, 1598) is a fabulous research tool. The French ambassador's letters expertly edited by A. Teulet, *Correspondance diplomatique de la Mothe Fénélon*, 7 vols. (Paris, 1838–1840), gives a different viewpoint that is illusive in English documents. Also, the *Correspondence du Cardinal de Granvelle 1565–1586*, 12 vols., E. Poullet and C. Piot (eds.) (Brussels, 1877-96) gave great insight.

Conyers Read's *Mr Secretary Cecil and Queen Elizabeth* (New York,

1955), *Mr Secretary Walsingham and the Policy of Queen Elizabeth*, vols. 1–3 (Oxford, 1925), *The Seizure of Alva's Payships* in the Mariner's Mirror (London, no. 21), *Lord Burghley and Elizabeth* (Oxford, 1925), and his *Walsingham and Burghley in Queen Elizabeth's Privy Council* in the English Historical Review (London, no. xxvii, January 1913) are essential reading. Susan Brigden's *New Worlds, Lost Worlds: The Rule of the Tudors 1485-1603* (London, 2001) provided a great overview of the period and helped to put me into the mind-set of the "ruling" Elizabethan classes (merchant and gentlemen adventurers or courtiers). John Guy's *Tudor England* (Oxford, 1990) remains essential Tudor reading. J. E. Neale's *Elizabeth I* (London, 2005 reprint) gives a highly readable overview of the queen and her dilemma regarding security, marriage, and Mary, Queen of Scots. Raphael Holinshed's *Chronicles of England, Scotland, Ireland* (London, 1577), though widely seen as historically inaccurate today, provides again a good understanding of the Elizabethan mind-set.

Finally, the two great national resources, *The Dictionary of National Biography* (Oxford, 2003) and the *Oxford English Dictionary* (Oxford, 1998–2003) were widely consulted online. I cross-referenced virtually every person I wrote about in the *DNB*, and checked my sixteenth century meanings in the *OED*, both of which I subscribe to online.

Introduction

I consulted original papers from the High Court of the Admiralty, H.C.A. 24, Letters of Marque, Bonds, etc., 3, 1585, as well as State Papers, SP 46/179/32-31; SP 46/180/59A; SP 46/179/36-38; SP 94/2/78, 100. J. H. Parry's *The Discovery of the Sea* (London, 1974) was most helpful in better understanding technical aspects of seamanship. Both Garett Mattingly's *Defeat of the Spanish Armada* (London, 1959) and Felipe Fernàndez-Armesto's *The Spanish Armada* (London, 2003) also provided source material. I also used the Folio Society's edition of Richard Hakluyt's *Tudor Venturers* (London, 1970).

Chapter 1. *The Lord's Doing*

Martin A. S. Hume (ed.), vol. 1 of the *Calendar of State Papers Relating to English Affairs with Spain* (London, 1892); Richard Starkey's *Elizabeth* (London, 2000); Simon Schama's *History of Britain* (London, 2000); and Geoffrey Parker's *The Grand Strategy of Philip II* (London, 1998) were the main sources for this introductory chapter. J. Denucé's original *Lettres Marchandes d'Anvers* (Brussels, 1961) was particularly helpful in my understanding of the concerns of everyday merchants in Antwerp at the time.

Chapter 2. A Realm Exhausted

Aside from the general sources mentioned above, and in particular all of the *Calendar of State Papers*, for the relevant years, and *Acts of the Privy Council*, R. B. Wernham's *Before the Armada* (1966) and *The Making of Elizabethan Foreign Policy 1558–1603* (1980) were particularly insightful; as was G. D. Ramsay's *The City of London in International Politics at the Accession of Elizabeth Tudor* (Manchester, 1964) and W. E. Lingelbach's *The Merchants Adventurers: Their Laws and Ordinances with Other Documents* (New York, 1971 edition).

Chapter 3. The Queen, Her Merchants and Gentlemen

Again, aside from the specific and general sources above as well as the relevant *Calendars* and *Acts of the Privy Council*, Benjamin Woolley's *The Queen's Conjurer* (New York, 2001), Richard Deacon's *John Dee: Scientist, Geographer, Astrologer and Secret Agent to Elizabeth I* (London, 1968), and Dee's own *Diaries* and *The Perfecte Arte of Navigation* (London, 1577) provided the basis of the information on Dee in this chapter and others. Regarding Thomas Gresham, I referred to J. W. Burgon's two- volume *The Life and Times of Sir Thomas Gresham* (London, 1839) and Raymond de Roover's *Gresham on Foreign Exchange* (Cambridge, USA, 1949), as well as Ann Saunders's (ed.) *The Royal Exchange London* (London, 1997). The best books on Sir Nicholas Bacon and his family are *The Golden Lads* by Daphne du Maurier (London, 1977), *The Winding Stair* (London, 1976) also by du Maurier, and especially Robert Titler's *Nicholas Bacon: The Making of a Tudor Statesman* (Athens, OH, 1976). J. A. Williamson's *The Cabot Voyages & Bristol Discovery Under Henry VIII* (London, 1962) helped, too, to put the pre-Elizabethan voyages of "discovery" into context. Derek Wilson's highly readable *Sweet Robin* (London, 1981) gives great insight into Robert Dudley's relationship with Elizabeth and the greater world.

Chapter 4. The Quest for Cash

On the value of English money at the time, and the effects of the debasement under Henry VIII, I consulted the definitive work by J. D. Gould, *The Great Debasement* (Oxford, 1970). In addition to naval texts mentioned above, Michael Oppenheim's *A History of the Administration of the Royal Navy, 1509–1660* sheds interesting light on the problems facing the country, though I relied more heavily upon N. A. M. Rodger's *Safeguard of the Sea* for the contents of this chapter, as well as appropriately dated *Calendars*, *APC*, letters from de Granvelle and Mothe Fénélon, and books on Gresham and Burghley.

Chapter 5. The Merchants Adventurers, Antwerp, and Muscovy

T. S. Willan's *Studies in English Foreign Trade* (London, 1959), and S. L. Thrupp's *The Merchant Class of Medieval London* (Chicago, 1948) supplemented W. E. Lingelbach's *The Merchant Adventurers of England* (New York, 1971), W. T. MacCaffrey's *The Shaping of the Elizabethan Regime 1558–72* (Princeton, 1968), and A. B. Beaven's two-volume book *The Aldermen of the City of London* (London, 1908–13). G. D. Ramsay's *City of London* and Kenneth Andrew's *Trade, Plunder & Settlement* were also consulted.

Chapter 6. The Politics of Piracy, Trade, and Religion

Geoffrey Parker's books on the interdiction of trade with England (*Grand Strategy of Philip II,* most especially) and the *Lettres* of Cardinal de Granvelle give the crux of the Spanish perspective here. I consulted, too, Julian Corbett's (ed.) *Naval Records Society Archives*, vols. I–XIII (London, 1898). F. C. Danvers's *The Portuguese in India* (London, 1894) and H. Stevens and G. Birdwood's (eds.) *The Dawn of Trade to the East Indies, 1599–1603* (London, 1886) provided background to the Portuguese position. J. W. Elliot's *The Old World and the New, 1492–1650* (Cambridge, 1972) was perceptive. Nick Hazlewood's *The Queen's Slave Trader* (New York, 2005) and Harry Kelsey's *Sir John Hawkins* (New Haven, 2003) are essential reading for anyone wanting to study John Hawkins.

Chapter 7. Raising the Stakes

All books previously used relating to the economy and naval matters, John Hawkins, the appropriately dated *Calendars* and *APC* were also used in this chapter. Also, I consulted G. D. Ramsay's *City of London*.

Chapter 8. Cunning Deceits

In this chapter, I used the aforementioned *Calendars* books relating to economics and politics, Elizabeth's and Philip II's strategies, John Hawkins, and Hakluyt's *Principall Navigations*. Additionally, I also consulted Dava Sobel's marvelous *Longitude* (London, 1998); vol. 8 of J. A. Froude's *History of England* (London, 1872); John Blake's *West Africa, Quest for God and Gold, 1454–1578* (London, 1977); and, of course, Julian Corbett's *Drake and the Tudor Navy* (Aldershot, England, 1988).

Chapter 9. The Gloves Are Off

Again, I used the appropriate *Calendars* and *APC* in this chapter. I also consulted C. Brady's *The Chief Governors of Ireland* (Dublin, 2004) and

his edition of *A Viceroy's Vindication* (Cork, 2002). Julian Corbett, Nick Hazlewood, and Harry Kelsey provided the detail on the Hawkins voyages.

Chapter 10. *Lovell's Lamentable Voyage*
Harry Kelsey's and Nick Hazlewood's Hawkins biographies formed the basis of this chapter, along with John Sugden's amazing biography *Sir Francis Drake* (London, 1996). I also consulted the original manuscripts listed above, regarding privateering.

Chapter 11. *The Troublesome Voyage of John Hawkins*
Original testimonies from the Inquisition contained in the Spanish-affairs manuscripts highlighted above, as well as Ortho E VIII formed the basis of this chapter. Richard Hakluyt's *Principall Navigations* was a core source. Kenneth Andrews's *The Spanish Caribbean*, N. Hazlewood's *The Queen's Slave Trader*, H. Kelsey's *Sir John Hawkins*, and J. Sugden's *Sir Francis Drake* were also used.

Chapter 12. *The Queen and Alba's Pay Ships*
I consulted the *Calendar of State Papers—Spain*, as well as Richard Hakluyt's *The Tudor Venturers* and J. Calvar Gross's (ed.) *La Batalla del Mar Oceáno* (Madrid, 1988), vols 1–3. Conyers Read's *Seizure of Alba's Payships* (Mariner's Mirror, London, no. 21, pp. 450–452) provides a succinct interpretation of the events. Charles Wilson's *Queen Elizabeth and the Revolt of the Netherlands* (London, 1970) was very useful, as was Geoffrey Parker's *The Grand Strategy of Philip II* (London, 1998). Julian Corbett's above referenced works were also used.

Chapter 13. *The Cost of Failure*
I consulted Spanish manuscripts, in particular AGI Patronato 265, containing eyewitness accounts and statements. I relied on John Hawkins's own *Troublesome Voyadge* (London, 1571), which recounts events of the 1568 voyage, as well as *Francis Drake Privateer*, John Hampden (ed.) (London, 1972), which incorporates Drake's own testimony from *Sir Francis Drake Revived*. In addition, I consulted English *Calendars* for the appropriate dates and E. Arber's (ed.) *An English Garner*, 10 vols. (London, 1903) was particularly useful.

Chapter 14. *Undeclared Holy War*
I referred to the same sources I used for Chapter 13, with the addition of J. S. Corbett's *Drake and the Tudor Navy* and the *Calendar* for Rome.

Chapter 15. Drake's War

MS Ashmole 830 from the Bodleian Library, John Sugden's *Sir Francis Drake*, Irene A. Wright's superb translation of *Documents Concerning English Voyages to the Spanish Main 1569–1580*, vol. 1 (London, 1973), and John Hampden's (ed.) *Francis Drake Privateer* were the main sources I consulted for this chapter. I also used *Calendars* and the other general histories outlined in the beginning of the bibliography.

Chapter 16. The Dread of Future Foes

In addition to consulting the *Calendars* for Rome and Spain, the English manuscripts I consulted included MS Cotton Caligula, C. III and MS Additional 30156. I checked the *DNB* for the biographies of those who appear in the chapter, and used Alan Stewart's highly readable *Philip Sidney, A Double Life* (London, 2004). On the queen and the Sea Beggars, I relied upon *The English Historical Review*, vol. XLVI 1931, "Queen Elizabeth, The Sea Beggars, and the Capture of Brill, 1572," in addition to Ellis's *Original Letters Illustrative of English History* (London, 1824). Raymond de Roover's *Gresham on Foreign Exchange* was also useful.

Chapter 17. Drake at the Treasure House of the World, and
Chapter 18. From a Treetop in Darien

All of the Drake biographies, and especially his own version of events, I relied upon heavily when working on this chapter. Additionally, Harry Kelsey's *Sir Francis Drake: The Queen's Pirate* (New York, 1998) was also useful.

Chapter 19. Success at a Cost

I relied on all the Drake biographies again here, as well as Julian Corbett's *Drake and the Tudor Navy*, and my book, *The Sancy Blood Diamond* (New York, 2004), specifically relating to previous research regarding Drake, Queen Elizabeth, and Dom Antonio of Portugal. Kenneth R. Andrew's *Trade, Plunder & Settlement* proved invaluable.

Chapter 20. Dr. Dee's Nursery and the Northwest Passage

Few of us today appreciate just how pivotal Dr. John Dee was to the exploration process. This becomes quite apparent in this chapter through his own writings in his *Private Diaries* (London, 1842 reprint) and *The British Monarchy or General & Rare Memoria* (London 1577), in which his treatise on the *Petty Navy Royal* first appears. Benjamin Woolley's *The Queen's Conjurer* and Nicholas Crane's exceptional *Mercator* (London, 2003) are gripping and wonderful reads, and I used them both in this chapter. I referred to George Beste's *A True*

Discourse of the Late Voyages of Martin Frobisher . . . (London, 1578), as well as Hakluyt's *Principall Navigations* and the Exchequer E351 State Papers.

Chapter 21. Dark Days at Rathlin Island
The Drake biographies (particularly Sugden), Sir Henry Sidney's *A Viceroy's Vindication*, C. Brady (ed.), and C. Brady's *The Chief Governors of Ireland* were my prime sources here. MS Additional 48015 and SP 63/51 and 63/54 (Ireland) were also useful. *The Correspondence of Sir Philip Sidney and Hubert Languet*, S. A. Pears (ed.) (London, 1845) was also illuminating.

Chapter 22. Drake's Perfect Timing
Drake's own account in *Sir Francis Drake Revived* forms the primary source for this chapter. Derek Wilson's *Sweet Robin*, about Robert Dudley, Earl of Leicester; Harry Kelsey's *Sir John Hawkins*; John Sugden's *Sir Francis Drake,* and Kenneth R. Andrews's *Trade, Plunder & Settlement* were used to corroborate some of Drake's assertions. Also BL MS Lansdowne 113, and John Dee's *A Petty Navy Royal* were integral parts of my research. I also referred to Thomas Greepe's account *The True and Perfect News of the Worthy and Valiant Exploits Performed and Done by That Valiant Knight, Sir Francis Drake* (London, 1587).

Chapter 23. The Northwest and the Company of Kathai
George Best's original *A True Discourse of the Late Voyages of Martin Frobisher* . . . was my primary source for this chapter. The appropriately dated *Calendar of State Papers—Domestic* and *Colonial* were also useful. I relied upon Richard Hakluyt's *Principall Navigations* and Andrews's *Trade, Plunder & Settlement*, too.

Chapter 24. In the Shadow of Magellan
The chapter in Samuel Taylor Coleridge's *More Light on Drake* (London, 1907), which in turn was based on Robert Winter's June 1579 report, was one source here. However, John Sugden's *Sir Francis Drake*, *Monson's Tracts,* J. Calvar Gross's *La Batalla del Mar Océano*, and N. A. M. Rodger's *Safeguard of the Sea* were my primary sources. Some of these sources relied heavily, in turn, on W. S. W. Vaux, *The World Encompassed* (London, 1628).

Chapter 25. Into the Jaws of Death
I consulted all of the Drake biographies here in order to determine a consensus of the actual events.

Chapter 26. The Famous Voyage

La Batalla del Mar Océano, which is a Spanish Calendar of State Papers, provides illuminating reading, and it was fascinating to see what the Spanish were or were not able to glean about Drake's circumnavigation. In today's age we often lose sight of truly historic events accomplished by the grit and determination of one man, and Drake's circumnavigation— though still appreciated by mariners everywhere—seems somehow not to be earth-shattering in the twenty-first century. I consulted all books relating to the period here, in particular the Drake biographies, Drake's own account in *The World Encompassed*, and de Herrera's *Historia General de Mundo* (Madrid, 1606). For reasons that were apparent in the book, this had to remain a secret.

Chapter 27. The World Is Not Enough

I referred to the *Calendar* of Spanish and Domestic State Papers—*Spain* and *Domestic* for the relevant years, but Julian Corbett's insight from *Drake and the Tudor Navy*, as well as the Drake biographies, made up the core of my research for this chapter. The *La Batalla del Mar Océano* also provided further insight.

Chapter 28. Elizabeth Strikes Back in the Levant

I say in this chapter that Elizabeth (as other monarchs in her time and after) held a copy of Niccolò Machiavelli's *The Prince* and his *Discourses* in her library. These would have both been essential reading for any ruler, and remained in print as Penguin Classics to this day. Hakluyt's *Principall Navigations*, S. A. Skilliter's *Harborne* (London, 1977), and Kenneth Andrews's *Trade, Plunder & Settlement* provided the core of my research for this chapter, double-checked against their own sources and the State Papers highlighted above.

Chapter 29. Katherine Champernowne's Sons Take Up the American Dream

When it comes to the early colonization of America, David B. Quinn is the acknowledged expert. His books—*England and the Discovery of America, 1481–1620* (London, 1974), *European Approaches to North America, 1450–1640* (Aldershot, 1998), *Some Spanish Reactions to Elizabethan Colonial Enterprise* (London, 1976), *The First Colonists* (London, 1978), *Ralegh and the British Empire* (London, 1973)—were extremely useful to this and subsequent chapters, with his *Ralegh and the British Empire* being the most widely quoted. Anna Beer's highly readable *Bess: The Life of Lady Ralegh* (London, 2003) gives an unusual insight into Raleigh, and especially his long-suffering wife. Of course the requisite Calendars and manuscripts also formed part of my

research. In addition, I consulted D. B. Chidsey's *Sir Humphrey Gilbert, Elizabeth's Racketeer* (New York, 1932), Benjamin Dutton's *Navigation and Nautical Astronomy* (Annapolis, 1951), Richard Hakluyt's *Divers Voyages Touching on the Discovery of America* (London, 1598), A. L. Rowland's *Studies in English Commerce and Exploration* (London, 1924), and J. E. D. Williams's *From Sails to Satellites, the Origin and Development of Navigational Science* (Oxford, 1992).

Chapter 30. The Defeats of 1582–84
I had previously written about the Dutch Revolt as part of *The Sancy Blood Diamond*, and so much of my background research was based on those sources. In addition, the John Sugden biography *Sir Francis Drake* and Harry Kelsey's *Sir John Hawkins* proved useful too. Spanish State Papers in *Justicia* 908 were also part of my core research.

Chapter 31. Water!
All D. B. Quinn's works formed my primary research for this chapter, as well as the collection of *The Letters of Sir Walter Ralegh*, Agnes Latham and Joyce Youings (eds.) (London, 2001). Richard Hakluyt's *Virginia Voyages* (London, 1973) and Derek Wilson's *Sweet Robin* (London, 1981) were also useful.

Chapter 32. Roanoke
E. G. R. Taylor's *Writings of the Hakluyts*, 2 vols. (London, 1935); Charles Deane's (ed.) *Discourse on Western Planting* (London, 1877); R. B. Wernham's *The Making of Elizabethan Foreign Policy* (Berkeley, 1980); Kenneth Andrews's *Trade, Plunder & Settlement*; D. B. Quinn's *Ralegh and the British Empire*; Richard Hakluyt's *Virginia Voyages*; and Giles Milton's highly informative and readable *Big Chief Elizabeth* (London, 2000) were all source material for this chapter.

Chapter 33. The Queen Lets Loose Her Dragon
I referred to the same sources I used in chapter 32, with the addition of David Loade's *The Tudor Navy* (Aldershot, 1992), which is a long overdue update of Julian Corbett's great work *Drake and the Tudor Navy*. I also widely consulted Geoffrey Parker's *The Grand Strategy of Philip II*, John Sugden's *Sir Francis Drake*, and the *Calendar of State Papers*.

Chapter 34. The Camel's Back
My *Sancy Blood Diamond* and its sources, as well as Garrett Mattingly's timeless *The Defeat of the Spanish Armada* (London, 1959) were my primary sources for this chapter.

Chapter 35. Cadiz

There were so many different accounts of the Cadiz expedition that I felt it wisest to revert to original sources here, then double-check against trustworthy secondary sources. I consulted the relevant *Calendars of State Papers—Spain* and *Venice*, as well as SP 12/193; BL MS Cotton Otho E VIII; BL MS Cotton Vespasian, CVIII; and the books mentioned throughout chapter 35.

Chapter 36. The Plundering of the Spanish Armada

I reviewed Julian Corbett's *The Spanish War* for this chapter and subsequent chapters. J. K. Laughton (ed.), *State Papers Relating to the Defeat of the Spanish Armada*, vol. 1 (London, 1898) carries a huge number of original letters and orders. N. A. M. Rodger's *Safeguard of the Sea*, Kenneth Andrews's *Trade, Plunder & Settlement,* R. Wernham's *The World Before Armada*, and of course Garrett Mattingly's *The Defeat of the Spanish Armada* were also primary research sources. R. W. Kenny's biography *Elizabeth's Admiral*, about Lord Admiral Charles Howard (Baltimore, 1970), also provided great background material, and is highly readable.

Chapter 37. America Again ... and Again?

Raleigh's *The Letters of Sir Walter Ralegh*, Agnes Latham and Joyce Youings (eds.); D. B. Quinn's *Ralegh and the British Empire*; Kenneth Andrews's *Trade, Plunder & Settlement*; Richard Hakluyt's *Principall Navigations*; T. S. Willan's *Studies in Foreign Trade* (London, 1959); A. L. Rowse's *Sir Richard Grenville of the* Revenge (London, 1937) and *The Elizabethans and America* (London, 1959); and Giles Milton's *Big Chief Elizabeth* were my main sources used in this chapter.

Chapter 38. The Last Gasp of the Early Roaring '90s

All the books I used in chapters 36 and 37 I used in this chapter, too. Additionally, I consulted Julian Corbett's *Successors of Drake* and his edition of *Papers Relating to the Spanish War*. The *Calendar of State Papers—Venice* was particularly useful, providing an "unbiased" view of the rampant English adventuring. D. Akenson's Talmudic *An Irish History of Civilization*, vol. 1 (London, 2005) provides a fascinating insight into the English in Ireland, incorporating a tremendously innovative, highly entertaining style.

Chapter 39. The Alchemy That Turned Plunder into Trade

All books used in the previous four chapters were again primary sources for this chapter. Additionally, Kenneth Andrews's *The Elizabethan*

Seaman; Michael Oppenheim's *A History of the Administration of the Royal Navy*; the *DNB* entry on Robert Cecil; Lord Burghley's *Advice to a Son*, Louis Wright (ed.) (New York, 1961); J. W. Shirley's *The Scientific Experiments of Sir Walter Ralegh: The Wizard Earl and the Three Magi in the Tower, 1603–1617* (London, 1949); A. Tenenti's *Naufrages, Corsaires et Assurances Maritimes à Venise, 1592–1609* (Paris, 1959); and V. M. Shillington's and A. B. W. Chapman's *The Commercial Relations of England and Portugal* (New York, 1970) proved extremely useful. R.W. Kenny's *Elizabeth's Admiral*, Kenneth Andrews' *Elizabethan Privateering and Trade, Plunder & Settlement*, and N. A. M. Rodger's *Safeguard of the Sea* were also widely used and often quoted.

Chapter 40. Essex, Ireland, and Tragedy
The *DNB* entries for Robert Devereux, 2nd Earl of Essex, and Hugh O'Neill were useful, though it was D. Akenson's *An Irish History of Civilization* that I found the most refreshing. Original manuscripts from the Folger Shakespeare Library (especially FSL, MS V.b.214) and the British Library's MS Additional 74287 were also useful. The relevant *Calendars of State Papers—Ireland*, *Spain*, and *Domestic* papers were also source material. Finally, G. R. Elton's *England Under the Tudors* (London, 1993) provided me with an overview.

Chapter 41. Raleigh, Virginia, and Empire
Again here, D. B. Quinn's books proved invaluable, particularly *Ralegh and the British Empire. The Letters of Sir Walter Ralegh*, by Agnes Latham and Joyce Youings (eds.) were incredibly helpful, too.

Chapter 42. The East and the East India Company
John Keay's *The Honourable Company* (London, 1993) was a prime source for this chapter, as well as James Lancaster's *Voyages to Brazil and the East Indies, 1591–1603*, W. Foster (ed.) (London, 1943); E. M. Jacobs, *In Pursuit of Pepper and Tea* (London, 1996); *Calendar of State Papers— Colonial* (vol. 1); W. Foster's *England's Quest of Eastern Trade* (London, 1933); *East India Company: The Dawn of British Trade to the East Indies ... 1599-1603,* Steven and Birdwood (eds.); and K. N. Chaudhuri's essential tome, *The English East India Company 1600-1640* (London, 1945).

Index ❧

Sweden, 55
Sydae, James, 193, 214
Temple, Richard, 124
The Lie (Raleigh), 371
Thévet, André, 177, 187
Throckmorton, Sir Francis, 253, 254, 258
Throckmorton, Sir Nicholas, 8, 29, 63–64
Tiepolo, Paulo, 67
Tipton, Hugh, 73
Tordesillas, Treaty of, 20
Torrequemada, García Fernández de, 283–84
trade: Anglo-Iberian, 57, 199; Anglo-Portuguese, 199; Antwerp and, xv, 28, 31–32, 38, 43–44; arming of England from Antwerp, 32; with the Barbary Coast, 199; British Empire and, 41; Calais and, xv, 28; Cathay Company, 206–13; China (Cathay), xv, 19, 52, 96; City of London companies, xx, xxiii, 15; Company of Merchant Adventurers, xix, 15 (*see also* Merchant Adventurers, Company of); with Constantinople (Ottoman Turks), 200; depressed by piracy, 343, 344; Dutch, 364–65; East Indies, 15, 345, 362–68, 372–73; Elizabeth suspends trade with Spanish Netherlands, 278; Emden replaces Antwerp, 76, 83, 98; English, in the Mediterranean, 199; English, with Brazil, 21–22; English economy dependent on, 41; English joint stock companies, 340; English loss of Calais and, 6; English maritime expansion and, xvi; English merchant adventurers, 17–18, 66, 89, 105, 116,

156, 158, 185, 340, 342–45; English-Middle Eastern, 200; English monopolies, 199; English munitions to Morocco and Ottoman Empire, 344; English port cities and, 15, 21, 22; English pound sterling and, 42–43; English tin, 43; English trade war with Spain, 99; English wine fleet, 130, 134, 146; English wool and cloth, 6, 15, 21, 26, 32, 38, 41, 70, 75–76, 100, 103, 146; foreign, in London, 43; French civil wars and, 63; Hamburg alliance with England, 38, 50–51; Hanse merchants, 39; Hanse trade block, 38; under Henry VIII, 22; illegal, by pirates, xix; India, 246–47; interloping into Spanish and Portuguese waters, 59, 69, 74; Italy and, 43; Levant traders, 199–200; 242, 245–47, 364, 365 (*see also* Levant Company); luxury goods for Elizabethan court, 22, 246; Mercers' Company, 21; Muscovy Company, xv–xvi, 21; Netherlands closed to the English, 75–76, 98; North America, 361, 371–72; Northeast Passage sought, 19, 46, 99–100; Northwest Passage sought, 179, 183, 185–90, 191, 231, 248, 249, 250; with Persia, 49, 50, 52; Portuguese empire, xvi; with Russia, xv–xvi, 47–49, 50, 100, 156; slave, 66, 68–73, 80, 103, 106, 117–19, 142; Spanish Company (English), 237, 344; Spanish merino wool, 43; Spanish seizure of English (Lutheran) ships, 57, 58, 67, 74; Spice Islands,